Masterpieces of Western Art

Volume II

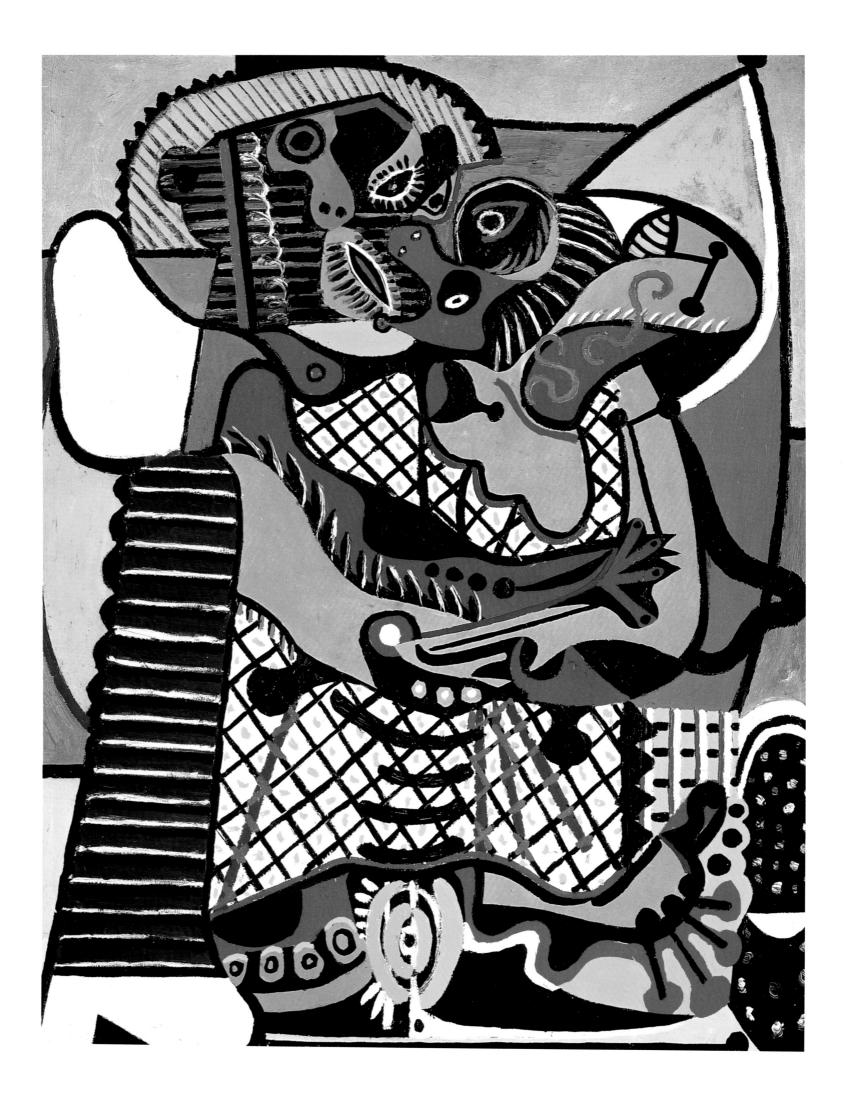

MASTERPIECES OF WESTERN ART

A history of art in 900 individual studies

Edited by Ingo F. Walther

Volume II

FROM THE ROMANTIC AGE TO THE PRESENT DAY

by Barbara Eschenburg, Ingeborg Güssow, Christa von Lengerke, Volkmar Essers

Page 2:
Pablo Picasso
The Kiss, 1925
Oil on canvas, 130 x 97 cm
Paris, Musée Picasso

This book was printed on 100% chlorine-free bleached paper in accordance with the TCF standard.

© 1996 Benedikt Taschen Verlag GmbH Hohenzollernring 53, D-50672 Köln © 1995 for the illustrations: VG Bild-Kunst, Bonn, artists' heirs and artists Editing and production: Ingo F. Walther, Alling Cover design: Angelika Muthesius, Cologne English translation: Ishbel Flett, Frankfurt/M.

> Printed in Germany ISBN 3-8228-8909-1 GB

Contents

Romanticism and Realism	407
Painting in the 19th century	
from Friedrich to Courbet	
Impressionism, Art Nouveau and Jugendstil	475
Painting from 1860 to 1910	
from Manet to Klimt	
Classical Modernism	543
Painting in the first half of the 20th century	
from Picasso and Matisse to Klee	
Contemporary Painting	615
New movements in painting since 1945	
from Pollock to Baselitz	
Appendix	681
Biographies of the artists	
Acknowledgements	
Authors	

Barbara Eschenburg/Ingeborg Güssow

ROMANTICISM AND REALISM

Painting in the 19th century

In the 19th century, for the first time, it was the bourgeoisie who determined the content and form of art throughout Europe. Major works by the French artists Géricault, Delacroix and Courbet were no longer dedicated to the glory of religious or secular power, but to heroic renderings of the nation and its people, workers, peasants or even artists. The longstanding rivalry between idealism and realism was finally settled in favour of artistic subjectivity. Abandoning the stringent rules of the state academies, painters whether they still regarded themselves as Neoclassicists, as Ingres did, or as romanticists and realists - now began claiming their own genius and nature as their sole sources of inspiration. Following the breakthrough of plein-air painting, such a claim could best be realized in landscape painting: in the work of Friedrich and Koch in Germany, Rousseau and Corot in France, Constable, Bonington and Turner in England, and Church and Cole in the USA. The exploration of natural light, which was to culminate in the work of the Impressionists, completely changed the handling of colour in paintings and may be regarded as the single most important innovation in painting during this period.

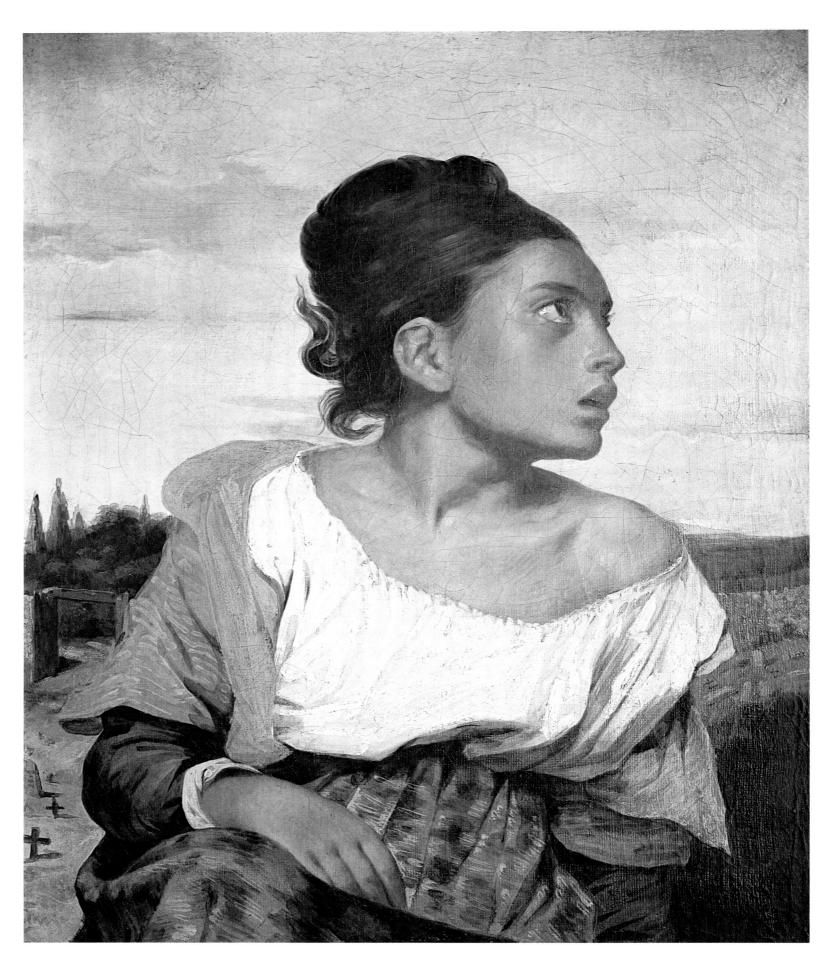

Eugène Delacroix Orphan Girl at the Cemetery, 1823 Oil on canvas, 66 x 54 cm Paris, Musée National du Louvre

1. IDEALISTS:

Academicians in France

Since the absolutist state of the 17th and 18th centuries had begun bringing its influence to bear on art and taste through the founding of academies, the officially recognized art promoted by the academies had been locked in rivalry with those who, though they had to rely entirely on the art market, nevertheless endeavoured to find a place for their work in the official exhibitions monopolized by the academies. The first Académie Royale de Peinture et de Sculpture was founded in Paris in 1648 under Louis XIV. With the Salon exhibitions held at regular intervals, every two years, from the second half of the 18th century onwards, the Académie achieved an influence on artistic production and the art market that made it imperative for artists to deal with this institution and, if possible, to seek a good position in the Salon exhibitions.

Remarkably enough, the French Revolution of 1789 changed very little in this respect. Although the Académie Royale was disbanded in 1793, its successor, the Académie des Beaux-Arts, exerted just as strong an influence on the French art world right through to the second half of the 19th century. As a member of the art commission of the National Convention, the already famous painter Jacques-Louis David presided over the dissolution and re-establishment of the Académie. A keen partisan of the spirit of the Enlightenment, David was an ardent proponent of the French Revolution and later a great admirer of its heir, Napoleon I (1769–1821).

In his capacity as a teacher at the Académie, David propagated the ideas of the Enlightenment. He saw art as a discipline that could, in principle, be taught, and believed that an artist could and should learn considerably more than the mastery of technique alone.

In contrast to the approach that prevailed under the old Académie Royale, however, David placed considerable emphasis on the personal relationship between teacher and student. It was still widely believed that art should serve the edification and moral education of the citizen, for which the Roman republican virtues were still seen as a rich source of allegorical material. Before the revolution, such motifs had been used to hold up a mirror to the ruling classes. Now, in the name of the same virtues, it was possible to glorify the ideals of the French Revolution and the new state. The stringent Neoclassicism based on draughtsmanship which David had already developed under the ancien régime was regarded as a suitable means to this end. David's students François Gérard (1770–1837) and Antoine-Jean Gros (1771–1835) upheld the tradition of this style, albeit with a certain painterly modification in the case of Gros, who went on to become the leading war artist of the Napoleonic campaigns (ill. p. 424) which David had also glorified in his monumental canvases (ill. p. 366).

In the post-revolutionary and post-Napoleonic period of the Restoration, Jean Auguste Dominique Ingres (1780-1867), another student and faithful follower of David, continued to propagate his master's style. Though he, too, initially produced history paintings based on Roman themes, he later became the sought-after portraitist of the aristocracy and of those members of the bourgeoisie (ill. p. 430) who had risen to wealth and power with the July Monarchy. The emphasis on material and texture in Ingres' portraits sets them apart from David's paintings which feature predominantly light backgrounds and blocks of colour frequently juxtaposed without mellowing chiaroscuro. The rich colours of sumptuous, flowing garments are given added brilliance by the use of glazing. His works were to have a profound influence on portraiture throughout the first half of the 19th century, especially on the Biedermeier period between 1815 and 1848.

Apart from bourgeois portraiture, which was one of the main genres of painting in the 19th century, Ingres concentrated primarily on female nudes. In his famous Valpinçon Bather (ill. p. 429), the bold spirit of innovation that informed David's paintings of the revolutionary period is still manifest, reflected in the Neoclassical monumentality of an otherwise insignificant motif, with none of the mythological or oriental trappings for which Ingres would later develop a taste. Bearing in mind that, before the French Revolution, the portrayal of naked female bodies in Rococo painting had had a distinctly erotic flavour, the new morality of this artist is clear. The sensuality of his works lies in the pleasure of contemplating the quiet beauty of objects in a light-flooded room, whose vertical and horizontal structure they absorb. The painting is like a still life. It is the presence of the objects alone that is important. Even the human figure becomes an object too, for the face as a sign of individuality is turned away from the spectator, lending the body the same silent existence of the ambient materiality, transfigured by light.

Opponents of the Academy in Germany: Neoclassicists in Rome

Just as the Académie in Paris was dependent on the French monarchy, so too were the academies founded by German territorial princes in the 18th century the instruments of their rulers. In Germany, as in France, the 1790s were marked by an increasing disaffection of artists with the stultifying strictures of academic regulations, which they saw as a restriction of their creativity. However, unlike France, where such resistance had resulted in the disbanding and reorganization of the Académie in the wake of the French Revolution, in Germany, where feudal rule continued, it remained a purely individual form of protest, the consequences of which were borne by the artists alone. It was not unusual towards the end of the 18th century for German artists to break with the acad-

emies in order to pursue their own aims in art. The Tyrolean artist Joseph Anton Koch (1768–1839) fled from the Karlsschule academy in Stuttgart, whose militaristic regimentation had also been reluctantly endured by Friedrich von Schiller (1759–1805). Asmus Jacob Carstens (1754–1798) was expelled from the Copenhagen academy for his oppositional views. Johann Friedrich Overbeck (1789–1869) and Franz Pforr (1788–1812) turned their backs on the Vienna academy out of protest. All these artists, to name but a few of the more famous, chose to live in Rome, which was then the leading international centre of art.

The French Académie was the first to hold regular competitions amongst its students on a topic of ancient history or mythology, awarding the winner an opportunity of studying art in Rome. England, Copenhagen and various German academies and art schools soon followed suit in sending their most accoladed artists to live and study in the Eternal City. The German artists mentioned above, however, all came to Rome as outsiders, without the support of the academies, and had to forgo the creature comforts such academic support could provide in Rome. Both Carstens and Koch actually went to Rome on foot and were obliged to undertake all manner of menial tasks to earn a living. They had to make considerable sacrifices in order to pursue their express aim of renewing German art by liberating it from courtly restrictions. Nor were they prepared, at the end of the normal study period, to return to the hated feudal society of their homeland, where outmoded conventions had survived well beyond the French Revolution. They had in common a deeply moral attitude to art and life, and an imperturbable faith in their own creative power and its ability to flourish without academic regulation. Carstens, who had already gone to Rome several years before, was joined there by his younger colleague Koch. Both were vehement anti-monarchists. Carstens even turned down an appointment as an academy professor in Berlin. On his journey to Rome, via Strasbourg and Switzerland, Koch joined the Jacobin Club in Strasbourg, opponents of the old order that still prevailed in Germany. It was an act of high treason.

Koch's paintings of the falls and mountains of Switzerland, such as his *Schmadribach* (ill. p. 450) or *Swiss Landscape* (ill. p. 450) reflect the spirit of the Enlightenment, which saw Switzerland as an exemplary country of free citizens. The sublime landscape was regarded as an appropriate symbol for the purported dignity of the people of this country. Koch's water-colours of his Swiss tour, executed in the 1790s, and on which these compositions are based, possess a painterly freedom no longer evident in his finished works. Their emphasis on the invention and construction of landscape leans heavily on the Neoclassical landscape painting of the 18th century, to which Koch added a remarkable degree of attention to detail, more akin to the art of the Renaissance and late Middle Ages than to that of the Baroque.

A stylistically freer approach would have been diametrically opposed to such a concept. Though a trend towards a more freely executed and sketchier style, even in the finished painting, had emerged in the 1830s and found increasing acceptance, Koch, who lived until 1839, did not adopt it himself. This goes some way towards explaining how an artist so bitterly opposed to the old-style academies and so openly disposed towards artistic and individual freedom eventually came to be held up as a shining example by the conservative academies in Germany against the emergence of *plein-air* painting, and how the radically oppositional art of Koch and his contemporaries finally came to be acknowledged by the prevailing authorities in Germany, from the second decade of the 19th century onwards, as the epitome of German art.

The artists who were the innovators of German art in the early years of the century had opposed the opinions of the academies in two ways. On the one hand, they acknowledged only the free invention of the creative individual, whereas academic tradition recognized invention in the skilled application of the acquired and the familiar. On the other hand, these artists valued an altogether unacademic concept of the dignity of craftsmanship, reminiscent of the late medieval and Renaissance tradition.

With their emphasis on free invention, they nevertheless embraced a tradition that owed its very existence to the academies. In the early modern age, artists had come to value intellectual creativity - that is to say, invention - more highly than skilled craftsmanship and had declared themselves the equal of poets and philosophers, who had been ranked as practitioners the liberal arts in the Middle Ages. when painting, sculpture and architecture were still regarded as merely mechanical crafts. The academies, which placed the main emphasis on the theoretical foundations of art, eventually became the guardians of fine art as an intellectual activity and therefore as a liberal art. The rebellious artists of the early 19th century wanted to uphold this basic concept, but in doing so, they looked back to the pre-academic or extra-academic tradition of the early modern period, in particular the Italian art of the 15th to 17th centuries.

Catholic Romantics: The Nazarenes in Rome

Carstens and Koch had already turned their backs on mythological and historical motifs inspired by the Roman republic. They drew their motifs from contemporary life, from the Bible and the writings of Hesiod (c. 700 B.C.), Dante and Ossian (3rd century A.D.). One of the most popular themes was the portrayal of the Golden Age of human harmony at the dawn of history, in which many leading figures of the German Enlightenment, from Immanuel Kant (1724–1804) to Schiller, saw the promise of a future society of liberty and equality, free from feudal privilege, the seeds for which had already been sown in their lifetime.

The younger artists in Rome, grouped around Overbeck and Pforr, looked instead to medieval and Renaissance religious art for their models. For them, Christianity was the guarantee of a life untrammeled by courtly superficiality, in which the truth, humility and profundity of the German soul could find expression. Unlike the Neoclassicists Carstens and Koch, they did not seek a future society free of autocracy, but dreamt instead of the emergence of a powerful empire of German nations in which spiritual and secular rule would hold equal sway, as in the medieval Holy Roman Empire, with the former possibly even taking precedence. In order to set an example of humility, the former exiles of the Viennese academy - Overbeck and Pforr - followed by artists from Düsseldorf and Munich (Wilhelm von Schadow, 1788-1862; Peter von Cornelius, 1783-1867; Julius Schnorr von Carolsfeld, 1794-1872), set up their own brotherhood along monastic lines. The Protestants amongst them converted to Catholicism. Because of their manifest piety, the Italians sarcastically dubbed them i nazareni in reference to Jesus of Nazareth.

In a bid to emphasize the serious intent of their objectives, the Nazarenes were not content merely to adopt medieval and Renaissance themes superficially. Instead, they were also eager to revive medieval painting techniques. For example, instead of the more conventional large canvases, they revived the practice of painting on small wooden panels and they used an extremely fine glaze painting on a white ground, superimposing layers of transparent colour to achieve the depth and brilliance of late medieval painting. It would nevertheless be wrong to surmise that these artists were willing to place themselves on a par with medieval craftsmen, for their ideas and their lifestyle were entirely the product of their own free and creative will, their "invention", and were not imposed upon them by any craftsman's guild. In other words, for all the apparent humility of their religious craftsmanship, they were not lacking in self-esteem or sense of vocation, as the key works of Overbeck and Pforr confirm.

In Pforr's painting Shulamith and Mary (Euerbach, Schäfer Collection), together with Overbeck's Italia and Germania (ill. p. 454), begun in 1811, the iconography of the Renaissance and the late Middle Ages is used to portray the imagined brides, which both artists saw as the muses of their art, equating them with the Madonna. Pforr, who glorified medieval chivalry in his other works, whereas Overbeck dedicated himself almost exclusively to reviving religious painting, has gone furthest in his equation of creative, private and religious concepts. Shulamith, Overbeck's future bride, is presented on the left like the Madonna with Child, set in the landscape, while Pforr's Mary is placed in an old German chamber like the Madonna of the Annunciation. In the final version of his painting produced in 1828, however, Overbeck avoided direct references to the Madonna paintings of the period around 1500, and rendered his female figures as

personifications of Italian and German art, to which the Nazarenes felt indebted.

The artists of the Nazarene Brotherhood also set about reviving medieval and Renaissance Italian fresco painting. This was, to all intents and purposes, a new start, as fresco painting had fallen out of favour in the age of the Enlightenment – even in Southern Germany, where it had been used to decorate innumerable Baroque churches – and the technique of painting on wet plaster had been all but forgotten. The Prussian Consul General in Rome, Jakob Salomon Bartholdy (1779–1825) offered a welcome opportunity of practising this technique by commissioning the Nazarenes to decorate his apartment in the Casa Zuccaro with scenes from the life of Joseph (ill. p. 454). The frescos they executed brought fame to Cornelius, in particular, who succeeded in creating figures of a monumentality that equalled their powerful gestural and physical expressiveness.

Such nationalistic fervour in the field of art did not go unrewarded. Three former Nazarenes received appointments as directors of academies, whose princely founders sought to employ the artistic ideals of these artists living in Rome for the purposes of reviving a monumental state art: Cornelius was appointed to Munich in 1825, Schadow to Düsseldorf in 1826 and Philipp Veit (1793–1877) to the Städel in Frankfurt am Main in 1828. Schnorr von Carolsfeld also received major public commissions in Munich. Their idealism in techniques of drawing prevailed in German monumental and history painting until well beyond mid-century. On the arrival of Karl Theodor Piloty (1826–1886) whose powerful realism was influenced by Belgian painting, this idealism began to fall into disfavour, and was no longer regarded as typically German, but simply as old-fashioned.

Protestant Romantics: Runge and Friedrich

Just as Rome was the centre of a southern Romanticism shaped by the spirit of Catholicism, Northern Germany was the home of another, northern, Romanticism imbued with the spirit of Protestantism. Its main exponents were Philipp Otto Runge (1777–1810) and Caspar David Friedrich (1774-1840). Both had trained at the Copenhagen academy, which had been founded in 1754 on the French model. During the period when Friedrich (from 1794) and Runge (from 1799) were students there, the training system of the 18th century still prevailed, with studies from plaster casts taking precedence over life studies. Runge had complained bitterly of this in his critique of the academy, entitled Rembrandt-Traum ("Dream of Rembrandt"), in December 1799. From the 1820s onwards, the situation in Copenhagen altered dramatically. Amongst the students of Christoffer Wilhelm Eckersberg (1783-1853), himself a student of David who had studied in Rome and taken up a professorship in Copenhagen in 1818, a light-toned realism emerged which was to influence the realism of the 1830s in Germany.

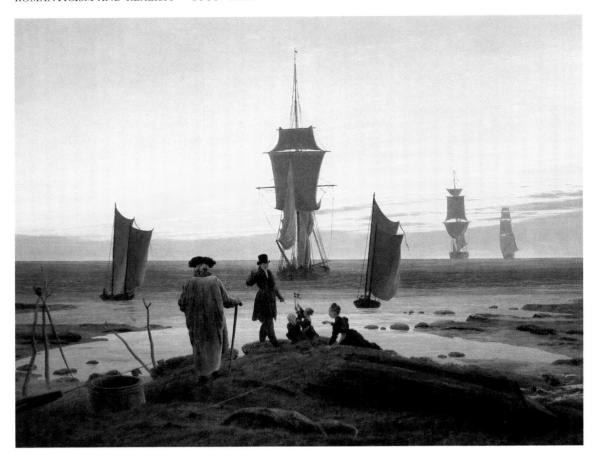

Caspar David Friedrich The Stages of Life, c. 1835 Oil on canvas, 72.5 x 94cm Leipzig, Museum der bildenden Künste

Dresden was the next important station for Friedrich and Runge. Here, they were influenced less by the academy itself than by their studies in the municipal gallery. Friedrich remained in Dresden, becoming a member of the academy with a fixed salary in 1816, retaining his contacts with his home town of Greifswald on the Baltic coast and visiting the island of Rügen on numerous occasions. Runge, on the other hand, moved to Hamburg, where his family background afforded him considerable financial independence. It is interesting to note that Rome did not feature in the artistic development of either of these two artists, important as the city was for most artists at that time.

Both Runge and Friedrich were deeply religious men who sought a renewal of German art on the basis of the pious Protestant spirit which so influenced Germany's educated middle classes. If art was to be religious, or if it was to generate a sense of religious spirituality, then this was certainly not to be equated with the portrayal of biblical figures and legends such portrayals had been commonplace in Catholic churches until the 18th century and the Nazarenes had sought to revive this in the spirit of the Middle Ages and the Renaissance. The northern Romantics did not aim to present a specific content, but to convey a certain spirit or attitude. Such an undertaking called for new forms of presentation. Runge's observation of a general "convergence towards land-scape" is a frequently cited description of the early Romantic movement that can also be applied to the 19th century, for it

invokes the late 18th century notion that the vision of a sublime landscape in art could guide the spectator directly towards an awareness of God's greatness.

In Runge's work, landscape came to symbolize man's close harmony with the divinity of the cosmos (ill. p. 453). In portraying this harmony, Runge transformed the colours of his objects into purely spectral colours, illustrating the natural cycle of life through light and darkness, or through symbolic figures merged with meticulously detailed plants and blossoms. Colours were thus used to lend a new and immaterial aspect to nature, while the symbolic figures added a psychological component that allowed the spectator to identify more closely with the cycle of nature. In this way, religion becomes a spiritual value whose content is inextricably linked with the subject itself. Indeed, it consists of an emotional perception of cosmic structures, for which art builds the psychological bridges.

Unlike Runge, Friedrich did not paint imagined, cosmic worlds of nature in which the earthly landscape is merely a part, but drew his inspiration instead from the real landscape, peopling it with figures from contemporary bourgeois reality. To this end, he undertook lengthy walks in the little-known and sparsely populated mountains of Saxony, Silesia and Bohemia, and on the island of Rügen. As neither tourism nor hiking trails existed, such travels were naturally fraught with difficulty. The works created on the basis of these journeys are quite evidently based on personal experi-

ence. Friedrich chose locations — a slope, a summit, the seashore — that had never before been presented in this form in landscape painting. He created, for the first time, images in which the viewer could identify directly with the standpoint of the painter or with the figures in the landscape. This standpoint is generally a perilous position from which the yearned-for expanses and the transfiguring light of distance are merely hinted at. In conventional landscape painting, the painter and the viewer generally remained at a safe distance from the image of nature. Now, in the work of Friedrich, the viewer became part of the scene, often teetering on the border between proximity and distance, darkness and light.

Friedrich's paintings convey a profoundly melancholic world view. Though they do express the hope that the divine light of the cosmos will reach the earthly existence of the individual, the fulfilment of that hope is almost invariably postponed to some future time. This individualistic piety, closely bound with nature, in which light is a symbol of divine power, was not only prevalent in Germany amongst painters. The poet Ludwig Theobul Kosegarten (1758–1818), a preacher on the island of Rügen, expressed similar views in his "sermons on the shore" which, as the name suggests, were not held in a church, but in the open air. Fried-

rich and Runge were amongst his followers. It is therefore no coincidence that two of the key works of romantic landscape painting, Runge's unfinished *Rest on the Flight into Egypt* (ill. p. 452) of 1805/06 and Friedrich's *Cross in the Mountains* for the the *Tetschen Altar* (Dresden, Gemäldegalerie) of 1807/08, were originally conceived as altarpieces – Runge's was meant for the Protestant church in the Baltic coastal town of Greifswald and Friedrich's for the private chapel of Tetschen Castle in Bohemia.

The landscape paintings of the Romantic age demanded a meticulously detailed study of nature and a religiously inspired interest in the fleeting atmosphere of changing light and weather conditions. In this respect at least, in spite of the smooth finish of glaze painting, it differed little from the sketchy *plein-air* painting already beginning to emerge, which, by the second half of the century, would become firmly established as "atmospheric" landscape painting. There was, however, a fundamental difference. In the controlled and sober paintings of the early years of the century, artists still sought to convey an objective content beyond the bounds of palpable reality – generally an awareness of cosmic divinity – through the vehicle of their own subjectivity. From the 1830s onwards, by contrast, artists began exploring the possibilities of capturing a spontaneous and natural

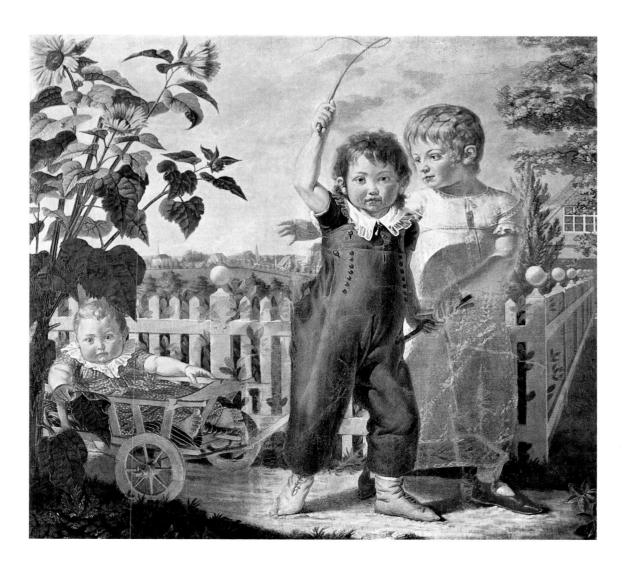

Philipp Otto Runge The Hülsenbeck Children, 1805/06 Oil on canvas, 130.5 x 140.5 cm Hamburg, Hamburger Kunsthalle

impression by using sketchy, impasto brushwork. The move towards this new surface finish did not originate in Germany, but in England and France, and was imparted to German artists in Rome. Moreover, artists from the north, such as the Norwegian painter Christian Claussen Dahl (1788–1857) also stimulated this new realism.

II. COLORISTS AND REALISTS

French Romantics

In the paintings of David and his followers, the finished picture was invariably worked through to the last detail. The Romantics, on the other hand, regarded a sketchy surface effect as a painterly principle in its own right, even in the finished work. The driving force and leading figure of this group was Eugène Delacroix (1798-1863). The contrast between his rough, painterly surfaces and the smooth linear style of David's student, Ingres, rekindled the age-old academy debate of the 17th and 18th centuries on the supremacy of line or colour as the theoretically appropriate vehicle for the portrayal of reality in painting. This does not mean that the idealists of the 19th century, who sought perfection in drawing could not be accomplished colorists, such as David and Ingres. The debate was more specifically about the ideal. Whereas the strict defendants of line over colour argued that only draughtsmanship could liberate portayals of nature from the impurities and debris of earthly imperfection, the proponents of colour over line took up the gauntlet for the transience of life in all its fleeting manifestations. They rallied to the defence of subjective sensual pleasure, which the moralists of draughtsmanship or line dismissed as an unintellectual pleasure. This did not mean, however, that the colorists were to be regarded as natural-

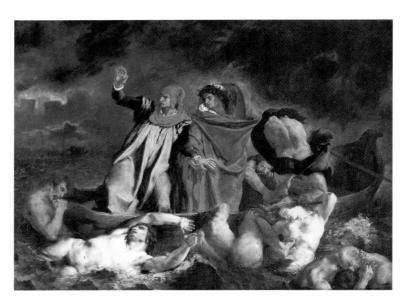

Eugène Delacroix The Bark of Dante (Dante and Virgil in Hell), 1822 Oil on canvas, 189 x 242 cm Paris, Musée National du Louvre

ists. For them, colour was actually a means of portraying a more lyrical view of the world. Their creed of subjectivity, propagated under the banner of "colorism", was a thorn in the side of the Neoclassicists, who sought perfection in the permanent continuity of life rather than in its arbitrary and temporal manifestations.

The first public contradication levelled at such idealism was articulated in the names of romanticism and realism: the monumental Raft of the Medusa (Paris, Louvre, see ill. p. 426) exhibited at the Salon of 1819 by the young and audacious Théodore Géricault (1791–1824). His painting illustrates a contemporary event. It has nothing of the cool Neoclassicism and emotional control to be found in the paintings by David and his students. Profound empathy with the plight of the shipwrecked mariners is expressed in the very angle from which it is painted – from a slightly elevated stance and at close proximity. We almost have the feeling that the painter himself is poised on a plank that is being carried along on the crest of a wave, while the corner of the raft sinks into a trough. By placing the dominant object, the raft, on the diagonal, Géricault breaks every rule of classical painting, in which the spatial organization and the narrative are to be rendered parallel to the spectator. Géricault's studies of dead bodies add an element of harrowing realism: hope and despair, the quick and the dead, numbness and passion charge the painting with tension. The artist goes beyond the momentary situation to reveal just how precarious the human condition is; there are no heroes in the face of such vulnerability, but only individuals struggling for survival. The bleak mood is underpinned by the gloomy and brooding colours that have ousted the luminosity of David and his students. In this highly realistic image, the romantic aspect is the artist's empathy and identification with the suffering of human fate, expressed by the painterly composition and handling of colour.

In Géricault's *Raft of the Medusa*, a tale of ordinary people is elevated to the level of great history painting, hitherto reserved for the portrayal of heroic deeds for the state or important state events. Such people as those depicted here by Géricault are included, if at all, only as relatively minor "extras" in paintings of stormy seas. Géricault lends their fate (which he read of in contemporary newspaper reports) all the monumentality and sublimity of a state event.

The roots of Géricault's art lay in a different aspect of Baroque painting than that of David. Whereas David worked in the strictly moralistic tradition of 17th century French and Italian Neoclassicism, Géricault saw his artistic forebears in the romantic leanings of the Neapolitan and Roman painting of the 17th century and its successors. Both thematically — man forlorn at the mercy of fate embodied by nature — and in its dark-toned colority, his works recall this period. Yet he portrays such a scene with a new sense of drama and empathy, a new realism in the presentation of detail.

His first major work, a scene from Dante's Divina Commedia exhibited at the 1822 Paris Salon under the title The Bark of Dante (ill. p. 414; also known as Dante and Virgil in Hell), was based on the painting by his friend Géricault, for whom he held a deep admiration. Here, though the figures are not shipwrecked, they are at the mercy of the River Styx. and are desperately trying to reach the safety of the bark carrying Dante and Virgil (70-19 B.C.). Even in this early work, it is clearly evident that the younger artist, who was to go on to become the leading figure of the Romantic movement in France, has charted a new course. Whereas, in Géricault's painting, passionate excitement is expressed by a bleak, cold chiaroscuro, Delacroix employs extreme contrasts of colour: the garish red of Dante's cap against the green water and the white tones of the wan bodies in the river, accompanied by the intensive greens, russets and blues of the other robes.

Delacroix's masterpiece, Liberty Leading the People (ill. p. 432) exhibited at the 1831 Salon following the July Revolution, would have been inconceivable without Géricault's Raft of the Medusa. The pale bodies of those who have fallen at the barricades and the republican fighters led by the allegory of Liberty storming away over them, their faces distorted by eagerness, passion and determination, addresses the same contrasts as Géricault's painting, albeit under different circumstances. Here, there is no sense of fatalism, for the dead and the fallen are shown as the necessary price of victory. Accordingly, apart from the use of light and shade, it is the blue, white and red of the tricolore that strikes the dominant chord in the painting. This is certainly not a conventional blend of colours, but evidence of Delacroix's new method of lending each scene its own appropriate and unmistakable colority. The artist's subjective empathy was intended to trigger the same emotion in the spectator, implied directly through the use of colour rather than indirectly through reflection on the content. The result is a remarkable reinterpretation of light and shade in stark contrast to the approach employed in Baroque painting. In Liberty Leading the People, chiaroscuro is no longer a cosmic and moral principle of the material world, but the product of a juxtaposition of pale to white hues with dark to black or dark-blue objects complemented by pure red in reiteration of the tricolore.

By 1824, Delacroix' backgrounds, in particular, dispense with non-colour chiaroscuro and adopt a specific and intense colority. The first example of this approach in his œuvre is *The Massacre of Chios* (ill. p. 432) with its background of blue, ochre and green, while *Liberty Leading the People*, six years later, uses blue and white. From the 1830s onwards, inspired by the sumptous oriental robes that had fascinated him on his Moroccan tour of 1831/32, Delacroix began breaking down bright colours in his figures into tiny particles of pure colour, giving his paintings a sumptuous brilliance, as in his famous *Women of Algiers* (ill. p. 433) of 1834.

Théodore Géricault The Madwoman (Manomania of Envy), 1822/23 Oil on canvas, 72 x 58 cm Lyon, Musée des Beaux-Arts

Delacroix's greatest contribution to the development of painting in the 19th century, the full impact of which was not to be felt until the late 1840s, was his handling of colour according to the principles of complementary contrast. He noticed that colours situated close together in the colour circle tend to heighten each other's impact when juxtaposed, whereas opposites (red/green, yellow/violet, blue/orange) tend to detract from each other. From mid-century onwards, he applied this principle to the overall composition of his paintings as well as to his handling of individual zones. Whereas the composition as a whole is generally based on contrasting colours such as red and blue or red and green, the individual zones are heightened in their intensity by a dense application of short brushstrokes, in which a wide variety of greens or reds create a plane. This heightened colority added lyricism to his pictorial world, transfiguring it to sublime beauty and sensuality. Delacroix sought his motifs in literature and in literary descriptions of war or love.

William Shakespeare (1564–1616), Goethe, Torquato Tasso and Dante were his sources. Contemporary events were of interest to him if he felt that they could be rendered lyrically on the canvas: the Greek liberation struggle, for in-

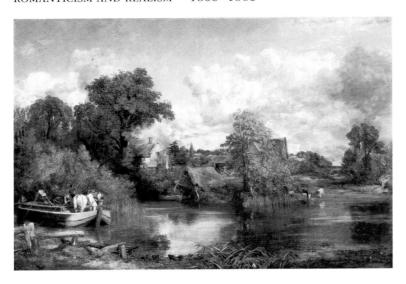

John Constable The White Horse, 1819 Oil on canvas, 131.4 x 188.3 cm New York, The Frick Collection

stance, or other struggles such as a lion hunt, preferably featuring oriental horsemen – all topics which he saw as expressions of heightened sensuality.

Plein-air Painting in England and France

The influential force behind this divisionistic handling of colour that was to pave the way towards Impressionism - in this case as an exploration of daylight and sunlight, rather than complementary contrasts – was the English landscape painter John Constable (1776-1837). His three paintings exhibited at the 1824 Paris Salon, including the famous Hay Wain (ill. p. 464) had a revolutionary impact on French painting and blazed a trail throughout the continent. Delacroix, who probably visited Constable in London following the Paris exhibition in May or June 1825, made a note in his diary on 25 September 1846 regarding Constable's principle of colour division: "Constable says that the superiority of the green of his meadows is due to the fact that it is made up of a great number of different greens. The lack of intensity of green in conventional landscape paintings results from its being portrayed by a single hue. What he says about the green of his meadows can be applied to all other colours." Delacroix proved as much in his own paintings.

Constable broke down his colours into tiny individual brushstrokes, juxtaposing various hues and shades. In these vibrant planes of colour, blackish and white brush-strokes create a sense of light and shade, surface and depth. The effect is one of density and vitality unparalleled in any previous landscape painting. The open spaces of Constable's paintings seem to be filled, from sky to earth, from far to near, with particles of matter bathed in light. The dominant impression is one of luxuriant growth, glistening, lush and moist. Constable succeeds in capturing by painterly means

alone the English woods and meadows that were the heritage of the 18th century. His handling of colour, light and shade is not based on observation, but constitutes an unprecedented painterly transcription of an overall impression.

Like Delacroix, Constable does not rely on convention to express his individual experience of nature, creating instead a colour system of his own in accordance with his subjective impression. The use of chiaroscuro is no longer a vehicle for projecting the theological or philosophical contrast between the darkness of the fallen and the light of the divine. Instead, it is part of a pure colour cosmos of enormous density and subtlety in which all things of colour possess a material quality imbued with properties of light and darkness. In this way, all matter – whether tree-trunk or cloud – is basically the same, differing only in terms of material density, which is distinguished in the painting by textural differences in the brushwork.

Constable was a pioneer of 19th century art, not only for his handling of colour, but also for the aspects of nature he chose to portray. He disdained to paint the cultivated park and garden landscapes of the wealthy landowners that were a source of such pride in England at the time and had been a favourite motif of 18th century artists. Instead, he chose to paint the unspoilt, wild and overgrown corners of English farmland.

The French landscape painters of the schools of Barbizon and Fontainebleau followed suit with what they termed paysages intimes. They withdrew to the unspoilt countryside of Fontainebleau near Paris, with its meadows, heaths and woodlands, in order to escape the hustle and bustle of the city and to avoid the landscaped gardens of the Park of Fontainebleau. They sought to paint an archetypal and hitherto neglected landscape with none of the heroic contrasts that had previously appealed to landscape painters. Like the works of Constable, the paintings of the Fontainebleau artists - most notably Théodore Rousseau (1812-1867), Jules Dupré (1811–1889) and Narcisse Diaz de la Peña (1808–1876) – possess a dense and patchy textural structure that seeks to do justice to the materiality of the subject matter. The slight shimmer of Constable's paintings that takes away the heaviness of the material, is absent here. Gustave Courbet (1819-1877) who was not directly associated with the Barbizon painters, went furthest in his landscapes, particularly in his younger years. He had a talent for echoing the ruggedness of stoney nature in the ruggedness of the way he handled colour.

Plein-air Painting in Rome

In the development of *plein-air* painting, there was one road that travelled through England and France and another that travelled through Rome. Throughout the centuries, Rome had been the meeting point of painters from many countries. The French had been the first to arrive in the 17th century.

In the 18th century, the English followed, and after the Glorious Revolution of 1688, it was considered *de rigeur* for a nobleman to complete his education with a journey to Rome. English painters also took up this custom, for the increasing popularity of travel quite naturally brought with it an increased demand for interesting views of foreign countries. Finally, the Germans followed in the middle of the 18th century, and their great innovators in the field of art were also based in Rome: the art historian Winckelmann was there, as was the painter Mengs, who might justifiably be regarded as the German equivalent to France's David, for his monumental canvases sought to recapture the greatness and natural beauty of classical Antiquity, according to Winckelmann's views. All three had turned against the courtly art of Rococo in their call for morality and seriousness in art.

The French living in Rome, in particular, had been familiar with oil-paintings created directly from nature as early as the 17th century. In his *Teutsche Academie der edlen Bau-, Bild-und Malerey-Kiinste* (1675–1679), Sandrart wrote that the French artist Claude Lorrain had produced just such *plein-air* studies. In the late 18th and early 19th centuries, it was the French in particular who used this technique, whereas the Germans tended primarily to draw from nature and the English concentrated more on water-colours.

In his memoirs, published under the title *Lebenserinnerungen* in 1885, the German Romanticist Ludwig Richter (1803–1884) who lived in Rome in the 1820s describes the

difference between German and French painters in Rome in their portrayal of nature: "The French painters, with their huge boxes, needed enormous quantities of paint for their studies, for they were wont to apply the paint with large brushes half a finger thick. They invariably painted from a certain distance, in order to achieve an overall effect or, as we would say, an impact. Of course, they also needed a great deal of canvas and paper, for they almost invariably painted and rarely drew; we, by contrast, tended to apply ourselves more to drawing than to painting. No pencil was hard enough nor sharp enough to capture the tiniest detail of each outline. Each and every artist would sit crouched over his work, no larger than a small sheet of paper, seeking to render painstakingly what he saw before him. We fell in love with every blade of grass, with every slender twig and did not want to miss a single appealing trait. The effects of air and light were avoided rather than sought; in short, each of us endeavoured to reiterate the object as objectively and truly as in a mirror."

When he writes of the German painters, he means those who were followers of the Nazarene or Neoclassicistic tradition, and with whom Richter, like the majority of German artists, identified. Yet in the 1820s such artists as Karl Blechen (1798–1840) from Berlin, were also living in Rome. As a colorist, Blechen certainly bears comparison with the French artist Jean-Baptiste Camille Corot (1796–1875) and the English painter J.M.W. Turner (1775–1851),

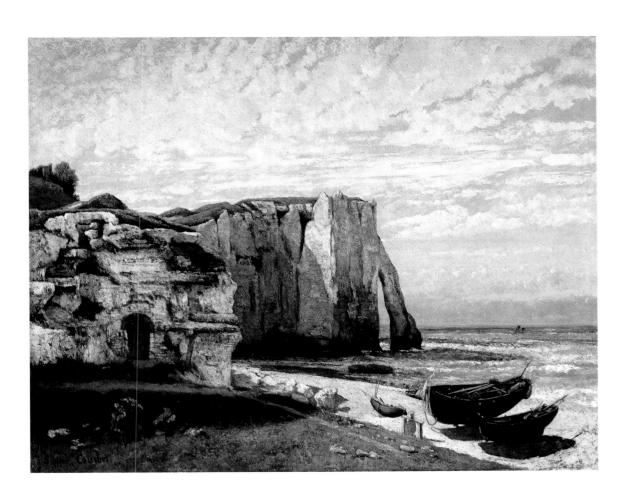

Gustave Courbet The Cliff at Etretat after the Storm, 1870 Oil on canvas, 133 x 162 cm Paris, Musée d'Orsay

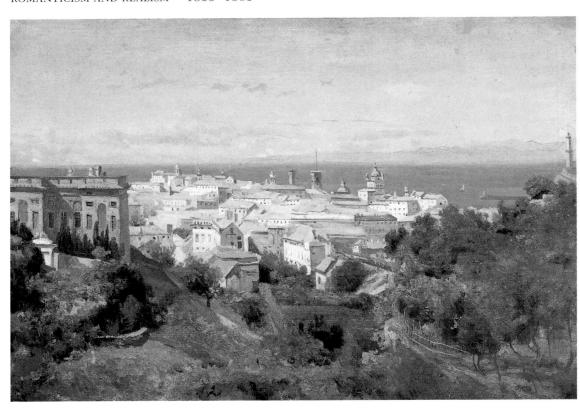

Camille Corot View of Genoa, 1834 Oil on canvas, 29.5 x 39 cm Chicago (II), The Art Institute of Chicago

who were also staying in Rome around the same time in 1828. Turner and Corot are amongst the most important painters of the early 19th century. On his return to Paris from Rome, Corot became a founding member of the school of Barbizon. In the studies he produced during his stay in Rome, he developed a light-toned colorism similar to that which was to become characteristic of landscape painting towards the end of the 19th century. It was only with the advent of Impressionism that the light-toned plein-air painting became a generally adopted principle. However, Corot's early sketches - in contrast to the impressionist paintings - consist of sweeping and almost monochromatic planes of vibrant colour, often contrasted with dark outlines delimiting them from the next homogenous colour plane. The chiaroscuro modelling that once dominated the entire painting is now abandoned in favour of large areas of colour in which there are no major differences in degrees of light and shade.

A similar planarity can also be found in the Italian sketches of Blechen. Unlike Corot, however, he preferred a pale colority without warm reds: ochre and violet, white and blue or white, blue and black are juxtaposed. Here we can recognise a principle similar to that applied by Delacroix: each painting has its own colority in accordance with its specific atmosphere or mood, whereby Blechen loved extreme opposites and was particularly interested in burnished or sparsely vegetated areas where the rocks take on the character of bleached bones. This alone was enough to attract the scorn of German critics, who were used to seeing Italy portrayed as an earthly paradise full of merry people and lush vegetation.

They expected to see a landscape based in the idyllic light familiar to them from the paintings of Lorrain. The extreme subjectivism in the choice of location and colority in Blechen's paintings annoyed the critics just as much as his failure to deliver an overall tone.

Turner, the great English landscape painter who spent time in Italy, particularly in Rome and Venice, in 1819 and 1828/29, had been influenced by Lorrain in his use of light, but the results he produced were very different indeed. In Turner's paintings, light is not, as is it in the works of Claude Lorrain, an immaterial brilliance produced by the use of glazing technique, but is directly linked with a certain colority or lightness of individual brushstrokes. Like other painters of his generation, Turner also structured each painting on the basis of its own individual colour contrast; in this respect he may well have influenced Blechen: for example black/brown/yellowish white or yellow/red or black/ochre/white/blue. The pictorial theme is merely the vehicle for an exploration of colour contrasts. By treating the colours more or less autonomously and liberating them from all representational givens, they become an expression of the struggle of elementary forces in the universe, presented as light and dark or as climatic factors. There are compositions whose swirling movement and title refers directly to cosmic forces: Shade and Darkness: The Evening of the Deluge and Light and Colour: The Morning after the Deluge, both c.1843 (London, Tate Gallery).

Based on a scientific analysis of colour, a subjective view of the cosmos was presented in a manner that was to remain unparalleled until the arrival of the Blaue Reiter group of artists in the early 20th century, particularly Franz Marc (1880–

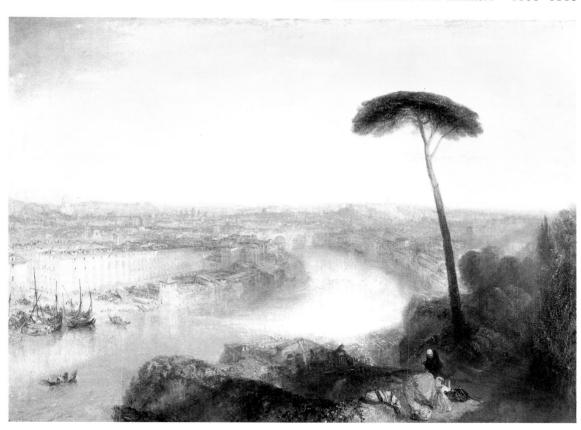

J.M.W. Turner Rome from Mount Aventine, 1836 Oil on canvas, 91.6 x 124.6cm Private collection

1916) and Wassily Kandinsky (1866–1944). In a calmer form and without the same claims to universal significance, Turner's autonomous colority influenced impressionism. This influence is distinctly evident in Claude Monet's (1840–1926) painting *Impression: Sunrise* (ill. p. 479) of 1873 that was to give the Impressionist movement its name.

The group of colorists dealt with in this chapter also included a number of idealists and realists - most of whom linked both these aspects. In the early 19th century, however, the word "realism" was rarely used. Instead, it was described as naturalism and generally meant that the artist had paid too much attention to the fleeting appearance of nature without idealistic refinement on the one hand, and on the other hand, colour - the most subjective of artistic means had not been controlled enough by line. In this respect, Constable and the painters of the school of Barbizon were realists or naturalists. Blechen, on the other hand, was not content with a subjectivist portrayal of actual givens, but added a pessimistic view of the world that made him appear an antipode to the Romantics, who invariably used light as a sign of godly transfiguration. Blechen found that this aspect was missing from light. Yet even in this reversal, there is an indication of a Romantic view of the world.

Corot, in his early sketches, which are colorist gems, is primarily a realist. Yet in his great Salon pictures from the mid-19th century onwards, with their famous shimmering groups of grey-silver trees by riverbanks, he reintroduces light, inspired by the landscapes of Claude Lorrain, as an element that adds a paradisical brilliance to a charmingly

idyllic world (ill. p. 434). In these paintings – in spite of the fleeting brushwork indicative of Impressionism – he is an idealist, if not a Romantic. And this form of colorism was by far the most popular with the public.

Turner's colorism with its cosmic world view had nothing to do with realism, in spite of its impasto handling of colour. These are visions of a universal context – albeit without the religious touch of love and empathy – rendered in colour, similar in principle to the works of Runge, who also pursued scientific colour studies. However, whereas Runge's paintings are allegorical images of a Neo-Platonic light metaphysics, Turner's images are based on the far-sighted and purely objective views of the 18th century which he imbued with new meaning through his colorism based on colour theory and *plein-air* painting.

A closely related form of landscape painting was brought to America by the English artist John Crome (1768–1821). Frederic Edwin Church (1826–1900), the great American painter of panoramic landscapes who exhibited from the 1840s onwards, was his student. In his views, the wide expanses of such landscape compositions became symbols of the size and expanse of the American continent.

Realist History Painting and Critical Realism in France The realism in landscape painting is characterised both by the choice of motif – undistinguished areas lying beyond land used for farming or gardens and off the beaten tourist track – as well as its form of presentation: colour material becomes a symbol for the materiality of the world. As this

genre of painting was dependent on the art market from a very early stage, it was here that the academic rules were first disregarded. After all, the highest task of art continued to be seen in the portrayal of human beings.

In this field, Delacroix and Ingres set the standards in France until 1848. Successors of Ingres such as Thomas Couture (1815-1879) pursued a staged Neoclassicism of erotic appeal. Théodore Chassériau (1819-1856), a former Ingres student, had joined Delacroix from the late 80s onwards and had continued his poetic colorism. He also shared Delacroix's preference for the portrayal of women and exotic subjects. These had developed into a genre of their own amongst such so-called orientalists as Alexandre Gabriel Decamps (1803-1860). The public's darlings, apart from that painter of modern wars, Emile Jean Horace Vernet (1789-1863), had been, since the 1830s, Jean Louis Ernest Meissonier (1815–1891) and Paul Hippolyte Delaroche (1797– 1856), painters of historical genre scenes. They combined coloristic skill with an interest in detailed scenes from history.

This form of "historical genre painting" had originated in Belgium, where the break with the Kingdom of the United Netherlands (founded in 1815) had led in 1831 to a reflection on history and culture by the painters Louis Gallait (1810–1887) and Edouard de Bièfve (1808–1882), creators of a patriotic history painting in the grand style. The themes of these paintings – frequently public commissions or state purchases – were drawn from the struggle for liberation from Spanish rule in the 16th century. They caused a sensation throughout Europe. They were regarded as appropriate vehicles for the portrayal of bourgeois rule, appealing in their realism.

When the Belgian paintings were shown in Germany for the first time in 1845, this heralded the end of prevailing Neoclassicist historical painting. Leaders of the Neoclassicistic school in Germany, such as Cornelius and Moritz von Schwind (1804-1871) in Austria and their followers retaliated by declaring the strict morality of Neoclassicism to be synonymous with profundity and German art, and scorning the realism of the historical genre paintings as reprehensible and as "superficial Frenchness". Historical genre painting, involving colour accents that highlighted the presentation of materiality, was established in Germany by Piloty, whose works finally overcame Neoclassicism. All these portrayals of "accidents of history", as Schwind called them, appealed to the empathy of the viewer. The world is clearly divided into good and bad, noble and unnoble, and fate is merciless. The moralistic claims of Neoclassicism continued to survive at the level of a historical novel, relating patriotic legends even to the uneducated.

Although this particular genre of painting found favour with the public, critics questioned its dignity. They repeatedly asked, for example, whether such superficiality was the necessary result of an art aimed at a broad sector of the bourgeoisie, or whether art should propagate an image of the individual suited to the democratic ideals of bourgeois rule. They also asked whether human dignity might be sought where historic greatness did not exist and where human greatness was an unembellished and unspectacular part of everyday life.

The painters who adopted such concepts after 1848 frequently chose to portray the peasant, for, from the point-ofview of the city dweller, the peasant embodied a life set apart from history. Even before 1848, rural life had been the subject of the so-called genre painting of the Biedermeier era. In this highly popular genre, the closeness and constraints of rural life, which had certainly not been alleviated by the onset of industrialisation, was presented as pious, humble and content. A distinction was made between those whose virtue and piety allowed them to enjoy "happiness in measure" (Jean Paul, 1763-1825) and those who did not belong. Koch's view of the community of Alpine peasants as the model for a future society of equality is no longer the theme of such portrayals. Instead, they present humble adaptation to the given circumstances as a prerequisite for happiness, as presented in the theories of the "Idyll" of such genre paintings.

The few socially critical peasant paintings by the Viennese artist Ferdinand Georg Waldmüller (1793–1865) created in the 1850s and 1860s, show the consequences of restriction and call such happiness into question. Nevertheless, a painting such as his The Last Calf (ill. p. 455) suggests that family bonds are strengthened in the face of misfortune, when the last calf has to be sold. The people leading the calf away are themselves only momentarily more fortunate members of the same social class and do not stand accused. The entire scene is primarily intended to present the different reactions of these people, who are confronted with bitter destiny. Scenes of misfortune were found to be particularly suitable vehicles for the kind of character studies that were a focus of 19th century genre painting. English artists of the late 18th and early 19th centuries, particularly David Wilkie (1785– 1841), were driving forces in this respect. In the work of Waldmüller, the God-fearing fatalism of the rural population arouses the sympathy of the painter and the spectator. Such works are generally informed by the same principle that is to be found in the historical genre paintings of Delaroche or Piloty, but for the fact that pure genre painting does not portray outstanding historical personalities, but simple people, who have to bear their fate in much the same way as the famous and the great.

Even at first glance, Jean-François Millet's (1814–1875) Gleaners (ill. p. 442), executed at around the same time, clearly demonstrates a different attitude. Honoré Daumier's (1808–1879) Washerwoman (ill. p. 440), Millet's Sower (Boston, Museum of Fine Arts), Courbet's Stonebreakers (destroyed

1945; formerly Dresden, Gemäldegalerie) and his Winnowers (ill. p. 443) all have one thing in common: in all of these paintings, the faces of the characters portrayed are either turned away or their physiognomy is so reduced that there can be no question of an individual character (as in the work for example, of Wilkie or Waldmüller). Moreover, the figures are not presented at a dramatic moment of decision or fate, but busily going about the monotonously repetitive work that shapes their lives. These paintings convey the message that it is work and work alone that determines the movements and postures of these figures, most of them bowed, some of them seemingly weighed down under the horizon in a sign of their eternal subjection, as Courbet said of his Stonebreakers. If they appear to be moving freely in front of the sky, like Millet's Sower, which was exhibited in 1850/51 at the same Salon as Courbet's Stonebreakers and his Burial at Ornans (ill. pp. 444/445), then it is only the mastery of their work that produces this movement.

Nature is sparse and barren in these paintings; it is merely a working material. However great the personal variations between the artists may be, they retain one thing in common: in all these images, the members of the lowest classes are portrayed in monumental size, at their work, according to the rules of art hitherto reserved only for the ruling classes. The fact that the peasants were particularly disdained by the city-dwellers as uncultivated and uncouth made the sacrilege of such art works all the greater.

In an article published in 1855 on the separate exhibition of his friend Courbet, the writer Jules Champfleury (1821-1889) wrote: "One does not care to admit that a stonebreaker is worth as much as a prince. The aristocracy is appalled to find so many yards of canvas dedicated to such common people. Only rulers have the right to be portrayed in full figure..." Everything that flew in the face of good taste and good manners in such a way was dubbed with the negative epithet "realism", as Champfleury explained. Courbet took up the term as the slogan for his exhibition of 1855, declaring that he refused to be restricted in his choice of themes and that painting could and should give expression to the dignity of objects conventionally regarded as ugly. It was the first exhibition of an "independent" exhibition parallel to the official Salon exhibition during the Paris world fair of 1855. Many were to follow, and they would line the path of modern art.

In contrast to Millet, Courbet regarded himself as a revolutionary and a republican and he publicised his attitudes by actively participating in the Paris Commune of 1870. Millet, on the other hand, expressly rejected the honour of being appointed an artist of the Commune and announced on several occasions that his painting had nothing to do with politics, that it arose from human empathy alone. He saw the moral stature of the peasants in their humility and acceptance of their lot, in the necessity of their existence and

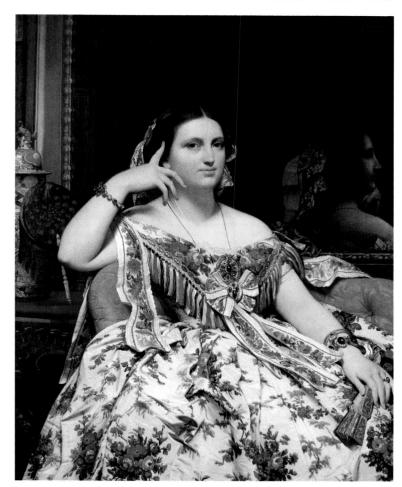

Jean Auguste Dominique Ingres Madame Moitessier Seated, 1856 Oil on canvas, 120 x 92.1 cm London, National Gallery

in the dignity of their close ties with the fertility of the soil. He wrote: "I try to show things in such a way that the necessity of their connections becomes clear, instead of making them seem as though fate had brought them together. I want to paint people so that the spectator can see which class they belong to and that it has nothing to do with the idea of wanting to be anything else."

His paintings thus had little to do with a struggle against the eviction of impoverished peasants from their land. The capitalist destruction of the peasant' livelihood since the 1840s was a fact lamented by many intellectuals. Yet one is unlikely to compare Millet's paintings with those of Pierre-Joseph Proudhon's (1809–1865) attack on property as the cause of poverty. Nor did Courbet have such ideas in mind with his *Stonebreakers* and, indeed, was only later persuaded by his friend Proudhon that he had created a painting that was revolutionary in more than just an artistic sense. Proudhon reported that the peasants of Courbet's hometown of Ornans wanted to purchase the painting and then display it on the main altar of their church, in an act of disrespect against the ruling order that was tantamount to an outright challenge.

The dignity of the impoverished peasant was invoked by others as well, including the historian Jules Michelet (1798–1874), who published a detailed work entitled *Le peuple (The People)* in 1846, prophesying the fall of France should the small farmers and crofters, the salt of its earth, be abandoned and left to ruin; for they had not only proved their heroism in their eternal struggle to cultivate the land, but as soldiers in Napoleon's armies. The peasants' love of their native soil and their French fatherland is held up as a shining example and the author calls for justice to be done, in the name of France's greatness, to these small farmers crushed by bourgeois creditors.

Whatever one's views may be on the question, the situation of the peasants had become an issue of national importance since the 1840s. As a result, the poverty of the farmers

or rural workers also became the subject of art. At least art should do justice to a class that had won special dignity through its necessary and sacrificing service. The aim, however, was truth in art rather than the support of a political struggle through art, which Courbet, unlike Millet, did not reject.

In Courbet's view, for the modern artist it was necessary to make all social classes – regardless of questions of social prestige – subjects of his art. This view is reflected in his famous *Painter's Studio* (ill. p. 446) which he showed at a separate exhibition in 1855 together with his *Stonebreakers* and his Burial at Ornans. In the *Painter's Studio*, the artist is presented as the person who, through his work, invokes the equality of all, by dint of the fact that they possess the same value for him as individuals and as subjects of his painting.

(The descriptions on pp. 423 bottom, 425 bottom, 436 top, 437 bottom, 438 bottom, 439 bottom, 466 bottom, 468 bottom, 471 bottom and 474 top were written by Annemarie Menke-Schwinghammer, and those on pages 444f. by the editor)

PIERRE-PAUL PRUD'HON

1758-1823

Napoleon commissioned this portrait of his wife a few months after her coronation. Although the Emperor had already considered a separation on grounds of her infertility, Joséphine persuaded him to marry her in church before the coronation. Nevertheless, her fears that Napoleon would abandon her in spite of coronation and marriage were confirmed in 1809.

Prud'hon shows the melancholy and loneliness of a woman confronted with this situation. Graceful and relaxed, she sits on a rocky outcrop in the park of Malmaison, far from the society she represents. The portrait employs the traditional visual syntax of 18th century English painting, in which the melancholy of the artistic intellectual is presented in a similar fashion. Prud'hon has exercised sensitivity in his depiction of Joséphine's inner turmoil, reflected in the gloomy autumnal atmosphere of her surroundings and has captured the special appeal radiated by this Creole woman born on the Island of Martinique. Her enigmatic gaze is reminiscent of Leonardo da Vinci, whose works influenced Prud'hon and from whom he has adopted the soft, silky sfumato of this painting.

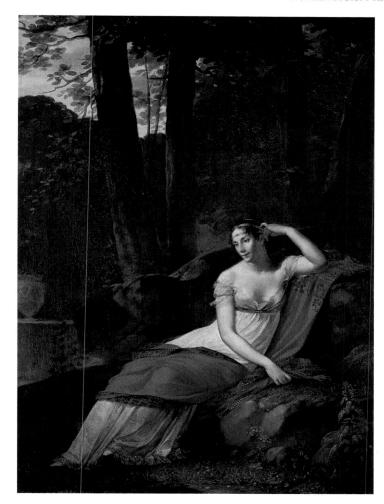

Pierre-Paul Prud'hon Empress Joséphine, 1805 Oil on canvas, 244 x 179cm Paris, Musée National du Louvre

FRANÇOIS GÉRARD

1770-1837

Juliette Bernard, who had married the considerably older Jacques Rose Récamier in 1793, invited artists and opponents of Napoleon to her Paris salon. Her beauty was famed. She was particularly delighted by the way in which Gérard emphasized her charms in this portrait. Five years earlier, she had commissioned Gérard's teacher Jacques-Louis David to paint her portrait, but was dissatisfied with the result and it remained unfinished (ill. p. 365). David had portrayed her reclining on the chaise longue that came to be known as a "récamiere" in the sparsely furnished surroundings of a Neoclassicist, cool room. Gérard, on the other hand, adds a glimpse of nature to the background and echoes the gently curving lines of her pose and the hue of her complexion in the forms and colours of her surroundings.

She is seated at a slight angle, allowing the painter to present her deep décolleté as effectively as her naked feet and thighs. This mode of dress and pose appeared perfectly natural at the time, in deliberate contrast to the mannered strictures of Rococo. In this respect, the great success of this portrait is also an indication of a new political attitude and a new, forward-looking image of humankind.

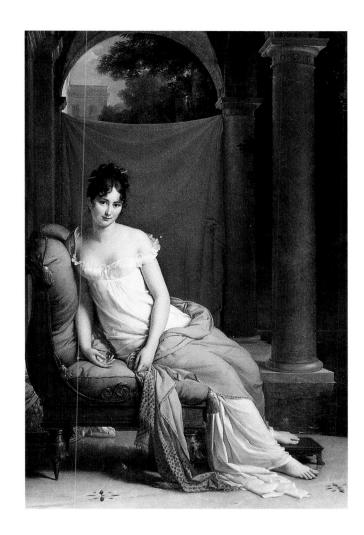

François Gérard Madame Récamier, 1805 Oil on canvas, 225 x 145 cm Paris, Musée Carnavalet

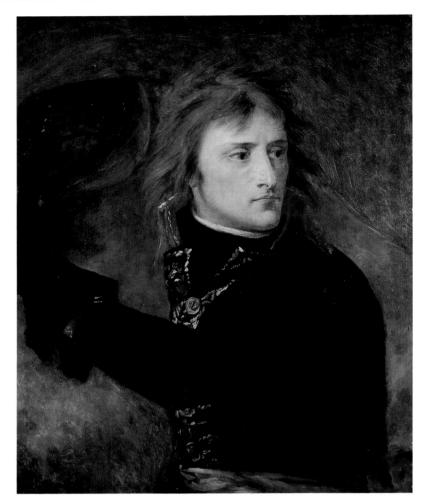

Antoine-Jean Gros Napoleon at Arcola, November 17, 1796, 1796 Oil on canvas, 73 x 59 cm Paris, Musée National du Louvre

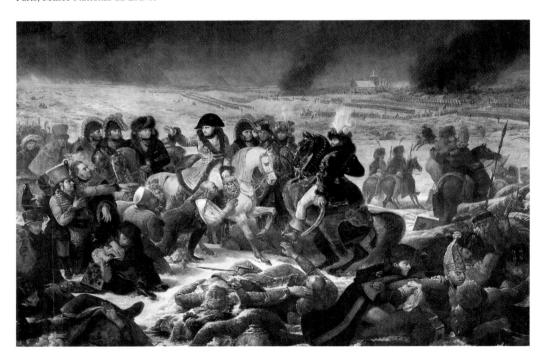

Antoine-Jean Gros Napoleon on the Battlefield at Eylau, February 9, 1807, 1808 Oil on canvas, 533 x 800 cm Paris, Musée National du Louvre

ANTOINE-JEAN GROS

1771-1835

In his portrayal of a historic event – the storming of the bridge of Arcola, held by the Austrians – Gros has chosen to depict only the figure of Napoleon himself, showing him at the very moment when he rides towards victory at the head of his troops, hair flowing and flag flying. The compelling force he radiates is heightened by the swirling brushstrokes that surround him, making the actual scene unclear and the incident only emotionally discernable.

By presenting Napoleon in the full dynamic force of his military leadership – the role on which his fame is based – yet at the same time isolating him from the immediate context of the turbulent events around him, Gros has created a universal psychological portrait of the "great man" in which the triumph of victory is as vital as the solitude of the brilliant leader. Napoleon's face bears an expression of absolute determination, and his gestures have an almost magical effect, as he drives his soldiers on in battle.

The backward glance suggests a link with the past history of the *Grande nation* from which Napoleon drew his motivation, and the colours of the tricolore are subtly suggested in the painting.

25.000 were killed or wounded at the dreadful battle of Eylau in Prussia where Napoleon narrowly defeated the Russian army. In order to project a kindly and caring image, the Emperor called a competition for a memorial painting of the battle, specifying the content in considerable detail and calling for a portrayal of "Napoleon with consoling gaze".

On the day after the battle, the Emperor rides over the battle field. The procession slows when a group of wounded enemy soldiers catches Napoleon's attention. He turns towards a Lithuanian officer, who kisses the eagle emblem on Napoleon's boot in gratitude for the assistance the Emperor has ordered. Napoleon, with sorrowful gesture and heavenward gaze, expresses his horror. Whereas the medical staff actually took care of only the French wounded, the Emperor is seen here taking care of the enemy soldiers as well. His act of clemency is further glorified by depicting him showing kindness to an enemy characterized as barbaric. In his painting, Gros succeeds in presenting the instigator and victor of the war as a man who declaims war as an evil that has been thrust upon him against his will. Napoleon personally awarded the artist the cross of the Legion of Honour for his ser-

Just how closely Gros' portrayal corresponds to Napoleon's own views is clear in a letter the Emperor wrote to Joséphine the day after the victory: "Yesterday there was a great battle. I gained a victory, but I have suffered heavy losses; the fact that the enemy's losses are even greater does not console me."

THÉODORE GÉRICAULT

1791-1824

The inspiration for this painting, that brought Géricault instant fame at the Paris Salon of 1812, came from a fair at Saint-Cloud where a horse, frightened by the noise and commotion of the festivities, suddenly reared. That same evening, he executed innumerable sketches and studies of the motif. After that, a coachman let him borrow his horse as a model, and a friend stood model for the portrait of the officer. At the same time, Géricault studied the works of Peter Paul Rubens, the *Battle of Constantine* by the school of Raphael and David's equestrian portrait of Napoleon.

Exhaustive life studies and a profound awareness of artistic tradition resulted in this sumptuous portrayal of a fiery steed rearing up at the sound of cannon fire, carrying its rider, who has already drawn his sable, into the dusty haze of the distant battle.

Géricault has followed the Baroque tradition in having the horse leap at an angle into the pictorial space, with rider and horse moving dynamically in all directions in a blaze of sumptuous colour.

The earthy, monochromatic beige and brown tones of the scene show a break at work in the muddy courtyard of a chalk furnace. Three heavy, dappled work-horses in the left foreground, still bridled and laden, are eating their oats from nosebags, in front of the pale, high-wheeled work-cart. To the right in the centre foreground, in front of the ponderous horizontal mass of the factory building, another two dapple-greys are also eating their ration of oats, standing at an angle in front of the high entrance. Thick white smoke is pouring through an aperture on the left of the factory building and drifting upwards in a dense cloud. The only sign of work and activity in a scene void of human figures, it forms a clear visual contrast to the gloomy overcast sky that dominates the left hand side of the painting.

In the touching poverty and grim tranquility of the scene, the painting has little of the narrative character normally associated with genre painting. Géricault's balanced treatment of pictorial elements, all in the same light and hues lend it a quality akin to a land-scape painting. The gloomy melancholy of the overall atmosphere has little to do with Romantic notions of landscape as the mirror of transcendental reality, but would appear to be based on the artist's own direct personal experience. Géricault had the misfortune to invest a considerable amount of capital in this rundown factory and on a visit there, he immediately made a sketch of his first impressions.

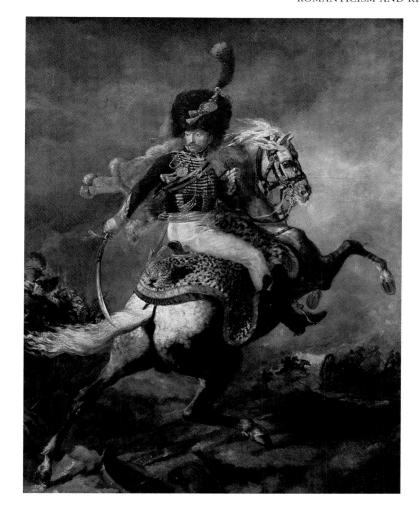

Théodore Géricault Officer of the Imperial Guard (The Charging Chasseur), 1812 Oil on canvas, 292 x 194 cm Paris, Musée National du Louvre

Théodore Géricault The Quicklime Works, c. 1821/22 Oil on canvas, 50 x 60 cm Paris, Musée National du Louvre

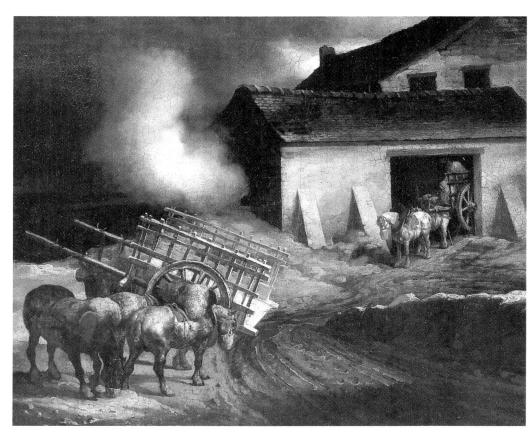

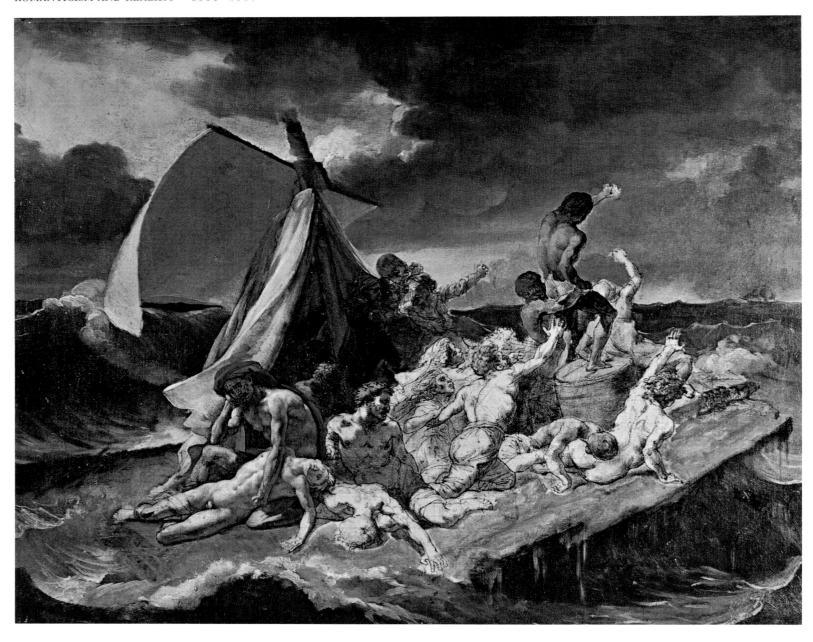

Théodore Géricault The Raft of the Medusa (sketch), c. 1818/19 Oil on canvas, 65 x 83 cm Paris, Musée National du Louvre

On 2 July 1816, the frigate Medusa, carrying French settlers bound for the colony of Senegal, ran aground off the West African coast. A raft carrying 149 passengers drifted on the high seas for twelve days before it was finally sighted. Only ten of them survived the terrible ordeal. The disaster was due primarily to the incompetence of the ship's captain who had gained his appointment solely as a favour from the regime. The report of two survivors caused a public outcry. Hardly surprisingly, the fact that Géricault should dare to rub salt in the wound by choosing this particular motif for the Salon of 1819 was seen as an affront to the new Bourbon rulers, and they accordingly prohibited the painting's title.

Nevertheless, Géricault's fascination with the subject matter was not necessarily politically motivated. Indeed, he was primarily interested in it as a vehicle for the portrayal of human existence under extreme conditions – a theme he explored soon afterwards in his paintings of the mentally ill. In his impassioned empathy with the victims of the Medusa shipwreck, he did everything in his power to

present the inconceivable suffering of real figures as drastically as possible. He contacted survivors, had a model raft built and made numerous studies of the dead and the dying in hospitals and morgues.

The viewer discerns the bodies and faces of the dead, the despairing and the hopeful in a diffuse twilight that bathes the scene in gloomy, heavy colours, seen from the slightly elevated position of the artist that brings the events frighteningly close. This painting is frequently compared with Michelangelo's portrayal of human suffering in the *Last Judgement*, which Géricault greatly admired and which he had studied closely when he was in Rome in 1816/17.

In the sketch shown here, Michelangelo's influence is particularly evident in the powerful chiaroscuro modelling of the bodies with their impressive gestures and distortions, portrayed at times in bold foreshortening.

THÉODORE GÉRICAULT

1791-1824

There is a world of difference between the Raft of the Medusa and the Epsom Derby, painted only two years later during a visit to England. It was to have a strong influence on the later Impressionists. Instead of the monumental gravity with which he had previously presented human fate, he now depicts a moment of exciting tension in the Englishman's favourite sport, horse-racing, which captivated Géricault, himself a keen rider.

The artist seems to channel the viewer's gaze through a pair of binoculars focused sharply on the distant horses and jockeys, so that the surroundings remain unclear, disintegrating into blurred strips of colour. This technique heightens the illusion of the speed of the galloping horses, in a way unparalleled by the popular prints, lithographs and engravings of racehorses that were so widespread in England, and which undoubtedly inspired Géricault to treat the subject in the first place. The strong colority influenced by English painting - particularly the intense green of the meadows - and the strange luminosity of the stormy twilight heighten our sense of witnessing a specific moment that has been captured on canvas just as the artist himself experienced it at a race, when a thunderstorm suddenly broke

A few months before his death, the 32-yearold Géricault noted: "a barely describable yet undeniable inner disorder." It was during this time that he was commissioned by the leading psychiatrist of the day, Dr Georget, to execute portraits of ten inmates at the Parisian mental asylum of Salpêtrière. Georget is regarded as one of the founding fathers of social psychiatry. He regarded insanity as a specifically modern expression of bewildered confusion, caused for the most part by social progress in the enlightened industrialized countries. Accordingly, the mentally ill under his care were freed from their chains and treated as people requiring help.

Géricault did not portray these mental patients the way they had been depicted since the Middle Ages - as creatures possessed by the devil and punished by God, or as grotesque fools. Instead, his meticulous physiognomical studies and the objective sobriety of his unadorned portraiture explored the fate of individual human beings, underlining their proximity to the healthy individual and the threat of insanity in us all is suggested. In the image of the mad-man, the empty and fleeting gaze, permitting no contact with the observer, the tense, alert, but immobile facial expression, the unkempt hair and beard and the dishevelled collar indicate a deviation from normality and an individual living entirely in his own world.

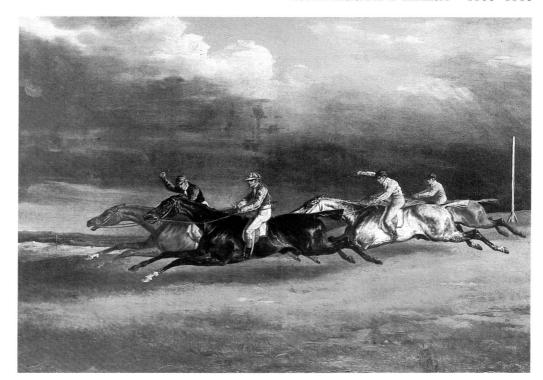

Théodore Géricault The Epsom Derby, 1821 Oil on canvas, 92 x 123 cm Paris, Musée National du Louvre

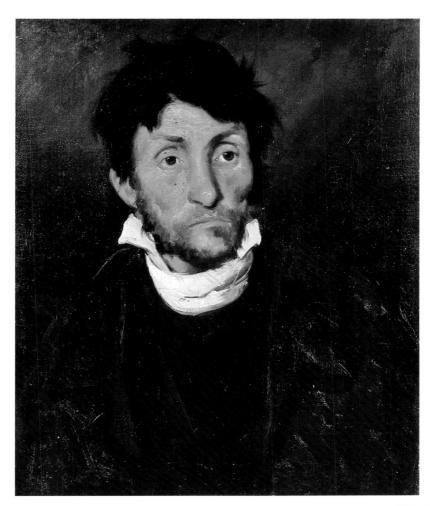

Théodore Géricault The Cleptomaniac, c. 1822/23 Oil on canvas, 61 x 51 cm Ghent, Musée des Beaux-Arts

Jean Auguste Dominique Ingres Joan of Arc at the Coronation of Charles VII in Reims Cathedral, 1854 Oil on canvas, 240 x 178 cm Paris, Musée National du Louvre

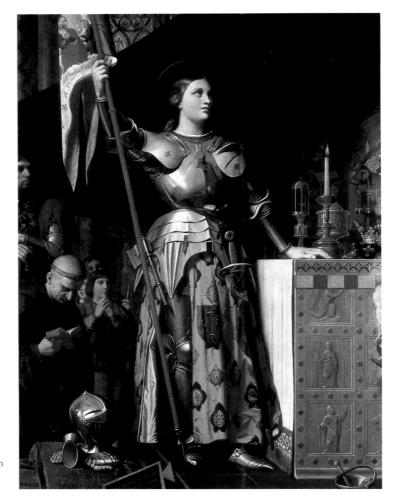

Below:
Jean Auguste Dominique
Ingres
The Turkish Bath, 1862
Oil on canvas, diameter 108cm
Paris, Musée National
du Louvre

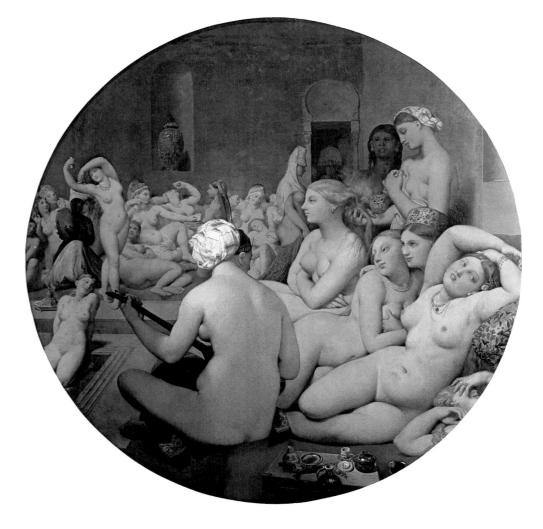

JEAN AUGUSTE DOMINIQUE INGRES

1780-1867

This painting was commissioned in 1852 by the director of the Academy of Fine Arts in Orléans for the memorial celebrations in honour of Joan of Arc. Ingres presented the victorious young woman who had liberated Orléans from the English siege in 1429 as a triumphant heroine whose heavenward gaze indicates the source of her fame. Three pages, the monk Paquerel and Ingres himself, in the guise of a royal servant, pay homage to Joan of Arc. The mood is one of great piety. A wealth of precious items and sumptuous materials painted with meticulous precision in superbly luminous colours, recall the origins of a nation in which church and state were once powerfully united.

In this painting, executed at the age of 82, Ingres reiterates the bathers and odalisques of his early years. The motifs for his idealized female forms, living for beauty and pleasure alone, are based on reports of the Orient describing the baths of the harem of Mahomet and the letters of Lady Montagu describing Turkish baths. He adhered in great detail to these reports, which describe the dignified grace of the women, their magnificent milk-white complexions, their beautifully formed bodies and their beautiful hair.

For all their sensuality, Ingres' bathers have an air of paradisical innocence, corresponding to the reports of Lady Montagu, who remarked with some astonishment that, in spite of their nakedness, there was never any indecorous gesture or behaviour amongst the women. The abstract and idealized beauty of these women, suspended in time and strangely intangible, is achieved through the economy of artistic means by which Ingres has portrayed them. The bodies are clearly defined, with particular emphasis on the surface, so that the subtle interplay of light creates a gentle modelling and the skin has a pellucid opalescence.

While the *Turkish Bath*, teeming with stretching and writhing nudes, is composed in a round format that creates a most unusual sense of unity, the aesthetic appeal of this famous nude study of 1808 lies in the monumentalization of the individual figure. Here, the artist already uses the approach that is the hallmark of his later work. "The more simple the lines and forms," says Ingres, "the greater the beauty and power."

Jean Auguste Dominique Ingres Valpinçon Bather, 1808 Oil on canvas, 146 x 97.5 cm Paris, Musée National du Louvre

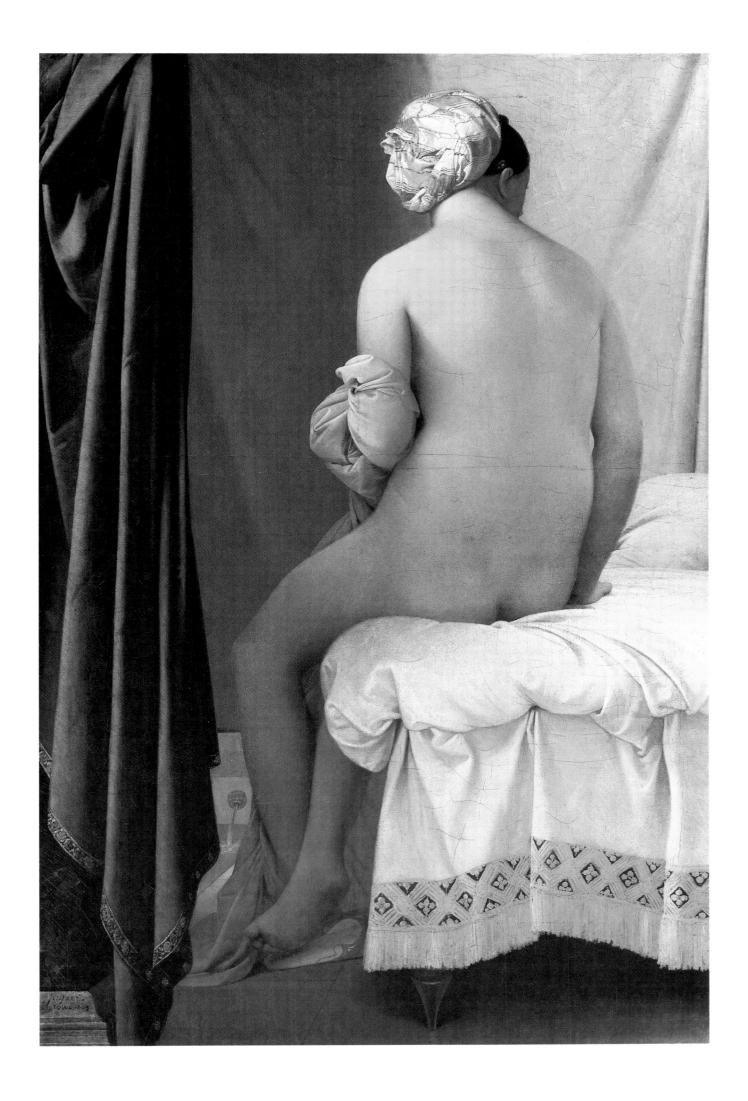

Jean Auguste Dominique Ingres Mademoiselle Rivière, 1806 Oil on canvas, 100 x 70 cm Paris, Musée National du Louvre

Jean Auguste Dominique Ingres Louis-François Bertin, 1832 Oil on canvas, 116 x 95 cm Paris, Musée National du Louvre

JEAN AUGUSTE DOMINIQUE **INGRES**

1780-1867

This portrait of a young woman from an esteemed Parisian family was executed in the early years of Ingres' artistic career, when he painted portraits for his living. Even as an old man, Ingres still spoke affectionately of the "charming daughter" who died at the age of 15, only a few months after he had painted her.

Ingres demonstrated enormous sensitivity in his portrayal of this still child-like girl on the threshold of womanhood, already endowed with all the confidence of her social station. There is something charmingly stiff about her pose, even though she has already mastered the art of the gracious gesture in the way she holds the white boa draped around her body. Above all, in capturing her facial expression, Ingres has succeeded in capturing the indecisiveness of a girl who is not yet an adult. Though her large brown almond eyes seem to gaze dreamily and the suggestion of a smile plays around her slightly open lips, her gaze is alert and directed with earnest attentiveness towards the spectator.

Ingres has achieved this effect by using fragile yet contrasting colours, soft yet precise, and clear-cut precise forms and contours. Even the background is in perfect harmony with the mood of the model: the hazy riverscape of the Ile-de-France is offset against a pale blue sky reflected in the surface of the water, and the dark bushes with their little flowers are reiterated in the ochre of the gloves and in the fresh bunches of grass in the foreground.

Bertin, publisher of the Journal des Débats, was one of the most influential figures and spokesmen of public opinion under the constitutional monarchy of Louis Philippe I, and his newspaper was a force to be reckoned with in the state. His critics saw in him the very epitome of the complacent and self-righteous bourgeois who had been brought forth by the July Monarchy. Manet called him the Buddha of the well-heeled, world-weary, triumphant bourgeoisie. Ingres, who regarded him as one of "the best and most intelligent of men", was a close friend.

The portrait is astonishing for the directness and forceful presence with which Bertin confronts the viewer. All signs of prestige and ornamentation are lacking. The mighty silhouette of this colossal figure has been further emphasized by the fact that he is seen from a slightly lower position, as well as by the compact gesture of the pose and the curve of the chair that frames the body. The heavy head with its tousled hair is also impressive. The face exudes an air of utter imperturbability, the expression is one of sensitivity and energy, while the direct gaze indicates a vital intensity.

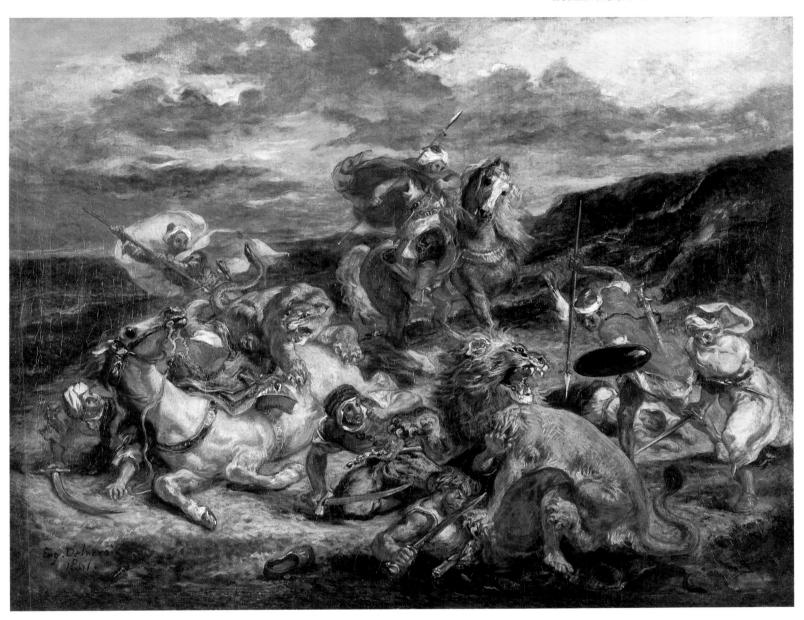

EUGÈNE DELACROIX

1798-1863

The perilous struggle to the death between humans and wild animals held a particular fascination for Delacroix throughout his life, just as it had for Rubens, whose work he greatly admired. Following his journey to Morocco, Delacroix executed several studies and paintings exploring the theme of the forces of nature in terms of the confrontation between humans and animals. In The Lion Hunt the intensity of this struggle is expressed primarily through the creation of tempestuosly swirling movement. Set in a coastal landscape, the scene takes the form of a sweeping, circular movement, illuminated from above, with repetitions in individual body movements and in the details of clothing and clouds. At the same time, the scene is grouped around the point of intersection of two diagonals, along which the positions and movements of the individual figures are aligned.

Only on closer examination of this surging mass of animal and human bodies caught in

the throes of a dramatic struggle, can we discern the balance of power and the imminent outcome. One Arab has been killed and two have been overwhelmed, but four others have already raised their lances and sables to attack the two wildly snarling beasts, while a rider is about to charge. This moment of tension when everything is still in the balance, is echoed by the indefinable weather conditions that bathe the entire event in a strangely shimmering light.

The presentation of nature is reduced to the elementary powers of heaven, water and earth, which merge in hues of bluish-green and in the structural formation radiating from the top right of the picture. In no other portrayal of a hunt by Delacroix are the primeval forces of nature so inextricably entwined with the struggle itself; even the human figures seem to share the suppleness and instinctive reactions of the animals.

Eugène Delacroix The Lion Hunt, 1861 Oil on canvas, 76.5 x 98.5 cm Chicago (IL), The Art Institute of Chicago

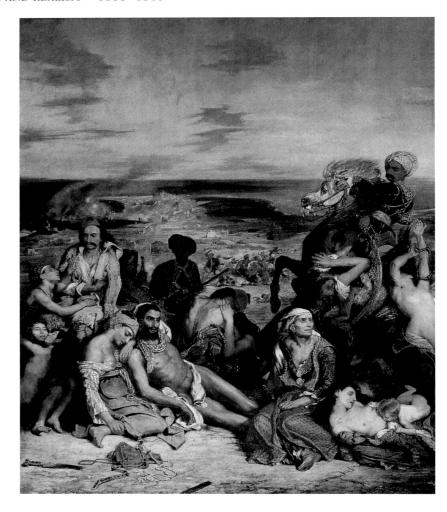

Eugène Delacroix The Massacre of Chios, 1824 Oil on canvas, 417 x 354cm Paris, Musée National du Louvre

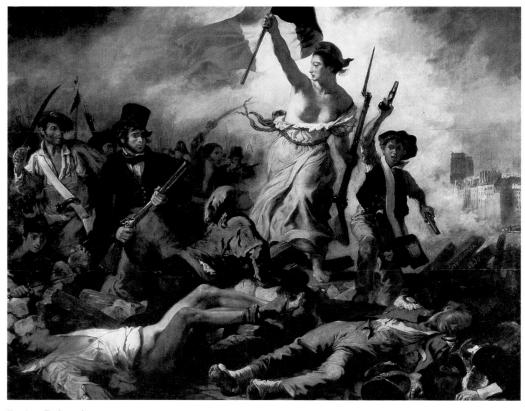

Eugène Delacroix Liberty Leading the People (28th July 1830), 1830 Oil on canvas, 260 x 325 cm Paris, Musée National du Louvre

EUGÈNE DELACROIX

1798-1863

The Greek struggle for liberation from Turkish rule fired the imagination of Europe's neo-Hellenistic liberal intellectuals. Delacroix chose the gruesome massacre of Chios in 1824 when 20.000 inhabitants of the Greek islands were murdered as an attention-catching subject. In 1821, he wrote to a friend: "For the next Salon, I want to make a painting based on the latest war between the Greeks and the Turks. I think that under the current circumstances, I shall be able to draw attention to myself in this way."

Delacroix skilfully structures the picture plane into three human pyramids of dead and dying Greeks, bathed in a harmonious light and colour. Although the painting had already been accepted by the exhibition committee of the Salon, he was no longer satisfied with it once he had seen some of the work Constable intended to submit to the Salon. Suddenly, his painting seemed to him "sad and void of light". Within four days, under the influence of Constable, he altered his painting, adding shimmering glazes and creating new effects with brief and forceful brushstrokes, densely juxtaposed.

The violation of the constitution by King Charles X, who sought the reinstatement of absolute monarchy, led to the bloody insurgency of 1830 which inspired Delacroix to create this painting of a modern subject, as he described it.

Delacroix portrays an extremely dramatic event within a strictly Neoclassical compositional structure based on an equilateral triangle. The people, fuelled by rage, are storming towards the viewer over a broad threshold of the dead and wounded and a barricade of stones and beams. The clouds of dust and gunpowder that envelope the central motif suggest the outlines of firearms in the background and, in spite of the relatively small number of figures in the painting, it gives the impression of a large crowd. The crowd is led on by the allegorical figure of Liberty, part goddess of antiquity and part Parisian marketwoman - wearing a Jacobin cap and brandishing a gun as she waves the tricolour. The crowd is fired by her enthusiasm, described as follows by Heinrich Heine: "These common people have one great thought, that gives them dignity and succour and reawakens the dormant dignity within their souls.

The painter is the sole exception, portrayed in the guise of an intellectual – the student with the hat – as the counterpart of the goddess. Unlike the boy who is shooting around him indiscriminately, the artist holds his gun hesitantly. His gaze, sceptical and thoughtful, is directed into the distance, suggesting that he is seeking the deeper meaning and purpose of it all.

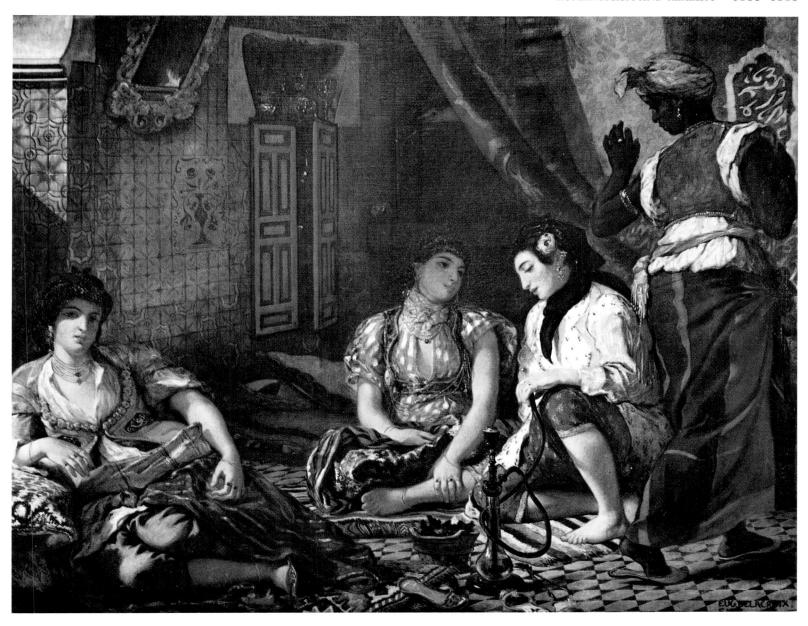

A highlight in Delacroix' tour of Africa which lasted of several months, was his opportunity to visit a harem. His companion, a French diplomat, reports that Delacroix was overwhelmed by the sight: "C'est beau! C'est comme au temps d'Homere!" ("It's beautiful! Just as in the days of Homer!") are said to have been his words. Here, in this enclave of women cut off from the world, he felt he had found the epitome of truth and beauty and the spirit of Antiquity.

These women exude the atmosphere that Charles Baudelaire described as "luxe, calme et volupté" and they seem to float somewhere between reality and dream. In the blend of oriental and Greek and the facial traits reminiscent of a sculpture by Phidias, these are embodiments of an ideal of womanhood which Delacroix describes as follows: "The magic that makes us love them is based on a thousand things... But what seduces the heart and fires its passion are beauties less defined and less delineated, unknown, unexplained, enigmatic and unspeakable."

In order to record his impressions reliably, Delacroix made water-colour sketches during his brief visit to the harem and noted the nuances of colour in pencil. The oil-painting, executed two years later, was to influence many artists, from Renoir to Matisse. This later generation of artists was particularly impressed by the heightened colority inspired by the overwhelming impressions of an oriental journey, and by the way in which Delacroix brightened the traditional brownish hues of the painting.

The handling of light, for example, is such that the light flooding into the room highlights the different materials of various objects, while the areas in the shadow have a deeper but nevertheless intensive colority which is graduated towards the points of transition between shadow and light. Given the sheer variety of magnificently opulent materials and the huge range of colours and reflections, the atmosphere is one of vibrant and vital commotion, woven into a bright and sumptuous tapestry of colour.

Eugène Delacroix Women of Algiers, 1834 Oil on canvas, 180 x 229cm Paris, Musée National du Louvre

Jean-Baptiste Camille Corot View of the Colosseum from the Farnese Gardens, 1826 Oil on cardboard on canvas, 30 x 49 cm Paris, Musée National du Louvre

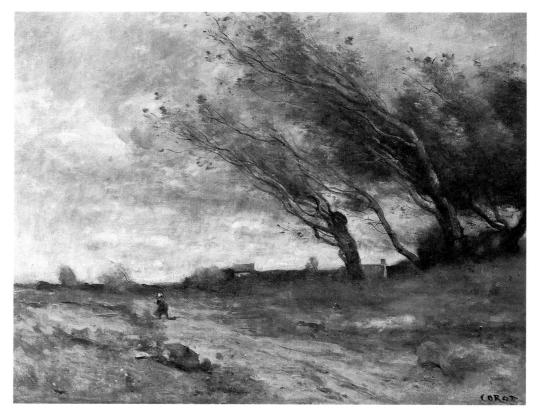

Jean-Baptiste Camille Corot Le Coup de Vent (The Gust of Wind), c. 1865–1870 Oil on canvas, 47.4 x 58.9 cm Reims, Musée Saint Denis

JEAN-BAPTISTE CAMILLE COROT

1796-1875

Corot painted this picture while he was in Rome on his first tour of Italy, where he developed the style of his nature studies on the basis of the classical tradition. It is one of a series of three views – each seen from the Farnese gardens – which, together, create a triptych of different times of day; this one shows the evening. The painting portrays the city with its historic monuments from an idealized viewpoint. It possesses clarity and documentary authenticity without being overburdened with details.

Distance and ideal heightening of the view are achieved by the stage-like framing of trees and bushes of the garden. The contrast between the plants in the foreground, the tectonic forms of the central plane and the empty spaces of the almost cloudless and unusually low horizon in gently graded light and dark tones lend this painting its particular appeal. The handling of light adds a vibrant brilliance to the entire scene, suffused by the evening play of light and shadow, so that the abandoned remnants of the past appear to take on a fresh immediacy.

Although Corot is primarily a painter of serene and sun-drenched landscapes, he created about ten paintings after mid-century in which the scene is shaken by heavy gusts of wind. Most of the landscapes are situated in the north of France, as in this painting showing dunes in front of a low, light horizon, where the movement of the passing clouds seems almost palpable.

A group of windswept trees make the force of the gust particularly clear. The typically hazy air near the sea is depicted by the gently shimmering graduations of colour from light, greyish-green and brown tones and a silvery veil cast over the entire picture. The effect created is a strange blend of natural realism and Romantic, lyrical atmosphere, typical of Corot's mature style.

Monumental and strongly sculpted, the figure of the young Italian woman rises up in front of an atmospheric village background. Her classical face is framed by a warm autumnal light as though by a nimbus. The compact blue and black tones of her costume make her stand out even more distinctly from the background, which seems to dissolve in the luminosity and colority, particularly towards the right-hand side of the painting.

Jean-Baptiste-Camille Corot Agostina, 1866 Oil on canvas, 130 x 95 cm Washington, National Gallery of Art

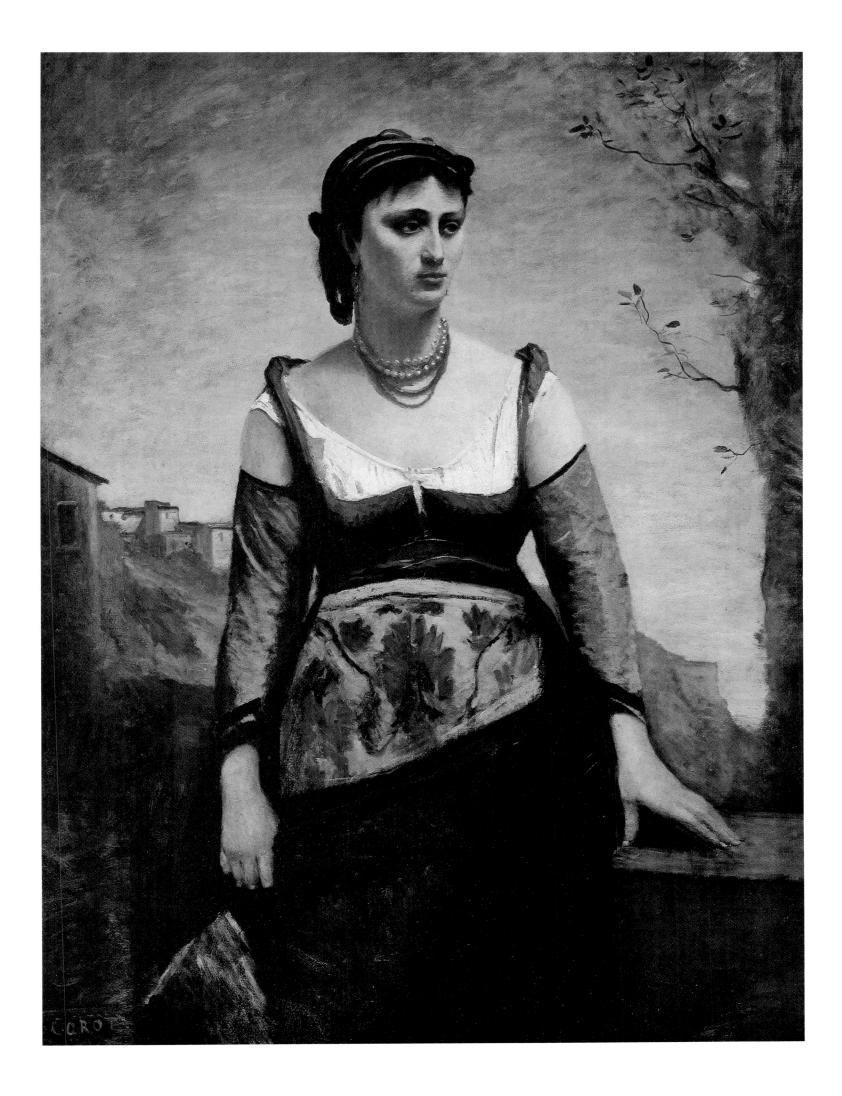

Jean-Baptiste-Camille Corot Woman in Blue, 1874 Oil on canvas, 80 x 51 cm Paris, Musée National du Louvre

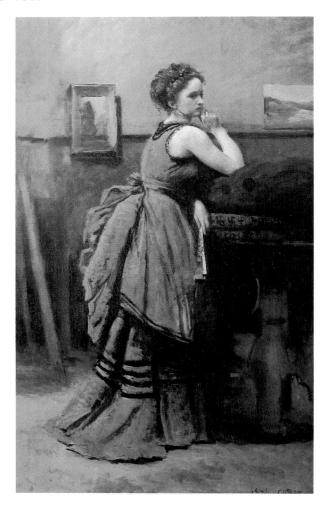

Below: Jean-Baptiste Camille Corot The Studio, 1866 (Young Woman with a Mandolin) Oil on canvas, 64 x 48 cm Paris, Musée National du Louvre

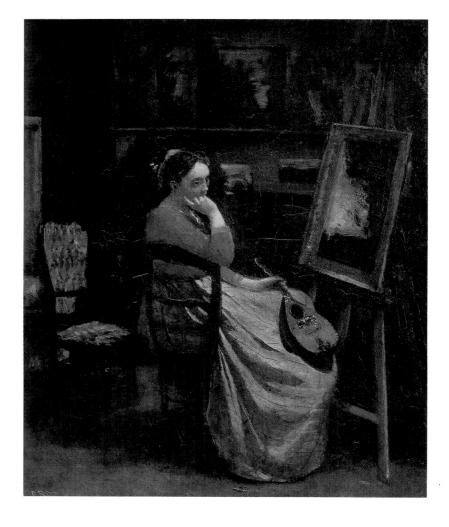

JEAN-BAPTISTE CAMILLE COROT 1796–1875

Both the melancholy gesture of chin on hand, and the setting within the artist's own working area, places this portrayal of a young woman firmly amongst Corot's repertoire of figural and studio paintings. Most of his studio paintings belong to his mature phase and many show women in a mood of melancholic reverie. This particular painting is, however, unusual not only because it portrays a full figure standing, but also because the woman shown here is dressed in extremely elegant and fashionable garb, in stark contrast to Corot's more frequent renderings of nameless models dressed considerably more simply and representing "types" in their Italian, Greek or oriental-style costumes. For this reason, many art historians believe that this painting may well be a portrait of the young Madame G.,

with whom the artist had been friends since

around 1870. Although Corot had gained considerable acclaim for his landscape paintings, his figure studies, which he had also worked on for several decades, did not come to public attention until after his death. He plainly felt that they belonged to the private domain in which he could experiment with his art undisturbed. This painting is from the closing months of the artist's life, and may well be his last figure study. The sophisticated density of his handling of colour, restricted to only a few hues, is extremely progressive. It had an enormous influence on the much younger generation of Impressionists, most notably on several portraits by Renoir, painted in the same year.

In the last fifteen years of his life, Corot worked primarily in his Paris studio, where he produced a number of studio paintings featuring dreamily pensive young girls, to whom he allocated attributes from the world of music, painting or literature. The girl in this painting has clearly just stopped playing a mandolin and is now sitting meditatively, her head leaning on her right hand. In front of her is the artist's easel with a landscape painting, and further paintings are placed on a shelf in the background.

In the dark, brown-toned room, the light falls from above, touching the girl, the painting on the easel and the brightly upholstered chair. The focal point of the painting is the brilliant red of the girl's blouse, reiterated in her hairband. Its warm colority blends harmoniously with the silky sheen of her sand-coloured skirt, the pale complexion of her face, the reddish-brown of the mandolin, the luminous golden frames of the paintings and the ambient dark browns. The dreamy, melancholy mood surrounding the girl is emphasized by the harmonious colours. This, for Corot, is essential: "What I seek in painting is... an equilibrium of hues. Colour is only secondary to me."

THÉODORE CHASSÉRIAU

1819-1856

Henri Lacordaire, who had abandoned his career as a lawyer in order to become a priest, was called to Rome in 1839 by Pope Gregor XVI to answer for his rebellious ideas. He submitted to the will of the papal chair and became an impassioned proponent of Catholicism, making a significant contribution to its renewal during the upheavals of the 1848 revolution.

Chassériau's portrait of Lacordaire, who had joined the Dominican order, was executed in Rome. The clergyman, dressed in a monk's habit, is standing in an attitude of meditation in front of the cloisters of Santa Sabina. Only the intelligent, sharply contoured face with the piercing eyes set firmly on the viewer indicate the passionate and courageous spirit of this man. Chassériau also expresses this in his painterly technique by having a ray of light fall upon the figure, creating strong chiaroscuro contrasts and contours in the face and robes, and at the same time separating the figure like a silhouette in relief against the softly painted architecture of the background. This is also in keeping with the reduced palette, consisting primarily of browns, that suffuses the background in a gentle reddish-brown, against which the dark brown and pale beige of the face and robes are distinctly set apart in their starkly contrasting hues of dark brown and light beige.

In this painting of his two sisters, who often stood as models for him, Chassériau chose to portray a bond of harmony and tenderness. The double portrait, for which preparatory pencil studies exist, shows his older sister Adèle on the left and Aline, twelve years her junior, on the right.

The age difference between the two women is barely discernable in the painting. Both have the same fine, sleek, dark hair and delicate complexion, particularly evident in the portrayal of their intertwined hands and wrists. They also wear similar clothing and jewellery. The immobility of the scene and the emphasis of line embracing both figures and making them stand out clearly against the background, expresses the harmony of these two women. Only the magnificent blossoming rose on her belt sets Adèle apart from her much younger sister.

The bold use of colour is in stark contrast to the linearity which lends the painting its own decorative quality. The influence of Delacroix' modern and intensively coloured painting on this former student of Ingres is clearly evident not only in the fine, though by no means overweeningly elegant dresses, with their blend of light browns and pinks, but most notably in the long, brightly coloured red shawls.

Théodore Chassériau Pater Lacordaire, 1840 Oil on canvas, 146 x 107 cm Paris, Musée National du Louvre

Théodore Chassériau The Sisters of the Artist, 1843 Oil on canvas. 180 x 135 cm Paris, Musée National du Louvre

Paul Huet Breakers at Granville, c. 1853 Oil on canvas, 68 x 103 cm Paris, Musée National du Louvre

Charles-François Daubigny Landscape at Gylieu, 1853 Oil on canvas, 62.2 x 99.7 cm Cincinnati (OH), Cincinnati Art Museum

PAUL HUET

1803-1869

Unlike Daubigny, who portrayed the calm and meditative side of nature, most of Huet's land-scapes are images of catastrophe, storm, and flood. The tempestuous seas lashing the peninsula at Granville, where the artist stayed in 1850, inspired numerous sketches, on which he based his famous wave paintings.

The sea dashing against the steep cliffs is painted at such proximity that it is almost as though Huet had set up his easel in the midst of the rising waves. The white crests of foam topping the breakers as they crash against the cliffs and the spray rising from them form the focal point of this dramatic display of the forces of nature. Broad brushstrokes create the brackishly green waves and the blurred and fleeting sketchiness of the dark brown rock formations. The menacing undertone of nature's powers unleashed is further heightened by the dark and thundery sky that makes the sea light up so strangely.

The famous critic Charles-Augustin Sainte-Beuve said of Huet's art: "In this way of observing and presenting location, the human being no longer plays any major role... nature comes first, nature alone."

CHARLES-FRANÇOIS DAUBIGNY

1817-1878

One of Daubigny's favourite subjects is the changing character of landscapes with water. His aim was to capture the momentary mood created by a specific weather or light situation. The forms of the objects and their materiality are subordinate to this purpose. The paint is hastily applied so that forms appear to be dissolved by light. The traditional distinction between sketch and finished painting was thus abandoned by Daubigny.

From the late 1840s onwards, the artist also worked on his landscape paintings in the Rhone valley. The pond of Gyliau near Optévoz fascinated him for some time; he even created an oil-painting of it as late as 1869. This version of 1853 was painstakingly prepared with several preliminary studies.

Daubigny not only determined the composition in his small-scale pencil sketches, but also noted the colours in which he would execute the finished painting. The balanced composition and the finely gradated, sometimes shimmering greens render the calm atmosphere of this undisturbed place on a bright summer day seemingly effortlessly. In the realistic, atmospheric presentation of landscape without pathos, Daubigny paved the way for the Impressionists.

THÉODORE ROUSSEAU

1812-1867

Rousseau painted the Chestnut Avenue in the park of Château Souliers in the Vendée, owned by the family of his friend, the painter Charles le Roux. The composition is reminiscent of a theatrical backdrop in which an illusion of great depth is created by means of architectonically structured and symmetrically gradated trees on either side of the alley. The fact that the upper edges of the painting have been rounded heightens this stage-like effect. It is further emphasized by the position of the viewer, who perceives the alley at a distance, although he is actually standing in its

A gloom-laden atmosphere is exuded by this painting, devoted for the most part to a dense and impenetrable vault of foliage with no sky above it. Only in the lower quarter of the painting is there some air and light to be seen through the short and stocky tree-trunks with their wizened branches, and even the horizon is merely a matt shimmer along the line where earth and sky meet.

Forest and trees are Rousseau's preferred subject matter. The atmosphere he expresses in his paintings is invariably based on a direct and unsentimental observation of nature. Nature never becomes a vehicle for the expression of human sentiment.

In his Oak Trees near Apremont, Rousseau brings to perfection an artistic endeavour that had previously been explored only by English painters, and one that was relatively new to the French art world. With objective precision, he portrays the burning mid-day light of high summer and its effect on the landscape. Like many of his artist colleagues from the school of Barbizon, Rousseau chose his local environment as the subject of his studies, painting it under different light and atmospheric conditions, then completing the painting in the studio.

A group of sturdy oaks takes up the central area, it is surrounded by grazing cows; a peasant can also be seen. The dark mass of the trees casts a short and compact shadow that is broken in only a few places by pools of light. To the right and left, the dark green outline dissolves into smaller, lighter foliage, shimmering in the sun. Behind the wide expanse of lush green meadow, dappled with patches of pale yellow, a small strip of yellowish vegetation stretches across the painting, cut by a sandy path.

The calm tranquillity of the scene and the compositional device of placing the horizon line at a low level, leaving considerable space for the sky, give us a clear indication of Rousseau's main influences, particularly amongst the Netherlandish landscape painters of the 17th century such as Meindert Hobbema or Jacob van Ruisdael.

Théodore Rousseau The Chestnut Avenue, 1837 Oil on canvas, 79 x 144 cm Paris, Musée National du Louvre

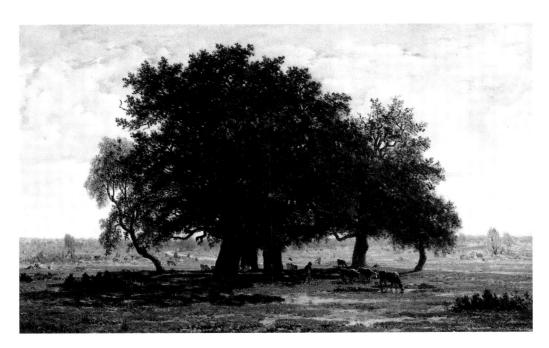

Théodore Rousseau Oak Trees near Apremont, 1852 Oil on canvas, 63.5 x 99.5 cm Paris, Musée National du Louvre

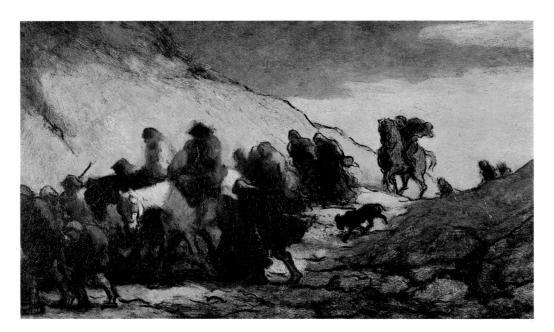

Honoré Daumier The Emigrants, 1852/55 Oil on panel, 16.2 x 28.7 cm Paris, Musée du Petit Palais

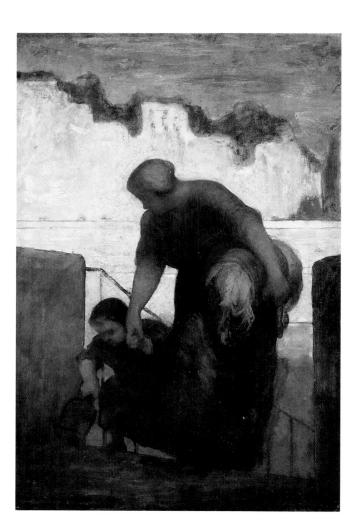

Honoré Daumier The Washerwoman, c. 1860 Oil on panel, 49 x 34 cm Paris, Musée National du Louvre

HONORÉ DAUMIER

1808-1879

Through a barren dunescape beneath a low, overcast sky in shades of brown, a bowed and ragged group of stragglers makes its way – the scene is one of utter despair and destitution. The anonymity of the landscape and the people, their unknown destination and the unknown reason for their march that seems to stretch into infinity beyond the picture frame, do not even permit the viewer a direct sense of sympathy with the fate of these individuals. There is only an unsettling sense of anxiety.

Throwing all artistic convention to the wind, Daumier has reduced the means available to him as a painter to this single statement. In doing so, the figures have been reduced to gloomy, earthy lumps, like the clay of the landscape around them, and it is only the occasional thick, black outline and the contrast of light and shade that makes them recognisable as human beings at all.

The immediate circumstances that would give use to this deeply affecting picture, as well as a series of oil-paintings, lithographs and a relief bearing such titles as *The Emigrants*, *Refugees* and *The Lock-Up* was the with less cruelty with which the government of Louis Philippe had crushed the workers' uprising of June 1848, in which thousands were killed or imprisoned as a result and some four thousand were deported to the highlands of Algeria.

Against the sketchy backdrop of a row of houses bathed in evening light, the dark silhouette of the washerwoman at the end of her day's work, her child by the hand, ascending the steps at the banks of the Seine, appears monumental. This working mother is not starved and emaciated. She has the heavy, wellproportioned body of a strong woman: here we find the Romantic socialism which, in the age of new social ideas sees the working woman as a heroine, as a "monument of solid decency". The same notion can be found in the paintings of Millet, who felt that the people only had to be "saved" and new heroes would emerge, and who – like Daumier – heightened everyday situations to the point of monumentality.

This painting of the washerwoman is the most famous of a series of seven by Daumier on the same theme. In all of them, the empathy of the artist is clearly evident. Daumier's work is peopled by ideal figures such as the washerwoman in the form of a conventional woman fulfilling her role as mother and worker with dignity and a deep sense of duty. However, as soon as they rebelled against their appalling situation – politically engaged women at the time were struggling against their social status as citizens without rights – he would caricature them and portray them in his lithographs as ridiculous and ugly Xanthippes.

Although Daumier's fame is based primarily on his prints, he is also one of the most important painters of his century.

Daumier illustrated the tragi-comic epic of the Spanish author Miguel de Cervantes in some 25 oil-paintings, watercolours and a number of charcoal-drawings. Don Quixote, who sets out in quest of adventure, vowing that "he would right every manner of wrong, placing himself in situations of the greatest peril such as would redound to the eternal glory of his name" is an idealist who cannot come to terms with the world as it is and who therefore sets out to conquer it according to his own chivalrous ideals.

Daumier's Don Quixote is repeatedly interpreted as the creation of an artist who was also an outsider and who saw himself reflected in the figure of the travelling knight. In this painting, Daumier has expressed the loneliness of the knight by portraying him as a sad figure in an empty, barren wasteland, a thin body riding an emaciated horse, looking for all the world like a caricature.

The physiognomies of both man and horse are skeletally grotesque and have been stylized to the point of anatomical deformation. The light does not model the figures, but illuminates them in an eerie manner, robbing them of all palpable corporeality and making them appear to the viewer as mere illusion, almost like a spectre. The strangely unreal intensity of the background colority, which resembles a moonscape, further heightens this impression.

In this way, Daumier makes Don Quixote and his horse in their symbiotic portrayal, a tragicomic incarnation of the outsider in the world.

"There are times when the audience becomes quite fanatical and the gallery is like a cage of wild beasts poised to leap into the fray and tear apart their victim, the conspirator, the traitor, the evil one, the faithless lover... Just imagine what they would be like if they were ever to break out seriously", writes Banville in his memoirs, describing a Paris theatre audience.

Daumier, who enjoyed visiting the theatre, has captured just such an audience in this painting. In fact, the audience tended to interest him more than the plays themselves. In front of the audience, on the stage, the pathetically triumphant murderer - it was clearly a good murder - shows a despairing and frantic woman the victim stretched out on the floor. The crowd is riveted in horror, unable to distinguish between fiction and reality. The highly effective one-sided lighting of the footlights, creating a contrast between the brightly lit stage and the dark auditorium, is used by Daumier to build up an atmosphere of high tension at the climax of the play. Daumier was the first major painter to portray the theatre stage, well before Toulouse-Lautrec and Degas.

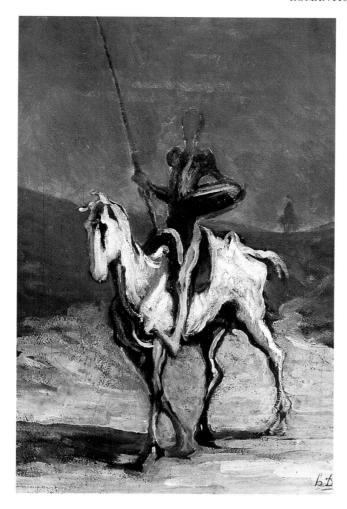

Honoré Daumier Don Quixote, c. 1868 Oil on canvas, 52.2 x 32.8 cm Munich, Bayerische Staatsgemäldesammlungen, Neue Pinakothek

Honoré Daumier The Melodrama, c. 1860 Oil on canvas, 97.5 x 90.4 cm. Munich, Bayerische Staatsgemäldesammlungen, Neue Pinakothek

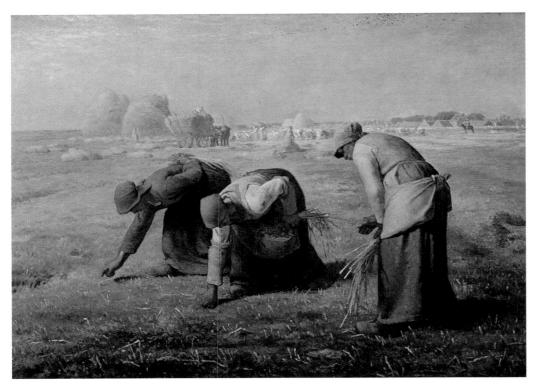

Jean-François Millet The Gleaners, 1857 Oil on canvas, 83.5 x 111 cm Paris, Musée National du Louvre

JEAN-FRANÇOIS MILLET

1814-1875

Honoré de Balzac has described gleaning in some detail: "Gleaning was permitted only with a certificate of need issued by the mayor, and gleaning was permitted only to the poor in their own community." This background knowledge is needed in order to understand the impact this painting had on a contemporary audience. One critic, for example, suspected that *The Gleaners* bore "the thorn of revolution and the guillotine of 1793". Millet's themes alone, drawn primarily from peasant life, seemed revolutionary and therefore dangerous.

Taken at face value, the painting of the gleaners, the poorest of the poor, presents a picture of absolute harmony. Humans and nature in perfect harmony express a higher natural order. The evening sun bathes the people and the landscape in gently atmospheric hues. The ponderous figures of the women, whose monumental silhouettes fill the centre of the painting, have frequently prompted comparison with Michelangelo's sibyls. The uniformity of their bowed posture and their movements take the form of a harmonious working rhythm that betrays nothing of the sheer physical effort of this heavy work.

Jean-François Millet The Evening Prayer, c. 1858/59 Oil on canvas, 55.5 x 66cm Paris, Musée National du Louvre

In this painting, two peasants are taking a break in their work at sunset in order to pray. A brief moment of peace is granted to them. They clearly have a hard day's work on the huge potato field behind them and the implements around them indicate that they will probably take up their work again once their prayer is over. They seem to be bound up in a natural order of things, within which they carry out their work "like priests in holy office" (according to a contemporary critic).

"It is quite impossible to imagine these people ever thinking of being anything but that which they are", Millet once said, "but we can see the oppression, even if they cannot. Perhaps it is revealed to us in the expectation that we shall respond to it." The socio-political intent behind Millet's paintings is not immediately evident. Clearly, however, he quite rightly anticipated a certain awareness on the part of his audience, who saw in him a republican revolutionary. Many of his contemporary critics, on the other hand, saw his paintings as sentimental. Cézanne even described Millet as a "tear-jerker", although Millet, as he himself once wrote, eschewed everything that might appear as pure sentimentality. Van Gogh, on the other hand, saw in Millet his spiritual father, and Dalí produced several variations on the theme of the Evening Prayer and devoted a book to it.

GUSTAVE COURBET

1819-1877

Courbet himself described this painting as strange. Indeed, it is quite unlike any of his other paintings. Although the women are busy at their daily work and surrounded by the requisite objects, the scene nevertheless appears distinctly artificial. One need only regard the postures and gestures of the women. The woman leaning against the sacks seems to be working as though in a dream, with stiffly outstretched fingers. The other, kneeling, seems almost frozen in her exaggerated pose. What is more, all three figures are completely isolated from each other, each immersed in their own thoughts.

It may be assumed that, in creating this painting, Courbet was inspired by the fashion for Japanese art that had been all the rage since about 1855, most notably the Japanese wood cuts introduced during this period. The elements that suggest this are, for example, the handling of light, the monotone grey and ochre tones of the pictorial space delineated by vanishing lines, the empty background wall and the figures like cut-outs in strongly-coloured red and bluish-green robes, and the many round and oval forms, especially those of the vessels and containers, reminiscent of Japanese lanterns and vases. Even the pose of the woman sifting the grain is similar to a pose frequently adopted by players in traditional Japanese kabuki theatre. Such distinctive artifice is not to be found again until the works of Gaugin.

Today, we find it rather difficult to understand how Courbet's Young Women on the Banks of the Seine, exhibited at the Paris Salon of 1857. could possibly have caused such a scandal. Two pretty young women on a sunny summer's day are taking a rest in the shade of a tree and enjoying the calm tranquillity. Both are beautifully dressed in the fashion of the period. To contemporary critics, these women were shameless and vulgar, and described as "biches", the term generally used in French to describe "kept women", as featured in the pornographic works of the Second Empire. Pierre-Joseph Proudhon saw in them a moral accusation, with the brunette immersed in erotic dreams and the blonde coldly calculating shares, stocks and business. The shock-waves triggered by this painting can only be explained in the light of the completely new form of realism that Courbet introduced into painting, both with regard to his form of presentation - strong colours closely bound to the objects they portray, unchanged by the specific daylight or light and shadow - and the subject matter itself. Courbet portrayed neither the mythological nudes of the Salon painters, nor the oriental beauties of Delacroix, but simply the perfectly normal situation of a summer excursion. Nor has he transfigured the girls or created any distance between them and the viewer, placing them instead, as it were, at his feet

Gustave Courbet The Winnowers, 1853 Oil on canvas, 131 x 167 cm Nantes, Musée des Beaux-Arts

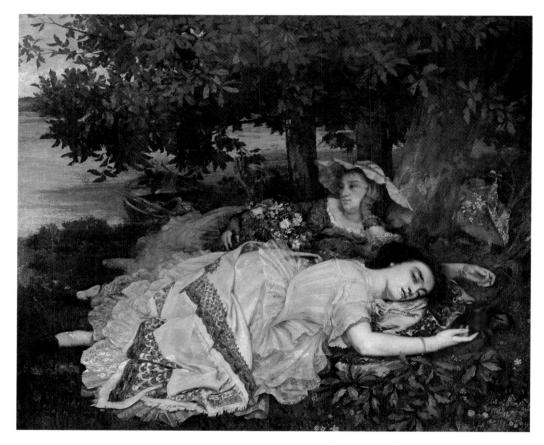

Gustave Courbet Young Women on the Banks of the Seine, 1857 Oil on canvas, 173.5 x 206.5 cm Paris, Musée du Petit Palais

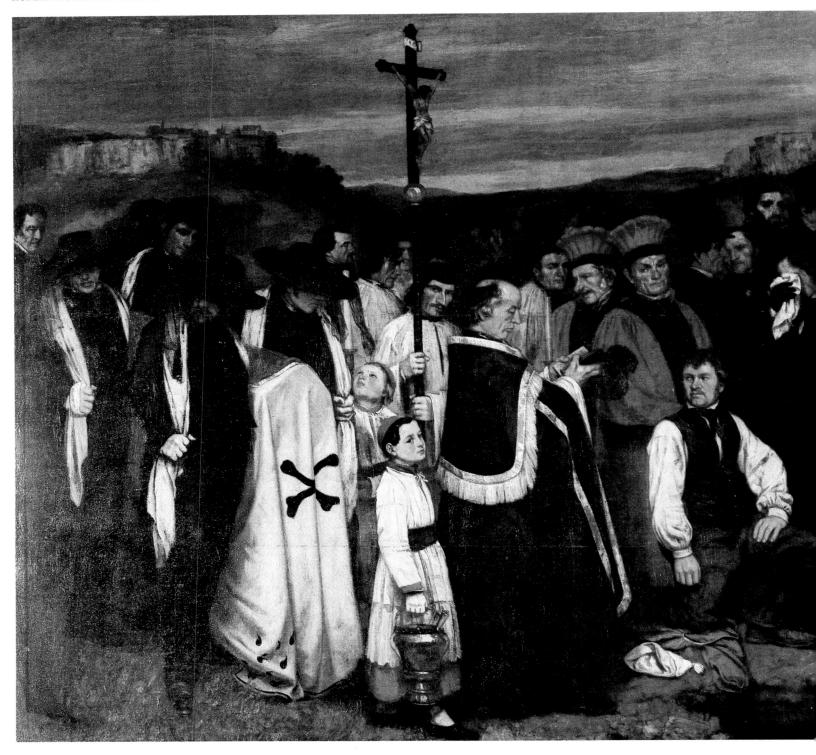

GUSTAVE COURBET 1819–1877

Ornans, a little provincial town near Besançon, was Courbet's home town and the place of his birth. He painted his *Burial* here, in the little studio he kept in his grandfather's attic, itself barely wider than the finished canvas. Against the rugged landscape of the Roche du Mont, the mourners have gathered at the open grave: the citizens of Ornans, farmers and wine-growers, merchants and bourgeois, clergymen and officials. Courbet knew them all and they all wanted to be in the painting. In the end, 46 of them were included – life-size and just as the painter saw them, neither more beautiful nor more ugly.

Four pall-bearers in wide-brimmed hats are carrying the coffin, their heads turned slightly to one side to avoid the smell of the decaying

corpse. Beside them, in his white robe, is the verger with the cross and two servers. Bonnet, the priest in the black robe, is reading the Prayer for the Dead; on the right, the two beadles in scarlet are the shoemaker Clemént with the long nose and the wine-grower Muselier. At their feet kneels the gravedigger in his shirt sleeves, and above him, next to the man in the top hat, is Courbet's father Régis.

On the right, with his hat in his hand, stands Proudhon, deputy Justice of the Peace. Next to him, is the plump mayor. Right beside the grave, two veterans of the revolution of 1793 attired in Jacobin garb, have come to pay their last respects. In front of them is a skull as the symbol of mortality. Perhaps it is also intended as a symbol of

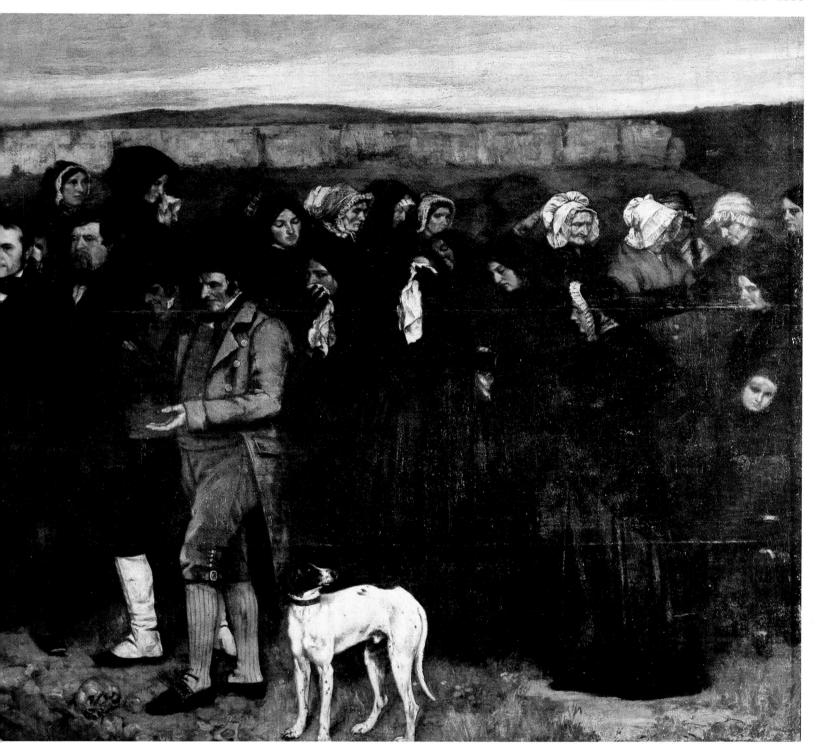

the failure of the revolution of 1793 and the dashed hopes of 1848?

Set apart from the men, as they would be if they were in church, are the mourning women who also complete the circle. Amongst them are the painter's sisters: Juliette crying, Zoé hiding her face, Zélie lost in thought. On the outside right, with a child holding her hand, is Courbet's mother.

But who are they mourning for? In 1848 Courbet's grandfather, Jean-Antoine Oudot, died. He was a keen republican and veteran of the 1793 revolution. He may be the dead person. Yet even as his Jacobin friends stand by his grave, he himself appears in the painting, at the left-hand edge, a witness to his own burial.

The composition is as simple as it is skilled. The horizontals of the background are reiterated in the parallels of the frieze-like group. The tonality is equally simple, with a distinct predominance of black and white, fractured by strong reds. The painting provoked an outrage.

The banality of a village burial, a genre scene, had been portrayed in the format of a history painting. The trivial had been treated as a state event. Courbet was accused of pursuing a "cult of ugliness" and of creating an "undignified, godless caricature". Above all, the "full-moon faces" of the beadles "smeared with scarlet, and their drunken posture" incensed the critics. Yet Courbet merely documented what he had seen.

Gustave Courbet Burial at Ornans, c. 1849/50 Oil on canvas, 315 x 668 cm Paris, Musée d'Orsay

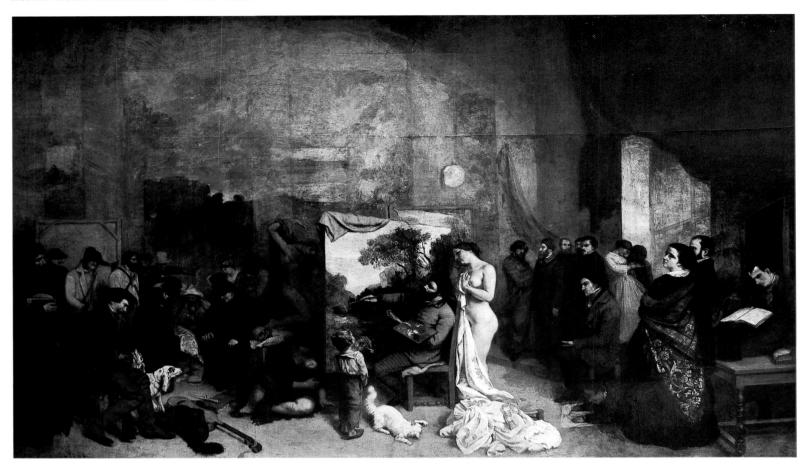

Gustave Courbet The Painter's Studio: A Real Allegory, 1855 Oil on canvas, 359 x 598cm Paris, Musée d'Orsay

GUSTAVE COURBET

1819-1877

Courbet himself described the composition of this remarkable painting of enormous dimension as follows: "I'm in the centre, painting, on the right are all of the participarts, that is to say my artistic and bohemian friends. On the left is the other world of daily life, the people, misery, wealth, poverty, the exploited and exploiters, people who live off of death." It was his expressed intention "to have the whole of human society pass through my painting".

Courbet showed this painting at a private exhibition, the Pavilion of Realism, organized in protest against the Salon of 1855. In the catalogue, he called it a "real allegory". For Courbet, being a realist meant "being an honest friend of full truth". As such, he divided human society into two groups, one impervious to the "world of art" and one participating in it. He presents himself as an artist working on a landscape painting of primal nature.

As ideal viewers, he shows the female nude model and the child; they represent the sensual and authentic perception of truth, untrammelled by reflection. The woman was immediately intepreted by contemporary critics as the "muse of truth". Both stand in contrast to that which Courbet presents as modern life. Jew, clergyman, old republican, hunter, reaper, fairground strongman, harlequin, peddler, working woman, labourer, gravedigger, Irishwoman, draper, specified by Courbet himself as personalities of the left side, are real allegories

in the sense that they represent specific spheres of life. Their reality comes from the fact that the painter has them appear on the stage of his studio, which means that the world becomes interesting through the significance with which the artist imbues it in his painting. Those accepted by him as spiritual participants in his "realistic" art (right) round off Courbet's world. We recognize his closest friends: Promayer, Bruyas, the socialist philosopher Pierre-Joseph Proudhon (in the centre of the standing group of five), Cuénot and Buchon; forefathers of literary realism, Jules Champfleury (seated) and Charles Baudelaire, the poet of the Fleurs du Mal (reading). In the window aperture in the background are two young lovers, while the elegant couple in the foreground represent lovers of art.

The focal point of the "reality" that he has created, is Courbet himself. Adopting the authoritarian and demonstrative posture of the demiurge, he is the only active person in the picture. The painter presents himself primarily as a protagonist and as the embodiment of the artist as such.

In contrast to previous studio paintings, which, since the Renaissance, had become a genre in its own right, Courbet is not interested in presenting his external surroundings and his social status, but in defining his special status on the basis of his creative powers. Courbet's studio is the stage on which the world evoked through his powers of imagination appears for the first time in all its authenticity.

france

CASPAR DAVID FRIEDRICH

1774-1840

This painting was acquired by the Prussian king at the Berlin academy exhibition of 1810, together with Friedrich's famous *Monk by the Sea*. It is not known whether the artist intended these two paintings of identical format to be a pair. Certainly, it is not unusual in the œuvre of Friedrich for two or even four paintings to refer to each other or indicate seasons or times of day, symbolically evoking various periods of time or ages of human life, and such an aim is also conceivable in this case.

In the painting itself, the oaks and the Gothic ruins presumably indicate two historical epochs: the pre-Christian era of natural religions and the Christian era which has replaced the forest with the church - culminating in the medieval Gothic cathedral – as the place of worship. It is strange that the funeral procession of the monks should pass by the open grave towards the doorway of the church ruin and then through it. Friedrich based this painting on the ruined church of Eldena in Pomerania, adding the crucifix in the portal and the window tracery above it in order to make the religious aspect clearer still. The path the monks are treading evidently leads them towards a world of light that goes beyond death and history.

This painting was described by Friedrich's contemporary, the poet Theodor Körner, in his *Friedrichs Totenlandschaft* (Friedrich's Landscape of the Dead) as follows: "Der Quell der Gnade ist im Tod geflossen, / Und jene sind der Seligkeit Genossen. / Die durch das Grab zum ew'gen Lichte ziehen." ("The source of mercy has flowed in death / And they are comrades of beatitude / Who pass through the grave towards eternal light") The skies have cleared over the darkness that weighs down upon the bleak winter scene and we can just discern the faint outline of the moon.

The wanderer is resting at a place typical of Friedrich's landscapes: at a slope in the foreground, beyond which there is a yawning abyss from whose unknown depths the mountains rise up in the darkness. Friedrich loved this rugged transition between foreground and background, zones he tended to identify as two fundamentally different levels of existence. Whereas the foreground in this painting seems almost physically tangible in the dying light of day, further emphasized by the bright clothing of the wanderer, the background heralds a transformation of impenetrable darkness into enigmatic night.

Other Romantics, including the poet Novalis, saw night as the realm of the soul and spirit, indicative of a higher existence than daytime, which is the realm of real, earthly life, dominated by the demands of the material world. In Friedrich's painting, a rainbow divides these zones of day and night, itself an enigmatic sphere. At the time, the biblical concept of the rainbow as a symbol of reconciliation between God and man was widely prevalent.

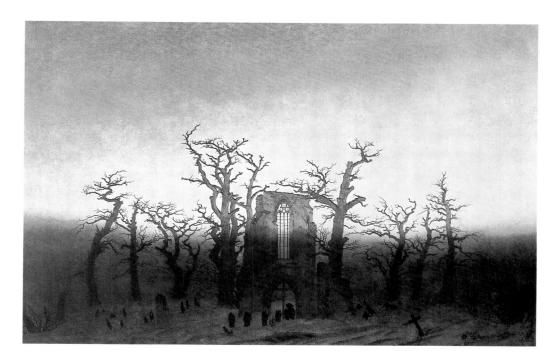

Caspar David Friedrich Abbey under Oak Trees, 1809 Oil on canvas, 110.4 x 171 cm Berlin, Nationalgalerie, Staatliche Museen zu Berlin – Preussischer Kulturbesitz

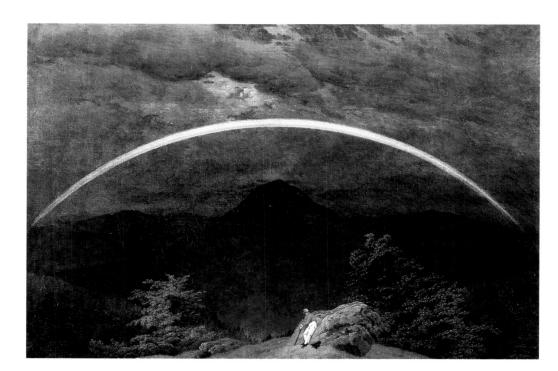

Caspar David Friedrich Mountain Landscape with Rainbow, c. 1809/10 Oil on canvas, 70 x 102 cm Essen, Museum Folkwang

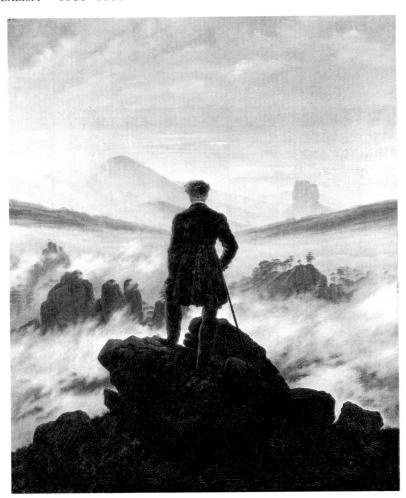

Caspar David Friedrich Wanderer watching a sea of fog, c. 1817/18 Oil on canvas, 98.4 x 74.8cm Hamburg, Hamburger Kunsthalle

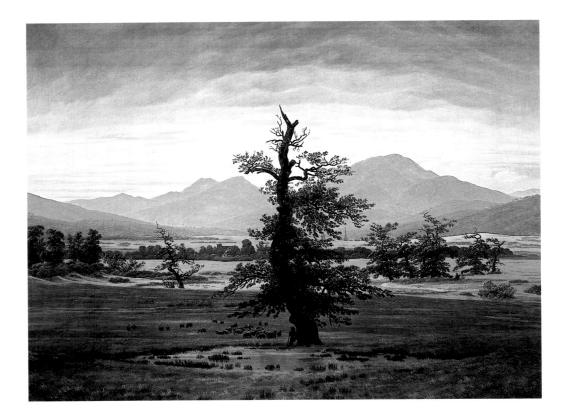

Caspar David Friedrich The Lone Tree, 1822 (Village Landscape in Morning Light) Oil on canvas, 55 x 71 cm Berlin, Nationalgalerie, Staatliche Museen zu Berlin – Preussischer Kulturbesitz

CASPAR DAVID FRIEDRICH

1774-1840

The figure portrayed may be an officer who was killed in the Napoleonic wars of 1813-1815, to which there is direct or indirect reference in many of Friedrich's works. With the unification of the German states in these wars, the bourgeoisie hoped not only to drive Napoleon from the territory of the former Empire, but also to dismantle the feudal structures in their own country. There have therefore been many attempts to interpret the recurring dualism in Friedrich's paintings - the restricted foreground with figures (the present) and the wide expanse of landscape in the background (the future) as the political allegory of a better, free Germany. The portrayal of the old-fashioned traditional German frock-coat, prohibited in 1818 and worn by the wanderer in this painting, is taken as a validation for such an interpretation. With this in mind, it is immediately evident that the wanderer has reached the utmost point of the material world and now, rising above its limitations, is enjoying a new sense of liberty that goes beyond material considerations and is accessible only to the spirit and the mind.

The Lone Tree is one of the works in which symbolism is actually secondary to the immediate aesthetic effect. Nevertheless, here too, the weathered oak is an entity with which the viewer can identify as a metaphor of the human being marked by the rigors and hardships of life.

In his Chalk Cliffs Friedrich has made a particularly unequivocal statement of his Weltanschauung. At the same time, this painting indicates the extent of the artist's interest in exploring hitherto unknown landscapes and viewpoints in painting. The figures are situated on the very brink of an abyss bordering two very different forms of existence. The inaccessible chalk cliffs elucidate the transition from the physical world in which the wanderers are located and the great beyond which is accessible only to the eyes and mind - a boundary not everyone is willing to cross, and one that divides opinions. We have little difficulty in determining which figure Friedrich himself identified with: certainly not with the bourgeois couple anxiously peering at some detail on the edge of the cliff, or searching for some lost object and looking quite ridiculous in doing so. The artist identifies with the man in the old-style German frock-coat leaning against the tree on the right and gazing pensively into the distance.

The magnificent, endless expanses of the sea were regarded in the 18th century as a symbol of infinity. In Friedrich's paintings, ships plying the wide ocean also indicate a certain yearning, for they suggest that the realm bound by the limitations of earthly existence has been overcome.

Caspar David Friedrich Chalk Cliffs on Rügen, 1818 Oil on canvas, 90 x 70 cm Winterthur, Stiftung Oskar Reinhart

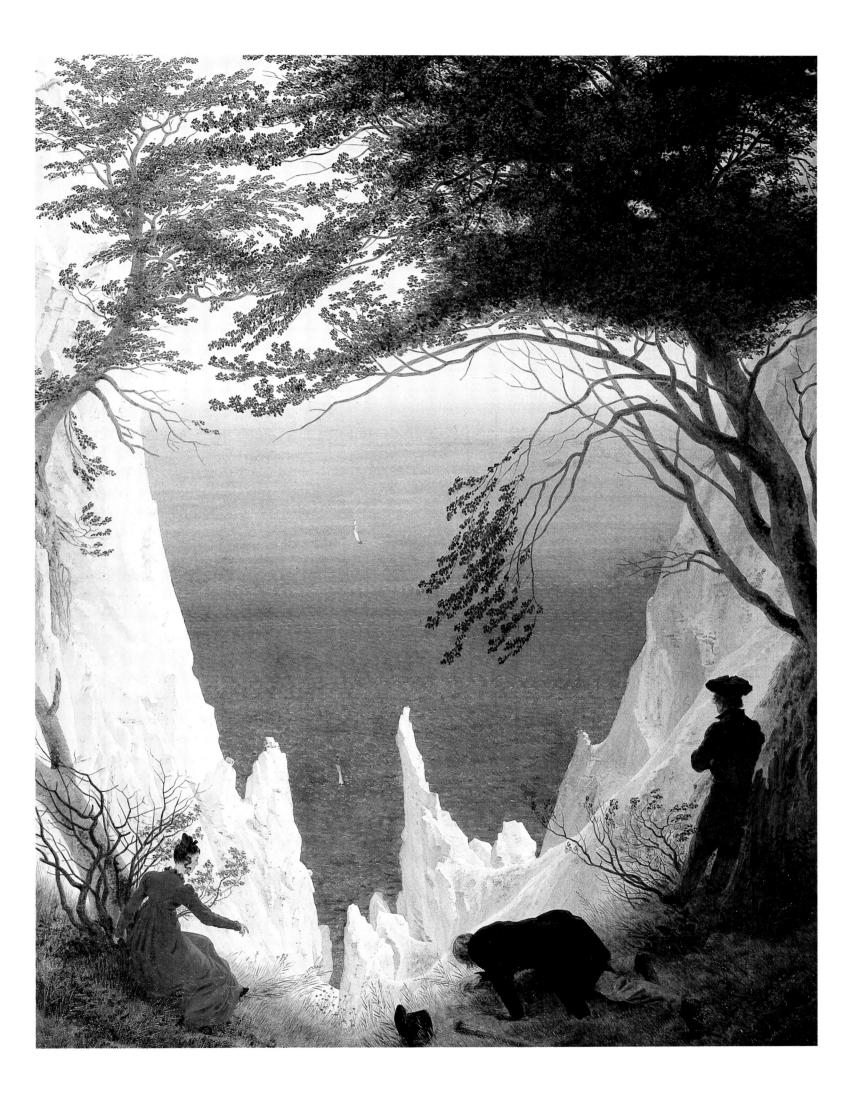

Joseph Anton Koch Swiss Landscape (Berner Oberland), 1817 Oil on canvas, 101 x 134cm Innsbruck, Tiroler Landesmuseum Ferdinandeum

Joseph Anton Koch Schmadribach, c. 1821/22 Oil on canvas, 131.8 x 110cm Munich, Bayerische Staatsgemäldesammlungen, Neue Pinakothek

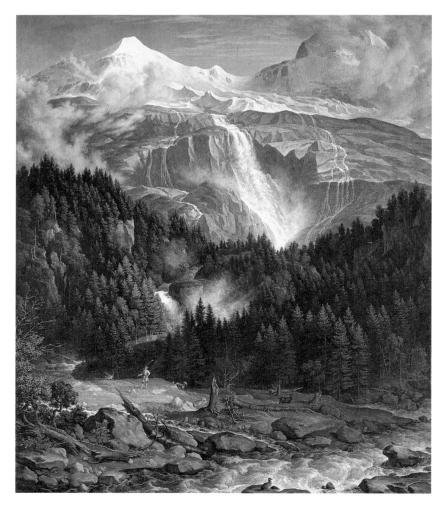

JOSEPH ANTON KOCH

1768-1839

This painting is composed in the grand format of the Neoclassical landscape of the 17th century. Accordingly, the picture planes are built up parallel behind one another, and the sides of the composition are framed by house and tree, while the mountains form a backdrop, creating a kind of interior space. Koch transfers Poussin's compositional structure, honed on Italian landscapes, to the world of the Alps, transforming the mythological and biblical figures that normally people such landscapes into figures of contemporary peasant life.

It is evening, and the people who have worked all day as hunters, herdsmen and gardeners are returning to the shelter of their village. The life of these people is clearly harsh, yet nature provides for them all. They are obviously happy and contented.

Here, Koch recalls concepts of 18th century Enlightenment, with its criticism of prevailing feudal structures and its evocation of a natural human existence, free of such structure and which they saw embodied in the free peasant communities of the Swiss Alps. In his famous poem *Die Alpen* ("The Alps") of 1729, the Swiss poet Albrecht von Haller praises the simple yet free life of the Alpine peasants and holds it up as a shining example against the envy, selfishness and evil of urban and court life.

In this view of the *Berner Oberland*, based on the impressions he gained during his tour of Switzerland in the 1890s, Koch projects an image of a holistic, natural world. The mountains have been recorded without distortion, from an angle that invites the observer to "read" the picture.

Our gaze is guided by the central axis, delineated by the waterfall, through various zones of vegetation and waste land. From top to bottom, these zones recall the sequence of natural history or creation, whose path also follows through from anorganic forms to various forms of vegetation and finally to animals and human beings, all of which are dependent on the life-sustaining and life-destroying element of water.

Water is also accorded its own individual features, being portrayed in every state from the haze of clouds to ice and snow, until, fed at first by a mere trickle, it becomes a rushing waterfall that carries away everything in its path. In Koch's lifetime, the path taken by water was frequently seen as a symbol of the path of human life.

Koch had already used the motif of the *Schmadribach* waterfall in a water-colour of 1794 (Basle, Kunstmuseum) and in an earlier version executed around 1811 (Leipzig, Museum der bildenden Künste).

GEORG FRIEDRICH KERSTING

1785-1847

The Enlightenment sought to change society through knowledge. Accordingly, the readingcircles that had sprung up throughout Germany towards the end of the 18th century were placed under strict supervision of censorship, for it was feared that they were potential hotbeds of free-thinking intellectuals. Education was wielded, if not as the weapon, then at least as the intellectual property of the bourgeoisie, against the superficial luxury of the ancient feudal order.

Kersting, who belonged to the circle of Romantics around Friedrich, liked to portray people working, especially reading, in an interior. His readers are invariably people of middle or upper social standing, as is evident from their surroundings. Yet nowhere in these paintings does the main emphasis fall on the useful or useless comforts of life, as is so often the case in the later Biedermeier period. Instead, the material world, as in Friedrich's landscapes, is merely the starting-point for the presentation of a spiritual world created within the reader and symbolized here by the immaterial play of light on the wall. The fact that this world of spiritual concentration stands in contrast to the real world is also made evident by the cumbersome bookshelves delineating a certain area of their own that has no outward appearance of beauty, in a splendidly proportioned room.

Georg Friedrich Kersting Reader by Lamplight, 1814 Oil on canvas, 47.5 x 37 cm Winterthur, Stiftung Oskar Reinhart

GOTTLIEB SCHICK

1776-1812

In 1794, Wilhelmine von Cotta married the famous Tübingen-based publisher Johann Friedrich von Cotta, who had made a name for himself with his editions of classics. The artist painted this young woman at the age of 31. The painting bears obvious traces of Schick's training in the Paris studio of David, especially in his adaptation of the type and posture in David's portrait of Madame Récamier. Nevertheless, Schick does not adopt the elegance of the French painting. Instead, his model has an air of freshness and relaxation in spite of her highly fashionable Empire-style clothing. The broad face, the laughing eyes, the curls and rounded arms all contribute to this impression. Moreover, Schick has replaced David' Neoclassicistic furnishings with a cubic stone bench that by no means follows the lines of the body. We also notice Schick's training as a sculptor in the fact that he is evidently interested in sculptural forms. More importance is placed on individuality of form than on its harmonization within an overall movement.

Full figure portraits set against a landscape background emerged in England in the 18th century and were adopted by the French. Schick's painting is reminiscent of Goethe's Wahlverwandtschaften (Kindred by Choice) in which the emerging landscape garden is closely linked with the fate of the heroine Ottilie.

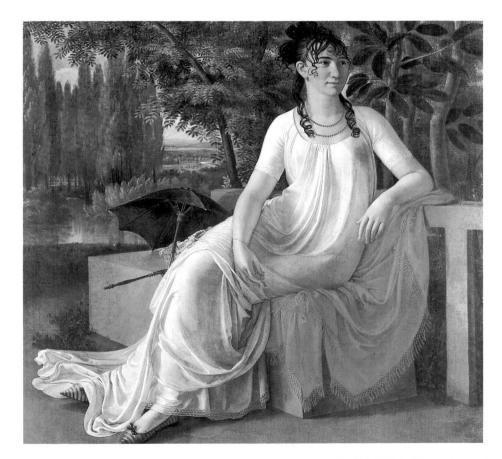

Gottlieb Schick Wilhelmine von Cotta, 1802 Oil on canvas, 133 x 140.5 cm Stuttgart, Staatsgalerie Stuttgart

Philipp Otto Runge Rest on the Flight into Egypt, c. 1805/06 Oil on canvas, 98 x 132 cm Hamburg, Hamburger Kunsthalle

Philipp Otto Runge The Artist's Parents, 1806 Oil on canvas, 196 x 131 cm Hamburg, Hamburger Kunsthalle

PHILIPP OTTO RUNGE

1777-1810

The Rest on the Flight into Egypt is a recurrent theme in Christian art. Runge has interpreted it as the "dawning of western civilization", adding the Nile riverscape and the blossoming tree with symbolic figures. As in his painting Morning, he explores the various stages in which the light of divinity reaches the earth. Joseph is more brightly lit by the glow of the fire he is putting out than by the morning light of the landscape behind him. The brilliance that lights up Mary's face, however, seems to come both from the morning sun and from the child who is let by the sun, but nevertheless seems to be the point of radiance of all light in the painting.

Runge executed a portrait of his parents at the age of 69, together with their grandchildren. Old age and youth are contrasted here as the extremes of the life-cycle: the children, illuminated by the light of the landscape and with floral attributes, are still within the boundaries of the garden, whereas the elderly couple have already withdrawn into the shadow of the house. The strict expression on their faces expresses "the spirit of undemanding piety devoted to the holy writings and the catechism" (Runge's brother Daniel on his parents).

Morning was originally intended as part of a cycle of paintings portraying the different times of day, but only drawings and etchings of the four stages exist. The "times" or "ages" that interested Runge from 1802 onwards are the visual form of his Neoplatonic-Christian view of the world and art. According to Runge, colours and the appearance of light contain "the entire symbol of the trinity:... we cannot grasp light and we should not grasp darkness, man has been given the Revelation and colours have come into the world, that is to say: blue and red and yellow."

In Morning, an intangible white light – in the cupola, the morning star and the lily radiates down to earth through the red of the roses and the fiery hair of Aurora/Venus/Mary and the yellow aura, finally reaching the place where the Eros/Christ child lies as its incarnation. What is seen as light falling in the centre of the picture appears around the edges as light rising from the darkness of an eclipse of the sun, through the yellow light of the sun and the red of the amaryllis to the blue and white of the cupola. Here, landscape is by no means the view of an area, but rather the presentation of the soul's progress along the path of the metamorphosis of lightless material into immaterial light.

> Philipp Otto Runge Morning (first version), 1808 Oil on canvas, 109 x 85.5 cm Hamburg, Hamburger Kunsthalle

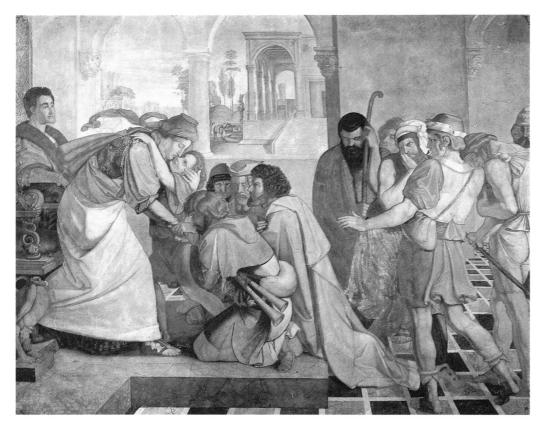

Peter von Cornelius Joseph makes himself known to his brothers, c. 1816/17 (from the Casa Zuccaro, Rome). Fresco, 236 x 290 cm Berlin, Nationalgalerie, Staatliche Museen zu Berlin – Preussischer Kulturbesitz

Johann Friedrich Overbeck Italia and Germania (Shulamith and Mary), 1828 Oil on canvas, 94.4 x 104.7 cm. Munich, Neue Pinakothek

PETER VON CORNELIUS

1783-1867

When the Prussian consul general in Rome had his flat decorated with a cycle of pictures from the life of Joseph, the Nazarenes were provided with an opportunity for the first time of putting into practice their aim of a revival of Renaissance fresco painting.

Cornelius' work achieves its monumentality from the exaggerated scale of the figures in relationship to their surroundings. This is further heightened by the narrow "stage" with its classical architecture and the allocation of only one specific, brilliant colour combination to each figure. By arranging the figures in two closely knit groups, the movement of the main figures is emphasized without making the others seem secondary in importance. The group on the right-hand side recoils on recognizing their brother, who, in his office as a high Egyptian dignitary, now holds in his hands the lives of the same brothers who sold him into slavery in his youth. The group on the left is dominated by the show of affection between Joseph and Benjamin, the favourite brother. The main technique used by Cornelius to express the inner emotion of the figures was, in keeping with the aims of the Nazarenes, concentration on the eyes and various ways of looking. Here we can see how intensively the artist had studied the frescos of Raphael and Michelangelo, as well as Dürer's Four Apostles.

JOHANN FRIEDRICH OVERBECK

1789-1869

This painting was begun in 1811 as a gesture of friendship to Franz Pforr and as a counterpart to his painting Shulamith and Mary. After the death of his friend in 1812, it remained unfinished. When Overbeck took up the idea again in 1828, the personal aspect of the wish to find a partner who shared the same goals in life, was no longer as important as it had previously been. As in Pforr's small picture, the future, ideal brides of these two friends were portrayed as Shulamith, the bride of the Song of Solomon and Mary, the mother of Jesus. Overbeck, who was by this time an acclaimed artist, gave the painting a new content and a new name. Now it was entitled Italia and Germania, a title indicating that the artistic ideals of the friends now took precedence. On the left sits Shulamith, Overbeck's ideal bride, as a dark-haired Italian woman crowned with laurels. On the right is Pforr's ideal bride Mary, a German Gretel with blonde braids and a wreath of myrtle in her hair. The background is also divided in two and pertains to the figures: behind Shulamith/Italia we see an Italian landscape, behind Mary/Germania a German landscape.

In the strong figures reminiscent of Raphael's female studies, we find two models for German Romantic art: Italian and German painting of the late Middle Ages and the Renaissance, the revival of which was Overbeck's aim.

FERDINAND GEORG WALDMÜLLER

1793-1865

The Last Calf is one of this artist's later works in which he tends to show the darker side of modern rural life, conventionally glorified in images of festive merrymaking. For him, the impoverishment of the small farmer is not, however, a reason to point an accusing finger at those who have caused the misery, for the true wrong-doers are unlikely to be the same people who finally purchase the calf cheaply. The sale of the last calf by a poor crofting family is seen as a blow of fate in which the reactions of loser and winner are portrayed. In this, Waldmüller adheres entirely to the principle of genre painting as a means of presenting the character of the people. The fact that this character is generally shown as one of patient fatalism is also in keeping with this genre, which tends to take as its theme the subject of "happiness in measure" (Jean Paul). The artist concentrates on the effect of the sunlight. Even the facial expressions of the figures are determined not only by the event, but also by the bright light that meets them as they leave their dark house.

In Waldmüller's work, light tends to overemphasize all things; later, it would serve the Impressionists as a means of dissolving outlines and blending the objects with their surroundings.

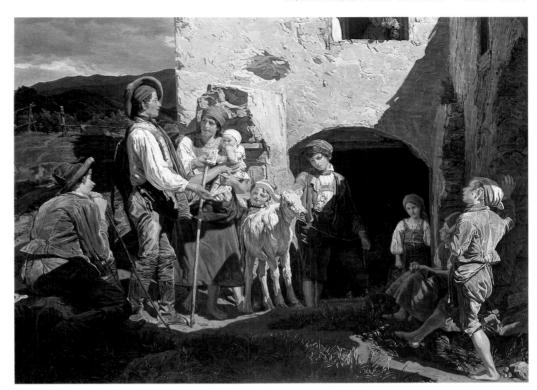

Ferdinand Georg Waldmüller The Last Calf, 1857 Oil on panel, 44 x 56.3 cm Stuttgart, Staatsgalerie Stuttgart

CARL ROTTMANN

1797-1850

This painting is a variation on the painting of the same name from the so-called Greek Cycle featuring twenty-three views of Greece which can now be seen in the Niedersächsische Landesgalerie in Hanover. The liberation struggle of the Greeks against the Turks with the backing of the major European powers provided considerable new material for landscape painting. In Bavaria, the subject was particularly topical, as a Bavarian prince had become King Otto I of Greece in 1832. Whereas Italian views tended to be idyllic landscapes, Rottmann's Greek paintings show a war-torn country, impoverished, infertile and hostile to life. Nevertheless it also lends an impression of sublime greatness, as the geological formations are shown here starkly and without any covering of vegetation.

The great days of ancient Greece, evident only in a few fragments that are barely distinguishable from the rocks, gives the landscape a melancholy atmosphere. Like the monk, gazing pensively into the depths and reflecting on the transience of human civilization in the face of nature's destructive power, the viewer, too, is called upon to consider the primal forces of nature and time, reflected in the geological lines as the true driving force behind history.

Carl Rottmann Sicyon and Corinth, c. 1836-1838 Oil on canvas, 85.2 x 102 cm. Munich, Bayerische Staatsgemäldesammlungen, Neue Pinakothek

Karl Blechen Monks at the Gulf of Naples, c. 1829 Oil on panel, 37.5 x 29 cm Cologne, Wallraf-Richartz-Museum

Karl Blechen
The Gardens of the Villa
d'Este, c. 1830
Oil on canvas, 126 x 93 cm
Berlin, Nationalgalerie,
Staatliche Museen zu Berlin –
Preussischer Kulturbesitz

KARL BLECHEN

1798-1840

The motif of this painting is comparable to that of Caspar David Friedrich's Chalk Cliffs on Rügen (ill. p. 449). Here, too, there is an abrupt break between foreground and background, with steep white cliffs contrasted against the blue of the sea. The subject matter, however, could hardly be more different. The monks in their black habits have turned away from the distance and are sheltering in the shadow of the cave. The distance holds no appeal, but seems impenetrable and neutral. The lack of vegetation heightens the impression of lifelessness, echoed in the appearance of the rocks, which look like bleached bones. The painter is interested in the effect of indirect light reflected brightly on objects which, like the rocks, place no bounds upon his creative imagination.

Whereas, for Friedrich, the distant sea evoked the longed-for infinity of future spiritual freedom, in Blechen's painting it is the point of departure for a reclusive existence in areas increasingly withdrawn from life and light.

Here, it is the future that is the foreground. There is an atmosphere of the spectral and the extinct, and of the victory of the life of privation to which the monks have subjected themselves. In this painting, Blechen has created an image of Italy that contradicts all coventional idyllic notions.

The Villa d'Este and its park were created in the mid 16th century by Cardinal Ippolito d'Este. Anyone visiting an Italian Renaissance park is astonished by the extreme contrast of light and dark created by the huge cypress alleys. Blechen has taken this phenomenon as the basis for his painting. Eerie figures from some past era move like ghosts through the fiery, multicoloured light that falls through the mature trees lining the path and sweeping over the edge of the long, vertical painting. Yet Blechen does not observe the past with the sober eye of the historian. Instead, these figures of the late 16th century have sprung from the imagination of an artist inebriated by contrasts of light. He lets history come to life in his mind's eye and in his mind it becomes inextricably linked with reality.

As this is a Romantic, imaginary world rather than a reconstruction of reality, the colours in the area where the figures are located have been heightened in a dream-like manner, with a most unusual predominance of violet hues. The subject matter alone determines the appearance of the world in this painting, lending it a magical aura that verges at times on the uncanny. The painting has nothing to do with any objectively documentary historicism, but draws its charm entirely from the feverish sensitivity of an artist in thrall to visions of the past, who seeks to lend expression to these visions through colour.

LUDWIG RICHTER

1803-1884

Richter stayed in Rome between 1823 and 1826, where he painted Italian landscapes in the manner of Joseph Anton Koch. Later, in Dresden, he initially continued to work in the same vein. It was not until the 1830s, inspired by walking tours through Saxony and Bohemia, that he turned to the landscapes of his homeland. Although he continued to portray the same idyllic subjects he had treated in Rome - monks and herdsmen's families, simple people living in harmony with nature he now sought his motifs in Germany rather than Italy. Neolassicists like Koch had presented the life of the people as a primal form of society for which nature was the only non-human point of reference. Romantics like Richter felt that the purest expression of the essence of nature required some reference to the Christian God as its creator. It was for this reason that they so frequently portrayed churches, in whose shadow people could be seen leading a life of harmony and piety guided by the rules of the church and thus according to God's will. The abrupt contrast between proximity and distance was interpreted by the early Romanticist Friedrich as a symbol of the contrast between material and spiritual existence. Richter eliminates this distinction by placing his church on the borderline, so that nature is now portrayed as an all-embracing unity.

Ludwig Richter Church at Graupen in Bohemia, 1836 Oil on panel, 56.7 x 70.2 cm Hanover, Niedersächsische Landesgalerie

MORITZ VON SCHWIND

1804-1871

Elves and fairies are creatures of nature in the Nordic sagas. Handed down through the generations, they can be found in the works of Shakespeare and entered the German literature of the day through translations of the eras of the Enlightenment and Romanticism and through the collections of folk-tales and fairy-tales that were made around that time. From then on, they came to be regarded as independent nordic creatures and as counterparts to the classical nymphs of Antiquity. For writers and artists who, like Schwind, had set themselves the task of placing German art firmly on an equal footing with French art, these creatures of fable were a favoured subject. The artists grouped around Schwind defended Neoclassical linearity as a fundamentally German approach to art and claimed that it possessed greater profundity than the painterly realism of the French artists.

In Schwind's group of dancing elves, an intimate community of children and women is presented. In this respect, the painting is very much in keeping with the glorification of the family as the haven of intimacy and the nucleus of the state, so prevalent in the constitutional theories of the Restoration and in the art of the Biedermeier era. As these are "human" circumstances, the life of these "natural creatures" differs in no way from the ideal image of the "better part" of the German bourgeoisie presented by Schwind in his society paintings.

Moritz von Schwind Fairy Dance in the Alder Grove, c. 1844 Oil on panel, 62.8 x 84 cm Frankfurt am Main, Städelsches Kunstinstitut

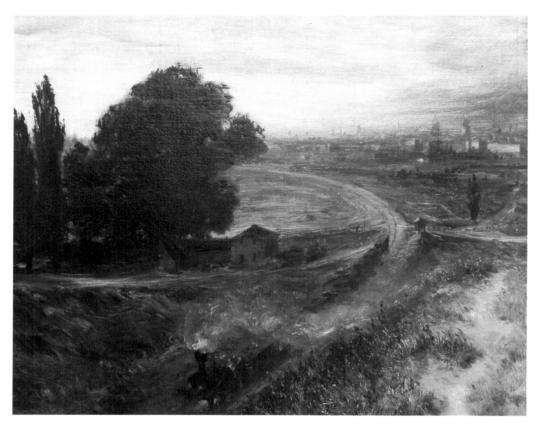

Adolph von Menzel The Berlin-Potsdam Railway, 1847 Oil on canvas, 43 x 52 cm Berlin, Nationalgalerie, Staatliche Museen zu Berlin – Preussischer Kulturbesitz

Adolph von Menzel A Paris Day, 1869 Oil on canvas, 50 x 71 cm Düsseldorf, Kunstmuseum Düsseldorf

ADOLPH VON MENZEL

1815-1905

The subject of this painting is speed, a dimension that had become part and parcel of everyday life with the advent of railway travel in the 1830s. Movement is presented here in two ways. On the one hand, the landscape appears blurred at the edges, as though seen flashing past through the window of a train compartment. On the other hand, the movement of the train is seen from outside, whereby the contours of the locomotive merge with the surroundings. Menzel has chosen a subject that was soon to become a central theme in the work of the Impressionists. However, the Impressionists, for whom the railway was no longer a novelty, were even more fascinated by the movement of horses on the racetrack. The sunny racecourses with their clouds of dust gave them ample opportunity to explore light and atmosphere. Menzel, however, still preferred a sombre brown tonality of a more traditional kind, which, further heightened here by the use of black, is actually a perfectly appropriate means of portraying the dirt of an industrialized suburban landscape, where even the air and the atmosphere see bleak and gloomy.

In 1867, Menzel painted scenes of everyday Parisian life for the first time. He prepared them *in situ* in the form of pencil sketches and later executed them in his studio in Berlin. Unlike the street scenes of the French Impressionists only a few years later, Menzel still uses the traditional brown tones in the foreground to bind the colours together, while light pastels are used for the background.

Menzel's sister, who was very close to him, is standing on the doorstep of the room in which she spent her childhood, gazing dreamily outwards into a new world that has yet to reveal itself entirely to her as a young girl. The past, embodied by the room where her mother is sitting working, can be clearly discerned. The doorstep is certainly intended here in the metaphorical sense of a threshold between two stages of her life, with background and foreground related to each other as past and future. For all its sketchiness, and the fleeting transience of the light, this composition points to a permanent state of human community. In the three figures, the young girl, the old woman and the putto suspended from the ceiling, we see the three ages of life, whose sequence is presented as a cycle. The life of the young girl will end like that of her mother. In this presentation of life as a series of pre-ordained natural stages, the painting is a typical example of the Biedermeier style.

> Adolph von Menzel The Artist's Sisters, 1847 Oil on canvas, 46.1 x 31.6cm Munich, Neue Pinakothek

Ferdinand von Rayski Portrait of a Young Girl, c. 1840 Oil on canvas, 68.5 x 57 cm Altenburg, Lindenau-Museum

Carl Spitzweg The Poor Poet, 1839 Oil on canvas, 36.3 x 44.7 cm. Berlin, Nationalgalerie

FERDINAND VON RAYSKI

1806-1890

Artists from the late 18th century onwards sought the essence of unspoiled nature in all things. It was therefore only logical that they should turn to the portrayal of children. For the first time, children are portrayed as independent individuals whose innocence has not yet been tainted, rather than simply as a smaller version of adults.

The care with which the girl is holding the basket shows how tentatively she seeks to conquer her world. The basket does not contain a magnificently arranged bouquet, but a bunch of fragile wildflowers and grasses that have not yet been cultivated. In this respect, they may be compared with the child who still regards and treats the world with an earnestness that lends weight to the smallest thing - an earnestness the educated adult lacks. The dog adds emphasis to the theme, as a creature that may express its temperament naturally.

Unlike the portraits of the 18th century, nature is not perceived here as a generalized or universal landscape, but as a precisely definable place: the child's actual home. The ideal of the natural is found by patient and loving observation of reality, rather than reality being shaped to fit the notion of the natural ideal. In contrast, all the outer trappings of materiality, so prevalent in the portraits of the Biedermeier era, are avoided.

CARL SPITZWEG

1808-1885

The Poor Poet is one of Spitzweg's earliest works and the painting that made him famous. The image of the poet or philosopher living in poverty in a garret originated in 18th-century France. Yet Spitzweg is not interested here in pointing an accusing finger at some wicked landlord for charging extortionate rents, but in attacking idealist art on behalf of the realism that had begun to take hold in Germany as well. Spitzweg's poet, who is clearly in thrall to the muses, is scanning a hexameter (the metre can just be discerned, written on the wall above the bed.) The hexameter was the metre of the epic poem and, with that, the measure of what was still regarded in those days as the highest form of art. There is something equally pompous about the stack of papers lying by the stove to be used as fuel, entitled in Latin: Gradus ad Parnassum (The Road to Parnassus). The pursuit of high art is made to seem all the more ridiculous in view of the impoverished setting which it is clearly incapable of improving. At the same time, the fine tonality and meticulous attention to realistic detail seems to be Spitzweg's admonishment to idealist artists: "like this poet, you may be able to portray high but fundamentally impracticable ideals, but you can't paint."

CHRISTOFFER WILHELM ECKERSBERG

1783-1853

Like the Baroque Italian architect, Giovanni Battista Piranesi, who created copperplate engravings depicting monuments of Antiquity, Eckersberg has filled his canvas with a classical architectural motif. Eckersberg, however, uses this motif as a vehicle to draw our attention to the transience of human greatness. Just as the bright light of day has ousted the *chiaroscuro* of the Baroque, so too has our view of history become more sober and objective. Yet the notion still persists that a view of ancient Rome must necessarily involve a statement on its history.

The three arches of the Colosseum, part of the curved inner wall of the ancient area, span the picture with such perfect regularity that the three background views seen through them with no intermediate transition seem to be of equal importance: to the left is the Capitol, the seat of power in ancient Rome, in the centre is the Torre delle Milizie, part of a 13th century fortress, alluding here to the power of the medieval princes, and on the right is the early Christian church of San Pietro in Vincoli, which underwent major alterations and extension in the Renaissance and which may be regarded here as an indication of the power held by the Christian church in Rome since the early modern period. The frontal view of the Colosseum arches is reminiscent of the compositional approach of Ingres, another student of David.

The sculptural plasticity and balanced contraposto of this nude – a girl with her back to us wearing a cloth draped in deep folds around her hips – is reminiscent of a classical statue. The motion of pinning up her hair and the items of her toilette are merely hinted at. The girl's face appears in the mirror as though in a picture.

The mirror image itself, the downward glance and the chin hidden from view, seems to transport her facial features to a much less tangible sphere than the nude in the foreground. The two views seem like a meeting of sculpture and painting, two forms of imagery that can illuminate very different aspects of one and the same object.

The age-old rivalry between painting and sculpture – a source of heated debate since the Renaissance – is alluded to here once more. In doing so, Eckersberg may also have been paying homage to his friend, the sculptor Bertel Thorvaldsen, whose work had impressed him greatly in Rome. At the same time, the discretion and tranquility of the action, and the handling of light that falls from an unknown source, give this painting something of the vibrant intensity of a 17th century Netherlandish interior.

Eckersberg, who taught at the Copenhagen academy and profoundly influenced Romantic painting, is justifiably described as the father of Danish painting.

Christoffer Wilhelm Eckersberg
View through three northwest arches of the Colosseum
in Rome. Storm gathering over the city, 1815
Oil on canvas, 32 x 49.5 cm
Copenhagen, Statens Museum for Kunst

Christoffer Wilhelm Eckersberg Nude (Morning Toilette), c. 1837 Oil on canvas, 32 x 25 cm Copenhagen, Den Hirschsprungske Samling

SCANDINAVIA 461

Johann Christian Claussen Dahl View through a Window to the Chateau of Pillnitz, c. 1824 Oil on canvas, 70 x 45.5 cm Essen, Museum Folkwang

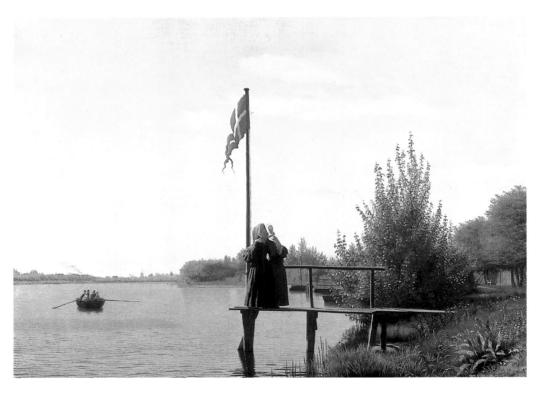

Christen Schjellerup Købke The Shore at Dosseringen, 1838 Oil on canvas, 53 x 71.5 cm Copenhagen, Statens Museum for Kunst

JOHANN CHRISTIAN CLAUSSEN DAHL

1788-1857

This painting was executed in Dresden in the 1820s. It documents the friendship that bound the Norwegian artist, who had been living and teaching in Dresden since 1818, with Friedrich and his circle of friends. The view is through the window towards the chateau of Pillnitz on the River Elbe, built in the early 18th century by Pöppelmann. Such window views were a favourite motif amongst the German Romantics. There are comparable paintings by Friedrich and Carus and even by Menzel as late as the 1860s. The contrast between the expanse of the landscape and the dark confines of the interior was regarded by the Romantics as a symbol of human existence between the temporal presence and eternity. Dahl's paintings, like Menzel's, do not lend themselves to such interpretation. Both artists were realists right from the start. Dahl is interested in light solely as a natural phenomenon and not as an expression of divine powers. In spite of the intensive colour of the sky, the landscape retains a certain sobriety, particularly because the colour is presented in its own right rather than as a sublimation of coloured matter. The transformation of the landscape into the realms of the irreal through its reflection in the window panes has only physical rather than metaphysical reasons. It sewes to present a different colouristic level and to stimulate the imagination.

CHRISTEN SCHJELLERUP KØBKE

1810-1848

Købke was one of the younger generation of Danish naturalists who consciously sought to create an independent Danish painting. Whereas his teacher Eckersberg was devoted to the international Neoclassicism of the school of David and had gained important experience in Rome, the younger painters turned increasingly to the landscape of their homeland, whose unprepossessing views they perceived as equalling any sun-drenched Italian landscape or dramatic nordic vista, both themes with a strong tradition. The tranquillity of nature in the environs of villages and towns, the clarity of colour and light and the unspectacular life of the people who live there, are Købke's subjects.

The fact that this is Denmark is emphasized by the red and white flag, whose colours further heighten the other hues in this painting. The fact that the women have their backs to us as they gaze out over the lake is not imbued with the same significance as such a gesture in the works of Friedrich. Here, they do not embody the consciousness of the viewer, but seem instead like quiet objects in a quiet landscape in which life always goes on in the same way. A charming finesse, dedicated to subtle detail, prevails in this work, which seeks to reflect something of the clear order of this life.

462 SCANDINAVIA

JOHN CONSTABLE

1776-1837

In the late summer of 1816, Constable spent his honeymoon with his wife Maria at Osmington, a village near Weymouth Bay. Only his honeymoon could have prompted him to paint such a wild and naked landscape, claimed one of his critics, for he was an artist who did not otherwise explore such solitary regions.

This quiet bay ringed by rocks and cliffs is painted in reddish-brown, muddy tones with fleeting brushstrokes and dabs of paint. The heavy sea, neither calm nor stormy, seems to push into the landscape. It is a rather unspectacular landscape, neither particularly beautiful, nor particularly ugly, neither sublime nor Romantic. Its charm derives from the singular atmosphere, with the expanse of overcast sky suffusing the entire landscape in an indefinable twilight.

The specific atmosphere is familiar enough to the viewer from personal experience and Constable presents it entirely unsentimentally. He initially documented it in a sketch prepared at the bay before producing two larger versions. It is precisely this unpretentious way of seeing that appeals so directly to the viewer and makes it clear what Constable meant when he said that, for him, feeling and painting are one and the same thing.

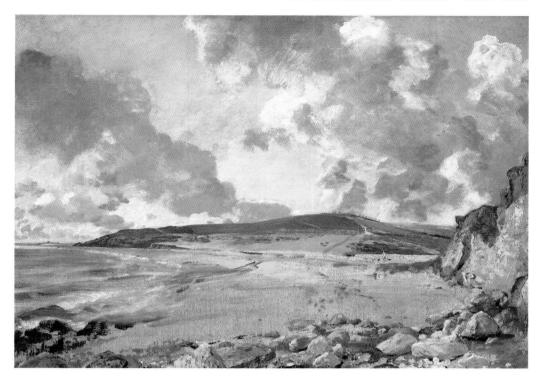

John Constable Weymouth Bay, c. 1816 Oil on canvas, 53 x 75 cm London, National Gallery

This painting was commissioned by Constable's friend, the Bishop of Salisbury, who also specified that the cathedral should be portrayed as seen from the garden of the bishop's palace. The bishop himself is present in the painting taking a walk with his wife and pointing towards the cathedral. "My cathedral looks very good," wrote Constable, who felt that it was the most difficult landscape painting he had ever had on his easel. Whereas he normally painted seemingly coincidental details of the English countryside, he now had to keep to precise specifications in his painting of the cathedral.

The view of the cathedral through the framing arch of trees is nevertheless most skilfully arranged, giving an impression of harmony between nature and human endeavour. Man has formed nature according to his needs, both for agricultural purposes, as indicated by the grazing cattle, and for his own edification, as a park. The further spiritual achievements of humankind are evident in the central motif — the cathedral bathed in sunlight.

The only disturbing factor in this altogether harmonious painting seemed to be, in the opinion of the bishop, the dark clouds forming in the sky. "If only Constable had left out the black clouds! Clouds are black when it begins to rain. When the weather is fine, the sky is blue," he wrote, and sent the painting back to the artist to be reworked.

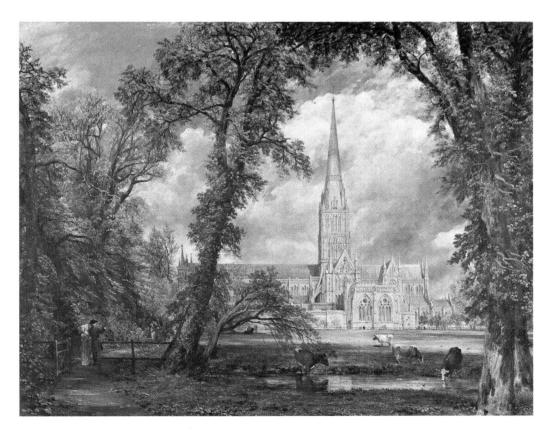

John Constable
Salisbury Cathedral from the Bishop's Grounds, 1828
Oil on canvas, 34 x 44cm
Berlin, Nationalgalerie, Staatliche Museen
zu Berlin – Preussischer Kulturbesitz

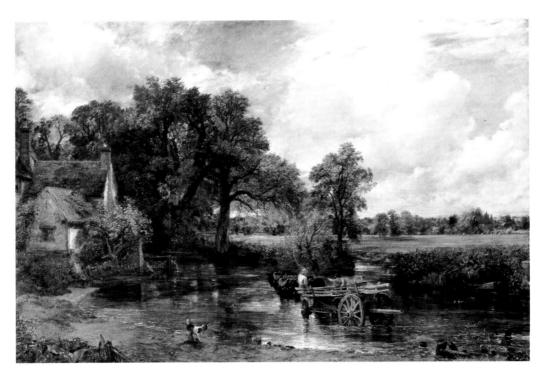

John Constable The Hay Wain, 1821 Oil on canvas, 130.5 x 185.5 cm London, National Gallery

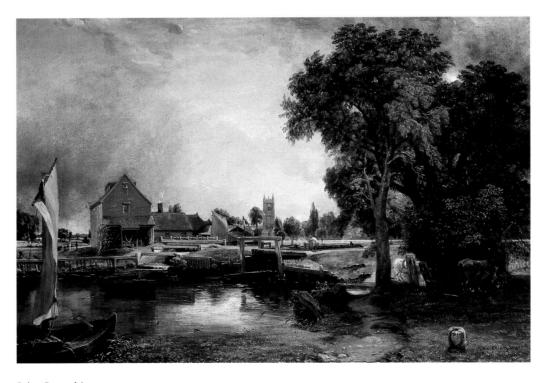

John Constable Dedham Lock and Mill, 1820 Oil on canvas, 53.7 x 76.2 cm London, Victoria and Albert Museum

JOHN CONSTABLE

1776-1837

Unlike the primarily idyllic images of rural life in the 18th century, with shepherds and shepherdesses frolicking in the fields, Constable presents objective, unadorned depictions of peasant life during the changing seasons. The Hay Wain shows a scene in the Stour Valley where Constable grew up. A horse drawing a hay cart is wading through the clear water of the river, a dog is watching the cart draw past; on the right a figure in the bushes is mooring a boat, while to the left an old farmhouse is almost completely hidden by trees and bushes. In this painting, Constable has drawn together many familiar details of rural life which, as a whole, evoke a concept of a natural universe in which man, animals and landscape are still bound together in primal harmony. The weather conditions, which Constable invariably based on direct study, show an overcast sky that promises a rapid succession of rain and sunshine.

In his painterly technique, Constable liberates himself from conventional principles of composition and colour handling. His bright colourity and often sketchy brushstrokes create a new and direct experience of the English countryside that goes some way towards explaining the enormous attention attracted by his paintings, particularly by *The Hay Wain* at the Paris Salon of 1824.

Constable preferred to paint in areas he had known since his childhood. This painting, one of three such atmospheric views created between 1818 and 1820, shows the mill at Dedham Vale owned by his father, the miller Golding Constable, where Constable himself had worked as a child.

Farmer Willy Lott's house in Flatford is a recurrent motif in Constable's œuvre, and it also appears in his famous painting, The Hay Wain. This Romantic view shows the house, set slightly in the background, nestled in the lush greenery of the Stour Valley. Only a few golden highlights cast by the last rays of a late sun illuminate the sombre brown tones of the gloomy autumn atmosphere. Constable himself was not satisfied with the painting and worked on it for several months after it had been returned from the Royal Academy exhibition. Even once he felt he had got rid of the "hailstones" and "snow" that covered the painting, attracting so much criticism, the surface nevertheless remained rough and grainy and did not achieve the brilliance of colour to be found in his masterpieces. Remarkably, however, Constable actually received the sum of 300 pounds for this particular painting, the largest sum he ever received for any of his works. Long before its completion, it was purchased by Robert Vernon.

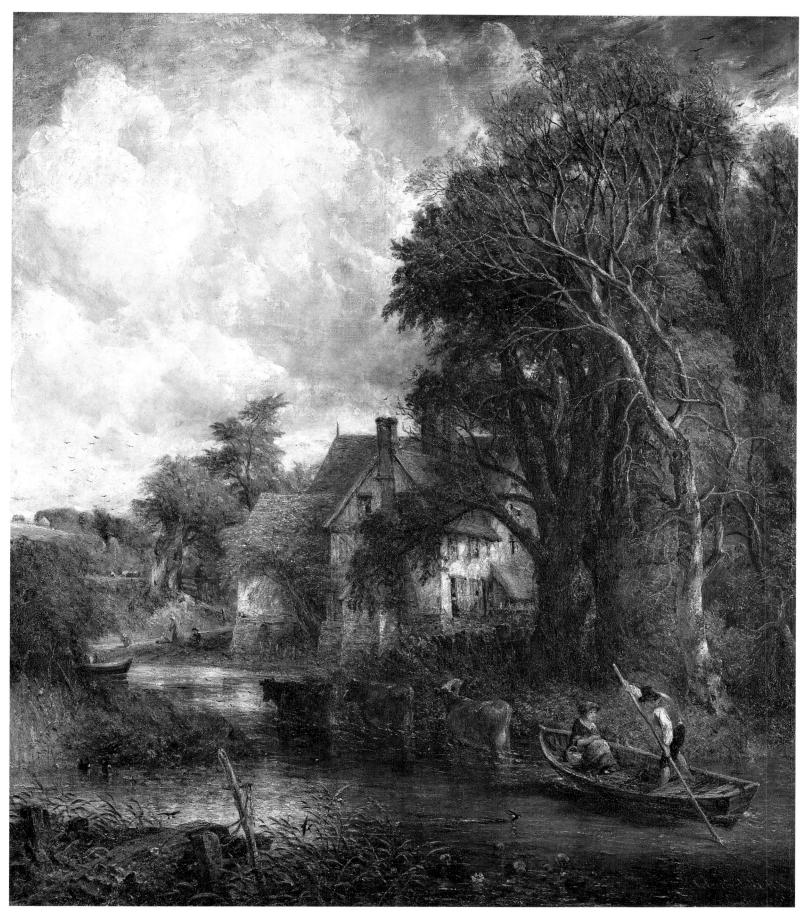

John Constable The Valley Farm, 1835 Oil on canvas, 147.3 x 125 cm London, Tate Gallery

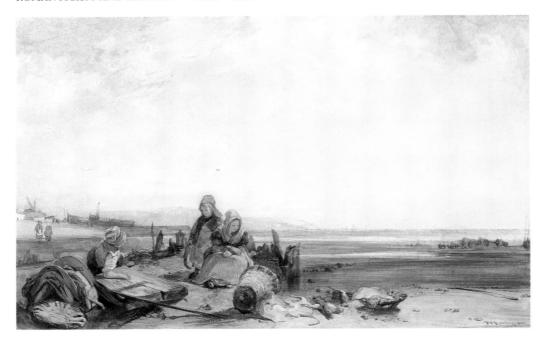

Richard Parkes Bonington Beach in Normandy, c. 1826/27 Oil on canvas, 33 x 44 cm London, Tate Gallery

Richard Parkes Bonington The Column of St Mark in Venice, c. 1826–1828 Oil on canvas, 45.7 x 37.5 cm London, Tate Gallery

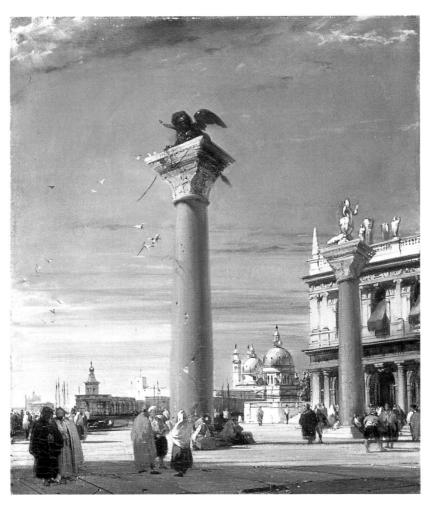

RICHARD PARKES BONINGTON

1802-1828

In 1824, Bonington was working on a series of lithographs to illustrate a volume on Normandy for Baron Taylor's *Voyage Pittoresque dans l'Ancienne France*. In this connection, he also created a number of oil-paintings showing the Normandy coast. These were highly acclaimed for their fresh and natural approach.

The tradition of English watercolour-painting, devoted to the exploration of atmosphere, light and colour, is as evident here as the influence of Flemish and Venetian painting. It is a charming genre scene portrayed with a delicately nuanced tonality that alternates between warm browns and cool blues, the predominantly brown tones of the foreground contrasting with the pale hues of the hazy distance in the light of the midday sun. In the foreground is a picturesque group of seated women with a child and fishbaskets. Behind them is the sea at low tide with ships, a distant strip of coastline and a broad expanse of sky.

The colourful dresses of the women with their high hats indicates that these are the wives of fishermen from Pollet, a suburb of Dieppe, whose inhabitants still wore the same traditional costumes they had worn in the 16th century.

The immediate visual appeal of this painting lies in the use of luminous colours more reminiscent of a watercolour than an oil-painting. The radiant blue sky is a dominant feature which, as in many works by Bonington, takes up more than half the picture and is contrasted with shades of white and — in the two pillars — a honeyed brown. In this painting too, the artist applies the stylistic device of an upward view, in which the dark lion of Saint Mark on the towering pillar at the left stands out sharply against the bright Italian sky.

The scene, captured during a one-month tour Bonington made to Venice in 1826, is an architecturally correct and detailed rendering of the actual topography, in the tradition of the veduta. Nevertheless, it is more than simply a superficial documentation: it is a deliberately structured composition, as is evident not only in the chosen angle, but also in the avoidance of symmetrical pictorial organization. Bonington was heavily attacked by French art critics for orienting his work towards a specific location rather than the ideal landscape painting of the 17th century.

However, his views of Venice proved so popular with the public that he executed innumerable variations in oils and watercolours. It was precisely this merging of realistic, topographically precise description with painterly elements that constituted the progressive trait of his art and was, at the same time, the target of criticism. In this respect, his work already anticipates the "pure" *plein-air* painting that was not to become established for another twenty years.

DAVID WILKIE

1785-1841

Wilkie was the most popular English genre painter of his day. His famous painting *Reading the Will* was commissioned by the Bavarian king Maximilian Joseph, who hung it in his bedroom. The subject had been proposed to Wilkie by the English actor and comic Charles Bannister, and he had undoubtedly also been inspired by similar scenes from contemporary plays, such as Armand Charlemagne's *My Uncle's Will* or by *Guy Mannering* written by his friend Walter Scott.

The stage-like lighting and spatial organization which Wilkie designed beforehand using model figures, create the effect of a theatre scene capturing the exciting climax of the plot. A motley crowd of relatives has gathered in the dead man's study, where his portrait is hanging on the wall, to hear the lawyer read the last will and testament. Only a child and the dog crouching below the empty armchair seem to be affected by the death. Already, a suitor is leaning attentively over the young widow who looks towards the viewer in an affected pose. The others are all listening to the words of the lawyer with a mixture of emotions, from curiosity and greed to undisguised irritation. Wilkie leaves us in no doubt whatsoever as to their characters.

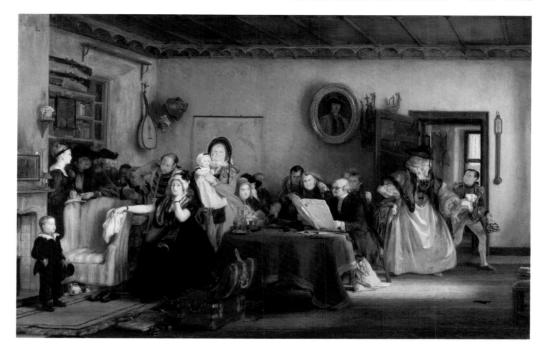

David Wilkie Reading the Will, 1820 Oil on panel, 76 x 115 cm Munich, Bayerische Staatsgemäldesammlungen, Neue Pinakothek

WILLIAM DYCE

1806-1864

The painting shows a scene during a holiday the artist spent with his family in Kent. In the foreground is his wife, her two sisters gathering shells and one of his sons. The title indicates that the artist was eager to regard the painting as a souvenir. As such, it prompts ambivalent feelings which he clearly linked with the event. On the one hand, presumably assisted by preliminary sketches, he reproduces each and every detail with almost photographic precision, lovingly capturing an image of the people he knows so well at some chance moment of repose and contemplation. With the same precision, he meticulously documents the bay with its chalk cliffs and the sea at low tide, evoking the specific atmosphere of a cool October day in the late afternoon light. On the other hand, in spite of this faithfully exact reproduction and in spite of the proximity of the figures in the foreground, the entire scene seems strangely distant and dreamlike. Dyce has used realism here as a means of portraying a sense of timelessness at a specific moment. One indication of this may be the fact that, on the very same date, the Donati comet appeared in the sky, an astronomical event that occurs only once every 2,100 years.

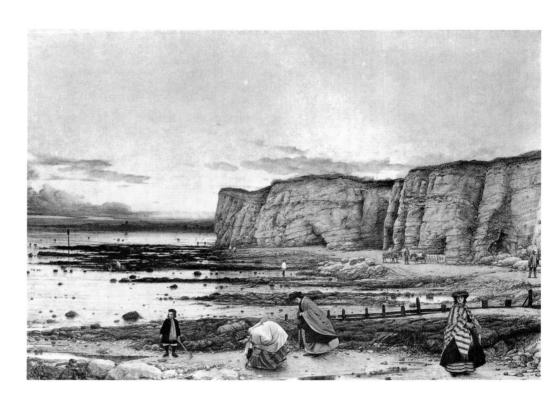

William Dyce
Pegwell Bay in Kent. A Recollection
of October 5th 1858, c. 1859/60
Oil on canvas, 63 x 89cm
London, Tate Gallery

J. M. W. Turner Snow Storm. Hannibal and his Army crossing the Alps, c. 1810–1812 Oil on canvas, 144.7 x 236cm London, Tate Gallery

J. M. W. Turner Peace – Burial at Sea, 1842 Oil on canvas, 87 x 86.5 cm London, Tate Gallery

J. M. W. TURNER

1775-1851

A terrible snowstorm lashes the Alps. The dark, menacing sky unloads its masses of snow. A milky orange disc of sun lights up the blackish-grey sky and eerily illuminates the mountains. At the very lower edge of the painting, there are scenes of robbery, murder and plunder between the rocks. In the middle ground, we see the vague outline of Hannibal's army. The Carthaginian military leader himself can just be discerned as a tiny speck in the middle distance, seated on an elephant and looking out onto the far-off, sun-drenched plains of Italy. Turner regarded the painting as a warning to England. With this example from history, he sought to point out that England could be subject to a fate that Rome was spared.

The main content of Turner's painting is not, however, the historic event in its metaphorical significance – this is merely indicated anecdotally at the edge of the painting. It is, instead, the whirling chaos of the forces of nature, enigmatic and magical, creating strange metamorphoses of colour and luminosity as the sunlight filters through the dark cloud. This painting is the first example of Turner's innovative compositional approach which disregards conventional structures of horizontal, vertical and diagonal, employing instead irregularly bisected arcs and cones that do not offer the viewer any point of reference, but draw him into the fray instead.

In his painting *Peace – Burial at Sea*, Turner pays homage to the Scottish painter David Wilkie who died on board a steamer on his return from a study tour of Palestine on 1 June 1841. As the port authorities at nearby Gibraltar had closed the harbour for fear of the plaque that had infested the Middle East, Wilkie had to be buried at sea that same evening.

The scene is dominated by a pale haziness that suffuses the water and the sky in the same cold light. The only warm and luminous point of the painting is at the scene of the burial itself, where Wilkie's corpse is lowered into the water by the light of flaming torches. The black of the dark ship's keel is dominant, and its compact mass seems to be rent in two by the searing shaft of light. The two black sails stand out starkly against the milky white of the sky. Their sharp outlines contrast with the blurring of borders, as for example, the reflection of the black ship in the water running menacingly into the foreground in a way that underlines the universal inevitability of transience and death.

Turner exhibited this painting in 1842 together with *War. The Exile and the Rock Limpet* (London, Tate Gallery), an allegorical picture of Napoleon that suggests a further political dimension to this pair of paintings.

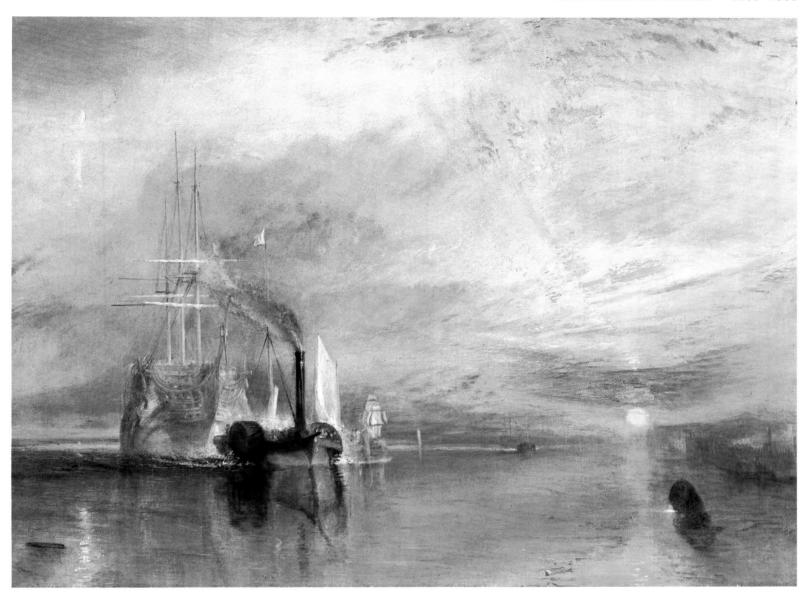

During Turner's lifetime, England rose to become Europe's leading maritime power. Turner depicted many of the great sea battles of the time. His early paintings, in particular, painted with realistic precision, brought him considerable success. In this painting of the Fighting Téméraire, objective presentation – a certain attention to detail is still evident in the portrayal of the ship – is combined with the predominant organization of light and atmosphere in a sweeping sky with a deep horizon, and its reflection on the surface of the water.

Turner, who was in fact a witness to the event, renders the tugging of Nelson's warship, Téméraire, in the summer of 1838 from the fleet base at Sheerness on the mouth of the Thames to a wrecker's shipyard, as a melodramatic event.

"Seen against and almost absorbed by a molten sunset, the fighting Téméraire, once a glory of British navel prowess in the Napoleonic wars, becomes a spectre on its way to a maritime grave. The poignancy of this symbolic burial is further underlined by the sooty little tugboat in the foreground, which offers a realistic foil of the mundane here and now to the visionary spectacle of the passing of man's

achievements beyond some distant horizon," writes Robert Rosenblum.

The pathos-laden depiction of the wrecked ship in the evening light becomes an enigmatic metaphor suggestive of the path of history and human life. The rise and fall of worldly power are thus closely tied with the progress of natural history. The art critic John Ruskin was to come to similar conclusions in his melancholy observations on the end of the Téméraire, in which he lamented that the sunset would never again dress her in golden robes, nor the light of stars shiver on the waves that ripple forth as she glides across the sea, and that even the child of the seaman would neither reply nor know that the dew of night lay deep in the war-torn timbers of the old Téméraire.

This painting, which Turner called his favourite, is also regarded as a reflection by the artist on his own age and on death.

J. M. W. Turner The "Fighting Téméraire" Tugged to her Last Berth to be Broken Up, 1838 Oil on canvas, 90.8 x 121.9cm London, National Gallery

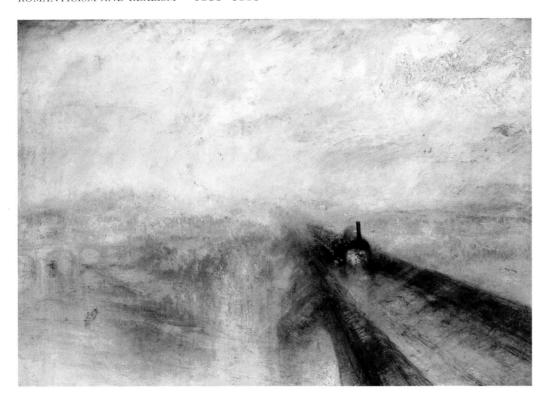

J. M. W. Turner Rain, Steam and Speed – The Great Western Railway, 1844 Oil on canvas, 91 x 122 cm London, National Gallery

J. M. W. TURNER

1775-1851

Turner admired modern technology. His painting shows a locomotive, the most modern of its kind, crossing the Maidenhead Bridge, which itself was a masterpiece of progressive engineering by Isambard Brunel. This railway painting was intended to show the beauty inherent in the merging of nature and technology. In this respect, Turner stood apart from most of his artist colleagues, who regarded industrial progress with suspicion and certainly did not consider it a worthy subject for art.

Although the painting is based on his own observations, it is not a realistic portrayal of an event, but, typically for Turner, its mythical exaggeration; in the words of Werner Hofmann, it is "the merging of natural forces and technically guided energies".

It is said that Turner frequently sought to create atmospheric tonality in his paintings by smearing the paint in short, broad brushstrokes from a dirty palette onto the canvas and then gradually drawing objective codes out of this colour ground. As in a dream, the haze rising from the water blurs with the veil of rain in the sky, and the steam of the locomotive, creating an atmospheric unity of colour.

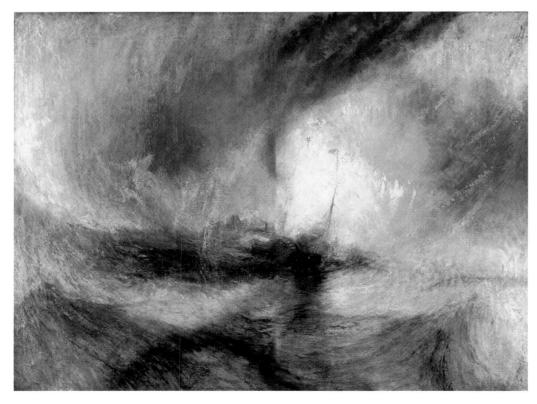

J. M. W. Turner Snow Storm – Steam Boat off a Harbour's Mouth making Signals in Shallow Water, and going by the Lead. The Author was in this Storm on the Night the Ariel Left Harwich, 1842 Oil on canvas, 91.5 x 122cm. London, Tate Gallery

Turner got sailors to lash him to the mast on board the Ariel Harwich for four hours so that he could observe a storm at sea. In the resulting painting, ships are swept between the whipped-up sea and the swirling clouds of snow. Sky and sea blend into a foaming mass of black/brown/grey/green and white whirling around the ships and only a tiny blue patch of sky gives any hope of an end to this situation. The viewer is drawn into the events in which his eye can find no fixed point. Atmosphere and the elemental forces of nature are the subject matter of the painting, even more so than in the painting that depicts Hannibal.

Turner's means of presenting the forces of nature lies primarily in his handling of colour freed from all precise representation. The magically abstracted colouring also makes the actual subject matter of the painting an enigmatic metaphor for underlying reflections, for example, on the creation of the world. The snowstorm conjures up the chaos at the beginning of the world, in which water was separated from earth and light from darkness. In his free handling of colour, Turner influenced not only the Impressionists, but also paved the way for abstract painting. In his later years, Turner's quest was to create a tapestry of light and colour independent of objects.

GEORGE CALEB BINGHAM

1811-1879

Even at the time when Bingham painted this picture, it appeared as a nostalgic memory of a lost world. The fur trade had long since been taken over by the great trading companies of the Mid-West who shipped their goods on large steamers and freighters. In Bingham's painting, father and son are bringing the furs they have trapped themselves to the nearest trading-post. The father, at the rudder, is an amiable grey-haired elderly man of French origins; his son, the child of an Indian mother, leans dreamily against the cargo and the gun with which he has shot a duck. Both men look directly at the viewer, drawing us into their peaceful existence.

The riverscape, with scattered bushes fading into the horizon is quite enchanting. Branches jut out of the water, whose surface is smooth as a mirror, unruffled by any breath of wind. It reflects the boat in pale colours. Everything is bathed in the pale pinkish-silvery mist of twilight, against which the half-savage, half-civilized clothing of the boatmen, with their black cat, stand out sharply.

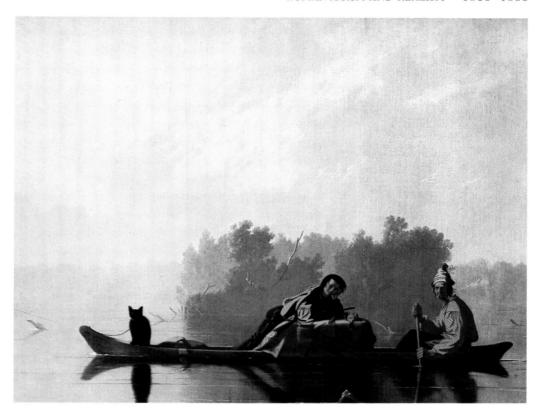

George Caleb Bingham Fur Traders Descending the Missouri, c. 1845 Oil on canvas, 73.5 x 93 cm New York, The Metropolitan Museum of Art

WILLIAM SIDNEY MOUNT

1807-1868

Mount makes us eye-witnesses to a village incident in which two men are striking a deal on the brown horse, saddled and quietly standing on the left. In accordance with local custom, the two men are whittling twigs until they have agreed on a price for the horse.

The anecdotal narrative of this scene is the focal point of the painting. Mount has taken great care to portray the rural atmosphere which, like the topic, has been drawn from his immediate surroundings and related with painstaking attention to detail. In the background is his own farm in Stony Brook, a small settlement on Long Island. The summer sun lights the scene as on a stage.

Mount was the leading representative of rural genre painting of the period in America. With evident self-confidence, he rejected a patron's suggestion to enhance his painterly skills by continuing his studies in Europe. Nevertheless, his paintings do possess certain similarities with European art, especially with German Biedermeier painting which emerged around the same time and which he may have known from reproductions.

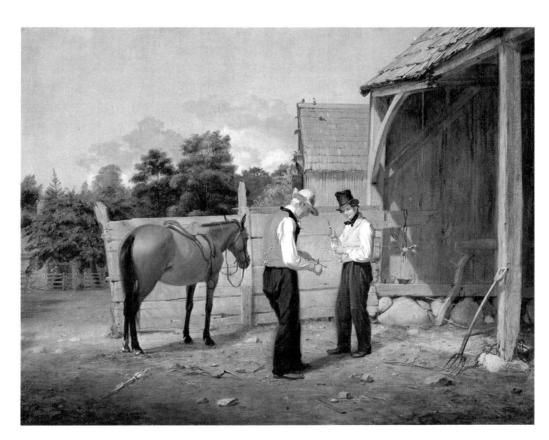

William Sidney Mount The Horse Dealers, 1835 Oil on canvas, 61 x 76cm New York, The New York Historical Society

UNITED STATES

FREDERIC EDWIN CHURCH 1826–1900

The magnificent Niagara Falls, a wonder of nature famed throughout the world, are commemorated by the American artist Church in this painting. The predominant impression is the sense of nature's boundless powers and the sweeping expanses of the open landscape. This is achieved on the one hand by the unusual pictorial format (almost twice as wide as it is high) and on the other hand by the bold compositional device of presenting the horseshoeshaped waterfall in the full force of its roaring masses of tumbling masses directly frontal to the viewer, while at the same time underlining the sheer enormity of its vast dimensions by means of the narrow horizontal strip of land in

the background that runs right across the painting.

The realism of the portrayal heightens the immediacy with which the forces of nature are perceived by the viewer. Numerous studies on location and a profound interest in natural sciences (optics, surveying techniques, geometry) equipped Church admirably for the task.

In contrast to the powerful motif, the painter employs a palette of remarkably pale and delicate hues, particularly the violet sky that merges with the rainbow and the haze of the spray and is even reflected in the darkly rippling water of the foreground. An air of

472 UNITED STATES

mystery elevates the motif to the realms of the symbolic. The powerful and irresistible (in both positive and negative sense) spirit of a huge, new nation is presented to without offering the viewer a firm position from which to view its gigantic force. The painting, exhibited for the first time in 1857 in New York, was a huge success for Church, not only in America. It was particularly important in enhancing the reputation of young American art in Europe, where it attracted considerable attention.

In London, where the painting was exhibited in the same year, *The Times* noted the arrival of this major work by an American

landscape artist on an American theme, underlining the achievement of sober authenticity. The painting was also highly acclaimed in France, where it was awarded a medal ten years later at the Paris World Fair of 1867. Frederic Edwin Church Niagara Falls, 1857 Oil on canvas, 108 x 229.9cm Washington, The Corcoran Gallery of Art

UNITED STATES 473

Thomas Cole The Voyage of Life. Youth, 1842 Oil on canvas, 134.3 x 194.9 cm Washington, National Gallery of Art

Thomas Cole The Giant's Chalice, 1833 Oil on canvas, 49.3 x 41 cm New York, The Metropolitan Museum of Art

THOMAS COLE

1801-1848

Cole's portrayal of *Youth* is bathed in the pale midday blue of summer. In a boat accompanied by angels, the young man holds the rudder himself and guides the boat, his right arm held aloft emphatically, along the path of life, which is frequently expressed by the metaphor of a river. In the distance, a "castle in the air" alludes to the optimistic ideals this young person still nurtures for his future. Even the lush and fertile landscape in all its tranquillity and mild luminosity clearly underlines the positive characteristics Cole attributes to this stage of life.

The three other scenes in the cycle, *Child-hood*, *Maturity* and *Old Age*, are by no means entirely positive. In them, the figures are also accompanied by guardian angels, but the path of life is often shadowed and surrounded by high mountains, or lashed by storms.

The entire series, executed twice by Cole and originally commissioned by a profoundly religious banker for his private villa, combines various metaphors of age, time and season with literary concepts in a way that would be unthinkable without the European Romantic movement. It is no coincidence, that *Youth* was the most popular motif in the series, and the one most widely distributed in numerous reproductions. It is a fitting reflection of the prevailing mood in 19th century America following the economic crisis of the 1840s.

In a panoramic landscape of mountains, plains and oceans, in which enclaves of human life are indicated by a small town on the seashore and some tiny ships, rises a gigantic chalice of stone. It is clearly a remnant of the long lost era of the Titans who, according to Greek myth, lived on earth before the days of men and gods. Now the chalice has lost its original function, its rim is overgrown, ancient settlements can be seen around it and ships sail on its surface. Only the painter and the viewer, in their all-seeing position, can recognize the contexts in which human life goes on.

Cole's known interest in the creation myth prompted him to code many of his landscape paintings with religious and allegorical allusions. *The Giant's Chalice* is intended to show that civilizations have no awareness of the powers of their development and renewal nor any sense of the vast dimensions of other worlds beyond their own. This painting, highly original for its time, was not fully appreciated until the advent of the surrealists.

Christa von Lengerke

IMPRESSIONISM, ART NOUVEAU AND JUGENDSTIL

Painting from 1860 to 1910

The second half of the 19th century spawned a wide diversity of stylistic trends in painting and brought forth a number of highly distinctive personalities. The very fact that so many different terms are associated with this period – Salon painting, Impressionism, Pointillism, Historicism, Pre-Raphaelites, Jugendstil, Art Nouveau and Belle Epoque – bears witness to the sheer variety of artistic movements. In France, inspired by the revolutionary painting of Manet, the Impressionists shook off the fetters of a rigid and outmoded artistic canon and determined the subject-matter and compositional organization of their paintings, themselves; Monet and Renoir, Pissarro and Sisley painted what they wanted as they wanted. Others soon followed suit, including Liebermann and Corinth in Germany and Cassatt and Chase in the USA.

The Pre-Raphaelites in England, Millais and Rossetti among them, called for a more profound and reflective intellectual approach to art and paved the way for the decoratively ornamental style known as Art Nouveau and its German-Austrian equivalent, Jugendstil, which was embodied in its purest form by the work of Klimt, while Symbolists like Moreau conjured up visions from the world of dreams and the realms of the imagination.

Dynamic brushwork and a highly expressive handling of colour are the predominant features of Van Gogh's paintings. Gauguin's images of the South Seas represent a journey of discovery to a more primeval life, while Cézanne's autonomy of form and colour brought him widespread recognition as the father of modern art.

Impressionism and Art Nouveau, or Jugendstil as it was known in Germany and Austria, are terms used to stake out the boundaries of a development in painting that took place within a period of about five decades, from the mid-19th century to the early years of the 20th century. On the one hand, there was so-called Salon painting, art cloaked in traditional means, whose meticulously crafted and often brilliantly executed works reflected a conservative attitude that did not question the prevailing order. On the other hand, a new painting was beginning to emerge whose creative freedom and forceful impact undermined conventional structures and pointed towards the dawn of a new era.

Although we have become accustomed to talking of stylistic pluralism as a 20th century phenomenon, it can already be observed in the 19th century, when a number of stylistic directions developed in rapid succession and at times even simultaneously. The origins of these styles are often difficult to trace. Some of them were full of innovative vitality and paved the way for subsequent developments, while others were merely the emasculated remnants of a movement whose energies were already spent. A few key words suffice to indicate just how heterogeneous the situation was in the field of painting during the period under discussion: Salon painting - Impressionism - Historicism - Pre-Raphaelites - Post-Impressionism - Japonisme - Symbolism - Fin de Siècle - Jugendstil - Art Nouveau -Belle Epoque.

Paris as the centre of art

Around the mid-19th century, the world was highly Eurocentric. Europe was seen as the model of progress, and its colonies, friendly states and even countries subjugated by force recognized European civilization and culture, whereas Europe continued, as it had done ever since the discovery of distant lands, to plunder the treasures of foreign lands for things of value, exotic rarities and fashionable articles. Since the reign of Louis XIV, France had embodied the very epitome of elegant life in the eyes of the European courts, aristocracy and haute bourgeoisie - a reputation it continued to savour in spite of a change of ruler, a revolution, a new empire and even a republic. Finally, in the second half of the 19th century, Paris was the exciting and scintillating centre of the art world, and justly so.

A number of favourable circumstances had secured France and thereby Paris, a foremost position in the world of art, which it was to maintain for many years, well into the 20th

Pierre-Auguste Renoir The Swing, 1876 Oil on canvas, 92 x 73 cm Paris, Musée d'Orsay

century. Rome's hegemony as a seat of learning and a coveted base for artists had declined almost unnoticed and Paris had stepped in to fill the breach. Artists still went on study tours of Rome and Italy, visiting museums and classical monuments, but the major events in the world of art were now taking place in Paris. It was the powerful Institut de France which directed and regulated cultural life under the auspices of monarch or parliament. This institution was in charge of the Ecole des Beaux-Arts in Paris and the Académie de France in Rome, constituting the only official training facility for painters and sculptors, who hoped that their training there would be a passport to status, recognition and wealth. Prizes, awards, public purchases and commissions, election to the Académie des Beaux-Arts from which the professors were appointed to the art schools in Paris and Rome and from which the jury members were chosen for the Salon exhibitions, constituted coveted career goals accessible only by this path.

The Salon was a high-profile exhibition and sales forum that drew many visitors and stimulated the kind of lively debate and public attention so important for artists in a period when art-dealing and commercial galleries were only beginning to develop. Salons were public and had enjoyed enormous popularity since Louis XIV had begun holding them in the court of the Palais Royal and later in the Louvre events attended by le tout Paris. Each Salon prompted a flood of art criticism from amateurs and professionals alike. The tradition of art theory as the basis for the development of art goes back to the 17th century when it was first established by Académie members like Le Brun and other active painters, later by connoisseurs and collectors who described themselves as "amateurs" and who had a distinct sense of responsibility towards the world of art. The proponents of the individual stylistic directions fiercely defended their controversial views and did not shy from even the most vehement debate. Just as the Rubenistes and Poussinistes had been implacable rivals in the 17th century, in the mid-19th century it was the disciples of Eugène Delacroix who pinned the banner of "colour" to their mast and railed against the predominance of line and drawing propagated by Ingres and the other academists. Out of these rivalries and controversies there grew a phenomenon that has come to be taken for granted in our day and age: publicity.

The Salon reports published in the form of newspaper articles, custom printed brochures or in letter form, as plays, satires or essays, were equally popular. Often renowned intellectuals - Denis Diderot, Charles Baudelaire (1821-1867), Emile Zola (1840–1902), Théophile Thoré-Bürger (1807– 1869), Joris-Karl Huysmans (1848–1907) wrote the Salon reviews, defending the work of one painter and his art or tearing others to pieces, and fuelling the already raging fire of debate. In an era not yet inundated with information overflow, they were received with eager interest, and provided welcome material for discussion in the salons of high society.

The situation in the rest of Europe was similar. In almost all the capital cities there were subsidized academies which awarded grants and prizes and organized exhibitions; there was no shortage of theoreticians and critics, nor of buyers, and yet it was Paris alone that was the main focus of attention. Elsewhere, there were capable artists, many of them outstanding individuals, whose talent remained in the wings, generally enjoying modest local patronage, but burdened with the disadvantage or even the stigma of not having achieved fame in France or in Paris.

Of course, in other countries – in England and Scandinavia, in Belgium, Holland, Germany, the Alpine countries, Eastern Europe, Russia and the USA – old and new trends, coloured by a regional and local vernacular or by the strong signature of an individual artist also existed. Yet it often took longer for these to emerge from the shadow of dominant French painting and find the attention and acclaim their significance deserved.

Official art and countermovements

The Paris World Fair of 1855, which included a separate section for the presentation of international art, was a major event. Twenty-eight nations exhibited, and it was the showcase for the first continental exhibition of the English Pre-Raphaelites. The section for French painting was not only accorded the most space, but was also the main focus of attention and admiration. The selection of French artists chosen to appear in the exhibition sheds some light on the situation of the Paris art scene at the time.

Ingres, represented by over forty works, was the radiant and highly accoladed star, and all the prizes and honours were awarded to artists who adopted his approach and painted in accordance with the doctrines of the Académie. As so often, Delacroix had to forego academic and state merits, although Baudelaire dedicated a brilliant eulogy to his work, and the painters of the school of Barbizon, referred to somewhat pejoratively as realists and naturalists, were allowed to display only a few poorly-placed paintings.

Only those painters conventional enough to follow the official artistic career-path by producing Salon art were well received. A hierarchy of motifs was applied as a scale of values that seems quite ridiculous from today's point of view. Historical, religious and allegorically idealizing themes met with the highest praise, followed by swagger portraits. Landscapes, genre painting and still lifes were even less highly thought of. Moreover, a certain technical skill was demanded in the execution of ceremonial postures, dignified reminiscences and academically correct classicism. The paintings that complied with these outward criteria often had little more than fashionable appeal and empty rhetorical brilliance and they were purchased and accoladed by a public that saw

itself mirrored in them. Unchanged for decades, and determined by civil servants, the requirements of academic perfection and the academic structures were a hindrance to vitality and an innovative spirit. Creative freedom and personal artistic development were quite unthinkable.

A tentative protest against the rules of the academy had already been voiced in the first half of the 19th century by groups of artists, such as the St Lukas Bruderschaft (Brotherhood of St Luke) in Vienna in 1809, while in France the rebel artists were those who had settled in rural Barbizon to paint outdoors and in the studio. Corot, Courbet, Millet, Rousseau, Charles-François Daubigny (1817–1878), Constant Troyon (1810–1865) and Diaz de la Peña had joined forces to step out in a new direction in painting and lend each other support when they could expect none from any official authority. In England, the Pre-Raphaelite Brotherhood was founded in 1848, adopting as their model the painting of 15th century Italy, the age of Raphael, and seeking a complete renewal in art. In Paris, the gradually awakening selfconfidence of non-academic painters or those rejected by the academy led in 1863 to the creation of a Salon des Refusés which, though it did not achieve the hoped-for success, caused a major scandal and unleashed storms of uncomprehending protest.

The eight group-exhibitions mounted by the Impression-ists in Paris out of necessity and protest between 1874 and 1886 were initially doomed to failure, but they nevertheless contributed towards making the artists concerned better known. In their wake came the Neo-Impressionists and the Symbolists. Throughout Europe, groups of artists began to form, culminating in the Secessions that sprang up everywhere, with their firmly anti-academic programme and regular exhibitions. It was not only the *avant-garde* painters who were in search of new contents and forms for their art. Similar trends could be found in literature and music, and it is therefore hardly surprising that interdisciplinary groups were also founded.

Cafés and restaurants played an important role in cultural life, and were often places of debate and lively discussion rather than mere watering-places. At that time, the Brasserie des Martyrs in Montmartre and the Andler-Keller were frequented by the realists grouped around Corot and Courbet, by the critics and writers Jules Castagnary (1830–1888), Champfleury and Baudelaire. Henri Fantin-Latour (1836–1904) and Gustave Flaubert (1821–1880) preferred the Café Taranne. Café Fleurus, decorated with murals by Corot, was a favourite meeting place amongst the students of Charles Gleyre (1806–1874).

Until 1866, Edouard Manet (1832–1883) was a regular at Café Bade, before he switched to Café Guerbois on the Boulevard de Batignolles, which was soon to become a popular haunt of the Impressionists and their friends. Later, they would also meet in the Café Nouvelle-Athènes, where Edgar

Claude Monet Impression: Sunrise, 1873 Oil on canvas, 48 x 63 cm Paris, Musée Marmottan

Degas (1834–1917), Pierre-Auguste Renoir (1841–1919), Monet and Alfred Sisley (1839–1899) were frequent guests, as were the critics and writers Armand Silvestre (1837–1901), Ernest Renan (1823–1892), Auguste Villiers de L'Isle-Adam (1838–1889), Paul Cézanne (1839–1906), the musician Cabaner (1832–1881) and George Moore (1852–1933), who initially wished to become a painter and then ended up as a writer. Café Volpini was later to become the meeting place and exhibition venue of the Nabis and the Post-Impressionists.

Impressionism and the Impressionists

At the Ecole des Beaux-Arts, the studio of Charles Gleyre was regarded as the most liberal. Though Gleyre himself painted very much in line with contemporary taste, he did not seek to impose this style on his students in any way, preferring to allow them to develop their own skills. His classes were understandably the most popular, particularly amongst young artists eager to explore new avenues in painting. At the Atelier Suisse on the Quai des Orfèvres, painters would gather to work for a small fee, without a teacher telling them what to do.

In the 1860s, these places attracted the young painters Monet, Frédéric Bazille (1841–1870), Sisley, Renoir and Camille Pissarro (1830–1903). These were the artists who were to develop the purest form of Impressionism, which reached its zenith in the 1870s and 1880s and, for several decades, constituted the "new painting" that swelled to become a

broad international movement and paved the way for the art of the future. They initially joined forces on a friendly basis with the intention of taking their training as painters into their own hands, in order to avoid the impasse of academic teaching.

Monet had come from Le Havre where he had been introduced to plein-air painting by the aimiably helpful, slightly older Eugène Boudin (1824-1898) and had learned to observe various different light situations from the same standpoint under different conditions. He passed on what he had learned to his friends and persuaded them to take up the experiment of plein-air painting so disdained by the traditionalists. In Paris, they studied the old masters in the Louvre and practised with dedication in the studio, executing innumerable studies and sketches before creating their compositions in oil. They never tired of studying the works of the painters of previous generations who had also gone against the academic direction. They revered Delacroix, who had died in 1863, and they sought the friendship and advice of the painters of Barbizon; Corot and Courbet earned their highest esteem.

Brought together by their common quest for a new spirit in painting and by their mutual admiration and friendship, an increasing number of painters, writers, musicians and other artists and critics as well as a few collectors, art dealers and patrons soon joined their circle. The two slightly older *plein-air* painters Boudin and Johan Barthold Jongkind (1819–1891) were invariably willing to undertake work

together, to spend time in the country and to hold discussions. With their light-flooded landscapes, they built a bridge between the school of Barbizon and purely Impressionist painting.

It was Monet, with his ideas and paintings, who made the most decisive contribution to the development of Impressionism. The fascination of capturing a fleeting moment, the observation and reproduction of colours and surface appearances changing under the influence of natural light became an increasingly important aim in his works. He chose to leave out the narrative, the sublime and the historic from his paintings, preferring from the start to portray simple motifs: landscapes, still lifes, tranquil scenes of his family and friends, urban and rural life, portraits of his mistress. All of his models and motifs were portrayed in close-up or at a distance in a manner that allowed an intimacy to be retained.

His new way of seeing – the outward appearance as the harmony of colour and light – could be expressed only by a new approach. The possibilities of Neoclassicist painting were exhausted and so he sought other models, gradually banning linearity and stark planarity from his paintings, and relaxing his brushwork until it came to resemble scumbled daubs.

Pissarro and Sisley were closest in style to Monet, both in their choice of motif and overall organization, and to Bazille, who died in the Franco-Prussian war in 1870. Renoir, with whom they frequently explored the same motifs, worked entirely according to the increasingly clearly defined principles of Impressionism.

Time and time again, with varying degrees of success, the young artists would submit their paintings to the Salon jury in the hope that they might be accepted, for these exhibitions were virtually their only opportunity of presenting their works to the public and of selling them. The further they strayed from the paths of academic tradition towards their own style, the more futile their chances became until the constant rejections finally drove them to take their own initiative.

They were also joined by painters like Edouard Manet, who was not entirely outside of the Neoclassicist camp. He had trained in the studio of Couture at the Ecole des Beaux-Arts and had enjoyed some initial success at the Salon. Manet's work is as much a milestone on the road to Modernism as that of the pure Impressionists, but it is based entirely on classical predecessors. Manet was a close friend of Monet and even adopted certain Impressionistic aspects of the latter's works, but he was never prepared to sever all ties with the Salon and the society that supported it, even though he suffered rejection because of the risqué liberality of his *Déjeuner sur l'herbe* (ill. p. 491) and his *Olympia* (both Paris, Musée d'Orsay) both of which caused a scandal. Degas also belonged to their circle and in his early work his clas-

sical training is still plainly evident. His gradual development towards a painterly technique in which structured fields of colour dominate in the portrayal of seemingly banal motifs positions him near the Impressionists.

The maverick Cézanne would meet up with the Impressionists whenever he came to Paris and he also exhibited with them from time to time. He adopted their *plein-air* techniques and explored Impressionist influences, but his struggle to find a pure new art eventually led him to adopt a highly analytic approach to the exploration of compositional structure.

Fantin-Latour was one of the group around Jean-Baptiste Armand Guillaumin (1841–1927) and Armand Gautier (1825–1895), Mary Cassatt (1845–1926) and Berthe Morisot (1841–1895). James Abbott McNeill Whistler (1834–1903) visited his Impressionist friends whenever he came to Paris, and their influence and inspiration are undeniable in his work.

Long before there was any precise term to describe it, a certain way of seeing and portraying had been developed which was pejoratively dubbed *Impressionnisme* and which soon came into common usage as an accepted term without negative connotations. The artists themselves often referred to the concept of "impression" in explaining the focus of their art. They forswore a precisely delineated reproduction of photographic precision in favour of atmosphere in their paintings — using painterly techniques to transfigure portrayals of distance and close-up objects, breaking down homogenous colour planes and lines, and using brushwork and texture as creative media in themselves

In their enthusiasm for plein-air painting, Monet, Sisley, Pissarro and Renoir had gone furthest in their experimentation with light, colours and shadows. They had instinctively recognized the psychological effects and characteristics of colour. Monet was the first to ban gloomy black from his palette, replacing it with a vital, vibrant blue. Today, in retrospect, it is often said that these artists were not particularly revolutionary. In the eyes of their contemporaries, however, they were revolutionary indeed, for the storms of indignation, outrage and ridicule triggered by their works were acutely and genuinely felt. Like their forerunners, the painters of Barbizon, they were referred to as realists and naturalists. This, however, applied to only one aspect of their painting: they sought their motifs in their actual surroundings and in nature, and they did not seek to imbue them with any sublime significance. The gentle anarchy of these painters aroused protest for many reasons. Even their lifestyle indicated that they were not artists in search of social approval and integration; they were interested first and foremost in true art and in the joys of their family life and their circle of friends. They turned their backs on the ideals of high society and broke the taboos of its superficial morality. Whereas the painters of Barbizon had been sober reporters of what they saw, the Impressionists glorified everything that had no place in the Salons: unspoilt nature, the simple life, people without airs and graces, nudity, Paris by day and by night.

Although the French Revolution had aimed to create a classless society, class differences had once again become firmly entrenched and were alien to a social dogma. The artists had dared to cross the borders of class difference. That alone was enough to provoke anyone who adhered to this divine order. After all, the higher echelons of society and academic art needed the artists as a mirror for themselves, and the bourgeoisie needed them too, for upward mobility was their heart's desire, and their bid to achieve it also meant adopting high society's taste in art.

The Impressionists, however, ignored the sublime motifs of Salon art, calling instead for the viewer to look at the artist's life, to see the snow in Normandy with them, to catch Madame Monet unawares sitting beneath the lilac tree, to look at the bar girl in the Moulin de la Galette – a bar that no gentlemen of fine society would actually admit to frequenting – to join them on a pleasure-steamer with ordinary citizens or to watch shirt-sleeved rowers in their boats. They asked the viewer to see as art things that had hitherto been arrogantly dismissed out of hand. That was quite simply going too far.

Even such painters as Manet, himself a wealthy man with social connections, were not immune from rejection if they took too many artistic liberties. One might be forgiven for asking whether they did so innocently or with some ulterior motive. Manet's *Nana* (Hamburg, Kunsthalle), a cocotte in her underwear, applying her make-up in the presence of a suitor, was viewed with considerable disapproval.

Their painterly technique was also seen as sacrilegious. It was not the first time since the Middle Ages that colours had been allocated a symbolic significance or that painters had discovered the power of colour as a stylistic device. According to the maxim ars superante materiam (art over matter) colour had long been subjugated and placed in the service of an exact fulfilment of the lines and planes of the motif. Whenever painters had liberated colour or brushwork and impasto from the strictures of line – Titian, Rubens, Frans Hals and Rembrandt, and in the 19th century Delacroix - it had been held against them. It was an act of artistic freedom that went against the grain of theory. The Impressionists and many of their contemporaries broke the mould of classical pictorial structure with its painstaking compositional approach, replacing it with a dynamic juxtaposition and contrast of bold and seemingly arbitrary colour planes which became an image when viewed at a distance.

Monet's famous painting *Impression: Sunrise* (ill. p. 479), from which Impressionist painting takes its name, shows a veil of mist enveloping water, sky, outlines of ships and

Edgar Degas Ballet (The Star), 1876/77 Pastel on monotype, 58 x 42 cm Paris, Musée d'Orsay

boats, a red sunrise and its reflection on the water. It has atmosphere and a touch of the unfinished, lightly daubed, that leaves room for the imagination. It does not tell the whole story. Looking at it, the viewer perceives the beauty with which light imbues matter.

Impressionist paintings do not express high ideals, but then again, that is not their intention. They pay homage to an attitude to life that is firmly rooted in the private sphere. They do not narrate, nor do they give us food for thought, but they invite us to take a brief break from the flow of time and delight in the beauty of a fleeting moment. They do not appeal to reason, but to the senses.

The phenomenon we describe as Impressionism is no longer associated solely with the painting of the 19th century. Today, we may speak of the Impressionistic painting of antiquity, Impressionist phases in the work of Titian, or the Impressionism of late 17th century Netherlandish landscape painting. Claude Debussy's (1862–1918) music is described as impressionist, as are the writings of Marcel Proust (1871–

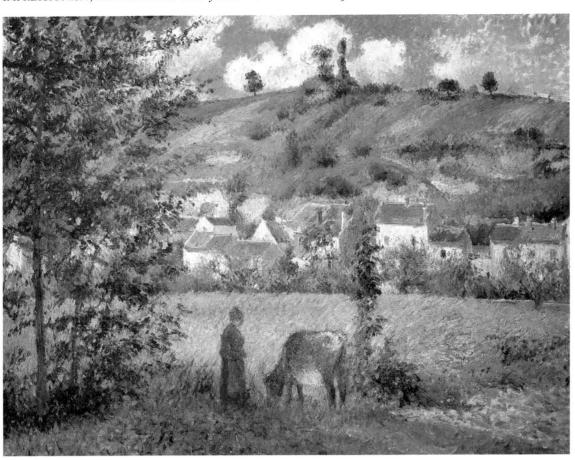

Camille Pissarro Landscape at Chaponval, 1880 Oil on canvas, 54.5 x 65 cm Paris, Musée d'Orsay

1922). The term is rarely applied to sculpture – though Auguste Rodin (1840–1917) and Medardo Rosso (1858–1928) are often referred to as impressionist sculptors – and it is not used for architecture at all.

The history of Impressionism is, at the same time, a history of the great bonds of friendship between artists, as is true of most of the non-academic art movements in the 19th century. The support offered by a circle of friends, including the often necessary financial assistance, gave the painters who had turned their backs on tradition and society the power and peace of mind to pursue their painterly aims unerringly. Even before the painters, worn out over the years by the constant rejection of their work by the Salon, joined forces and formed the Société des Artistes Independants in 1874, they had already found buyers for their paintings amongst a few aficionados and patrons.

Art dealers, patrons, critics

Most of the art dealers in Paris in those days were conservative and the few who supported the new painting at first paid dearly for it. Louis Martinet (1810–1894), a courageous art dealer with a gallery on the Boulevard des Italiens, had shown many artists from the Salon des Refusés at his gallery. Nevertheless, his programme was still fairly conservative and he was more supportive of the school of Barbizon and Manet than he was of such extremists as Monet, Renoir, Sisley or Pissarro.

The art dealer Paul Durand-Ruel (1831–1922), whose rival was Georges Petit (1835–1900), insisted, even in the face of bankruptcy, on representing the Impressionists and he made an immense contribution to their recognition. Ambroise Vollard (1865–1939) AND "PÈRE" MARTIN (C. 1810–c. 1880) had faith in their talent and supported them with purchases and small exhibitions.

The Romanian doctor Georges de Bellio (1828–1894) began collecting Impressionist works and the French doctor Paul-Ferdinand Gachet (1828–1909) not only provided medical care and advice for two generations of painters, but also came to their rescue in moments of need by purchasing their works. The customs officer Victor Choquet (1821–1891) invested his entire savings in his collection of paintings. He possessed many works by Delacroix, Cézanne, Monet, Renoir, Manet, Pissarro and Sisley. The singer and composer Jean-Baptiste Faure (1830–1914) was a customer of Durand-Ruel and he also purchased from the artists themselves. Eugène Murer (1846–1906), restaurant owner and patissier, expressed his approval and support by holding the famous Wednesday dinners so greatly appreciated by the painters.

Ernest Hoschedé (1838–1890), owner of the Au Gagne-Petit department store on the Avenue de l'Opéra, was enthusiastic about the work of the Impressionists, collected their paintings and organized two auctions. When he went bankrupt, Monet was able to return the favour by taking

him and his large family in. After the death of both Monet's wife and Hoschedé, the latter's widow Alice (1844-1911) became Monet's second wife.

Politicians such as Georges Benjamin Clemenceau (1841-1929), who would later become Prime Minister, and Antonin Proust (1832–1905) admired the Impressionists, bought their paintings, and even dedicated their writings to them. Critics and writers like Baudelaire, Zola, Thoré-Bürger and Champfleury, who praised the new painting in several articles, have already been mentioned in this connection. In 1878, the art critic Théodore Duret (1838–1927) published his ground-breaking study Les Peintres impressionnistes which brought them recognition, and his views were soon echoed by other critics, including Philippe Burty (1830-1890), Castagnary, Ernest Chesneau (1833-1890) and Edmond Duranty (1833-1880).

Japonisme

When Japan opened up to trade with the United States and Europe, Japanese art and Japanese crafts were imported in quantity, particularly to Paris. At the Paris World Fair of 1867, there was a highly acclaimed section dedicated to objects from Japan. On the European art market, particularly in Holland, England and France, Japanese art was available and large, exclusive department stores also stocked these coveted articles.

The rage for beautiful fans, kimonos, china, enamel, lacquer work and metal work, parasols and coloured woodcuts triggered a veritable passion for all things Japanese. People began collecting Japanese art for their homes and so-called "Japonisme" was to have a lasting impact on the artists, that was particularly evident in the period from Impressionism to Art Nouveau.

On the face of it, this Japanese fashion was similar to the craze for Chinese fashions in the 17th and 18th centuries. At that time, exotic, beautiful and precious items had been imported from China, and then Europeanized by modifying or copying them. China cabinets and lacquer cabinets were used to display collections, gilded decorations were applied to vases, wall-screens were dismantled and integrated into Rococo wall decorations as picture panels, Chinese painting was imitated as Chinoiserie. China responded to this fashion by producing export goods specifically for European taste. This simple mechanism also took effect in the case of Japanese works. At first, the fact that a painting included a Japanese object was merely an indication of the widespread popularity of Japanese crafts in Europe at the time - a phenomenon no more noteworthy than any other fashion or fad.

Yet it was the artists, in particular, who were inspired by Japanese art and who integrated it into their work, modifying it to sent their purposes. They were particularly impressed by the woodcuts, but also by the painted paravents, textiles, fans, lacquerwork and porcelain. The boldly fore-

shortened perspectives, figures cut off at the edge of the picture, elongated vertical picture formats, the quiet intimacy of the genre scenes, the fragile beauty of landscapes and plants, stylized almost to the point of ornament, and the partial abstraction were all sources of inspiration for the artists.

Whistler's tall, narrow formats have their origins here, and they will also occur later in the work of Edouard Vuillard (1868–1940) and Pierre Bonnard (1867–1947), going on to dominate the field of poster design from the 1880s onwards. The cut-out simplification of planar figure schemes in the work of Paul Gauguin (1848-1903), Synthesists and Nabis as well as in the work of Henri de Toulouse-Lautrec (1864-1901) is Japanese-inspired, as are the figures clipped at the edge in the works of Manet.

Monet's great cycles of paintings – the cathedral of Rouen, the Gare Saint-Lazare, poplars and grainstacks – showing the same objects again and again in changing light conditions, are inspired by the serial paintings of Katsushika Hokusai (1760–1849) and Utagawa Hiroshige (1797– 1858). Vincent van Gogh (1853–1890) loved Japanese woodcuts so much that he translated them into oils, seeking inspiration in their rhythmic linearity and planarity as he did so. Symbolism, Art Nouveau and Jugendstil are unthinkable without the influence of Japanese art.

The recognition of Japanese art as such indicates the changing consciousness of the 19th century in comparison to earlier times. It is conceivable only with an understanding of the Historicism that re-evaluates the art of earlier epochs and prepares the ground for an appreciation of primitive and naive art.

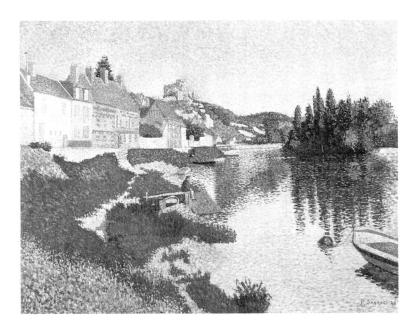

Paul Signac Riverbank, Petit-Andely, 1886 Oil on canvas, 65 x 81 cm Paris, Private collection

Impressionism in Germany

The term German Impressionism is generally used with certain reservations. Although there was no widespread and uniform movement as there was in France, certain Impressionistic traits can be found in the works of individual artists such as Wilhelm Leibl (1844–1900), Max Liebermann (1847–1935), Max Slevogt (1868–1932), Lovis Corinth (1858–1925), Wilhelm Trübner (1851–1917) or Fritz von Uhde (1848–1911).

In the second half of the century, official painting in Germany was the preserve of society painters. Swagger portraits, history paintings in which size and pathos were equated with quality, cloying allegory, idealization and sentimentality predominated and were celebrated and purchased by a public whose taste reflected the wealth and pomp of the economic boom years known in Germany as the *Gründerzeit*. Many painters saw this as a dead end, turned their backs on tradition and academic painting and sought a fundamental renewal of art. The realism of the *plein-air* painters of Barbizon and the French Impressionists was welcomed as a stimulating source of inspiration.

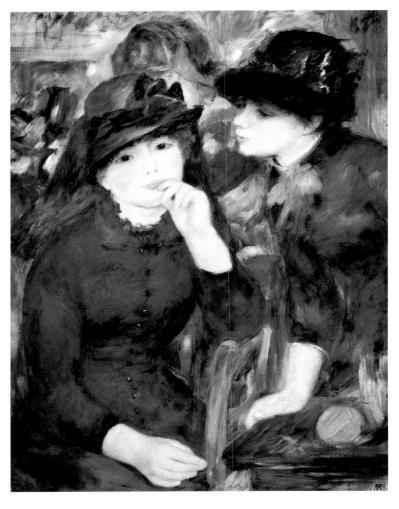

Pierre-Auguste Renoir Two Girls, c. 1881 Oil on canvas, 80 x 65 cm Moscow, Pushkin Museum

Leibl, who achieved considerable early success with his highly acclaimed portraits, left his chosen home in Munich for the solitude of Bavarian village life, creating an œuvre that went against prevailing concepts of art. Influenced by Courbet and the Impressionists, he did not seek to pander to prevailing taste either in his choice of motif nor in his presentation. His portraits and the peasant paintings he created from 1873 onwards show him to be a master of acute observation (ill. p. 532).

With meticulous finesse and the calm of a still life study, he shaped his motifs and models with coloristic inventiveness from the distance of a neutral observer. He developed a subtle realism whose mordant edge is invariably softened by the brilliance of his colours. Occasionally, especially in his later works, we find Leibl moving closer to his Impressionistic sources of inspiration. His friends and colleagues included the painter Johann Sperl (1840–1914), Carl Schuch (1846–1903) and Wilhelm Trübner. Like the French Impressionists, they painted together in the open air and, like them also preferred subjects drawn from their personal surroundings and explored the outward appearance of things and their relationship to light. Schuch's still lifes and Trübner's landscape paintings may best be described as Impressionist.

Liebermann's work evolved from an almost raw realism to *plein-air* painting and an Impressionistic approach. The clear linearity of his early works dissolves increasingly as he models with light. Liebermann had a considerable influence on Uhde. Uhde's painting, which was realistic for some time, began to move towards Impressionism both thematically and technically once he gave up religious motifs around 1900.

Slevogt is frequently mentioned in connection with German Impressionism, and many of his paintings, especially his landscapes, do owe much to the Impessionist movement. His art nevertheless also contains certain naturalistic traits of the old masters that bear witness to the broad range of his artistic imagination and talent, making him difficult to classify under a single stylistic scheme.

Apart from Liebermann and Slevogt, Corinth should also be mentioned in this context. Whereas his early works are still dominated by a dark-toned palette, his colours become lighter and brighter, especially under the influence of Manet and the *plein-air* artist Jongkind, taking on distinctly Impressionistic hues. His later work, however, the rhythmic Alpine landscapes of the Walchensee region with their strongly expressive colority, and his portraits and self-portraits, have rather more in common with Expressionism.

England – from the Pre-Raphaelites to Modern Style The Pre-Raphaelite Brotherhood of artists was founded in England in 1848 and their aims of achieving a renewal in art were to hold sway until the advent of Symbolism and Art

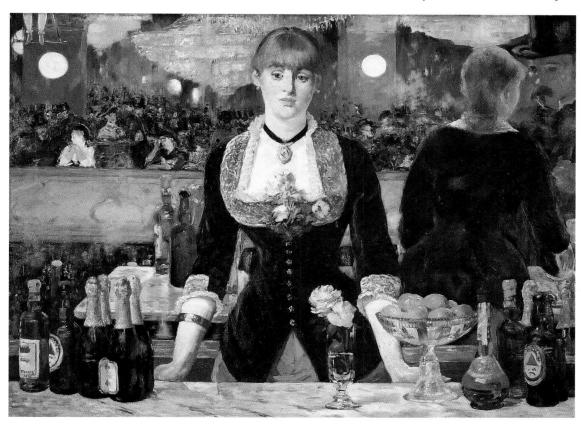

Edouard Manet A Bar at the Folies-Bergère, c. 1881/82 Oil on canvas, 96 x 130 cm London, Courtauld Institute Galleries

Nouveau. The founding members of the Pre-Raphaelite Brotherhood included the painter and poet Dante Gabriel Rossetti (1828–1882), the painters William Holman Hunt (1827–1910) and John Everett Millais (1829–1896), the writer William Michael Rossetti (1829–1919) and the sculptor Thomas Woolner (1825–1892). Their close circle also included the painters Ford Madox Brown (1821–1893) and Edward Coley Burne-Jones (1833–1898), William Morris (1834–1896) and John Ruskin (1819–1900), who, as art critic and writer, provided the literary and ideological background.

They adopted a primarily anti-academic line directed against the official canon of Victorian art. Right from the start, their concept of renewal included not only the field of painting but also that of poetry. Over time the applied arts and crafts came to be included as well — innovations in interior decoration, and even the revival of the printer's craft towards the end of the century would owe much to their endeavours. Although the aims of the group were never actually formulated in writing, they were clearly expressed in the works of the individual artists.

New forms of presentation based on the works of the old masters were to be used to generate authentic sentiments. They drew their motifs from literary and religious sources, undertook studies from nature and practised *plein-air* painting. In their treatment of fairy-tales and sagas, they became the first to explore such thoroughly English themes as Arthurian legend or tales from Shakespeare. Religious motifs were frequently transposed to a contemporary setting – a

modern step indeed – and occasionally portrayed in a fairy-tale or historicizing setting.

The Pre-Raphaelite faible for medieval themes and meticulously detailed landscapes also betrayed a certain affinity with the Romantic artists. Though it is rather difficult for us today to appreciate what appeal they could possibly have found in the cloying sentimentality of the loving couples that people a small proportion of their pictorial themes, some of the Pre-Raphaelite artists, most notably Brown and Millais, did address socially critical subjects as well. They also dealt with allegorical and mythological material, in which the pathos and sublime gravity of the beautiful woman was often a dominant feature. In many of their works, it is not difficult to trace the sources of inspiration from art history.

From the 1870s onwards, the Pre-Raphaelites drew closer to Symbolism, as some of their titles, such as Burne-Jones' *The Heart of the Rose* (London, Tate Gallery), or Rossetti's *The Daydream* (Karlsruhe, Badisches Landesmuseum) indicate. With their aims of renewing craftsmanship and interior decoration, they instigated the Modern Style that was equivalent to Art Nouveau in France or Jugendstil in Germany.

Philip Speakman Webb (1831–1915), Rossetti and Burne-Jones were all involved in the firm of Morris, Marshall, Faulkner and Co., which was founded in 1861. They designed large friezes and panel cycles as well as fabrics, wall-papers, tapestries and stained glass. Morris was particularly inventive in creating variations on organic and floral forms,

whose sweeping, ornamental curves already anticipate the emergence of Modern Style. Later, they also turned their attention to furnishings, tiles, picture-frames and bookbindings. The idea behind the firm - unity in the arts and harmony in decorative form and function - was to emerge later in the Art Nouveau and Jugendstil movements of the continent. In Scotland, this development was represented by the work of Charles Rennie Mackintosh (1868-1942) and the artists grouped around him, and in England by the Arts and Crafts movement.

The collaboration between Burne-Jones and Morris at Kelmscott Press resulted in a series of magnificently designed book editions which were truly works of art for biblio-

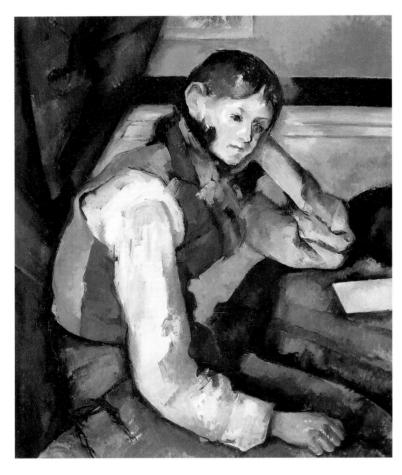

Paul Cézanne Boy with a Red Waistcoat, c. 1888-1890 Oil on canvas, 80 x 64.5 cm Zurich, Stiftung Sammlung E. G. Bührle

philes. Walter Crane (1845-1915), a friend of Morris, was also a designer, a political caricaturist, and designer of posters and prints. Aubrey Vincent Beardsley (1872-1898) created numerous illustrations based on the work of the Pre-Raphaelites and inspired by Japanese woodcuts, in an œuvre with a distinct hint of decadence that embodied the fin de siècle spirit in a formal syntax that bore distinct affinities to Jugendstil and Art Nouveau.

Symbolism - Fin de Siècle

As a counter-movement to the realistic and naturalistic trends in art, and diametrically opposed to the Impressionistic glorification of superficial beauty, the Symbolists brooded on an aspect of human existence that cannot be grasped by reason and rational observation: the realm of the soul, the sentiments and the imagination, which they articulated by drawing upon the ability of the individual to symbolize such immaterial phenomena and lend them form.

There have always been individual artists who condensed the unemotional allegorical language of allegory into the language of Symbolism in order to appeal to the emotions or express them. Now, towards the end of the 19th century, a distinct approach to art was emerging which had evidently been nurtured by these roots and which, without necessarily following in the footsteps of French art, spread throughout Europe and even as far as Russia. Symbolism in painting would have been unthinkable without the literary connection and the fin de siècle mood.

The 19th century, so enthusiastically hailed as the century of discovery, invention, science and progress, was drawing to a close and with the growing realization that these high aspirations had not been fulfilled and had failed to bring the hoped-for paradise, the disappointed hopes of a generation were channeled into a melancholy sense of the end of an era. On the one hand, it triggered an egocentric avoidance of reality and quest for oblivion and an exaggerated interest in individual personality, together with reveries on the hidden forces of life and feverishly angst-ridden lust, while on the other hand it prompted escapism in the apocalyptic pursuit of pleasure, aestheticism or mysticism.

Few artists can actually be classed as pure Symbolists. Most of them combine Symbolism with certain other stylistic features, such as Historicism, Jugendstil or Art Nouveau - and later, Expressionism - or display a strongly idiosyncratic creativity, as in the case of Van Gogh. Sigmund Freud (1856-1939), who posited the importance of the subconscious as an element of the individual's psychological make-up and explored the coded Symbolism of mood and emotion in dreams, was working at around the same time as the Symbolist movement.

The symbiotic coexistence of literature and painting is a distinctive feature of Symbolism: many artists were not only painters, but also writers. The Symbolist ideal or the narrative material was frequently articulated in words before being translated into a visual language, while the work of painters often inspired poets as well. Certain topics, frequently contradictory, were preferred by the Symbolist painters and expressed by them in ways specifically aimed at triggering emotions. Romantic motifs from fairy-tales and sagas, pathos-laden references to the world of mythology, feverish visions, lyrical relationships between man and woman, overweening sexuality and the sophisticated pleasure of eroticism, woman as demonic femme fatale, evil seductress, good or bad mother, elfin innocent or beguiling nymph. Sickness, death, fear, solitude as threats to the individual stood in contrast to the expectation of redemption through religion and virtue.

The means of evoking emotion and a mood charged with significance are more limited in painting than they are in literature and were handled in very different ways. Apart from using familiar allegorical symbols such as a skull, fantastic imaginary creatures were invented, the psychological effect of colours was exploited, facial expressions, gestures and poses were exaggerated and underlined by breaking down realistic proportions and dissolving the unity of time and space.

In England, the Pre-Raphaelites, following in the footsteps of Fuseli and Blake, had reintroduced symbolist elements into their painting, interwoven with historical ideas and underlined by literature. In France, the circle of painters and writers grouped around the poet Stéphane Mallarmé (1842-1898) presented their ideas in the magazine Le Symboliste published by Gustave Kahn (1859–1936). Pierre Puvis de Chavannes (1824–1898) placed his symbolist ideals (hope, dove) in coolly inaccessible landscapes and settings. Gustave Moreau (1826-1898) was fond of highlycharged imaginary landscapes, pompous architecture, fantastic creatures and baroquely bejewelled beautiful women as harbingers of death. Odilon Redon (1840–1916) whose graphic works were described as "strange, enigmatic, sick visions, hallucinations", developed a fragile and subtle symbolism in his later works.

In Belgium, Fernand Khnopff (1858–1921) remains the most famous representative of Symbolism. His preferred topics, inspired by Symbolist poetry, are tranquility, solitude, the deserted city, mystery and woman as Sphinx. Jan Toorop (1858–1928) and Jan Thorn-Prikker (1868– 1932) represent Symbolism and Jugendstil in the Netherlands, while the Norwegian artist Edvard Munch (1863-1944) created visions of fear and menace, not unlike the works of the Symbolists, but which integrated the sweeping curves and distorted forms of Art Nouveau or Jugendstil with a highly dramatic psychological force that anticipates Expressionism. In Rome, the German expatriates Hans von Marées (1837–1887) and Anselm Feuerbach (1829–1880) and the Swiss artist Arnold Böcklin (1827-1901) looked to the classical art of Italy and ancient Rome and blended the emergent Neoclassicism with Symbolistic traits.

Gauguin, the School of Pont-Aven and the Nabis

Gauguin belonged to the generation of painters who had already begun to regard Impressionism with scepticism. Although, for some time, he had painted Impressionistic landscapes of captivating fragility and tonal transparency, around the age of forty, he had begun to seek other forms of expression and statements for his painting. By this time, he re-

Henri de Toulouse-Lautrec Jane Avril Dancing, 1892 Oil on cardboard, 85.5 x 45 cm Paris, Musée d'Orsay

garded Impressionism as empty and meaningless, and sought an antithesis to it as a basis for his work. It was this quest that finally resulted in the compelling and forceful visual language that put him firmly on the path to modern art without ever entirely abandoning all aspects of Impressionism. Throughout his life, he loved to paint outdoors, and in his handling of large colour planes he would fragment them into a tapestry of nuances and a patchwork of varying intensity.

Vincent van Gogh Garden in Bloom, 1888 Oil on canvas, 92 x 73 cm Private collection, on loan to Metropolitan Museum of Art, New York

On his return from a journey to Martinique in 1888, he took up work again in the Breton village of Pont-Aven. Together with his younger colleague Emile Bernard (1868–1941), who admired him greatly, Gauguin developed Synthesism and Cloisonnism, a style of painting in boldly contoured, flat colour areas, derived from stained glass and cloisonné enamel techniques. In Gauguin's painting The Vision after the Sermon (Edinburgh, National Gallery of Scotland) Symbolist elements occur for the first time: from now on, his paintings are frequently charged with a religious symbolism that imbues them with higher meaning. Later, on his return to the South Pacific islands, he would transpose biblical scenes into the local setting, in an early step towards acknowledging their equality.

Together with Bernard, whose Synthesist paintings are laden with Symbolistic content, he gathered other painters around him, and this circle, which came to be known as the school of Pont-Aven, explored new concepts in painting. Gauguin himself, regarded by the members of the movement as the leader of the Symbolists, did not always adhere to the criteria of symbolic reference in his paintings. He worked on strong simplification of linearity and forms, cre-

ating images of enormous intensity, whose greatest strength lies in the impact of their colours.

Influenced by Gauguin and the Pont-Aven group, Paul Sérusier (1864–1927) gave the the Hebrew name "nabis", meaning prophets, to the association of painters he had founded in 1889. They, too, sought to counter Impressionism with a religiously mystical painting of intensive colority and decorative planarity. They saw the principles of Bernard and Gauguin as their artistic message of redemption. This group included Bonnard and Vuillard as well as Maurice Denis (1870–1943) and later Félix Vallotton (1865–1925); they were joined still later by Aristide Maillol (1861–1944) who was then a painter, and Henry van de Velde (1863–1957), who was to achieve fame primarily as an Art Nouveau architect and designer. The forum for their ideas was the *Revue Blanche*.

Symbolism had never been a predominant aspect of the group's work, which turned increasingly towards the decorative arts in the early stages of Art Nouveau. In keeping with contemporary trends, they soon began exploring the possibilities of book illustrations and posters, theatre décor and interiors. Denis concentrated strongly on religious Symbolism and in 1919 he founded the Ateliers d'art sacré (Studios of religious art). Bonnard and Vuillard left the group.

Post-Impressionism and Pointillism

Following the achievements of Impressionism, which took pure, free painting as its aim and content, calls for a consolidation of content and form began to take hold again in art. The Impressionists had experimented with colour and with the effects of light on colour. Their findings had been gained intuitively and through observation, and were not bound by rules or regulations.

The colour theories of Charles Blanc (1813-1882) and Eugène Chevreul (1786–1889), based on chemical research, attracted considerable attention and were also adopted by artists. Pissarro had begun drawing up a theory as foundation for his painting, an experiment that never got beyond its early stages. Before recording it in writing, he abandoned the experiment, feeling that it restricted his spontaneous creativity. Georges Seurat (1859–1891) and Paul Signac (1863– 1935), the main protagonists of Pointillism, also known as Divisionism, sought to make a systematic science of the Impressionist painting process. Carefully calculated dots of pure colour juxtaposed so that they would add up to an image in the eye of the observer were intended to create a precalculated impact. The motif became the vehicle for technical experimentation. Purely divisionistic paintings, however, remained considerably less effective than those of the Impressionists, for they lacked the magic of the fleeting moment.

Vuillard and Bonnard, a generation younger than the first Impressionists, followed on from the initial experiments of Impressionism, which they developed further and brought to a worthy conclusion in the early years of the 20th century. These two artists remained friends for life and even shared a studio at times. Their œuvre, not surprisingly, has many similarities. After a brief association with the Nabis, which had no major impact on their style, they took up the ideas of the Impressionists and remained faithful to them. The influence of Japanese art is undeniable, especially in their prints. Their interiors, still lifes and cityscapes bear the hallmarks of a subtle, but intoxicating enthusiasm for the miracle of colour and light, its beauty and harmony, as the quintessence of life's quiet joys.

Van Gogh, Toulouse-Lautrec, Cézanne

Apart from Gauguin, there are three other artists, in particular, whose work paves the way towards modern painting on the basis of Impressionist achievement. They are Van Gogh, Toulouse-Lautrec and Cézanne.

Van Gogh, who said of himself that he painted everything with true passion, saw his task as an artist to strive for the good of mankind. His paintings were intended to be of significance in this endeavour. The stark simplicity of his forms and the absoluteness of his colours had an enormous impact on the generations of artists who followed him. The dynamic expressiveness of his brushwork and his planar distortion of perspective to the point of negation constitute major steps towards 20th century painting. The Symbolism of his colours and motifs arose from his individual mood and situation, but nevertheless make a universal statement to the viewer that goes far beyond the mediation of aesthetic values, opening a window on a psychological view.

Toulouse-Lautrec elevated the sketchy, the unfinished and the fragmentary to the level of a stylistic principle in his paintings at around the same time as Rodin's sculptures were establishing the torso as an independent motif. In many of his paintings, Toulouse-Lautrec comes very close indeed to dissolving form and space to the point of abstraction. He ignored class differences and hierarchies, seeking his motifs in the aristocratic circles into which he had been born as well as in the demi-monde he chose to frequent. He saw the beautiful, the ugly and the vulgar and he interpreted it in a way that went far deeper than a mere social or character study; his form of presentation was capable of arousing an understanding far removed from aesthetic exaggeration, sympathy or social criticism. With subtle psychological empathy, he stylized typical features, creating an astonishingly modern image of individuals and their daily lives by means of laconic reduction and strong, expressive colours.

Cézanne is frequently referred to as the father of modern art. From the very beginning of his artistic career, he sought to achieve more than his contemporaries, the realists and Impressionists. Though he strictly rejected Neoclassicism, he saw himself as a classical artist; he sought to express a universal and timeless truth, based on his exploration of the fun-

Paul Gauguin When will you marry? ("Nafea faa ipoipo?"), 1892 Oil on canvas, 101.5 x 77.5 cm Basle, Öffentliche Kunstsammlung Basel, Kunstmuseum, Rudolf Staechlin'sche Familienstiftung

damental principles of painting. He regarded narrative, idealist and symbolist factors as detrimental. He invariably worked from nature, seeking to capture the essence without creating a mere reproduction of what he saw. In his analysis of the relationship between colour, form, light and space, he gradually achieved a unity of drawing, colour and forms of presentation that paved the way for Cubism and abstraction. He modelled and modulated with colours and colour values. Gradually, the classical perspective disappeared from his compositions and he constructed objects, volumes and space on the basis of painterly interpretations of basic geometric patterns and forms.

Jugendstil – Art Nouveau – Modern Style – Secessionism

These various terms, current in Germany, France, England and Austria respectively, have not been applied to painting for quite as long as they have actually existed. Originally, they belonged to the field of applied arts and crafts. In the last two decades of the 19th century, applied arts, crafts and

interior decoration achieved artistic heights that made them the main bearers of creative design. A kind of prototypical Art Nouveau initially emerged amongst the Pre-Raphaelites in England, and went on to influence the paintings as well as in the boldly structured posters and illustrations of Crane. Beardsley worked as a draughtsman and illustrator. His works may be regarded as important documents of a refined Art Nouveau, in which object and ornament are playfully interwoven to the point of illusion.

The continental art of the poster is superbly represented in the work of Bonnard, Toulouse-Lautrec and Alfons Maria Mucha (1860–1939). The most characteristic features of Art Nouveau are the unsymmetrical curve which lends vitality to the ornament (occasionally with a leaning towards abstraction), floral forms and geometric variations. Frequently, the assimilation of Japanese elements is also evident. In the painting of the turn of the century, which can be regarded according to this stylistic aspect, symbolistic content is coupled with the fluid ornamental forms of Art Nouveau.

Ferdinand Hodler (1853–1918) and Giovanni Segantini (1858–1899) in Switzerland, van de Velde in Belgium, Toorop and Thorn-Prikker in Holland, Max Klinger (1857–1920) and Franz von Stuck (1863–1928) in Germany were

the leading proponents of an art in which Symbolist content merged with the formal syntax of Art Nouveau.

In the last two decades of the 19th century, in Paris, Berlin, Munich and Vienna, Secessions were founded. The Secessions were organizations based on anti-academic principles uniting all artists who had no truck with conventional artistic tradition and the accepted canons of art. Having no fixed programme, they were in favour of the realization of new, unconventional and free artistic ideas. After the turn of the century, it was the artists of the Secession who paved the way for Expressionism and related stylistic directions.

In Vienna, the Secession is closely linked with Jugendstil. Indeed, it is used to refer to everything associated with the Viennese Art Nouveau, which reached its scintillating zenith in the work of Gustav Klimt (1862–1918). His figures, mostly women, are presented against an abstract background, swathed in mystery and ornament. His colours range from subtle nuance to sumptuous oriental magnificence, on radiant gold backgrounds. Egon Schiele (1890–1918) overcame the dominant aestheticism of his paintings to achieve a tensely expressive illumination of his motifs. In doing so, he broke away from Jugendstil and forged a link to Expressionism.

EDOUARD MANET

1832-1883

Manet's Déjeuner sur l'herbe or Luncheon on the Grass, as it is sometimes known, caused a scandal in 1863. Rejected by the official Paris Salon, together with almost 3,000 other paintings submitted, it was then exhibited at the instigation of Napoleon III in the Salon des Refusés. Déjeuner sur l'herbe was the most controversial painting in an exhibition of works rejected by the Salon jury and therefore unlikely to meet with public praise. Several of the works shown at that exhibition are today the pride of many a major museum. Though Manet was acknowledged as a talented artist on the basis of his skilled draughtsmanship and his mastery of perspective, his choice of motif – two fully clothed men in the company of a female nude outdoors - met with utter incomprehension and earned him accusations of decadence and bad taste. The public was outraged not only by the provocative way in which his naked model looks directly at the viewer, but also by the fact that the artist did not trouble to cloak the scene in the guise of some allegorical title.

Manet struck upon the idea for this painting on a Sunday outing to Argenteuil, on the banks of the Seine. When he decided to capture the peaceful artistic idyll in a painting, he was already aware that he would be torn to pieces on grounds of the subject matter. Nevertheless, the idea obviously appealed to him so strongly that he set about conscientiously working out his design. Having taken the Spanish masters as his source of inspiration for a long time, he now turned to Italian art, and sought to create a modern version of Giorgione's Concert Champêtre (ill. p. 164). Because the motif is drawn directly from the immediate personal environment of the artist, critics refer to Manet's work as Pre-Impressionist, while the technical execution of the painting is Neoclassical in style.

Emile Zola, a friend of Cézanne since his youth, had always taken a keen interest in painting. He was particularly enthusiastic about the work of the artists rejected by the official art critics, and in 1866 he wrote an article about Manet, who had been rejected by the Salon jury yet again, claiming him to be a master of the future, whose path would lead straight to the Louvre. In order to express his thanks for the article, Manet proposed making a portrait of the critic. Zola was 27 years old at the time. His writings document that he sat for Manet in the artist's studio in February 1868. Manet presented Zola in an environment that characterizes his personality, his life and his profession. He is seated at a desk, on which Manet has arranged a busy still life of books, inkwell and other utensils – including the brochure Zola had written in Manet's defence. The book Zola is holding in his hand is very probably L'Histoire des Peintres by Charles Blanc. To the left behind the writer we can see part of a Japanese screen, and above him, in a frame, a sketch of Manet's Olympia another painting Zola had defended in his writings - and a Japanese woodcut.

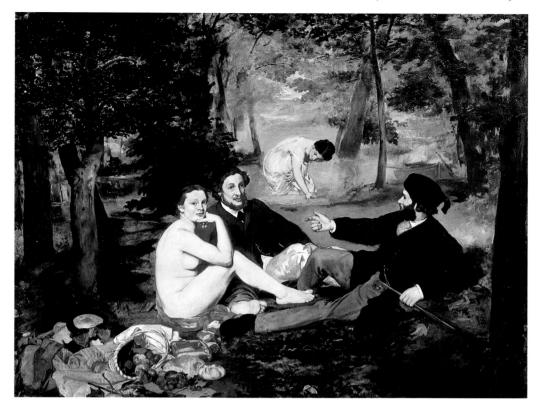

Edouard Manet Déjeuner sur l'herbe, 1863 Oil on canvas, 208 x 264.5 cm Paris, Musée d'Orsav

Edouard Manet Portrait of Emile Zola, 1868 Oil on canvas, 146.3 x 114cm Paris, Musée d'Orsay

Edouard Manet Luncheon in the Studio, 1868 Oil on canvas, 118 x 154 cm Munich, Bayerische Staatsgemäldesammlungen, Neue Pinakothek

Party), 1874 Oil on canvas, 149 x 115 cm Tournai, Musée des Beaux-Arts

Edouard Manet Argenteuil (The Boating

EDOUARD MANET

1832-1883

This breakfast scene - the subject of widely varying interpretations over the years - was in fact originally conceived as a representation of a studio, as an X-ray of the painting has shown. In its original state, the grey back wall had a typical studio window with metal spars. The figures, who seem to have no relation to each other, have also been clearly identified. The young man in the foreground is Léon Koëlla-Leenhoff, who is thought to be Manet's son. For some time, Monet was the model for the cigar-smoking man at the table, but in the final version it is Auguste Rosselin, a student friend of Manet from the Gleyre and Couture studios. The woman with the silver coffee pot is a housemaid and not, as was previously believed, Madame Manet.

This painting also includes a number of still life features reminiscent of Netherlandish compositions of the 17th century: the arrangement on the checkered table cloth and the weapons on the left are typical studio props. The black cat, often a feature of Manet's work, adds a certain intimacy to the painting.

Monet lived in Argenteuil, Manet spent his summers in nearby Genevilliers, Caillebotte lived in Petite Genevilliers and Renoir also joined them frequently. It was here, under the influence of Monet, that Manet began to explore the possibilities of plein-air painting. Argenteuil or The Boating Party may well be one of the paintings created in this way. It is certainly one of the most Impressionistic of Manet's paintings in terms of the handling of light, colour and atmosphere. Rudolph Leenhoff was his model here. The identity of the female figure is unknown.

Manet found his inspiration for the painting The Balcony in 1868 during a visit to Boulogne-sur-Mer. The arrangement is a transposition of Goya's Manolas on the Balcony. For this painting, whose chief appeal is the superb use of only a few colours, three friends of the family stood model, sometimes finding it quite tiring. The figures of the three young people emerge against a dark background, in which the outline of a servant with a water-jug can just be discerned. The man standing with a cigar in his hand is the landscape painter Antoine Guillemet. He is wearing a deep purple tie that seems almost luminous against the white of his shirt. The woman beside him in a white dress with an emerald-green silk parasol and a white, green-edged hat is the violinist Fanny Clauss. In the foreground, dreamily leaning against the balcony railing is the painter Berthe Morisot, seated on a black stool wearing a white voile dress. Next to her is a white plant pot with purple rhododendrons.

> **Edouard Manet** The Balcony, c. 1868/69 Oil on canvas, 170 x 124.5 cm Paris, Musée d'Orsay

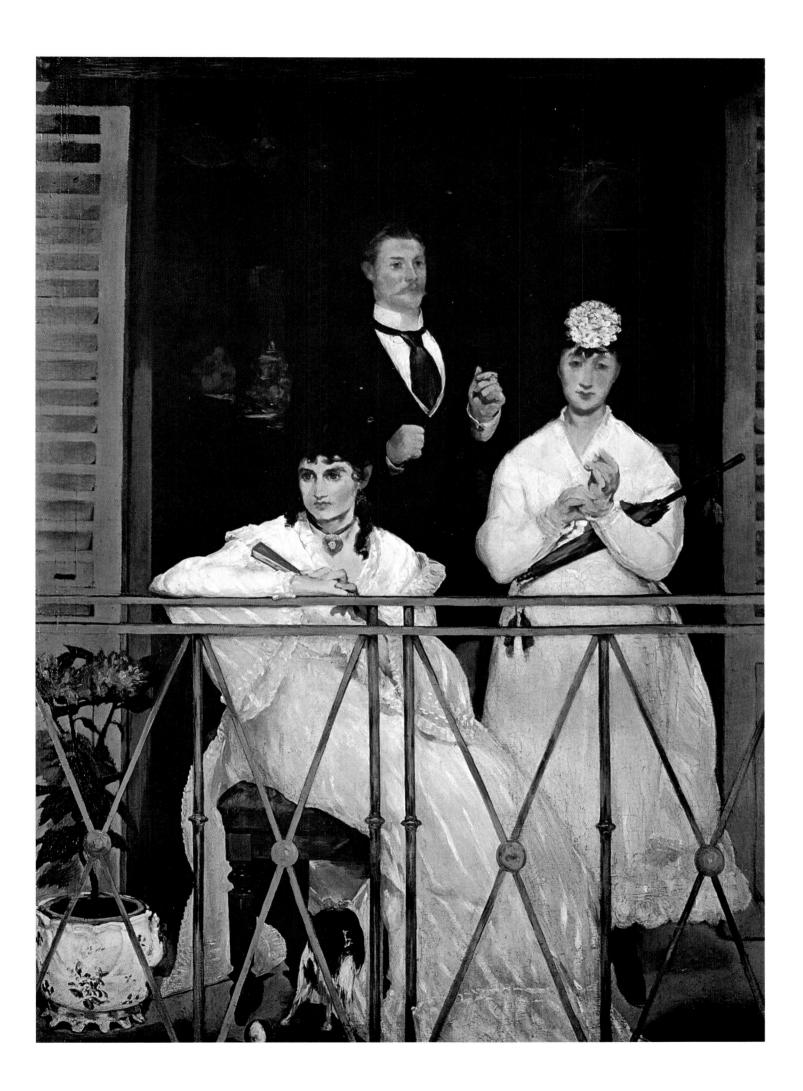

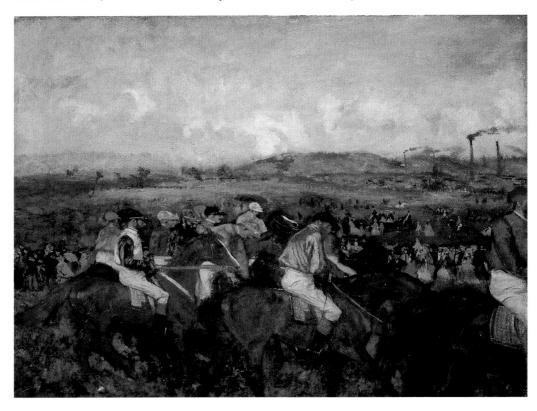

Edgar Degas The Gentlemen's Race: Before the Start, 1862 Oil on canvas, 49 x 62 cm Paris, Musée d'Orsay

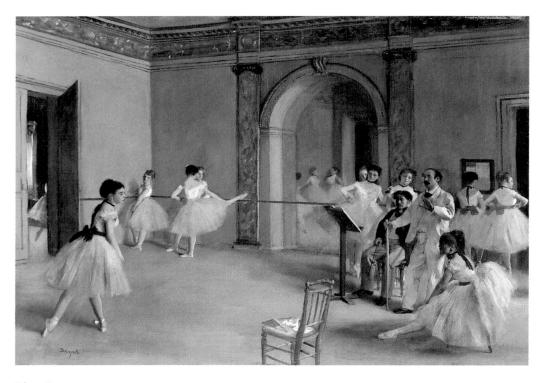

Edgar Degas Dance Class at the Opéra, 1872 Oil on canvas, 32 x 46cm Paris, Musée d'Orsay

EDGAR DEGAS

1834-1917

Degas was fascinated by the atmosphere of the racecourse, which was very much a part of "la vie parisienne" and the meeting-point of elegant society, the *demi-monde* and ordinary citizens in search of entertainment. The racecourse paintings that constitute such a significant part of Degas' œuvre were created on the basis of many *in situ* studies.

Here, the painter has chosen the position of an observer at the start, just before the race. The gentlemen riders (as opposed to professional jockeys) form the dominant group in the foreground. The impression of spontaneous immediacy is created by a portrayal in the manner of a snapshot in which the riders are shown in relaxed pose, further heightened by the apparently arbitrary way in which the front right edge of the painting is cut off. The riders in their garishly coloured tricots and the well-groomed horses have an almost sculptural presence, whereas the background is matt, diffuse and extremely reduced: the row of viewers, the green and rolling meadow and an industrial area which, in spite of its smoke stacks and slagheaps, is by now means bleak or gloomy, under a hazy sky.

In the world of the theatre, it was the young ballet girls in their little tutus, their satin shoes and bows that Degas observed at rehearsals and performances. He created innumerable variations on this motif in oils, pastels and as sculptures. In this painting, he gives us a glimpse of the rehearsal room at the Paris Opéra. The ballet master has just interrupted a young dancer. He is leaning on the stick he uses to tap out the beat and explain corrections, and is giving instructions to the gracefully posed girl in front of him with a gesture that calls for discretion and subtlety in the passage they are rehearsing at the moment. A violinist, who provides the melody and tempo, is sitting waiting by his music stand. The other girls of the corps de ballet are taking note attentively or are practising at the barre.

Degas himself often frequented cafés. In his younger years, he preferred the Café Guerbois. later the Café la Nouvelle-Athènes at Place Pigalle. It was here that he was inspired to paint his portrait of Desboutins and the actress Ellen Andrée known variously as In a Café, The Absinthe Drinker or, quite simply, Absinthe. This painting of two people sitting side by side yet in total isolation is a virtuoso psychological portrait that conveys the different moods of the figures with great precision but without pathos. Desboutin, in bohemian dress, drawing on his pipe, gazes sceptically into the interior of the café which the viewer cannot see. The woman, resigned and lost in thought, is lost in solitary thought, contemplating the glass with the drink that will bring oblivion.

> Edgar Degas Absinthe, 1876 Oil on canvas, 92 x 68 cm Paris, Musée d'Orsay

494

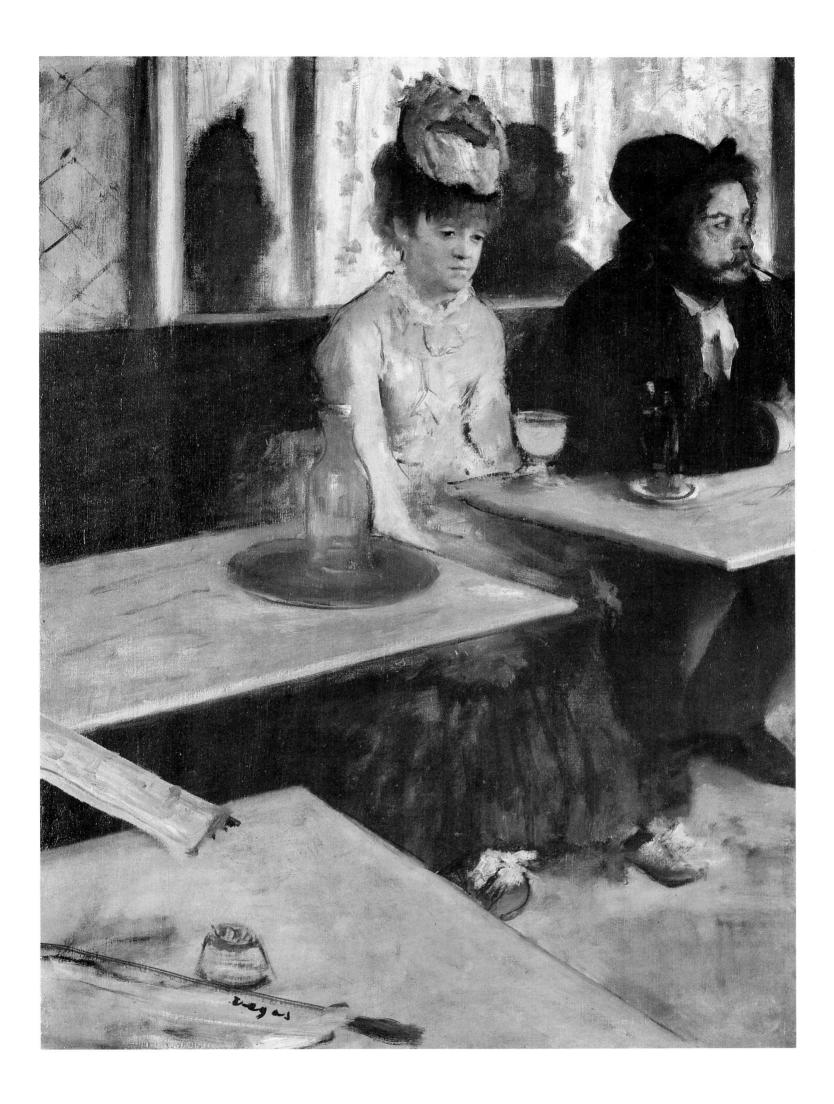

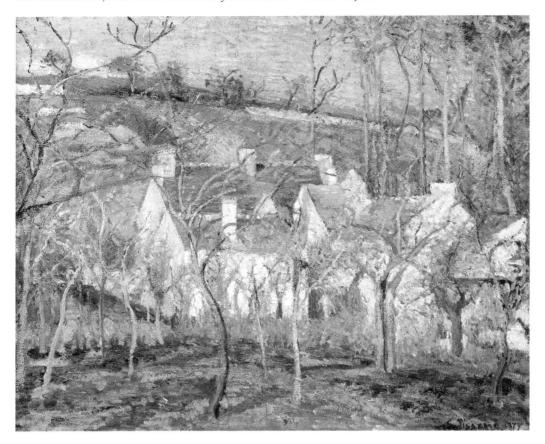

Camille Pissarro Red Roofs (Village Corner, Impression of Winter), 1877 Oil on canvas, 54.5 x 65.6cm Paris, Musée d'Orsay

Camille Pissarro The Old Marketplace in Rouen and the Rue de l'Epicerie, 1898 Oil on canvas, 81 x 65 cm New York, The Metropolitan Museum of Art

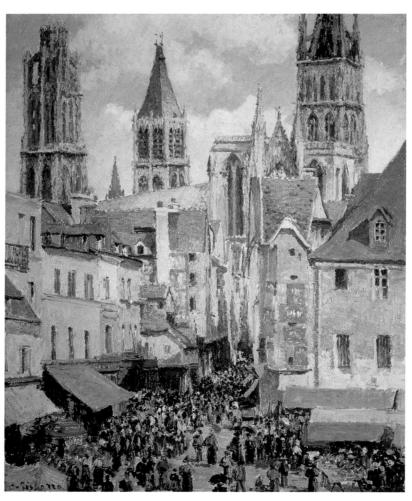

CAMILLE PISSARRO

1830-1903

The Louvre acquired this small-scale work as part of the bequest of Caillebotte, a friend and patron of the Impressionists. The painting is one of the earliest Impressionist motifs by Pissarro. It shows a few houses in a humble little village at the foot of a hill, surrounded by fields, orchards and bushes, under a strip of blue sky.

Only the leafless trees give us some indication of the time of year. It is a winter day with-

The landscape is bathed in sunshine and the red roofs of the houses are echoed in the red of the earth, the distant trees and bushes. The individual parts of the painting are merged in small, rapid brushstrokes, and the texture of the paint and the brushwork are easily recognizable.

The intertwined branches, the uneven ground, the roofs and the chimneys are consolidated by the play of light on the colours in a charmingly natural way. The artist thus captures only the momentary impression of a a brief and specific instant, while the precise location of the village is of lesser importance. Like Cézanne, with whom he had a long friendship that benefited both, Pissarro loved simple and unaffected rural motifs.

In 1894, Monet painted his famous series of twenty views of the cathedral of Rouen, capturing its appearance at various times of the day and in various light conditions. Sisley had attempted a similar series for the Gothic church of his home town of Moret. Pissarro, on the other hand, studied the effect of different times of day on the thronged boulevards of Paris. In Paris, modern life as he sought to chronicle it was easier to portray than elsewhere. Nevertheless, he made several journeys to Normandy, to Dieppe and Rouen, in order to paint street life from his hotel windows. Here, too, he produced cycles of paintings and sought to sublimate the harmony of a cityscape entirely in its colourity, creating a new, interactive tonality.

In this painting of Rouen, the bustling old marketplace seems to channel the crowd into the Rue de l'Epicerie which leads into the maze of streets in the historic heart of the town. The carefully considered composition draws the viewer's gaze far into the pictorial space. Numerous breaks and tiny details arrest the gaze, making it sweep anew over the façades. The towers of the cathedral seem to float above the picturesque roofs of the houses.

Nevertheless, for all the medieval romanticism of the scene, Pissarro makes it quite clear in a few laconic details, such as the advertising posters on a house wall, that modern life has taken firm hold in the town. The writer Octave Mirbeau had nothing but the very highest praise for this painting: "Here, life is invoked, the dream ascends, floating, and what seems so simple and so familiar to our eyes is transformed into an ideal image."

ALFRED SISLEY

1839-1899

This painting was executed at a time when the hard core of the Impressionist group - Monet, Sisley, Pissarro and Renoir – frequently painted together outdoors. It was a time when the main principles of their painting had already been determined by constant observation, experimentation and discussion. These artists often chose to portray the same motif, preferring to work outdoors in order to capture aspects of nature and landscape or characteristic features of particular seasons which had aroused their visual curiosity. It is a period when the works of Monet, Pissarro and Sisley bear a close stylistic resemblance, as they were produced according to the same principles. Cityscapes and landscapes were frequent themes during this period.

The Flood was a particularly fascinating natural phenomenon for Sisley; in his painting, he does not portray the tragic effects of the flood, nor the inconvenience it caused to those affected by it, as Emile Zola, his contemporary and close friend of the Impressionists was to do, so realistically and dramatically in his novel *L'inondation* ("The Flood"). Sisley has chosen to portray the moment when the clouds have begun to clear from a pale sky which casts its light onto the flooded banks and streets of Marly, shimmering bright and golden with the reflections of sunlight on the water.

A lapse of twenty years lies between these two paintings. We can see that Sisley's love of simple, rural motifs has not altered during this time. In his depiction of this view of a small town near Paris, his brushwork seems to have changed little, though it has perhaps become a little finer. Throughout his life, Sisley preferred to live in the country, where he could lead a simple and modest life. The famous and often lyrically evoked light of the Ile-de-France, the light of changing days and seasons, the experience of natural elements, sky, clouds, water, snow - it was this that he sought to capture in his paintings. The landscapes themselves, the villages, bridges, streets and rivers, meant more to him than a mere occasion to set up his easel. Yet in his limited choice of motifs - Sisley seldom painted interiors, portraits or still lifes - he created an œuvre that faithfully documents France's rural charms. There are no factories here, no city sounds, but no labouring peasants either. What comes across most strongly is the tranquility of the landscape.

A skilfully structured composition draws the gaze along the bridge and into the picture. The scattered figures and the horse and cart are mere staffage. Our gaze is drawn directly into the centre of the picture, where the white walls of the mill break the line of flight of the bridge. Sisley intended to convey an impression of calm tranquillity in his balanced distribution of the groups of houses, the river and the trees, spanned by a mild, blue sky.

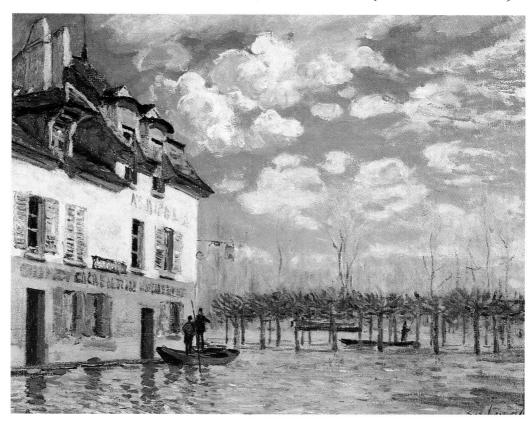

Alfred Sisley
The Bark during the Flood, Port Marly, 1876
Oil on canvas, 50.5 x 61 cm
Paris, Musée d'Orsay

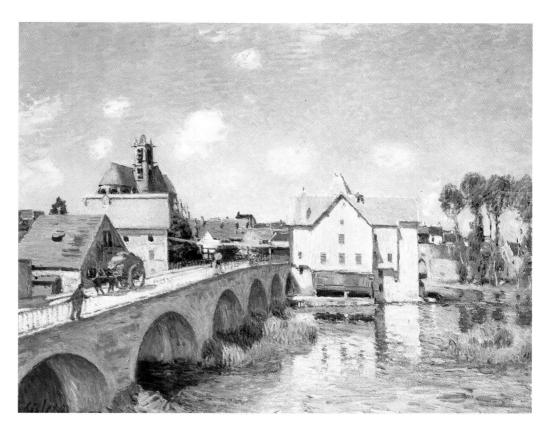

Alfred Sisley The Bridge of Moret, 1893 Oil on canvas, 73.5 x 92.5 cm Paris, Musée d'Orsay

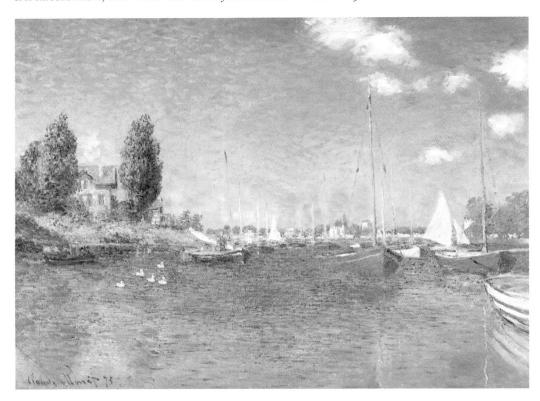

Claude Monet The Red Boats, Argenteuil, 1875 Oil on canvas, 60 x 81 cm Cambridge (MA), Fogg Art Museum, Harvard University

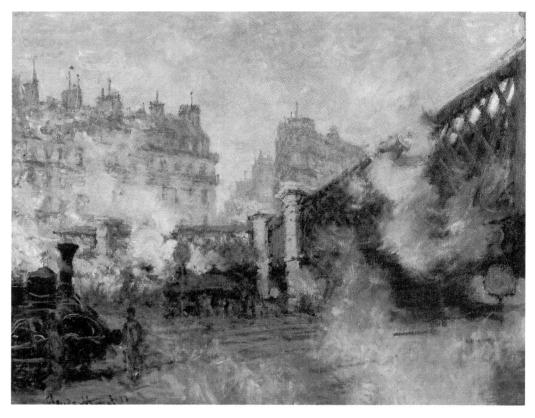

Claude Monet Le Pont de l'Europe, Gare Saint-Lazare, 1877 Oil on canvas, 64 x 81 cm Paris, Musée Marmottan

CLAUDE MONET

1840-1926

Monet's painting of The Red Boats, Argenteuil indicates that he has already, by this time, reached the point of concentrating entirely on the principles of free Impressionistic painting. He explores the luminosity, radiance and shimmering light in its interaction with matter. He is not interested in the structure of matter or its characteristics, but in surface appearances and the way they change under the effect of light. Monet's light is gentle and mild. He explores the finest nuances of shimmering objects. Water, sky, smoke, clouds, boats, houses and trees merge here to evoke a summer idyll that exudes an air of calm and invigorating freshness. Monet dedicated his œuvre to capturing fleeting moments of appearance, which he himself described as "impressions".

Monet never ceased to be fascinated by the way in which one and the same object, one and the same place, could change under differing light conditions, and he never tired of observing and portraying his motifs in different conditions. Haystacks, poplars, his beloved waterlilies, the façade of the cathedral of Rouen and the Gare Saint-Lazare in Paris are just a few such motifs. Monet may well have adopted the idea of creating cycles of paintings from the world of Japanese art, which he collected, and which was a rich source of inspiration to him. The steam of a locomotive, otherwise regarded as a nuisance, is transformed here by Monet's brush into a beautiful bearer of light. It blends with the pale light of the sky and lies like a shimmering silken veil over the railway tracks and the façades of the houses. At the Impressionist exhibition of 1877, Monet showed seven variations on this theme

Monet's Women in the Garden was created at a time when he had already turned his back entirely on academic painting and was well on the way towards Impressionistic painting. Light, which was to become the focus of his œuvre, already plays an important role in this painting. The group of women in summerdresses, enjoying the delights of a flower garden, is portrayed by the artist as though glimpsed by some chance observer of whom they are unaware. Light, shadow and halfshadow create magical reflexes on their hair, their skin, their sumptuous, light dresses, on the blossoms and leaves, and on the path. None of the women is shown here as in a portrait; instead, Monet has captured the atmosphere of a happy summer day. This large canvas was painted in the studio, and apparently posed a considerable challenge to the artist. One of his models was his wife. The relatively dark palette, so typical of his early works, still bears some of the hallmarks of classical inspiration and the masters of the school of Barbizon.

> Claude Monet Women in the Garden, 1867 Oil on canvas, 256 x 208 cm Paris, Musée d'Orsay

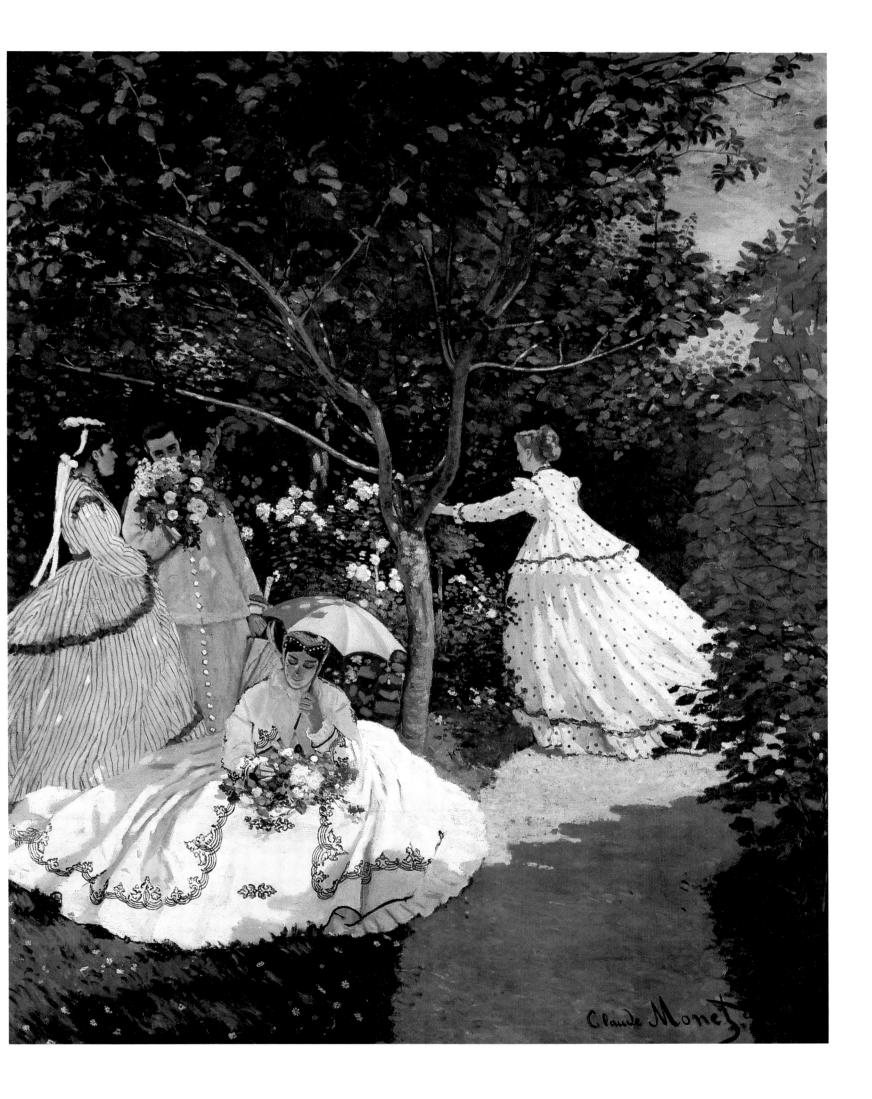

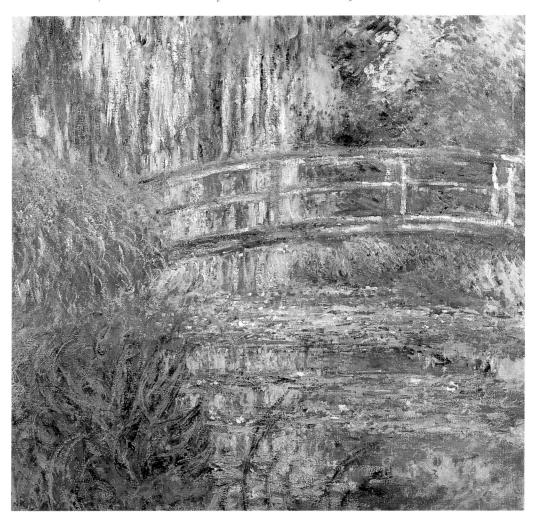

Claude Monet The Waterlily Pond, 1900 Oil on canvas, 90 x 92 cm Boston (MA), Museum of Fine Arts

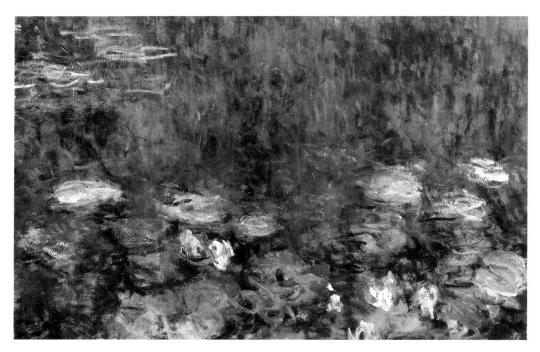

Claude Monet Waterlilies (Green Reflections), c. 1916–1921 Hall I, detail of the east wall Oil on canvas, 200 x 850 cm Paris, Musée de l'Orangerie des Tuileries

CLAUDE MONET

1840-1926

Monet had lived with his large family in Giverny since 1883. There, he dedicated himself daily to creating the fairy-tale garden which Marcel Proust once said was as dear to him as a favourite wife to a king. He had plants sent to him from all over the world, and liked to spend his time by the waterlily ponds. The waterlilies themselves, which he affectionately called *Nénuphars* were a constant source of pleasure to him.

He chose his motifs with an inner tranquillity reminiscent of oriental contemplation, from which he drew his visual sensitivity and acute awareness of the finest nuances of almost imperceptible changes. Nature, for him, was not red in tooth and claw, but a quiet, shimmering beauty, manifested in the landscape, flowers, trees, water, sky, clouds and snow.

Monet loved all that was plant-like, slow and languorous; he was captivated by the phenomena of the changing seasons and weather conditions, and he had the peace of mind to spend hours watching blossoms open and close, observing hoarfrost come and go, or the changing appearances and reflections of snow, rain and ice.

His meditative observation of objects and his meditative contemplation of colour blending with light, is fundamental to his art. This explains why all of Monet's paintings have an air of harmony, and why most of them are imbued with calm serenity.

Monet painted the Japanese bridge in his garden many times, with the waterlilies below it, the reed-covered banks, the exotic bushes and trees, all in the shade of magnificent weeping willows. The bright summer light bathes the scene in dancing reflections.

Nymphéas, shimmering waterlilies on shimmering water: this is the key theme of his later work. Monet's attitude towards his waterlilies became almost religious in the last years of his life. In 1916, he had a particularly large and airy studio built for him and began work on nineteen monumental canvases of waterlilies, to which he dedicated several years, finally bequeathing them to the French state in 1922 through the mediation of his friend Clemenceau. Since 1927, they have been on permanent display in the Musée de l'Orangerie, where they are a deeply moving source of pleasure to visitors. They completely fill the walls of two large halls, giving the visitor the impression of standing on an island surrounded by waterlily

Moner's waterlily paintings in the monumental *Nymphéas* cycle culminate in a virtual dissolution of naturalistic form. They are a hymn to colour and light. Nevertheless, for Monet, they do not represent a step towards total abstraction, for they are not intended as something abstract, but as something spiritual, requiring neither firm contour nor strictly delineated form.

HENRI FANTIN-LATOUR

1836-1904

Fantin-Latour, whose superb still lifes are a highlight in many museums and collections, is frequently mentioned in the same breath as his contemporaries and friends, the Impressionists. At the Musée d'Orsay, the museum of Impressionism in Paris, he is represented by a number of group portraits showing the French avant-garde intellegentia of the day and a few still lifes. Nevertheless, he never was a true Impressionist. He spent many hours in the Louvre, where he studied and copied the old masters, and his work bears eloquent witness to this training, without forgoing its distinc-

Fantin-Latour's still lifes echo the classical sublimity and dignity of the great French, Italian and Spanish artists who influenced him. The structure of his Nature morte dite aux fiangailles could well have been inspired by Zurbarán. A few objects are arranged on a table against a pale background of a single colour. A white china dish of ripe strawberries, with pale red cherries and a single strawberry in the foreground, next to it a blue and white china vase with a magnificent bouquet, to the right of that a white camelia with shining green leaves and behind it a glass of red wine. The painting has an air of cool dignity and sublime aesthetic elegance.

Henri Fantin-Latour Still Life ("Aux Fiançailles"), 1869 Oil on canvas, 32 x 29.5 cm Grenoble, Musée de Peinture et de Sculpture

BERTHE MORISOT

1841-1895

Like Mary Cassatt, Berthe Morisot was one of the few women artists who were active members of the Impressionist circle. She had undergone a long and comprehensive training and her works subtly indicate the influence of Corot, Jongkind, later of Manet and Renoir. Although she often exhibited with the Impressionists, she did not play as important a role within the group as Monet, Renoir or Pissarro, for she was not actually instrumental in furthering the movement. Nevertheless, her works were highly esteemed and, in spite of her assimilation of Impressionistic principles, they have their own highly distinctive style. She sat as a model for Manet on several occasions, and is one of the figures in his painting The Balcony (ill. p. 493). In 1874, she married Manet's brother Eugène.

This intimate interior showing a young woman in déshabillé, sitting at a table and powdering her face at a tilted mirror, unites all the typical features of Morisot's painting. Her own outward appearance is said to have been distinctly feminine, graceful and gentle, and her works also have something of these qualities. Delicate, contrasting tones are used to depict this young woman in her boudoir, and light is used to model the scene gently. Morisot's strength lay in her ability to present her models as contemplative without falling into the trap of banality or sentimentality.

Berthe Morisot Young Woman Powdering Herself, 1877 Oil on canvas, 46 x 38 cm Paris, Musée d'Orsay

Pierre-Auguste Renoir The Painter Sisley and his Wife, 1868 Oil on canvas, 105 x 70cm Cologne, Wallraf-Richartz-Museum

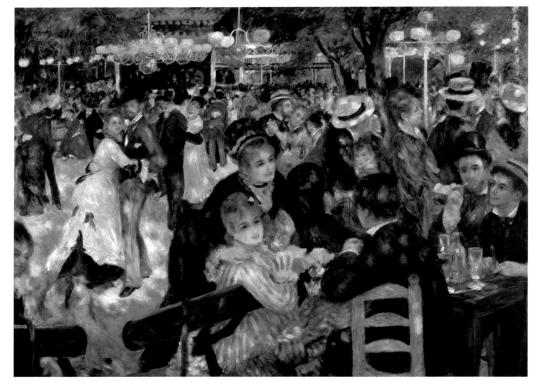

Pierre-Auguste Renoir Bal au Moulin de la Galette, 1876 Oil on canvas, 131 x 175 cm Paris, Musée d'Orsav

PIERRE-AUGUSTE RENOIR

1841-1919

There is a the continuity in Renoir's œuvre in which we can recognize not only his strongly distinctive personal style, but also his eagerly experimental exploration of a wide variety of compositional approaches. In fact, he actually started out as a painter of porcelain and the brilliant radiance and luminosity of his colours certainly reflect that early training.

The Painter Sisley and his Wife is an early work dating from a period when he and his friends were beginning to move towards an impressionistic style. The overall structure of the composition with its large-scale figures is still very much in the traditional mode, with the devoted couple expressing their bond in a rather awkward gesture of affection, portrayed in considerable detail and faithful portraiture. The background, however – a garden or park bathed in light - is already distinctly Impressionistic. The choice of motif - scenes and figures from his own immediate environment also indicates that, even at this early stage, he was already on the way towards pure Impressionism.

Renoir himself liked to frequent the taverns and nightclubs of Montmartre, and he was a frequent guest at the Moulin de la Galette, which had a large garden for dining, drinking and dancing in summer. It was an unpretentions and popular place, rarely visited by society ladies.

Renoir observed the predominantly young clientele of the Moulin de la Galette as they enjoyed their Sunday leisure, dancing, drinking, seeing and being seen, chatting and relaxing. In the foreground, seated at a table, is the writer and critic George Rivière, a friend of the artist and a major supporter of the Impressionists.

La Première Sortie gives what appears to be a chance glimpse into a box at the opera, where two pretty young women are sitting, looking down onto another theatre-box below them.

The main figure is seen in profile, with her face turned slightly away from the painter, who has captured the charming contrast of her youthful fresh pale complexion, her reddish hair, her dark dress and the light blue and mauve of her hat and lace at a moment when she is looking down into the lively audience in the other theatre-boxes. Large colour planes and contours dissolve in a vibrant shimmer of light and colour. The atmosphere of intimacy in the foreground theatre-box and the teeming vitality of the opera audience who are not there simply for the pleasure of culture alone, has been wonderfully captured in this painting.

Pierre-Auguste Renoir La Première Sortie (The First Outing), c. 1876/77 Oil on canvas, 65 x 49.5 cm London, Tate Gallery

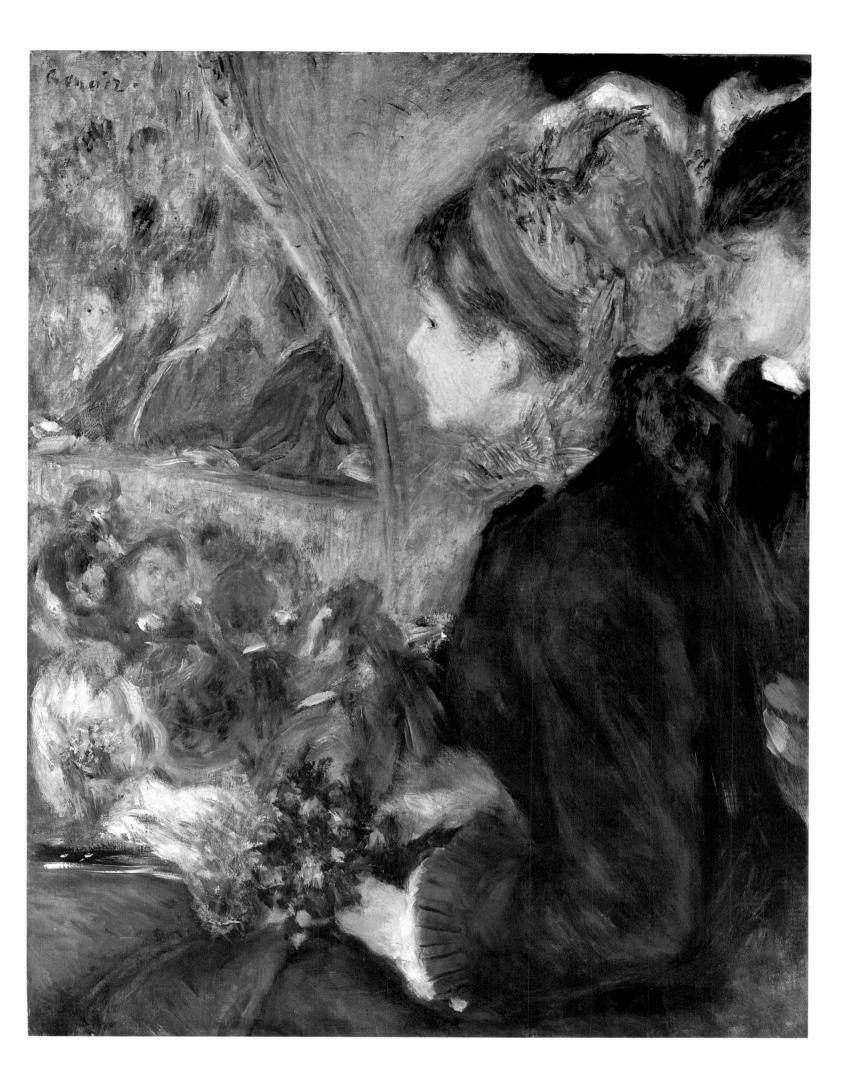

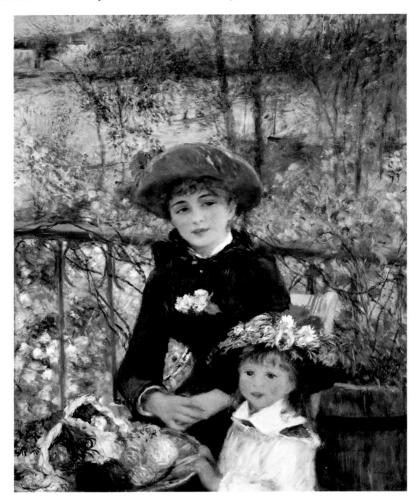

Pierre-Auguste Renoir On the Terrace, 1881 Oil on canvas, 100 x 80cm Chicago (IL), The Art Institute of Chicago

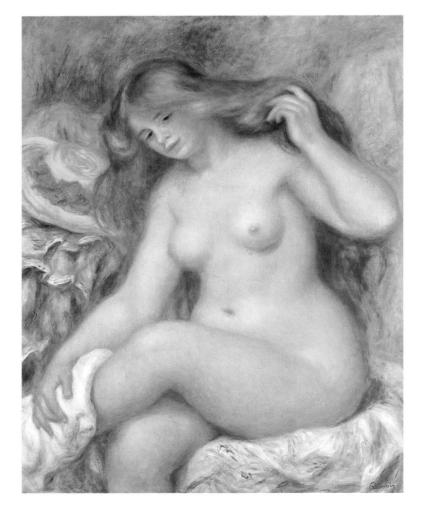

Pierre-Auguste Renoir Bather with Long Blonde Hair, 1895 Oil on canvas, 92.7 x 74.3 cm Vienna, Kunsthistorisches Museum

PIERRE-AUGUSTE RENOIR

1841-1919

Although Renoir's œuvre went through a number of different stylistic phases, it always remained true to the modern direction, as an art based on visual experience in which the artist himself selected the motifs and their pictorial organization on the basis of his own aesthetic criteria. Renoir never wanted anything ugly in his paintings, nor any dramatic action. He found his inspiration in his immediate environment, in nature and landscape. Landscape interested him only when it was enlivened by the vitality of spring and summer, perhaps by the colours of autumn. Unlike his Impressionist friends, he never painted snow, hoarfrost or ice, all of which he considered ugly. This lends all his paintings an atmosphere of peace, tranquility, relaxed serenity and charming beauty echoed in the combination of colours, nuances and dissonances.

Renoir's entire œuvre is dominated by the depiction of people. He found his models in the studios of the artists, amongst his friends, in the environs of Montmartre where he lived for many years and in the high society he studied and scrutinized and which inspired him to his aesthetic compositions.

In the painting, On the Terrace, in front of a wrought iron railing, we see a young woman in a dark blue dress, with her little daughter dressed in white beside her. The woman is wearing a red hat with a bouquet of poppies and a posy on her chest, while the little girl's straw hat is garnished liberally with blossoms. The woman's hands are calmly folded on her lap, and she is smiling amiably, apparently enjoying the calm of a fine day in the country. The intensive colours of this peaceful group in the foreground are echoed in the basket of brightly coloured skeins of wool and in the green pot of plants. Looking into the background, we see an overgrown area of bushes and trees in blossom, and a riverbank bounding the bright band of glittering water. Sky, houses, water and trees are all painted in delicate colours which lend the scene a radiant aura.

Bathers gave Renoir an opportunity of exploring variations on the theme of the female nude, a motif to which he returned time and time again. This Bather with Long Blonde Hair is seated on a light-coloured cloth, her legs crossed, displaying the charms of her ample young body, the freshness of her pale complexion and the healthy blush of her lips and cheeks, and the beguiling mane of reddishblond hair that flows down to her hips. This unapologetic homage to beauty underlines once again one of Renoir's primary working principles: only to paint what seemed to him serene, beautiful and appealing.

FRÉDÉRIC BAZILLE

1841-1870

It is a hot summer day. Some young men are taking a refreshing dip in the cool blue water of a pond, others are relaxing in the shade of a tree. Some are undressed or in the process of undressing, most of them are wearing bathing trunks. Two young men are wrestling on the meadow. The lush green grass with a few shady trees, a gently rolling landscape in the background and the hint of a village, under a radiant blue sky in which white summer clouds drift along, provides the setting for this calm and carefree scene.

Bazille has drawn the motif from his own environment in his own day, and what he has recorded in his painting is very probably based on personal experience. The handling of light and shadow already indicates the move towards Impressionist techniques, while the figures of the young men, their various actions and postures suggest a precise study of motion and the intention of incorporating this into the composition, are features more reminiscent of realism. The handling of colour is also early Impressionist. The organization of the theme a comparatively trivial motif for the prevailing taste of the time – is a far cry from the ideals of Salon painting.

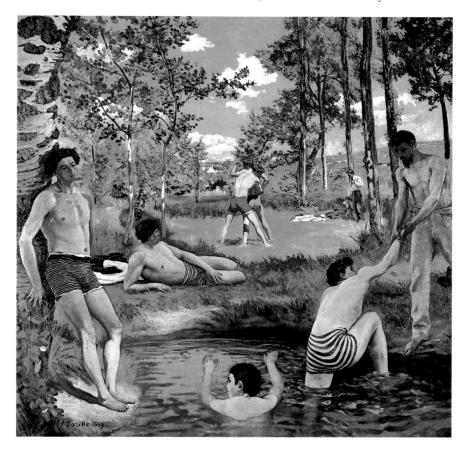

Frédéric Bazille Bathers, 1869 Oil on canvas, 158 x 159cm Cambridge (MA), Fogg Art Museum, Harvard University

GUSTAVE CAILLEBOTTE

1848-1894

Although the Impressionists were his friends and although he exhibited with their group, Caillebotte did not adopt their principles and techniques lock, stock and barrel, preferring instead to retain his own distinctive style. In this large canvas of a Paris street scene, Caillebotte's intentions are quite evident.

The artist has captured a chance moment, an everyday motif, with neither pose nor artificial sublimity. In this respect, his painting is very much in the spirit of Impressionism. He draws the viewer into a typical street scene, showing the spacious and – at the time this painting was executed - extremely modern architecture and urban planning of Baron Haussmann. At the time, the cobbled streets were still the preserve of horse-drawn carriages and pedestrians. Nevertheless, the painting is strictly organized in a carefully conceived structure of horizontal and vertical zones. The foreground has extraordinary clarity and smoothness, with painstaking attention to detail. The figures walking with umbrellas are painted with the precision of portraiture and every object in the foreground is meticulously rendered with sharply delineated contours. Towards the background, however, the painter has adopted more impressionistic means, introducing slight unclarities.

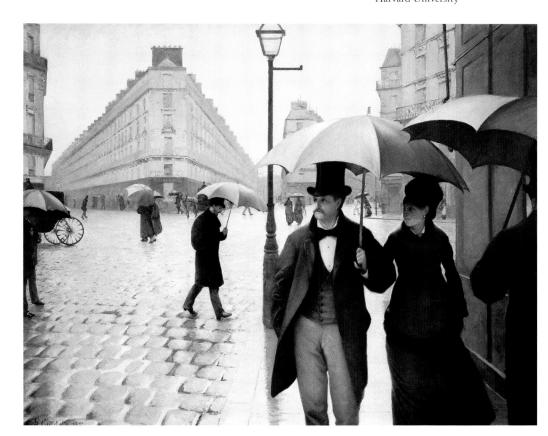

Gustave Caillebotte Paris Street: A Rainy Day, 1877 Oil on canvas, 209 x 300 cm Chicago (IL), The Art Institute of Chicago

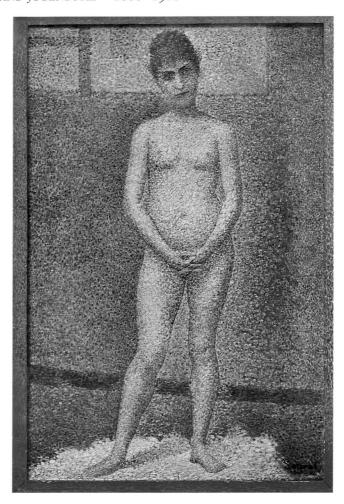

Georges Seurat Model, Front View, 1887 (study for "The Models") Oil on panel, 26 x 17 cm Paris, Musée d'Orsay

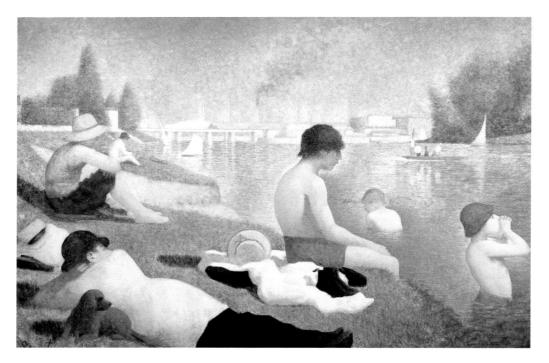

Georges Seurat Bathers at Asnières, c. 1883/84 Oil on canvas, 201 x 301.5 cm London, National Gallery

GEORGES SEURAT

1859-1891

Seurat based his painting firmly on theory, believing that Impressionism had exhausted its possibilities and required a complete renewal. He studied not only the writings of painters and art philosophers, but also the theories of chemists and physicists: Charles Blanc, Eugène Delacroix, Eugène Chevreul, Ogden Rood, David Sutter. For his own theoretical treatises, he adopted entire passages from the books that had influenced him.

Seurat was the main protagonist of Post-Impressionism, also known as Neo-Impressionism, as his works followed on from the paintings of the Impressionists. He gathered a group of artists around him who adopted his theories and worked in the manner he had developed.

The main foundations of his pictorial conception were the chemical and physical findings of colour studies and colour theories, which he sought to transpose to the field of painting without any regard for the fact that these were very different media indeed. Seurat's painterly ideal was to break down the colour plane and lines into dots of contrasting colours or complementary colours in close juxtaposition. This stylistic direction, which was also adopted by his friend Signac, was known as Divisionism, and the painterly technique of dots or points was known as Pointillism.

At a distance from the painting, the myriad dots are intended to add up in the eye of the observer. This theory does not quite work in practice, as Seurat's paintings invariably have a shimmering, dancing effect of oscillating dots of colour. On the basis of the theories posited by Humbert de Supervilles, he integrated his own guidelines of positive and negative effects of specific colours, of horizontal and vertical dominance, and of rising and falling lines. This manner of painting, in which technique clearly dominates the handling of colour, permits only specific results. Nothing is left to chance, to the spontaneous artistic idea, to experimentation or imperfection.

In terms of colour handling, the possibilities are also restricted; there are no gentle transitions and no sharp contrasts, no drastic emphasis or de-emphasis, no voids, and no precisely detailed portrayals.

It is for this reason that Bathers at Asnières does not have the light-hearted atmosphere of a hot summer day that has drawn people to the riverside. The divisionistic method has robbed the figures of their individuality, just as it has in the nude female study for The Models.

The atmosphere and appeal that gives the Impressionist paintings their charm are incalculable, for they have their roots in creativity itself, and Seurat has failed to take into account the profound significance of this. Occasionally, Seurat actually broke his own rules and painted in an unorthodox manner.

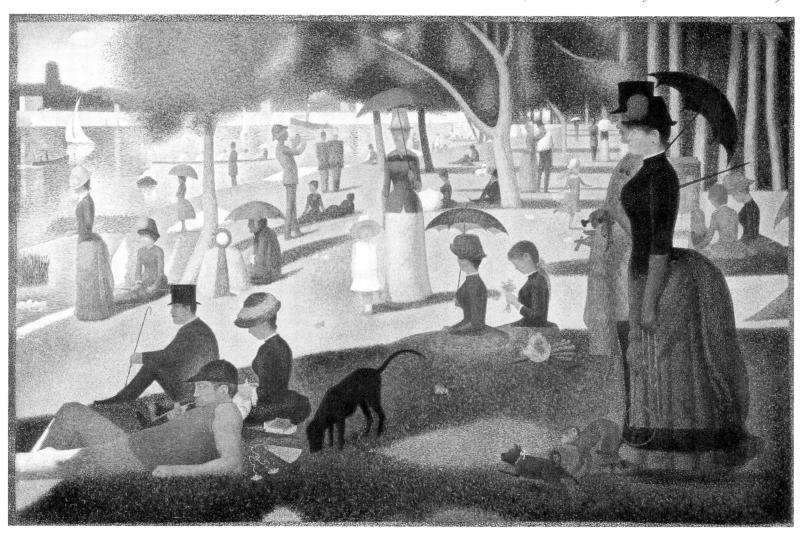

Seurat worked on this painting for more than two years. When he presented it to the public for the first time at the eighth and last Impressionist exhibition in May 1886, he was immediately hailed as the most important painter in a new generation of artists. The painting was like the statement of a manifesto and this, together with its huge format, made it the hotly debated centrepiece of the exhibition.

The painstaking preparation involving no less than sixty-two sketches in oils which he then put together in his studio in a precisely calculated composition, corresponds to the extremely precise and detailed application of the tiny dots of paint. Depending on the object to be portrayed, the paint is applied in a variety of ways: the dabs of paint are superimposed crosswise to achieve the green of the grass, while they are applied in horizontal layers for the water. The colours are reduced more or less to the basic tones. Nuances are created by varying the distance between the dabs of colour: lilac, for example, is created by juxtaposing red and blue. The lines in the painting are also created by delineating colour areas or by creating contrasts.

All the forms have been reduced to simple, stereometric bodies distinctly separated from their respective surroundings. In his schematic handling of form, Seurat may be regarded as a forerunner of cubism.

In painting a summer day in a park full of people, Seurat chose a topic that had also been popular amongst the first generation of Impressionists. He showed the bourgeoisie of Paris on a weekend excursion to an island in the Seine between Neuilly and Courbevoie, to the west of the Bois de Boulogne, where there were restaurants, cafés and dance-halls and meadows, and where it was possible to hire boats or go fishing. At first glance, it appears as though Seurat has captured a fleeting moment of an ordinary day, in the manner or Renoir. Yet the careful positioning of the forty or so figures, void of all individuality and strangely rigid in their distribution throughout the pictorial structure, indicates the highly structured and theoretical character of this painting. The everyday world has been integrated into an almost classical framework of verticals and horizontals, which give the picture its stability. The Pointillist technique has been extended through to the frame, so that even the painting itself is distinctly separated from its surroundings.

Seurat lived only five more years after exhibiting the *Grande Jatte*. An attack of diphtheria forced him to give up *plein-air* painting. He withdrew to his studio and painted exclusively interior scenes, such as *The Models*, which he used as a vehicle for portraying the work of the artist with his models. Other motifs included music-halls and circus scenes.

Georges Seurat Sunday Afternoon on the Island of La Grande Jatte, 1884–1886 Oil on canvas, 206.4 x 305.4 cm Chicago (IL), The Art Institute of Chicago

Paul Signac Two Milliners, Rue du Caire, c. 1885/86 Oil on canvas, 111.8 x 89cm Zurich, Stiftung Sammlung E.G. Bührle

Paul Signac The Port of Saint-Tropez, 1907 Oil on canvas, 131 x 161.5 cm Essen, Museum Folkwang

PAUL SIGNAC

1863-1935

The early work of Paul Signac was strongly influenced by Monet and Sisley, and it was his friendship with both these painters that led him to develop his first Impressionistic phase. A wealthy man with no financial cares, he painted incessantly and was personally committed to the advancement of contemporary avant-garde art. Through his friendship with Caillebotte, he became an enthusiastic yachtsman. In June 1884, he met Seurat and, under the influence of this new artistic friendship, he increasingly integrated structural compositions into his paintings. From around 1885, he identified so strongly with the ideas propagated by Seurat that he also began painting in a strictly Divisionistic style and creating purely Pointillist paintings.

The Milliners shows how well Divisionist theories can be applied to the portrayal of interior scenes. Here, Signac has endeavoured to overcome a number of compositional problems at the same time. The milliner who is bending down to pick up the fallen scissors is presented in extreme foreshortening – a device intended to add depth to the pictorial space. This is contrasted by the flatness of the still life featuring a hatbox, rolls of felt and fabric in the lower right-hand corner. The even application of short brushstrokes for the tablecloth and wallpaper is interrupted in the portrayal of the rounded forms, such as the back of the woman bending down and the hatbox. This device facilitates the portrayal of corporeal volumes. The scene itself is familiar from a number of Impressionist paintings. However, in contrast to, say, one of Degas' women ironing, the atmosphere of a fleeting moment captured on the canvas is secondary to the controlled handling of colours and forms. In spite of the technical similarities, Signac's palette has always been more generous and fresh than the increasingly gloomy and rigid colorism of Seurat.

Signac's book D'Eugène Delacroix aux néo-impressionnistes published in 1889, in which he presents the history of the Pointillist movement and the scientific foundations of his theories, is an important document of Pointillist theory. Signac shared libertarian and even anarchist convictions with his friends Félix Fénéon and Maximilien Luce, which placed him in constant opposition to bourgeois conventions. After Seurat's death, Signac decided to continue his school and keep alive his artistic memory.

In 1892, he discovered the picturesque port of Saint-Tropez, which he portrays here, as in many other paintings, using the Pointillist technique so characteristic of his work. From this point in time onwards, he stopped composing his paintings directly from the motif, but merely took notes instead and thus liberated himself gradually from the self-imposed doctrines of strict theory. His style became more relaxed and free, and his compositions more picturesque.

PIERRE PUVIS DE CHAVANNES

1824-1898

Apart from his major mural cycles and the mordant caricatures published after his death, Puvis de Chavannes also created a large number of panel paintings with religious and allegorical themes. Together with Moreau and Redon, he belongs to the Symbolist movement, whose aim it was to lend expression to the realms of the imagination, fantasy and magic. The motif of *The Poor Fisherman* is one he treated several times, the best known version being this one, which hangs in the Musée d'Orsay.

On the banks of a quietly meandering stream, we see a humble little boat, in colours as grey and earthy as the stoney tongue of land bordering the brackish water. Only a few scattered shrubs grow on the land. A woman, presumably the fisherman's wife, is kneeling to pick flowers, and near her lies a small child asleep. The boat is reflected in the still waters of the river that stretches to the horizon, bounded by dark, flat land, and the sky in the background has the same melancholic, dull colours as the river. At the front of the boat, a net has been attached to a tilted mast and dipped into the river. Behind it, in humble attitude, his hands folded as if to pray, stands the bearded fisherman with his eyes closed.

Pierre Puvis de Chavannes The Poor Fisherman, 1881 Oil on canvas, 155 x 192.5 cm Paris, Musée d'Orsay

GUSTAVE MOREAU

1826-1898

André Breton said of the beguiling charms and corrupting decadence of Moreau's female figures that "This type of woman has probably concealed all others from me; it was complete enchantment. The myths rekindled here as nowhere else have had their effect. She is the woman, who almost without any external changes becomes, in turn, Salome, Helen, Delilah, Chimere or Semele, shaping herself into these different embodiments." In his motifs and in his painterly technique, Moreau consciously turned away from reality, lending form to dreams of morbid eroticism, mystically fascinating death and pathos-laden suffering.

The Apparition is placed in an architectural setting which might equally be a church, a temple or a palace. The background remains unclear, like a relief carved in sonorous, russet tones with a paucity of light reflexes, almost swallowing up the outlines of the sketchy figures in their rigid poses.

Only the apparition itself has a sculptural presence: the bloody, decapitated head of John the Baptist, eyes wide open and staring at Salome, surrounded by gleaming rays of light, and Salome herself, her nudity veiled in a diaphanous robe, dripping with gold and jewels. Her arm and her gaze are directed imperiously towards the victim whose death she has caused.

Gustave Moreau The Apparition (Salome), c. 1875 Oil on canvas, 142 x 102 cm Paris, Musée Gustave Moreau

FRANCE

Paul Cézanne The Card-Players, c. 1885-1890 Oil on canvas, 47.5 x 57 cm Paris, Musée d'Orsay

PAUL CÉZANNE

1839-1906

Cézanne defied the wishes of his father, a banker, in order to become an artist. The role of misunderstood outsider, however, was to remain with him all his life, even as an artist. His difficult, uncompromising character and his self-doubts, nurtured by the high standards he set for himself and the quality of his art, frequently drove him into isolation and spawned works which, from today's point-ofview, make him the father of modern art.

His interest focused, often for years at a time, on a few key themes which he frequently repeated. It was not unusual for him to rework his paintings over lengthy periods. Cézanne regarded the work on each new version as an attempt to gain new and progressive aspects from his painting. The Card-Players presents a topic he was to treat no less than five times in the course of the 1890s.

Throughout his long friendship with Pissarro, he had explored the possibilities of pleinair painting and Impressionism. Pissarro proved a sympathetic mentor and sought only to encourage Cézanne, whose artistic prowess he had fully recognizad. Cézanne benefited from their collaboration. He adopted a new, lighter approach to colour and a stronger brushstroke and developed a lasting love of plein-air painting and landscape.

Two simple peasants, slightly awkward, are seated opposite each other, completely immersed in their game of cards. A bottle of wine on which the light is reflected forms the central axis. This structure gives the composition an almost geometric stringency and order, as well as a timeless atmosphere. Although the subject matter itself is Impressionistic, the painting has a density, strength and gravity that goes well beyond the Impressionist aesthetic.

510 FRANCE Cézanne had abandoned conventional ways of seeing and the spatial organization of central perspective in his paintings. Instead, he created a non-illusionistic pictorial space in which a new planar dimension is won by means of colour and its modulation.

He liked to work on still lifes, arranging the objects at will in positions permitting detailed studies. It was on this basis that he developed his distinctive means of expression. He preferred using apples and oranges in his still lifes for the very simple reason that they did not perish quickly, as he often spent a considerable time working on each painting.

In his Still Life with Apples and Oranges specific objects (in this case dishes, fruit and a jug) are juxtaposed in a picture plane with hardly any depth. The vibrant colour contrasts and graduations give the painting a deceptive hint of a naturalistic portrayal. Almost ironically, this impression is offset by the considerable abstraction of the pictorial space achieved by deliberately displacing the planes and fields of colour in a way that densifies the composition, creating a sense of reality all its own.

Cézanne's creative endeavours invariably involved certain self-imposed tasks and creative challenges that dominated his motifs. He produced a series of portraits, including self-portraits and figural compositions of models. For each of these paintings, a great number of sittings were required. The physiognomical similarity, however, played only a secondary role.

In his own invariably highly critical self-reflections, the painter noted that he had not achieved as much in portraiture as he had in other genres. Today, we might be tempted to regard this as an unjustified sense of inferiority or insecurity. In fact, the identity of the people he painted at close quarters is not the main problem. Cézanne's portraits are not character studies. In fact, he uses them, as he uses all his objects, to explore the rules of painting he has established for himself.

Woman with Coffee Pot is an example of Cézanne's pictorial reality and the new concept of space gained in the previous years. He admired Courbet as a realist and also considered himself a realist. Nevertheless, he did not seek to give a photographic rendering of the essential features and characteristics of his models or motifs (he saw each of his motifs as something imbued with a constantly changing vitality) but sought instead to construct truth creatively by his own means. The quiet strength of this woman and her simple, stylized physiognomy characterize the kind of person for whom time is a static dimension as in The Card-Players. In her motionless pose, the woman is as much a part of a still life as the cup and the coffee pot on the table beside her.

Paul Cézanne Still Life with Apples and Oranges, c. 1895–1900 Oil on canvas, 74 x 93 cm Paris, Musée d'Orsay

Paul Cézanne Woman with Coffee Pot, c. 1890–1895 Oil on canvas, 130.5 x 96.5 cm Paris, Musée d'Orsay

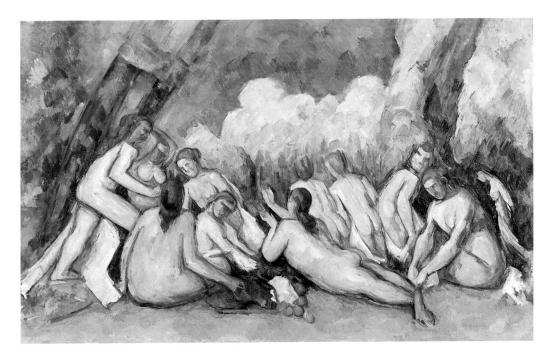

Paul Cézanne Les grandes baigneuses (Large Bathers), c. 1895-1904 Oil on canvas, 127.2 x 196.1 cm London, National Gallery

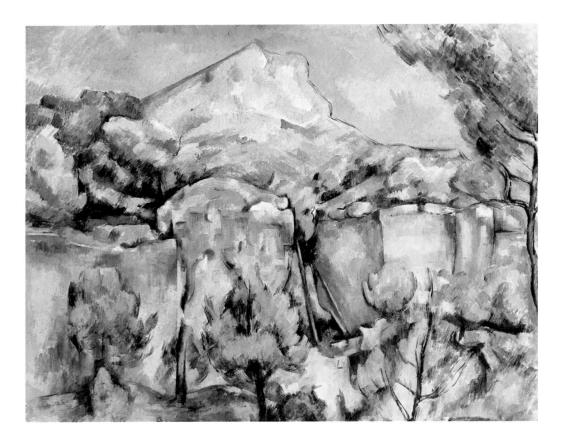

Paul Cézanne Mont Sainte-Victoire Seen from the Quarry at Bibémus, c. 1898-1906 Oil on canvas, 65 x 81 cm Baltimore (MD), The Baltimore Museum of Art

PAUL CÉZANNE

1839-1906

The motif of Bathers, in which figural compositions are merged with landscape was a concept that fascinated Cézanne right from the start of his artistic career. Many versions, some of them in large formats, were created over a lengthy period. One critic, having seen the Reclining Bathers (1875/76), dubbed the painter a radical. Although this was intended as an insult, it nevertheless contained an element of truth. With each new version of his bathers, Cézanne forged on in a direction that involved not only a radical break with the traditional possibilities of painterly presentation, but also meant turning his back on the prevailing ultramodern trends of the day, seeking to overcome them and create paintings of timeless value. In doing so, he paved the way for subsequent generations of painters. He deliberately structured his paintings so that they would not appeal superficially to the fleeting viewer, radically banning all decorative, anecdotal elements which might detract from the true

The nude female bodies of the Large Bathers have not been included in the picture because of their female charms, as some almost sarcastic details would indicate. The group is reduced, both in body and posture, to elements too true to life to appear stylizad. This is already a step on the way towards abstraction. Cézanne handles space in much the same way, with depth playing no major role in the spatial organization. Abstractive and already abstract formations take over the function of specific landscape details, giving the painting enormous tension and density.

The Mont Sainte-Victoire is a central motif in Cézanne's œuvre and one that he painted repeatedly from a number of diffferent angles, analysing it artistically. The mountain, which dominates the Provencial landscape, was to be a recurrent motif in the œuvre of this artist, particularly in his later years, and one which allowed him to test and explore his own laws of painting.

Cézanne subjected each and every brushstroke to the merciless scrutiny of his analytical mind, seeking a unity of colour, composition, planarity and tectonics. He sought to underpin his experience and experiments theoretically. Although he painted only by observation, using models, and often in the open air, he sought neither to achieve a static rendering of what he had seen nor to capture a fleeting glimpse.

Everything we see disperses, disappears. Nature is always the same, yet nothing of its visible appearance remains. Our art must lend nature the sublimity of duration, with the elements and the appearance of all its changes. Art must make nature eternal in our imagination. What is behind nature? Nothing, perhaps. Or perhaps everything.'

ODILON REDON

1840-1916

Redon was, in his day, a completely isolated figure who stood like a stranger in his era, distantly linked at most to writers like Edgar Allan Poe or Charles Baudelaire. Born at the same time as the first generation of Impressionists, he did not share their artistic style. His art has no impressionistic approach. There is no dominance of colour or line, but a synthesis of both, for they exist side by side in his compositions.

After he had exhausted the possibilities of his lengthy Symbolistic phase, he began to devote his attention to floral paintings, watercolours and pastels. The change coincided with the advent of a new century, and followed a trip to Venice which deeply impressed Redon. The demons of his Symbolistic visions now began to make way for an air of serene tranquillity, as evidenced most clearly in the many variations of his floral still lifes.

In this flat composition, the spatial organization may only be understood in terms of visual experience. The decorative alignment of the vases and their contents, bouquets of flowers which cannot necessarily be identified, alongside easily recognizable types, dominate the composition. The three vases and their contents seem to emerge without location out of an incandescent surrounding to unfurl their many-coloured charms.

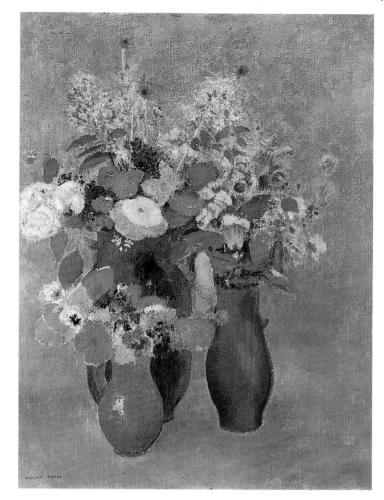

Odilon Redon Still Life (Flowers), c. 1910 Oil on canvas, 73 x 54 cm Wuppertal, Von der Heydt-Museum

HENRI ROUSSEAU

1844-1910

With no artistic training, and without respect for traditions or the painters who had gone before him, driven solely by his wish to paint only the works he imagined, Rousseau represents the type of artist who draws his inspiration entirely from the powers of his own lively imagination and individuality. He serenely ignores classical compositional structures. His lack of technical skill is offset by his disarming improvisation, creating images of elementary force that are nurtured by the unspoiled originality of his ideas. Rousseau's fascinating appeal lies in the immediacy with which he organizes his frequently heavy and cumbersome forms, his carefree symbolic language and the unspoiled freshness and luminosity of his colours.

His painting War was preceded by a lithograph already containing the main elements of the composition, which took on a colossal force of expression and density in the oil-painting. The galloping, black horse takes up almost the entire width of the painting, leaving the fallen beneath it. Black birds of death have lighted upon the dead and dying, drawing on their blood, as they lie on the charred black earth. The horse is the bearer of war with its flaming torch and sword, symbol of the ineluctable madness of war.

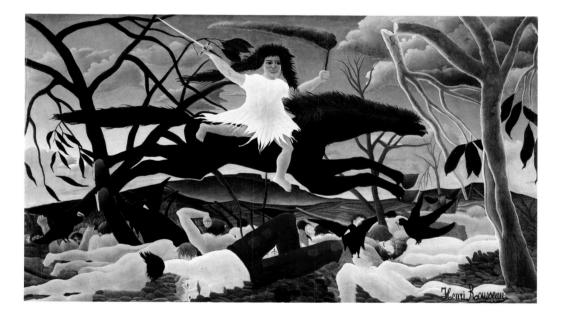

Henri Rousseau War, 1894 Oil on canvas, 114 x 195 cm Paris, Musée d'Orsay

FRANCE 513

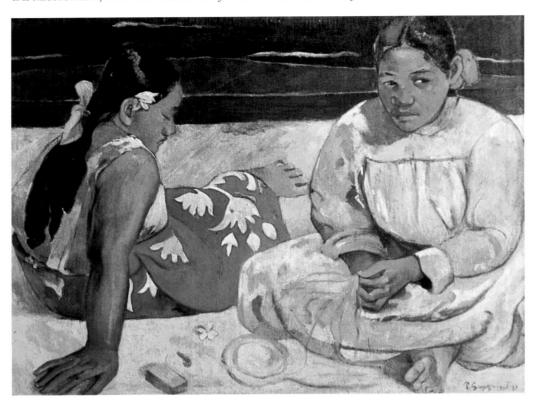

Paul Gauguin Tahitian Women (On the Beach), 1891 Oil on canvas, 69 x 91.5 cm Paris, Musée d'Orsay

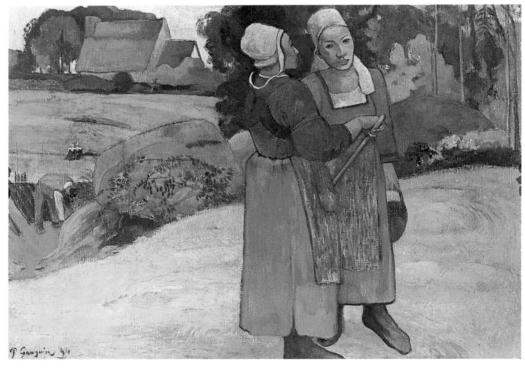

Paul Gauguin Breton Peasants, 1894 Oil on canvas, 66 x 92 cm Paris, Musée d'Orsay

PAUL GAUGUIN

1848-1903

Gauguin arrived in Tahiti in June 1891 and, after a brief stay in Papeete, withdrew to a secluded part of the island as yet unspoiled by civilization and colonialism. There, he lived amongst the natives, "far from those prisons of European houses," in a Maori hut which "never banishes people nor severs them from life, from space, from infinity." He painted daily, and worked on carved sculptures and reliefs, taking his motifs from the everyday life and spiritual world of the islanders to whom he now felt a closer bond than to his own origins.

In the strong Maori women, Gauguin discovered a beauty nurtured by other sources than that of European women. He admired their unspoiled naturalness, their strength, their pride, their dignity and the nonchalance with which they took it upon themselves to work hard or enjoy relaxing and doing nothing. He found the lifestyle of the islanders, their religion, their morality and their inextricable involvement in their rich, natural surroundings considerably more attractive and purer than life in Paris and he completely submerged himself in their world.

On his return from the South Seas in 1894, Gauguin visited Brittany once again to paint there. An exhibition of the paintings he had created on Tahiti was mounted at the Galerie Durand-Ruel. It was a total failure. Throughout his life, Gauguin would always be plagued by financial cares. Nevertheless, he worked on relentlessly, and his new paintings - like the Breton Peasants in their traditional costumes with the starched white caps - also reflect his Tahitian experience. The painting still bears certain elements of Cloisonnism - stark contours, bold, flat planes of colour - but it is dominated by the delicate magic of Gauguin's colours. The figures of the women are simplified and stylized in their postures, gestures and facial traits. The right half of the painting is bordered by large grey rocks flanking the pale path and by a copse in strangely delicate colours, while the left side of the painting shows a view onto green fields and a group of buildings.

The title of this painting is a symbolic translation of a situation in which reality merges with the realms of the imagination. Two native women, dressed only in loincloths, with blossoms in their hair, are sitting side by side – one of them in lotus position – surrounded by grey clouds, exotic flowers and sumptuous vegetation. Behind them, like a magician, or perhaps like someone spellbound, sits a man in a lilac robe, with fiery red hair, whose physiognomy is similar to that of the painter Meyer de Haan.

Paul Gauguin Contes barbares (Barbarian Tales), 1902 Oil on canvas, 131.5 x 90.5 cm Essen, Museum Folkwang

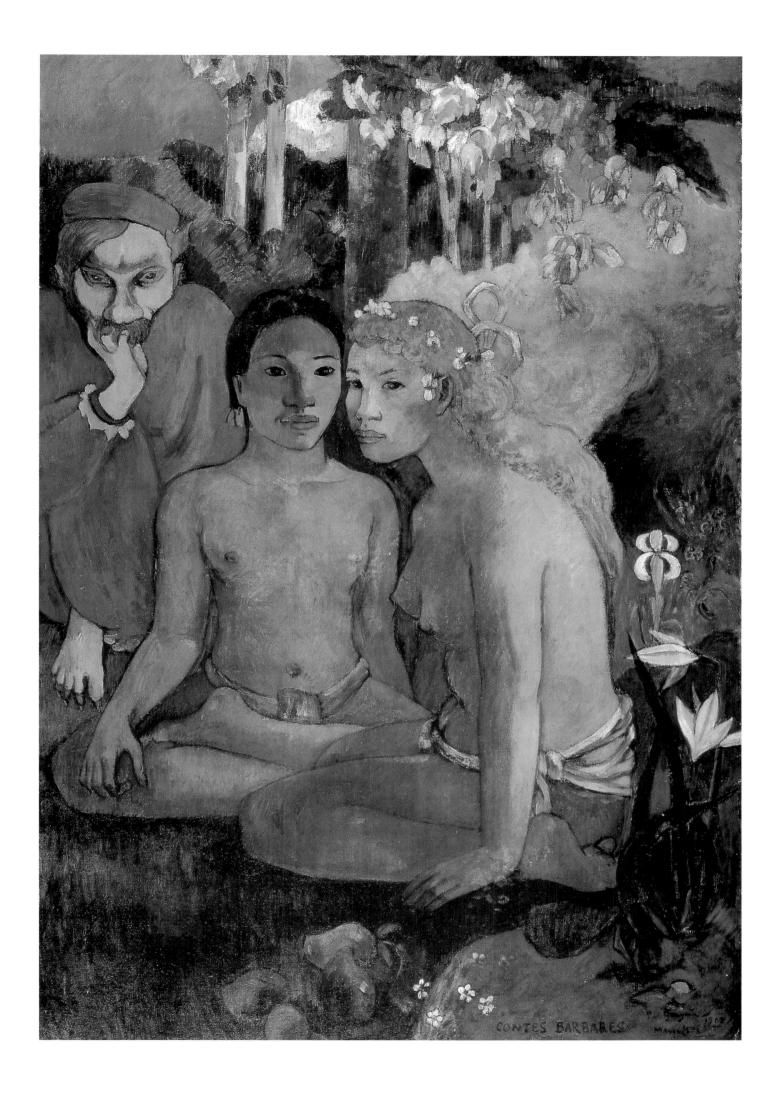

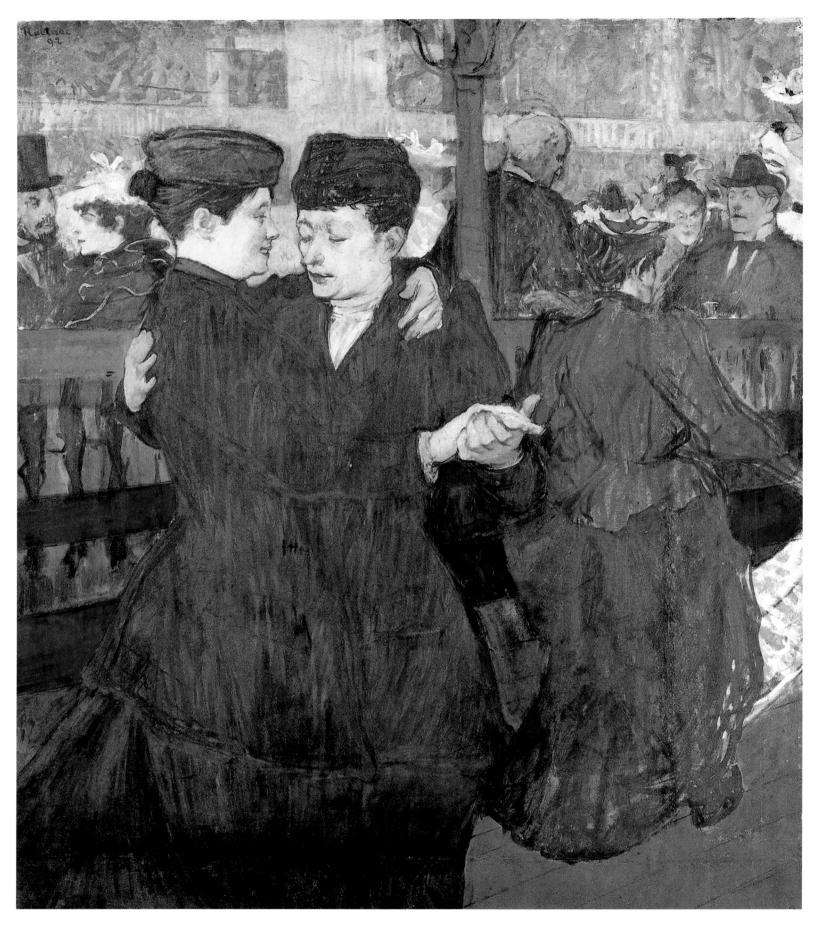

Henri de Toulouse-Lautrec Two Women Dancing at the Moulin Rouge, 1892 Oil on cardboard, 95 x 80cm Prague, Národni Galeri

HENRI DE TOULOUSE-LAUTREC

1864-1901

Toulouse-Lautrec spent much of his time exploring the haunts of Paris night-life with its twilight pleasures and it was here that he sought the inspiration and motifs for his work. He did not see this demi-monde through the eyes of his own social class, but through the eyes of a man for whom all barriers of class difference had long since fallen. He reports without the complacent superciliousness of one of higher social standing, but he also avoids the pitfall of sympathy and false sentimentality. With subtle empathy, he translates his observations into realistic images charged with atmosphere and creates character studies that give a lively insight into their respective situations. Colour in all its nuances and graduations is the main vehicle of expression for Toulouse-Lautrec.

The painting of two women dancing together shows a detail of the lively night-life at the famous Moulin Rouge in Montmartre, where Toulouse-Lautrec was a frequent guest and for which he created a series of magnificent posters. In the foreground we see the dancing women. Behind them is a railing that sections off a larger, crowded room where guests are seated at tables. The dancing women are dressed simply in plain dark dresses and hats. The woman on the right with the rather masculine traits often stood model for the artist for his Moulin Rouge paintings. The women are preoccupied with each other and their dance. They are part of the Moulin Rouge scene where bourgeois morality holds no sway, where high society and the proletariat merge, where simplicity and vice exist side by side.

Toulouse-Lautrec had a keen eye for such detail and a talent for portraying life as it was lived. For him, all are equal – the top-hatted dandy, the intellectual, the worker, the elegant cocotte and the servant girl. On the right in the painting, he has shown the painter Charles Conder, and on the left, François Ganzi. The woman in the red jacket is Jane Avril, the singer and dancer who became world-famous as a figure on Toulouse-Lautrec's paintings and posters.

The actor Henry Samary belonged to the ensemble of the Comédie-Française. Here, he is portrayed in full figure on the stage in the role of Raoul Vaubert in a popular comedy. He is in fashionable dress, with French jacket, lace cravat and collar and black patent leather shoes, his top hat in his hand, the very epitome of the Parisian dandy.

The clowness, Cha-V-Kao, an onomatopoeic name meaning something like "noise and chaos" (which was exactly what her performances at the circus and music-hall caused) frequently stood as model for the artist. Here she can be seen as a blowsy, ample figure, sitting on the sofa of her dressing room, wearing a funny white wig. The contrast of dominant colours, brilliant yellow, quiet lilac, red and turquoise, lends the scene a spontaneous vivacity.

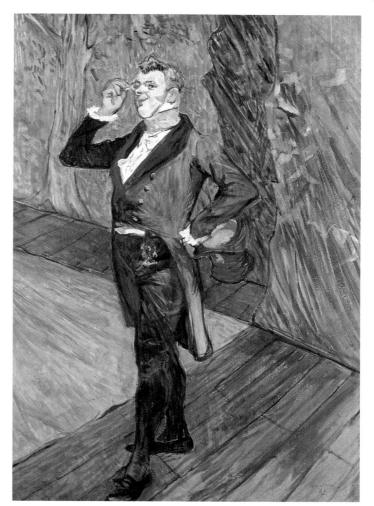

Henri de Toulouse-Lautrec Henry Samary, 1889 Oil on cardboard, 74.9 x 51.9 cm Paris, Musée d'Orsay

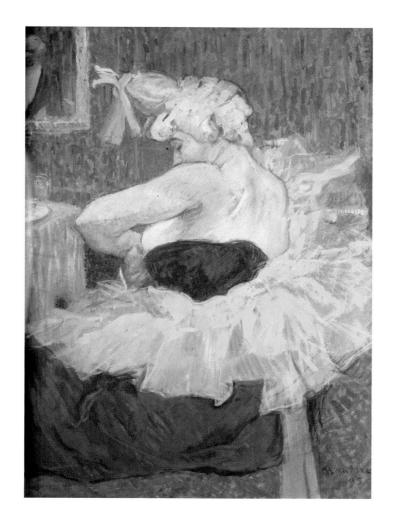

Henri de Toulouse-Lautrec The Clowness Cha-U-Kao, 1895 Oil on cardboard, 64 x 49 cm Paris, Musée d'Orsay

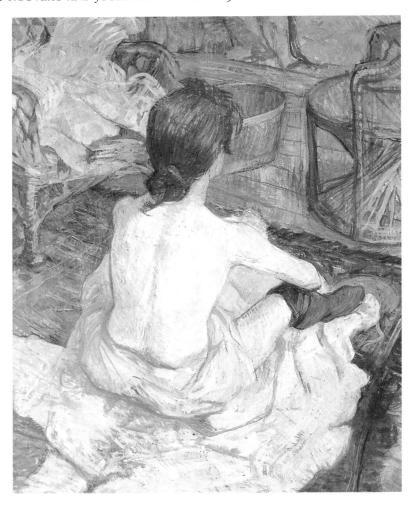

Henri de Toulouse-Lautrec The Toilette, 1896 Oil on cardboard, 67 x 54 cm Paris, Musée d'Orsay

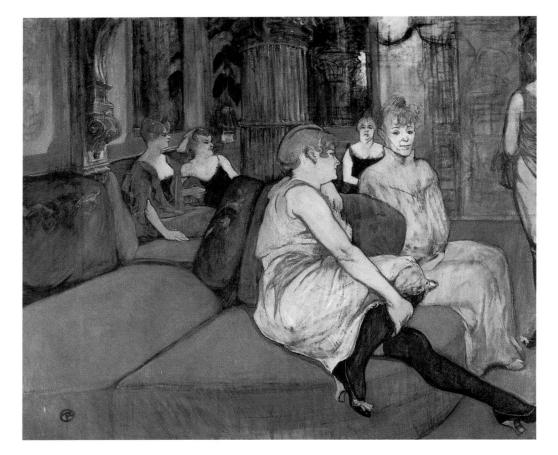

Henri de Toulouse-Lautrec Interior in the Rue des Moulins, c. 1894 Oil on canvas, 111.5 x 132.5 cm. Albi, Musée Toulouse-Lautrec

HENRI DE TOULOUSE-LAUTREC

1864-1901

The painting *The Toilette* is one of a number of female nudes by this artist. It shows a young woman sitting on the floor with her back to the viewer. Ignoring the rules of classical perspective, the artist conveys the room and setting from an elevated standpoint, with objects overlapping and juxtaposed to create the atmosphere.

The young woman with her red hair caught at the nape of her neck is sitting in a relaxed pose on a rug with a light garment wrapped around her hips, her right leg still stockinged. On the two wicker chairs in front of her are her crumpled clothes, and between them stands a bluish bathtub. The painter portrays his model as though looking over her shoulder just as she is taking a rest, without striking any pose.

Irrespective of whether Toulouse-Lautrec used oil-paints, pastels or the lithographic technique in which he was so consummately skilled, he invariably preferred a matt surface, which heightened the cool luminosity of his colours, his bold and unusual tonality and his forceful brushwork. Like so many of his pictures, this too has a touch of unfinished sketchiness.

This glimpse into the salon of a brothel in the Rue des Moulins is less sketchy. In the translucence of the clothing in which the lightly dressed women ply their wares, Toulouse-Lautrec had nevertheless used the possibilities of the incomplete to reveal their wan flesh. The tired faces of the women are portrayed with unflattering candour, but nevertheless with kindness and sympathy. The dusty pomp of the velvet furnishings exudes a tired and hackneyed charm. The wide sofa keeps the spectator at a distance, under the scrutinizing and almost pitying gaze of the elderly lady with the chignon, who is the madam of the establishment.

Toulouse-Lautrec would sometimes spend weeks in this brothel, sketching and painting the life of the prostitutes there. Because of his physical disability, he felt rejected by aristocratic and bourgeois society; sickness and disgust with life made him seek refuge amongst the exploited and the disdained. With his paintings of the demi-monde, he documented the hidden side of bourgeois civilization, which sought to indulge in vice only in specially secluded places and denigated physical love to the level of a business transaction. His paintings stand in stark contrast to the works of the academic and Symbolist painters who were his contemporaries, or to the illustrations of, for example, the novels of Huysmas, which barely conceal their voyeuristic attitude. Toulouse-Lautrec counters the hypocritical allegories of the day by casting an almost clinical eye on the life of the social outcasts with whom he identified.

518 FRANCE

EDOUARD VUILLARD

1868-1940

Vuillard has been described as an "intimist". This applies not so much to the way he portrays his figures, for he never actually violates the intimacy of his models in his paintings, but to his choice of motifs and models, which he invariably sought in the immediate surroundings of his own life. In this respect, at least, he has much in common with the Impressionist choice of motifs.

Vuillard's life and work were always inextricably linked, and he constantly portrays the same subjects and models, his environs, his close circle of friends, impressions of the few journeys he made. Although, like Bonnard, he belonged to the nabis group of artists, his works do not necessarily bear the hallmarks of their style, nor can any links with Symbolism be detected. He was an independent and rather reclusive artist.

This portrait of his friend and colleague Toulouse-Lautrec shows the artist dressed in bright yellow, baggy trousers and a red shirt with a red-and-white kerchief, and a jaunty little hat on his head, standing at a table and glancing over in the direction of his portraitist. Vuillard, who invariably portrayed his surroundings with great empathy, has conveyed an image of Toulouse-Lautrec as a stocky and affable character and has played down his disability.

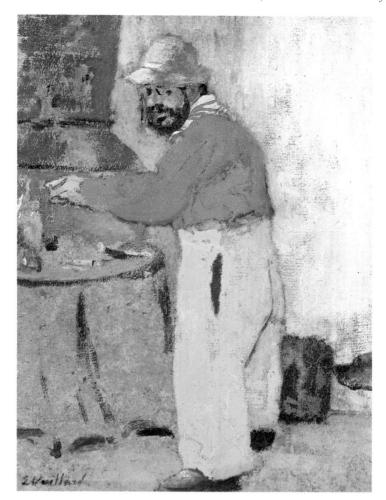

Edouard Vuillard Portrait of Toulouse-Lautrec. Oil on cardboard, 39 x 30 cm Albi, Musée Toulouse-Lautrec

MAURICE DENIS

1870-1943

Maurice Denis is regarded as the theoretician of the group of young artists who called themselves the nabis. His most famous statement is also regarded as one of the fundamental tenets of modern art: "A picture - before being a warhorse, a female nude, or some anecdote - is essentially a flat surface covered with colours assembled in a particular order.'

The radicalism of this statement is not fully realized in his early work. Admittedly, the colours, like the lines, are painstakingly selected in accordance with ornamental considerations, and the painterly means already anticipate the decorative curves of Art Nouveau. This gives the painting a rhythmically structured planarity, but the artist has not yet taken the step of dissociating colours and forms from the object portrayed.

The theme of this painting is influenced by the Sacred Grove motif adopted from antiquity by Puvis de Chavannes. Denis, however, has transposed the motif of The Muses entirely into contemporary life: here, the muses have become mortal. Under the strictly stylized trees, a young girl is sharpening her crayon; she is the goddess of painting. Another looks up from her book; she is the goddess of poetry. This contemporary treatment of ancient mythology and the stringent stylization make this painting appear both ambivalent and enigmatic.

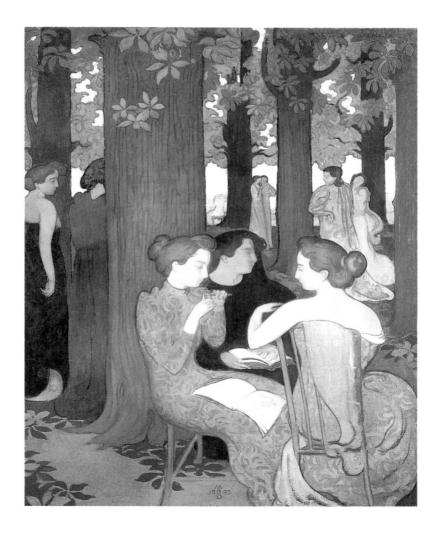

Maurice Denis The Muses, 1803 Oil on canvas 171.5 x 137.5 cm Paris, Musée d'Orsay

FRANCE

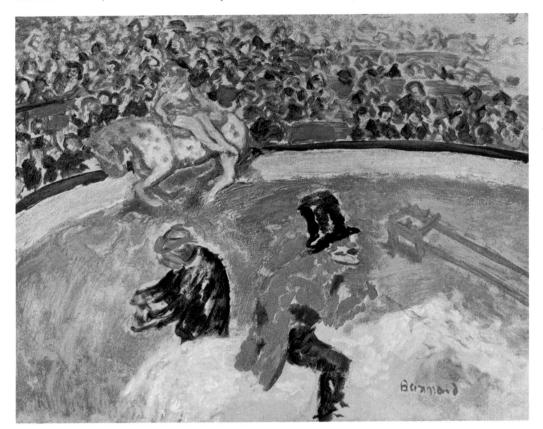

Pierre Bonnard At the Circus, c. 1879 Oil on canvas, 54 x 65 cm Paris, Private collection

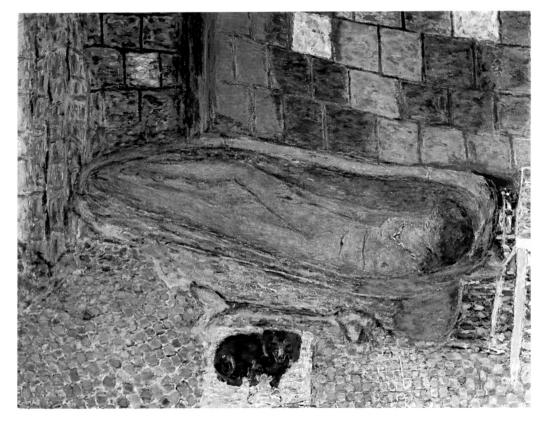

Pierre Bonnard Female Nude in the Bathtub, c. 1938 Oil on canvas, 122 x 151 cm New York, The Museum of Modern Art

PIERRE BONNARD

1867-1947

All of Bonnard's paintings express a certain *joie de vivre*, and seem to be full of sheer enjoyment at the events and occurrences life brings. His profound admiration for Monet and Renoir prompted him to continue along the path paved by the older generation of Impressionists. Like many of his contemporaries, Bonnard also encountered the strong influences of Japanese art which was imported in large quantity to Paris at the time, and he also closely studied the works of his contemporaries Gauguin and Cézanne.

Having painted continuously for some sixty vears of his long life, Bonnard left us a rich œuvre that reflects a number of different stylistic trends - Post-Impressionist works as well as those influenced by Art Nouveau and by East Asian art. Nevertheless, his own distinctive style predominates throughout and his rendition of sensual perception remains very much in the foreground. He does not narrate, analyse or moralize. He merely conveys what he has selected from the wealth of his surroundings, coloured by his own personal way of seeing. A peaceful serenity permeates his motifs, and a sense of joy is conveyed in his sumptuous mosaics and tapestries of delicate colour and form.

The circus was a welcome event in an era before the age of entertainment overkill and one people could look back on with pleasure. Circus motifs are frequent in painting. Bonnard, Toulouse-Lautrec, Picasso and other artists treated themes from the famous Médrano circus and the Cirque d'Hiver.

Here, we see a detail of the circus ring with the anonymous grey mass of viewers and an artiste in a pink tricot with a tutu riding on a dappled horse, painted in a strangely alienating shade of green. A red-coated rider in black trousers and a black top hat is galloping across the foreground on a white horse, and next to him we see part of a figure in black with red headgear. The forms and details have been deliberately executed in bold brushstrokes to give even greater vibrancy to the individual colour areas.

In this much later female nude which could, however, just as easily be mistaken for an early work, Bonnard creates a kaleidoscope of shimmering and luminescent colour areas. A young woman lies naked in a bathtub filled with water which is standing on a blue and gold mosaic-tiled floor. The reflections of light on the water and on her skin vie with those to be seen on the wall. Light, gold, blue, orange, lilac, pink, and a few daubs of bright red shimmer side by side in a visual symphony that is a delight to the eye. The young nude body seems to merge completely with the dominant colours and light.

VINCENT VAN GOGH

1853-1890

In 1888, van Gogh moved to the south of France, where the landscape, the light and the people of the Provence brought him a sense of happiness that triggered an almost feverish burst of activity on his part. He saw in everything around him a vibrant beauty that moved him deeply, it was a beauty he had not encountered in the previous places that he had painted - whether at be his Netherlandish home, Paris, the Île-de-France, as northern France.

The Langlois bridge near Arles was a motif van Gogh painted several times (Otterlo, Rijksmuseum Kröller-Müller; Cologne, Wallraf-Richartz-Museum; Paris, private collection). In this version, he has chosen a position close to the bridge, on a grassy and reedgrown strip of the left bank. A bark, tiled on its side and filled with water, is moored at a little jetty built into the river, where a group of women is busy at their washing.

The entire painting is filled with the bright, crystalline light of the Mediterranean. The hazy blue of the sunny sky is reflected in the water of the river, its surface rippled by the washerwomen's work. The solid masonry of the bridge creates a horizontal framework. The draw-bridge construction is light and pale against the sky, as are the smouldering red trunks and branches of the leafless poplars. A two-wheeled covered wagon is crossing the bridge. Reeds grow on the river bank, and on the left we see a strip of the fertile red soil of the Provence. It is a painting that conveys all the hope and strength of a spring day.

Van Gogh's love of Mediterranean light and colour constantly drew him outdoors and many open air works were created by him during this period. The plain of La Crau with Mont Majour in the background is another motif he treated frequently. He found it invigorating to paint a landscape that Cézanne, whom he deeply revered, had also known. Unfortunately, the admiration was not mutual and Cézanne was quite unmoved by van Gogh's work.

In this painting, van Gogh guides the viewer's eye with masterly skill in handling of perspective, across the ripe harvest fields to the distant mountains and the vibrantly blue summer sky. In shimmering reflections, the light dances on the waving fields of grain, the fences and hedgerows, the carts and houses.

Van Gogh was fascinated by the art of Japanese woodcuts and this is clearly reflected in his work. He believed that the contrasts of Japanese prints could be heightened in their intensity by the use of oil-paints. A delicate touch of East Asian charm certainly comes across in both paintings. Van Gogh himself called his beloved landscape "my provençale Japan".

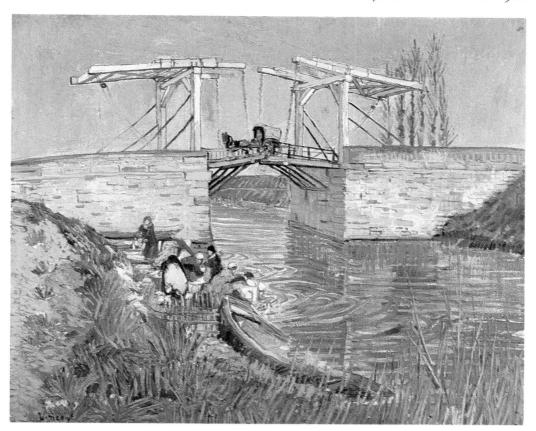

Vincent van Gogh The Langlois Bridge at Arles, 1888 Oil on canvas, 54 x 65 cm Otterlo, Rijksmuseum Kröller-Müller

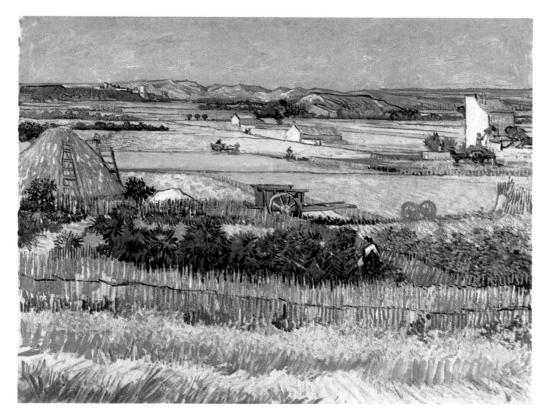

Vincent van Gogh Harvest at La Crau, with Montmajour in the Background (Blue Cart), 1888 Oil on canvas, 73 x 92 cm Amsterdam, Rijksmuseum Vincent van Gogh, Vincent van Gogh Foundation

Vincent van Gogh The Artist's Bedroom in Arles, 1889 Oil on canvas, 73 x 92 cm Chicago (IL), The Art Institute of Chicago

Vincent van Gogh Portrait of Doctor Gachet, 1890 Oil on canvas, 68 x 57 cm Paris, Musée d'Orsay

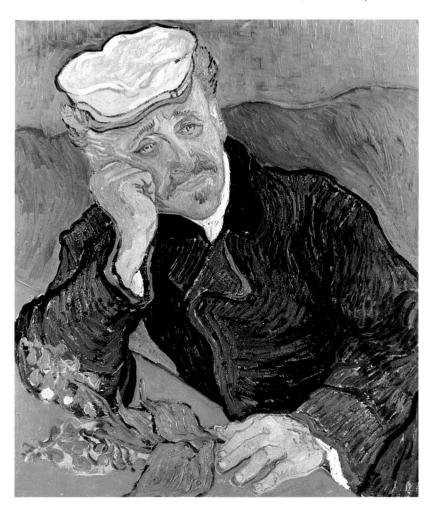

VINCENT VAN GOGH

1853-1890

Van Gogh's bedroom in the Yellow House he rented at Arles gives us a precise document of his simple abode. Only the bare necessities were there: a bed, with some hooks for his clothes behind it, two chairs, a small wooden table, some paintings on the wall. For the artist, however, it was a place of promise and the first place he could call a home of his own. Although the shutters are closed, the room is flooded with a bright light that lets each object appear with all the force and clarity of its colours. In the crowded perspective with its characteristic slight distortions, the painting also reiterates van Gogh's belief, expressed in a letter to his brother Theo, that "colour expresses something in itself, one cannot do without this, one must use it;...the result is more beautiful than the exact imitation of the things themselves.'

The Parisian homeopathic doctor and psychiatrist Paul Gachet was a close friend of the artist. He had a small practice in Paris that brought him little pleasure and in his free time he painted and etched, and was not without talent. Gachet was a patron and friend to many artists, including Pissarro and Cézanne, and was one of the first to purchase their paintings. In 1952 Dr Gachet's son bequeathed this major collection to the French nation. Dr Gachet had agreed to look after van Gogh in Auvers-sur-Oise after his discharge from the asylum at Saint-Rémy. Vincent lived there in an attic room above a café and spent much of his time at the doctor's house.

Soon after his arrival, Vincent expressed a wish to paint the doctor's portrait. Pensive, almost careworn, with a slight hint of scepticism, his pale face, framed by blonde hair and topped by a white cap, stands out against the blue of the jacket and background. The artist felt a distinct affinity between the doctor and himself, of whom he said that he was "at least as nervous as I am".

Van Gogh spent some time painting the flowers in the doctor's garden before he began to explore the little village and its surroundings. The late Gothic village church sits like a plump and brooding hen on a small rise spanned by a blue summer sky. It is surrounded by green grass and sunlit paths, and the blue of the sky is reflected in the broad windows with their fine tracery. At the edge of the painting, we see the houses and trees of the village. A peasant woman is making her way towards them. Although this is one of his last works, it betrays nothing of the deep despair that finally drove van Gogh to take his life. A calm tranquillity lies in this painting. The force of the colours and the decisive brushstroke seem to be anchored in the redeeming principle of hope.

> Vincent van Gogh The Church at Auvers-sur-Oise, 1890 Oil on canvas, 94 x 74 cm Paris, Musée d'Orsay

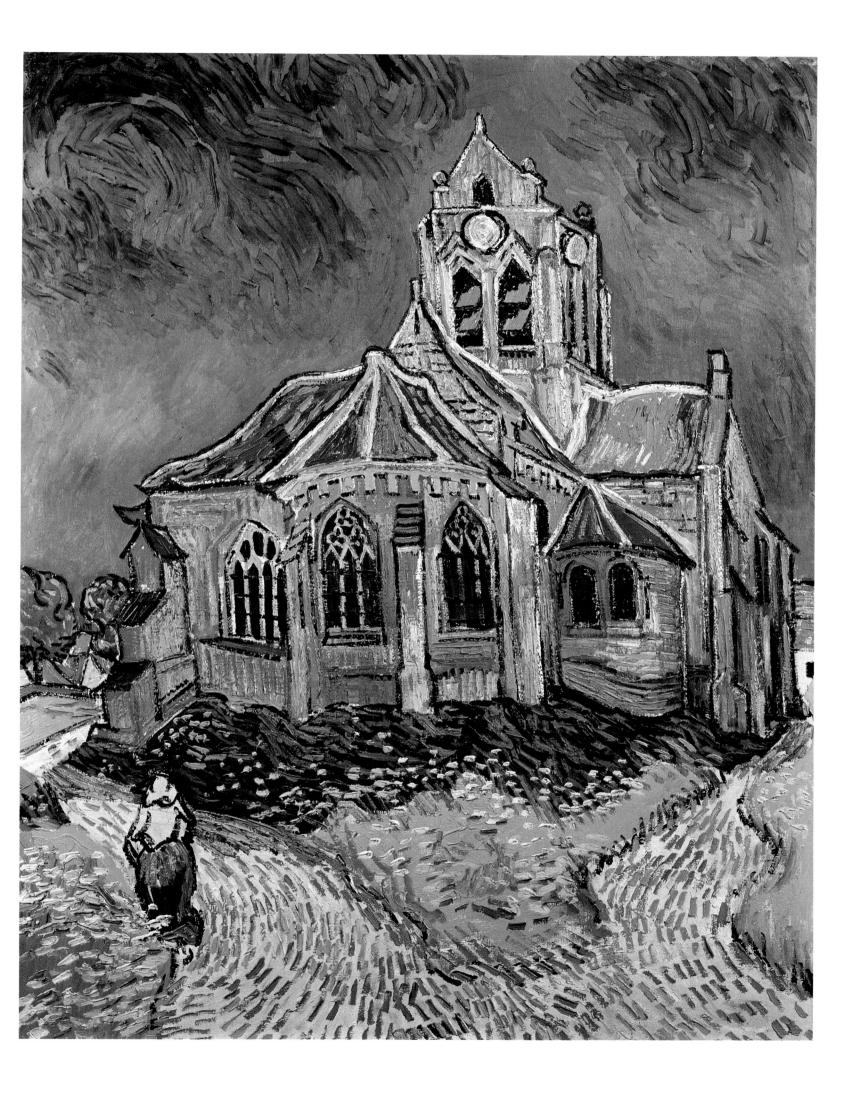

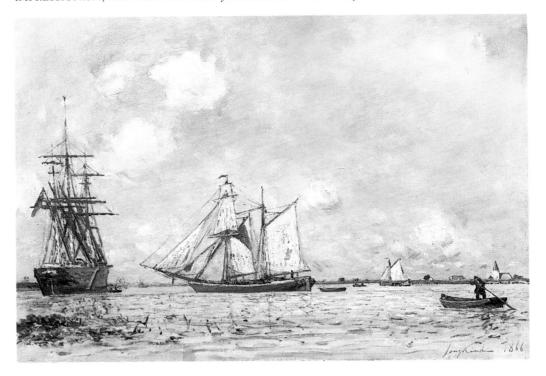

Johan Barthold Jongkind The Maas at Maassluis, 1866 Oil on canvas, 33 x 47 cm Le Havre, Musée des Beaux-Arts

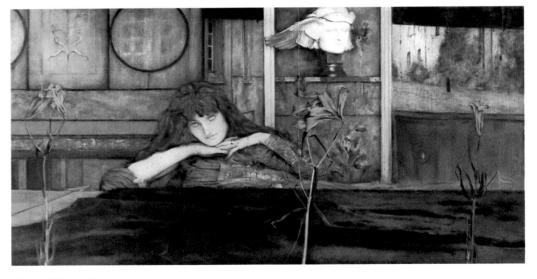

Fernand Khnopff I Lock my Door upon Myself, 1891 Oil on canvas, 72 x 140cm Munich, Bayerische Staatsgemäldesammlungen, Neue Pinakothek

JOHAN BARTHOLD JONGKIND

1819-1891

This Dutch, artist whose work is rooted in the great artistic tradition of his home country, and who dedicated himself primarily to landscape painting, was to become a key figure in French painting rather than in Dutch painting. He lived in France from 1846 onwards and it was here that he found the inspiration that liberated his painting from the technical and coloristic heritage of the 17th century masters. Light tonality and a deliberate dissolution of line and contour appear initially in his watercolours, later in his oil-paintings as well. He is rarely accorded the recognition he deserves as a forerunner of Impressionism, which he anticipated with his plein-air painting.

His choice of motif and his structuring of the horizontal plane – a low horizon, broad stretches of water with boats, and a narrow strip of land - certainly place this painting firmly within the Netherlandish landscape tradition. In formal terms, however, it already uses the new structural elements that Jongkind was to pass on to the young Monet and his friends: expressing the motif through the qualities of light, reiterating a brief and fleeting moment, strong brushstrokes without firm delineation, capturing reflections on surfaces. His invariably small-format paintings were the first impressionistic landscapes.

FERNAND KHNOPFF

1858-1921

Towards the end of the 19th century, Belgium, and most notably Brussels, was an important centre of the artistic avant-garde. Symbolist art, in particular, was well represented in this period. Khnopff is one of the great masters of Belgian Symbolism. He was a member of the groups L'Essor, Les XX and Libre Esthétique and enjoyed an international reputation. He frequently adopted motifs from Symbolist literature, for example from the works of Maurice Maeterlinck and Emile Verhaeren, as the themes of his paintings. I Lock the Door upon Myself is the seventh line of a poem by Christina Georgina Rossetti, sister of the English painter Dante Gabriel Rossetti.

This narrow, horizontal painting is executed in delicate, translucent colours, in which a pearly and by no means gloomy grey is predominant. A red-haired woman with grey eyes is leaning dreamily in front of a stage-like background: it is a "picture within a picture" that gives a glimpse into a monastery garden on the right, and a view of a locked grey door in the middle. The atmosphere is vaguely melancholic, reminiscent of Khnopff's enigmatic cityscapes at night, and contains such Symbolistic signs as the withered red lilies, the poppy, and the bluewinged head of Hypnos.

NETHERLANDS/BELGIUM 524

JAN TOOROP

1858-1928

This painting, whose tonality is restricted to only a few hues – white, black and various degrees of russet brown – combines various typical elements of Symbolism and Art Nouveau. The young girl – the woman as bride – was a popular theme at the turn of the century. The scene is organized with the symmetry of a ballet choreography and filled with symbolic props and a large cast of main characters, a background choir and right and left in the foreground two groups of semi-naked women, whose flowing hair – a symbol of female charms – is woven into curving ornaments.

This initiation scene focuses on three very different brides, all dressed in white robes and bathed in a bright light. On the left, pious and primly clad, is the bride of anxious innocence. In the centre is the crowned and willing bride who offers herself naked beneath her veils. On the right is the enigmatic and demonic bride with Egyptian headwear, her breasts shimmering through her magnificent robe.

White blossoms, bells from which tresses flow, sacrificial bowls and jugs, curls of rising smoke, crucified hands, nuns shielding their gaze – the picture is teeming with Symbolistic motifs, yet it is executed in the fluid planarity of ornamental Art Nouveau.

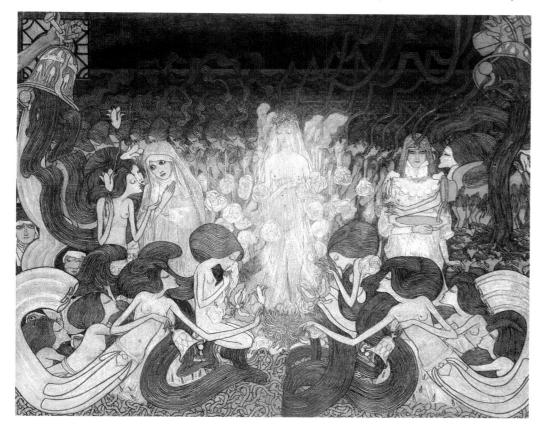

Jan Toorop The Three Brides, c. 1892/93 Pencil, black and coloured chalk on paper, 78 x 98 cm Otterloo, Rijksmuseum Kröller-Müller

JAN THORN-PRIKKER

1868-1932

In Thorn-Prikker's painting *Madonna among the Tulips* we find a number of elements showing the transition from Impressionism to Art Nouveau. The background is almost conventional: a sky with clouds, beneath it a village, a rural house to the right and endless tulip fields whose coloured rows lead towards the foreground, lending spatial depth and dimension as well as a certain atmosphere.

This vertical-format painting is divided by the beam of what may be assumed to be a cross, on which only the feet of Christ can be seen, as in a stylized wooden sculpture. The head and body of Mary are completely dematerialized, merging with the beam of the cross like a planar ornament. The sweeping curves of the sumptuous robe divided into magnificent ornamental zones seems almost anachronistic in view of the theme. Mary has become an Art Nouveau ornament.

The division of planes into individual decorative zones is a technique borrowed from French Cloisonnism. The draughtsmanship anticipates Thorn-Prikker's later stained glass and mosaic works. The colours themselves also have a symbolic significance. The *Madonna among the Tulips* creates a patron saint for Holland.

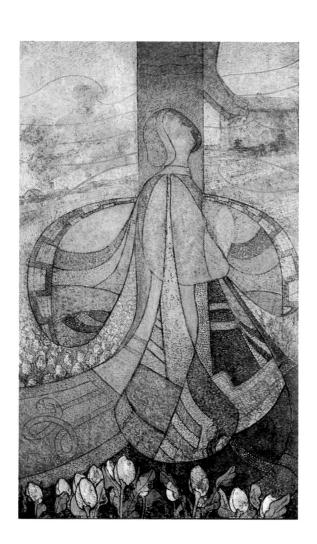

Jan Thorn Prikker Madonna among the Tulips (Before the Cross), 1893 Oil on canvas, 146 x 86 cm Otterloo, Rijksmuseum Kröller-Müller

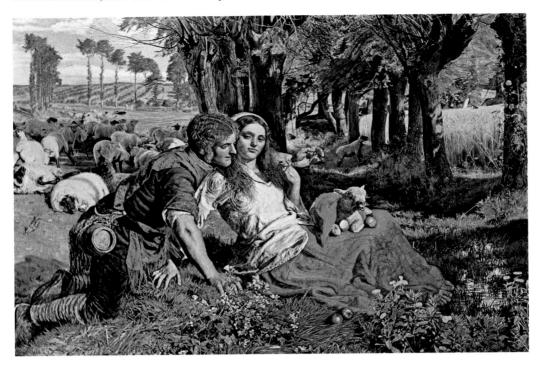

William Holman Hunt The Hireling Shepherd, 1851 Oil on canvas, 76.4 x 109.5 cm Manchester, City of Manchester Art Gallery

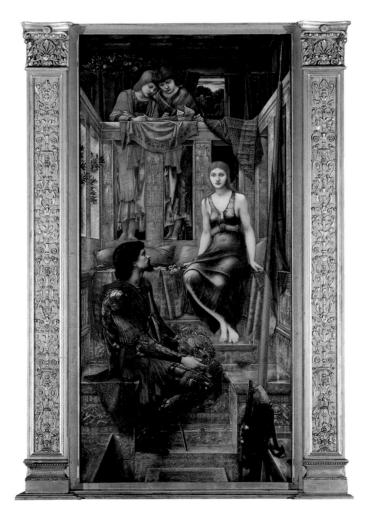

Edward Coley Burne-Jones King Cophetua and the Beggar Maid, 1884 Oil on canvas, 290 x 136cm London, Tate Gallery

WILLIAM HOLMAN HUNT

1827-1910

Apart from glorifying medieval themes, the Pre-Raphaelites also concentrated on land-scape painting. Landscape was seen from a romantic point of view and gave them the opportunity of presenting each detail with loving care, meticulously portraying blades of grass, flowers, leaves, light and shadow. Nevertheless, for Hunt, being true to nature was not an end in itself.

Instead, he sought to give art a firm moral foundation and to make it a "servant of justice and truth". He was the only one of the Pre-Raphaelite artists who sought to portray nature and the events within it in all their colority as something to be grasped emotionally – in accordance with the principles propounded by John Ruskin.

The purity and naivety with which he portrays the shepherd leaning over the pretty young girl's shoulder in order to catch a glimpse of the little lamb sitting on her lap is quite disarming. It is a fine summer day, the corn is ripe, the sheep are grazing and resting, and the couple is linked in perfect harmony. The flowers, the grasses and the marshy stream are portrayed with almost microscopic precision, as are the figures and robes of the shepherd and the girl. The colours are as brilliant as enamel.

EDWARD COLEY BURNE-JONES

1833-1898

The wide range of Pre-Raphaelite pictorial themes includes religious, allegorical and historical material as well as motifs from the world of saga and fairy-tale. Most of the paintings portray a literary scene that can be precisely pinpointed. The theme of this painting, for example, is taken from an old Elizabethan ballad that also made a considerable impression on Shakespeare. It tells of King Cophetua's love for a poor beggar-girl whom he marries and enthrones as his queen.

Burne-Jones' paintings, like those of his Pre-Raphaelite friends, were executed on the basis of detailed preliminary studies and preparatory sketches. He began work on this painting in 1880 and did not complete it until four years later. In 1883, he executed a large watercolour on the same theme for a Mr Graham. When the oil painting was completed in 1884, it was hailed as a masterpiece. On the basis of this work, the artist was offered membership in the Academy one year later and in 1889 he was awarded the first class medal and the Order of the Legion of Honour in Paris for this painting.

Within a framework of historicizing ornament, the king, in full armour with the crown in his hands, sits at the feet of the young beggar-girl dressed in grey as specified in the ballad, gazing up at his beloved, who shyly sits on one half of the throne, while two pageboys look down on the scene from above.

526 ENGLAND

JOHN EVERETT MILLAIS

1829-1896

The tragi-romantic character of Ophelia was frequently portrayed by 19th century artists. A fascinating figure dangerously linked with water, she belongs in the same category of motifs as Undine and Nymphe, who were adopted in Symbolist painting. In an attitude of transfigured pathos, with her scattered garland, she drifts on the water, bouyed only by her robes. Millais depicts with almost literal precision the scene in Shakespeare's tragedy *Hamlet* that describes Ophelia's death.

The narrow stream is framed by reeds, bushes and trees and Ophelia's long dress has the same earthy colour as the soil of the river bank and the mysteriously dark marshy riverside. The water on which she floats is like a still moorland pool, adding a touch of demonic melancholy. In her euphoric, hallucinatory madness, she has no awareness of the danger of drowning. According to Shakespeare, "Her clothes spread wide / And mermaid-like awhile they bore her up, / Which time she chanted snatches of old lauds / As one incapable of her own distress / Or like a creature native and indued / Unto that element."

In this painting, Millais has created a framework within which he draws the viewer into a close-up view of Ophelia's perilous situation. In spite of the painstaking precision with which he portrays the details, he succeeds in giving the scene an air of credible tragedy.

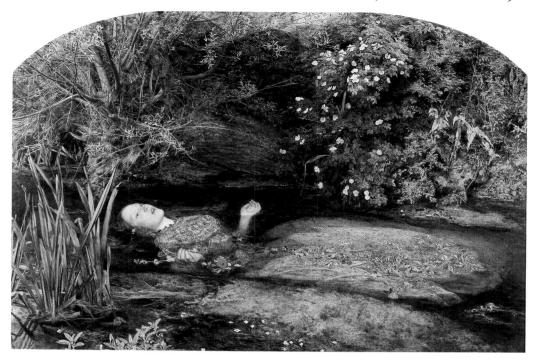

John Everett Millais Ophelia, 1851 Oil on canvas, 76 x 112cm London, Tate Gallery

DANTE GABRIEL ROSSETTI

1828-1882

We know from the letters of Rossetti that this painting already existed in his mind's eye as early as 1863 and that he had even made a start on it then. It was originally intended as a *Beatrice* commissioned by Ellen Heaton. Force of circumstances, however, dictated a change of motif and the painting was given an entirely new meaning.

Rossetti invariably worked with models and his working method was strictly aimed at depicting exactly what he saw. In 1863, for example, he wrote to Ellen Heaton telling her that he had already painted the entire face and that he felt the painting would be one of his best works, but that the model Mary Ford was simply not the perfect Beatrice, though he did not dare to paint over the figure and give her the facial traits of another model. He went on to explain that he now had the idea of presenting the young woman as a bride inspired by the biblical Song of Solomon.

The artist prepared several sketches of other models and then merged the group of young women into a static arrangement in which the adorned young woman forms the centre, framed by her companions bearing flowers.

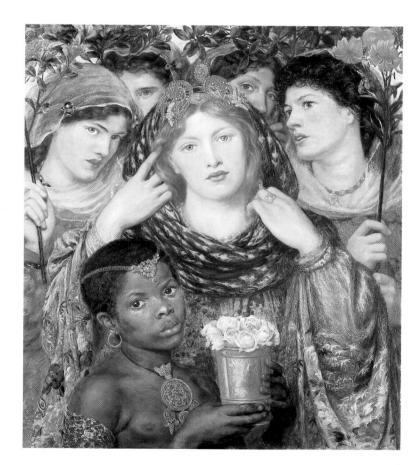

Dante Gabriel Rossetti The Bride, 1865 Oil on canvas, 80 x 76cm London, Tate Gallery

ENGLAND

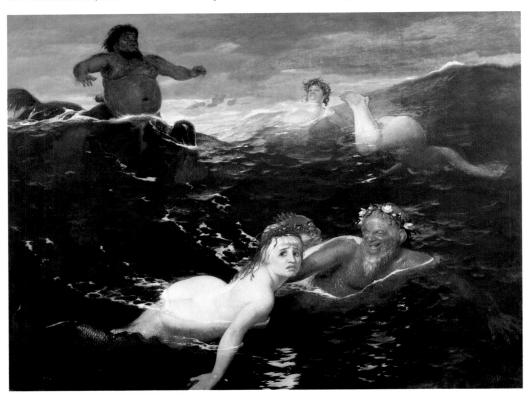

Arnold Böcklin The Waves, 1883 Oil on canvas, 180.3 x 237.5 cm Munich, Bayerische Staatsgemäldesammlungen, Neue Pinakothek

Félix Vallotton Sandbanks on the Loire, 1923 Oil on canvas, 73 x 100 cm Zurich, Kunsthaus Zürich

ARNOLD BÖCKLIN

1827-1901

With this painting, Böcklin draws us into the fabulous world of sea creatures, nymphs Nereids, nixens and Tritons. It is one of a large cycle of works featuring imaginary creatures whom he brings to life in his paintings. These creatures do not have an ideal human form; they are plump, course, often arrogant and clumsy.

In The Waves we see a group of such creatures at play in the sea. Crowned with water plants and flowers, seaweed and coral, their pale, bronzed or coppery-red bodies shimmer in a bluish-green sea with white foam, and the waves merge with the greyish-pink horizon. Böcklin has captured their movements and gestures, which are drastically heightened to the point of being grotesque. This impression is further underlined by their coarse and almost exaggerated facial expressions. Such are the expressive qualities and characteristic traits that the painter allocates to this world. Portrayals of this kind prompted his critics to claim that he had no artistic talent whatsoever. Yet the powerful colours, their luminosity and contrast, are carefully calculated and deliberately used as a forceful means of expression. This, in fact, is the key to understanding how this particular painting is related to Böcklin's other mystic and Symbolistic themes.

FELIX VALLOTTON

1865-1925

This landscape by Vallotton was created in the final years of his life. In his œuvre, he covered a wide range of stylistic influences; Pointillism, Naturalism, a late Impressionism that was inspired by Hodler and he also benefited from the influence of Japanese woodcuts. After the turn of the century, his works move clearly in the direction of modern art with neo-realistic and Expressionist features, and the Surrealists see in him a forerunner. In all of his works, Vallotton sought simplicity, regarding his subject matter soberly and critically in an unsentimental light, purifying his forms of all ornamentation and reducing them to essentials.

The Sandbanks on the Loire is one of a group of paintings widely acknowledged as anticipating pittura metafisica. At first glance, the gentle slopes and curves of the sand, the arms of the river, the riverbanks and the groups of trees standing in the bright light under a limpid blue sky, the lone fisherman on the bank, all seem to present a peaceful situation with no deeper significance. The reduction of colours to blue, green, the yellow of the sand and the deep shadows nevertheless create an atmosphere that makes us pensive.

FERDINAND HODLER

1853-1918

"It is the mission of the artist to lend form to the eternal in nature and to reveal its inner beauty. The artist tells of nature by rendering things visible; he pays homage to the forms of the human body..." Hodler's maxims were certainly not evident to all viewers of his works. During his lifetime, the response to his work was extremely ambivalent and often negative. Just as he had begun to gain some recognition in his own country, and just as people were beginning to understand and appreciate his works, he introduced a change of style around 1890, heralding the creative period in which he was to produce the paintings we regard today as typical of Hodler's style.

In the early phase of his work, spanning almost seventeen years, he created paintings closely modelled on the example of the old masters both in subject matter and in tonality. With the beginning of this new period, his palette became distinctly lighter, achieving that intensity of colour so typical of his work, and introducing the element of expression and movement.

For the painting Autumn Evening Hodler was awarded second prize at the Concours Calame in 1893. It is a composition created in the studio along the lines of earlier landscape paintings. Nevertheless, this painting is more than just the portrayal of a large-format landscape. The path strewn with fallen russet leaves and flanked by chestnut trees that have lost most of their foliage, leads into nothingness. The upper half of the painting is taken up by a sky in which the evocative colours of sunset flare up briefly before darkness falls. The sky is tinged with yellow, the clouds are radiantly lilac, and just above the end of the path we see a red strip - the last rays of the dying sun.

This painting already gives a strong indication of Hodler's new approach and his intention of imbuing his paintings with a more profound significance than that of simply illustrating nature. In doing so, he makes use of the strongly expressive powers of colour as a bearer of atmosphere and the universally comprehensible symbolism inherent in the theme "autumn evening".

Another of Hodler's newfound aims was to evolve new ways of addressing new topics. The success of his Symbolistic painting The Night (Bern, Kunstmuseum) in several European cities confirmed that he had been right to choose this new, monumental approach. In Communication with the Infinite he created a single figure composition in which a sense of space is secondary to planarity. A nude woman (for which Augustine Dupin, the mother of Hodler's son Hector, was the model) standing on a grey cloth lifts her eyes and hands in a gesture of prayer towards the pale strip of sky above the green hill before which she stands. This zone of light may be regarded as the universe or the infinite.

Ferdinand Hodler Autumn Evening, 1892 Oil on canvas, 100 x 130 cm Neuchâtel, Musée des Beaux-Arts

Ferdinand Hodler Communication with the Infinite, 1892 Oil on canvas, 159 x 97 cm Basle, Öffentliche Kunstsammlung Basel, Kunstmuseum

Giovanni Fattori Roman Carts, 1873 Oil on canvas, 21 x 32 cm Florence, Galleria d'Arte Moderna, Palazzo Pitti

Giovanni Segantini The Hay Harvest, 1899 Oil on canvas, 135 x 149 cm. St. Moritz, Museum Segantini

GIOVANNI FATTORI

1825-1908

Fattori, the most productive and most expressive painter in the Macchiaioli group of artists, preferred to paint on small wooden panels. His *Roman Carts* is one of the first works he painted in macchia technique, which involves a rapid juxtaposition of individual daubs of colour. This type of brushwork, closely related to that of Impressionism, also broke with traditional classical techniques. The motif, in its simplicity, also broke with academic doctrines. Apart from landscapes and rural scenes, Fattori's preferred motifs were battle paintings.

The laden, two-wheeled carts to which the horses are harnessed are standing in the bright sunlight on cracked dry earth in front of a high wall. A man is lying on the ground, in the foreground a horse is resting on straw, and behind it stands a saddled horse. The motif cannot be interpreted as romantic, for the atmosphere is too sober and realistic.

Here, the light has more than a coloristic function: it is a bearer of atmosphere. The midday sun has broken the blue of the sky and the trees behind the wall into a light and shimmering haze, bathing the scene in a paralyzing brightness that even robs the colours of their strength.

GIOVANNI SEGANTINI

1858-1899

The Hay Harvest was completed in the last year of Segantini's life, ten years after he had begun to paint. It belongs to a part of his œuvre that earned him the rather inapt epithet "the Italian Millet".

Apart from his major Symbolist themes and cycles, Segantini also studied the life of the mountain peasants, the quiet mysteries of the mountain world, and the majestic sublimity of nature. Like most of his contemporaries, Segantini undertook studies of nature and painted in the open air. In the quiet solitude of the mountains, he explored the changing light conditions in the course of the day, and the changing seasons. He developed a kind of Divisionism, involving a technique of dividing the picture plane into individually juxtaposed brushstrokes that was closely related to Impressionistic techniques.

This painting shows peasants gathering in their hay on a plateau fringed by mountains, with a young woman in a white apron and white cap in the foreground bending down to gather a bundle. A brilliant blue sky with stylized grey and pink clouds spans this peaceful scene. The people and animals are integrated into the landscape, transfigured by the radiance of the light and the gentle lyricism of the scene

530

ANSELM FEUERBACH

1829-1880

Feuerbach saw his ideals reflected in the classical sovereignty and beauty associated with Antiquity and the Renaissance. These ideals, together with his romantically transfigured notion of the past, permeate his entire œuvre. As the son of an archaeologist, he was not only familiar with the literary themes he treated in his paintings, but he also had an eye trained from an early age on the monuments of classical Antiquity and the Renaissance.

According to the artist himself, this painting, originally entitled Ariosto at the Court of Ferrara, caught the attention of Count von Schack, who purchased it and thereupon commissioned further works. It was the literary reference in the painting that appealed particularly to von Schack, and because of this, critics accused him of failing to recognize Feuerbach's true genius and of forcing him to repeat his treatment of literary material.

Ariosto, one of the great poets of the Renaissance, is portrayed here wearing a laurel wreath in the manner of Dante. Ercole d'Este, the theatre-loving Prince of Ferrara, was one of the first to put Ariosto's plays on the stage. Ariosto is seen strolling here amongst a group of intellectuals and beautiful women, in a magnificent garden-setting before an architectural backdrop that reiterates the majestic forms of classical Antiquity. In this painting, Feuerbach also takes up an earlier Dante theme.

Anselm Feuerbach The Garden of Ariosto, 1863 Oil on canvas, 102 x 153 cm Munich, Bayerische Staatsgemäldesammlungen, Schack-Galerie

FRANZ VON LENBACH

1836-1904

Lenbach was regarded by his contemporaries, as he is today, primarily as a brilliant portraitist of high society. Using a predominantly brown and golden tonality in the manner of the old masters, he painted Bismarck, the Prince Regent Luitpold, Emperor Wilhelm I, Pope Leo XIII, Richard Wagner and many other famous personalities and figures in politics and high society. All these portraits are objective depictions of the respective persons in the dignity of their office and their position. However, when younger women with less famous names are his models or when he paints his wife and children, a distinct tendency towards cloying sentimentality is undeniable.

Lenbach also created a cycle of paintings depicting peasants and shepherds, standing, sitting or reclining, which clearly appealed to his visual interest. He showed them in all their simplicity, in their rural surroundings. The Young Boy in the Sun sitting on a grassy, sandy knoll looks sweet and simple. He is blonde, with a ruddy complexion, a little dirty, simply dressed and portrayed against the limpid blue of a summer sky. This harmless idyll undoubtedly appealed to the emotions of Lenbach's late 19th century spectators. His skill in the portrayal of plants is as virtuoso as any old master.

Franz von Lenbach Young Boy in the Sun, с. 1860 Oil on canvas, 33.5 x 26cm Darmstadt, Hessisches Landesmuseum

Wilhelm Leibl Three Women in Church, 1881 Oil on panel, 113 x 77 cm Hamburg, Hamburger Kunsthalle

Wilhelm Trübner Landscape with Flagpole, 1891 Oil on canvas, 48 x 65 cm Winterthur, Stiftung Oskar Reinhart

WILHELM LEIBL

1844-1900

The painting of *Three Women in Church* shows Leibl at the height of his creative powers. A slow worker, who considered and composed even the tiniest areas of his paintings with painstaking care, he has succeeded here in creating a perfect example of his realist phase with all the consummate skill of the fine artists of the old school.

The painting shows two old women and one young woman in rural dress, seated side by side on a church pew, deep in prayer. The Baroque carving of the church pews is rendered with the same photographic precision as the figures of the women themselves.

Leibl achieved a superb mastery of colour, allowing its luminosity to speak for itself. In front of the light-coloured background, the peasant woman in her dark dress and dark headwear stands out strongly, her gaze turned away from the viewer towards an altar that is situated somewhere beyond the picture frame. Beside her, in the centre of the painting, an old peasant woman bends over the prayer book she holds in her large, rough hands. Her striped dress acts as a compositional transition to the young woman with her light shouldercovering and apron, her fresh complexion and the golden bands of her hat. The dispassionate precision of this portrayal draws the viewer into the quiet contemplation of the scene.

WILHELM TRÜBNER

1851-1917

Like the work of his friends in the circle of artists grouped around Leibl, Trübner's approach is anti-academic, invariably seeking the new and the lively, even though he was trained in the tradition of the old Netherlandish, German, Spanish and Italian masters. His talent lies in his unerring sense of colority, authenticity of form, and in the simplicity and reduction of his structures. He countered the widespread contemporary rejection of his works by taking up the pen and anonymously publishing, in 1892 and 1898 respectively, two polemical tracts entitled Das Kunstverständnis von heute (Attitudes to art today) and Die Verwirrung der Kunstbegriffe (The confusion of artistic concepts). From 1890 onwards, he dedicated himself increasingly to plein-air painting and travelled widely during the summer months.

His Landscape with Flagpole at Chiemsee documents one such journey, and it is quite evident that he has now reduced his early principle – "stringency of draughtsmanship and supreme handling of colour" – to the principle of coloristic painting in the Impressionist mode. The short, angular brushstrokes of his earlier works are increasingly replaced by freer, broader and longer strokes. Clear and bright, the sky and the blue lake contrast sharply with the village and the lakeside. In addition to landscapes, Trübner's œuvre also includes portraits, still lifes and interiors.

MAX KLINGER

1857-1920

Klinger invariably created his works with the inner calm of an artist who had withdrawn from society and who was nevertheless open to all contemporary influences. In his complex and prolifid œuvre, we find elements reflecting all the prevailing stylistic tendencies of contemporary art.

In addition to realist paintings, he also created works of imaginary and fantastic motifs, history paintings and mythological themes. In Paris, he became closely involved with Impressionism, and in his later years he came to be regarded as one of the leading masters of German Jugendstil.

The Landscape at the Unstrut is a relatively unusual work in Klinger's œuvre. Whereas he generally tended to prefer scenic portrayals with an allegorical, imaginary, religious or historical content, he turns here to a purely landscape motif. The hilly landscape divided horizontally in the centre by a narrow river, is completely uninhabited and the tranquillity of nature is disturbed neither by narrative nor by any human figure.

The foreground is dominated by reeds, and the water flows down a series of steps, with a steep riverbank on one side, upon which there are three trees, with bushes of glowing russet, bluish mountains and an almost violet sky in the background. This is a typical Jugendstil landscape.

1863-1928

The Dinner Party documents an authentic event: the great gala dinner held to celebrate Stuck's fiftieth birthday on 23 February 1913 in the studio of the Villa Stuck in Munich. The artist is not interested in creating portraits of the guests, but in capturing the festive atmosphere and the majestic effect of the room he had designed and decorated himself.

Ladies and gentlemen in formal dress are seated at a long table lit by magnificent candelabra. That is almost all we can recognize. They are dark figures in the shadow or pale outlines in the light. The dignified surroundings of this gathering, the high ceiling of the aristocratic artist's studio, is designed in the Neoclassicist style inspired by the architecture of ancient Rome. On the walls, between pilasters, hang magnificent tapestries, and the room is spanned by a richly ornamented coffered ceiling.

The guests are celebrating Stuck's birthday; he accepts their attention and even celebrates himself by documenting the event, thereby merging life and art. Imagination, pomp and circumstance are the main motifs here. At the time this painting was created, Cubism was already in its second phase. War was to break out in 1914.

Max Klinger Landscape at the Unstrut, 1912 Oil on canvas, 192 x 126cm Altenburg, Lindenau-Museum

Franz von Stuck The Dinner Party, 1913 Oil on canvas, 57.5 x 68.5 cm Munich, Bayerische Staatsgemäldesammlungen, Neue Pinakothek

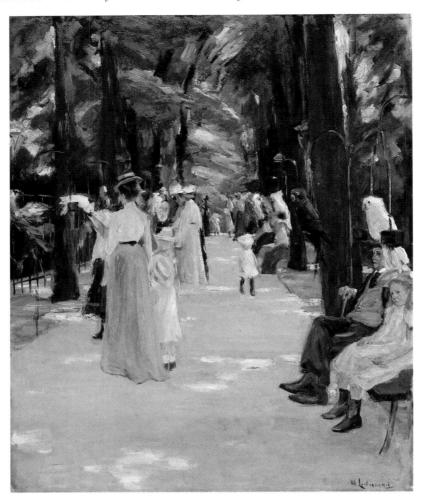

Max Liebermann The Parrot Walk at Amsterdam Zoo, 1902 Oil on canvas, 88.1 x 72.5 cm Bremen, Kunsthalle

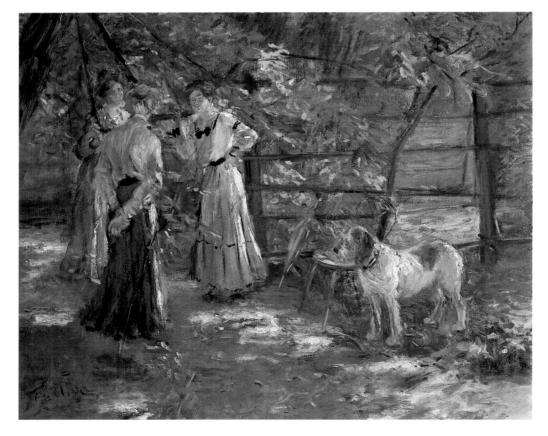

Fritz von Uhde In the Garden (The Artist's Daughters), 1906 Oil on canvas, 70 x 100 cm Mannheim, Städtische Kunsthalle Mannheim

MAX LIEBERMANN

1847-1935

This painting was created at a time when Liebermann had already found his own personal style. After some initial work in which the realist influence of the Hungarian artist Mihály Munkácsy and the school of Barbizon were undeniable, he began a close study of the old Dutch masters, the French Impressionists and contemporary German painters. In the end, he chose to break with tradition and became the most important representative of German Impressionism.

In this Parrot Walk he has captured the atmosphere of a warm summer day. A pale, broad sandy path is flanked by high trees with dense foliage, between which magnificent parrots are perched, rustling their feathers, to the delight of the women and children in their light summer dresses and straw hats. On the benches by the side of the path, some of the walkers are taking a rest.

The viewer remains an outsider, for the events captured in the painting are not directed towards his perspective and all the people in the picture are busy strolling about, looking at or feeding the exotic birds. The pools of light on the path and on the grass indicate the sunlight falling through the dense foliage. Everything in this painting is modelled with light.

FRITZ VON UHDE

1848-1911

Uhde created the modern religious painting as a vehicle for his quest to endow his work with deeper meaning. He also devoted his attention to themes inspired by an observation of his immediate surroundings. Invariably, people are at the centre of his work.

Although traditional motifs abound in his œuvre - history paintings, allegorical or mythological motifs, narrative genre scenes and although many of his early works show the influence of classical painting, he eventually developed his own unacademic style. Both the subject matter and the technique are closely related to French naturalism and Impressionism which he adapted in his own way. His close family life, the figures of his wife and his three daughters, provided a motif Uhde frequently painted.

In a garden with trees, through which the sunlight falls, casting pools of light on the ground, his three adult daughters are clearly engaged in conversation. A parasol is leaning against the fence, there is a chair to rest on and the white and brown dog stands faithfully waiting. The calm contentedness of this summer idyll is an example of Uhde's tendency towards the picturesque.

LOVIS CORINTH

1858-1925

Corinth's *Self-Portrait with Straw Hat* executed in 1923, two years before his death, unites two of this artist's main motifs: self-portraiture and the landscape of Walchensee in the Bavarian Alps. Like Rembrandt and Beckmann, Corinth was an artist who frequently subjected his own physiognomy to critical and considered study, making it the subject matter of his painting.

We know that Corinth had undertaken to create a self-portrait each year to mark his birthday. He suffered a stroke in 1911, which severely affected his life and forced him to withdraw from many of his Berlin activities as president of the Secession and director of a school of painting for women. From then on, he spent most of his time in the south of Germany and, from 1919 onwards, at his house by the lake, Walchensee.

Most of the picture area is taken up by the head and shoulders of the straw-hatted artist in the middle of this small horizontal painting, viewed from an elevated position above the lake, which is fringed by mountains on the opposite shore. This is not a psychologically detailed portrait. The sun-tanned artist, wearing a moustache, is gazing almost absentmindedly into the distance. He appears introverted and pensive. Stylistically, this painting is closely related to the works of the Impressionists.

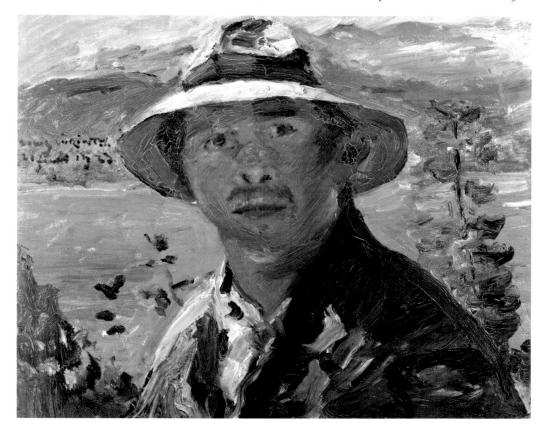

Lovis Corinth Self-Portrait with Straw Hat, 1923 Oil on cardboard, 70 x 85 cm Bern, Kunstmuseum Bern

MAX SLEVOGT

1868-1932

Slevogt is frequently described as the master of German Impressionism, a description which is justified in many ways if we do not make too close a comparison with French Impressionism. After all, Slevogt developed his own highly distinctive and modern forms of expression. Apart from his considerable graphic output, he dedicated his time intensively to painting. Portraits, figural compositions and still lifes were, for a long time, his preferred subjects. He turned to landscape painting at a fairly late stage, after he had begun to paint all his motifs in natural light.

When Slevogt travelled to Hamburg on the invitation of the art historian Alfred Lichtwark in order to paint the portrait of senator William Henry Oswald, he took the opportunity of painting some scenes of Hamburg as well. None of these is, strictly speaking, a veduta. Nevertheless, this painting with a view of the river Alster does show a detail of a real scene which can be precisely pinpointed. Slevogt's main aim is to clarify the spatial situation. He shows an clearly defined area with a distinct background formed by the opposite lakeshore and gives an authentic rendering of the atmosphere between daytime and twilight.

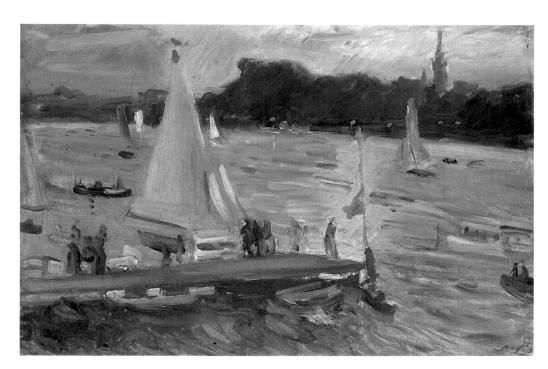

Max Slevogt
The Alster at Hamburg, 1905
Oil on canvas, 59 x 76cm
Berlin, Nationalgalerie, Staatliche Museen
zu Berlin – Preussischer Kulturbesitz

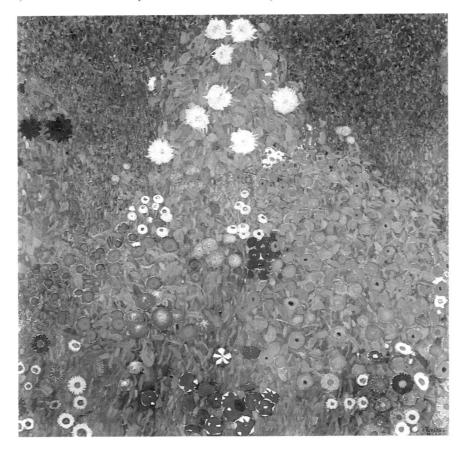

Gustav Klimt Flower Garden, c. 1905/06 Oil on canvas, 110 x 110 cm Prague, Národni Galeri

Gustav Klimt The Virgin, c. 1913 Oil on canvas, 190 x 200cm Prague, Národni Galeri

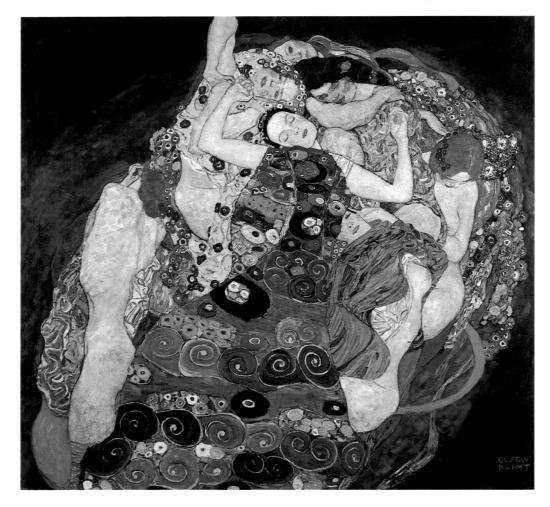

GUSTAV KLIMT

1862-1918

Many of Klimt's paintings are created in a kind of millefiori technique, in which colours, patterns, figurative areas, ornaments are juxtaposed and merged into a plane in which the boundaries between seemingly arbitrary pattern and real materiality are often blurred. He invariably uses colours of sumptuously oriental luminosity or with a precious, enigmatic shimmer, heightening the intensity with gold backgrounds or gold ornaments. For his landscapes, he chooses a different handling of colour, in subtly impressionistic tones.

His *Flower Garden* is a tiny landscape detail portrayed in close-up. Klimt does not indicate spatiality, showing instead a rich cornucopia of summer flowers, a dense tapestry of blossoms through which no soil shows, over which no sky is spanned, crossed by no path, flanked by neither tree nor bush.

The flatness and planarity of the picture make it seem as though it is suspended in some indefinable place. The blossoms are like a pattern that could be repeated *ad infinitum*, a chance glimpse of a vast sea of flowers. In a technique verging on Pointillism, the colours have been juxtaposed in tiny, rapid brushstrokes in which the blue and green of the little leaves merge together and the bright splashes of the flowers seem to have been dabbed on the canvas at random. The painting thrives on the contrast of vibrant colours in an oscillating tonality that creates a dynamically rhythmic effect.

In this large and almost perfectly square painting, which Klimt entitled The Virgin, an interwoven group of bodies, ornaments, flowers and bands seems to float like an island within a dark, diffuse area. We see the faces, arms and naked bodies of young women nestled there, drowsily interlaced in symbolic unison with the blossoms, bands and ornaments on which they lie. Some of the girls are still fast asleep, others have opened their eyes slightly and, still gazing dreamily, are looking out of the picture. They are in various stages of the unconscious, before awakening as women. A lascivious tranquility prevails; the colours have a magical and potent radiance, and the entire ensemble is orientally sumptuous.

The painter plays a confusing game with the appeal and sensation of materials, colours and ornaments, with the contrast of concrete materiality and abstraction and with the wealth of what he portrays. Corporeality and décor merge completely.

The subject of "woman" is a key motif in

The subject of "woman" is a key motif in Klimt's work and he invariably shows woman in all her corporeality as an essentially attractive creature – enigmatic, mysteriously beautiful and sublime.

EGON SCHIELE

1890-1918

Like van Gogh, Schiele's creative career as an artist spanned barely a decade and yet, even in this brief period, he succeeded in producing works of such arresting power and outstanding quality that he is regarded today as one of the most important of Austrian painters.

Though his art would have been inconceivable without the work of his mentor, friend and Secession colleague Klimt, the work in which Schiele follows on from Klimt's groundbreaking œuvre nevertheless possesses its own highly distinctive style.

"In the case of Schiele, as with anyone who died so young, one cannot avoid seeing the traces of what Trakl calls the November destruction – what the hopelessly healthy calls morbid and the smart nascal calls decadent." With these words, the Viennese academy professor Albert Paris Gütersloh, painter, writer and a contemporary of Schiele ironically characterized his work. Yet he touches upon only one aspect of Schiele's œuvre, whose body of artistic work also lays bare the underlying structural forces of life, expressively symbolized in glowing colours.

Schiele's overriding interest was the human figure, the body and the face. With sceptical curiosity and an anatomically coloristic attention to detail, he analyzed himself and his models time and time again. Another aspect of his work is his landscape painting. With flighty, almost nervous brushwork he applies colours whose vibrant luminosity is moretheless often translucent. He elongates his objects and fragments them into many parts. Light, empty areas contrast with sonorous, dark colours in tonal passages of alternating intensity and density.

Female Model in Red shows the importance of movement in his work, portrayed by means of a distortion akin to that of the Expressionists: movement as a strong and colourful independent entity, merging to a singular and almost unsettling tonal conglomerate. The fiery red of the robe is picked out again here and there on the skin of the model - on her cheeks, arms and legs - while the brown of the undefinable garment into which the model is trying to slip her foot is reiterated in the hair and on the skin. No sense of space is indicated; in spite of the heavy physicality of the woman, her body remains flat. The vertical angle, the planarity, the way the head is deliberately clipped at the upper edge, the expressive movement - all these features suggest the influence of Japanese woodcuts. Many of Schiele's nudes have a similar structure and frequently radiate a powerful eroticism, while, as in this work, they are also overlaid with quite different sensations: the reciprocal tension of form and colour.

Schiele spent a lot of time in the picturesque little southern Bohemian town of Krumau, which he immortalized in many of his paintings. Here, the individual elements houses, gardens, river, sky and fields - are broken down into myriad mutable patches of colour.

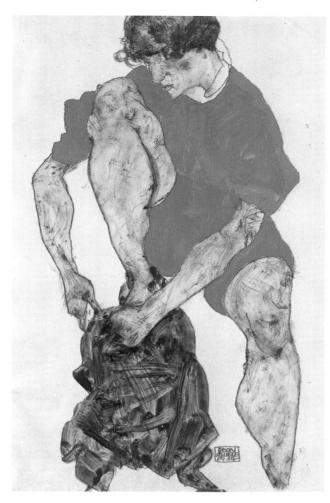

Egon Schiele Female Model in Bright Red Jacket and Pants, 1914 Gouache and Pencil, 46.5 x 29.7 cm Vienna, Graphische Sammlung Albertina

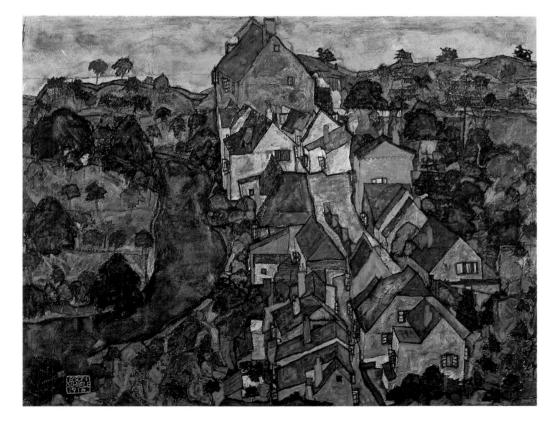

Egon Schiele Krumau Landscape (Town and River), 1915/16 Oil on canvas, 110 x 140.5 cm Linz, Wolfgang-Gurlitt-Sammlung in der Neuen Galerie der Stadt Linz

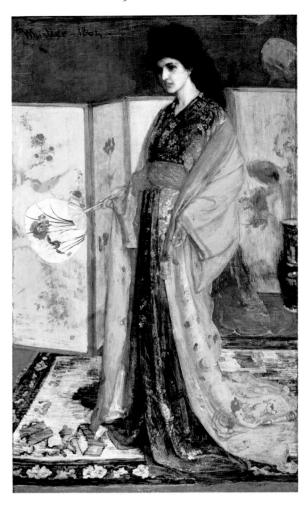

James Abbott McNeill Whistler Rose and Silver: La Princesse du Pays de la Porcelaine, 1864 Oil on canvas, 216 x 109.2 cm Washington, Freer Gallery of Art

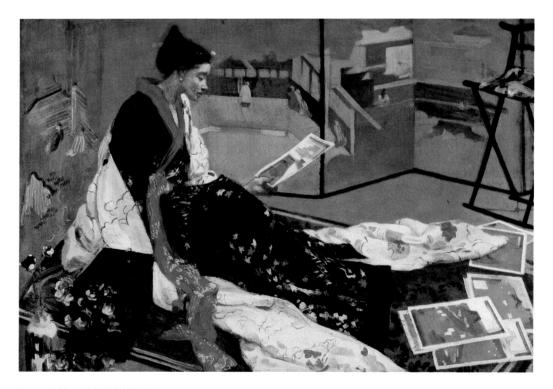

James Abbott McNeill Whistler Caprice in Purple and Gold, No. 2: The Golden Screen, 1864 Oil on panel, 51 x 68.5 cm Washington, Freer Gallery of Art

JAMES ABBOTT McNEILL WHISTLER

1834-1903

Whistler loved to title his paintings according to the gentle colour harmonies that dominated their respective tonality. His work is informed by the subtle and compelling charm of finely nuanced hues in a shimmering luminosity that conjures up a sense of materiality. A profound love of East Asian art influenced Whistler's life as much as it did his art. This affinity is clearly based on a certain inner harmony that prepared him for the influences from a world in which a heightened aesthetic sensibility played a predominant role. He collected East Asian porcelain, textiles, paintings and objets d'art of all kinds and lived surrounded by

A profound identification with Far Eastern principles of design, motifs and aestheticism is evident in all his work and he loved to portray objects from his collection in his paintings. Like Japanese and Chinese artists, Whistler created for himself a stamp-like seal with a stylized design. Far from leading to superficial imitation, Whistler's close study of Eastern art produced independent interpretations which nevertheless bear clear witness to their sources of inspiration.

In Rose and Silver: La Princesse du Pays de la Porcelaine we see a European woman of lyrical beauty dressed in a magnificent silver brocaded kimono and a pink, silk robe standing on a Chinese rug in front of a screen. Painted fans, a tall vase, part of a pink, silk tablecloth, a glimpse of flooring and the background all reiterate the tonal variations on pink and silver. These are extremely delicate colours juxtaposed without contrast, drawing their vibrancy from the charm of their delicate gradations.

In the painting Caprice in Purple and Gold, No. 2: The Golden Screen the colours and contrasts that determine the composition are stronger. The upper half of the painting is dominated by a Japanese folding screen with a warm golden ground on which, in characteristically sharp perspectival depth, we can discern buildings and landscape elements.

In front of it, a European lady with a pale complexion, her hair piled high, is seated on a red rug. She is dressed in a dark, embroidered silk kimono with a scarlet shawl collar, a scarlet embroidered obi (a long broad sash) tied around her waist, with a cream-coloured silk shawl embroidered in gold and red thrown loosely over her shoulder. Beside her are a small lacquer cabinet and a porcelain vase with pink flowers. Here, Whistler explores the delightful contrasts between light and shade and between the shimmering of nuances of similar colours. He felt that his work bore a profound relationship to music, which explains why he so often gave his paintings such titles as Caprice or Harmony.

538 UNITED STATES

MARY CASSATT

1845-1926

It was through her friendship with Degas, who was extremely critical when it came to accepting his friends as artists, that Mary Cassatt came into contact with the Impressionists. An invitation to take part in their exhibitions liberated her from the pressure of presenting her works to the jury of the Salon and allowed her to concentrate on painting quite independently the subjects of her choice as she saw fit. Yet the direct influence of the Impressionists on her art remained limited. Though she brightened her palette and worked with broader and bolder brushstrokes, her forms remained self-contained and were not broken down into colours and light.

The Boating Party is a typical composition in the œuvre of Mary Cassatt and one that involves one of her favourite motifs: mother and child. The choice of detail, the silhouette of the rowing man in black, whose back is turned to the viewer and who fills much of the foreground, the deep blue surface of the water and the corner of the greyish sail all indicate that Mary Cassatt was thoroughly familiar with the Japanese masters of the woodcut. The woman holding her child on her arm is turned towards the man, looking at the him, so that the viewer is excluded from the painting. The cool, discreet handling of the scene is typical of her work, while the strong colour contrasts add a sense of tension.

Mary Cassatt generally found her models within her close circle of friends; in fact, these two little girls, fully immersed in their game on the beach, were the children of a friend. The artist concentrates mainly on the little children whom she has placed in a narrow and almost photographically structured detail, as can be seen by the way the edge of the picture clips the legs of the girl with the hat. Cassatt painstakingly captured the charming facial traits of the little girl with the shovel. The textile structures of their aprons are brilliantly mastered. The surrounding area, on the other hand, is fleeting and sketchy: sand and sea, cliffs and sailing boats are reduced to colour impressions. In this way, the observer is led through the composition and through the various brushstrokes into the centre of the pic-

Contemporary critics applauded the way Cassatt had succeeded in presenting this scene naturally and authentically, praising her rendering of the children's cheeks, their chubby arms and their little legs, and comparing their wonderful, sun-tanned skin to the firm, dense texture of nectarines. The artist was certainly not interested merely in the picturesque effects she could achieve in this picture. She approaches the children at their own level rather than looking down on them from above. In this way she regards their game seriously as a means of exploring the world. The very fact that Cassatt's children could be regarded as independent personalities is a sign of the changing perception of humanity towards the end of the 19th century, in the wake of Darwin's theories.

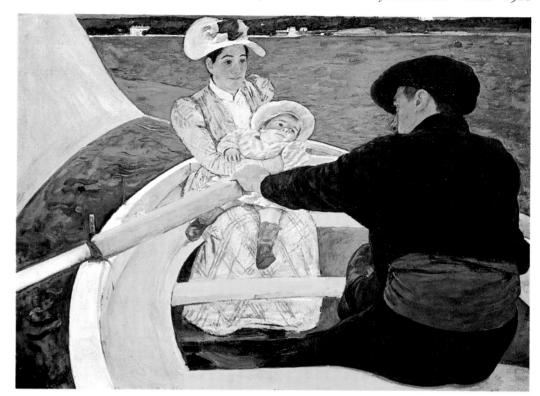

Mary Cassatt The Boating Party, c. 1893/94 Oil on canvas, 90 x 117 cm Washington, National Gallery of Art

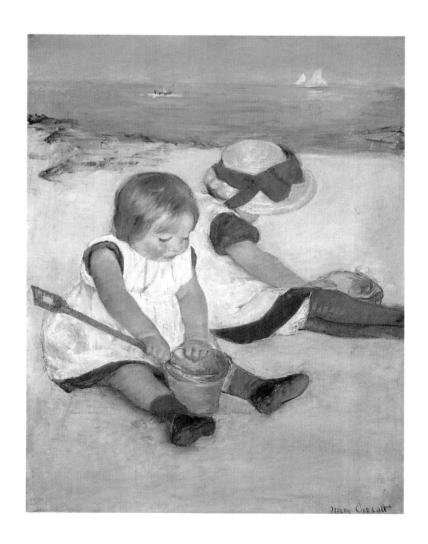

Mary Cassatt Two Children on the Beach, 1884 Oil on canvas, 97.6 x 74.2 cm Washington, National Gallery of Art

UNITED STATES

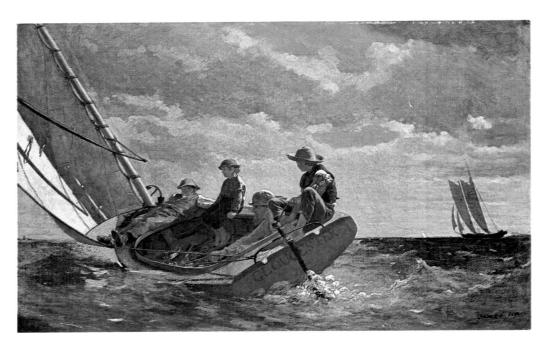

Winslow Homer Breezing up, 1876 Oil on canvas, 61 x 96.5 cm Washington, National Gallery of Art

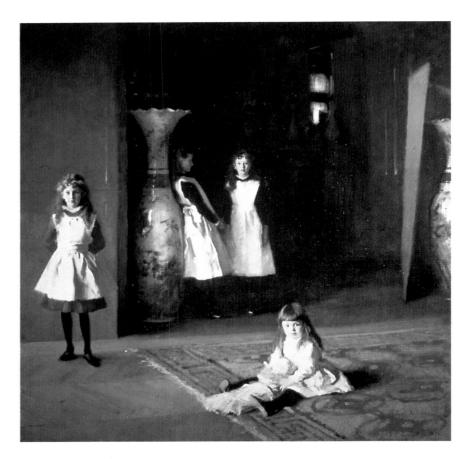

John Singer Sargent The Daughters of Edward Darley Boit, 1882 Oil on canvas, 222.5 x 222.5 cm Boston (MA), Museum of Fine Arts

WINSLOW HOMER

1836-1910

Before Homer had the opportunity of seeing the paintings of French artists on a European tour, he had independently arrived at an almost Impressionistic handling of light. He painted outdoors, painstakingly observed the times of day and weather conditions and reproduced them authentically. Yet in doing so, he never went so far as to break down the entire surface of the painting, adopting a realistic approach to reproduce certain elements instead. His colours invariably remained subdued and almost cool. The atmosphere he does achieve verges on tension. Homer loved to spending time by the sea and to portray man's struggle with the elements – wind, waves and weather.

Breezing Up (A Fair Wind) is one of his more mature works. It shows a bearded man with three young boys enjoying a sailing trip just as the wind begins to come up and their sport may be expected to become rather more strenuous. The breeze is beginning to ruffle the tops of the waves, and dark clouds are drawing across the sky, on the right side of the horizon we can see the dark outline of a large sailing-boat.

The vast presence of the sea was to remain one of Homer's key motifs to the end of his life. Henry James wrote of him: "He is almost barbarously simple, and, to our eye, he is horribly ugly; but there is nevertheless something one likes about him."

JOHN SINGER SARGENT

1856-1925

In the second half of the 19th century, American artists began once again to look to Europe, just as they had done a century before. This time, however, they did not do so only in order to learn from the European artists, but also in order to follow the stylistic developments that were emerging there. Sargent, a cosmopolitan man of the world, had trained in Europe, and had spent his formative years there amongst Americans who had chosen to live in the Old World. Sargent's teacher for many years was Carolus-Duran, a friend of Manet, who also was a great admirer of Velázquez. In his day, Carolus-Duran was a celebrated and sought-after portraitist. It was from him that Sargent learned to study his models and motifs with precision and to pay attention to balancing the tonal values. Portraiture was his preferred genre and the field in which he achieved his most skilfully structured works.

Although we can undoubtedly detect the influence of Whistler, a friend of Sargent, as well as that of Velázquez and other Spanish masters, the artist nevertheless retained his own distinctive artistic style. *The Daughters of Edward Darley Boit*, showing four little girls in delightfully relaxed pose in their bourgeois surroundings.reflects the influence of the old masters, blended with Impressionist brushwork.

540 UNITED STATES

WILLIAM MERRIT CHASE

1849-1916

In his country home near Shinnecock, Chase held a summer school of *plein-air* painting for twelve successive summers. Before beginning with this school, he had tended to paint in the darker, earthier tones used by his teachers at the Munich academy. Now, with an increasing interest in a more relaxed depiction of landscape, he turned in the 1890s to the stylistic techniques of the French Impressionists and, in doing so, influenced an entire generation of American painters. The brighter palette and the more relaxed brushwork of the new style perfectly suited his concept of an atmospheric portrayal of landscape.

The sweeping beaches and dunes of Long Island were ideal motifs to use as a vehicle for portraying the carefree mood of a summer day. The two women and the children are splashes of white on the grassy dunes: figures in a land-scape. The atmosphere of the landscape is transferred to the figures themselves. Yet unlike his French colleagues, Chase did not explore the impact of modern industrialized life on people. His landscapes tend to be pictures of escape from hectic city life to the unspoiled freedom of the countryside.

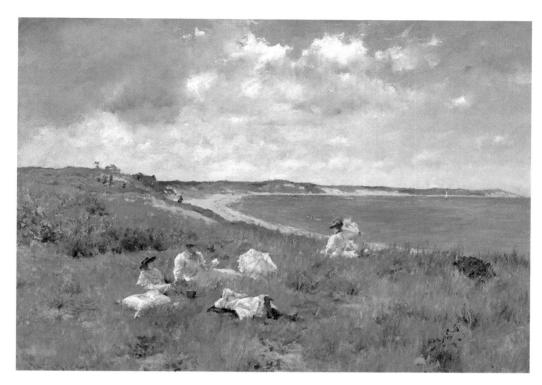

William Merrit Chase Leisure, 1894 Oil on canvas, 64.8 x 90.2 cm Fort Worth (TX), Amon Carter Museum

MAURICE PRENDERGAST

1859-1924

Prendergast, who was born in the same year as Seurat, went one important step further than the French Impressionists who influenced him. He, too, structured his picture plane with rough brushstrokes of pure colour; yet the reduction of his forms already indicates the direction that art was to take in the 20th century. He ignored the fashionable colour theories of the day and allowed himself to be guided by his own painterly intuition in the composition of his pictures, juxtaposing daubs of colour in a bid to capture the glittering and shimmering light of fleeting movement. Prendergast's painting never demonstrated any political commitment or critical social commentary and he chose peaceful scenes as his motifs, transposing them to the canvas like a prism of ever-changing colour.

Around the turn of the century, the path from Piazza San Marco to the Riva degli Schiavoni was thronged with crowds, their hats, parasols and dresses creating a refreshing and colourful contrast to the expanses of water and sky and the huddled houses. Stylistically, Prendergast represents the end of American Impressionism and the beginning of a truly modern style of painting in the United States.

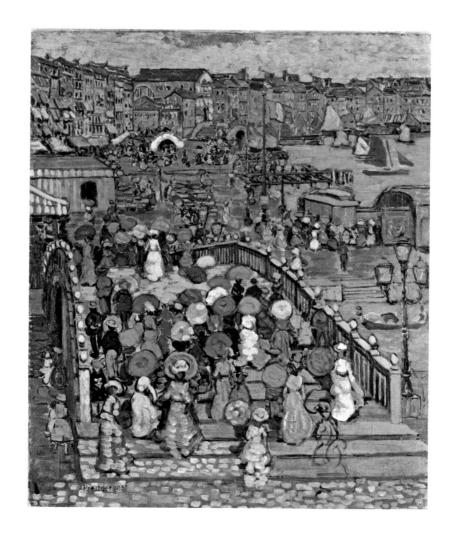

Maurice Prendergast Ponte della Paglia in Venice, 1899 Oil on canvas, 71 x 58.5 cm Washington, Philipps Collection

llya Yefimovich Repin Zaporozhian Cossacks (sketch), c. 1878 Oil on canvas, 67 x 87 cm Moscow, State Tretyakov Gallery

llya Yefimovich Repin Portrait of Vera Alekseevna Repina, 1882 Oil on canvas, 140 x 91.5 cm Moscow, State Tretyakov Gallery

ILYA YEFIMOVICH REPIN

1844-1930

Repin was very much an artist of his time and of his country, and in his art he naturally united the influences he had drawn from seemingly contradictory sources. On the one hand, the painting associated with the royal court and high society would have been quite inconceivable without the constant contacts with Central Europe and, of course, Paris. On the other hand, enormously expressive popular and religious art of high quality had always existed in Russia. The liberal intelligentsia of the day was full of unrest, and many new directions were beginning to evolve, heralding a reorientation of lifestyles and social structures.

For Russian art, this brought with it a nascent self-confidence in its own achievements, emancipation from the European model and recognition of the country's own specific characteristics and requirements. This found expression in distinctly Russian forms of realism, Impressionism and symbolism.

Repin's oil sketch of *Zaporozhian Cossacks* exists in two further monumental versions in Kharkov and St Petersburg. The motif has an authentic historical background: in 1675, the Cossacks had crushed the Turkish sultan, but the sultan nevertheless sought a capitulation agreement with the victors. In strong, bright colours, Repin gives a realistic portrayal of the Cossacks and their exuberant delight at penning a reply to the sultan. The wording of the letter still exists; it is a flood of florid oriental metaphor and ridicule.

Repin was also a talented and sought-after portraitist. In his Portrait of Vera Alekseevna Repina he combines the subtle skills of his portraiture with his ability to capture the mood of a fleeting moment. In doing so, he has created a symphony of dark reds and browns that bears comparison with Titian's handling of colour. Every tone and nuance has been explored, blended and contrasted with the paler hues of skin and fabric. The actual subject has been rendered with the meticulous precision of fine painting, bringing out each detail of the materials, their surface textures and the effect of light, while the ambient surroundings are more diffuse and impressionistic - in itself a delightful contrast. A young woman is resting in a large armchair upholstered in wine red. Her eyes are closed, her posture graceful, with one hand at her head, and with her legs crossed. Though Repin has portrayed the young woman at a moment of rest, he is a quiet observer and not an intruder, for she presents herself in an attitude of perfection that brooks no indiscretion.

542 RUSSIA

Volkmar Essers

CLASSICAL MODERNISM

Painting in the first half of the 20th century

Classical Modernism evolved within the atmosphere of tension generated by the dichotomy between figurative and non-figurative art, realistic portrayal and abstraction. Changing perceptions of society brought in their wake new perceptions of form, space, light, time and movement. In France, Matisse created images of peerless harmony born of his enthusiasm for colour, while Braque and Picasso broke the mould of conventional concepts of form. Delaunay combined form and colour in a way that influenced the painters of the Blauer Reiter group. Whereas such new movements as Fauvism, Cubism and Futurism still retained certain figurative elements, Kandinsky was the first to take the radical step to pure abstraction. For Klee, on the other hand, abstract forms were a source of inspiration for his highly imaginative creative approach.

Painting as a vehicle of personal expression was taken to new heights by Chagall, Modigliani, Kirchner and Beckmann. The surrealists Dalí, Magritte, Max Ernst and Miró plumbed the depths of the subconscious in their works. In Russia and the Netherlands, Malevich and Mondrian sought to ban all that was personal from the new visual world they created, using strictly geometric forms of abstraction.

The painting of the 20th century, from the earliest works of classical Modernism onwards, simply cannot be understood as long as we expect artistic freedom to remain within certain bounds or demand that a painting should have some recognizable subject matter. Not only the abstract painters, but also those who still retained some signs of a mimetic relationship between art and visible reality, took art to extremes in the context of their day and age, permanently rolling back the boundaries of traditional ways of seeing.

When El Lissitzky (1890–1941) and Hans Arp (1887–1966) published *Die Kunstismen* (The Artisms) in 1925, they were able to list as many as fifteen different movements, with illustrations by way of example, even though their treatise was restricted to the ten years between 1914 and 1924. "Cubism, Futurism, Expressionism, abstract art, metaphysics, Suprematism, simultanism, Dadaism, purism, neoplasticity, merz, proun, verism, constructivism, abstract film." The sheer diversity they presented seems all the more confusing given the fact that, in the 20th century, so many different visual approaches were explored in rapid succession and sometimes even antithetical movements occurred simultaneously. Nevertheless, it is possible to identify certain correlations and basic undercurrents which permit us to link individual movements or understand how they influenced each other.

In terms of form and content, the many and varied changes that took place in the painting of classical Modernism can be pinnned down to a few fundamental transformations in visual concepts. These were: the liberation of colour and form from the reproduction of the object, culminating in abstraction; an emphasis on emotion and heightened personal expression on the one hand and a depersonalisation of the image in favour of structure and a new collective order on the other hand; the exploration of the subconscious in dreamlike and fantastic images.

The Liberation of Colour

The use of pure, unbroken colours irrespective of the natural colour of the objects portrayed is the single most obvious characteristic of a group of artists that included Henri Matisse (1869–1954), Maurice de Vlaminck (1876–1958), André Derain (1880–1954), Albert Marquet (1875–1947), Georges Rouault (1871–1958), Raoul Dufy (1877–1953) and Georges Braque (1882–1963). When they exhibited together at the Salon d'Automne in Paris in 1905, their strident colours prompted the critic Louis Vauxcelles (*1870) to ridicule them as "fauves", meaning "wild beasts". The exhilarating abandon with which they handled colour liberated one of the most fundamental elements of painting.

Pablo Picasso Portrait of Dora Maar, 1937 Oil on canvas, 92 x 65 cm Paris, Musée Picasso The explosive tonality of the Fauves was not without precursors. Other painters before them had sought to use colour in new ways, either by making it the foremost structuring element in the composition, as Seurat had done, or by using it to express emotions, as in the work of van Gogh, whose memorial exhibition in Paris in 1901 was the single most important event leading up to the formation of the Fauves. Apart from the influence of van Gogh, a keen interest in divisionism had also been aroused by the 1904 exhibition of paintings by Signac.

The Fauves rejected the gentle nuances of the Impressionist palette and sought a new expressive force in colour. They were not interested in a realistic rendering of nature. Instead, they created visions of green skies, yellow trees, blue roads and emerald green faces, by using the paints just as they were, straight from the tubes - or "dynamite cartridges", as Derain called them. A sense of space was created with neither perspectival depth nor shading, simply by superimposing, juxtaposing and interweaving areas of colour. The subject matter was no longer an independent entity, but merely a function of colour, and it was only through the distribution of colour in varying proportions on the canvas that the context and equilibrium of the picture was created. As a vindication of their aims rather than an explanation of its sources, the Fauves invoked an astonishing panoply of influences: the primitives, Gothic art, Rubens, El Greco, folk art, African sculpture.

Within five years, the shock of the Fauves had lost its sting. Some of the original members of the group began to turn once again to more traditional artistic values. Others, like Braque, moved on to explore new terrain. Matisse alone developed his life's work continuously on the basis of his enthusiasm for colour. Though he used garish and discordant tones, he was capable of profoundly subtle gradations of hues and, by limiting his palette to only a few colours and distributing them to create a delicately balanced structure, he produced images of incomparable harmony, as in his early masterpiece *Le luxe* (Paris, Musée d'Art Moderne) executed in 1907.

In Germany, Ernst Ludwig Kirchner (1880–1938), Karl Schmidt-Rottluff (1884–1976), Erich Heckel (1883–1970) and Fritz Bleyl (1880–1966) adopted an approach similar to that of the Fauves, and very possibly influenced by them. In 1905, they founded the Die Brücke group in Dresden. In 1906, when they held their first group exhibition, they were joined by Max Pechstein (1881–1995) and Emil Nolde (1867–1956) who remained with them for only two years.

The name Die Brücke, which means "the bridge", was intended to symbolize their aim of linking all the revolutionary tendencies of the day in Germany. Their sense of innovation and of moving forward into a new era is expressed in their programme, formulated by Kirchner in 1906: "With faith in progress and in a new generation of creators and spectators we call together all youth. As youth, we carry the future and want to create for ourselves freedom of life and of movement against the

long established older forces. Everyone who reproduces that which drives him to creation with directness and authenticity belongs to us." Clearly, for the artists of Die Brücke, their innovative approach was not a question of exploring colour for its own sake, but one that addressed existential issues right from the start.

Like the Fauves, van Gogh, whose paintings were shown in Dresden in 1905 and 1908, was an important influence on the artists of Die Brücke, as were Gauguin and Seurat. Munch was also exhibited, and his ecstatic imagery, in which colour reflects inner emotion and turmoil, did not miss its mark. In fact, the work of this German group is often charged with an emotional and psychological tension quite alien to the paintings of Matisse, and it is this, in particular, that sets them apart from the pure colorism of the Fauves. The clear distinction between their respective styles was not diluted by the increasingly direct contact between the two groups; Pechstein met the Fauve artists in Paris in 1907, and in 1908 they exhibited in Dresden. In 1909, Kirchner visited the Matisse exhibition in Berlin. Another important factor in their development was the fact that an interest in folk art and visits to ethnological museums were gradually becoming a must for any progressive artist.

The artists of Die Brücke heightened colority to the point of dissonance. Kirchner and Heckel outlined their ornamental

Alexei von Jawlensky The Red Shawl, 1909 Oil on canvas, 54 x 49 cm Private collection

colour fields with bold, angular contours, while Schmidt-Rott-luff openly juxtaposed them. They also explored the possibilities of the woodcut, a technique ill-suited to the more light-hearted approach of the Fauves, and adopted some of its formal severity and angularity in their paintings. Their motifs were drawn from their immediate surroundings: the studio, a holiday landscape, their artist friends, nudes and still lifes. The period in which Die Brücke produced paintings of unbroken, radiant colour was as brief as it had been for the Fauves. When the group moved to Berlin in 1911, the explosion of colour calmed to a more subdued tonality and a renewed emphasis was placed on content.

The Renewal of Form

Shortly after the liberation of colour from the representation of objects, form and structure underwent a similar process. Influenced by a close study of Iberian and African sculpture, Pablo Picasso (1881–1973) began preparing preliminary sketches in 1906 for his 1907 painting, Les Demoiselles d'Avignon (ill. p. 569). The influence of the "primitives" was further consolidated by the impact of the 1907 Cézanne exhibition in Paris. According to Cézanne, "Everything in nature is modelled on the sphere, the cone and the cylinder." When Braque began to apply these ideas in his landscapes of L'Estaque, the critic Vauxcellles referred to the results disdainfully as "little cubes". So it was that the selfsame person whose scorn had given the Fauves their name was also instrumental in coining the term "Cubism". During the brief period between 1908 and 1914, Picasso and Braque developed the key aspects of this style that was to revolutionize our way of seeing.

In the first phase of Cubism in 1908/09, a few pictorial themes such as landscape, still life and figure (usually a half-figure with a musical instrument) were built up of basic geometric forms, resulting in angular entities whose self-contained corporeality underlines the sculptural quality of the objects. The palette, reduced to ochre, brown and green, has no independent value, but serves solely to lend clarity to the form. The illusionistic depth of central perspective is replaced by the simultaneous projection of different views and angles. Instead of a uniform pictorial space, we find an independent network of interconnected volumetric forms.

During the second Cubist phase, from 1910 to 1912, the term analytic Cubism gained currency, referring to the increasing deconstruction and dissection of volumes, lines and planes and the breakdown of clear delineation into a fluid interpenetration of planes that created an alternating interaction of positive and negative forms. Volume and space became inextricably linked. The break with a realistic representation of objects was pushed to its limits until the subject matter or theme of the painting became barely recognizable and pictorial structures verged on abstraction. Colour alternated in fragments of ochre and grey, and short, abrupt lines created a rhythmic formal texture.

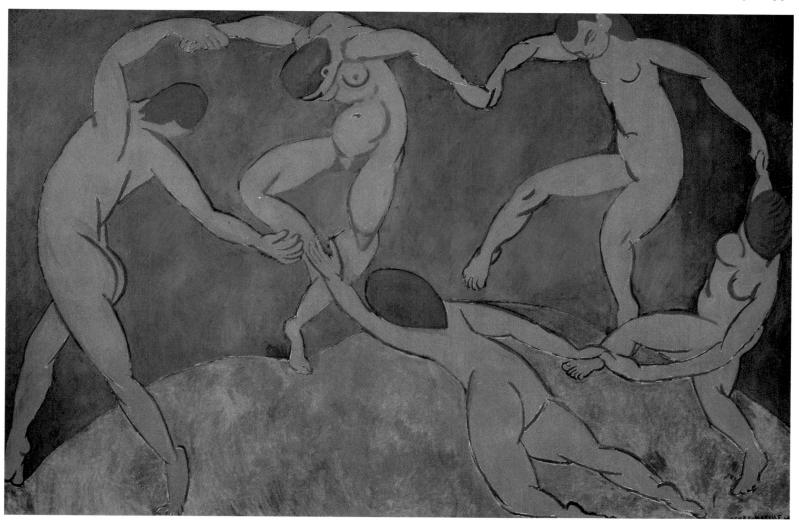

Henri Matisse Dance (La Danse), 1910 Oil on canvas, 260 x 391 cm St Petersburg, Hermitage

Between 1912 and 1914, the third phase, known as synthetic Cubism, began with a technical innovation: a wide variety of everyday materials such as newspaper cuttings, cigarette packs, matchboxes and scraps of wallpaper were pasted into the pictures. The introduction of collage exerted an influence on 20th century art that was destined to go far beyond the bounds of Cubism. Picasso and Braque increasingly integrated aspects of daily reality into their work, while at the same time drawing attention to the materiality of the picture itself as an object. The carefully constructed layering of paper fragments influenced their overall style. Large-scale structuring created a more self-contained imagery, while the abbreviated portrayal of objects in distinctly contoured planar fragments took on a new representational clarity. Everything seemed to be pressed together in a single, flat layer. A return to a broader and brighter palette structured the planarity of the paintings and heightened the tension inherent in its forms. At the same time, however, the renewed colority began to regain an independent significance that verges on the garishly bright in Picasso's case.

Although Picasso and Braque eschewed exhibitions while they were systematically developing Cubism, their innovations fired the imagination of young artists in Paris right from the start. As early as 1910, Robert Delaunay (1885–1941), Albert Gleizes (1881–1953), Jean Metzinger (1883–1956) and Henri Le Fauconnier (1881–1946) joined the ranks of the Cubists, followed a year later, by Juan Gris (1887–1927). In 1911, the Cubists, with the exception of Picasso and Braque, exhibited their works as a group for the first time. Gleizes and Metzinger undertook the first attempt at a comprehensive definition and vindication of the new painting in *Du Cubism* (On Cubism), published in 1912. Amongst the circle of writers who supported the new movement, Guillaume Apollinaire published his book *Les peintres cubistes* (The Cubist Painters) in 1913.

Whereas Picasso and Braque explored the possibilities of Cubism in the domain of landscape, still life and figure, Fernand Léger (1881–1955) addressed the visual world of the machine age. Explaining his choice of motifs, he wrote: "Each artist possesses a weapon that allows him to attack tradition. In

Georges Braque Fruit Bowl and Glass, 1912 Charcoal and papier collé, 62 x 44.5 cm Private collection

search of the explosive and the intense, I looked to the machine, just as others look to the nude or the still life. I try, with mechanical elements, to create a beautiful image." Léger developed a special form of Cubism whose leitmotif is the tube or cylinder. In 1913, Léger began work on a series of paintings entitled *Contrastes et formes* (Contrasts of Form) in which various constellations of cylindrical forms are presented in shades of blue-evoking metal, machinery and technology without any specific functional correlation. Though Léger was fascinated by the machine age, he did not seek to reproduce it in his paintings, preferring instead to adopt individual machine forms for his imagery.

Colour, which the Cubists had neglected for several years, giving precedence to form, became Delaunay's focal theme. In 1912, in his series of *Window* paintings, he explored the dissolution of form in colour. The lyricism of his work prompted Apollinaire to speak of a cubism of light and colour, for which he coined the term "orphism". Delaunay proclaimed the independence of the image: "Not a copy of nature – but the first abstract painting in colour. Colour, colours with their own laws, their contrasts, their slow vibrations, their intervals – all these rela-

tionships form the basis of a painting that is no longer imitative, but inherently creative on grounds of technique alone." Delaunay's paintings and theoretical statements had an enormous impact on the German artists of his day, most notably Marc, August Macke (1887–1914) and Paul Klee (1879–1940). Delaunay's treatise *Sur la lumière* (On Light) was translated into German by Klee and published in his Berlin magazine *Der Sturm* in 1913 under the title *Über das Licht*.

Movement and Time

By breaking down the object and structuring images of simultaneity, Cubism prepared the ground for the portrayal of movement. Movement defies direct, realistic representation in painting. Whereas in film, it can be captured in temporal sequences, in painting it is represented by the simultaneous reiteration of a series of different stages of movement.

The aim of visualizing movement and time, dynamics and energy was taken up by a group of Italian artists who called themselves futurists in reference to their forward-looking orientation. Their *Manifesto of Futurism*, penned by the Italian poet Filippo Tommaso Marinetti (1876–1944) was published on the front page of the renowned Parisian daily *Le Figaro*, marking the birth of a movement that went on to produce some 180 manifestos addressing every domain of life and art. The very fact that it was published in Paris ensured that the manifesto gained international attention. Marinetti announced provocatively: "We affirm that the world's magnificence has been enriched by a new beauty: the beauty of speed. A racing-car whose hood is adorned with great pipes, like serpents of explosive breath — a roaring car that seems to ride on grapeshot is more beautiful than the *Victory of Samothrace*."

Umberto Boccioni (1882–1916), Carlo Carrà (1881–1966), Luigi Russolo (1885–1947), Giacomo Balla (1871–1958) and Gino Severini (1883–1966) followed suit on 11 February 1910 by drawing up and signing their *Futurist Painting: Technical Manifesto*. They were enthusiastic supporters of modern technology, the exhilaration of velocity and a new beauty that is not born of harmony, but of aggression and struggle. They had little interest in the past or in tradition, which they felt merely hindered their own powers. They saw war as a means of destroying the past and starting anew out of chaos. Their artistic ideas did not stand the test that came with the outbreak of the First World War, in which several of them were killed.

For the Futurist painters, the late Impressionist division of colours and, above all, the influence of Cubism since 1911, paved the way for them to put their new creed into practice. On this basis, Boccioni succeeded in heightening the dynamics of simultaneous permeation into a vivid impression of the spiralling movement of a maelstrom in his 1911 painting *The Noise of the Street Enters the House* (ill. p. 576). Boccioni even portrays time in his painting. The futurists did at least draw the viewer's gaze towards simultaneous perception and succeeded in raising the question of visualizing movement, time and space.

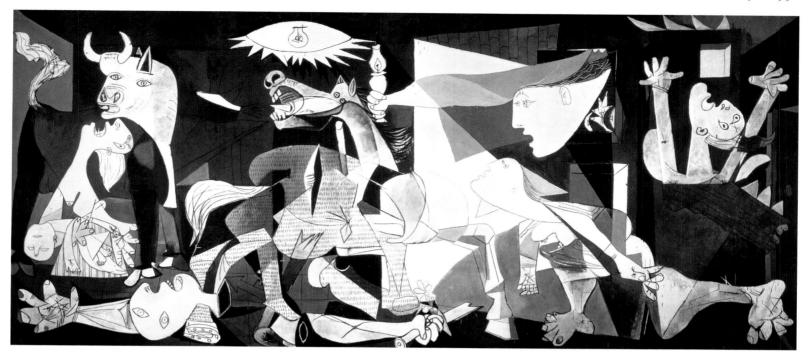

Pablo Picasso Guernica, 1937 Oil on canvas, 349.3 x 776.6cm Madrid, Centro de Arte Reina Sofía

The Advent of Abstract Art

Although every new movement since 1900 - Fauvism, Die Brücke, Cubism and Futurism - had radically questioned the mimetic function of the image and focused instead on the inherent laws of painting, all of them had retained signs of visual reality. The total break with figurative painting that was to revolutionize traditional attitudes to art was achieved by a small circle of progressive artists who had grouped together in Munich under the name Neue Künstlervereinigung (New Artists' Association). They included Adolf Erbslöh (1881–1947), Alexander Kanoldt (1881–1939), Marianne von Werefkin (1860– 1938) and Gabriele Münter (1877–1962). Marc, Karl Hofer (1878-1955) and the brothers David (1882-1967) and Vladimir Burliuk (1886–1917) soon joined them. The spokesmen of the Neue Künstlervereinigung were Kandinsky and Alexei von Jawlensky (1864–1941). Their work was closely related to Fauvism and folk art traditions.

In his autobiography *Riickblicke* (Reminiscences) Kandinsky reports on an incident he experienced in his Munich studio in 1909: "I was returning, immersed in thought, from my sketching, when on opening the studio door, I was suddenly confronted by a picture of indescribable and incandescent loveliness. Bewildered, I stopped, staring at it. The painting lacked all subject, depicted no identifiable object and was entirely composed on bright colour patches. Finally I approached closer and only then saw it for what it really was — my own painting, standing on its side against the wall. Next day I tried to recapture the same impression in daylight, but I did not succeed fully: even lying on its side, I could still recognize the ob-

jects and the fine sheen of twilight was missing. One thing became clear to me: that objectiveness, the depiction of objects, needed no place in my paintings, and was indeed harmful to them."

In 1913, Kandinsky painted his first abstract watercolour, later backdating it to 1910. Between 1910 and 1914 he painted figurative, abstract and mixed figurative-abstract works. Although a number of painters since 1900, including Fancis Picabia (1879–1953), František Kupka (1871–1957), Robert Delaunay, Franz Marc, Hans Arp, Mikhail Larionov (1881–1957), Kasimir Malevich (1878–1935) and Piet Mondrian (1872–1944), had independently abandoned the figurative in their work, Kandinsky is generally acknowledged as the founder of abstract art. This is because he is the one artist who consistently pursued the path of abstract painting and systematically underpinned his innovations and discoveries in theoretic writings.

Kandinsky's conversion to abstraction led, in 1911, to the break-up of the Neue Künstlervereinigung. That same year, Kandinsky and Marc founded the Blauer Reiter as an association of like-minded artists with a committee for exhibitions and publications. Apart from Kandinsky and Marc, the first exhibition of the Blauer Reiter group included Heinrich Campendonk (1889–1957), Macke, Münter and, as a guest from Paris, Delaunay. Klee was represented in the second exhibition in 1912.

1912 was also the year in which Kandinsky and Marc issued the Blane Reiter Almanach addressing painting, music and folk art, and the year in which Kandinsky published his major programmatic treatise Über das Geistige in der Kunst (On the Spiritual in

Wassily Kandinsky Untitled, 1910 (1913) Pencil, watercolour and ink on paper, 49.6 x 64.8 cm Paris, Musée National d'Art Moderne, Centre Georges Pompidou

Art). Inaccessibly complex as the fundamental principles of his book may be, it has remained a key text on abstract art right up to the present day.

Kandinsky rejected materialism and embraced spirituality. He made a clear distinction between nature and art, regarding art as separate from the practicalitites of life. For him, art did not mirror nature, but arose from an inner emotional urge capable of expressing itself independently of the external forms of nature. He saw "the principle of internal necessity" as the yardstick of all art, meaning that art renders perceptible something otherwise imperceptible, namely the universal law of a *harmonia mundi*. He considered two painters as the pioneers of abstract art: "Matisse - colour. Picasso - form. Two indicators of a great aim."

Music, which requires neither words nor tangible content, was a central point of reference for Kandinsky, who also linked various emotions and synaesthetic relationships in a simultaneous perception of colours and sounds. According to Kandinsky: "Colour is the keyboard. The eye is the hammer. The soul is the piano, with its many strings. The artist is the hand that purposefully sets the soul vibrating by means of this or that key." Kandinsky's theory of art had its roots in turn of the century Symbolism and bore affinities with the pre-war Expressionist movement. His orientation towards the cosmic was in keeping with the spirit of the times. Only in their choice of words do we discern a difference between Kandinsky and Klee: "The making of a work of art is inherently cosmic. The originator of the work is the spirit. That is the cosmic tragedy in which hu-

mankind is only a sound, just one single voice among many and in which the centre is pushed into a sphere that approaches divinity."

For Kandinsky, colour had a musical, symbolic and cosmic significance. Yellow sounds to him like a trumpet, an aggressive and typically earthly colour. Blue, depending on how dark or pale it is, sounds like a flute, a cello, a double bass, or an organ; it is the colour of tranquility, the typical celestial colour. Red, depending on the shade, sounds like a tuba or a violin; it is passion and channeled force. White means the nothingness before the beginning, before the birth, symbol of a world high above us. Black, on the other hand, is a silence with neither future nor hope. Marc, who went furthest of all the Blauer Reiter artists along Kandinsky's road towards abstraction, also attributes symbolic meanings to colours. For him, blue is the male principle, yellow the female principle, while red signifies matter in general.

Music, so frequently invoked in legitimizing the abandonment of subject matter, was represented in the exhibition and the *Blauer Reiter Almanach* by the composer Arnold Schönberg (1874–1951). At the same time as Kandinsky was developing abstract paintings, Schönberg took the decisive step towards atonal music. Driven by them same urge to underpin his works theoretically, Schönberg published his *Harmonielehre* (Theory of Harmony) in 1911. Schönberg's influential publication bears some remarkable correspondences to Kandinsky's *On the Spiritual in Art*. Both are interested in the hidden inner sound of the world; both posit and document the spiritual principle of art.

After visiting a Schönberg concert in Munich in January 1911, Marc wrote to Macke: "Can you imagine a music from which tonality (that is to say, the adherence to a certain key) is entirely absent? I couldn't help thinking of Kandinsky's great compositions and of Kandinsky's 'leaping colours' when I heard this music, which lets each note stand for itself (a kind of white canvas between the patches of colour!) Arnold Schönberg seems to be convinved of the ineluctable dissolution of the European laws of art and harmony in the same way as the Munich Artists' Association." Marc regarded this dissolution as a positive and liberating gain, as the revelation of a new creative beginning, whereas the critics saw in it only a decline into utter chaos. On the outbreak of the First World War, in which both Marc and Macke fell, Kandinsky left Munich and returned to Russia.

Unsettling Reality

An important motivation for the Brücke artists – Kirchner, Heckel, Pechstein and Schmidt-Rottluff – to move to Berlin in the autumn of 1911 was their hope of reaching a broader and more enlightened public in the capital city. In Berlin, Herwarth Walden (1878–1941) had been publishing his art magazine *Der Sturm* since 1910. It was to become the most important forum for introducing the German public to contemporary French and German art. At the same time, Walden was also a talented organizer of exhibitions, which he held at the Sturm gallery or sent on tour. In 1912 he showed the work of the Blauer Reiter artists.

In 1911, the art historian Wilhelm Worringer (1881–1965) published an article in Der Sturm in which the word Expressionism was used for the first time to describe the visual arts. Worringer actually applied the term to Cézanne, van Gogh and Matisse, for whom it is no longer used today. Nevertheless, this would certainly seem to indicate that the work of these artists was regarded at the time as a heightened form of expression and that their work was felt to be in some way related. With respect to the Blauer Reiter exhibition at the Sturm gallery the term was also used in connection with the modern trend in German art; that is to say, with artists whose new formal language sought to express both emotional and social perceptions. Expressionism is not a uniform movement in terms of either form or content. The spectrum ranges from Marc's endeavour to "pantheistically sense the trembling and flowing of blood in nature" to Max Beckmann's (1884–1950) fascination for the "great human orchestra" of the city.

The bewildering diversity of impressions and perceptions and the hustle and bustle of the city was what captured the imagination of the Expressionists, providing them with a complex subject, that would be taken up by them in their art, literature and film. The city was a mirror of existential struggle and sensual pleasure, teeming masses and solitude, affluence and poverty, exhilaration and danger. For the Expressionists, the people were more important than the backdrop, and they

often portrayed figures on the margins of bourgeois society as typical representatives of urban life.

Amongst the artists of the Brücke, the most vehement reaction was that of Kirchner. His Berlin street scenes of 1913/14 are images of urban alienation. His protagonists are prostitutes and their clients. Their encounters are rituals of soliciting and selling. Sharp, incisive lines and stark contrasts of light and shadow give the figures something threatening and aggressive. Their faces are as anonymous as masks. His works describe the lonely, the forlorn and the loveless. Apart from these images of alienation, Kirchner also portrayed a life of freedom in nature, executed during the summer months he spent on the Baltic island of Fehmarn or at Lake Moritzburg near Dresden.

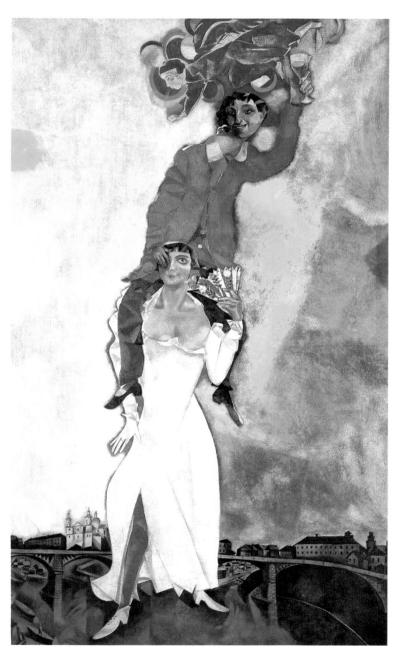

Marc Chagall
Double Portrait with Wineglass (Bella and Marc), 1917
Oil on canvas, 235 x 137 cm
Paris, Musée National d'Art Moderne, Centre Georges Pompidou

Piet Mondrian Broadway Boogie-Woogie, 1942/43 Oil on canvas, 127 x 127 cm New York, The Museum of Modern Art

In Ludwig Meidner's (1884–1966) Anleitung zum Malen von Großstadtbildern (Guidelines for Painting Urban Scenes) published in 1914, he writes: "We have to start painting our home at last, the city, which we love infinitely. On countless canvases the size of frescos, our trembling hands should scribble all that is magnificent and strange, monstrous and dramatic, in the avenues, railway stations, factories and towers." Meidner's street scenes and cityscapes of 1913 have an unsettling futuristic dynamism full of plunging perspectives. Meidner's apocalyptic visions are bursting with an angst-ridden sense of being cast at the mercy of civilization's destructive potential. One year before the outbreak of the First World War, the cities in his canvases were harbingers of impending doom.

The war unleashed a deep moral crisis amongst the German artists Beckmann, Otto Dix (1891–1969), George Grosz (1893–1959), Kirchner and many others. In 1915 Kirchner painted himself as a drinker and as a soldier with his hand shot away, even though he had not even been to the front during his brief military service. Nevertheless, his fear was barely under control. Kirchner wrote in a letter in 1916: "The pressure of war and the increasing superficiality weighs heaviest of all. I constantly have the impression of a bloody carnival. It is as though the decision is hanging in the air and everything is topsy-turvy. Bloated, staggering to work, though all work is futile and mediocrity is storming everything in its path. Becoming like the whores I used to paint. Washed out, gone next time. All the same, I still try to order my thoughts and create an image of our time out of the confusion, which is, after all, my task."

Grosz, who was invalided out of the armed forces, described the motivation behind his artistic production: "I drew and painted out of contradiction and tried, through my work, to portray the world in all its ugliness, sickness and mendacity." For Grosz, the street was a place of violence, terror and brutality; he castigated the bourgeoisie by revealing its perverse and even criminal side.

Beckmann took a rather different stance in his Schöpferische Konfession (Creative Credo), published in Berlin in 1920: "The war has now dragged to its miserable end. But it hasn't changed my ideas about life in the least, it has only confirmed them. We are on our way to very difficult times. But right now, perhaps more than before the war, I need to be with people. In the city. That is just where we belong these days. We must be a part of all the misery which is coming. We have to surrender our heart and our nerves, we must abandon ourselves to the horrible cries of pain of a poor, deluded people. Right now we have to get as close to the people as possible. It's the only course of action which might give some purpose to our superfluous and selfish existence - that we give people a picture of their fate. And we can only do that if we love humanity." In his paintings, Beckmann shows people in harrowingly claustrophobic situations, deformed by brutality and passions.

In contrast to the dismay and suffering expressed by some at the circumstances of the time, there were other artists who vociferously proclaimed their sarcastic criticism of outmoded values, monotony and empty functionalism. From Zurich, where the members of the Cabaret Voltaire had adopted the meaningless name Dada, the anti-art movement spread through the art centres of New York, Paris, Berlin, and even took hold in Hanover and Cologne.

Max Ernst (1891–1979) who was a member of the Cologne Dada group from 1918 to 1922, wrote: "A war as terrible as it is was senseless robbed us of five years of our lives. We were there when everything we had been taught was right, beautiful and true was plunged into an abyss of ridicule and shame. My works of that period were not meant to please, they were meant to make you howl."

Designs for a New World

Even during the First World War, artists in Russia and the Netherlands were joining forces with the aim of creating designs for a new world, and breaking down the barriers between art and technology. Every field of modern life was to be included: fine arts, architecture and urban planning, typography and advertising, photography and film. Geometric forms began to predominate in the visual arts.

In Russia, Kasimir Malevich presented his *Black Square* (St Petersburg, Russian Museum). In an accompanying text, he described his new style: "The midnight hour of art has tolled. The fine arts have been banned and ostracized. The artist as idol is a prejudice of the past. Suprematism compresses all

painting into a black square on a white canvas. I have invented nothing. All I sensed within me was night and in night I glimpsed that which is new, that which I called suprematism. It is expressed in the black area that forms a square."

After the October Revolution of 1917, Suprematism became the predominant style in Moscow. Apart from painting, Malevich also turned his attention to architecture, and his suprematist theory was aimed at a universe with neither aims nor boundaries. According to Malevich, the world in which we live is an illusion born of our habit of separating individual entities from the universe by giving them names and allocating certain functions to them. He sought to present the true universe pictorially in coloured planarity, but even this, he felt, was not going far enough, and so he exhorted his readers to "swim in the white, free abyss; infinity is before you." In the west, his ideas had reached a wider public by 1927 at the latest, when Malevich had an exhibition in Berlin and his book *The Non-Objective World* was published by the Bauhaus under the German title *Die gegenstandslose Welt*.

El Lissitzky was also working on the realization of new ideas. Between 1919 and 1924, he created the abstract paintings he called Prouns. The word "proun" is actually an acronym made up of the first letters of the Russian phrase meaning "foundation of new forms in art". As Lissitzky said of his "prouns": "the canvas has become too small for me, and I have created the proun as a transition between painting and architecture. I treated the canvas and wooden panels as a plot of ground where my structural concepts are subject to a minimum of inhibitions. I used the range of black and white (with a blaze of red) as matter and material. In this way, a reality is created that is clear to all." Like Malevich, Lissitzky was fascinated by movement in space: "New inventions enable us to move in space in a new way with new rapidity will create a new reality. The static architecture of the Egyptian pyramids is overcome: our architecture rolls, swims, flies. Floating oscillation emerges. I want to be involved in inventing and designing this reality." In accordance with his concepts, Lissitzky turned his back on autonomous creative work after 1924 and worked as an inventor, constructor, photographer and typographer.

After 1921, the terms "Suprematism" and "proun" were superseded by the more all-embracing term "Constructivism" – a term derived from the relief constructions of Vladimir Tatlin (1885–1952), who concentrated on formal and material qualities and on the relationship between matter and space. Tatlin's 1919/20 design for the *Monument to the 3rd International* has come to be regarded as the very epitome of revolutionary art in Russia. A gradual reaction against Constructivism began to set in, culminating in the dismissal of their work as "degenerate" by 1931; Socialist Realism was gaining the upper hand.

In the Netherlands in 1917, a group of painters, sculptors and architects were associated with the magazine *De Stijl* which was published until 1928 by Theo van Doesburg (1883–1931).

Kasimir Malevich Suprematist Painting, 1916 Oil on canvas, 88 x 70.5 cm Amsterdam, Stedelijk Museum

Their aim was to present a universal harmony in which individualism was overcome. Like the Russian artists, geometrism and constructivism are their artistic means of creating a better world.

The artist who transposed their ideas into painting most persuasively was Mondrian, who also introduced the term "new plasticity". His images show full-blown abstraction in the sense that they completely dismiss sensual perception of visual reality. The pictorial elements are reduced to their basic elements: straight line, right angle - horizontals and verticals - and the primary colours red, yellow and blue with the non-colours black and white. It is a highly disciplined and reduced painting. Mondrian, however, is not interested primarily in designing elementary forms, but in elementary correlations. The balanced interrelationship of various proportions is the expression of his Weltbild based on the antagonism between microcosm and macrocosm, or, as Mondrian himself said: "Through the horizontal-vertical division of the rectangle, the neoplasticist gains the tranquility and equilibrium of duality: of the universe and of the individual."

In Germany, the design for a new world did not begin until after the end of the First World War. Following on from van de Velde's Kunstgewerbeschule (school of applied arts), the Staatliches Bauhaus was founded in Weimar in 1919. Its aims were less utopian than those of Malevich's Suprematism or Mondrian's neoplasticity. As a training facility, it was also rather more down-to-earth. The students were to be taught to apply artistic experience to the design of architecture and everyday objects. The programme issued by Walter Gropius stated: "Architects, painters, sculptors, we must all return to the crafts! For there is no such thing as 'professional art'. There is no essential difference between the artist and the craftsman. The artist is an exalted craftsman. By the grace of heaven and in rare moments of inspiration which transcend his will, art may unconsciously blossom from the labour of his hand, but a foundation in handicraft is essential for every artist. It is there that the primary source of creativity lies."

Lyonel Feininger (1871–1956), who illustrated Gropius' Bauhaus programme with a woodcut of a cathedral in his own distinctive style of crystalline cubism, was a painter at the Bauhaus since its foundation. He was followed by Paul Klee, Oskar Schlemmer (1888–1943), László Moholy-Nagy (1895–1946) and Kandinsky, who had returned from Russia. Teaching at the Bauhaus encouraged painters to become more aware of their attitudes in order to enable them to pass on their knowledge of the effects of colour, form and materials to their students.

Klee published his Wege des Naturstudiums (Towards a Study

of Nature) in 1923 and his *Pädagogisches Skizzenbuch* (Pedagogical Sketchbook) in 1925 as Bauhaus Book 2. At the art association in Jena, Klee held his famous lecture "On Modern Art". Kandinsky's teaching at the Bauhaus produced his *Punkt und Linie zu Fläche* (Point and Line to Plane), which was published in 1926 as Bauhaus Book 9. He drew up a grammar of elementary forms and explored planimetric figures to determine their fundamental properties and their expressive value, by combining the objective with the subjective. He defined composition as "an exact, regulated organization of vital forces contained within the elements in the form of tension."

The *avant-garde* music of the day also underwent a similar transformation. Schönberg systematized free atonality to create the twelve-tone method. The strictly atonal compositional approach based on this row or sequence of twelve notes was extremely strict. It arose from the composer's urge to "create the greatest possible interrelationship between the various parts" and it also meant a reduction in individuality.

The rational atmosphere of the Bauhaus encouraged the use of geometric elements by painters. Between 1914 and 1921, while he was in Russia, Kandinsky used geoemtric forms along-side irregular, organic forms for the first time, possibly under the influence of Suprematism and Constructivism.

At the Bauhaus, he completely abandoned the free structure of his early abstract pictures. Geometric forms are superimposed and seem to move as though within an endless space. Whereas

Joan Miró
The Poetess, 1940
Gouache and turpentine paints on paper, 38.1 x 45.7 cm
New York, Collection Colin

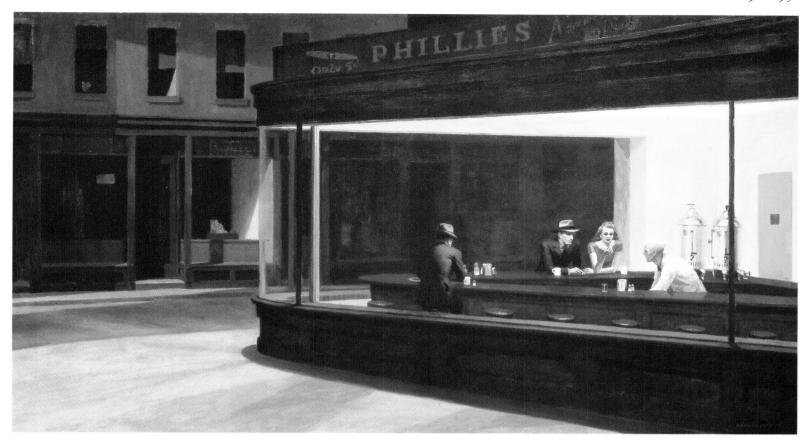

Edward Hopper Nighthawks, 1942 Oil on canvas, 76.2 x 152.4cm. Chicago (IL), The Art Institute of Chicago

Kandinsky avoided figurative associations, Klee positively sought them. Unlike Kandinsky, Klee sought to combine the laws of nature and art. Both these artists, however, retained the fundamental principles of the Blaue Reiter period, seeing a network of interactive forces in geometric forms as well, and maintaining the cosmic dimension of their art. In the work of Moholy-Nagy, on the other hand, the constructivist images are linked with a new order of concrete reality.

The tension between fine art and applied art was not entirely swept aside at the Bauhaus. Schlemmer, in his many activities as painter, sculptor, set designer, ballet choreographer and art teacher, acted as a mediator between various disciplines, but rather than seeing a bond between them, he retained their individual independence. On 18 March 1924, he noted in his diary: "I see the way towards the future like this: the paths diverge. The architectural, constructive tendencies of recent movements in art lead to direct application, constituting a solution for so many recent problems. Application: designing the everyday objects around us or, even better - house construction and everything that entails. On the other hand, the death of art proclaimed by the proponents of application (the true, non-painting Constructivists, incidentally) is found to be untrue; I mean the picture, painting, the metaphysical, are saved and demonstrated by the same constructivist tendencies that some apply pragmatically and others apply ideally in design."

As the political situation in Germany became increasingly tense, the Bauhaus was forced to move from Weimar to Dessau in 1924/25 and then to Berlin in 1932. Ludwig Mies van der Rohe (1886–1969), the last director of the Bauhaus, endeavoured to keep the school going, but had to give up in 1933. The National Socialists equated abstract art with Bolshevism and proclaimed the entire modern movement to be *entartet* ("degenerate"). A touring exhibition entitled *Entartete Kunst* (Degenerate Art) was organized to pillory modern art.

Beyond Reality

Giorgio de Chirico (1888–1978) sought to go beyond the bounds of mere physical reality with an art he called *pittura metafisica*. Impressed by the city of Turin, we wrote: "On the city squares, shadows cast their geometric riddles. Above the walls stand senseless towers, heightened by bright little flags," and, continuing in this vein, he added, "it is the frosty twilight hour of a clear day towards the end of spring. The depths of the celestial dome, green as the ocean, makes anyone who gazes at it dizzy."

For de Chirico, it was clear that "madness is an inherent element of any profound artistic statement." In his view, madness meant the loss of memory: "The logic of our normal actions and daily lives is a continuous band of memory of the relationships between the environment and ourselves." In de Chirico's metaphysical paintings of the period between 1909 and 1919, this

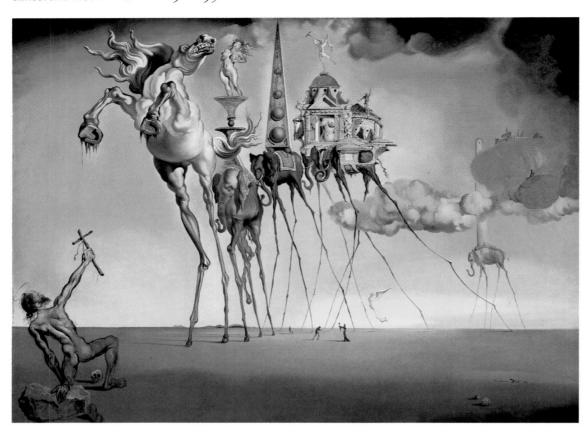

Salvador Dalí The Temptation of St Anthony, 1946 Oil on canvas, 89.7 x 119.5 cm Brussels, Musée Royaux des Beaux-Arts de Belgique

memory is erased. He could already look back on a considerable œuvre of metaphysical paintings when he was joined in 1917 by Ferrara Carrà, who had left the Futurists, Alberto Savinio (1891–1952) and Filippo de Pisis (1896–1956). Together, they founded the *arte metafisica* group. Giorgio Morandi (1890–1964) joined them a year later. *Pittura metafisica* became a direct precursor of surrealist art, which recognizes de Chirico as its main influence.

Surrealism emerged in the mid 1920s in response to increasing rationalization and perfectionism on the one hand, and as a counterpart to the rediscovered realities of the unconscious on the other hand. André Breton (1896–1966), the spokesman of the Surrealists, claimed in 1924, provocatively referring to the Christian credo: "I believe in the future dissolution of these apparently contradictory states of dream and reality into a kind of absolute reality, as one might say: *sur-réalité*." Each of the Surrealist painters had their own personal language, their individual mythology, their personal pictorial themes. The enigma lay in the spiritual approach rather than in the artistic form. The poet and *avant-garde* spokesman Apollinaire used the word "surrealist" for the first time in 1917.

As the description of an art movement, however, the term only began to take hold gradually once the writers Breton, Louis Aragon (1879–1982) and Philippe Soupault (1897–1990) had founded the magazine *Littérature* in Paris in 1919. Under the influence of Tristan Tzara (1896–1963), *Littérature* was initially concerned with Dadaism, before turning increasingly towards Surrealism. In 1922, with the arrival of Ernst and Man

Ray (1890–1976) in Paris, the circle of writers extended to include the visual arts a year before the actual founding of Surrealism. In 1924, Breton published the first *Manifeste du surréalisme* (Surrealist Manifesto). At the same time, the magazine *La Révolution Surréaliste* was launched and the Bureau de Recherches Surréalistes was opened in Paris.

Surrealism rendered the realms of the subconscious visible in paintings. It was an artistic revolution which, unlike Fauvism and Cubism, was not interested primarily in questions of colour and form, but in seeking new artistic possibilities and processes as a vehicle for expressing new subjects. By combining scientific research into the subconscious with findings on painful and pleasurable experiences, the Surrealists drew upon many contemporary and historical sources: psychoanalysis and the Fredian interpretation of dreams, fairytales and myths, spiritualism and alchemy, German romanticism and fantastic elements of art from the earliest days to the 20th century, naive painting and the art of the mentally ill, children and "primitive" peoples. In the world of literature, they acknowledged the influence of the Marquis de Sade (1740-1814), Edgar Allan Poe (1809–1849), Count Lautréamont (1846– 1870), Arthur Rimbaud (1854-1891) and Alfred Jarry (1873-1907).

In their quest for appropriate means of expression, the Surrealists developed a number of processes which include chance as a source of artistic inspiration: *frottage*, in which a paper is placed over a relief and the design is transferred to the paper by rubbing with charcoal or crayon; "decalcomania" in which ink

or paint is applied to paper, then folded or blotted onto another paper and the chance image obtained in this way is then elaborated by the artist; the scratch technique known as "grattage", the smoke technique known as "fumage" and the "sand painting" technique of scattering sand onto a canvas primed with paste. By alternating between different forms but also by combining them — automatic handwriting, chance and deliberate processes — multi-layered possibilities of expression emerged and the fantastic was also given a new dimension.

The first Surrealist exhibition at the Galerie Pierre in Paris included works by Arp, de Chirico, Ernst, André Masson (1896-1987), Joan Miró (1893–1983), Picasso, Man Ray, Pierre Roy (1880–1950) and Klee. Yves Tanguy (1900–1955), René Magritte (1898–1967), Salvador Dalí (1904–1989) and Alberto Giacometti (1901–1966) joined them and widened the spectrum that ranged from traces of subconscious painting to the principle of "automatic writing", including coded and symbolic portrayals and even representational renderings of dreams or enigmatic reality. The Surrealists explored literary, artistic and above all political questions with an intensity that led to changes in the magazine, which eventually adopted the name Le Surréalisme au Service de la Révolution and also prompted Breton to publish the second Surrealist Manifesto in 1930. During the Second World War, many of the surrealists emigrated to New York, where they were to have a profound influence on American art.

Abstract or Concrete Art?

Around 1930, Paris once again became the centre of an international artistic avant-garde. Devotees of abstract art formed groups such as the Cercle et Carré and Art Concret. These two groups were the precursors of Abstraction-Création, which was founded as an association to organize exhibitions of non-figurative art and publish statements on it in their Cahiers or yearbooks. "Abstraction, because certain artists have come to the concept of non-figuration by the progressive abstraction of forms from nature. Creation, because other artists have attained non-figuration direct, purely via geometry, or by the exclusive use of elements commonly called abstract such as circles, planes, bars, lines, etc..." What is referred to here as "creation" was to become established under the term "concrete art" from 1930 onwards – a term also adopted by Kandinsky, who emigrated to Paris in 1933. It refers to an art with no relation to the visual reality of purely geometric forms and correspondences, and whose painterly technique is precise, immaterial and impersonal.

Alongside the cool geometry of abstract art, however, more and more lyrical and coded aspects were developed. The geometry of Kandinsky's Bauhaus paintings was combined wih organic, semiotic and even musical forms and movements. The Symbolists also adopted semiotic aspects of form. In the 1930s, the work of Miró and Masson moved closer towards abstraction. The work of Arp, with its mutable organic forms, bears distinct

affinities to that of the Surrealists. The semiotic aspect became a key factor in art after 1945, influenced more by Kandinsky, Klee, the Surrealists and, in Germany, Willi Baumeister (1889–1955) than by the geometrists. This influence spread to the USA in the early 1940s, where Kandinsky's early *Improvisations* together with the surrealism of such painters as Arshile Gorky (1905–1948), Willem de Kooning (* 1904) and Jackson Pollock (1912–1956) led to the painting that came to be known as abstract Expressionism.

Never before in the history of art had the appearance of things – their colour, form and spatiality – changed so much, and never before had the range of concepts involved been so broad. The *avant-garde* movements added new dimensions of perception to what was already familiar, but also narrowed the view of their specificity and fragmented the holism of experience. Many important artists adopted aspects of the *avant-garde* movements, but nevertheless continued to develop their œuvre in concert with both their own inner motivation and with past tradition.

Such artists as Amedeo Modigliani (1884–1920), Marc Chagall (1887–1985), Chaïm Soutine (1893–1943) and Georges Rouault (1871–1958) spring to mind in this context. Others

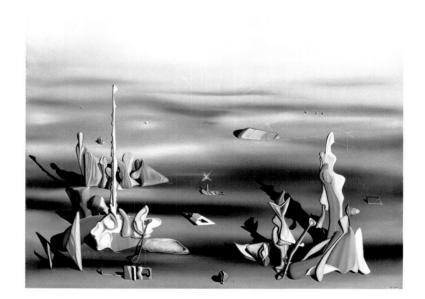

Yves Tanguy
The Five Strangers, 1941
Oil on canvas, 98 x 81.3 cm
Hartford (CT), The Wadsworth Atheneum,
The Ella Gallup Sumner and Mary Catlin Sumner Collection

flirted briefly with the revolutionary movement in art before returning to a more traditional approach; they include Derain, Carrà, de Chirico, to name but a few. Severini, who had distanced himself from Futurism and was one of the first to try to merge avant-garde portrayals with tradition, published his book From Cubism to Classicism in 1921. In 1915, Picasso produced drawings in the Neoclassicist style of Ingres and even applied this approach to other themes in drawings and paintings in 1917. For Léger, the cubist and mechanical period in which he broke down the planes to create a distinct dynamism, was followed in 1920 by his monumental period which reintegrated the human form.

The history of painting during the period of classical Modernism is rather more complex than a mere sequence of fresh starts. Indeed, these many and varied innovations and changes of direction may be regarded as its constitutive framework, rather than as a means of evaluation. In 1912, Kandinsky wrote in *Über die Formfrage* (On the Question of Form): "The embodiments torn by the mind out of the storehouse of painting can be ordered quite easily between two extremes: 1. great abstraction, 2. great realism. These two extremes open up two paths which lead eventually to one destination." In other words, both figurative and non-figurative art are based on a creative force and not just on a representative force.

JAMES ENSOR

1860-1949

Because of the ambiguity of this painting, with its blurring of boundaries between masquerade and fantasy, it has come to be known variously as *Skeletons Fighting over the Body of a Hanged Man* or *Masks Fighting over the Body of a Hanged Man*.

One of the three female figures who have been fighting with each other is lying on the ground, but continues to keep up the fight by attempting to pull the others down, clutching at the hems of their skirts. The figure on the left in a richly embroidered cloak over a long dress is a lady. Her opponent with a feathered hat, pseudo-military jacket and patent leather boots is a girl of easy virtue. The defeated figure lying prostrate on the ground in a cotton jacket and striped skirt is a domestic servant.

The three figures could be the wife, the mistress and the housemaid of the dead man. A number of threads linking the hanged man with the stick his wife is wielding as a weapon indicate that, in his lifetime, the man was the puppet of his wife. The sign saying CIVET (a stew of hare and other game) suggests that he is to be devoured. Greedy masks are pushing into the room from both sides in an embodiment of raw passion. This painting is an expression of Ensor's hatred of women, his repulsion of marriage and his view of humankind as a barbarous hoard.

Ensor's desire to flee daily existence and seek refuge in the world of make-believe prompted him to turn to masks as a central means of expression. Ensor's self-portrait of 1899 shows him gazing sadly out at the spectator wearing a rather eccentric hat and surrounded, indeed stormed, by a mob of masks. Behind his back, the masks are in the company of skulls. They have a threatening and menacing air. Those in front of him, with their bizarre faces and long noses, seem more friendly.

In Ensor's œuvre, the self-portrait turns to role-play. Here, Ensor plays the part of Peter Paul Rubens, whose self-portrait (Vienna, Kunsthistorisches Museum) he assimilates fully. Only the hat is a parody. As early as 1883, Ensor had taken Rubens' self-portrait as his inspiration for a self-portrait with a floral hat (Ostende, Museum voor Schone Kunsten). The various levels of role play, self-scrutiny and parody are difficult to distinguish. Ensor said of the meaning the mask had for him: "I have happily abandoned myself to the realms of solitude in which the mask is enthroned in all its violence, light and magnificence. To me, the mask means freshness of tone, exaggerated expression, sumptuous decor, grand and unexpected gesture, uninhibited movement, selected turbulence."

The intense and highly expressive colority of Ensor's paintings influenced the Expressionists, while his bizarre and often macabre fantasy inventions influenced the Surrealists.

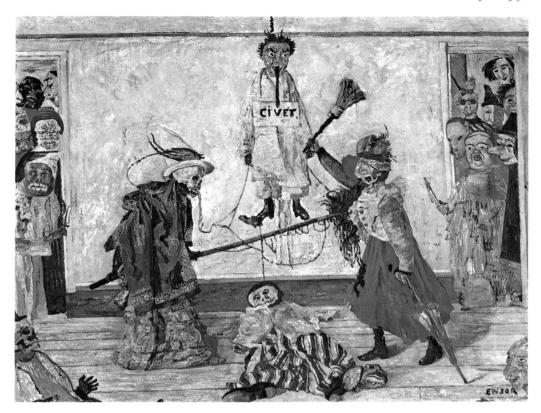

James Ensor Skeletons Fighting for the Body of a Hanged Man, 1891 Oil on canvas, 59 x 74cm Antwerp, Koninklijk Museum voor Schone Kunsten

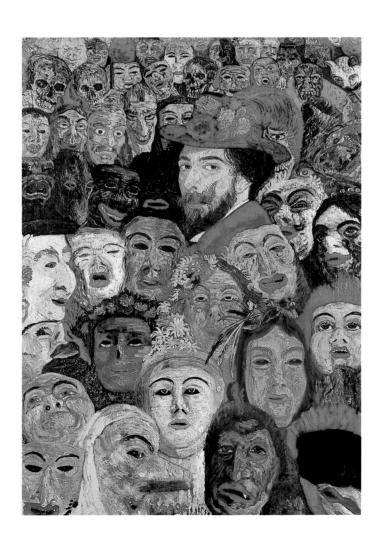

James Ensor Portrait of the Artist Surrounded by Masks, 1899 Oil on canvas, 120 x 80 cm Antwerp, Collection Jussiant

BELGIUM 559

Edvard Munch Puberty, 1895 Oil on canvas, 151.4 x 109.9 cm Oslo, Nasjonalgalleriet

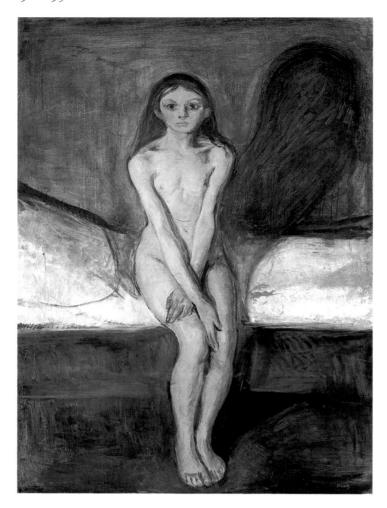

Below: Edvard Munch Girls on a Bridge, 1901 Oil on canvas, 135.9 x 125.4cm Oslo, Nasjonalgalleriet

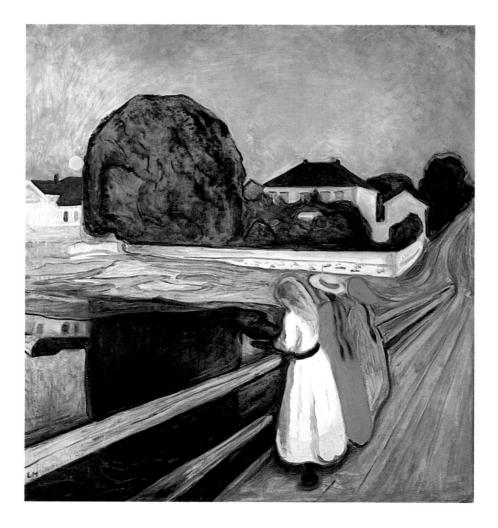

EDVARD MUNCH

1863-1944

In this painting, Puberty, Munch explores the anxieties of being on the threshold of adult life. He dares to enter the borderland between the physical and the psychological. Sitting rather awkwardly on the edge of the bed, a naked adolescent girl stares wide-eyed out of the picture. Her pale body cuts across the white sheet. Her lanky arms are crossed over her lap, as though seeking to conceal the source of her anxiety. The deeply disturbing new experience has created a stage of great excitement. In the unornamented surroundings, the shadow of the girl does not appear as a natural accompaniment, but has something mysteriously threatening, dark and fluid. The girl is helplessly confronted with her own sexuality.

Munch's simultaneous evocation of attraction and repulsion lies in the subtly expressive presentation of the same themes explored by Sigmund Freud. It is evident that Munch was not interested in revealing the girl's vulnerability, but in showing understanding and empathy, for in spite of the inner turmoil, the portrait possesses a formal austerity and solemnity reminiscent of portrayals of Christ in suffering.

The three *Girls on a Bridge* which Munch painted during a summer sojourn in Aasgaardstrand possesses a quiet lyricism. Munch did not invent this situation, but actually portrayed a specific point on the Oslofjord: the long bridge that continues into a sloping street, the sandy shoreline with its green patches of grass, the old house with its shady trees, framed by a white wooden fence. Yet he has drawn all these elements together into large, melancholic forms that are mirrored in even darker tones on the surface of the water. Only the yellow star, whose silvery light makes it unclear whether it is sun or moon, does not appear in the reflection.

Three girls are standing at the railing of the bridge. Sketchily portrayed in white, red and green, they appear more as a triad of colour than as human figures. They have turned away from the viewer so that they cannot be grasped as individuals. Apart from their compositional function in the painting, they also pose a challenge to the viewer, calling us to observe the landscape and its atmosphere in the same way as they do. It is the mood of the painter that is reflected in the viscous forms of what is an almost melancholy gravity.

This interpretation is confirmed by Edvard Munch's own words: "In a strong emotional mood, a landscape has a specific effect on people – by portraying such a landscape one can arrive at an image of one's own mood – it is this mood that is the main thing – nature is merely the medium."

As in so many themes that were important to him, Edvard Munch painted several versions of this oil-painting and also portrayed the scene in various different printing techniques.

GEORGES ROUAULT

1871-1958

Throughout his life, Rouault endeavoured to find the meaning of life through the Christian faith. The theme of *The Holy Face* is one he treated repeatedly. According to legend, Veronica approached Christ on the road to Calvary and wiped his face, and the imprint of his face was left on the cloth. Rouault's painting is based on this apocryphal text.

The face of Christ is presented frontally, with solemn ceremony, on the white cloth. In order to underline the precious value of this honoured relic, Rouault has painted a frame of roses and fine ornaments around the cloth. The expression of the face is heightened by strong black contours, the proportions painfully elongated. Repeated overpainting of individual parts has created an encrusted surface structure, lending the painting the character of something ancient, venerable and timeless. The artist has combined his painterly means with his faith in the permanent validity of the pictorial theme.

Time and time again, Rouault's pictorial themes expressed his faith. Even *The Old King* is not a spontaneous pictorial creation, but one based on designs from the year 1916. As in *The Holy Face* we are reminded of a much more distant past. The biblical Book of Kings and the tale of King David spring to mind. This king, however, is not dressed in the garb of a specific era, even if the portrayal tempts us to think of Gothic stained glass windows.

Rouault's distinctive ability to emphasize contours so that each plane of colour is bounded by a broad line like a fragment of stained glass in its lead setting, has frequently been cited as evidence of the continuing influence of his apprenticeship as a stained glass maker. The contoured weave of black lines and figural stylization create clarity in various respects: it divides the various zones of the painting and at the same time heightens the iconographic and compositional clarity, the completely planar approach without perspectival depth, is frontal to the viewer and, finally, the detail is restricted to only the most essential aspects of expression.

Rouault retained this technique of linear compositional structuring to the end of his life. But it has to be complemented by colour. It is colour that determines the overall atmospheric character of his work and it is applied in a technique that occasionally appears "scarred": in the red of the robe, the yellow of the crown and chain, in the white of the flowers. Because they are applied in several layers, the colours develop an enormous luminosity that is almost phosphorescent. All these artistic techniques serve to heighten the impression of stringency, earnestness and solemnity. As Rouault himself said: "I do not seek beauty, but expression."

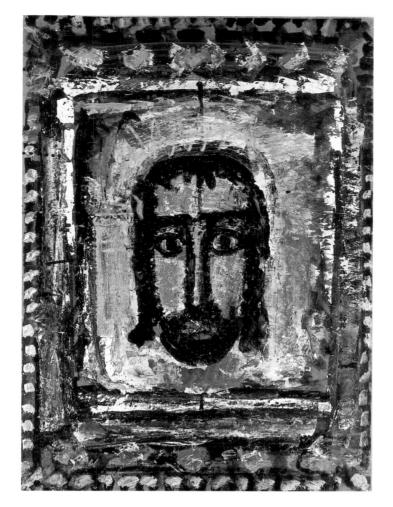

Georges Rouault The Holy Face, 1933 Oil on canvas, 91 x 65 cm Paris, Musée National d'Art Moderne, Centre Georges Pompidou

Georges Rouault
The Old King, 1937
Oil on cardboard,
77 x 54cm
Pittsburgh (PA), The Carnegie
Museum of Art

Albert Marquet
The Beach at Fécamp, 1906
Oil on canvas, 51 x 61 cm
Paris, Musée National d'Art Moderne,
Centre Georges Pompidou

Maurice Utrillo Impasse Cottin, 1911 Oil on cardboard, 62 x 46 cm Paris, Musée National d'Art Moderne, Centre Georges Pompidou

ALBERT MARQUET

1875-1947

Marquet met Matisse at the Ecole des Arts Décoratifs in Paris in 1890 and remained a friend all his life. In 1905, his paintings were shown alongside those of Matisse, Derain and Vlaminck in the exhibition that brought them the name Fauves. It is important to recall this connection in the case of Marquet.

The motif of the Mediterranean beach so beloved by the other Fauves, seems singularly subdued in Marquet's work. There is no brilliant sunshine, no explosion of brilliant colourity, no brio of frenzied brushwork. His painting is sweeping and tranquil, and does not break the boundaries of convention; it seems to posses a subdued harmony. The beach running diagonally into the painting is cut off in the background by a hill sloping downwards and protruding into the sea like a wall. People walking on the beach and sailing boats at sea are portrayed in laconic, dark brushstrokes. The only colourful figures are the two sailors in the foreground on the wall. Their blue collars are as bright as the red flag in front of the green hill behind them. This build-up of colour on the left hand side of the painting creates a contrast to the quiet planes of colour of the beach, sea and sky, in their selfcontained forms. The proximity to Matisse is evident.

MAURICE UTRILLO

1883-1955

A distinction is made between various different phases in Utrillo's œuvre. Impasse Cottin dates from his "white period" between 1910 and 1914 when he explored the sensual qualities of the pale facades of Parisian houses by experimenting with the use of zinc white, plaster, cement and adhesive. This gives his paintings a highly distinctive, material aesthetic. Ridges and streaks create a shallow surface relief that gives the impression of a slightly dilapidated street, and the peeling paintwork of the houses is hinted at with plasticity. His paintings of this period thus become signs of his search for tangible reality, symbols of his quest to breathe some real life into the canvas.

This "impasse" in Montmartre, a district far from the grand boulevards, and one whose quiet streets and picturesque buildings Utrillo recorded in innumerable paintings, ends with a steep stairway towards which the lines of perspective run. The alleyway is virtually empty. Only in the background, in front of the entrance to a house, do we see a silhouette. A few women making their way up the steep stairway add rhythm and movement to the painting, drawing the viewer's gaze upwards along the flight of steps. Yet before our gaze actually reaches the sky, it meets with a burst of blossoming life, in the form of the quivering foliage of a group of trees.

562

ANDRÉ DERAIN

1880-1954

In the company of Matisse, Derain spent the summer of 1903 in Collioure on the Mediterranean coast, where he painted. From Collioure, he wrote to his friend Vlaminck: "I have been seduced by colour as colour."

The harbour of Collioure is shown here from a strongly elevated vantage point. A few people are moving around on the shore of the bay, where three boats are lying at anchor. Everything is compiled of luminous daubs of colour which are elongated to lines only in the boats and masonry or in figures. The individual colours are not broken down into their basic hues in the manner of the pointillist Paul Signac, but in larger daubs that allow the colour to stand for itself. In retrospect, Derain once said: "The colours become dynamite. They detonate in light." Derain does not use Divisionism in the sense of breaking down colours, but as a means of structuring space. Paintings using this technique can be found in the œuvre of Derain only in the period between 1905 and 1906. After that, his brushstrokes become longer again and he uses colour planes, frequently framed by contrasting lines of colour.

André Derain Boats at Collioure, 1905 Oil on canvas, 60 x 73 cm Düsseldorf, Kunstsammlung Nordrhein-Westfalen

RAOUL DUFY

1877-1953

Like Braque, Raoul Dufy also started out with a dark-toned palette and was influenced by the Fauvist handling of colour at the Salon of 1905. However, it was not until the period when he painted his *Sailing Boat at Sainte-Adresse* that he developed his distinctive personal style which is essentially based on techniques of line drawing and watercolour. An abbreviated description of the objective repertoire is projected onto coloured backgrounds whose colours are to all intents and purposes independent of the objects themselves, and generally based on variations of one colour hue.

In this view of the bay of Sainte-Adresse, the decorative form of the detailed drawing and the almost calligraphic contours project a consciously intended naiveté that integrates the predominant rhythm of colours. The crests of waves, houses, rooftops and the boat seem like written signs or codes featuring deliberate rhythmic repetitions. From the pier with its fencing and flagpole in the foreground, a diagonal cascade of colours rushes towards the shore with its broad, horizontal structure, while the white of the boat and the houses creates a second diagonal.

Dufy's approach gives the impression of a playful levity that may well owe much to Impressionism and folk art, both of which he studied closely in his early period.

Raoul Dufy Sailing Boat at Sainte-Adresse, 1912 Oil on canvas, 86.4 x 114.3 cm New York, The Museum of Modern Art

Kees van Dongen Portrait of Fernande, 1905 Oil on canvas, 100 x 81 cm Private collection

KEES VAN DONGEN

1877-1968

It was through Picasso, who lived in the famous Bateau-Lavoir studio complex in Paris, that the Dutch artist Kees van Dongen heard in 1905 of an available apartment. In December, he moved in with his wife and daughter, and he stayed there until February 1907. Occasionally, Fernande Olivier, then Picasso's mistress, would act as his model. Whereas Picasso was in his "rose period" in 1905, van Dongen was exploring the richly contrasted and garish colority of the Fauvists grouped around Matisse. Van Dongen toned down the brashness of the Fauvists in his own paintigs, creating modulated planes, but at the same time choosing strong colours and harmonies which influenced and enhanced each other mutually.

In his *Portrait of Fernande* van Dongen brackets the foreground and the background in a cool shade of blue. Fernande is holding a blue cloth in front of her naked body, and it casts a greenish shadow on part of her uncovered skin. A fiery red in the lower background zone emphasizes the green highlight. The figure is bounded by strong contouring lines, which also increase the intensity of the colours without creating an effect of plasticity. This large painting, in which the palette is reduced to only a few colours, coolly distances the woman from the spectator in spite of the frontal view.

Maurice de Vlaminck Les Bateaux-Lavoirs, 1906 Oil on canvas, 50 x 73 cm Paris, Musée National d'Art Moderne, Centre Georges Pompidou

MAURICE DE VLAMINCK

1876-1958

Of all the Fauves, Maurice de Vlaminck was the most impetuous. His contempt for all conventions applied not only to art, but also to life in general: "My passion pushed me to all kinds of bold risks against convention in painting. I wanted a revolution of social mores... I gave myself no other goal but this: to use new media to express the profound relationships that link me with the old earth... I suffered at not being able to hammer more strongly, at having arrived at the maximum of intensity, limited by the blue and red of the paint-seller."

1906 is regarded as the zenith of Vlaminck's vital and instinctive painting, an artist who did not hesitate to use his fingers instead of the paintbrush in order to apply his paint to the canvas. Yet he never ignored the question of compositional balance. At the foreground riverbank where the *Bateaux-Lavoirs* are anchored, the triad of primary colours – red, blue and yellow, is strongest. It is echoed in a milder form on the other shore. The painting gains its compositional stability from the bridge with its horizontals, intersected and touched by the verticals of the boats' masts.

HENRI MATISSE

1869-1954

Dance is one piece of a two-part decoration commissioned by the Russian collector Shchukin on the basis that the design shown here had struck him for its *noblesse*. Its counterpart is *Music*. The main difference between the two versions – the final version is now hanging in the Hermitage in St Petersburg – is the intensity of their colours (cf. ill. p. 547).

Hands join to create a whirling circle that appears as an oval in the spatial perspective. The confined space drives the dance on the hill to the point of frenzy. Between the figure on the left and her neighbour on her right there is a considerable distance. In order to fill up the empty space and close ranks again, she is leaning forward to stretch her hand out to the other, who is leaning backward and endeavouring with all her might to stem the movement that is pulling her towards the background, but they do not quite connect. The effort of the dance changes the figures to the point of distortion, which at the same time adds to the expressiveness of the image. In Dance the "religion of happiness" takes shape. Lust for life is conveyed by the subconsciously contagious effect. The "decorative' style merges with the sacred content. According to Matisse, "What I am most interested in is neither still-life nor landscape, but the human figure. In it, my religious attitude to life is best expressed."

The "character of elevated dignity" that these figures possess can be explained on formal grounds. Their majestic monumentality is the result of increasingly simplified painterly means: a few colours applied in large homogenous planes, a drawing that tends towards pure line and the outlining of forms.

The Piano Lesson is an elegiac, earnest image in transparent and geometric forms. Its predominant form is the triangle, the form of the metronome, the sign of music that may also be regarded as the emblem of Matisse's art. The triangle is also the distinctive feature in the face of the young boy Pierre, the artist's son, at the piano. The multiple significance of the triangle is highly informative: Matisse had decided, against the boy's wishes, that Pierre should study music. The rather earnest-looking child is subjugated completely to his father's will, and this is expressed in the painting's unmitigated formal severity. The boy is confined between quotations of the painter's own work: to the lower left, the Decorative Figure (1908) and behind him the Woman on a Stool (1914). In the stringent and static structure of geometric forms, there is a calm and clarity strengthened by the cool grey of the background. As in a mosaic, the colour planes of complementary contrasts - green to red and blue to orange - are integrated into the back-

Henri Matisse Dance (La Danse, first version), 1909 Oil on canvas, 259.7 x 390 cm New York, The Museum of Modern Art

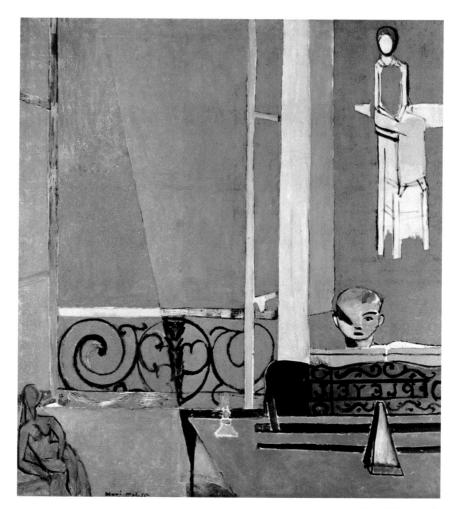

Henri Matisse The Piano Lesson, 1916 Oil on canvas, 245.1 x 212.7 cm New York, The Museum of Modern Art

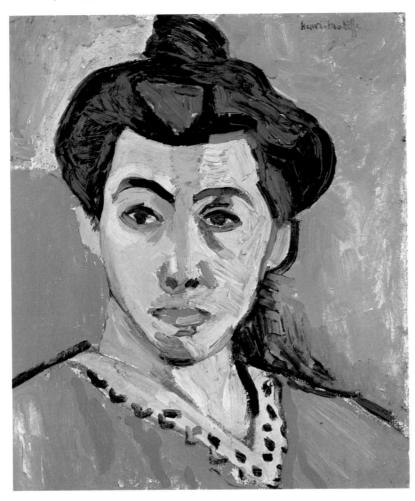

Henri Matisse The Green Stripe (Madame Matisse), 1905 Oil on canvas, 40.5 x 32.8 cm Copenhagen, Statens Museum for Kunst

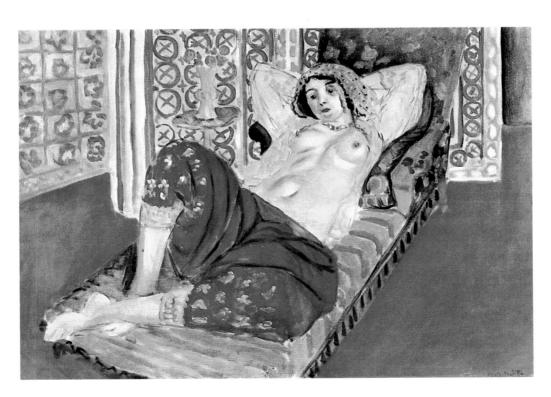

Henri Matisse Odalisque with Red Trousers, 1921 Oil on canvas, 65 x 90 cm Paris, Musée National d'Art Moderne, Centre Georges Pompidou

HENRI MATISSE

1869-1954

In the summer of 1905, Matisse created a painting of great tranquility in spite of its strident colours. It is a portrait of Madame Matisse. Here, Matisse has simplified the forms of his model to the essentials. In its sovereign frontal attitude, the portrait has the air of an icon. The green stripe which seems so unnatural at first glance is by no means arbitrary. In fact, it designates the border between the zones of light and shadow on the face. At the same time, it emphasizes the beautiful and regular facial structure of the model. Yet it is also symptomatic of a painting structured into colour fields which are reciprocally enhancing without actually imposing on each other, because they are clearly divided.

Complete concentration on colour gave way in the 1920s to a combination of great reality, spatial depth and rich detail, as in the Odalisque. Of the apparent conventionality of his odalisques, who recall the work of Delacroix, Matisse said: "The oriental decoration of the interiors,... the sumptuous costumes, the sensuality of the heavy, slumbering bodies... all the magnificence of the siesta, in which arabesque and colour are heightened to a maximum, should not deceive us: I have always rejected the merely anecdotal. Under this atmosphere of voluptuous languor and sun-drenched lassitude in which people and object are bathed, smoulders an enormous tension that is purely painterly and based on the relationships between the elements."

While the Odalisque in her plasticity and diagonal position in the room effortlessly stands apart from the decorative elements of her surroundings, the Decorative Figure on an Ornamental Background is almost drowned out by the loud colours and florid details. The kitschy French baroque wallpaper has been exaggerated to the very limit. The tastelessly eclectic mix of objects in this corner of the room has been arranged to create an unbroken wall of garish motifs. The seated woman stands out against the surroundings that seem liable to overwhelm her completely. Her body parts seem cylindrical, as though she were merely a "life-machine". The position of the figure makes it possible to distinguish between the verticals of the back wall and the horizontals of the floor. The position of her legs reiterates the two directions in which the floor stretches. A shadow borders the figure in the upper area against the background. In the contrast between the angularity of the figure and the arabesque background, Matisse attempts to maintain dimensional depth within a decorative space.

Henri Matisse

Decorative Figure on an Ornamental Background, 1925 Oil on canvas, 131 x 98 cm Paris, Musée National d'Art Moderne, Centre Geoges Pompidou

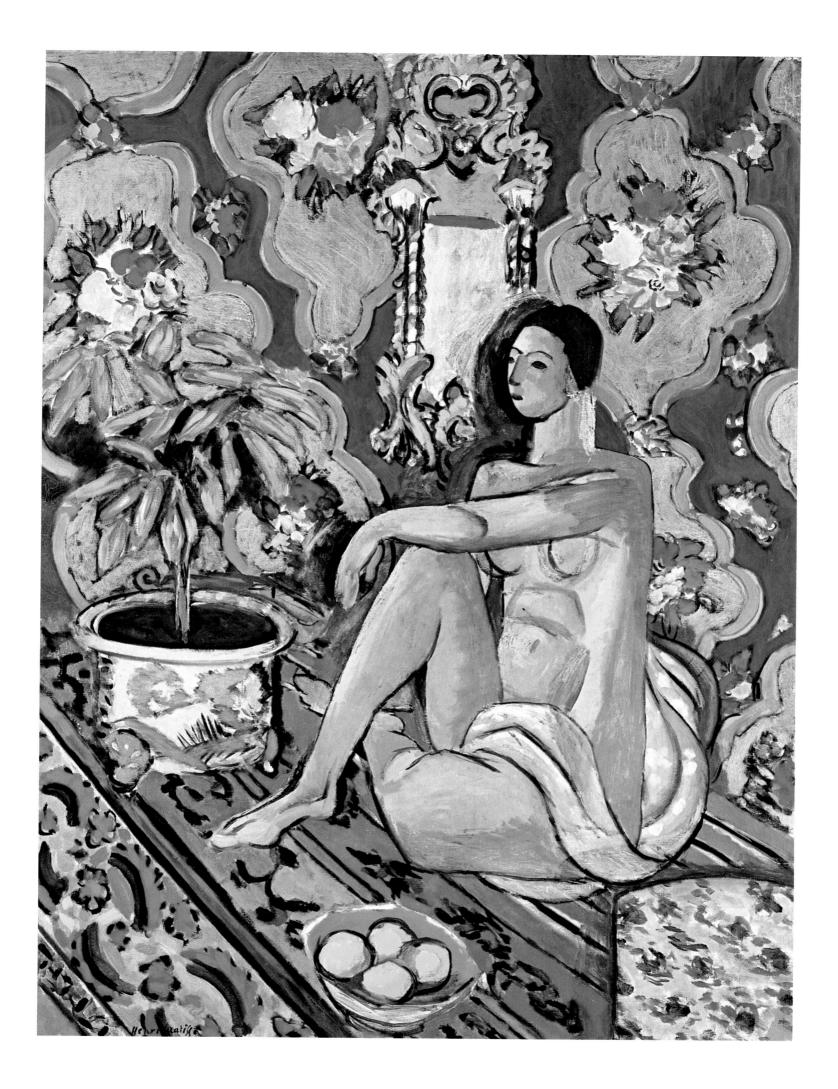

Juan Gris The Teacups, 1914 Papier collé, oil and charcoal on canvas, 65 x 92 cm Düsseldorf, Kunstsammlung Nordrhein-Westfalen

Juan Gris Le Déjeuner, 1915 Oil and charcoal on canvas, 92 x 73 cm Paris, Musée National d'Art Moderne, Centre Georges Pompidou

JUAN GRIS

1887-1927

In 1912, Picasso and Braque introduced a new artistic process of integrating pieces of paper in their pictures. The technique came to be known as collage. It was an innovation that was to have far-reaching consequences for the art of the 20th century, for it broke the hegemony of oil-painting and went on to be adopted by many art movements. In his collage *The Washstand* of 1912, he even incorporates a fragment of mirror.

In the work illustrated here, the surface of the table with its teacups, glasses, a bottle and a pipe, is not painted by hand, but represented by a piece of imitation wood-grain wallpaper which has been pasted into the picture. Further pieces of wallpaper, snippets of paper and newspaper also add to the structural contrasts. The pieces of paper pasted into the picture do not seem like foreign bodies, but are fully assimilated into the architectonic pictorial structure.

Spatiality is not unequivocally determined in terms of foreground and background, but seems ambivalent and puzzling. The planarity of the objects makes them seem alternately positive and negative, tangible and intangible. The reduction of colours to only black and white in addition to the wooden tone gives the work a delicate equilibrium that creates an overall sense of pictorial harmony in spite of the enormous contrasts.

Just like *The Teacups* his picture *Le Déjeuner* is also representative of the phase known as synthetic Cubism. Even though all the parts of this picture are actually painted, it nevertheless looks like a collage in which various differently contoured planes have been superimposed; above all, the way it imitates woodgrain is reminiscent of collage technique.

The individual planes with their different colours and structures form the architectonics of the painting. The result is an almost abstract planar structure with very little depth. Figurative elements have been drawn onto the abstract composition: newspaper, bottle, glass, coffee-pot and bowl. The very fact that they have been drawn in this way clearly underlines the fact that the painting is a surface onto which the objects have been projected. In the centre of the picture, the portrayal of the coffee-pot on three different coloured planes demonstrates various degrees of pictorial presentation: as a negative form in a pale outline on a black ground, as a sculpturally tangible object in the midfield and as a contour on the right, green field. The degree of reality becomes a pictorial problem.

The first art dealer to represent the Cubist artists, and one of their most important chroniclers, Daniel Henry Kahnweiler, praised Gris particularly for his pictorial structure: "If we consider regaining the integrity of the artwork to be one of the most important aims of Cubism, the will to create perfect organisms rather than sketches, then none of the Cubists has pursued that aim more consistently and successfully than Juan Gris."

PABLO PICASSO

1881-1973

This painting represents a revolutionary breakthrough in the history of modern art. Whereas the central figures are still indicative of that stage in which the painting was begun, the nudes that frame the composition already demonstrate the decisive change of direction in Picasso's art that was to be of such seminal importance to Cubism. The motif of five female nudes grouped around a still life, remains in-

debted to classical convention. The structure itself can be traced back to Cézanne's *Bathers*. The large figures are angular, with the influence of ancient Iberian sculpture evident in the heads of the central figures, whereas the corner figures with their large, firmly contoured planes herald an entirely new approach. The faces themselves possess a compelling force that owes much to African sculpture. The figures and the background seem to form a relief that forgoes all pursuit of spatial depth and retains the close relationship to the pictorial surface.

Pablo Picasso Les Demoiselles d'Avignon, 1907 Oil on canvas, 244 x 234 cm New York, The Museum of Modern Art

SPAIN 569

Pablo Picasso Ma Jolie, 1914 Oil on canvas, 45 x 40cm Collection Berggruen

Pablo Picasso Three Women at the Spring, 1921 Oil on canvas, 204 x 174cm New York, The Museum of Modern Art

PABLO PICASSO

1881-1973

The still life Ma Jolie belongs to a group of works created in 1914 whose light-hearted mood and elegant articulation have earned them the epithet rococo Cubism. The objects are recognizable, the formal syntax more relaxed, and the attitude more playful than before. The objects are arranged on a small table portrayed in a contour drawing of straight lines on the pictorial ground. In their planar graduation they seem to be stuck together rather than painted. Stippled brushwork is used to indicate areas where light and shadow permeate. The words "Ma Jolie" on the musical score leaning on the back wall are taken from a popular song of the time. It was also the name by which Picasso called his new mistress Marcelle Humbert in 1912.

The painting Three Women at the Spring may be regarded as a model example of Picasso's Neoclassicism. His new found interest in the sculptural volumes of the human figure, suppressed during his phase of formal cubist analysis, may have been reawakened in 1917 on a journey to Italy, where he encountered the art of classical Antiquity. One standing, one sitting and one leaning on the rocks, three women have gathered at the well around which their hands seem to circle. Their corporeality has been heightened to the point of the colossal. The folds of their robes are vaguely reminiscent of Roman sculptures and Pompeian frescos and, even more so, they recall the fluting of classical columns. The subdued, fresco-like colours add to the sculptural effect of volume that creates the overall effect of a relief rather than that of a free-standing sculpture. The painting expresses an awareness of just how near and yet how far the influence of classical Antiquity remains.

Picasso may well have been inspired to paint this Girl before a Mirror by his love for the sensual Marie-Thérèse Walter. Of all his paintings of the early 1930s, this is the most painstakingly executed in its lavish luminosity, its decorative pattern and its expressive yet coolly analytical traits. In the world of art, women with mirrors traditionally represent vanitas images, suggesting the vanity or transience of earthly life. In the case of Picasso, we are tempted to think of the mirror as representing the idea of the painter's superiority in terms of his ability to create an image more lasting than that of a mirror. The girl does not hold the mirror like an attribute, but embraces it like a second self. She is both clothed and naked and seems to be radiated by x-rays. The rounded form of the womb is the formal leitmotif of this distinctly erotic painting.

Pablo Picasso Girl before a Mirror, 1932 Oil on canvas, 162 x 130 cm New York, The Museum of Modern Art

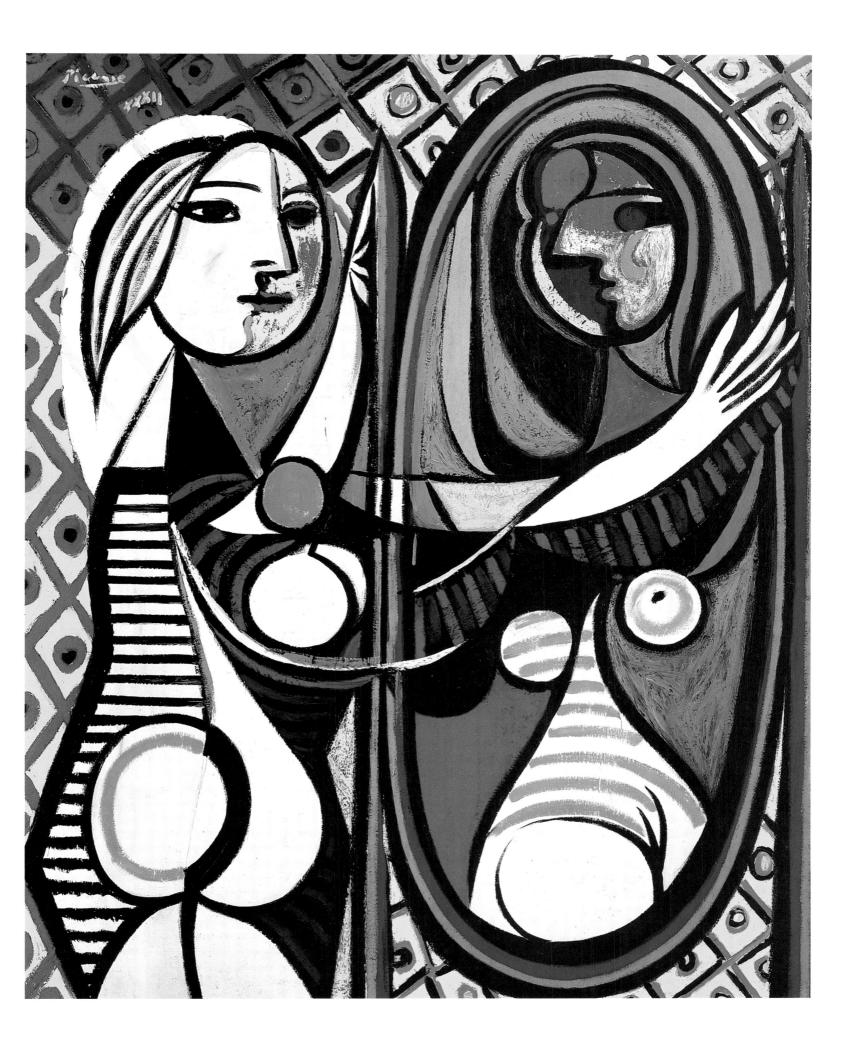

Georges Braque The Portuguese, 1911 Oil on canvas, 117 x 81.5 cm Basle, Öffentliche Kunstsammlung Basel, Kunstmuseum

Georges Braque The Duo, 1937 Oil on canvas, 131 x 162.5 cm Paris, Musée National d'Art Moderne, Centre Georges Pompidou

GEORGES BRAQUE

1882-1963

Towards the end of 1910, a new phase of Cubism began, in which the deconstruction of the object was taken further than ever before. The central figure in *The Portuguese* is broken down into its individual formal components to such an extent that they can be recognized only with difficulty: eye, nose, shoulders, upper and lower arms. *The Portuguese* is holding a guitar. The surface is rhythmically divided into the many facets of objective forms. The convex cubes and concave spatial fragments have been flattened to create a self-contained effect. Colour has been reduced to two tones: grey and brown.

The stencilling that appears for the first time in *The Portuguese* is not contexturally associative, but formally rhythmic. Braque explained, "In my constant search for reality, I introduced letters into my paintings in 1911. These were forms that were not to be changed; because they are flat, letters are situated outside space, and their presence in the picture made it possible to distinguish the objects within the space from those outside it."

After the still lifes of the 1920s and 1930s with their wealth of objects, Braque devoted his energies between 1936 and 1939 to a group of key works in which there is a return to classical figure compositions. His painting The Duo belongs to this phase. The scene is framed theatrically by curtains at the side. An ornamental wallpaper pattern forms the background, with one light and one dark half contrasting. The figure of the singer holding a score by Debussy, whom Braque admired, is divided into a black zone and a pink zone. The piano in the middle has been cubistically compacted. Its brown colour unites it with the pianist. The interaction of light and shade determines the enigmatic dialogue between the two musicians.

At a later state of Cubism, Braque began presenting objects in the form of differently contoured planes whose distinctive, earthy tonality creates a harmonious whole, as in the *Still Life with Bowl of Fruit, Bottle and Mandolin* dating from 1930. The still-life is architectonically structured, but in spite of the handling of space, it avoids any perspectival illusionism. The individual zones are layered and superimposed in the manner of a collage and, as in earlier collages, the marbling of the table top is emphasized as a reiteration of material surface finishes.

Georges Braque Still Life with Bowl of Fruit, Bottle and Mandolin, 1930 Oil on canvas, 116 x 90 cm Düsseldorf, Kunstsammlung Nordrhein-Westfalen

572

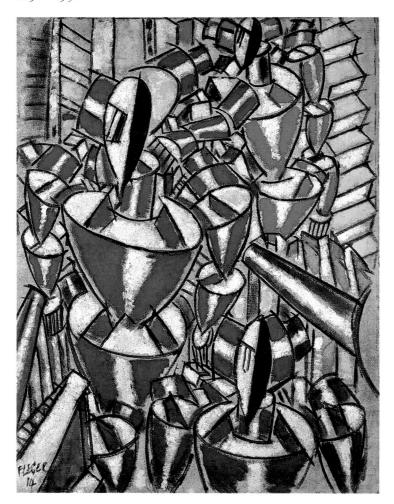

Fernand Léger The Stairway, 1914 Oil on canvas, 130 x 100 cm New York, The Museum of Modern Art

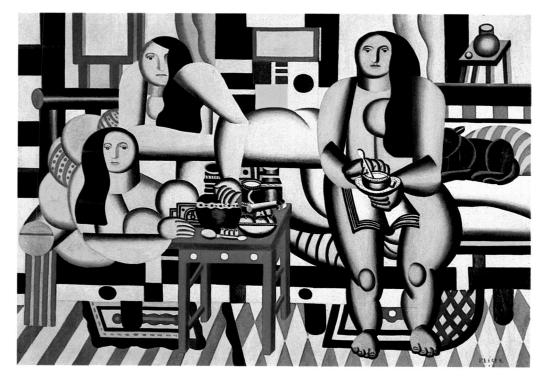

Fernand Léger Three Women (Le Grand Déjeuner), 1921 Oil on canvas, 182 x 251 cm New York, The Museum of Modern Art

FERNAND LÉGER

1881-1955

In 1913/14, Léger painted several pictures featuring a stairway as an important motif. Everything is geared towards the contrast of cylindrical components and angular steps, and towards the contrast between the primary colours red, blue and yellow, outlined in black on a pale grey ground. The sculptural volume has been emphasized effectively, without allowing us to forget that it is the surface of the painting that forms the plane of projection. In this way, "the simultaneous coordination of the three basic elements, line, form and colour," are embodied for Léger.

However, unlike his Contrastes et formes (Contrasts of Form), the cylindrical components in this work remind us not only of the machine world that fascinated Léger, but of the human world as well. These are creatures who seem to consist only of a coat of armour, and who move like mechanized robots. The face, in which all human expression is concentrated, becomes a black and white visor. All sentimentality has been exorcized. Léger was perfectly aware of the break with tradition when he noted: "Since abstract art has liberated us entirely from the fetters of tradition, it has become possible for us to consider the human figure as a purely pictorial component rather than as a sentimental component."

After 1920, a phase began which Fernand Léger himself described as his "monumental era," and of which he said: "I have increased the sense of planarity by applying the same formal approach to my figures and objects as in the machine era, but without the same dynamism. I had smashed the human body, so I began putting it together again, finding the face again."

When Léger put the human figure back together again after 1920, he nevertheless portrayed the collective rather than the individual. He is not interested in emotion. Nor in psychology. In his painting *The Three Women (Le Grand Déjeuner)* the compositional arrangement of the three nude women is determined by horizontals and verticals. The two reclining women are intersected by the seated woman. Their bodies are mainly made up of basic geometric forms. The colour is modelled at the edges to give them some corporeality. The faces show no emotion.

The detachment of his portrayal does not, however, have the effect of separating the figures from their surroundings. The interior has merged with the persons to a geometrically patterned surface. The tonality of the painting is as clear and harsh as its forms. The grey tones used for the bodies seem to break the colourful geometry of the entire room. Léger said of the use of these techniques: "I contrast curved lines with straight lines, flat surfaces with modelled surfaces, purely local colours with finely nuanced tones."

574

ROBERT DELAUNAY

1885-1941

At the centre of the prismatic cubic forms of houses and rooftops stands the Eiffel Tower. The transparent colour planes seem to radiate from it like facets. They are not restricted to the pictorial field alone, but are continued onto the frame. The colour becomes the sole carrier of pictorial structure. It is used in planes as light, form and movement in space, with individual colours receding or protruding on grounds of various intensities. Guillaum Apollinaire described these paintings by Delaunay as "orphism", in reference to their lyrical character. This painting inspired him to one of his finest poems, *Les Fenêtres* (The Windows).

In 1933, Delaunay wrote about the design principle behind his *Window* paintings: "No nature – more like initial abstract painting in colours. The paint, the colours with their inherent laws, their contrasts, their slow vibrations, their intervals – all these relationships form the basis of the painting that is no longer imitative, but creative in itself through its inherent technique."

Whereas Delaunay was rejected as Impressionistic by the Cubists, whose handling of colour he had described as "web-like", his *Window* paintings were enthusiastically received immediately by the German artists Marc, Macke and Klee.

In his *Sun and Moon* series, Delaunay sought to capture the different light effects of sun and moon. The painting does not aim to give a descriptive portrayal of the celestial bodies themselves. What the artist is interested in is in reiterating the specific light through colour forms.

On the right in the painting, the disk of the sun spreads out, with a circle and axial cross at its centre, around which contrasting fields radiate and interweave, heightening the atmosphere. On the left, we see the floating sphere of the moon, based on a simple formal motif of two dark ovals on a tilted axis holding an oval light form between them, enveloped in circular colour zones of iridescent blue, green, pink and violet.

The light gains substance from the colours perceived simultaneously by the viewer. The more intense the light, the more the colours have to activate. Each colour is an amorphous entity in itself; only the juxtaposition with a contrasting or related colour gives it expression, intensity and movement, and certain dimensions have to be sustained to determine the form. In this way, form is born of colour and becomes one with it. In his portrayal of both worlds of light, Delaunay was interested in exploring the concept of "pure" painting.

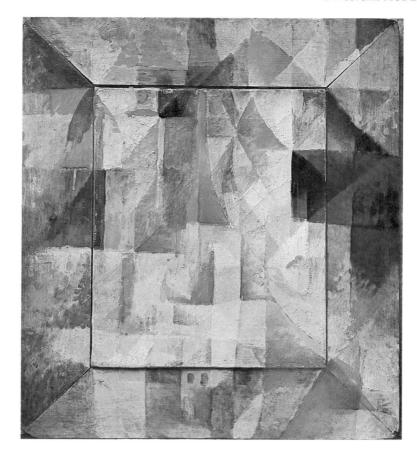

Robert Delaunay Simultaneous Windows on the City, 1912 Oil on canvas and wood (painted frame), 46 x 40 cm Hamburg, Hamburger Kunsthalle

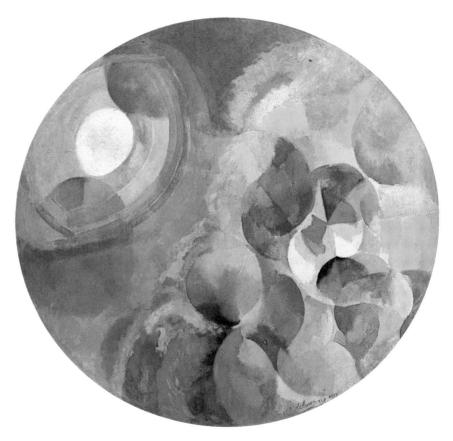

Robert Delaunay Simulaneous Contrasts: Sun and Moon, c. 1912/13 Oil on canvas, diameter 134.5 cm New York, The Museum of Modern Art

Umberto Boccioni State of Mind II: The Farewells, 1911 Oil on canvas, 71.2 x 94.2 cm New York, The Museum of Modern Art

Umberto Boccioni The Noise of the Street Enters the House, 1911 Oil on canvas, 100 x 106.5 cm Hanover, Sprengel Museum Hannover

UMBERTO BOCCIONI

1882-1916

In May 1911, Boccioni was working on his first series of paintings entitled *States of Mind*. Each of the three paintings in this series was given a subtitle: *The Farewells*, *Those Who Stay*, and *Those Who Go*. In the melting swirl of his first version, Boccioni presents the concept of separation. Farewells at railway stations are his metaphor of the pain of breaking a sense of community. At the end of 1911, following a visit to Paris where he had been particularly impressed by the work of Picasso, Boccioni began a second version: *States of Mind II*.

In his painting *The Farewells* the influence of Cubism in the fragmentation of forms and compositional structure is evident. The numbers integrated by the Cubists as flat, non-spatial elements and indications of reality, have been adopted by Boccioni in the centre of the picture.

Guillaume Apollinaire, who was familiar with the artists of his day, immediately recognized the significance of the numbers: "Boccioni's best painting is the one that is most directly inspired by Picasso's latest works. They even have those stencilled numbers that give Picasso's recent works such simplicity and magnificent reality." Boccioni's number is the number of the locomotive that drives apart the embracing couples to the right and left. A red, diagonal snaking line of velocity accompanies the machine. The red highlights and dramatizes the clouds of smoke, the evening sun, the stop signals and the tail lights. The excitement of the moment is captured.

"Let us praise the hubbub of voices, the mathematical division of work in the laboratories, the whistling of the railway trains, the confusion on the station platforms and the restlessness! And the speed! And the precision! Let us praise the screech of the sirens as a substitute for the boring, bronze peal of the church bells, the sound of engines and the ear-clipping rattle of the drive-belts!" wrote Boccioni in 1912.

A square flanked by houses has become a building site. A woman looks down from the balcony of her room into the hustle and bustle that swirls around her like a maelstrom. All structure seems to have been abandoned. Everything seems to be collapsing towards the centre - and the centre is the woman leaning out. Her head, in which all these impressions are gathering, is positioned precisely at the point where the diagonals of the painting cross. Just as the square and the houses seem to vibrate with the distortions, displacements and fragmentations, so too do the colours vibrate in order to heighten this impression. The paint has been applied in every possible variation from smooth and flat to daubed and striped, but it is always radiant and, above all, juxtaposed in colours so stridently clashing that they almost scream aloud.

576

GIACOMO BALLA

1871-1958

Of all the Futurists, it was Balla, more than any other, whose dissolution of the pictorial motif into fields of movement came closest to the abstract compositions of Kandinsky. Yet in the superimposition and permeation of the forms, we find the "plastic dynamism" and simultaneity so characteristic of Futurism. The artist aimed to present various phases of movement and aspects of a sculptural body at the same time. The radiating rhythm of the "window" colour facets fractured by the light in the work of Robert Delaunay are very different indeed from Balla's emphatic dynamism.

Balla expanded the cognition of movement to cosmic dimensions. His painting Mercury Passing before the Sun is based on an eclipse of the sun that he observed on 7 November 1914 with a telescope and dark glass filter. It is a worldly enthusiasm for cosmic expanses and movements, informed by an awareness that not only the visual medium of painting, but also the forces of life have cosmic origins. The Futurist Technical Manifesto of 1910 claims: "We Futurists shall climb the most sublime and radiant summit and proclaim ourselves lords of light, for we drink from the source of the sun!"

Giacomo Balla Mercury Passing before the Sun, 1914 Oil on canvas, 120 x 100 cm Milan, Private collection

GINO SEVERINI

1883-1966

Severini's 1913 manifesto begins with the words "We want to capture the universe in the art work. Objects no longer exist." For Severini, there is only the reality of consciousness with its mechanisms of memory and analogy: "The sensation reality invokes in us, of which we know that it is square in shape and blue in colour, can also be expressed in its complementary forms and colours, which means in round forms and yellow colours."

The rhythm of the picture is determined by the radiation and refraction of light. There is nothing figurative at all. Only triangles and circles structure the plane. The paint is applied in tiny rather than flat dots, in order to render the process of dissolution even more clearly. From the pale yellow in the centre, it darkens towards the edges on all sides, right through to black. Its radiant force spreads out. Whereas Divisionism created the basis for breaking objects down into light and colour, it was Cubism that provided the fragmentation by which the handling of space could be determined. In this painting, the density of colour creates a rhythmic ebb and flow.

Gino Severini
Spherical Expansion
of Light (Centrifugal), 1914
Oil on canvas,
61 x 50cm
Milan, Private
collection

Amedeo Modigliani Bride and Groom, c. 1915/16 Oil on canvas, 55.2 x 46.4 cm New York. The Museum of Modern Art

Amedeo Modigliani Reclining Nude on White Pillow, 1917 Oil on canvas, 60 x 92 cm Stuttgart, Staatsgalerie Stuttgart

AMEDEO MODIGLIANI

1884-1920

Modigliani concentrated primarily on individual portraits. This painting is one of the few exceptions. The poet Jean Cocteau pointed out that this painting was probably inspired by some *nouveau riche* couple the painter had seen on the boulevard.

Both are elegantly dressed. The man is wearing an evening suit with a stiff white collar and bow-tie. The rim of his top-hat is discernible just below the upper edge of the picture. The woman's earrings are somewhat larger than discreetly elegant understatement might allow. They are too showy to seem entirely serious. The age difference also indicates that the title of the painting is ironic. This constellation of elderly playboy and young mistress is a common motif in painting.

What is unusual about the composition is the way the figures are arranged in the pictorial space. The woman can only be seen just above the lower edge of the painting to her shoulders, whereas the man is shown from the chest upwards, so that his head reaches the upper edge of the painting. There is a clear interaction between sweeping space and detailed areas.

In their facets and geometric simplification, the faces reflect the influence of Cubism, but also have something of the austerity of African masks. In large capital letters of the kind the Cubists also used as non-spatial pictorial elements, Modigliani has included his name in the composition like a company logo.

Modigliani's first and only solo exhibition was in 1917 at the Berthe Weill gallery in Paris. Most of the paintings exhibited there were nudes. The police of a city accustomed to considerably more erotic images declared the nudes a public nuisance and closed the exhibition.

While this reclining nude is certainly not unerotic, nor is it in any way obscene; it is far too consciously unreal as an art product for that. Whereas other artists surrounded their nudes with furniture, draperies and flowers, sometimes adding a clothed male figure as a dramatic accent, Modigliani avoids all such effects. The woman lies like a Venus on the red divan, her gaze transfigured. While the upper half of the body is portrayed in three-quarter view, the lower half has been turned to an almost frontal view. In comparison to the rest of the body, her lap takes on the dimensions of a fertility goddess. The interior forms have been modelled sparsely with light and shadow. The main focus is on the outline of the body with its flat, pale red. The stringency of the contour underlines the planarity of the body, while the volume is subdued. The few strong colour contrasts have no spatial effect.

ALEXEI VON JAWLENSKY

1864-1941

From around 1907, it was the influence of the Fauves, most notably Matisse, that helped Jawlensky to develop his pictorial concept on the basis of colour. He adopted Matisse's concept that: "It is not possible for me to copy nature slavishly; I am obliged to interpret it and subjugate myself to the spirit of the painting. From all my relationships of found tones, a vital chord of colour must result; a harmony similar to that of a musical composition."

Jawlensky's Woman with a Fan is painted as a purely planar composition, just as the French artists required. Yet, unlike paintings of the same period by Matisse, the handling of colour is more strongly modulated and the black outlines and bands of colour seem to vibrate. Areas of different shades of blue in the blouse and hat of the woman contrast with the red of the background and the flowers on her hat. The structure of the painting draws together all the details, ornamentally arranging them in the picture plane. Jawlensky has retained something of the tonality of his Russian origins: exaggeration and eastern folk art. His painting deliberately lacks the lightness of Matisse. The colour is not an end in itself, but is combined with an emotional mood dominated by the slightly melancholy expression of the woman.

Alexei von Jawlensky Woman with a Fan, 1909 Oil on cardboard, 92 x 68 cm Wiesbaden, Museum Wiesbaden

WASSILY KANDINSKY

1866-1944

In his 1912 treatise *On the Spiritual in Art* Kandinsky distinguishes between three types of paintings in his œuvre – impressions, improvisations, compositions – according to their various sources of origin. He describes his "improvisations" as mainly unconscious, sudden expressions of inner processes or impressions of inner nature. This wish to explore inner nature led Kandinsky to choose religious themes occasionally in his works of the period 1909–1912, which form a transition from figurative to abstract art. They show how profoundly rooted he was in the Christian concept of redemption and how he translated it into imagery.

Improvisation 8 and the preliminary study for it which, like most preliminary studies, is very different from the finished version, both date from 1910. On the left stands an archangel holding the sword in the centre of the picture. On the right, crouching or standing figures await judgement. Above them, as though floating in a yellow valley, we see a Russian town with its churches and domes, the Kremlin or Heavenly Jerusalem. Then again, it could just as easily be the upper Bavarian town of Murnau where Kandinsky lived and worked at the time.

Wassily Kandinsky Study for "Improvisation 8", 1910 Oil on cardboard on canvas, 98 x 70cm Winterthur, Kunstmuseum

Wassily Kandinsky Improvisation Gorge, 1914 Oil on canvas, 110 x 110 cm Munich, Städtische Galerie im Lenbachhaus

WASSILY KANDINSKY

1866-1944

Around 1910, Kandinsky began dismantling the function of black outlines as definers of figures and boundaries, replacing them with bold curves, angles and zigzag lines as direct expressions of inner movement without actually portraying any external reality. Opposites play a subordinate role in this whirl of colours and forms in *Improvisation Gorge*. Like a landing-jetty, we see a pathway penetrating diagonally into the picture in the lower half.

On it stands a couple in Bavarian costume. Beside them, a colourful cascade rushes like a waterfall. The other forms cannot be figuratively interpreted with quite the same clarity. They are in the field of the visionary. The mountain landscape with the evening sky and red sun is only the starting point. In the open pictorial structure, there seems to be no top or bottom. Some of the lines are taut, others seem distorted by the force of energy. The handling of colour alternates between clear delineation and fluidity. The forms float freely in space.

From 1914 to 1921 – the period of the First World War and the Russian revolution - Kandinsky was living in Russia. During this time, possibly influenced by Suprematism and Constructivism, we find geometric forms occurring alongside the irregular, organic forms in his paintings for the first time. During the period 1921 to 1932 – when he was teaching at the Bauhaus in Weimar and Dessau - Kandinsky used almost exclusively geometric forms, cool colours, dynamic lines and frequently chose the circle as his central motif. In 1933, he moved to Paris. Freed from the obligations of teaching, his art now turned in a new direction, in which we find a synthesis between natural forms and the geometric forms of his Bauhaus period. Unaffected by the events in Germany, he created a serene and light-hearted œuvre in Paris in his

Strange creatures inhabit the world of his Sky-Blue painting, whose title is derived from the background colour. The colour blurs at the edges, suggesting infinity rather than firm delineation. Against this lucid background, clearly delineated forms of luminous colority stand out. Geometric basic forms swell into irregular shapes, becoming organic, resembling fantastic animals. They are reminiscent of the little animals which Kandinsky created in 1926 to illustrate his Bauhaus book Point and Line to Plane. Cold and cloying colours are harmoniously balanced. The predominant basic tone scatters the figures, creating the impression that they are hovering in space. Kandinsky gives us no hint as to the interpretation of this painting. He merely speaks vaguely of a "hitherto unknown world" he has discovered.

In his painting *The Arrow* Kandinsky once again presents a highly charged figuration in a seemingly playful manner. In the interaction of rest and movement, geometric forms can be transformed into organic forms. The arrow at the centre of a midnight-blue field of action symbolically emphasizes the direction of attack launched by two amorphous forms on a geometric entity that recoils under the onslaught. To the right and left, unstably stacked geometric forms manage to hold their balance. As in Kandinsky's early paintings, there is a sense of cosmos with the forces that affect it.

The formal syntax of Kandinsky's paintings may have changed in the course of time, but the basis for his imaginary world remained constant. For him, art was a spiritual world alongside the natural world. Both are subject to the laws of the cosmic world, the laws of an overall harmony. In 1938, Kandinsky stated "The abstract world constitutes a new world alongside the 'real world', and one which, on the surface of it, has nothing to do with 'reality'. In this way, a new 'art world' is placed alongside the 'natural world' – a world just as real and concrete. Which is why I personally prefer to refer to so-called 'abstract' art as concrete art."

Wassily Kandinsky Sky-Blue, 1940 Oil on canvas, 100 x 73 cm Paris, Musée National d'Art Moderne, Centre Georges Pompidou

Wassily Kandinsky The Arrow (La Flèche), 1943 Oil on cardboard, 42 x 58 cm Basle, Öffentliche Kunstsammlung Basel, Kunstmuseum

Emil Nolde Christ among the Children, 1910 Oil on canvas, 86.8 x 106.4cm New York, The Museum of Modern Art

Emil Nolde Nordermühle, 1932 Oil on canvas, 73 x 88cm Munich, Bayerische Staatsgemäldesammlungen, Staatsgalerie moderner Kunst

EMIL NOLDE

1867-1956

In the summer of 1910, Nolde painted several religious pictures at Ruttebüll in northern Silesia. In these paintings, he expresses the religious sentiments of his youth: "The biblical images are intensive memories of youth, to which I have given form as an adult."

Christ's words "Suffer the little children to come on to me, and forbid them not: for of such is the kingdom of God" is the basis for Nolde's painting in which a division into dark and light graphically expresses the biblical story, which continues "whosoever shall not receive the kingdom of God as a little child, he shall not enter therein."

In the darker part of the painting, we see the astonished apostles, who believe themselves to be the chosen ones, in discussion. Their robes are dark blue and violet. Christ is bending forwards away from them in his bluish-green robe, towards the children with their candid expressions. They are of lighthearted innocence. Shades of yellow and red flare up like a bright light in their area. Everything radiates serenity. The yellow of the bodies and faces is also reflected in the faces of the apostles, bracketing the antithetically structured picture. The expressiveness of the colours red-yellow and blue-violet is evident. Nolde developed his expressive approach to painting entirely on the basis of colour.

Just as the mature painter turns to his youth in Christ among the children so too does he return to his youth in Nordermühle. The sight of windmills standing majestically on the sweeping flat land left a deep impression on Nolde. He recalled "the great thatched grainmill soaring high above everything. As a young boy, when we were driving our livestock in the spring or autumn, I would look up to those powerful sails cutting through the air and my impressionable child-like self was deeply moved. It seemed to me as though the great mills, confident and proud, were calling to the humans: See my beauty! And as though their sails were reflected in the surrounding canals."

In this painting, the mill seems huge and inaccessible, as though surrounded by something enigmatic. There is not a breath of wind to move its heavy sails. They seem to be a firm and unmovable part of the building. In black and white, the mill stands out against the dark, streaming colours of the landscape. Dark clouds loom over the flat horizon. In a brilliant yellowish-red, the reflection of the setting sun breaks through, lighting up the sky and fading on the surface of the water. It evokes the first day of creation, before the elements had been separated from each other, one flowing into the other, while only the mill seems to stand fast. It is a theme to which Nolde returned time and time again. The landscape, as in the work of Munch, expresses the sentiments of the painter and the way he experiences colour.

ERICH HECKEL

1883-1970

For four years, from 1907 to 1910, the fishing village of Dangast am Jadebusen became Heckel's summer workplace, apart from his Dresden studio. It was here that he created the first of the works that were to distinguish him as a unique creative force.

Windmill at Dangast clearly indicates his contribution to the expansion of colour. The few, but extremely intensive, colours of northern Germany's coastal landscape - the green of the meadows and trees, the yellow of the sand, the red of the path and the houses, the radiant blue of the sky - are heightened to the greatest possible luminosity. The two sets of colour opposites - green and red, orange/yellow and blue - underlines the effect. The spontaneity of the painterly act is legible in the fluidity of the brushstrokes. The traces of movement turn the entire picture into a field charged with energy. Black lines swirl and spiral above the fence, the meadow and the mill, breaking off at its sails. The spiral movement is not a spatial element, but a structural and compositional one. The flat effect of the dry pigments the artist ground himself stands in stark contrast to the more impasto brushwork of the Fauves, but it is also unlike Heckel's own earlier works as it has been diluted like watercolour, leaving parts of the background free. In this way, the paint unfurls all its vital, energetic powers.

KARL SCHMIDT-ROTTLUFF

1884–1976

Like Heckel, which whom he spent the summer of 1910 in Dangast, Schmidt-Rottluff abandoned the thickly applied paint of previous years, influenced by the Neo-Impressionists and van Gogh, in favour of a flatter application of broad bands of colour in his *Gap in the Dyke*. Heckel's *Windmill* and Schmidt-Rottluff's *Gap in the Dyke* bear witness to the common ground they share from the early period of the Die Brücke group.

All the vitality of this painting lies in the way the painter has handled colour. The dominant, unbroken red of the earth in the foreground finds its basis and its hold in the black fence that curves like the rim of a plate. In the paths running up the banks of the dyke, the red is carried on up over the roof of the house at the level of the strip of evening clouds. Its effect is heightened by the contrast with the deep blue of the sky that penetrates from the upper edge of the picture into the red zone that sweeps across the dyke and the figures on the path. The tension is further increased by the few yellowish-greenish tones that seem to echo the sparse, sandy coastal landscape, which has been circumscribed only sketchily with broad brushstrokes. The process of composition is here at one with emotion. Schmidt-Rottluff had "only the inexplicable yearning to capture what I see and feel and to find the purest expression for that.'

Erich Heckel Windmill at Dangast, 1909 Oil on canvas, 70.7 x 80.5 cm Duisburg, Wilhelm-Lehmbruck-Museum

Karl Schmidt-Rottluff Gap in the Dyke, 1910 Oil on canvas, 76 x 84 cm. Berlin, Brücke-Museum

GERMANY

Ernst Ludwig Kirchner Negro Dance, c. 1911 Oil on canvas, 151.5 x 120cm Düsseldorf, Kunstsammlung Nordrhein-Westfalen

Ernst Ludwig Kirchner The Red Tower in Halle. Oil on canvas, 120 x 90.5 cm Essen, Museum Folkwang

ERNST LUDWIG KIRCHNER

1880-1938

In October 1911, Kirchner moved with Heckel, Pechstein and Schmidt-Rottluff from Dresden to Berlin. Like no other painter of the Brücke group, Kirchner explored the theme of the city in his paintings with a mixture of fascination and unease. He painted street scenes or music-hall performances such as Negro Dance. He was interested in musichall performances for their movement and dynamism, their hustle and bustle, the erotic frisson, the tension created between the girls on stage and the uninvolved musicians. In the foreground, we see the orchestra pit with the conductor and musicians. On the stage, two black girls are dancing in flouncing skirts. Their pose forms an x-shape. The angular movements correspond to the angular hand movements of the conductor. This highly dynamic presentation is clearly structured and composed. Amidst the fragmented colority, only the flash of red stands out sharply, and for the first time, Kirchner uses white in his scale of colours - as though exoticism had paled in the eyes of the civilized

With the outbreak of the First World War and military conscription, Kirchner's psychological crisis was exacerbated. Already emotionally unstable, the artist broke down completely. The conflicts of the era and the conflicts of his life could not be solved by art alone. Nevertheless, in 1915, he entered one further brief and feverish creative period in which his urban landscape The Red Tower in Halle was produced.

This painting shows the so-called "red tower" a freestanding late Gothic belltower with a neo-Gothic brick base, one of the landmarks of the city of Halle. It stands on same square as the Marktkirche (the church to the left in the background) which Feininger chose as a motif in his work. The square is portrayed at such a strongly distorted angle that it seems to have been folded into the picture plane. It is surrounded on all sides by high buildings. Within this setting, the tower combines stability and aggression. In order to underline its monumentality, Kirchner chose a larger scale for the tower than for its surroundings.

The square base, distorted to a rhombus by the perspectival angle, points towards the lower edge of the picture. In this position, the tower exudes an air of aggression as well as stability. The point of the base seems to stand like a breakwater against the tide of the approaching tram. The red streets emphasize the rhomboid form of the square and the tower base. The aggressive red of the lower floor, the streets and the tram cut through the cold blue that dominates the surrounding area. Violet cumulus clouds are gathering behind the tower. Yet the cold tonality predominates, expressing Kirchner's sense of forlorn solitude. No passers-by add life to the square.

GERMANY 584

The Street was one of the first high points of Kirchner's early artistic career. The street scenes he painted in Dresden and Berlin between 1908 and 1909 record his views of city life more intensely than the other artists of Die Brücke. Kirchner himself always regarded his first Dresden street scene as a milestone on his artistic path. In his diary he called it "the first great painting".

The painting shows a lively street with passers-by. The background is a closed wall of people, broken in the middle by a tram. On the right, women in lavish hats and a man are moving frontally towards the viewer, while the passers-by on the left are moving away with their backs to us. Between these two directions of movement on either side of the road, a little girl is standing in the middle of the road. Her huge hat seems like a nimbus or even a target against the red street.

The rhythm of curved lines within the composition, set in motion by the hats of the women with their various rims, builds up to a vortex in the centre of the painting. It is the surging movement of curved lines, spiralling out from this vortex, and the contours of the figures in all parts of the composition that creates a restless dynamism on which the exuberant vitality of this painting thrives.

Ernst Ludwig Kirchner The Street, 1908/19 Oil on canvas 150.5 x 200.4cm New York, The Museum of Modern Art

OTTO MUELLER

1874-1930

The focus of Mueller's art is the human condition and paradise lost. He saw his ideal of primordial existence embodied in the life of the gypsies, which explains why they are his preferred models. They are often presented as lovers in a landscape or natural setting. Even when the situation is by no means as explicit as it is in this portrayal of *Lovers*, the erotic aspect is nevertheless muted.

The theme is approached with considerable simplicity. A young couple is gently leaning on each other. The elongation of the figures and their slender, angular features make them appear almost Gothic. Their angular movements subdue the erotic appeal of the clothed young boy embracing his lover in her unbuttoned blouse. The predominant mood is one of an indefinably passive love that closes out the external world.

The composition is dominated by vertical lines, further heightened by the fence and the tree trunks. This makes the interaction of diagonals – the line of the arms and hips – all the more effective. The muted palette is limited to only a few shades of green, yellow and brown. The cool blue creates a contrast and adds the necessary touch of tension.

Otto Mueller Lovers, 1919 Distemper on burlap, 106 x 80 cm Ravensburg, Private collection

Max Pechstein Open Air (Moritzburg), 1910 Oil on canvas, 70 x 80cm Duisburg, Wilhelm-Lehmbruck-Museum

Oskar Kokoschka Venice, Boats at the Dogana, 1924 Oil on canvas, 75 x 95 cm Munich, Bayerische Staatsgemäldesammlungen, Staatsgalerie moderner Kunst

MAX PECHSTEIN

1881-1955

In the summer months between 1909 and 1911, Heckel, Kirchner and Pechstein worked together, painting by the lakes around Moritzburg near Dresden. Pechstein wrote in his memoirs: "We lived in absolute harmony, working and bathing. If a male model was missing, one of us three would fill the gap." Life studies painted out of doors were regarded as a contrast to the rigid poses of academic painting. Life and art, it was felt, should be reunited. A relaxed and natural physicality was the ideal they strove for in the manner of Gauguin, who had sailed to the South Sea islands in order to escape social strictures. In Pechstein's painting with the programmatic title Open Air, nude and landscape have been combined in a single motif. The human individual is regarded as a part of nature. The models are shown in relaxed poses and fleeting movements. The yellow of their bodies and the towel is adopted by the landscape. Only the red of the contours delineates them and stabilizes the form. The figures stand out against a background of smooth, rich green that forms the grass and trees with very few graduations and contour lines. The blue of the sky heightens the tension of the painting. Like Heckel, Pechstein also diluted his paints like water-colours to achieve a greater sense of lightness.

OSKAR KOKOSCHKA

1886-1980

In early 1924, Oskar Kokoschka gave up his professorship at the academy in Dresden and then travelled throughout Europe, getting as far as the southern and eastern Mediterranean. His view of Venice is not a veduta in the manner of Canaletto. Kokoschka is not interested in a topographically precise rendering of the city.

While the green church domes rise in front of the horizon over a strip of low houses with red roofs, familiar to us as the silhouette of Venice, the harbour entrance bustling with everyday life takes up most of the space. The water of the lagoon, shimmering in many colours, plied by large and small boats and by a steamer with a blue-grey hull and a pale pink deck, stretches out towards the sea. To the left, in front of the old customs-house with the golden globe on the roof, the surface of the water shines almost white in the glare of the sun, and seems to be drawn down towards the depths of an abyss. Over the horizontal line of houses that anchors the pictorial structure, the blue sky spans the upper third of the painting. The transparency of colour emphasizes that water and sky are not firm elements. The expressive structure of the brushwork makes them appear like forcefields. This view of Venice is to be seen as an urban landscape, perhaps even as a universal

586 GERMANY/AUSTRIA

FRANZ MARC

1880-1916

Franz Marc used highly expressive pure colour for his symbolic portrayal of animals. In his painting Tyrol he explored wider cosmic contexts.

In an imaginary space of radiant colour, we can pinpoint individual elements of recognizable reality. A bare pine tree juts into the picture in the foreground. Below the tree, on a blue hill, there are two white farmhouses. In the upper right-hand corner of the picture, on a steeply soaring violet cliff, we see a white chapel with a black roof. The main theme of the painting, however, is the vision of the sun breaking through the mist. The light of the sun breaks against the peaks of the mountains and casts glowing bands of red and yellow into the blue twilight.

This composition, completed in 1913, was returned to the easel in 1914. Marc added a very abstract, but still recognizable, madonna in the centre of the light. Her triangular outline is reminiscent of simple peasant devotional paintings. She is standing on a green crescent moon above the tree. The child is merely hinted at in the lower corner of the yellow field.

In the almanac of the Blauer Reiter, Marc specified his goal in 1912 as follows: "to create symbols that will grace the altars of future spiritual religion.'

Franz Marc Tyrol, c. 1913/14 Oil on canvas, 135.7 x 144.5 cm Munich, Bayerische Staatsgemäldesammlungen, Staatsgalerie moderner Kunst

AUGUST MACKE

1887-1914

In November 1913, Macke moved to Hilterfingen on the shores of Lake Thun. The motif of the shore would suggest that his largest painting, Girls Amongst Trees was begun there before he left in April with his painter friends Louis Moilliet and Klee for his legendary travels to Tunisia. The artistic groundwork for the decisive Tunisian experience had already been provided by Delaunay's orphism, with its fragmentation of forms into colour and light. Delaunay's influence and the experience of the Tunisian journey are also reflected in this painting which Macke completed in the studio on his return.

The girls playing amongst the trees on the banks of the lake blend into the colour, light and space of their surroundings. The figurative is subordinated to the fleeting interplay of light and shadow and the alternation of tonality. Cool blue creates a sense of tension with warm yellow, red and brown. However, the choice of colour is used so that it unites the figures with the landscape. The blue of the lake is reiterated and continued in the dresses of the girls, carrying it right into the foreground, and countered by the reddish-brown of the tree trunks and dresses. Through the constant alternation between light and dark, cold and warm, we have an impression of movement further emphasized by the segmentlike composition.

August Macke Girls Amongst Trees, 1914 Oil on canvas, 119.5 x 159cm Munich, Bayerische Staatsgemäldesammlungen, Staatsgalerie moderner Kunst

Max Beckmann The Night, 1918/19 Oil on canvas, 133 x 154 cm Düsseldorf, Kunstsammlung Nordrhein-Westfalen

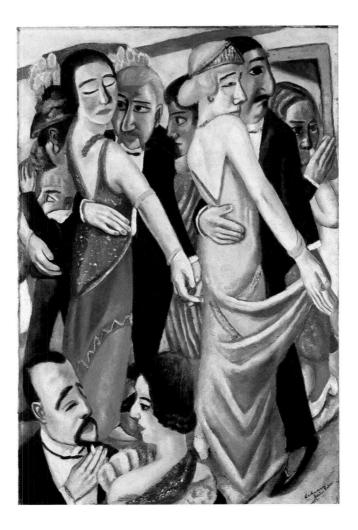

Max Beckmann Dance in Baden-Baden, 1923 Oil on canvas, 100.5 x 65.5 cm Munich, Bayerische Staatsgemäldesammlungen, Staatsgalerie moderner Kunst, Stiftung Günther Franke

MAX BECKMANN

1884-1950

In 1920, Max Beckmann admitted "It is really pointless to love humankind, that egotistical heap (of which one is also a part). But I do, all the same. I love them in all their pettiness and banality." In Beckmann's paintings, his pessimistic world view is expressed in disturbing images of distress, especially in *Night*.

The scene is a crowded attic with seven people and various props. A family is being attacked in their home by a gang. A semiclothed man on a table is being strangled and tortured by two men with bandaged heads. In the background stands a woman, and under the table a dog is howling. An almost naked woman is sinking to the floor with her legs spread wide. Her hands are tied to the window frame.

A man whose face is shaded by the peak of his cap is dragging another woman into the room. He is pulling down the curtain. The bodies of the figures, with their angular movements, seem deformed. Their faces are distorted by pain or brutality. Victims and perpetrators alike have lost their humanity. The scene appears to be lit by pale moonlight. Only a few colours flare up amidst the structure of pale tones and black lines, as though Beckmann had coloured a woodcut.

As in *Night*, Beckmann's *Dance at Baden-Baden* is also crowded with figures. Fashionably dressed couples are jostling past each other in an elegant dance-bar. The figures fill out every available space in the picture so that the floor and the back wall of the bar are barely visible. The close physical contact and angular movements suggest that the couples are moving to the rhythms of a tango.

The dance does not seem to have any particularly enjoyable or relaxing effect. Slender and cool, the figures stand stiffly, arms jutting out and hands pointing downwards. While the blonde gentleman scrutinizes his darkhaired companion, she turns her face away with a calculated look of world-weary disdain. The other couple, in similar pose, are both looking in the same direction, but not at each other. All the figures seem to be watching the others.

Beckmann has condensed his impressions of the spa resort of Baden-Baden into an image of society but he has done so without the accusing directness and aggression of Dix or Grosz. The painter appreciated the expensive elegance of low cut, sequined dresses and the masquerade of the black tuxedo. Nevertheless, the magnificence of this society game does not make him blind to human weakness disguised at great expense. The coolly shimmering tonality of the painting is merely an accompaniment. The large faces with their expressions of grim determination tell us all too clearly that the game is, in reality, a struggle.

588 GERMANY

GEORGE GROSZ

1893-1959

Grosz painted this picture during the First World War, when his feelings of disgust and repulsion for bourgeois society were at their strongest. In a letter dated 15 December 1917, he wrote: "At the moment I am working on a large hell painting – schnapps alley of grotesque dead men and madmen, there is lots going on – the man himself is riding on a coffin through the painting, on the right a boy is vomiting, vomiting all those beautiful illusions of youth onto the canvas – I have dedicated this picture to Oskar Panizza. Teeming with obsessive human animals – I am convinced that this era is sailing into destruction – our soiled paradise..."

Panizza, to whom the painting is dedicated, was a writer and psychiatrist. He had appeared in court twice for his satirical statements, accused of blasphemy and *lèse majesté*. From 1904, he was in a mental asylum near Munich. Grosz himself had spent three months in a psychiatric hospital in 1917.

As in an apocalyptic vision, the funeral procession pushes through the abyss of a city street. The human with the animal traits is painted in the tradition of Hieronymus Bosch, while the dynamic movement of the painting with its fragmented faces and falling perspective owes much to Futurism.

George Grosz
The Funeral –
Dedicated to Oskar
Panizza, 1917/18
Oil on canvas,
140 x 110 cm
Stuttgart, Staatsgalerie Stuttgart

OTTO DIX

1891-1969

The importance *Portrait of the Artist's Parents* in the œuvre of Dix was recognized as early as 1925 by contemporary critics: "In the life of each young artist, there is a great work. As far as we know this artist, he achieved that great work in July 1921. He painted his parents. Apron and blouse, rough hands and the signs of age are portrayed mercilessly and without tenderness, but with deep understanding. Cold hate gleams in the clear eyes of the old worker: I'll do it if I have to."

Otto and Louise Dix are portrayed with enormous objectivity and painstaking care, not only as familiar figures, but also as representatives of the working-class. The parents are not looking at each other, and they are looking past the viewer. They are seated in a pose of dull and almost menacing inactivity, their oversized hands resting on the arm of the sofa, or on a thigh or knee. The angle at which father and mother are seated close to each other captures them in this narrow room as a mirror image of the cramped conditions of their life. The light falling in from the side creates a sculptural quality, but also emphasizes the harshness of the modelling. Dix once said of the art of portraiture: "Each artistic statement is, to some extent, selfprojection." His emotional involvement has been transformed here to a revealing accusation.

Otto Dix Portrait of the Artist's Parents, 1921, Oil on canvas, 101 x 115 cm. Basle, Öffentliche Kunstsammlung Basel, Kunstmuseum

GERMANY

Marc Chagall I and the Village, 1911 Oil on canvas, 192 x 151.5cm. New York, The Museum of Modern Art

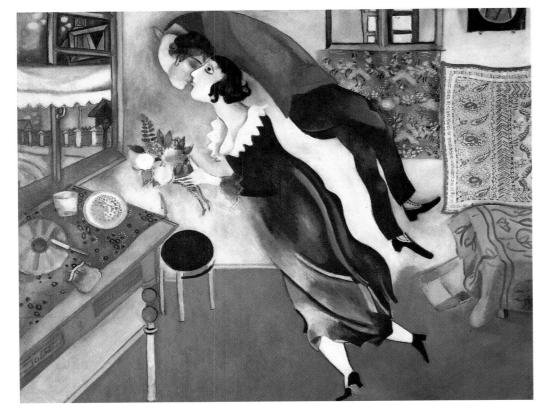

Marc Chagall The Birthday, 1915 Oil on canvas, 80.7 x 99.7 cm New York, The Museum of Modern Art

MARC CHAGALL

1887-1985

Marc Chagall moved from St Petersburg to Paris in 1910, where he met Fernand Léger, Robert Delaunay and Amedeo Modigliani. He adopted the formal possibilities of Cubism and orphism, constructing a mirror of his memories in his painting I and the Village. The stringent form of circle and diagonal cross forms the structure of order for the dream of his Russian home village of Vitebsk, in which individual facets are reiterated like transparent fragments. The stylized profile of the artist, holding a glittering posy in his hand, crowds into the painting opposite a cow whose mouth is pushed forward to meet the point of intersection of the diagonals. In the head of the cow, we see a milking scene.

For Chagall, the cow is the epitome of village security and, for him, it is almost human. Between the two heads, we see a farmer with a scythe going to the fields, while a woman points the way. The fact that she is upside-down is quite unimportant in this dream-like scene, but on the other hand it emphasizes counter-movement in space. The synagogue and the houses are on the horizon. It is as though the cosmos of memory circles round a hub.

In 1913, Chagall returned to Russia, where he met his beloved Bella once again. The emotional enthusiasm that inspired Bella and Chagall was expressed in the flying motif of lovers – almost a *leitmotif* in the work of Chagall – first presented in *The Birthday*.

Bella visited the artist in his room overlooking the Ilych church and brought with her a bouquet of flowers. We see her hurrying weightlessly towards her lover, who floats around her with a malleable body, expressing his inner emotion in outward movement. In the sparse colours of the painting, the red floor over which Bella glides and the green jacket of the floating artist create complementary contrasts.

Against a blue background, the bride appears as in a dream. She has raised one hand to her head, as though to check whether she is awake or dreaming. Although Chagall and his wife were in Paris at the time this picture was painted, we see a small Russian-style wooden cottage beside Bella, indicating the village life of her origins and, as though to indicate joy and happiness, a huge bunch of flowers is growing over the hut. Yet nothing really takes on firm contours – neither the daubed bunch of flowers, nor the lightly contoured hut. Even the bride is partly swallowed up by the dark blue. Everything in this picture is drawn together, as though there were no firm place on earth, but only in the imagination of the

> Marc Chagall Bride with Bouquet, c. 1924/25 Oil on canvas, 69 x 55 cm Mannheim, Städtische Kunsthalle Mannheim

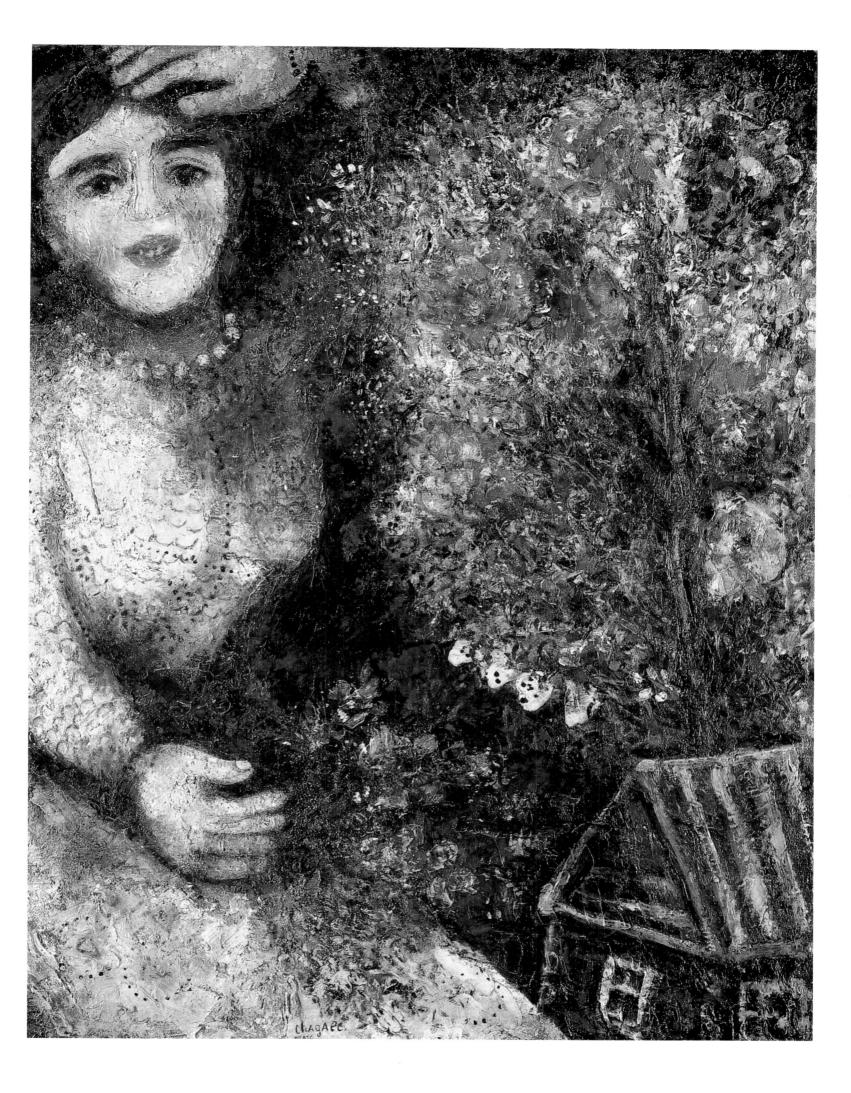

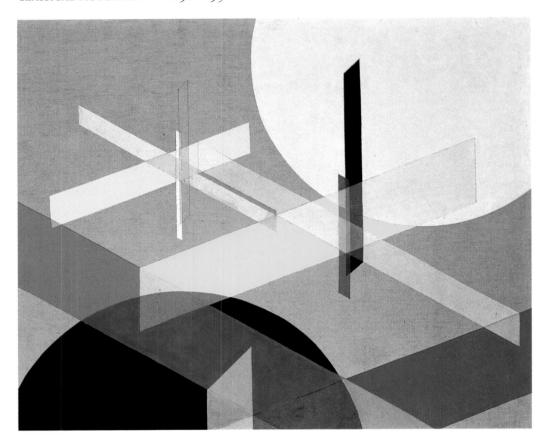

Lázló Moholy-Nagy Composition Z VIII, 1924 Distemper on canvas, 114 x 132 cm Berlin, Nationalgalerie, Staatliche Museen zu Berlin – Preußischer Kulturbesitz

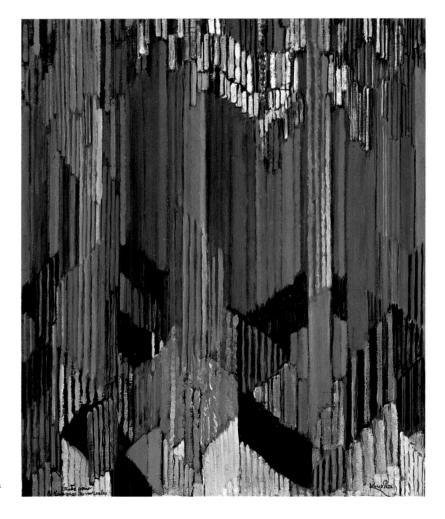

František Kupka The Language of Verticals, 1911 Oil on canvas, 78 x 63 cm Madrid, Museo Thyssen-Bornemisza

LÁZLÓ MOHOLY-NAGY

1895-1946

Vigorously dynamic movement energizes the Constructivist paintings of Moholy-Nagy, for all their compositional stringency. His Composition Z VIII is made up of an alignment of segments and bars against an unprimed canvas. Between the black and pale blue segments, placed on a diagonal, there are two closely linked constellations: a central one that dominates the picture and a secondary one that appears as a distant projection of the first. The large configuration is spanned by a yellow stripe between the two segments. One black and one grey parallel component are placed vertically, as though they were meant to meet the ground. Further stability is offered by two red bars of colour that cut through the dominant black segment. The intersections create a colourful blend of superimpositions. Subordinated configurations are shown as lighter colours. Some form sections, however, do not consistently follow this system and have been treated in retrospect according to compositional criteria.

The lightness of colours and the way the formations are integrated in the picture space suggest a fragile constellation.

FRANTIŠEK KUPKA

1871-1957

Bohemian-born Kupka exhibited abstract paintings in Paris in 1912. Yet three years earlier, he had already come very close to abstraction. The floral and ornamental forms of Jugendstil and symbolism had prepared the ground for him to break away from figurative painting. Like Kandinsky, who moved towards abstraction at the same time, Kupka was also inspired by music. The Language of the Vertical may well have been inspired by the artist's experience of the interior of a Gothic cathedral. The slender vertical stripes could well be the pillars of a church aisle, through which the purple light of the stained glass windows flows. They could just as easily be a set of organ pipes. The visual relationship with the original object, triggered by the picture, can no longer be reconstructed.

For Kupka, observation of the real world is merely the starting point for an abstract composition structured according to strict rules. Although there is an obvious displacement in space between the surface strips and others that seem to recede into the background, the overall impression is one of a picture plane evenly divided by stripes. The pattern created by the change of colours follows the basic compositional alignment.

592 HUNGARY/BOHEMIA

KASIMIR MALEVICH

1878-1935

Although Malevich drew international acclaim as a Cubo-Futurist, from 1915 onwards, he continued to guide his art away from figurative painting in the direction he had begun to take with his *Black Square* (St Petersburg, Russian Museum). According to the artist, the concept of the *Square* can be traced back to a stage design he created in 1913 for the premiere of A. Kruchenych's opera *Victory over the Sun* in St Petersburg. Lissitzky reports that the stage curtain featured a black square. This is the most radical contrast imaginable to the sunlight apotheosis of Delaunay.

While the motif of the black square may still have been vaguely compatible with conventional concepts of art in the context of a stage set, it was bound to provoke a challenge to viewers as the sole subject matter of a panel painting, especially as it was hung over a corner in an elevated position, in the tradition of Russian icons, at its first showing in St Petersburg in 1915. The intended religious allusion was confirmed by Malevich himself in a letter he wrote in 1920: "In the square, I see what people first saw in the face of God."

Suprematist Composition shows a black square and a red square on a white ground, with the red square tilted until it is almost standing on one corner. The variation of colours, proportions, and position of the squares in relation to each other and their alignment on the picture plane creates a subtle dynamics whose source of impetus remains invisible. The painting gives an impression of both movement and stability, as though some eternal power were meant to be rendered visible.

The Knife-Grinder is generally regarded as the most important Futurist-style painting by a Russian artist. Malevich explores the repeated movements of the knife-grinder by gradating the individual phases of movement in front of each other: the foot driving the wheel of the grindstone, the arms and hands holding the knife to be ground. These are movements that oscillate according to the principle of shimmering around a centre, without destabilizing the picture. Malevich not only presents the movement of the knife-grinder, but also shows his surroundings shimmering from the knifegrinder's own point of view: On the left we see the table with the knives and on the right we see the steps. The Futurists intended to transpose the vibration of the figure and surroundings to the viewer.

In 1912, the Futurists wrote: "In their lines, even inanimate objects reveal languor or wildness, sadness or happiness. By its lines, each object shows how it would deconstruct if it could follow the tendencies of its inner forces."

Kasimir Malevich Suprematist Composition, c. 1914–1916 Oil on canvas, 71 x 44.4 cm New York, The Museum of Modern Art

Below: Kasimir Malevich Knife-Grinder, 1912 Oil on canvas, 79.5 x 79.5 cm New Haven, Yale University Art Gallery

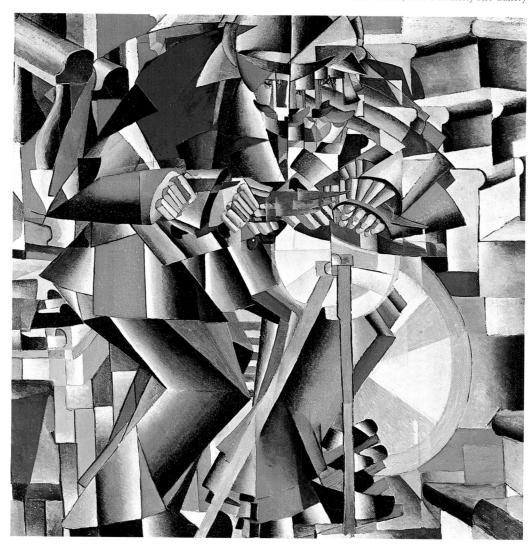

Marcel Duchamp Nude Descending a Staircase No. 2, 1912 Oil on canvas, 146 x 89 cm Philadelphia (PA), Philadelphia Museum of Art, Collection Louise and Walter Arensberg

Marcel Duchamp The Bride Stripped Bare by Her Bachelors, Even or The Large Glass, c. 1915-1923 Oil, lead, wire, foil, dust and quick-

silver on plate glass, 278 x 176cm Philadelphia (PA), Philadelphia Museum of Art

594

MARCEL DUCHAMP

1887-1968

1911 was an important year in the painterly œuvre of Duchamp. Elements of Cubist and Futurist painting, evoking processes of movement, herald the development that was to culminate in his most famous painting Nude Descending a Staircase in 1912. Immediately before that, in December 1911, he had painted his Sad Youth in a Train in which the torso, legs and head of a male figure are recognizable in spite of their cubistically deconstructed form. The repeated forms, like parallel strips, withdraw increasingly from the centre so that a spatial effect is created. Through the repetition of forms, Duchamp rendered visible a movement based on the method of serial photography that had also inspired the Futurists. Duchamp, however, does not show the inherent movement of the man, but the effects of the shuddering railway car-

In his Nude Descending a Staircase the inherent movements of the figure are presented and the individual phases of movement are clearly separated. With the aid of Cubist formal vocabulary, Duchamp has radically mechanized the Nude which is barely recognizable as a naked woman. The monochrome colouring distinctly emphasizes the mechanical movement, contributing to a further alienation. Contemporaries ridiculed the painting as "an explosion in a shingle factory".

In a later work, The Bride Stripped Bare by Her Bachelors, Even, which is also known as The Large Glass, there are no longer any indications of a human figure. The mechanical aspect is entirely dominant. With perspectival precision, Duchamp portrays a series of cones, a waterwheel, a kind of metal rack, piston-like components of wire, a grinder and geometric figures from the eye-test panels of an optician projected onto glass. This picture remained very much an enigma until Duchamp himself, a decade later, published an accompanying

The picture consists of two glass panels of equal size. The upper panel is the domain of the "bride", and the lower panel is the domain of the "bachelor machine". Both are separated by the three "insulation slabs" also known as the "bride's dress" or horizon. In the centre of the "bachelor apparatus" is a "chocolate grinder" which Duchamp defined as a symbol of masturbation: "The bachelor grinds his chocolate himself." The bachelors are presented as "nine manly moulded forms", piston-like components framed in wire. Duchamp has created the "bride" from an analogy with a combustion engine. The bride is stripped bare not by her contact with the bachelors in the male sphere, but by the bachelors inherent within her, the pistons of the motor. This picture is a pseudo-scientific diagram of the psychology of a wedding night. Duchamp was interested in exploring an antipainterly, anti-traditional principle. He wanted his pictures to have something of the precision, rationality and emotional indifference of technical articles.

FRANCE

MAN RAY

1890-1976

Man Ray's intention was to present the movement of the shadows cast by a dancer in space. The dancer has dissolved in movement. Lines mark the movement and colour planes mark the shadows. Man Ray himself described the creative process of this picture, the motif for which was a rope dancer he had seen in a music-hall performance. First of all, he sketched various positions of acrobats, each on a different piece of coloured paper, intending to indicate movement not only through drawing, but also through the transition from one colour to another. He cut out these forms and arranged them in various sequences. Having changed the composition several times, he became increasingly dissatisfied. Then he noticed the coloured paper cuttings that had fallen on the floor. He threw away the original forms of the dancer and went to work on the canvas, producing large planes of unbroken colour, whose forms corresponded to the pieces that had been thrown away when he created the first drafts of the dancer. He explained that he had made no attempt to achieve harmony of colour, using red against blue, purple against yellow, green against orange, with the greatest possible contrast, and applying the paint so generously that he used up all his supplies.

Man Ray The Rope Dancer Accompanies Herself with her Shadows, 1916 Oil on canvas, 132.1 x 186.4 cm New York, The Museum of Modern Art

Francis Picabia

Catch as catch can, 1913 Oil on canvas, 101 x 82 cm Philadelphia (PA), Philadelphia Museum of Art

FRANCIS PICABIA

1879-1953

Picabia arrived at orphism - whose driving force was Delaunay - in 1910. Orphism sought a pictorial solution to the problem of simultaneity of space and movement, taking as its starting-point proportions borne by colour alone, through which figurative elements may occasionally appear. The first exhibition of Futurist paintings in Paris in 1912 confirmed Picabia's own intentions.

Not unlike the Contrastes et formes (Contrasts of Form) by Léger, with whom Picabia had exhibited his work at the Salon de la Section d'Or in Paris in 1912, the forms take on a machine-like character. The moment of movement in space, illustrated by the reciprocal emphasis and overlapping and at times portrayed by the permeation of forms has taken on a harsher edge than orphism. The individual form gains independence. The smooth surfaces of the sharply contoured forms evoke associations with machine elements. The structural parts are arranged freely, consistently foregoing conventional rules and laws of composition. Picabia is not interested in the design of functioning machinery, but in its absolutely free variations. In 1914, Marc had entitled one of his paintings Fighting Forms. Picabia's title is Catch as catch can.

El Lissitzky Proun 19D, c. 1922 (?) Gesso, oil and collage on plywood, 97.5 x 97.2 cm New York, The Museum of Modern Art

Theo van Doesburg
Simultaneous Counter-Composition, c. 1929/30
Oil on canvas, 50.1 x 49.8 cm. New York, The Museum of Modern Art

EL LISSITZKY

1890-1941

The pale background of the picture is not seen as a two-dimensional surface, but as a three-dimensional space with different axes of projection. This explains why there is no immutable orientation from above or below, right or left. That, at least, is Lissitzky's intention. In *Proun 19* D he achieves this effect by means of a black triangle pushing up from the lower edge of the picture, thereby creating the visual field of reference for the two structural relationships with their different directions of movement.

The influence of his Russian compatriot Malevich is evident not only in the white ground and the use of grey, yellow and black, but above all in the system of planes crossing the pictorial plane diagonally with eccentrically aligned circular areas. The picture becomes a *proun* in the sense Lissitzsky intended by the fact that the diagonal planar system appears to be overlapped by a horizontal component and a spatial system running at right angles to it.

What Lissitzky was preparing in his pictures was the completely new design of the environment. He enthused: "the new elements we have brought forth in painting we shall pour over the entire world to be constructed by us and we shall make the rawness of concrete, the smoothness of metal and the mirror of glass the skin of a new life."

THEO VAN DOESBURG

1883-1931

In his article entitled Painting - from Composition to Counter-Composition published in the De Stijl magazine, Doesburg wrote in 1923: "On the one hand, the term counter-composition contrasts with the classical and even the abstract concept of composition and design. On the other hand, it contrasts with the fundamental, predominant structural elements of nature and architecture." Van Doesburg sought to break free from all regulations that had structured composition in a traditional sense: "Elementary (antistatic) counter-composition: it adds a new, angular dimension to the orthogonal, peripheral composition. In this way, it dispels the horizontal-vertical tension in a very real way. Introducing angular planes, areas of dissonance in opposition to gravity and architecturally static structure... introduction of colour as independent energy."

Van Doesburg has veered away from the strict concept of the right angle in this counter-composition by tilting and cropping the yellow, blue and red colour planes. Compositionally, however, he has created a balance through the position and size and repetition of certain angles. The black of the right angle repeats itself in the bars that frame the colour fields.

PIET MONDRIAN

1872-1944

When Piet Mondrian moved from Amsterdam to Paris in 1911, he came into contact with the Cubists. He adopted their preference for an oval frame and their compositional principles.

In his *Oval Composition*, he elaborates on the phase of analytical Cubism in which the greatest possible degree of abstraction is achieved. In Mondrian's work, too, the figurative starting-point – in this case, trees – has been dissolved to the point of unrecognizability. The colour changes between grey and ochre tones, applied in brief brushstrokes in the Cubist manner, and the use of short black lines that add a distinctive rhythm to the picture is also Cubist. The basic directions of horizontal, vertical, diagonal and round, however, create a network of greater density than we might normally find in Cubist painting. The picture is more tense and more stable.

For Mondrian, Cubism was only a preliminary stage in the quest for more absolute solutions: "Gradually, I began to realize that Cubism did not take on the logical consequences of its own discoveries. It did not develop abstraction through to its ultimate goal of expressing pure reality. I felt that it could only be achieved through pure compositional design and that this should not be determined essentially by subjective feelings and imaginings. For a long time, I endeavoured to discover the special qualities of form and natural colour that arouse subjective emotional states and obscure pure reality. Natural forms thus have to be traced back to pure and immutable conditions.'

Mondrian made the contrast of vertical and diagonal principle the basis of what he called the "nieuwe beelding", or "new plastic" as it has come to be known in English. His aim was to create a universal harmony and overcome individualism. He saw total abstraction as the only possible means of doing so, by completely eradicating any element of the sensual perception of visual reality. This meant limiting the pictorial means to their basic elements: straight line, right angle, primary colours red, yellow and blue, non-colours black and white. The radical application of these principles in a large scale structuring of his paintings and their reduced colourity began in 1921.

The degree of reduction is most advanced in those paintings which are not based on the three primary colours, but on the dominant tone of one basic colour. The larger red field is both enhanced and subdued by the smaller blue field. Most of the areas delineated by the black lines of varying thicknesses are taken up by the non-colour white, in accordance with Mondrian's view that "Equilibrium generally requires a large expanse of non-colour or empty space and a small expanse of colour or matter."

Above:
Piet Mondrian
Oval Composition
(Tree Study), 1913
Oil on canvas,
94 x 78 cm
Amsterdam,
Stedelijk Museum

Piet Mondrian Composition No. II; Composition With Blue and Red, 1929 Oil on canvas, 40.5 x 32 cm New York, The Museum of Modern Art

Paul Klee Villa R, 1919 Oil on cardboard, 26.5 x 22 cm Basle, Öffentliche Kunstsammlung Basel, Kunstmuseum, Imv. Nr. 1744

PAUL KLEE

1879-1940

The foreground of the painting Villa R consists of a grassy knoll with graphically suggested trees. Behind them, like a monument, stands a large green R. A red path winds diagonally across the landscape past an architectural structure that looks like a house made of building bricks. It looks more like a backdrop than a real and inhabitable house. It is flat and unreal, and even the mountains in the background seem ornamental, without any structural volume. They are framed by a large green crescent moon on the left and a yellow sun on the right. The brighter corner areas at the upper edge draw the picture together. Klee has given this picture the magical depth of a glass window through his contrast of dark and luminous colours.

When Klee described the *Wege eines Naturstudiums* (Ways towards a study of nature) in 1923 to students at the Bauhaus, he explained the aim of studying as follows: "The development of the student in the observation of nature enables him, the closer he comes to a world view, to achieve a new naturalness, the naturalness of the work".

In Senecio Klee takes the circle as his basic form, dividing it into geometric colour fields, drawing a flat figure of eight and placing round red discs in the almond-shaped eyes. The figurative association becomes all the more clear and is further developed. The forms become eyes, the vertical line becomes a nose, the squares become a mouth, the circle a head. It seems like the head of a child with the wisdom of an adult. Klee has created his "little old person" Senecio on the basis of geometric components.

The blue dish with the fish and bunches of dill seems to float in the middle of the picture against the dark background, surrounded by various figures and objects that have been symbolically reduced: above the table, a full and a crescent moon; on the left, emphasized by the arrow and the exclamation mark, the head of a person growing on a stem that protrudes from a cylinder; on the right, a cross under a trefoil that seems to grow like a flower out of another cylinder; at the lower edge of the picture, another flower and a cut lemon.

The fish, symbol of Christianity, forms the centre, around which the cycle of death and resurrection moves. It appears in two forms: as a living creature superimposed over its own shadowy shape. The two cylinders are channels of transformation; the one on the right is recognizable as the channel of death, signified by the cross, and the one on the left as the channel of resurrection, symbolized by the branch, the head and the banner. The double moon underlines the concept of the cycle. This painting is one of the first Klee produced in Dessau after the Bauhaus moved there from Weimar in 1925.

Paul Klee Senecio, 1922 Oil on gauze on cardboard, 40.5 x 38 cm Basle, Öffentliche Kunstsammlung Basel, Kunstmuseum

Paul Klee Around the Fish, 1926 Tempera and oil on cotton, 46.7 x 63.8cm New York, The Museum of Modern Art, Abby Aldrich Rockefeller Fund, Inv. Nr. 271.39

Oskar Schlemmer Bauhaus Stairway, 1932 Oil on canvas, 162.3 x 114.3 cm New York, The Museum of Modern Art

Lyonel Feininger Marktkirche in Halle, 1930 Oil on canvas, 100.7 x 85 cm Munich, Bayerische Staatsgemäldesammlungen, Staatsgalerie moderner Kunst

OSKAR SCHLEMMER

1888-1943

In spite of the wide range of his creative work, Schlemmer concentrated almost exclusively on a single theme: people and space. In 1923, he noted in his diary: "The birth pangs of the new – controversial – unacknowledged. Yet a major theme remains, ancient forever new, object and creator of all time: man, the human figure, of which it is said that it is the measure of all things."

After nine years at the Bauhaus, where it proved impossible to resolve the conflict between fine and applied arts, Oskar Schlemmer moved to the academy in Wroclaw in 1929. There, he painted from memory the stairway of the Bauhaus in Dessau, designed by Walter Gropius, which undoubtedly embodied an ideal architecture for him. The stairway allows him to gradate a number of male and female figures in the space. They are aligned at various angles; back, frontal and profile. Bodies, heads and faces are all made up of standardized basic forms that avoid any sign of individuality. The result is a distinctive vertical, horizontal and diagonal linearity in the painting.

The square panes of the window form the background. Plane and volume, architecture and figure interact. Here, Schlemmer has used the colours that tend to predominate in his œuvre as a whole: shades of grey, blue and reddish brown.

LYONEL FEININGER

1871-1956

The Cubists had a decisive influence on Feininger's stylistic development. In Paris, he met Delaunay, with whom he shared an interest in the refraction of light and questions of colour. However, he was not interested in exploring the problem of form detached from sensual perception of the environment. In 1913, he began working on architectonic compositions, whose themes were primarily the villages and towns of Thuringia. Feininger once said of his preference for these motifs: "The church, the mill, the house – and the cemetery – have filled me with a profound sense of reverence since my childhood."

The Marktkirche in Halle was painted in 1930, when he had a studio in a tower at the invitation of the museum director of Halle. The west façade of the church, with its double spires, is positioned frontally at the centre of the picture, and the nave is portrayed in foreshortening. There are some houses around the church. On the square in front of it, we see tiny little figures, and their small scale underlines the monumentality of the building. The church and the sky are prismatically divided in the same manner. The forms are transparent and flooded with light. Although Feininger adopted the Cubist method of deconstructing down objects, he developed his own set of rules, which he called "prismaism".

GRANT WOOD

1892-1942

When Grant Wood exhibited his painting *American Gothic* at the Art Institute of Chicago, he was accused of caricaturing American rural life. On the other hand, he was also accused of idealizing Mid-Western antipathy to civilization and the rural rejection of progressive urban attitudes. Wood was not interested in taking sides, but chose the themes he felt he could portray best because he knew them best.

A farming couple, described by Wood as father and daughter, are standing in front of a wooden house with the kind of pointed window arch that earned this form of architecture the epithet "carpenter's Gothic". Wood's sister Nan and his dentist Doctor McKeeby were the models for this couple with their old-fashioned clothes and direct gaze. The prongs of the hay-fork, a metaphor for rural America, reiterate the Gothic window. Like the hay-fork the man is holding, the flower-pots behind the woman, the house, the barn and the church tower are all indications of the property, profession and attitudes of the two figures. The puritanical sobriety of the couple corresponds to the dry realism of the portrayal which corresponds in many ways to the Neue Sachlichkeit (New Objectivity) movement in Europe.

1882-1967

A key motif in the work of Edward Hopper, who was always interested in the question of lighting, is the portrayal of various times of day and, in particular, night. The special atmosphere of night is portrayed here in the simple motif of a corner building with three illuminated windows.

In the confrontation between the dark outside world and the brightly lit room, he places the viewer in the situation of a voyeur. In order to allow the spectator to participate in what is going on in the room, he chooses an elevated point of view. The cornice of the building and the floor of the room are seen from above. Through the central window, we can recognize the figure of a woman in a petticoat with her back to us. The intimacy of the situation makes the spectator's gaze seem intrusive.

Unlike other artists, Hopper uses the window as a motif that intensely clarifies feelings of separation, uninvolvement and alienation. On the one hand, the artist and the spectator are shut out from the scene they are observing, but on the other hand, those observed are also shut out from the outside world. In order to add tension to the contrast between the contemplative mood of the self-contained interior and the frequently more vibrant outer world, Hopper often uses motifs such as fluttering curtains, as he does here.

Grant Wood American Gothic, 1930 Oil on beaverboard, 75.9 x 63.2 cm Chicago (IL), The Art Institute of Chicago

Edward Hopper Night Windows, 1928 Oil on canvas, 73.7 x 86.4 cm New York, The Museum of Modern Art

Giorgio de Chirico The Silent Statue (Ariadne), 1913 Oil on canvas, 99.5 x 125.5 cm Düsseldorf, Kunstsammlung Nordrhein-Westfalen

1888-1978

De Chirico painted six important pictures in 1913 featuring the statue of Ariadne as a motif. This ancient Greek work was familiar to him in the form of Roman copies in the Vatican and Florence. The statue shows the restless sleep of Minos' daughter, plagued by nightmares, on Naxos. Ariadne was abandoned by her husband Theseus as she slept.

De Chirico has placed the statue diagonally in the picture and has moved so close to it, closer than in his other paintings, that the motif appears in detail. The face, worn by sleep and dream, is the main motif. In his essay *The Desire of the Statue* De Chirico states: "She loves her strange soul. She conquers. The sun is high in the centre of the sky. And in constant contentment the statue bathes her soul in the contemplation of her shadow."

The statue stands on a square in front of a building with deeply shadowed arcades and in front of a tower with fluttering flags. De Chirico explains: "The Roman arcade is fate. Its voice speaks in riddles filled with singular Roman lyricism." In the background, the sea appears as a black plane. The volumes of the objects have been projected into the plane so that everything appears incorporeal and intangible.

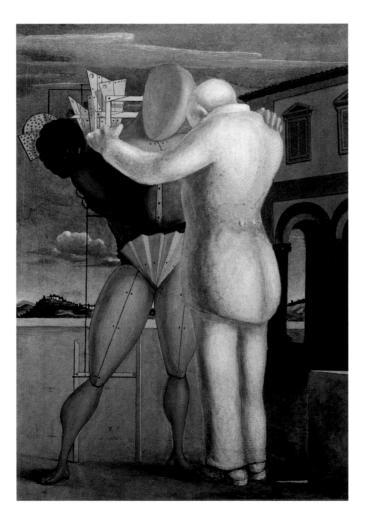

Giorgio de Chirico The Prodigal Son, 1922 Tempera on canvas, 87 x 58 cm Milan, Civico Museo d'Arte Contemporanea

In the early 1920s, De Chirico began to take an interest in the techniques of Renaissance artists. The Russian painter Nicola Lochoff introduced him to the secrets of *tempera grassa* vernicata. The Prodigal Son is painted in this revived technique, but nevertheless retains the ambiguity of pittura metafisica.

In De Chirico's painting, we find none of the stirring pathos that normally imbues portravals of this encounter between father and son. De Chirico's painting shows their meeting as the meeting of two representatives of different ages, an encounter between fossilized tradition and helpless modernity. The father stands as a stoney monumental figure in front of the son, on whose shoulder he has placed his hand. The son stands there, large and powerful, but as a puppet without facial traits and incomplete limbs, requiring the support of a complex structural frame. For De Chirico, the puppet is a metaphor of the modern anti-hero in a universe in which the heroism of classical Antiquity - the heroism of Achilles, Hector or Roger - is no longer possible. The place at which the monumental figure and the puppet meet has all the stability and dignity of Renaissance architecture. In the background, we see a cultivated, hilly landscape. The yearning for refuge in tradition is not fulfilled.

602

CARLO CARRÀ

1881-1966

In the early 1920s, Carrà began painting seascapes in the manner of Giotto. Carrà, who had distanced himself from the principles of *pittura metafisica*, published a book on Giotto in 1924, in which he pointed out: "In the magical tranquillity of Giotto's forms our gaze comes to rest; our ecstasy grows and gradually dissolves in a sense of transfiguration."

Carrà's *Summer* also exudes an air of tranquillity. It is an everyday scene on the beach. The woman on the left in profile is drying her hair, her face covered by the towel, while the woman on the right with her back to us is drying her knees with the towel wrapped around her waist. Between them sits a dog, and the right-hand side of the picture is bounded by a bathing cabin. Behind it, we see the bay, with a boat and some hills.

The appeal of this painting does not lie in the subject matter, but in the almost monumental simplicity of the composition. In their strength, simplicity and unornamented stringency, the large figures herald the emergence of a new Classicism after the formal experiments of the early decades of the 20th century. Time seems to stand still. Both of the figures have turned away from the viewer. Not even the dog reacts. In this way, Carrà closes the picture, and at the same time arouses our curiosity which is satisfied only by the form.

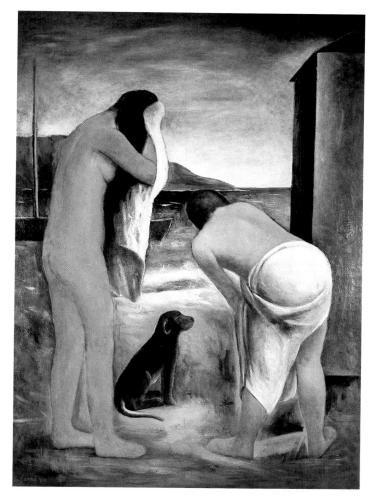

Carlo Carrà Summer, 1930 Oil on canvas, 166 x 121.5 cm Milan, Civico Museo d'Arte Contemporanea

GIORGIO MORANDI

1890-1964

The work of Morandi has only one brief close link to the movements of classical Modernism: the metaphysical still lifes of the period 1918/19. Just one year later, Morandi was to go his own way – entirely independent of the trends of his time.

In his still lifes, Morandi explored an artistic problem which he explains quite simply: "The only interest that the visible world arouses in me has to do with space, light, colour and form." Morandi severely restricts the traditional handling of space based on the use of central perspective. The depth of the table surface foreshortened in a flat curve is reduced by the wall immediately behind it parallel to the picture plane.

The components of the still life are arranged on the table: bottle, vases, round fruit, a box with a fruit dish on it. Light models the objects only to the point of creating an impression of tangible volume, but the self-contained form remains. The result is a balancing act, combining planar elements with volume and space. The colours, limited to ochre, brown and white, creating a soft *chiaroscuro*, underline the ambivalence of positive and negative forms.

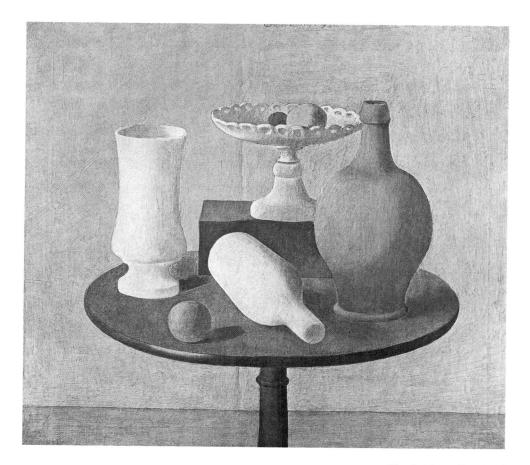

Giorgio Morandi Still Life, 1920 Oil on canvas, 60.5 x 66.5 cm Milan, Private collection

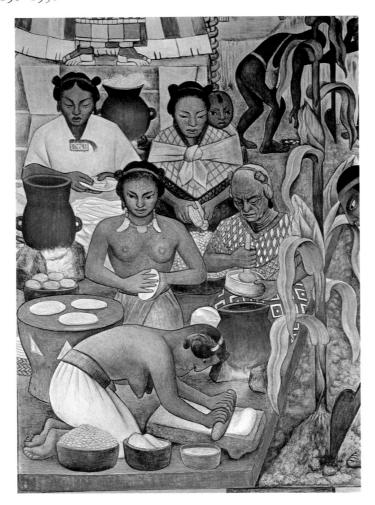

Diego Rivera The History of Mexico: Huastec Civilization, 1930-1932 Fresco (detail) Mexico City, Palacio Nacionale

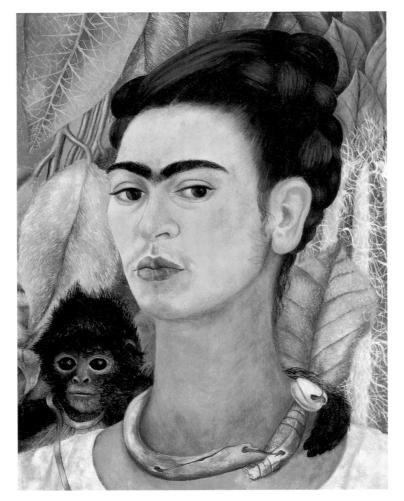

Frida Kahlo Self Portrait with Monkey, 1938 Oil on hardboard, 40.6 x 30.5 cm Buffalo (NY), Albright-Knox Art Gallery, A. Conger Goodyear Bequest, 1966

DIEGO RIVERA

1886-1957

Rivera, who had closely studied contemporary art in Europe, particularly in Paris, returned to Mexico in 1921, where he joined the Communist Party. Drawing on the traditions of Mexican folk art, he began painting murals intended to present the country's history to its uneducated people. For the National Palace of Mexico City, he created a narrative sequence of pictures on the theme of Mexican culture in the period before the arrival of the Spanish conquistador Hernán Cortés. With the painstaking thoroughness of a historical researcher, he gathered all the available sources and translated them into realistic paintings of compelling clarity and monumental impact.

Huastec Civilization shows grain and corn being milled and made into tortillas. In the foreground, a woman is kneeling on the ground, grinding grain to flour on a stone. Behind her, four women are seated on the ground. A young woman is shaping tortillas by hand, while the older woman beside her is stirring. A mother is removing the grains of maize from the cobs and her neighbour is making tamales. On the right beside the five women, a man is planting corn.

The scene is watched over by protective gods, of whom all we can see in this particular detail is the feet. In the background there are cornfields. Rivera's didactic intention is reflected in the clarity of the composition.

FRIDA KAHLO

1907-1954

With a proud and almost imperious gaze, the artist looks directly at the viewer in this self portrait. Her deep brown eyes are fixed on us and her pink lips demand our attention. Frida Kahlo stylizes herself as a confident artist and woman.

The simple, apparently naive pictorial language, in which elements of Mexican devotional painting are blended with classical portraiture, emphasize the symbolic meaning of the attributes. The necklace of bones around her neck may be read as a metaphor of death. The foliage in the background indicates the jungle as the origin of nature and all life.

The little monkey is one of the many animals that lived in the Blue House of Diego Rivera and Frida Kahlo. He has placed his arm around the artist, and behind his large eyes, we seem to perceive a vulnerable soul. In Western and Mexican iconography, the monkey is a symbol of lust, though Mexican mythology also treats the monkey as a patron god of dance.

Here, Kahlo is making a reference to her complex relationship with her husband Rivera who had an affair with her sister Christina a few years earlier. In 1938, as an expression of her new found independence, she travelled alone to New York for the opening of her solo exhibition.

MEXICO 604

CHAÏM SOUTINE

1893-1943

Between 1927 and 1929, Soutine painted many pictures of choirboys, restaurant staff and hotel porters. The *Page Boy at Maxim's* is shown as a frontal three-quarter figure. He is wearing a red uniform with gold buttons. He stands, arms akimbo, as though seeking to demonstrate the sleekness of his slender, wiry figure. The instability of his stance is underlined by the little hat balancing on his head. The cap also makes the face of the boy seem caught between it and the uniform. The rather audacious, tongue-in-cheek expression also has something tortured about it. The background is formed by the instable movement of a heavy blue velvet drape.

Soutine was probably fascinated by the single colour and identical structures of uniforms, which have fewer variations than civilian clothing. What is more, uniforms tend to subdue individuality, depersonalizing the unique and emphasizing anonymity. Painted in thick, heavy brushstrokes, it becomes a vibrant material, an artificial skin. In his work, Soutine explored one colour after another: the white of the chef, the red, dark green and blue of the page and valet, the white and purple of the choirboy. He was constantly seeking the right form for his motif.

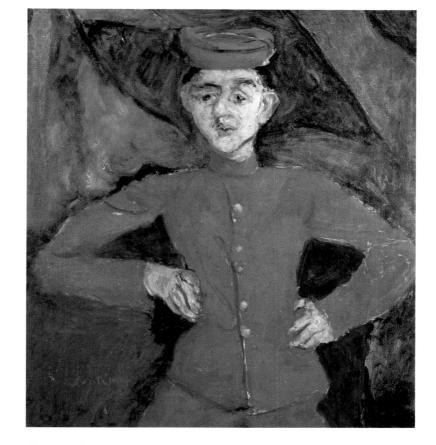

Chaïm Soutine
Page Boy at Maxim's, c. 1925
Oil on canvas, 81.9 x 74.9 cm
USA, Private collection

André Masson Meditation on an Oak Leaf, 1942 Tempera, pastel and sand on canvas, 101.6 x 83.8cm New York. The Museum of Modern Art

ANDRÉ MASSON

1896-1987

Masson, who fled to America from France during the Second World War, wrote that he still imagined the country in which he was exiled in terms of a virgin forest, and that this had a psychological influence on his painting in America. The cities, he claimed, did not affect him in any way; it was the proximity to nature that became a typical characteristic of his American work.

Concentrating on an oak leaf triggered associations for Masson. The picture is positively teeming with biological symbols of germination and growth of individual cells or larvae to the point of totemic configurations of floral, faunal and human nature. The link in this chain of associations is the oak leaf which can be seen as a silhouette and blue shadow at the top left. Within this silhouette, its outline is reiterated in a smaller form like a cell division. The result is a labyrinthine constellation reminiscent of the cycles of nature, and the trauma and fantasy of the soul. The forms as a whole create a totem, crowned by a cat's head symbolizing the animal kingdom.

LITHUANIA/FRANCE 605

Joan Miró Harlequin's Carnival, c. 1924/25 Oil on canvas, 66 x 95 cm Buffalo (NY), Albright-Knox Art Gallery

Joan Miró Hirondelle Amour, 1934 Oil on canvas, 199.3 x 247.6cm New York, Collection, The Museum of Modern Art, Gift of Nelson A. Rockefeller

JOAN MIRÓ

1893-1983

Harlequin's Carnival shows Miró's breakthrough to the portrayal of the imaginary and the miraculous in an atmosphere of levity and serenity. Many figures, objects and signs appear, overlap and take part in the magical game that is a mixture of carnival, theatre and fairytale. A harlequin with a moustache and a mechanical guitarist with a wind-up key take the leading roles. Around them we see cats playing with a ball of wool, birds of paradise laying eggs from which strange butterflies emerge, flying fish encountering comets. An insect is crawling out of a cube. On a ladder hangs a huge human ear, and between its rungs there lurks an eye. Eyes open on cubes, cylinders and cones between the living fairytale toys scattered on the floor. A window gives a view of a black triangle, a red flame and a star against a blue sky. The luminous colours are subordinated to the precise drawing of the forms. Through repetition and distribution of colours, reference and pictorial rhythm are created.

Miró did not distinguish between painting and poetry. Time and time again, he painted pictures in which he includes words or poetic phrases. The freely associative inscript "hirondelle amour" that inserts the two words without any syntactic connection, corresponds to the Surrealist refusal to insist on certain qualities or intrinsic properties of objects. Yet the signs bear such an unequivocal significance that a sexual element is clearly evident in their playful levity.

From 1926 onwards, Miró developed his own highly distinctive alphabet of pictorial signs, which he continued to use increasingly freely over the years and, in the course of which, his pictorial world became more serene and humorous. The material and grain of the canvas play an important role in a number of paintings towards the end of the 1940s. The priming is irregular and emphasizes the coarse texture. On the other hand, the forms appear more planar. The result is an attractive interaction between the background, the colour planes on it and the black lines. Two figures are interwoven. The form of the red sun corresponds to the large head of the figure directly on the lower edge. The body of the figure soars vertically into the air. Only if we turn the picture around does the figure stand on its feet. As on a playing card, the concepts of "above" and "below" are no longer valid.

> Joan Miró People and Dogs before the Sun, 1949 Tempera on canvas, 81 x 54.5 cm Basle, Öffentliche Kunstsammlung Basel, Kunstmuseum, Stiftung Emanuel Hoffmann

MAX ERNST

1891-1979

The basic concept of this painting is based on the work of de Chirico. Behind a square, stagelike floor we see a brief indication of a landscape with a low-lying horizon spanned by the high arch of the sky. A two-legged, drum-like monster stands firmly on the ground, crowned by a figure based on one of de Chirico's geometric elements. In the foreground, a headless female figure raises her arm, and we see fish swimming in the sky. The objects are unreal, yet the precision of the painterly technique lends them the appearance of reality.

Max Ernst did not actually invent the name *Celebes*. In fact, Celebes is one of the Greater Sunda Islands of Indonesia. The island has a singular four-armed shape consisting of an almost square central part with large peninsulas. The form of the elephant is derived from a picture of an African grain silo.

Found objects have been combined in this picture as in a collage, of which Max Ernst explained: "Collage technique is the systematic exploitation of the coincidental or artificially provoked encounter of two or more unrelated realities on an apparently inappropriate plane and the spark of poetry created by the proximity of these realities." For the Surrealists, collage served to find new contents, rather than new forms, as in the work of the Cubists.

Above:

Max Ernst
Elephant of the
Celebes, 1921
Oil on canvas,
125 x 106cm
London, Tate Gallery

Max Ernst
Après nous la
maternité, 1927
Oil on canvas,
146.5 x 114.5 cm
Düsseldorf,
Kunstsammlung
Nordrhein-Westfalen

Birds play an important role in the work of Max Ernst. The repertoire of birds is ambivalent in its significance. It is both evil and tender, coy and demonic, a metaphor of liberty and of menace.

In the painting *Après nous la maternité*, creatures that are part bird and part human are grouped in a triangular hierarchy. The character of the painting itself is as ambivalent as the creatures. The central figure embraces a smaller bird-like creature in an attitude of matriarchal security, while the soaring bird-like creature above it embodies independence from that security and, therefore, liberty. The central group is an ironic reference to Raphael's Madonna paintings.

As in many other pictorial motifs, Max Ernst traces the blend of bird and human to an experience in his youth: "A friend by the name of Hornebom, a clever, colourful, loyal bird, dies in the night: a child, the sixth, comes to life that same night. Confusion in the brain of the otherwise healthy boy. A kind of interpretative madness as through the innocence just born, sister Loni, had taken the dear bird's vital juices. The crisis is soon overcome. Yet in the boy's imagination, there is a voluntary, irrational imaginative blurring of people and birds and other creatures; and this is mirrored in the emblems of his art."

In 1945, Max Ernst won a painting competition held by an American film company on the theme of *The Temptation of St Antony* for Albert Lewin's film *The Private Life of Bel-Ami*. One of the eleven artists who entered the competition was Dalí, Max Ernst gave the following statement on his painting: "Over the brackish water of his dark, sick soul, St Anthony receives the echo of his fear as a reply: the laughter of the monsters born of his imagination."

St Antony in the red monk's habit is suffering terrible tortures in the hallucinations embodied by the fantastic creatures surrounding him. They are creatures made up of parts of mammals, birds, reptiles and humans. Though the concept and artistic technique in this painting are closely linked with surrealism, this work also owes much to the tradition of medieval German painting, especially the same theme treated by Grünewald.

Max Ernst has used the technique of decalcomania for a considerable proportion of the image, in which paint is applied to a sheet of paper or glass and a second sheet is then superimposed on this background and raised, creating characteristic structures on the painted surface. The painter can then use the imprints or blots created in this way to identify forms and find in them the structure of the monsters. The figure of St Antony himself was created by conventional painterly techniques.

Max Ernst The Temptation of St Anthony, 1945 Oil on canvas, 108 x 128 cm Duisburg, Wilhelm-Lehmbruck-Museum

KURT SCHWITTERS

1887-1948

Schwitters began creating pictures made of waste materials in 1919, one year after the end of the First World War. He called them *Merz* pictures. They correspond to his mood at the end of the war: "I felt free and I had to cry out my joy to the world... You can also cry out with waste products, and that was what I did by gluing them and nailing them together."

The Merz pictures blur the boundaries between painting and relief. Different materials are mounted on the cardboard background: snippets of paper, can lids, pieces of cardboard, wooden batons, wire, string, tickets and newspaper cuttings. The objects have not been left in their found state, but most of them have been painted over. Against the earthy brown background, lighter colours stand out in faceted fragmentation: ochre, red, blue and green.

Only fragments of the newspaper clippings are legible: Offener Brief [open letter], (R)eichsk(anzler) [chancellor of the Reich], Die Korrupt(ion) [corruption], Mathias (Erzberger). The mention of Mathias Erzberger, who signed the ceasefire at Compiègne in 1918 and who was Minister of Finance in 1919/20 gives the picture a specific time-frame. The found items are used in terms of their formal quality, while the disks reiterate the late Expressionist concept of the cosmic.

Kurt Schwitters Merz 25 A. The Constellation, 1920 Montage, collage and mixed media on cardboard, 104.5 x 79 cm Düsseldorf, Kunstsammlung Nordrhein-Westfalen

Paul Delvaux The Encounter, 1938 Oil on canvas, 90.5 x 120.7 cm Private collection

Yves Tanguy The Palace of the Window Cliffs, 1942 Oil on canvas, 163 x 132 cm Paris, Musée National d'Art Moderne, Centre Georges Pompidou

PAUL DELVAUX

1897-1994

The frozen stillness and stage-like scenery of *The Encounter* is derived from the metaphysical urban imagery of de Chirico, which profoundly influenced Delvaux and Magritte from 1936 onwards. From this treasure-trove of motifs, Delvaux created a distinctive pictorial cosmos that explores the impossibility of communication between the sexes. Like Magritte, Delvaux used a meticulously detailed technique to present improbable, dream-like encounters.

Delvaux also adopted from René Magritte the motif of the well-dressed man in the bowler hat with the traits of the artist. He greets his model and ideal human: an academic female nude barely clothed in a magnificent drape. In the windows of the stage-like facades of Renaissance buildings running towards the background, we see further classically dressed women. Disturbed by the arrival of a streetcar, another woman flees into the forest in the background. Here, the Surrealist love of expectations confused by combinations of improbability is evident. Encounters between civilization and nature, modern man and antique Venus are possible in a moment of frozen time in which reality is interrupted and undermined.

YVES TANGUY

1900-1955

Around 1926, Tanguy found the theme that he was to vary continuously until his death: the Surrealist landscape. In *The Palace of the Window Cliffs* no horizon line divides the sky from the earth. They merge in a mutual, pale, greyish-blue tone. In the foreground are indefinable objects – some like stone, some like coloured plastic. Some stone-like elements have the regular form of architectural components. Apertures are placed like noses. The individual components are linked with each other by lines and points of connotation, as though to present them dissolving into the infinite space.

André Breton, who, like Tanguy, had emigrated to the USA during the Second World War, wrote of Tanguy in the year this painting was created: "Until Tanguy, the object, even though it was subject to a number of external attacks, remained unmistakable and a prisoner of its identiy. With him we enter the world of complete indeterminability for the first time: 'at any rate no actual appearances' promised Rimbaud. The elixir of life seeks to set itself apart from all the upheavals of our transient individual existence."

RENÉ MAGRITTE

1898-1967

The combination of eroticism and sadism finds its extreme expression in the theme of the crime of passion that played such an important role in German art in the 1920s. In French and Belgian art of the same period, Magritte's painting is a thematic anomaly.

The room is structured like a stage. A red *chaise-longue*, on which the pale corpse of a naked woman is lying, juts into the room. Her throat has been cut. Blood is streaming from her mouth.

At the front of the room, a man is standing beside a small table on which there is a gramophone. The distinctly well-dressed man is listening to music. His face shows no sign of emotion. It is as though a doctor had made his visit in this bright, sparsely furnished room and was listening to a little music to help him relax after his strenuous work. But the room is surrounded. Three men, a rugged mountain landscape behind them, are looking into the room over the balcony railing. In the foreground, a man with a club is standing to the left of the entrance to the room, while a man on the other side is waiting with a net. In their neat clothing, the gentlemen look distinctly bourgeois. They are all quite immobile, and everything has frozen to a state of uneventfulness.

Magritte has coupled the horror of the situation with bourgeois harmlessness. The picture shows the dichotomy between social adaptation and the overstepping of social norms. The Surrealists took the provocative stance of seeing the positive aspect of the criminal as an individual who does not comply with social strictures.

In August 1927, Magritte moved from Brussels to the Parisian suburb of Perreux-sur-Marne, where he became involved with the Parisian surrealists. In his new circle of friends, he gained fresh inspiration and it was here that he produced his first paintings involving words.

Interpretations of these paintings frequently refer to the philosopher Ludwig Wittgenstein and his critique of the inadequacy of language. This approach tends to underestimate the influence of Magritte's direct contact with André Breton in Paris. In 1927, Breton criticised the fact that poets were incorrigible word fetishists, and that words took the place of things and even of living creatures and that for a poet to move from language to reality merely signified a tautology. For Magritte, a picture or a word can never be identical with reality.

The designation alone says nothing. Magritte points out this problem of "naming" in his *Palace of Curtains III* by juxtaposing image and word. Two irregularly-shaped framed panels are leaned against the panelling of an interior room. One frame contains a painterly portrayal of the sky, while the other contains the word "ciel" (sky). Language and image mean the same and, for Magritte, are both equally detached from reality.

René Magritte The Menaced Assassin, 1927 Oil on canvas, 150.4 x 195.2 cm New York, The Museum of Modern Art

René Magritte
Palace of Curtains III, c. 1928/29
Oil on canvas, 81 x 116.5 cm
New York, The Museum of Modern Art

Victor Brauner Miroir de l'incréé (Mirror of the uncreated), 1945 Oil on canvas, 77 x 56.2 cm Private collection

Wifredo Lam Umbral (Senil), 1950/51 Oil on canvas, 188 x 173 cm Paris, Musée National d'Art, Centre Georges Pompidou

VICTOR BRAUNER

1903-1966

Victor Brauner painted in wax on canvas from the early 1940s onwards. In his place of exile in the Alps, he initially used this technique quite simply due to a lack of other materials. The warm wax, thinly applied with a trowel, covers a drawing on the canvas, whose contours and colouring are added by scratching

Brauner was obliged to simplify his enigmatically emblematic imagery with enormous stringency. For him, the layer of wax possessed alchemistic qualities, and transformed a banal canvas into an esoteric image.

A chimera-like female creature with a double head is seated at a small table. One of the heads gazes at the viewer with large, visionary eyes, opened wide. The other head, resting in the crook of her arm, is contemplating its reflection in a mirror on the table with closed eyes.

Brauner would appear to be referring to the séances frequently held by the Surrealists, in which mediums in a trance delighted the participants with their prophecies and enigmatic utterances. Above the creature floats a male torso, heated by two candles. This may be a reference to the actual production process of the picture itself.

WIFREDO LAM

1902-1982

Wifredo Lam's pictorial motifs and his distinctive surrealist style are rooted in the exotic imagery of his homeland, where Caribbean, European and African cultures blend. His mythical figures are inspired by the voodoo spirits of Cuba and by African jungle motifs. Since the 1940s, Lam's formal syntax, previously influenced by his imitation of the entangled organic forms of the jungle, becomes firmer and clearer. *Leitmotifs* such as the vertical rhomboid figure are developed and their obsessive repetition gives them a fetish character.

Umbral is a work from this phase of clarification and emblematic condensation. Three-horned rhomboids, enigmatically enlivened totemic figures, seem to float and dance against a dark, night-like background in some obscure ritual. The structure of their bodies is reduced to a sign by the geometric figure. The object of this sacrificial act lies before them. Another creature with a moon-like face and plaited hair is watching the scene from the background. Beyond such figurative interpretation, the strict composition of the picture with its harshly delineated forms accentuated by the two smaller yellow rhomboid figures, is particularly striking.

SALVADOR DALÍ

1904-1989

It was around 1930 that Dalí developed his theory of the "paranoid-critical" method. Paranoia is expressed in chronic hallucination, megalomania, persecution complex.

In a sparse landscape with a high horizon lies an amorphous form and, on the left, a platform with a tree stump, on which a deformed clock is draped, following the forms of the object on which it has been placed. The amorphous form on the ground has human traits, not unlike those of the artist himself. But the mouth is missing. The Surrealists adopted the psychoanalytical correlation of the mouth as a symbol for the female genitals. The lack of a mouth maybe interpreted as a fear of impotence with regard to the partner. The soft clocks have the form of relaxed tongues. Tongue-like entities are frequently featured in Dalí's paintings, supported by crutches, again expressing a fear of impotence. The clock that has been turned over so that we cannot see its face maybe regarded as a symbol of fear of revelation.

Dalí himself derives the Persistence of Memory from an everyday situation without exploring the reasons for his association: "We had finished our dinner with an excellent camembert and, as I was alone, I remained for a moment with my elbows on the table, thinking about the problems of this super-soft runny cheese... The picture I was working on at the time showed a landscape near Port Lligat, whose cliffs seemed to be illuminated by the transparent light of the dying day. This landscape was to serve as the backdrop for an idea, but for which idea? I needed a surprising image and I could not find it. I switched the light off and was about to go out when I literally "saw" the solution: two soft clocks, one of which would be hanging miserably on the branch of an olive tree.'

In a similar landscape with a low horizon and distant blue mountains where the evening light throws long shadows, we see the Burning Giraffe standing calmly. Stranger still is the female figure in the foreground. Tongue-like entities supported by crutches jut out of the back of her body, while a number of opened drawers jut from the front. Dalí, who had intensively studied psycho-analysis, may have been familiar with Freud's essay The Theme of the Three Caskets when he created paintings and sculptures in 1936 featuring many caskets built into the human body. In view of these works, Dalí spoke of the "narcissistic pleasure", perceived in the "observation of each of our caskets". The burning giraffe is an elementary object of desire yearned for by the female who is devitalized by the strictures of moral caskets and by the painter with his fear of impotence.

Salvador Dalí The Persistence of Memory, 1931 Oil on cancas, 24 x 33 cm New York, The Museum of Modern Art

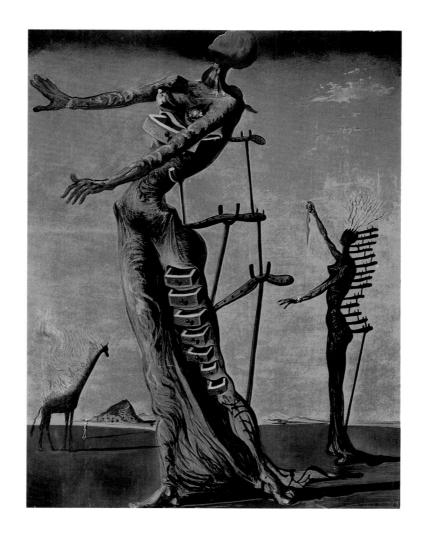

Salvador Dalí The Burning Giraffe, 1936–1937 Oil on panel, 35 x 27 cm Basle, Öffentliche Kunstsammlung Basel, Kunstmuseum

SPAIN

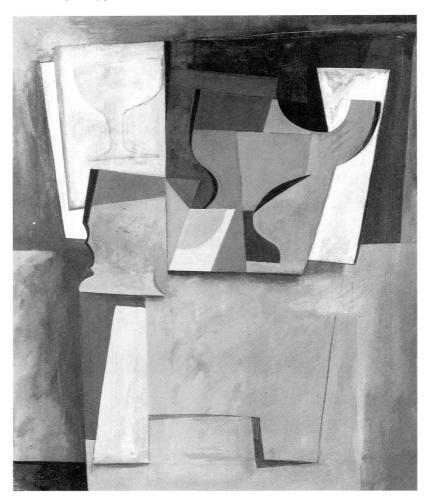

Ben Nicholson Still Life, 1947 Oil and pencil on canvas, 61 x 50.8 cm Private collection

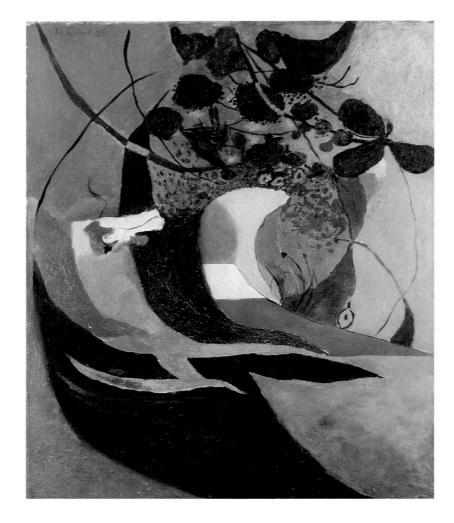

Graham Sutherland The Bridle Path, 1939 Oil on canvas, 60 x 50 cm London, Tate Gallery

BEN NICHOLSON

1894-1982

For Nicholson, the late 1940s were a period of recollection and collection. He attempted to consolidate the pictorial forms he had already developed in his major series, and collect them within a secure canon. Whereas, until the outbreak of war, he had explored questions of organic connections between image and canvas by way of abstract reliefs, he now began to return to more traditional morifs.

In his still life, Nicholson draws upon the pictorial syntax of synthetic Cubism. The classical motifs such as a jug and a glass are reduced to flat forms and interconnected groups. Although they are still recognizable as objects, they can now be used as material with which to create a balanced, planar composition. Soft and hard colour tones are contrasted, allocated associatively to the pictorial objects, and juxtaposed.

Nicholson said of his paintings of this period: "In painting a still life one takes the simple everyday forms of a bottle – mug – jug – plate-on-table as the basis for the expression of an idea: the forms are not entirely free, though they are free to the extent that each object can be seen from as many viewpoints as you wish at one and the same time, but the colours are free."

GRAHAM SUTHERLAND

1903-1980

To Sutherland, the landscape of western Wales, and especially of Pembrokeshire, was a revelation. He had learned from the Surrealists to awaken the unobserved, and to breathe life into arbitrary forms of nature in a visionary moment. It is this that creates the magic of his paintings. The point of departure for his *Bridle Path*, which is regarded as exemplary for this process of vitalization, was the precise observation of nature. In a number of preparatory sketches, he worked out the dramatic and mysterious aspect of the landscape.

Sutherland once described his approach as a process of starting to learn again, stressing that he found himself incapable of simply sitting down and painting from nature what he saw: "I did not feel that my imagination was in conflict with the real, but that reality was a dispersal and disintegrated form of imagination."

In the painting, the forms used in the drawings were further simplified and accentuated. Sutherland was interested primarily in the curving line of the village road. Brilliant white and yellow give the impression of strongly reflecting sunlight with branches reduced to coded signs and surrounded by fields of colour that can barely be interpreted as land-scape motifs.

614 ENGLAND

Christa von Lengerke

CONTEMPORARY PAINTING

New movements in painting since 1945

Contemporary painting reveals new techniques, new materials, new pictorial forms – emerging in parallel or in sequence. It spans a range from abstraction to realism, from purist stylization to the monumentalization of trivia, from tongue-in-cheek revelations of subculture to sober and even visionary presentations of political or personal trauma.

In the USA, Pollock and de Kooning developed free abstraction to its zenith. Their abstract Expressionism has its lyrical counterpart in European informel or Tachisme. The pictorial statements of Reinhardt, Newman and Noland are determined by the quality of colour. The world of the object and the metaphysical qualities of material are united in the work of Dubuffet and Tàpies to symbolistic assemblages.

Vasarély, with his decorative, rhythmic grids, is the founder of Op Art. Warhol and Lichtenstein follow on from Jasper Johns and Rauschenberg in elevating the clichés of the consumer world to the realms of Pop Art, scrutinizing them with an ironical eye. In the portraits by Bacon or in the works of Baselitz, Kiefer and Richter, the classical painting, once declared dead, seems to find its continuation.

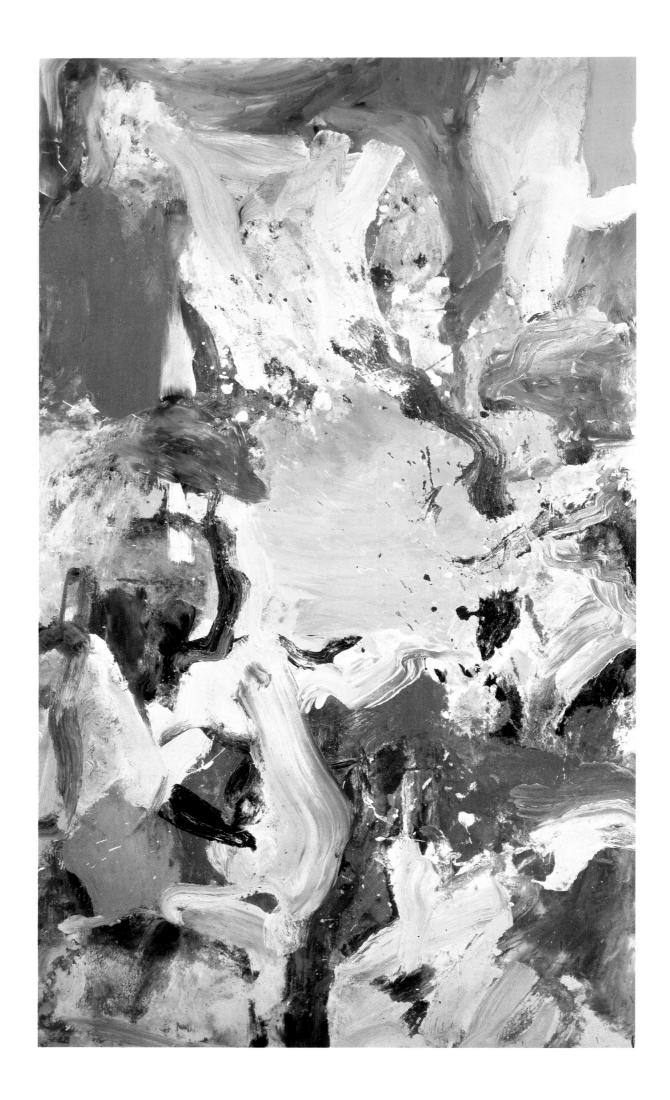

The artistic environment after 1945

The end of the Second World War marked a break with the past, whose impact went far beyond the political dimension alone. It heralded the end of European hegemony, dividing the world into a system of eastern and western power blocs that was to last for more than forty years. Against this background, artistic life in America ranked for the first time on an equal footing with art in Europe.

In the post-war years, the western world built up and perfected interactive institutions and instrumentaria that facilitated the dissemination and popularization of art: museums and exhibitions, art trade and art criticism. Until the 1970s, the art of the socialist world was barely acknowledged in the west. The eastern bloc produced commissioned art that was strongly influenced by politics; until the end of the 1980s, creative freedom in that part of the world was possible only in underground movements.

Ever since the discovery and settlement of America by the Old World, everything considered to be of a higher standard – and that included art – had to be imported from Europe. Invariably, it was measured by a European yardstick, and all things European were copied and imitated: America's consciousness was defined by the Old World. Paris, the capital city of the 19th century, had to share its previously unchallenged position as cultural leader with other centres after the turn of the century: initially, within Europe, with Berlin, Milan, Vienna and Zurich, and even with such provincial towns as Weimar, where the *avant-garde* created its forum at the Bauhaus.

Now, after the end of the Second World War, the situation was entirely different. Although strong artistic personalities and groups continued to emerge in Europe, new stylistic directions also began to evolve that were acknowledged everywhere; just as the eyes of the art world had focused for centuries on Europe, they turned now increasingly towards North America. For a good two decades, it was North America that produced the most exciting innovations and vibrant impulses for art. As a world power, the USA developed its own cultural consciousness. Confidence in the power of industrial society was as boundless as the faith in the blessings of the American way of life. Those beliefs were to be shattered politically in the 1970s, first by Vietnam and Watergate, then artistically in the 1980s by the advent of Neo-Expressionist "wild" painting.

New York has been able to maintain its position as an international centre of art up to the present day. The relationship between art and commerce that emerged there has been taken up elsewhere. This liaison between media and management has

Willem de Kooning Untitled, 1970 Oil on parchment on canvas, 182.8 x 107.9 cm Zurich, Thomas Ammann Fine Art made art as consumable as any mass-produced wares, though the enormous profits involved in art and its surrogates and in art ownership, connoisseurship and understanding remain the preserve of an elite.

Since 1929, the Museum of Modern Art and since 1939 the Solomon R. Guggenheim Museum in New York have held exhibitions. Both go beyond their primary function of presenting art works. With their wide-ranging activities, they have become highly influential cultural institutions. They heralded a new era of museumship and still have a lasting influence on artistic activity. A small group of exhibition organizers, museum curators, critics, academics, patrons and collectors, together with the powerful lobby of the art dealers, thus ensure that the latest art is not only accessible to the public, but is also made attractive through interpretation. The art of the past decades is not neglected, for it is meant to retain its ideal and material value. Finally, the artists themselves have also turned their eyes towards New York. The hustle and bustle of the world's capital city seems to create a fertile working atmosphere, for not only do many artists exhibit here, but they also have their studios in New York.

Painting today - traditions and trends

Once the long days of war were finally over, there was a general sense of starting out in a new direction. Art, too, called for a new start instead of merely upholding old traditions. As in the first half of the century, it was art that sought new ways and new solutions in keeping with the spirit of the times. Much had already been achieved by the artists of Expressionism and Cubism, by the Dadaists, Futurists, Surrealists, Constructivists and the painters of the Neue Sachlichkeit. Even the most revolutionary innovators of our day continue to draw upon ideas that were developed in the first decades of the 20th century.

The most lasting influences on contemporary art come from Dada and Surrealism. "Dada invited misunderstanding, challenged it, supported every kind of confusion: on principle, on whim, out of fundamental opposition" (Hans Richter, 1888-1976). The combination of a wide variety of materials and techniques became the means of expressing this will to provocation: Marcel Janco (1895-1984) was the first to integrate objets trouvés (found objects) into his work. Johannes Baader (1876-1955), a founding member of the Dada movement, called for the use of new materials in painting as early as 1918. The ideas of Marcel Duchamp (1887–1968) proved the strongest basis for new approaches. By declaring everyday objects to be art simply by adding his signature, Duchamp demonstrated the artist's demiurgic powers. The object is no longer portrayed or represented, but represents itself, so that everyday reality and artistic reality become one.

The "psychic automatism" of the Surrealists liberated painting from pre-formulated, intellectually guided concepts. Psy-

chic occurrences and stirrings, the unconscious and the spontaneous, trauma, dreams and visions found a place in painting and expanded the realm of motifs to previously unexplored limits. Carl Gustav Jung (1875–1961) described chance as an order outside causality. Arp and Tzara then discovered chance as an artistic principle.

After 1945, painting adopted this approach in its search for a pictorial language that can not only be discovered through education and intellect, but which is also capable of triggering complex psychological processes in the viewer. Irrespective of whether it is figurative or abstract, this is art that is intended to be regarded and understood as a bearer of meaning, as an exploration of the materials and realities of the socio-political environs, and the dreams and nightmares of our time and culture. It represents a quest for truth free of values, far from social conventions and aesthetic structures. It is a question of new pictorial forms, approaches and functions in the integration of external reality. This involves the need for a redefinition of such concepts as "painting" and "picture".

The painterly process is no longer an exclusively manual application of paint onto a ground. It can also take the form of a physical action with its own forceful dynamics (Action painting, Tachisme). It can be complemented or substituted by collecting, selecting and arranging found objects (Combine painting). The manual act of painting can be aided or substituted by the use of reproductive processes such as photography or silk-screen printing (Pop Art, Photo-Realism). This de-individualization culminates in the concept art of the 1970s. With his maxim "concept over reality" Raymond Roussel (1877–1933) anticipated the artistic approach of the 1920s. The intellectual concept, rather than the material realization, constitutes the art work.

The idea of image as representation is no longer crucial to contemporary art. The path towards abstraction opened up new expressive possibilities for the artists and new dimensions of experience for the spectator. It is no longer nature alone that creates the store of pictorial motifs; the individual's psyche, the forms and colours used by foreign or "primitive" cultures, the elementary power of children and the mentally ill are all discovered as creative sources.

Pictures also take on a more political function. They are rarely intended merely to confuse, provoke or shock. They are invariably used with the intention of tearing away a veil that cloaks something sacred or perilous. A picture can be its own protest against its consumption as a purely aesthetic object. Pictures can also express philosophical and religious concepts, or can be brought back to their original function as a call to meditation.

The viewer's encounter with the art work is a vital, dynamic and constantly changing process in which personal mood and leanings, *Zeitgeist* and the passing of time constantly determine and influence the reception of the work and its impact. These components are variable. The constant givens are the contents

intended by the artist, the statements intended by him, frequently supported by a written instruction or explanatory title. For the active viewer, however, it can take on its own dynamics. Through his or her own ideas and associations, the viewer can construct a personal pictorial truth and an individual pictorial expression. Through distance in time or changing awareness, the original statement can be dissolved or guided in completely different directions.

The New York School

It was the painters of the Ash Can School who turned their backs on European ideals and ideas. As early as 1908, they portrayed monotonous rural existence and the hard life of America's streets and slums with a critical and realistic eye. In doing so, they created an approach that was entirely independent of the European art tradition. At the same time, they elevated themselves above the provincial and naive level of American folk art. The leading representatives of this socially committed realism were Edward Hopper (1881–1967), Grant Wood (1892–1942) and Ben Shahn (1898–1969). Arshile Gorky (1904–1948), whose development away from the objective figurative towards expressive abstraction was the link between this "American scene" painting and post-war art.

Alongside this national development in the world of art, the names of certain European emigrants are closely linked with the emergence of the New York School. Duchamp, the most popular and by then the most influential visitor, brought Dadaistic ideas to New York in 1915, together with Francis Picabia. Hans Hofmann (1880–1966) and Josef Albers (1888–1976) followed, and both went on to become highly influential teachers of art in the USA. Ernst, Robert Matta (* 1912), Tanguy and Breton also brought their Surrealist ideas with them.

In response to the Ecole de Paris, which had become ossified in its virtuoso aestheticism, the New York School emerged full of self-confidence in the 1940s. For a full two decades, it would shape the world of art on an international scale, breaking new ground with abstract Expressionism, Drip Painting and Action Painting.

At her progressive Art of this Century gallery in New York, Peggy Guggenheim (1898–1979) offered the emigrants and the entirely unknown painters of the American *avant-garde* the chance to exhibit their works. As a patron and collector, she was able to build up relationships with such artists as Pollock, Franz Kline (1910–1962), de Kooning, Robert Motherwell (1915–1991), Clyfford Still (1904–1980), Barnett Newman (1905–1970), Mark Rothko (1903–1970) and Ad Reinhardt (1913–1967). In the independent processing of Dadaist and Surrealist elements, these painters forged an individual path towards abstraction.

Gorky is the main pioneer of abstract Expressionism. Initially, his work leaned heavily on Cézanne and Picasso, but later, under the influence of Matta, he arrived at a new and inde-

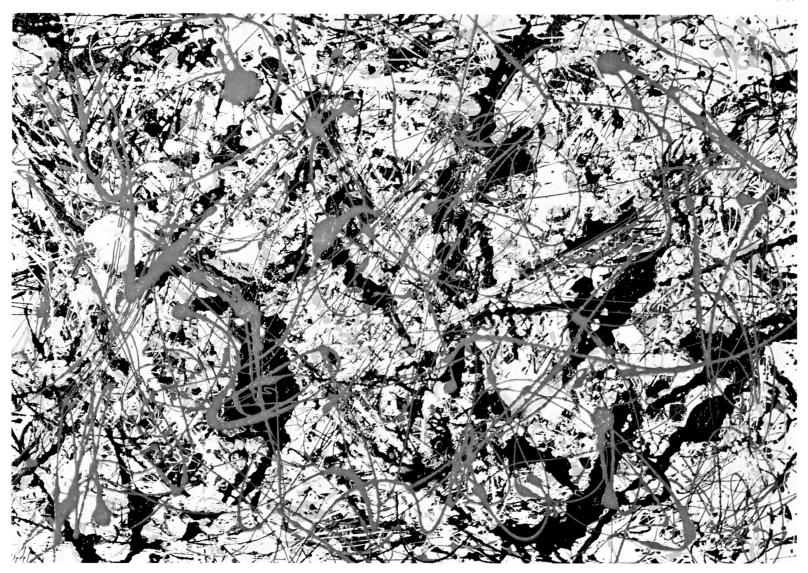

Jackson Pollock Painting, 1948 Oil on paper, 57.3 x 78.1 cm Private collection

pendent pictorial language. Gorky's later work already contains the nucleus of every characteristic of the later movement. He took his life just as their ideas were beginning to develop more widely.

Pollock was the first to adopt Gorky's pictorial formulations. In his tendency towards folk art, Pollock was inspired by the Indian culture with its symbolic forms, brilliant colours and interlaced patterns, which led him directly to abstract painting. The partially figurative motifs of his early work cover the canvas with density and regularity. The combination of these painterly forms with psycholgical processes indicates an affinity with certain principles of Surrealism. On the basis of their psychic automatism, Pollock eventually developed an automatism that involved the entire person. In a rapid action, while his senses and his body were entirely concentrated on the energy-charged act of painting, he worked on the canvas spread out on the floor. Conventional instruments such as brush, easel or pallet were a hindrance and would have inhibited the spontaneous process.

He let the paint drip out of cans and tubes, mixed it with all manner of materials such as sand or ground fragments and distributed the dripping colours with sticks and rags. This technique of drip painting soon earned him the epithet Jack the Dripper. For all the vehemence of his gestures, his works indicate a strong inner control over the creative process in these expressive pictorial patterns. In this way, Pollock created a new aesthetics – an aesthetics of action.

The fully abstract paintings created after 1946 indicate a radical break with classical painting. They demand an entirely new way of seeing, in order to acknowledge this iconography of energy as a physical reality. Harold Rosenberg (1906–1978), who gave this painting the name Action Painting, wrote: "At a certain moment the canvas began to appear to one Amercian painter after another as an arena in which to act – rather than as a space in which to reproduce, redesign, analyze or 'express' an object, actual or imagined. What was to go on the canvas was not a picture but an event." This trend determined artistic creativity until well into the 1950s.

Motherwell, who had worked with Pollock and exhibited with him at Guggenheim's gallery, developed more tranquil forms of expression in his paintings, in keeping with his calmer personality. They are the result of careful consideration and, because of Motherwell's love of history and literature, they often have a profound ideal significance, as in his *Elegy to the Spanish Republic* (ill. p. 634) series. In his large-format paintings, the subdued, expressive brushwork is often dominated by a lyrical atmosphere. Motherwell's activities went beyond the field of painting, and he was influential as an author, publisher and lecturer.

In the 1950s, de Kooning was the leading exponent of abstract Expressionism. For de Kooning, who came from Europe, a link with western tradition was a matter of course, though he upheld that heritage with a progressive and vitalizing approach. Against this background, he developed an unparalleled convergence of abstract and figurative painting. In 1928, he met Gorky in New York.

As in the work of Pollock, the painterly process took on a life of its own in de Kooning's works, with a vehement brushstroke and brilliant colours documenting unleashed aggression. The vulgarity of his motifs correspond to this exalted formal syntax. His series of male and female figures project a brutally distorted image of the human condition.

Kline was relatively late in joining the abstract Expressionist movement. At first, he painted small-format Cubist im-

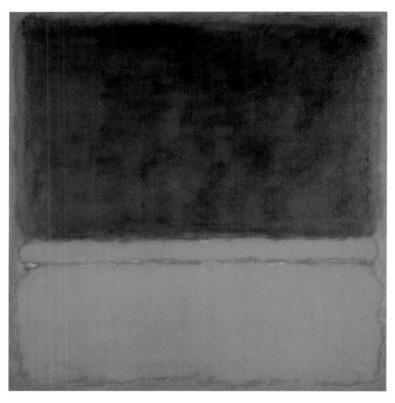

Mark Rothko Red, Green, Blue, 1955 Oil on canvas, 207 x 197.5 cm Milwaukee (WI), Milwaukee Art Museum

pressions of city life and realistic portraits and landscapes. Under the influence of de Kooning, his characteristic black and white paintings emerged from the early 1950s onwards: broad, beam-like brushstrokes on large white canvases. These works have a distinct similarity with East Asian calligraphy. More important still in Kline's pictorial language, however, is its distinction from calligraphy: his paintings are not to be regarded as black traces of paint on a white ground, but as an equal interaction of both. The manual preparation of priming and the creative act of applying the paint thus contribute essentially to the creation of pictorial tension. It was not until the late 1950s that Kline also began including colour in his work.

Attempts to categorize various artists according to a single stylistic concept on the basis that they worked around the same time are not always entirely convincing. The term abstract Expressionism linked with the artistic production of the New York scene between the end of the Second World War and the end of the 1950s applies, strictly speaking, only to the work of Jackson Pollock, Robert Motherwell, Willem de Kooning and Franz Kline.

Abstract Symbolism

For some artists, the path towards abstraction meant developing a symbolically coded pictorial language. Individual abstract, non-figurative forms, can be indicative of appearances in reality.

The work of Mark Tobey (1890–1976) is largely influenced by philosophical reflections. His attempt to exclude definable forms and structures from his art is influenced by his close reading of Cubism and his conversion to the Bahai faith, which emphasizes the spiritual unity of human kind. From 1935 onwards, Tobey developed his mature style with his *White Writings*: a network of thin white lines against a dark background. He regards these abstract compositions as symbols of the unity of form and movement in the universe.

Mark Rothko, Clifford Still, Barnett Newman and Ad Reinhardt tended to work primarily in monumental formats on monolithically abstract pictorial blocks. By deliberately going beyond the familiar dimensions of a classical easel painting, the artist gives the viewer a sense of the sublation of the pictorial boundary. The aim is the experience of space as such.

Around 1950, Rothko reduced his forms to large, rectangular, converging "colorfields" which shimmer out of the monochromatic background. The simple presentation of colours takes on a sophisticated artistry. The colours themselves are neutralized in a sonorous tonal harmony, and their effect materializes purely in the shimmering substance of the paint itself. Instead of many colours, the potential wealth of monochromatic gradations and carefully chosen colours create solemn and celebratory accents. In his paintings, Rothko associates archetypes, metaphors of possible responses to fundamen-

tal questions of human existence and life, mystic formula that cannot be named, but repose within the magical twilight of their appearance.

Still also addresses metaphysical themes in his paintings. In 1947, through his interest in the presentation of universal ideas, he arrived at his distinctive style: a characteristic hallmark of his huge canvases is the large monochromatic ground that covers almost the entire surface of the painting, framed at the edges by flaming forms.

Newman concentrated on colour, which he sought to "create". In his huge horizontal or vertical canvases, we note a tendency towards ever larger and ever simpler forms. The rudimentary composition develops on a calm surface that tends to negate the personal brushwork. Newman's distinctive formal reductions created the basis for the purist formal syntax of minimal art. The philosophical implications of his work, however, were not adapted by his followers.

As a critic, art historian and painter, Reinhardt sought to create a purely abstract art. From 1950 onwards, he divided the canvas into sharply contoured rectangles which he filled with slightly varying hues of a single colour. Whereas the colority of his early paintings was still light and vibrant, his later works are painted in darker tones, culminating in his characteristic Black Paintings which are probably the most subtle of all colorfield paintings. For Reinhardt, art was a clearly defined object, independent and separated from all other objects and circumstances, whose significance is not explicable or translatable. For him, artistic progress meant increasing negation of its formal means.

Tachisme and Informel in Europe

In Europe, at almost exactly the same time as American abstract Expressionism, a new direction in painting was developing which had many essential similarities: informel. This new expressive painting initially developed under the influence of the École de Paris, but from the 1950s onwards there were artists all over Europe seeking new means and concretizations. All of them followed a similar path.

It was Antoni Tàpies (* 1923) who coined the term informel and who first spoke in 1950 of the "significance of formlessness" in new painting. Informel as a style can only be outlined in its fundamental traits. The emergence of informel paintings has its roots in the Surrealist concept of psychic automatism. Informel has no traces of the figurative, and its formal syntax emerges from the spontaneity of movement. Colour is predominant as a coloristic and mutable element as well as in terms of its materiality.

New techniques involving the use of unconventional media or mixing colours with materials not previously employed in painting, such as sand, resulted in new visual impressions, requiring also that the viewer to adopt new ways of seeing. Working from the spontaneous inspiration of the subcon-

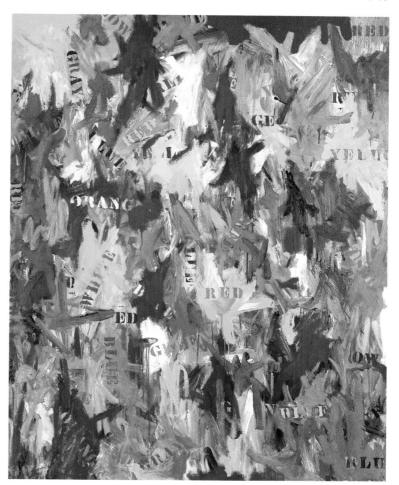

Jasper Johns False Start, 1959 Oil on canvas, 171.5 x 134.7 cm New York, Private collection

scious, the rapidity of the act of painting and the inclusion of the principle of chance determine the process of creation of informel paintings.

In France, it was Jean Fautrier (1898–1964), the German immigrant Wols (1913–1951) and Hans Hartung (1904–1989) together with Georges Mathieu (* 1921) who represented the new painting emancipated from traditional rules of composition. As a synonym for informel, the term tachisme took hold in French, derived from the French la tache meaning a "daub" or "stain". The work of Wols, in particular, is often described as lyrical abstraction.

The pictorial worlds of Pierre Soulages (* 1919) bear certain similarities to the structures of Kline's work. His œuvre and that of Mathieu are often subsumed under the term calligraphic abstraction. Two painters who emigrated to France in the wake of the Russian Revolution, Serge Poliakoff (1906-1969) and Nicolas de Staël (1914–1955) complete this broad spectrum of French informel painting.

In Germany, Ernst Wilhelm Nay (1902–1968) Emil Schumacher (* 1912), Baumeister and Bernhard Schultze (* 1915) worked out new artistic aims entirely in accordance with their individual painterly temperament.

Jean Dubuffet - The CoBrA Group

Jean Dubuffet (1901–1985) paved the way for an extended concept of art that included formulations by children and the mentally ill. The expressive potential of primitive art had already been recognized and put to use by the Expressionists in the first half of the century. Inspired by them, he initially began collecting what he described as "art brut". It became the point of departure and orientation for his own pictorial inventions, through which he sought to emancipate himself from conventional principles of design and aesthetic guidelines. This allowed him to declare as superfluous the stylistic, contentual and thematic values of the western culture he disdained. He found a correlation to this anti-traditional view of art in the visual worlds of the mentally ill. He created backgrounds of plaster, sand, paste, putty and other materials, working them over with a palette knife, scratching and scoring them, in flights of lyrical imagination. Dubuffet's preference for cycles of works culminated in his Hourloupes, puzzlelike juxtapositions of amorphous forms which overgrow the background.

The members of the CoBrA group pursued similar aims. Their programmatic rejection of the aesthetic dictates of the Ecole de Paris was accompanied and legitimized by their vociferous condemnation of a civilization that was responsible for unleashing two world wars. The CoBrA artists came from Denmark, Belgium and the Netherlands, and the first letters of the capital cities of these countries were used to form the group's name. The main representative of the artists association that lasted for only three years, from 1948 to 1951, were Pierre Alechinsky (* 1927), Karel Appel (* 1921), Constant (* 1920) and Asger Jorn (1914–1973). Like Dubuffet, they, too, saw more originality and vitality in the pictures by children and the mentally ill than in the classical canon of art history and, accordingly, they called for a break with all aesthetic norms in a total liberation of thought. The group's ideas were expressed in joint exhibitions, publications and a magazine of the same name.

Geometric Abstraction, Op Art

Geometric abstraction developed out of the Bauhaus tradition, as a sober art bearing no personal signature and no trace of craftsmanship. Based on the ideas of the Constructivists and the De Stijl group, they followed in the footsteps of the *abstraction-création* movement which had united the leading representatives of modern abstract art in the 1930s.

Van Doesburg, one of the spokesmen of geometric abstraction, described it as "concrete art", feeling that it was not bound to a process of abstraction, but based entirely on concrete geometric elements. This fundamental concept was also adopted by Max Bill (1908–1994), who substituted geometric abstraction for anaturalist art, distinguishing it clearly from Cubism and from the intuitive and naturalist movements. Like

the work of Bill, the œuvre of Albers is accompanied by art theoretical reflections and academic teaching. "When I paint, the first thing I see and think is – colour." Albers used the form of the square to exemplify the changing effects of colour in a multitude of variations.

Op Art once again addressed a number of the questions Albers had already raised in his work. For example, a row of geometric forms was aligned in an area in such a way that colour variations or gradations of light and shade optically confused the viewer. Victor de Vasarély (* 1908) is the most inventive and varied designer of Op Art objects. He regards himself as the creator of a harmonious order that does not exist in this form in the real world. Vasarely aims to transform the "monotony of modern life into a determination of beauty with manifold forms". Op Art seeks to unsettle the viewer by involving him in the visual confusion that it has deliberately created and which in fact serves as its structural concept.

Post-Painterly Abstraction: Colorfield and Hard Edge

Like Op Art, so-called post-painterly abstraction also originated in the Gestalt psychology colour studies of the Bauhaus system. Disseminated by Albers in America, it provided fertile ground for the painting of the 1960s which superseded abstract Expressionism. Following on from the tranquil, intensively coloured paintings of Rothko and Newman, it sought to achieve an absolute application of colour while avoiding spatial illusion by emphasizing planarity in large and even huge formats. It was painting for its own sake, unfettered by any thematic strictures. No longer the bearer of a message or a Weltanschauung, it is not at the service of literature, religion or philosophy, does not narrate and does not imitate. Anyone can understand the language of this painting without initiation, for it transports no coded messages or personal experience of the artist. Its variations are called colorfield and hard edge, terms that tend to overlap.

With new paints, thinners and unorthodox methods of application, Kenneth Noland (* 1924) and Morris Louis (1912–1962) explored the dimension of colour. Paint with all its inherent characteristics – opacity, transparency, impasto and sheen – is merely the bearer of coloristic qualities and visual sensations. The colorfields consist of elementary geometric forms. These paintings can be regarded as a purist emancipation in which a deliberately simple form is linked to the chromatic.

Frank Stella (* 1936) took the reduction of colorfields one step further in his *Shaped Canvas*. The elementary basic form was no longer the prescribed rectangular canvas; instead, the colorfield determined the pictorial format, resulting in paintings with a triangular, V-shaped, or polygonal outline. Colour is treated as an object bounded by external form. In this way, it becomes part of the third dimension, developing sideways and parallel to the wall into the room itself.

Ellsworth Kelly (* 1923) also regards the picture plane as a neutral container of colour. He was the first to use ready coloured canvases which merely had to be sewn together as standardized pictorial forms. Colour thus took on its own, "concrete" reality, inherent in the original carrier and no longer perceptible as material.

Combine Painting, Material Painting

The Dadaists had already discovered the lyrical appeal and painterly quality of *objets trouvés*. In the same way, Cubist collages contain fragments of everyday objects, and a fascination with the fragmentary is evident, which exerted an influence on Surrealist montage.

Following abstract Expressionism, artists returned again to this integration of everyday objects in their work. In classical Modernism, this stood for an extension of pictorial language, an emphasis of the lyrical and chromatic qualities of things, ensuring the homogeneity of the art work, whereas the artists from the late 1950s onwards clearly sought to use them — in a combination and convergence of art with daily reality — as a means of questioning the effectiveness of an art language. Their exploration of everyday subjects is to be seen as a response to introverted and intellectualized abstract Expressionism. It ensures an element of recognition and familiarity. The painting now becomes the bearer of relief-like arrangements that combine a variety of materials, techniques and objects. By fixing them on a ground, it is their identification that creates the image.

In the spirit of *informel* and lyrical abstraction, Tapies created his early material paintings. Paint mixed with sand and binder takes on a relievo structure. Code-like scratching and splitting are reminiscent of old masonry. Representational elements – the canvas that becomes a relief through the combination with sand – and the object they represent – the wall – become virtually synonymous.

Joseph Beuys (1921–1986) also integrated found objects and materials in his drawings and his painterly, sculptural works. For Beuys, each material and each object was the bearer of symbolic meaning, because it was linked to some universal tradition or personal experience. In his life and in his work, Beuys sought a reconstruction of the lost unity of nature and spirit, countering rationalism with a way of thinking that included the archetypal, the mythical and the magical religious. For example, fat, in accordance with its functions in nature, also functions as an energy store in the œuvre of Beuys.

Alberto Burri (1915–1995) composed his material paintings using burnt, torn sack-cloth and colour areas. Eventually, many painters turned to a free application of diverse materials and techniques, when painting alone no longer seemed capable of making a forceful statement. Appel and Jorn applied paint like thick plaster, thereby dissolving the purely painterly impression of their works.

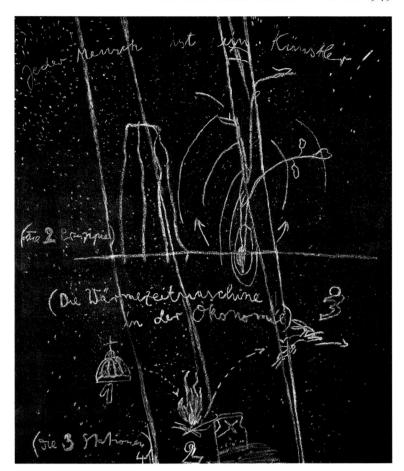

Joseph Beuys Is it about a bicycle? IV, 1982 Coloured chalk on panel, 150 x 122 cm Private collection

In the USA, it was Robert Rauschenberg (* 1925) who invented combine paintings after some earlier experimentation with Action Painting. He began to integrate individual elements in collage technique into his expressive painting. These were objects that he had found and that belonged to the waste thrown up by civilization. They certainly possessed no lyrical flair, merely the misery of a short existence as cheap mass-produced articles.

This Junk Art blossomed in the 60s, and found an increasing number of exponents, including the sculptors John Angus Chamberlain (* 1927), Robert Mallary (* 1917) and Richard Peter Stankiewicz (* 1922). The movement culminated in the creation of *Watts Towers*, towers built of garbage and decorated with garbage, in the slums of Los Angeles.

If we look at Junk Art from today's viewpoint, with our awareness of certain social and environmental problems, we are tempted to perceive it as an eloquent incrimination. However, these works were not created with the intention of making a socially critical statement. At the time they were produced, the problems implied by them were not part of the public consciousness. Nevertheless, creative design is no longer an act of creation, that produces aesthetic objects alien to reality. This uninhibited foray into the treasure-trove of shabby symbols

of mass culture may be regarded as a breaking-down of social barriers.

Jasper Johns (* 1930) created monumentalized everyday clichés such as the American flag, targets and maps. In presenting these deliberately simple things, he forged a correspondence between the object of the painting and the painted surface for the first time, thereby raising the question of the identity of thing and its portrayal: "Is it a flag or is it a painting?" asked one critic when his first flags emerged. The simplicity of the motifs and their relationship to large format images with advertising panels and advertising hoardings anticipate certain characteristics of Pop Art.

In his early work, Jim Dine (* 1935) was strongly influenced by Johns and for both these artists abstract Expressionism had been the starting-point. The repertoire of Dine's motifs, like that of Johns, is fairly limited: household objects, furniture, tools, items of clothing. In his paintings, he often integrates real objects with painted shadows, reiterating them in paint on the canvas or underpinning their existence in the painting by an accompanying text.

Pop Art

Pop Art is a term coined by the critic Lawrence Alloway (1926–1990). In the 60s, the American variant of Pop Art achieved a degree of popularity unparalleled by any previous art movement. Pop Art derived its inspirations and motifs from the world of mass consumer society, industrial mass production, the consumer – oriented and taste – defining influences of advertising and the media. The resulting phenomena such as sensationalism, star cult, loss of individuality and glorification of the banal and the trivial, in short, the eminent significance and effectiveness of clichés, were the foundations on which Pop Art was built and the soil that nurtured its success.

The motifs of American Pop Art were generally adopted from other media: magazine cut-outs, film stills, advertising images. Special printing techniques and printing processes were used to transfer the image to its ground, whereby it was coloured and alienated. Everyday themes from politics to gossip were adopted. The motifs, which already reduced the complexity of the statement, were transformed into an effective trivial cliché by enlarging the format, simplifying the colours and repeating the motif. Although the Pop artists drew their motifs from a generally accessible store, their works are distinctly different. Their respective styles are constituted by their personal selection of pictorial patterns, technical processes and specific colours.

Andy Warhol (1928–1987), who was the most famous representative of Pop Art, staged spectacular public appearances along the lines of advertising campaigns, thereby creating a true symbiosis of personality and work. He himself was a superstar, and in his view it was through his work that other

persons, events and products became superstars themselves: Elvis Presley, Marilyn Monroe, Albert Einstein and Mao Tsetung all share the same entertainment quality as the stars of short-lived daily news-spots: accidents, catastrophes, executions. The stars of American life can also be dollar bills, cola bottles, soup cans, packs of washing powder. Warhol's creed was: "Everybody is plastic, but I love plastic, I'd like to be plastic."

Roy Lichtenstein (* 1923) cited the trivial fantasy world of the comic strip in his large-scale canvases. The screening of the print is reiterated in the painting as a pattern of painted dots. Individual images are torn out of their narrative context and the selected image reveals the triviality of the story as a whole, while at the same time, this isolation emphasizes the formal properties of the original medium.

Tom Wesselmann (* 1931) is famous first and foremost for his artistically stylized presentations of the naked female body. Sex as a consumer article has developed its own clichés in the course of its marketing. By reducing the body to flat, simple forms, in which mouth, breasts, thighs are emphasized, Wesselmann varies uniform gender traits in his *Great American Nudes*. James Rosenquist (* 1933) started out as a painter of bill-boards. For his monumental paintings, he had no need to change his theme or his technique.

Trivial pictorial forms – comics, advertisements, reports – in magazines or on television have a broader impact than art. In Pop Art, ennobled by the selection by an artist, they return as art. Removed from their normal context, monumentalized, in an exhibition, gallery, a museum, a private collection or a prestigious apartment, they serve as an affirmation of consumption.

Before the emergence of American Pop Art, English Pop Art arose in the 1950s, and was echoed in other European countries. The themes explored by the English artists were much the same as those chosen by their American counterparts, but apart from printing processes, they also used collage and other methods of integrating everyday objects. In doing so, they developed principles similar to those used by their contemporaries Rauschenberg and Johns in their combine paintings. On the whole, European Pop Art had a more socially critical approach.

Richard Hamilton (* 1922) caricatured the double-edged blessings of the consumer world and fashion in his collages. Peter Blake's (* 1932) painted collages contain mordant comments on familiar emblems, clichés and trademarks from the world of media. Reducing woman to an object of sex and lust was an approach pursued by Allen Jones (* 1937) in his paintings and objects to the point of affrontary. Such artists as David Hockney (* 1937) and Ronald B. Kitaj (* 1932) adopted elements of Pop Art without committing themselves completely to this direction.

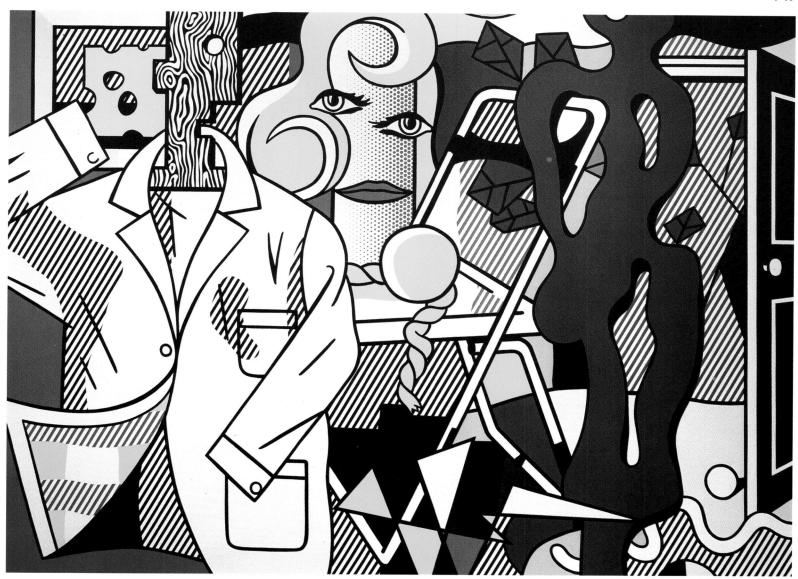

Roy Lichtenstein Razzmatazz, 1978 Oil and magna on canvas, 243.9 x 304.8 cm Boston (MA), Collection Graham Grund

Concept Art

The dematerialization of art was taken to the limit in Concept Art. The ground was broken by the art forms of the 1960s and early 1970s, such as colorfield painting and minimal art. They appeared to reject any emotional involvement on the part of the artist and avoided creating a reference to any reality beyond the world of art. Concept Art sought to provide objective information as the documentation and fixing of thought processes. The traditional art form in its material existence is abandoned and presented purely as thought, as concept in the form of texts, photos, diagrams.

Two artists anticipated the development towards Concept Art in the 1950s: Lucio Fontana (1899–1968) whose *Concetti Spaziali* (Spatial Concepts, see ill. p. 654) sought to interpret and present the void as a positive principle, and Yves Klein (1928–1962) whose characteristic blue does not reiterate a fragment of reality, but seeks to master all of reality through the medium of colour.

Photo-Realism

Photographs form the basis for all the paintings in this hyperrealistic style. They are clearly not art photos, as they seem like snapshots, polaroids or passport photos with trivial motifs, as though they had been captured at some arbitrary moment. Projected as a slide onto the canvas, they provide the motif for a painting executed with a spray gun or a brush. Not only the choice of subject, but also the way in which colour and form are intensified, transfigured and alienated, the nuances added by the painter, indicate the personal signature of the artist. Reality is represented here illusionistically. An apparent lack of professionality – the photos seem to be underdeveloped, unsharp, amateurish – is compensated by the precision with which they are transformed into a highly artificial form of painting.

Richard Estes (* 1936) prefers to take urban life as the motif for his paintings, with its neon sterility and sober anonymity. Chuck Close (* 1940) is interested more in questions of percep-

Francis Bacon Self-Portrait, 1973 Oil on canvas, 35.5 x 31.8 cm Private collection

tion: he applies the three primary colours in separate layers, so that the fragmented colour scheme of the painting is put back together again by the spectator. Europe's leading photo-realist is the Swiss artist Franz Gertsch (* 1930) who fills monumental canvases with portraits of his friends.

Figurative Painting in Europe

In an event in Düsseldorf in 1963, the ironic expression "capitalist realism" was coined, which is associated with the names Sigmar Polke (* 1942) and Gerhard Richter (* 1932). Polke is the more sarcastic of the two; independent of all group involvement, he developed a distinctive and ironic pictorial language that presents humorous pictorial puzzles full of visual puns, contradictions and clichés.

Richter endeavours in his large-scale series, to transpose news-paper articles, colour sample charts and amateur photographs into painting. He is interested in painting as painting. Konrad Klapheck (* 1935), who, like Richter, teaches at the Düsseldorf academy, interweaves the magical materiality and associative aspects of technical apparatus such as telephones and typewriters with distinctly human qualities in an approach that bears certain affinities with magic realism.

Until the fall of the Iron Curtain, all official art that was permitted and encouraged in eastern Europe went under the label "socialist realism". Following on in the tradition of Expressionism and Neue Sachlichkeit, this art permitted, to some extent, an exploration of certain problems of classical painting, but in the choice of themes it remained subject to the dictates of a state-run cultural bureaucracy. The main premise was universal comprehensibility. Werner Tübke (* 1929) clothes his themes in the rich colours and forms of the Italian Renaissance. Werner Heisig (* 1925) creates gloomy visions of human impulses comparable to the works of Goya and Beckmann.

Defying all classification, Giacometti pursued a concept of figure and space in his sculptures and paintings that was profoundly influenced by existentialism. Francis Bacon (1909–1992), whose overall world view was similar to that of Giacometti, also explored the ideas of Jean-Paul Sartre (1905–1980) and Albert Camus (1913–1960), especially in his early work. Bacon's later work adopts some of the characteristics of Pop Art in the planarity of presentation and in the ornamentalization of colority. Lucian Freud (* 1922) has continued to concentrate for decades on the portrayal of the human body, apparently uninfluenced by all trends in art.

Georg Baselitz Motivschimmel Zerbrochene Brücke (Dappled motif broken bridge), 1986 Oil on canvas, 173 x 139cm. Private collection

Painting in the 1980s

In reaction to past movements in art in which painting gradually lost its creative inspiration and individual message, a number of personalities emerged, especially in Germany and Italy, to revive a new and distinctly subjective form of expression.

In Germany, Georg Baselitz (* 1938) has been exploring the possibilities of expressive painting for many years. He became famous particularly for his paintings in which the subjects are turned upside down. The demonic expressiveness of his style and, most notably, its visionary distortion of the human figure, clearly reflects the influence of German Expressionism and the later work of Corinth.

All the representatives of new painting in Germany such as A. R. Penck (* 1939), Anselm Kiefer (* 1945) or Markus Lüpertz (* 1941), and in the group of Italian artists (Sandro Chia, * 1946; Francesco Clemente, * 1952; Enzo Cucchi, * 1950; Mimmo Paladino, * 1948) aim to liberate themselves from the fetters of ideology in expressing their dismay and unease, visualizing their individual and intuitive experiences, or clothing their impressions, experiences and nightmares in explosive or meditative forms. Theirs is a deliberate and conscious return to painting, albeit without the stringent framework of regulations posited by academic dictates.

The quest for liberty, and the wish to elevate themselves above all stylistic, iconographic and aesthetic strictures is already evident in their respective choice of unconventional motifs. The new painting draws upon Expressionism, Futurism and Surrealism; yet at the same time it does not constitute a complete break with the tradition of art.

In the 1980s, initially in New York and later in Europe, those on the margins of society, the underprivileged, the ethnic minorities began to establish themselves on the art scene, as did women, to an extent previously unparalleled. It was no longer imperative to have studied at an academy in order to exhibit at the leading galleries and museums of the capital cities. The first wave of these new artists emerged from the North American graffiti scene.

The heroes of this subculture such as Keith Haring (1958–1990) and Jean-Michel Basquiat (1960–1988) were able to introduce their semiotically imbued art in the New York subway as well as in the highest circles of the art world. Gallerists hoped that by showing their work, they could revitalize an art form increasingly perceived as jaded and spiritless. Other ethnic minority painters soon followed, some of them vehemently representing the rights of their respective ethnic groups in images that abandoned the traditions of European painting and returned to the stylistic means and pictorial forms of their own cultural roots, albeit occasionally falling into the trap of a rather anodyne political correctness.

Gerhard Richter Ema – Akt auf einer Treppe (Ema – Nude descending a staircase), 1966 Oil on canvas, 200 x 130cm Cologne, Museum Ludwig

Painting and Post-Modernism

A typical feature of painting around 1990 is its utterly confusing stylistic pluralism. With the death of Beuys and Warhol in 1986 and 1987 respectively, two of the last great heroes of art died, and the history of 20th century art as a continuous project of constantly developing sequences of mutually enriching *avant-garde* movements seemed to have come to an end. It was therefore only logical that the painting of the 1990s came to be known as post-*avant-garde*. This term also refers to the term Post-Modernism which was initially coined for architecture and similarly indicated the end of an era without having a fitting description for the coming period.

Admittedly, in recent years, there have still been such classic artistic careers as that of the New York stars Julian Schnabel (* 1951) and David Salle (* 1952) whose meteoric rise to fame seemed to follow the pattern set by Warhol. Both these artists

achieved success with large-format paintings for which they plundered the treasure-trove of art history and the consumer world.

In the meantime, however, there was no longer any style or artistic direction that could clearly make its mark on the period. The painting of the 1990s is shaped by a detached attitude and a clear awareness of what has been achieved. There are painters such as the Dutch artist Rob Scholte (* 1958) who have followed on from pop art, while others, such as the German artist Martin Kippenberger (* 1953) and the brothers Albert (* 1954) and Markus Oehlen (* 1956) cultivate a Dadaistic attitude. There are Neo-Constructivist tendencies as rep-

resented by the Swiss artists John Armleder (* 1958) and Helmut Federle (* 1944) and by the German artist Günther Förg (* 1952). In the USA, on the other hand, minimal art is undergoing a revival in the work of Brice Marden (* 1938) and Agnes Martin (* 1912). The same is true of Concept Art; with such forebears as Duchamp and Malevich in the background, artists like Sherrie Levine (* 1947), Philip Taaffe (* 1955) and Jeff Koons (* 1955) reprocess citations of acknowledged *avantgarde* positions, questioning their effectiveness. Though much of their work may appear calculated and superficial, it nevertheless makes one thing clear: a canon of painting vindicated by an exemplary ethical attitude no longer exists.

(The text on the last page of the introductory essay and the descriptions of works on pages 630, 643 bottom, 645 bottom, 648, 651 bottom, 653 top, 659, 663 bottom, 673, 674 top, 675 bottom, 677, 678 top, 679 and 680 were written by the editor)

ARSHILE GORKY

1904-1948

This painting is one of Gorky's most important works. It was created at a time when he succeeded in breaking away from the influence of his early role models Paul Cézanne, Pablo Picasso and Joan Miró and had already begun constructively integrating the Surrealist elements which were to shape his work decisively from then on. From the early 1940s onwards, Gorky began moving away from figurative painting, developing fluid, organic forms and a subtle colourity full of luminosity, calligraphic lines and symbolic codes.

The painting is extraordinarily bright, and includes almost every possible permutation of the palette. The title indicates its origins in Surrealist language. Even the colour fields and "hybrid" forms are juxtaposed in a distinctly Surrealistic manner creating a partly painterly, partly sketch-like effect. The image on the whole is full of vibrant motion, almost to the point of aggression, even when it foregoes figuratively realistic elements. The spontaneity of colour and the direct gestures of the brushstrokes already contain elements of action painting and abstract Expressionism. In this work, warmth of colour alternates with cool zones, giving the painting a distinctive rhythm through the repetition of individual forms and colour areas. In this respect, it may be regarded as a summary of all his creative ideas.

Arshile Gorky The Liver is the Cock's Comb, 1944 Oil on canvas, 183 x 249cm Buffalo (NY), Albright-Knox Art Gallery

ROBERTO MATTA

*1912

Matta, who joined the Surrealists towards the end of the 1930s, based his painting on the psychic automatism propounded by André Breton and practised by André Masson. Le Vertige d'Eros is one of his many large-scale paintings with a title that gives some indication of its interpretation and the painter's intent. Important as the aspect of automatism may have been, Matta nevertheless felt obliged to make a statement in his work. He unites messages received through the psyche from the subconscious, with reflected perceptions, considerations and findings. In this way, he formulates

With his paintings, he reacts to certain political situations (he was a volunteer in the Spanish Civil War) and at the same time, seeks to express states of mind. He is interested more in collective, timeless issues than personal or momentary issues. The overall mood of his insights is one of scepticism and even pessimism. He regards the human individual as a creature open to threat, illusion and surprise. His pictorial syntax is made up of symbolic signs, some of which possess an archaic magic, others a modern abstraction, with remnants of the figurative. In this respect, his paintings have a strongly dynamic and expressive aspect.

Roberto Matta Le Vertige d'Eros, 1944 Oil on canvas, 195.6 x 251.5 cm New York, The Museum of Modern Art

UNITED STATES/CHILE 629

Hans Hofmann Blue in Blue, 1954 Oil on canvas, 127 x 101.5 cm Private collection

Clyfford Still Untitled, 1954 Oil on canvas, 297.2 x 256.3 cm Private collection

HANS HOFMANN

1880-1966

Hans Hofmann was one of the great mediators, who brought European abstract art to America. Although his work in New York as a teacher of generations of abstract painters was widely acknowledged at an early stage, his own paintings were long neglected. They do, however, take a special place within abstract Expressionism through their specific personal touch. Hofmann was often inspired by particularly moving events, to which he reacted with dynamic streams of colour reminiscent of calligraphy. Abrupt brushstrokes charged with energy form the colour planes in Blue in Blue which are generally derived from rectangular forms. These forms collide, blend and dissolve. It is a pure painting, but one charged with significance through its sheer force and physical presence. It is not a question of aesthetic pleasure, but the expression of a profound inner sentiment.

Hofmann himself, in writing of his artistic career, pointed out that he had devoted his entire life to the quest for the real in painting: "The only values which make a work of art great are emotional and sensory. Life-content. Expressed experience." He claimed he had never believed in academic training, which he had not undergone himself. His maxim was instinct alone, and he believed that he had to find everything within himself if he was to achieve anything meaningful in the course of his artistic development.

CLYFFORD STILL

1904-1980

Still banned all reference to the visual world from his paintings. He sought to liberate colours from the significance allocated to them and keep his painting free from all characteristics of an individual signature. He was one of the most vociferous proponents of artistic autonomy: "We are now committed to an unqualified art, not illustrating outworn myths or contemporary alibis. The artist must accept total responsibility for what he executes. And the measure of his greatness will be lie in his inner depth and in his courage in realizing his own vision." After a few years, he gave up giving his paintings significant titles.

The irregular colour planes, which seem to have been torn apart, are generally vertical. The colours are interlocked as though in battle, and reciprocally heighten their effect and intensity. Until well into the early 1940s, Still preferred to inundate his canvases with menacing, and at times meditative, black tones. The painting shown here was created during a phase when Still was increasingly interested in coloristic confrontation, in which black invariably played the most important

WILLEM DE KOONING

*1904

Woman, I was created when de Kooning was at the height of his artistic vitality. Abstract compositions from the same period indicate the purely painterly intentions of the artist: art as an action linked with energy and physical movement. He works in a state of outer emptiness and inner concentration, oriented solely towards the act of creativity. The result is not pre-programmed, but completely open and is constituted by the end of the painterly act.

In the violent, tension-charged composition of this painting with its aggressive colours, the image of a woman is integrated. The figure is monstrously ugly, a distorted image of woman. She is not Venus, an idol of ideal figure, a fertility Goddess – attempts at interpretations that have been tried but have proofed unconvincing. She is the fading, decadent woman. Robbed by society of her inner self, her better characteristics and abilities, she remains reduced to exaggerated physical features – large eyes, flashing teeth, huge breasts, heavy thighs.

The subject of "woman" captivated him for more than ten years and each interpretation he attempted resulted in a new version of a caricature, a travesty of the stylized media clichés of femininity. De Kooning's paintings not only show what is missing, they scream it out: soul and humanity. He uses a shocking anti-aesthetics to reveal the alarming background of this appearance – a stylistic medium that was to be adopted once again decades later by Germany's *Neue Wilde* artists.

In this later work by de Kooning, we can see his stylistic development from the abstract expressionism of the 1950s to his mature work in the 1980s. The figurative elements have completely disappeared from his paintings, and even his abstract compositions are structured differently. They are still strongly rhythmic in their structure, but there is less movement than before. The colours are almost all mixed with white, some only through their application on the canvas. The large area is tectonically structured by multi-faceted colour fields and zones.

Art of this kind can be interpreted only through the artist. Traditional canons of aesthetic standards are of little help to us here, for they do not apply to this kind of painting. The way in which the artist integrates his emotional and intellectual energy into the act of painting, as though he were in an existential situation, gives the canvas its statement. Painting as a physical process is invariably dependent on the constitution of the artist at the moment of painting. De Kooning works in an attitude of open possibilities in which nothing is pre-programmed, and only the result of the spontaneous painterly act is evaluated.

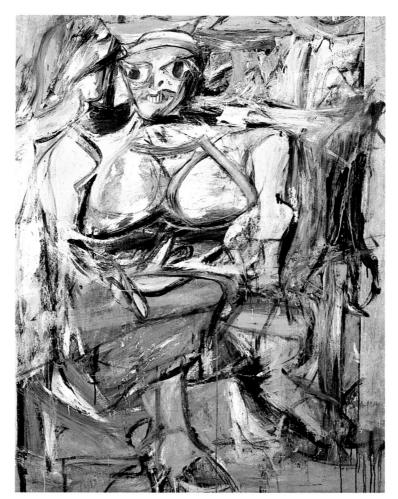

Willem de Kooning Woman, I, 1950–1952 Oil on canvas, 192.7 x 147.3 cm New York, The Museum of Modern Art

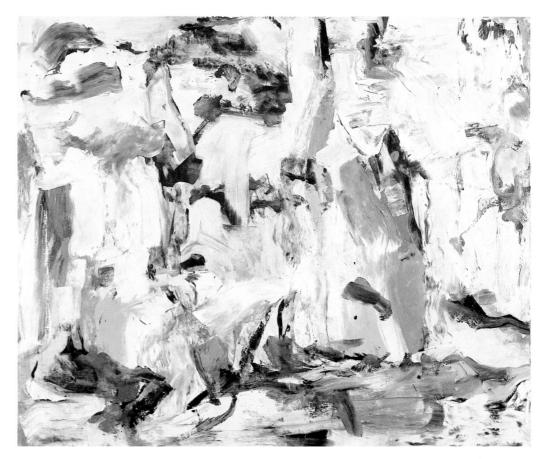

Willem de Kooning Untitled, III, 1980 Oil on canvas, 178 x 203 cm New York, Collection Xavier Fourcade Inc.

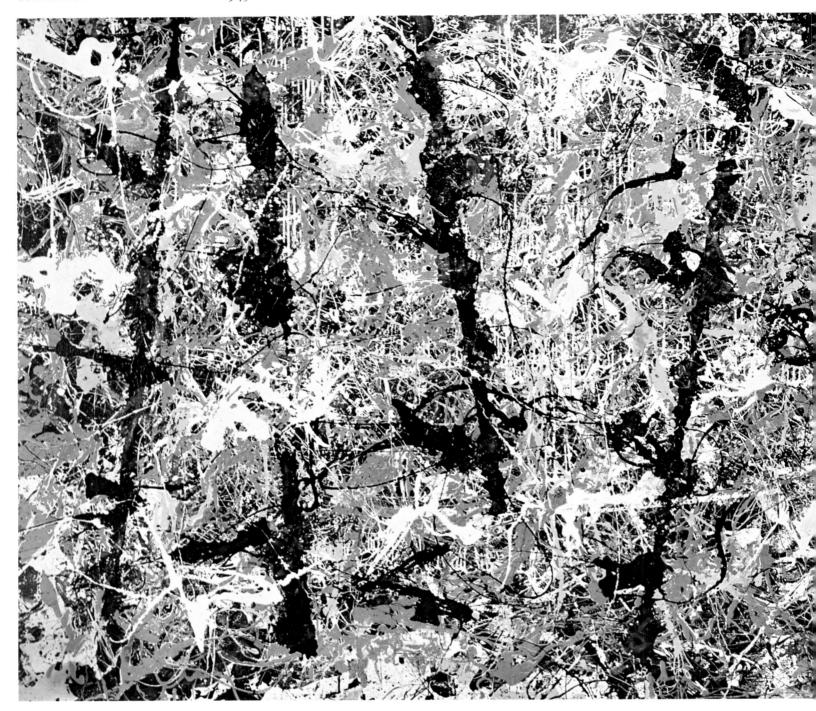

JACKSON POLLOCK

Jackson Pollock is the pioneer of the American post-war *avant-garde*. Today, he is recognized as the artist who fundamentally renewed abstract painting. *Blue Pole* a painting dating from 1953, was created using the painterly technique he himself described as drip painting. His early figurative works possess an almost coarse and even ungainly formal syntax full of raw vitality. Later, he adopted elements of Surrealism, and the works of the early 1940s are marked by an impetuous brushstroke.

The decisive break with his earlier ideas came in 1947. Pollock no longer wanted to create carefully considered and constructed compositions. The brush as instrument seemed to him too restrictive, as was the easel. He cleansed his art of all previously existing forms and motifs. He placed his canvases on the floor. In this way, he could work

on them from all four sides, a method he had seen used by Indian sand painters in the American West. In this type of process, he felt he was literally "in the painting". As the substratum of his Surrealistic endeavours, he retained psychic automatism, the spontaneity of the painterly act, that led him to the creation of his drip painting method. He no longer took a brush in his hand, but dripped and sprayed the colour onto the canvas instead. In doing so, he followed an inner willingness and tension geared entirely to the action with his materials. He himself described this state as follows: "When I am in the painting I'm not aware of what I'm doing ... the painting has a life of its own. I try to let it come through." In a painting like this one, however, we can also see the control with which Pollock pursued the direction, thick-

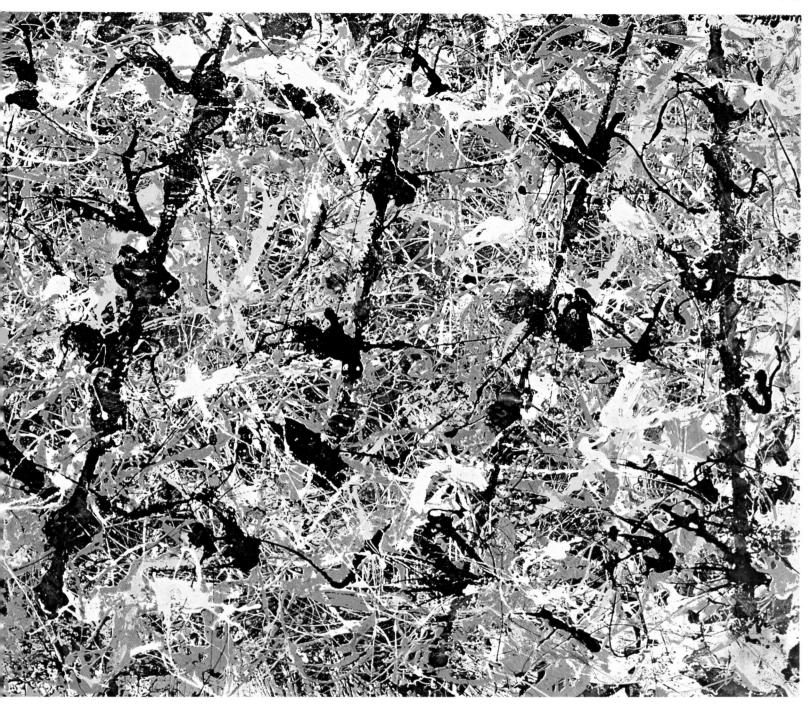

ness and continuity of the drops and rhythmic lines.

Blue Pole is well-organized and balanced in colours and forms. In 1951, the critic Harold Rosenberg coined the term "action painting" for Pollock's work. The paintings were created out of fluid drops of paint, heavy pastes, mixed with sand, glass splinters and other additives

Pollock used sticks, cloths, knives to apply and distribute the paint. When the action and the material harmonized, the rhythmically abstract pictorial patterns were created. Strongly charged with expression, they reflect the dynamics of their creative process. *Blue Pole* was created a good four years after the first drip paintings. It is situated at a lower level of reflection than the first paintings in the new technique, in which the joy of experimenta-

tion and automatism are more clearly evident in the painterly technique. By 1953, Pollock had gained more confidence in his painterly technique and was able to control the application of paint more precisely without losing his spontaneity. The colours no longer refer to some natural impression. The dark blue, luminous orange, yellow, black, white and silver, are all artificial colours - the painter used a rapidly drying, brilliant car paint and aluminium. These were blended to a garish tonal chord, in keeping with the strong and confident application of paint. The colours are distinctly American and a sign of the radical break with the European painterly traditions. Finally, with his large-scale pictorial format, Pollock virtually forces the viewer to confront his new visual world. The overwhelming dimensions permit no escape.

Jackson Pollock Blue Pole, 1953 Oil, car lacquer and aluminium paint on canvas, 210.8 x 488.9cm Canberra, Australian National Gallery

Franz Kline New York, 1953 Oil on canvas, 201 x 128.5 cm Buffalo (NY), Albright-Knox Art Gallery

Robert Motherwell Elegy to the Spanish Republic No. 34, 1953/54 Oil on canvas, 203 x 254 cm Buffalo (NY), Albright-Knox Art Gallery

FRANZ KLINE

1910-1962

Kline's New York, a canvas of monumental dimensions and boldly abstract forms created in strong, broad brushstrokes, is a highlight of action painting and abstract Expressionism. Although the painting looks spontaneous, it is painstakingly prepared, for Kline invariably worked on the basis of carefully considered and organized draft sketches. Only the final execution was then created with concentrated speed and intensity in a motoric action, in which the physical movements were intended to be integrated into the colour fields as "signs of power". He used large decorators' paintbrushes and preferred industrial paints to oilpaints because of their effects and their quickdrying properties.

Although this painting bears the specific title *New York*, the painter denied any reference to bridges or scaffolding in his tectonic black and white structures. Nor did he approve of comparisons with calligraphy. He saw only the painterly aspect of his works and he wanted them to be understood as the end results of a painterly act, as the confrontation of the artist with the vital "act of painting". The colours black and white are intended to be equally valid and mutually permeable.

ROBERT MOTHERWELL

1915-1991

Although Robert Motherwell is an action painter, and a key figure of abstract Expressionism in New York, the elements of this spontaneous, gestural painting are relatively subdued in his work. His paintings are invariably intellectual. In 1948, when he founded the short-lived cooperative The Subjects of the Artist together with Rothko, Newman and other artists, he discovered the theme that he would continue to work with over the next three decades in more than a hundred versions: his *Elegy to the Spanish Republic*. The civil war in Spain triggered a moral crisis in the late 1930s comparable to that of the Vietnam war.

With his *Elegies to the Spanish Republic*, Motherwell did not intend to give a coded report, nor to describe a local situation, nor even to refer to a special event. According to Motherwell, "I take an elegy to be a funeral lamentation or funeral song for something one cared about. The Spanish elegies are not "political" but my private insistence that a terrible death happened that should not be forgotten. They are as eloquent as I could make them. But the pictures are also general metaphors of the contrast between life and death and their interrelation." Whereas black and white dominate in the *Elegies*, his palette later becomes more colourful.

SAM FRANCIS

1923-1994

Sam Francis' painting is closely linked to the work of the American abstract Expressionists. Even before he began to study art at the University of Berkeley, he had already developed his own style in abstract painting. Two elements are typical of his approach: irregular, cell-like structures or daub-like colour areas and a preference for undiluted acrylic and oil-paints.

Though he was born and brought up in California, Francis is not exactly a typical representative of American painting. His travels to Eastern Asia and lengthy stays in his chosen home of France, where he lived in Paris, make him a cosmopolitan artist whose work integrates a wide variety of influences. The largescale Basle Mural thrives on the tension between a rhythmically structured network of interconnected colour zones and a uniformly pale ground. The few colours - red, blue and yellow - are applied, partly with a palette knife, in overlapping, cell-like zones that create a pictorial pattern. The works of Sam Francis from this period have a scintillating colour force. The intellectual concepts behind his work are frequently influenced by Asiatic philosophies.

Sam Francis Basel Mural II, 1956-1958 Oil on canvas, 400 x 608 cm Amsterdam, Stedelijk Museum

MARK TOBEY

1890-1976

Tobey developed his painterly style relatively independently of prevailing artistic trends. His pictorial patterns are vaguely reminiscent of Pollock's drip paintings, but they are derived from very different roots. Although, as in Pollock's paintings, a kind of calligraphic pattern covers the entire canvas, Tobey's paintings, like Newman's work, have their origins in the religious sphere.

Until the discovery of his own pictorial pattern, Tobey's involvement with the Bahai sect and his study of oriental brushwork were decisive influences on his artistic development. In his calligraphic paintings, Tobey found a possibility of uniting Eastern and Western cul-

Tobey's paintings invariably involve similar conceptual structures. Colours, signs and patterns are varied respectively. Their limitation at the edge of the painting seems arbitrary, as though they could continue ad infinitum to all sides. Tobey's transition from figurative art to abstract art is not founded in his formal development, but in his wish to create an art that is an internationally comprehensible pictorial language. He sees humane ideals and aims in the harmony of his intimate picture patterns, as well as the restlessness of human endeavour and the interweaving of human fates.

Mark Tobey North-west current, 1958 Oil on cardboard, 117 x 100 cm London, Tate Gallery

Hans Hartung T 1956–9, 1956 Oil on canvas, 180 x 137 cm Private collection

Pierre Soulages Painting 21, 6, 53, 1953 Oil on canvas, 195 x 130cm Private collection

HANS HARTUNG

1904-1989

In the 30s, the work of Hans Hartung was understood neither by the representatives of abstraction, nor by the equally influential Surrealist movement. It took a good ten years for his simple harmonic, graphically structured compositions to gain recognition as significant works. At a very early stage, Hartung developed the idea that no form can be created without movement and the idea of the large line of one colour that breaks into rays

This painting, created in 1956, is typical of the forms developed and frequently varied by Hartung: the colour palette is restricted to a few yellow/brown/black tones that create a vibrant, but harmonious pattern on a pale ground. The large, lens-like signs are superimposed and interconnected. Out of a meditative painterly movement, a vital organism seems to have grown. The structures of the bundles of lines take on a balanced tectonic structure through the various intensities of pale and dark, yellow and brown. The alternating thickness of the brushstroke, the complexity of the superimpositions and the gentleness and vehemence with which the brushstrokes are executed are reminiscent of Oriental ink drawings. It seems only logical to compare Hartung's work with Japanese Zen calligraphy.

PIERRE SOULAGES

*1919

After 1945, Soulages, who had visited the academy only briefly, presented his paintings to the public. He is one of the best known representatives of the École de Paris and French tachisme. His abstract compositions do not generally have explanatory titles. The paintings are coloristically and formally reduced, restricted to a relatively narrow canon of forms. The luminosity of the colours is rarely in the foreground, and is generally mixed with black. The connection of black with brown, grey, green or blue, determines the mood of each painting. The strength of the colour layer, alternating between the strongly impasto and the gently transparent, creates the subtle gradations and effects.

Soulages' pictorial codes are mutable. The contrast of dark and light, reflection and opaqueness, add vitality to his compositions. The plasticity of his pictorial structure suggests density in the dark areas, while the paler semi-transparent parts create a vague impression of space. Soulages' formal syntax, although abstract, is inspired by the impressions he gained during his childhood in the Massif Central where he was familiar with prehistoric menhirs and the sculptures of Romanesque churches. Later, the influence of calligraphy was added.

GEORGES MATHIEU

*1921

In the post-war years, Mathieu was one of the most famous representatives of the Ecole de Paris. After a brief realistic early phase, inspired by his reading of Joseph Conrad's texts, he began exploring questions of the essence of art and decided to work abstractly. His first non-realistic paintings already include the elements that were to become the hallmark of his painting from then on. The Decapitation of Olivier III is one of this group of works.

There is no unequivocal relationship between the title and the painting. Mathieu's preference for historic-sounding titles can be explained by his philosophy and his readings in history; he studied the Capetian dynasty of French rulers particularly intensively. Against a calm, black ground, two white geometric forms appear in balanced alignment to the right and left: a rectangle and a rectangle from which a circular shape has been cut out. In the centre, we see Mathieu's "hallmark", an impulsively drawn emblem in brown-beige impasto. It is clear that Mathieu regarded the painting of a picture as an action, and that he enjoyed celebrating a painting in a kind of performance before an audience. Various attempts have been made to classify his works as "lyrical abstraction", "tachisme", "informel" and "calligraphic abstraction".

Georges Mathieu The Decapitation of Olivier III, 1958 Oil on canvas, 60 x 92 cm Paris Private collection

SERGE POLIAKOFF

1906-1969

Although Poliakoff left his Russian homeland at the age of twelve and spent his artistically formative years in Paris, his works nevertheless betray certain subtle Russian elements. The icon painting of his homeland and the decor of the orthodox churches undoubtedly influenced Poliakoff's work. His paintings are abstract and cannot actually be described as religious, yet their overall mood is one that invites meditation. The mystical colour chords, the gentle shimmer of light that seems to be inherent within the colours, the tension that emanates from his formally similar compositions, are all unthinkable without the influence of Russian art. The generally angular forms interact, rarely overlapping, thereby creating a spatial illusion.

The diversity of Poliakoff's oeuvre is based on his virtuoso handling of colour. It varies in tonality and luminosity within a single field, and even the material character of the colour changes from area to area, becoming more gentle or appearing more grainy. Unlike his contemporaries Kasimir Malevich, Wassily Kandinsky and Robert Delaunay, Poliakoff did not place his painting at the service of political agitation or functionality. He remained a painter of decorative easel works, concentrating on a few colours.

Serge Poliakoff Composition, 1959 Oil on canvas, 130 x 96.5 cm Vienna, Museum moderner Kunst, Sammlung Ludwig

Maria-Elena Vieira da Silva The Library, 1949 Oil on canvas, 114.5 x 147.5 cm Paris, Musée d'Art Moderne, Centre Georges Pompidou

Nicolas de Staël Figure on the Beach, 1952 Oil on canvas, 161.5 x 129.5 cm Düsseldorf, Kunstsammlung Nordrhein-Westfalen

MARIA-ELENA VIEIRA DA SILVA

1908-1992

Though its overall format is large, the painting *The Library*, executed in 1949, is structured in small detail. At first glance, it appears abstract, with many small areas interacting to create a pictorial surface. Vieira da Silva's paintings guide the spectator's gaze across the canvas, inviting us to ponder some detail or go on a journey of discovery with fantastic associations. The way she plays with various pattern zones, anchored in a sweeping and bold network of lines, turns out to be a virtuoso interaction of frontal, angular views from above and below. The painting is a dream-like, visionary illusion of space, independent of real dimensions.

An atmosphere of timelessness informs the architecture, structured on several levels. In the same way, the painting has the possibility of a connection with reality even though it seems to have no real boundary at top or bottom. In the mosaic-like facets, we recognize endless walls of books, stairways, corridors, ceilings, floors and galleries. The widespanned arches and angles and the irreal spatial layering create a realistic situation and distort it to the point of absurdity. After all, this is not the image of a specific library; instead, it draws our imagination into spheres that can be reached through the treasures of a library.

NICOLAS DE STAËL

1914-1955

Hans Arp, Sonia and Robert Delaunay and Alberto Magnelli were the first artist friends to recognize de Staël's talent and encourage him to paint. Abstraction had entered the world of art four decades earlier, and already seemed to have exhausted its possibilities when it experienced a revival in the 1940s in the USA and Europe. De Staël initially joined the European abstract movement and created *tachiste-informel* works. Today, they appear fashionably faddish, unexperimental and void of personal characteristics. Only the paintings that bear the inimitable hallmark of his own highly distinctive style are truly convincing.

The Figure on the Beach is one of the great classic paintings by de Staël. Although it is actually non-figurative and has no reference to the external visual world, its proximity to reality is determined by the title. The various large colour fields that define the tectonic structure of the painting have a direct relationship to the spectator. The colour is recognizable in its materiality and the traces of the palette knife at work suggest the moment of creation. The juxtaposition and interconnection of the many zones with their shimmering layers is captivating in the appeal of its sublime choice of colour whose luminosity is reminiscent of the Impressionists.

638 PORTUGAL/FRANCE

WILLI BAUMEISTER

1889-1955

Around the same time that a number of major upheavals affected his life – the loss of his professorship in Frankfurt am Main and the Nazi threat – Baumeister turned his back on an art that was still geared towards reality and reflective of it. After a phase in the late 1930s and early 1940s, when he experimented with interpretations of prehistoric patterns and concepts of collective subconsciousness, he turned increasingly towards abstraction.

Montaru, Aru, Monturi and Han-i are series of abstract compositions on which he worked for many years. For Baumeister, abstract forms were not void of content. Instead, he saw in them the bearers of metaphysical powers and perceived abstraction as a contemporary form of expression with intellectual parallels to science. "The paintings show forms, colours with their contasts and intersections, lines and rhythms so that, through these, they arrive at an order or so-called harmony. Order can help us to gain a standpoint in the confusion and multiplicity of the world... the modern painter does not create his work after nature, but in the manner of nature." In other words, the artist no longer studies creation, but is himself the creator of a world in the picture.

Willi Baumeister Montaru-G VI, 1954 Oil auf Hartfaserplatte, 185 x 130cm Düsseldorf, Kunstsammlung Nordrhein-Westfalen

ERNST WILHELM NAY

1902-1968

Ernst Wilhelm Nay was one of the most important and renowned representatives of abstract painting in post-war Germany. In a process that lasted more than three decades, he moved his earlier figurative topics - still lives, landscapes and mythological themes - further and further from the real world and the world of imagination. During his final period of figurative painting, a distinct tendency towards expressive portrayal was evident. In the mid-1950s, he broke entirely with all figurative motifs and devoted himself entirely to purely abstract painting, and it was at this time that painting took on a new meaning for him. His own aims best describe his intentions: "Painting means forming a picture with colour."

Nay's abstractions contain no coded message. They are painting for its own sake. The most important formal statement is the coloristic and material quality of the paint. The title *Yellow Chromatic* indicates that the impulsively applied colour fields, daubs and circle segments are a question of harmony. Colour and form stand in a tense relationship to one another, in contrasts and harmonies. An expressive motion creates a sense of space.

Ernst Wilhelm Nay Yellow Chromatic, 1960 Oil on canvas, 125 x 200 cm Essen, Museum Folkwang

Jean Dubuffet Le Métafisyx, 1950 Oil on canvas, 116 x 89.5 cm Paris, Musée National d'Art Moderne, Centre Georges Pompidou

Jean Dubuffet Business Prospers, 1961 Oil on canvas, 165 x 221 cm New York, The Museum of Modern Art

JEAN DUBUFFET

1901-1985

Dubuffet did not seek his inspiration or role models in academic painterly tradition or in the generally acknowledged and binding aesthetic canons. For him, true art, expressed in creativity, spontaneity, vitality, freshness and originality, came from other realms. In the drawings and scribbles of children, in the painterly endeavours of the mentally ill, mavericks, prisoners or in the art of primitive peoples, he saw an unspoiled approach that he himself sought to achieve.

In the forms of expression used by people beyond the bounds of academic art training, he recognized a magical and spontaneous force that he described as "art brut". The bizarre lyricism of his paintings, drawings and sculptures stand apart from the various movements of art to which he never wanted to belong. They are a response to the appealingly beautiful, academic and intellectual art, whose formal syntax and colour rules Dubuffet deliberately ignored.

Le Métafisyx is a wild, raw figure, bluntly scratched into the pictorial ground, not carefully painted, and with an archaically brutal expressive force, full of terrifying, simple and symbolic coding. Dubuffet himself was attracted to the ugly and the chaotic, because it is an integral part of the world. He did not intend his world to contain anything ordered and adapted. Nothing that subjugated itself to any other rule than that of total freedom: "Seek spiritual worlds that have nothing to do with culture... it should always be badly made like a clumsy dance."

Business Prospers is a broad, horizontal-format painting. Individual, divided forms seem to blend with each other in the manner of millefiori (a technique involving polychromatic floral patterning). On closer inspection, we see that it is indeed an ordered and interactive tapestry of individual forms: blocks of houses, streets, squares, cars, a bus and many people. The individual buildings are schematized into colour fields so strongly that they are designated as "bank", "butcher" etc. The vehicles look as though they had been flattened, but on the inside we can see the passengers. People have been simplified to matchstick figures with total disregard for proportion and perspective.

Dubuffer's painterly approach, which he himself described as "art brut" goes beyond traditional and *avant-garde* modes of presentation, and pits itself against all conventional aesthetics. It denies all the achievements of centuries of pictorial technique. The result is a painting that looks more like a living organism with all its growing forms and multiple layers.

640 FRANCE

WOLS

1913-1951

Le Bateau ivre is the title of a poem by Arthur Rimbaud describing the journey of life. Wols adopted it as a poetic metaphor for his own brief, painful and often aimless life. The title of the painting is therefore more metaphoric than literal. From around 1941/42, Wols' paintings, which had previously been figurative, began to become increasingly abstract. Ecriture automatique became his pictorial language. The abstract forms and the fine and delicately selected colours still maintain a fragile relationship to real concepts. Wols did not regard himself as a professional artist, and he hated the official art trade, the cultural circus, and the self-projection of all those involved in it.

His works distinctly reflect the influence of Paul Klee, Max Ernst, Joan Miró, but also that of George Grosz and Otto Dix; yet Wols used all these sources of inspiration only in order to create his own highly individual oeuvre. With his work, he belongs to an artistic movement that influenced the painting of artists in many countries and came to be known from country to country under different names: *informel*, abstract Expressionism, *tachisme*, abstraction *lyrique*.

Wols Le Bateau ivre, 1945 Oil on canvas, 92 x 73 cm Zurich, Kunsthaus Zürich

JEAN FAUTRIER

1898-1964

Fautrier worked for well over twenty years without his work attracting widespread attention. He started out as a painter of nudes and animals and, from 1932 onwards, he developed his new technique. It was only after the Second World War that he achieved recognition as the creator of an art autre, an other art, through which he distinguished himself particularly from the American painters. The term "art autre" could also be used to describe his own development, for his early works appear to be preparatory to his path towards nonfigurative post-war works. He called these paintings Otages (Hostages). They are not pure painting, but an interaction of many technical processes and reworkings that constitute an interim stage on the path towards material and object art.

The canvas is generally prepared by creating a ground. For example, paper may be pasted onto it. On the still damp ground, a drawing is sketched with the brush, onto which pastel powder and pigment substances are then distributed.

Finally, Fautrier adds a thick layer of paint over the outline of the first drawing. With coloured powders, brush and palette knife, he works in various layers in which different areas are more or less intensively processed, repeating the procedure and then adding grooves and scratches.

Jean Fautrier Nude, 1946 Oil on canvas, 114 x 146cm Private collection

GERMANY/FRANCE

Antoni Tàpies Relief in Brick Red, 1963 Mixed media with sand on canvas, 260 x 195 cm Düsseldorf, Kunstsammlung Nordrhein-Westfalen

Antoni Tàpies Armchair, 1982/83 Oil on canvas, 146 x 114 cm Private collection

ANTONI TÀPIES

*1923

Tàpies is regarded as the most important master of informel and tachisme in Europe. In this material painting, he not only uses painterly means. The heavily applied binder is mixed with sand. This gives the painting the character of a relief, with signs and scoring applied to the still soft surface. The range of colours used here is reduced to reddish-brown hues, black, white and grey. Painterly and sculptural forms interact in this abstract painting in which not everything is actually meant in an abstract sense. Both the colours and the signs scratched into or painted onto the surface have a meaning. However, Tapies has no intention of telling the spectator what to think. He does not even want his work to be analysed intellectually. "It is more important that the spectator should follow the intuition that sets his spirit moving. Art affects our general sensibilities, and not just our intellect."

Tàpies sees himself as someone who has retained his universal connection with nature and a certain mysticism. For him, art should have depth and should contain a design for a new positive awareness that also includes philosophy and ethics, and gives everything a new meaning. In addition to the laws of pure pictorial design, he expects the artist to possess an inner dynamic force or emotional power that enables him to undertake his own development, with the aim of finding new formula that will make his work more efficient.

Tàpies' paintings are created through intuition, following lengthy meditation. In their finished form, they are often beyond the control of his feelings and his intellect. After a Surrealistic early phase influenced by his reverence for the two great Spanish painters Miró and Dalí, Tàpies turned to abstract painting. For many years, he created the stringent panels known as his Wall Paintings. The composition of Arm Chair is also stringent. We see a white outline on a black background, which, on closer inspection, might come to be recognized as the shell of a chair or arm chair. Yet the painting is so planar, so strongly abstracted, that we might just as well consider it to have no figurative

Black, white, grey and earthy brown, occasionally mixed with white, are the few colours used in this picture. The sign of the cross, which Tapies so often uses, grooves scored into the thickly applied paint, splashes of paint and scraped areas all give this work a strongly dynamic feeling. Tapies believes that all those who are as strongly bound to a tradition as he is can "read" or interpret his paintings: "I am not in favour of making it easier for people to understand by lowering our language to their level; the people have to come up to our level. The struggle to find the necessary materials for this process is everyone's responsibility."

ALBERTO BURRI

1915-1995

The prosaic title *Sack No. 5* that Burri gave this painting clearly indicates that this material collage is not a question of content rooted in narrative, and that Burri did not actually intend to portray any particular object. Instead, he was turning his back on the traditional media of painting. The sack is not a substitute for the canvas as the carrier of the picture, but, together with the painterly elements used, is a component part of the work with its own significance. Objects and materials are no longer taken as a motif and painted illusionistically. In the sense of a new realism, they are self-referential.

Here, the act of painting is translated into an action whose result is no longer an unreal painting. In this respect, he adopts the concepts of early Cubist collages and Surrealist montages. The materials combined in a pictorial format on a single plane with all their injuries, repairs, knots and painted areas, have their own poetic pictorial language that allows the spectator to develop his or her own associations. As Burri frequently used burnt and shabby materials, the spectator's feelings are guided in a specific direction. Often, his works are regarded as a challenge. From the 1950s onwards, other artists also used similar materials, as did Tàpies and Beuys.

EMIL SCHUMACHER

*1912

In this painting, Schumacher achieves a new quality. Although the composition of large geometric components is still vaguely reminiscent of the Cubist landscapes he painted directly after the Second World War, the paint is already used here as material. It is no longer a question of using paint or colour to portray something, either figurative or abstract. The paint or colour is no longer the medium, but the subject matter of the design. The constructive framework of the forms will disappear completely in the years to follow. The two deep blue, luminous pictorial zones contrast effectively with the areas of earthy brown and beige. At some points, Schumacher has scratched the heavily applied paint with a knife or the handle of the brush, and in other places black trails of colour lie across the canvas like threads, drawn together at some point - such as the centre - to create relieflike structures. With his ability to lend the colours a sense of palpability, Schumacher goes beyond the bounds of the informel. The emphasis on material that was soon to lead him to integrate lead, asphalt, straw and paper into his paintings, was to influence a new generation of painters who, like Anselm Kiefer, sought to charge such materials with mythical meaning.

Above:
Alberto Burri
Sack No. 5, 1953
Mixed media and collage,
150 x 130 cm
Città di Castello,
Fondazione Palazzo
Albizzini, Collezione Burri

Emil Schumacher Spatial Division, 1955 Oil on canvas, 90.6 x 74.3 cm. Private collection

Asger Jorn Without Boundaries, c. 1959/60 Oil on canvas, 46 x 55 cm Private collection

Karel Appel Reclining Nude, 1966 Oil on canvas, 190 x 230 cm Private collection

ASGER JORN

1914-1973

Jorn was an active member of the CoBrA group and his painting was oriented towards the group's aims. Even after the group was disbanded in 1951, he continued to uphold their basic intentions as the foundation of his work. For his painting, that meant turning away from Surrealist influences and ideas, but also from lyrical and aesthetic *informel* approaches, but without radically breaking with abstraction

Without Boundaries is a painting in strong, highly contrasted colours with three formless, but strongly modelled, restless zones set within colour fields. The brushwork is strong and spontaneous, the oil-paint emphasized in its materiality, and in the intensity of the individual colour zones. The colours are simple, but charged with tension and contrast, even slightly aggressive, as is the brushwork itself, legible on the surface of the painting.

Given the concepts of the CoBrA group, associations with the figurative are legitimate. The original, "uneducated" art of children is regarded as a source of inspiration, as is the work of the mentally ill, indigenous peoples, and the truth and magic of ancient mythology, or the forces of nature. Art and artists are meant to be socially effective in this respect.

KAREL APPEL

*1921

In the history of painting, the theme of the "reclining female nude" is to be found throughout the centuries. The unclothed reclining woman is invariably seductive, as Venus, Odalisque or some anonymous model whose name the painter does not tell us, even if, as in Francisco de Goya's *Naked Maja* (ill. p. 397) the viewer has some sense of recognizing a specific person. Only rarely do we find portraits of audacious and frivolous women in such intimate poses.

Appel's Reclining Nude follows on in this tradition. Somewhere between figuration and abstraction, the vaguely discernible body forms dissolve into planes of colour. The physical characteristics are reduced, and yet the female attributes are discernible. However, they do not exude any aesthetic or even erotic appeal, nor do they recall any specific figure. Space and body are blended in the plane. Masses of colour seem to be juxtaposed with neither rule nor order, applied with brush and palette knife, superimposed. The strong, bright colours, in their impasto materiality, give the painting a unique quality to which the subject matter itself seems secondary. Together with Constant Nieuwenhuis, Corneille and Jorn, Appel was a member of the CoBrA group. Though only seven years his senior, Jorn was Appel's teacher.

ALBERTO GIACOMETTI

1901-1966

On his death, Giacometti left a painterly oeuvre to equal the quality of his sculptures. This portrait of the writer Jean Genet is situated within an intangible space of light and shadow, bounded by a painted frame. The face and figure are rendered in a manner that is not portrait-like.

Genet said of himself that he had a rather rounder face, but Giacometti has made it longer. The tonality, as in all Giacometti's paintings, is strongly reduced and limited to only a few shades of white, graphite grey and brown.

In his sculptures and paintings, the artist sought to understand "how the world is really made, even if it is only a small part of it, such as a human figure." The needs, visions and experiences of the writer Genet and those of his figure are what Giacometti seeks to capture. For this reason, he places Genet's portrait within its own impenetrable spatiality, thereby creating a sense of place as a setting for angst and trauma. Throughout his life, Giacometti's main concern was to master the world of space that seemed to him so boundless and terrifying, and to master the sense of misery in the face of silent existence around him and the oppressiveness of human alienation.

Alberto Giacometti Portrait of Jean Genet, 1955 Oil on canvas, 73 x 60cm Paris, Musée National d'Art Moderne, Centre Georges Pompidou

LUCIAN FREUD

*1922

Lucian Freud paints what he knows: his family, his lovers, his friends, still lifes, and the area around his home. He might spent years working on a painting, and some of his friends sit as models for entire series. The Big Man is a typical painting for Freud, created in his studio, in which he has portrayed a friend from an unusual angle. The man, placed in front of a mirror, is painted from above, adding a certain distance and objectivity. The heaviness of the body, sunk into the shabby armchair, is emphasized by this choice of perspective. Freud renders visible different textures and finishes through his painterly technique. He has paid considerable attention to detail in his rendering of the flesh tones of the hands and head of the man.

The uncompromising directness of this artist is reminiscent of the paintings of the Neue Sachlichkeit movement and some of his statements echo their programme. According to Freud, "I want paint to work as flesh, which is something different. I have always had a scorn for la belle peinture and la delicatesse des touches. I know my idea of portraiture came from dissatisfaction with portraits that resembled people. I would wish my portraits to be of the people, not like them. Not having a look of the sitter, being them. I didn't want to get a likeness like a mimic, but to portray them, like an actor... As far as I am concerned the paint is the person. I want it to work for me just as flesh does."

Lucian Freud The Big Man, c. 1976/77 Oil on canvas, 91.5 x 91.5 cm Private collection

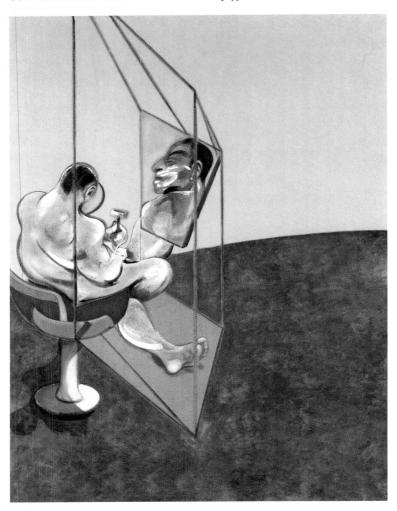

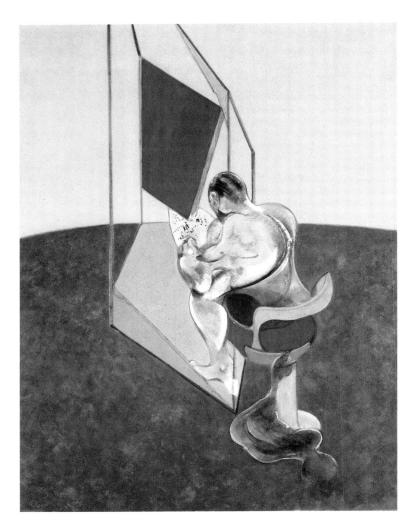

Francis Bacon Three Studies of the Male Back, 1970 Triptych. Oil on canvas, each 198 x 147.5 cm Zurich, Kunsthaus Zürich

FRANCIS BACON

1909-1992

A triptych was originally a three-part altarpiece whose central panel was the focus, both formally and in terms of content. Bacon used this format for the first time in his work Three Studies at the Foot of a Crucifixion (1944). From then on, he frequently adopted the theme of the crucifixion and used three-part canvases even for profane portrayals. He saw the triptych as an opportunity for multiplying his motif. It is presented in several paintings from different angles which are to be regarded simultaneously. In his portrayals of people and his portraits, Bacon often used only one model for large series. His subject matter would sometimes occupy him for years. The finished versions were then frequently titled "studies" in order to rob them of the absoluteness of perfection and completion.

The three panels in this triptych show a naked man sitting in an armchair with a magnifying mirror in front of him. On both the outer panels, the man is shaving, and his face can be seen in the mirror. In the central panel, we see the man reading a newspaper; the mirror is dark, without a reflection. The man is fleshy, muscular, corporeal. His face, like his heavy body, is distorted in curves that seem to follow the strands of his muscles. He is seated within a framelike structure that Bacon often

used as an artistic device. It is certainly not to be understood in real terms, but, like the large colour planes of the floor and wall, is intended to emphasize and intensify the figure. It is a kind of cage in which the figure has only a limited sphere of action. The observer is standing outside the space, but can watch the man unhindered. Private rooms and actions are rendered visible and therefore public.

Bacon was a figurative painter, in many ways related to Giacometti, but more expressive and radical. He was not the chronicler of a "world in order". Of all the possibilities of human existence and sentiment, he chose to portray despairing extremes. In his paintings, Bacon created "mythical translations of our inner structures". He rendered subconscious perception visible. His pictorial language thrives on the elementary force of his forms and colours. In his work, colour became a physical substance with which he recreated the brutality of daily life in his paintings. His exploration of painting was a constant act of looking chaos in the face, a constant awareness of transience and death, resigned to the meaninglessness of human existence.

646

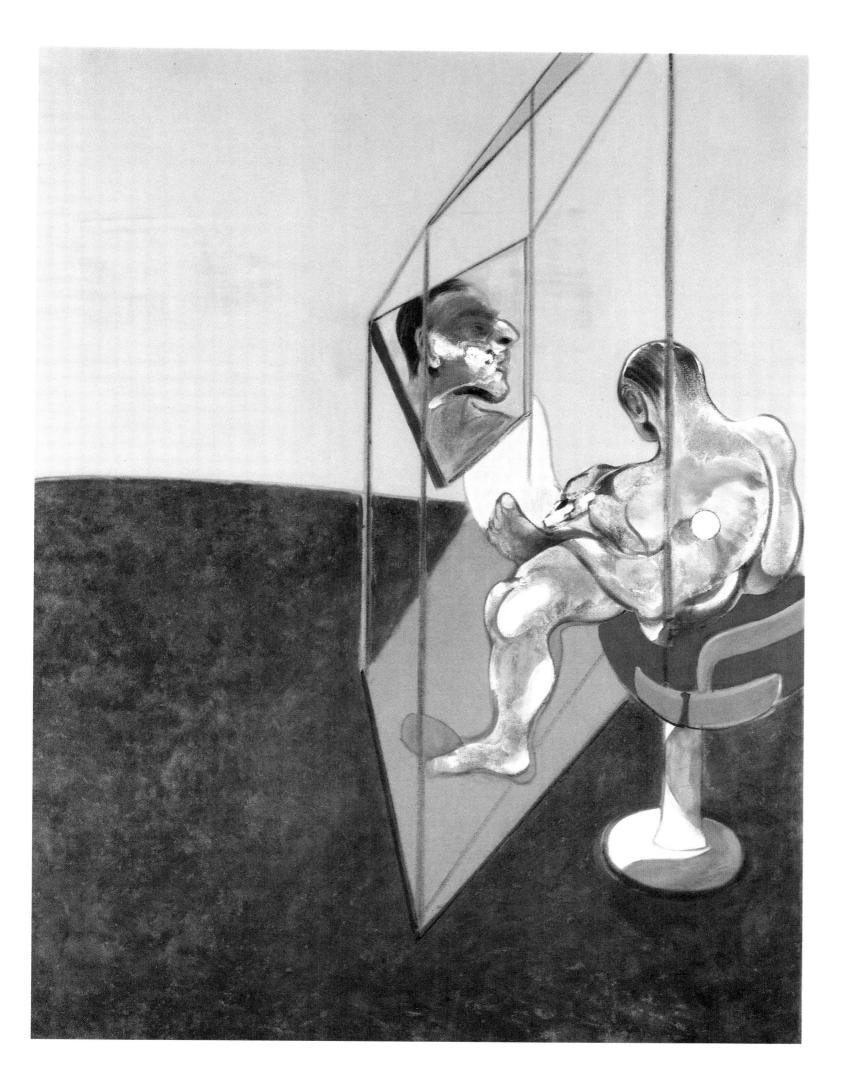

Ad Reinhardt Red Abstract, 1952 Oil on canvas, 152.4 x 101.3 cm New Haven (CT), Yale University Art Gallery

Josef Albers Study for "Homage to the Square": Star Blue, 1958 Oil on Masonit, 121.8 x 121.8 cm. Private collection

AD REINHARDT

1913-1967

Reinhardt, who was also a consistent art critic and art historian, sought to present the absolute in his paintings. Following on from the tradition of the Constructivists, primarily Piet Mondrian, he increasingly reduced his painterly means, colours and forms in order to ban all that was irrational and arbitrary from his pictures. For Reinhardt, the first rule and absolute measure of beautiful art and painting, which he regards as the highest and freest of the arts, was its purity. He believed that the more references and additions a painting had, the wose it was. Reinhardt called for the revival of art as art, rejecting the expressive gestures of his American colleagues as vehemently as those of the Surrealist automatisms. At the end of his development, we find monochrome black panels that he painted from 1960 onwards in the same format until his death.

Red Abstract illustrates the process by which his monochrome paintings emerged. Reinhardt superimposed rectangles of almost identical colours over one another, so that a cruciform could be seen in their structure. This cruciform was the last still portrayable step before his works turned to purely spiritual appearances that could only be grasped mentally.

JOSEF ALBERS

1888-1976

From 1950 onwards, Josef Albers worked on a series that he called *Homage to the Square*. He determned two formats at an early stage (60 x 60cm and 120 x 120cm) and also settled on the alignment of squares within a vertical symmetrical axis. On the basis of this strictly regulated form, he spent more than 25 years of concentrated work creating a large series of oilpaintings on hardwood panels, offset-prints and serigraphies. Albers varied only the number of squares and the colours. For many of these square paintings, the colours were determined after a series of studies. There are paintings with contrasting colours and variations on single colours, in which the transition from square to square is minimal. Albers himself described the process in a prose poem: "When I paint and construct / I seek visual articulation 1... / In my work it is enough for me / To compete with myself / To attempt multiple instrumentation / With a simple palette and simple colours / And to dare to make further variations" Albers gave his paintings freely associative poetic titles that would give the spectator scope for individual interpretation. On the other hand, the simple pictorial structure makes us consider the actual process of painting.

MARK ROTHKO

1903-1970

Following a realistic phase in the 1930s, Rothko began experimenting with the automatic painting propagated by the Surrealists. His own personal and artistic development did not profit much from it, for he went in an entirely different direction. Rothko was particularly interested in Greek and Roman mythology and in the theories of Freud and Jung, particularly in their theory of symbols. For Rothko himself, symbols were tragic, timeless expressions of primitive fears and impulses, in every country and in all situations. On the basis of this notion, Rothko began treating forms and colours like an adventure into an unknown world: "Ideas and plans that existed in the mind at the start were simply the doorway through which one left the world in which they occur."

In the 1940s, he often painted with water-colours or gouache, to achieve a transparent effect. Soon he turned to abstraction, believing that reminders of the world of the figurative and nature would disturb his exploration of ideas. He wanted to avoid any object-oriented association in his portrayal of objects, in order to be able to create entirely value-free statements. For this reason, he simplified his work methods and motifs increasingly, reducing his formal repertoire drastically to the rectangle.

By the end of the 1940s, he had developed the typical pictorial form with its two or three rectangles, which he continued to vary from then on. Rothko was one of the most important figures in the New York School of abstract Expressionism, but he was not an action painter. His abstract compositions were not created in a process of frenzied action, but in a contemplative attitude. His paintings are the result of an inner calm, and they mirror meditative processes. The theme in Rothko's large paintings, including Number 10 is the theme of the infinite, of the universe. He sought transcendence through the constant equilibrium of only a few forms in his paintings and through the powerful statement of his colours. Applied thinly, not delineated at the edges, linked with the structure of the canvas, with a matt, almost dull surface, the colour fields give an illusion of atmosphere and the impression of an

As in the work of Albers and Poliakoff, Rothko explores painting through colour: a form once found is subjected to minimal variations, while colour is constantly re-explored and, thereby leading to new atmospheres and moods. His paintings possess an atmospheric quality of spiritual, contemplative nature, in contrast to the dynamic mood of Pollock, Kline or de Kooning.

aura. The dynamics of the painting lies in the tension between the floating colour fields.

Mark Rothko Number 10, 1950 Oil on canvas, 228.6 x 114.6cm New York, The Museum of Modern Art

Morris Louis The Third Element, 1965 Acryl on canvas, 217.8 x 129.5 cm New York, The Museum of Modern Art

Barnett Newman Vir Heroicus Sublimus, 1950/51 Oil on canvas, 242.2 x 513.6cm New York, The Museum of Modern Art

MORRIS LOUIS

1912-1962

Morris Louis founded the Washington Color School together with Kenneth Noland. They wanted to devote themselves entirely to the painterly process, exploring the interaction between artist, colour and canvas, the properties of colour and the resulting possibilities for painting.

The Third Element is a typical result of these experiments in a new pictorial structure invented by Louis. Technically, it is based on the method he developed on the basis of an approach differing from that of classical painting, which has much in common with the approach of the abstract Expressionists and action painters.

Paint is poured onto an unprimed canvas and the colour is guided into stripes. Diluted colours, which would shine through at certain points, gave his early paintings their typically veiled effect. What is more, he often allowed several layers of colour to permeate each other. All his colours were combined on the canvas. In this way, the subtle gradations of colour on the surface of the painting give a sense of depth and warmth. His experiments with the new water soluble latex paints also give his work an impression of sublime levity and spontaneity. In his last paintings, he abandoned symmetry altogether.

BARNETT NEWMAN

1905-1970

Newman, together with Rothko, was one of the main exponents of colorfield painting. Colorfield painting emerged in the 1950s in reaction to abstract Expressionism. Newman painted very large-format works. Taking as his starting point the rectangular canvas, he divided the painting horizontally or vertically. Just as Motherwell was the intellectual amongst the abstract Expressionists, Newman was the scholar amongst the colorfield painters.

Schooled in the Jewish tradition of the Bible, the rabbinic teachings of the Talmud and the mystical teachings of the Kabbalah, he had painted works in the 1940s featuring magical signs inspired by the symbols of primitive cultures.

From 1948 onwards, however, he limited his expression to line and plane. For him, the line was the first creative act, the gesture with which God intervened in the great void and parted light and darkness. For Newman, the creative act was a repetition of the Creation. By limiting his form of expression to a few structuring lines on a large colour plane, he sought to banish the chaos of possible forms. For him, this pictorial structure was ordered truth, reflecting his attitude to the mysteries of life and death.

KENNETH NOLAND

*1924

Kenneth Noland was a member of the Washington Color School. Together with Morris Louis, he put Washington firmly on the map of the art world. Like Louis and Helen Frankenthaler, Noland colours the canvas. He uses colour to create an illusion of changing spatial impressions. He returns time and time again to a few basic forms, which he reiterates in different colours. In the past, these forms were mainly targets and V-motifs, later horizontal stripes. The square canvas of Ember is unprimed, so that the motif and its colours appears to float in a diffuse space. The simple form of concentric colour rings is the only subject matter of the painting. There is no philosophical metaphor behind it that might permit a subjective interpretation. Correspondingly, the title bears no relationship to the world beyond the painting itself.

In his art, Noland represents a new kind of abstraction that breaks away from the concept of the active artistic personality and the notion of an interaction between body, spirit and painting, so that it becomes more objectified. The restriction to a few emblematic forms and the rejection of all traces of the pictorial process create a cool sense of distance. The emergence of a new spirit of objectivity is evident.

Kenneth Noland Ember, 1960 Acrylic on canvas, 179 x 178 cm Private collection

ELLSWORTH KELLY

*1923

Intensifying perception through drastically reduced means has been Ellsworth Kelly's aim since his return to the USA in 1954, having studied the stringent compositions of the European Constructivists. Kelly uses pure colours, and tries to avoid all traces of the painter's hand on the surface of his paintings in order to create perfect pictorial objects. Whereas Kelly initially chose traditional rectangular frames at first, like Frank Stella, he began developing irregularly shaped canvases, and a large range of different carriers. The forms of his canvases were increasingly determined by the intensity of the colours, and the painting thus took on the characteristics of an object.

In *Red Blue* the combination of two triangles creates a fragile equilibrium. The new pictorial structure is an open parallelogram created by the juxtaposition of two coloured triangles. The different qualities of the two colours, their "temperatures" as it were, are linked with the alignment of the triangles. The quiet blue stands on its broad base like a pyramid; the aggressive red, by contrast, is a triangle standing on its point. Where the two colours meet without transition, there is a flickering that grants no respite to the eye of the spectator.

Ellsworth Kelly Red Blue, 1968 Oil on canvas, 228 x 244 cm Düsseldorf, Kunstsammlung Nordrhein-Westfalen

Jasper Johns Flag, 1954/55 Oil and collage on plywood, 107.3 x 153.8cm New York, The Museum of Modern Art

JASPER JOHNS

*1930

The American flag is one of the most frequently painted motifs in Johns' oeuvre. Using various techniques and materials, he seeks to retain a certain relationship to reality, but at the same time appeals to the viewer, catching his attention, perhaps disturbing him, and making him think. This is not a photographic portrayal, nor does it have the texture of real cloth.

Johns works entirely with the painterly means of abstract Expressionism, with paint applied in free gestures, leaving obvious traces of his work. Yet his subjects are as trivial as those of the Pop artists: in addition to the national flag, he has repeatedly painted numbers, targets and maps.

Johns chose to portray objects that seemed typical of everyday life, "things which are seen and not looked at" because they are so familiar and their aesthetic qualities so inconspicuous. "Using the design of the American flag took care of a great deal for me because I didn't have to design it." Johns believes that seeing familiar objects can prompt the viewer to explore their poetic qualities. There are a number of versions of the American flag, executed in a variety of formats and techniques. This re-

peated treatment of a simple pictorial pattern is not something Johns regards as monotonous. Instead, there is an aspect of Dadaistic irony behind it. Johns' use of encaustic wax technique is very rare today.

Johns' paintings in the early 1950s made him famous almost overnight; they were an important source of inspiration for the Pop artists. A motif from a prefigured repertoire of forms, a kind of symbol or emblem, calm instead of chaos - these were the things that fascinated him. His first alphabet paintings were created in 1956, and in 1959 he began painting numbers. In 1958, he created his first painted sculpture in bronze, and in 1960 he turned his attention to the serial production of lithographs. Johns himself finds everything he makes "pre-formed, depersonalized, conventional". His works remain impersonal, irrespective of what we might interpret into them. This stands in deliberate contrast to the process of creation and the end-products of the abstract Expressionists, who include the emotions and physical movements of the artists in their work. Many of Johns' newer paintings do not lack realism, but depth, and the traditional belief in the necessity of meaningful motifs is firmly negated. These paintings are an important preliminary step on the path towards minimal art.

From the mid 1970s on, Johns created works that might be described as purely abstract. This painting is created entirely from a single pattern of "cross-hatching" which Johns also used later in the background of two figurative paintings. According to the artist, "I was riding in a car... when a car came in the opposite direction. It was covered with these marks, but I only saw it for a moment - then it was gone - just a brief glimpse. But I immediately thought that I would use it for my next painting." Even if the patterns are based on a real source, this is no longer evident in the pattern repetition of the finished work. Johns refers to the Drip Paintings by Pollock. He tried to reiterate the overall compositions of the action painters in a less improvised and more controlled pattern on a similarly proportioned canvas.

The painting is divided into three, citing the traditional altarpiece form of European painting. The dividing lines have been subtly emphasized by Johns. At the point of transition from the left panel to the central panel, the direction of the cross-hatching changes, while the colours are retained. At the point of transition from the right panel, the direction of the lines is maintained, but the colours are changed. If we imagine the two outer edges of the left and right panels joining up, the crosshatching continues unbroken. The choice of colours is as carefully considered as the composition itself. Johns has painted on a black background in the three primary colours and their complementary colours.

Jasper Johns Untitled, 1980 Acrylic on plastic on canvas, 77.5 x 138.2 cm Private collection

FRANK STELLA

*1936

Whereas other artists pared down their paintings, increasingly freeing them from optical additions of all kinds, Stella's oeuvre developed in precisely the opposite direction. He invented the "shaped canvas" in which the outline of the canvas is adapted according to the composition of the painting and not, as traditionally, the painting composed into the limitations of the given canvas.

With his shaped canvas in the form of a V, an X or a circle, he fundamentally changed conventional concepts of composition and their relationship to the form of the canvas. Until the early 1970s, not only was the repertoire of his forms deliberately limited to a few repeated forms, but his colour scale was also purist.

In his painting Guadalupe Island he has made the move from sparse reductionism to lavish opulence. The painting is made up of a number of material components, all painted in the same way as the background. The brushstrokes and patterns are wholly abstract, comparable with the paintings of the abstract Expressionists. The colours are garish and loud, but the brushwork is gentle and there is no concentration in a single centre. Some of the component parts are cut out and superimposed over the background. As Stella himself said: "You can see the whole idea without confusion.

Frank Stella Guadalupe Island, Caracara, 1979 Mixed media and aluminium, 238 x 307.5 cm London, Tate Gallery

Yves Klein Monochrome Blue, Untitled (IKB 3), 1960 Sponges, pigment and resin on panel on canvas, 199 x 153 x 2.5 cm Paris, Musée National d'Art Moderne, Centre Georges Pompidou

Lucio Fontana Concetto spaziale, Attese (Spatial Concept), 1959 Water-based paint on canvas, 100 x 125 cm Milan, Fondazione Lucio Fontana

YVES KLEIN

1928-1962

In 1946, Yves Klein symbolically divided the world with his friends Arman and Claude Pascal: lying on the beach at Nice, looking up at the sky, he chose for himself the sky and its colour blue. From then on, blue was of central significance in his œuvre. The focus of his later painterly experiments was on the monochrome, and even though he later worked with other colours, including gold, blue continued to remain his preferred colour. In order to achieve the greatest possible intensity for his blue canvases, he applied pure, dry pigment onto the canvas which had been moistened with petroleum. He explored all the possibilities of blue tones until he finally found the luminous ultramarine that became his trademark IKB (international Klein Blue).

In 1957, in Milan, Klein announced the advent of the Blue Epoch. From then on, he created further monochromatic canvases, in IKB, some of which included dyed objects, such as sponges, which he regarded as relics of the real world. His blue canvases were intended to sensitize the viewer, giving a sense of the infinity of space and wide expanses, stimulating an experience of his own reality. Klein was an important pioneer of Concept Art.

LUCIO FONTANA

1899-1968

Lucio Fontana's paintings, which he himself described as "concetto spaziale" demonstrate just how far the boundaries of painting were rolled back after 1945. The classical concept of the painting had to be extended, for the canvas had by now become the bearer of a painterly message in only a restricted sense. We can hardly even use the word "painting" in its original sense. With the advent of abstraction, the canvas, which, for centuries, had been the material fundament for the painted illusion of reality, took on a new function as the background for signs both with and without meaning, for colours signifying only themselves, their coloristic qualities or their materiality.

Here, the canvas is so uniformly and evenly covered in luminous yellow that we cannot discern any brushstrokes, nor any signs of the act of painting, though we do recognize the rough structure of the canvas itself. A few bold, long slashes with a sharp knife have cut the surface; the traditionally hermetic picture plane has been given apertures. The edges of these abrupt incisions curve inwards, creating a spatial impression – not as a window on the world, but as a sparse and abstract spatiality.

VICTOR DE VASARÉLY

*1908

Vasarély's art is intended to have a positive impact on society. He is not interested in creating intellectually complex content, nor in producing entirely dysfunctional decoration. Gradually, he removed all anecdotal narrative from his work, replacing it with formal structures intended to appeal to the eye of the viewer through their impression alone. He developed a kind of modular system involving a repertoire of geometric forms and colours. With these fundamental prototypes, he experimented until he had worked out the "score" or basic pattern for a model. It can then be executed as a painting, as a panel, as a silk-screen print or as a multiple. The mass distribution of his works are intended to have a profound and far-reaching influence on our lives, and on urban planning, for Vasarély is particularly interested in having his optical creations included in the design of buildings and urban facilities, whose bleak monotony he attacks. According to Vasarély, people without a more profound knowledge perceive the rhythm of sound in exactly the same way as they perceive the rhythm of form and colour. With regard to his Op Art works, the artist believes it is extremely important for contemporary productions to be presented to a broad public so that they can train their eyes and their sensibilities. Arcturus II with its architectonic, square grids, is a typical example of Vasarély's Op Art.

FRIEDENSREICH HUNDERTWASSER

*1928

The spiral, in ever new variations, is one of the key motifs in the work of Hundertwasser (born Friedrich Stowasser). Here, it is set like a labyrinth against an almost square background with a blue core, transverse links and inserts on the left-hand side. Hundertwasser's art is based on Viennese Jugendstil, and would be unthinkable without such forerunners as Egon Schiele or Gustav Klimt. Although Hundertwasser takes abstraction a step further, he uses the same luminous and vibrant colours. Spiral and labyrinth are closely related in terms of symbolic content. In the work of Hundertwasser, universal and traditional symbolism are still closely linked with specific personal issues.

The Great Way is a self-contained image, in which the lines of the spiral can lead inwards to the centre, or outwards from the centre, on a path that does not lead to infinity, but to an outward point of rest. This creates a double possibility of exclusion or inclusion. In the spiral, there is at the same time the motif of a constant dynamic, an action that is always in motion and never static. Comparisons with plant forms spring to mind, or with the rings of a tree or with the skin and core of a fruit.

Victor de Vasarély Arcturus II, 1966 Oil on canvas, 160 x 159.7 cm Washington, Hirshhorn Museum and Sculpture Garden, Smithsonian Institution

Friedensreich Hundertwasser The Great Way, 1955 Polyvinyl on two joined strips of canvas primed with chalk and zinc white, 162 x 160 cm. Vienna, Österreichische Galerie

Richard Lindner The Meeting, 1953 Oil on canvas, 152.4 x 182.9cm New York, The Museum of Modern Art

RICHARD LINDNER

1901-1978

Lindner's painting *The Meeting* is one of his most important works. All the typical elements of his art can be found here. His creative oeuvre was invariably closely linked with his personal experience, his memories and his current situation. Throughout his life, Lindner's topics remained the same, though after his emigration they took on increasingly American features with some reminiscences of Europe. Lindner's figures and scenes are always set in a very flat space, whose volume is expressed in planes. He uses strong and often garish colours.

The figures in the painting are arranged in a strictly pyramidal structure and portayed in frontal, rear and profile views. In terms of content, they have no relationship to one another: the Bavarian fairy-tale king Ludwig II, the lady in the prim grey coat, the frivolous

red-head showing her leg, the old-fashioned couple in the sailor suit and *belle-époque* costume, the lady in the red evening dress, the casually dressed gentleman, the huge ginger cat and the woman in the tightly laced corset with suspenders, a cabinet of motley marionettes, full of ambiguous references, a meeting of past and present, dream and reality. It is this inner quality that sets Lindner's paintings apart from Pop Art. Here, we find cold scepticism clothed in the garb of the burlesque. Style and subject matter are congruent.

Lindner's planar pictorial zones are filled with bright and sometimes garish colours, the individual parts are clearly separated by sharp edges, with passages of blurred perspective. He models with the poster-like forms of clothing, shells, bodies, external appearances. His figures often possess erotic qualities expressed by such props as corsets, suspenders, high-heeled shoes and boots. His figures are standard types, strangers, spectators.

656 UNITED STATES

ROBERT RAUSCHENBERG

*1925

Having started out by painting in the manner of the abstract Expressionists, Rauschenberg arrived at his own new pictorial concept in the early 1950s. *Charlene* is typical of the so-called Junk Art he produced for two decades. Pure painting is no longer the foremost consideration. Instead, objects and fragments have been included in the pictorial surface, some of them left as they were found, some of them reworked with paint. Purely painterly passages in the forceful, spontaneous style of action painting fill the interim spaces.

The technique of these works is similar to the collages of the Cubists and Surrealists, but the lyrical aesthetic appeal and the distinct element of surprise inherent in the collages and paintings of Georges Braque, Pablo Picasso and Kurt Schwitters take on a different aspect in Junk Art. After all, these are objects drawn from the garbage heap of the affluent society and, instead of lyricism or poetry, they exude a raw, banale realism that is further heightened by the rough brushstrokes over or between them. The discarded and the worthless is thus elevated to a higher plane by its integration into a work of art. At the same time, this act calls into question the aesthetic standards of today's mass culture and consumer society.

Like Jasper Johns, who is a close friend of his, Rauschenberg adopted the large-scale canvases and brushwork of the abstract Expressionists. By addressing banal everyday subjects, they guided art in a new direction. Both these artists are regarded as mediators on the way to Pop Art.

Robert Rauschenberg Charlene, 1954 Collage, 225 x 320cm Amsterdam, Stedelijk Museum

The title Trophy I may be regarded both ironically and as a laconic narrative. The trophy in question consists of the waste of our consumer society. The found objects of mass production, having reached the end of their brief life-cycle and having ended up on the garbage heap, are collected by Rauschenberg. Integrated into what he describes as his combine painting, they are transformed into artistic objects. Trophy I may be the house-altar, the collecting cabinet of a naive and unthinking consumer who has not had the fortune to live in more noble spheres; for him, the found items are valued as reminiscences. At the same time, the painting can also call into question contemporary lifestyles and the medium of contemporary

Rauschenberg's fellow artist Allan Kaprow called for artists to deliberately dispense with craftsmanship and permanence and to turn instead to distinctly perishable media such as newspaper, string, adhesive tape, grass and real foodstuffs so that there could be no doubt whatsoever, right from the start, that the work would soon become garbage or dust. The ideas of Junk Art were adopted by many other artists.

Robert Rauschenberg Trophy I, 1959 Combine Painting, 168 x 104 cm Zurich, Kunsthaus Zürich

UNITED STATES 657

Andy Warhol 200 Campbell's Soup Cans, 1962 Oil on canvas, 183 x 254cm Private collection

Andy Warhol
Do it yourself – Landscape,
1962
Acrylic on canvas,
178 x 137 cm
Cologne, Museum Ludwig

ANDY WARHOL

1928-1987

When Warhol began putting Jacqueline Kennedy and Marilyn Monroe onto the canvas in silk-screen prints, creating entire series of these pictures, painting entered realms that had certainly never before been associated with painting. Warhol's pictures have nothing whatsoever to do with painting in the classical sense. He deliberately depersonalized the art work, and in all his portrait series the origins of the image in a commercial print and the technical process of production are clearly evident.

Warhol has portrayed the famous face of Marilyn Monroe against a blue background. This picture is based on a photograph which has been enlarged and silk-screened onto the canvas. Warhol often left the actual printing and colouring of his pictures to his assistants, thereby negating the identity of the person portrayed as well as the individuality of the artist who designed and executed the art work. Long before Warhol adopted her image as a motif, Marilyn Monroe was already an idol. Warhol's presentation of the isolated, enlarged individual image underlines this status. In a sequence of several different work processes, the photo was reproduced by superimposing monochrome silk-screens in different colours. This has in no way detracted from Monroe's appeal: the blonde hair, the sensually painted lips, the eye-shadowed lids veiling an enigmatic gaze, and the arch of the eyebrows.

In other motifs, such as the soup cans, the same picture is repeated in series, with variations only in the lettering of the label. Here, advertising becomes Pop Art and the image is at the same time an indication of the mechanization and dehumanization of modern society with its alienation and boredom.

While gourmets may turn up their noses at the very idea of opening a can of soup, here we find two hundred of them stacked up. They are the stars of the supermarkets. In the iconography of Pop Art, they take up the same position that was once held by Chinese vases, Venetian glasses, oysters or lemons in early still lifes. The two hundred soup cans create a contemporary still life. Here, Warhol has taken a do-it-yourself, painting-by-numbers picture as his motif.

The very idea of do-it-yourself hardly sounds like high culture; after all, the pattern, the material and the instructions are all supplied so that all you have to do is apply the right colour to the area labelled accordingly. It is a more or less foolproof method. The finished painting then exists in countless copies, decorating the walls of countless homes. This prefabricated art prompted Warhol to make an ironic comment on the fundamental principles of his own production process. Warhol intended to use industrially produced pictorial series to call into question the classical notion of originality.

It was only logical that Warhol should have named the loft where he produced his images of the consumer society and the glamour world, The Factory. In a bid to compete with Picasso's legendary prolific output, Warhol employed a number of assistants who helped him to create his silk-screen prints. Within six months, from August to the end of 1962, some 2,000 pictures were produced.

Warhol also produced underground films at The Factory with the many friends and fans who lived with him there. The topics of these films were generally trivial, showing people going about their daily life, sleeping

or smoking a cigar. His eight-hour film *Empire* shows the Empire State Building in the course of the day from a static camera viewpoint. True to the maxim that every individual could be famous, Warhol described his actors as superstars, caricaturing the myth-machine of Hollywood. When the films approached the conventional narrative structures they had some commercial success. Warhol, the self-styled universal genius, geared his life entirely to the principles of pop stardom.

Andy Warhol Marilyn, 1964 Silk-screen, ink and acrylic on canvas, 101.5 x 101.5 cm Private collection

UNITED STATES 659

Jim Dine Cardinal, 1976 Mixed media on canvas, 274.3 x 182.8cm New York, Pace Gallery

Robert Indiana The American Dream, I, 1961 Oil on canvas, 183 x 152.7 cm New York, The Museum of Modern Art

JIM DINE

*1935

Jim Dine has explored the motif of the coat in various versions, techniques and materials, ranging from silk-screen print to combine painting (a painting involving the montage of materials). The item is invariably some kind of bathrobe in the posture of the person who would be wearing it.

Cardinal is a brilliant red bathrobe with a shawl collar and belt, painted in an extremely sculptural, corporeal way on a dark background through which lighter patches shimmer. The arms akimbo recalling the bathrobe's wearer, hands comfortably in the pockets, give the picture a direct vitality that is surprisingly cancelled by the lack of a head. The impression of immediacy is heightened by the painterly approach: many layers, some superimposed, add light and fluctuating motion to the picture.

In a variety of techniques which he explored in his motifs, Dine also saw an opportunity for self-exploration. Constantly reiterated motifs in his art, such as tools, hearts, palettes and coats, have a personal significance for him. For Dine, these headless bathrobes embody the person who is meant to be wearing them. Sometimes it is a self-portrait, but here it is a cardinal, symbolically expressed by the colour red.

ROBERT INDIANA

*1928

The American Dream is the dream of fairy-tale wealth and freedom: everybody can take their chance. Yet the American dream has come true only for a few. Like many Pop artists, Indiana gleans his motifs from the immediate daily environment of those consumers and citizens for whom the American dream has not brought the splendid isolation of a world full of unique luxury goods. His planar codes and emblems are taken from the daily iconography of a trivial sphere. These four discs are taken from the world of the gambling casino, inspired by one-armed-bandits and targets.

Indiana chooses large formats to lend his colour panels, full of signs, numbers and slogans, the impact of posters. In this lettered painting, he deliberately chooses pre-existing signs, and his own creative contribution is restricted to the arrangement, the combination and the choice of colour.

In contrast to early Dadaist play with typography, Robert Indiana's *American Dream* has a significance, a deeper meaning, almost an ambiguity. The slogans TAKE ALL and TILT, the many stars and the promise of The American Dream may be taken literally as goals that can be achieved only in a game.

TOM WESSELMANN

*1931

A bathroom setting undoubtedly lends itself to the portrayal of a female nude. Painted panels and real objects have been juxtaposed here in a huge assemblage. This is not an environment the spectator can enter, but a pictorial object to be viewed frontally.

In *Bathtub III* we see a naked, pale-skinned woman in a bathtub. She is drying her back with a red and white striped towel. Her femininity is underlined by the emphasis on her lips, blonde hair, red fingernails, navel, nipples and pubic hair. Her slender figure is painted in a flat, poster-like way. The image of the woman is degraded to a faceless cliché. The blue bathtub in which she is standing, the dark-blue tiled wall of the niche and the yolk-yellow wall

bordered by a blue stripe are all painted. These painted panels are given an unexpected element of reality by the juxtaposition of objects that turn the painting into an assemblage. In the perspectivally painted niche, a shower rail has been fitted above the bathtub, from which a red shower curtain is hanging. In front of the bathtub, a blue synthetic bath mat has been placed, next to which stands a blue laundry basket. A real white door concludes the righthand side of the object, with a door handle and a towel rail on which a bath towel is hanging. The curtain is in the tradition of European painterly motifs. Yet the intimacy of the nude is completely offset by the functionality of the ambient surroundings and trivialized by the act of drying.

Tom Wesselmann

Bathtub 3, 1963

Oil on canvas, plastic and various objects (Bathroom door, towel and laundry basket), 213 x 270 x 45 cm Cologne, Museum Ludwig

UNITED STATES 661

Roy Lichtenstein M-Maybe (A Girl's Picture), 1965 Magna on canvas, 152 x 152 cm Cologne, Museum Ludwig

ROY LICHTENSTEIN

*1923

Lichtenstein is one of the key figures of American Pop Art. He took the motif for this picture from a comic, magnifying one frame enormously onto the canvas. In doing so, he creates an outline drawing of his chosen motif, projects it through an episcope onto the canvas and fixes it there with the brush. Using stencils, he then grids individual areas or the entire painting using what is known as the benday process.

Finally, he applies the colour, concluding with the black outlines. He uses only primary colours. Because they are easily soluble in turpentine, he uses magna-acrylic paints. Because these paints leave no traces on the background when they are removed, they permit corrections to be made easily. Like other Pop artists, he uses motifs with which everyone is familiar, and also cites the old masters or Japanese woodcuts. In this respect, Lichtenstein aims at an audience that will recognize his quotes and understand the irony in his work. He has reached the threshold at which Pop Art becomes intellectual.

JAMES ROSENQUIST

*1933

Marilyn Monroe is the prototype of the famous film star. During the Vietnam war, she was the pin-up in every GI's locker, but with the advent of Pop Art, her image graced the walls of museums. Rosenquist created a simultaneous collage with the face of Marilyn Monroe; her smiling mouth and her eye are blended over and alienated by lettering from the advertisement. The individual parts of the picture are placed at different angles and are intercon-

Before Rosenquist turned to art, he had been a painter of billboards. While he was working on a huge advertising image, he suddenly realized how much the effect of an image changes when seen close up. Deeply impressed by the constant impact of advertising on the citizens of the consumer society, he sought to use the persuasive powers of these billboards and their visual language for his art. A preference for oversized formats and poster-like painting became his hallmark. He used all the available reproduction procedures and every possible technical aid. Rosenquist considered other kinds of painting to be outmoded and lacking in impact. Behind these apparently superficial aspects lies a distinctly critical approach.

James Rosenquist Marilyn Monroe, I, 1962 Oil and spray enamel on canvas, 236.2 x 183.5 cm New York, The Museum of Modern Art, Collection Sidney and Harriet Janis

RONALD B. KITAJ

*1932

Kitaj is regarded as one of the mediators between American and English Pop Art, since arriving in London on a scholarship in 1958 and staying there. He soon joined the group of artists gathered around the Institute for Contemporary Art and familiarized them with developments in America. However, as he himself tended to draw his motifs primarily from philosophy and cultural history rather than from the trivial myths of everyday life, he soon began to distance himself increasingly from Pop Art during the early 60s.

Kitaj presents his critical social stance in Value, Price and Profit. The three mainstays of capitalism are transposed as in a collage onto the golden-yellow surface of the picture, true to the maxim that a painting can only be the surface for the projection of events in the world. The three figures have been made up of fragments taken from different contexts; we recognize parts of photographs and drawings, monochrome colour areas and ornaments that may be part of a wallpaper pattern. The foolish facial expression on each of the three figures also suggests that Kitaj does not hold any of the concepts mentioned in his title in particularly high esteem. For him, they are mere formula, which cannot mediate any actual content.

Ronald B. Kitaj Value, Price and Profit, 1963 Oil on canvas, 153 x 153 cm Private collection

Below: Allen Jones Man Woman, 1963 Oil on canvas, 214.6 x 188.5 cm London, Tate Gallery

PETER BLAKE

*1932

Together with Hamilton, Blake was one of the first to use the motifs and techniques that were to shape English Pop Art. The style, reminiscent of advertising graphics, and the choice of daily mythologies as a pictorial motif are the hallmarks of Pop Art. In spite of all the innovation, however, Blake also retained certain painterly elements.

The 1950s and 1960s were the heyday of rock 'n' roll bands and stars. *Bo Diddley* was a hit for Elias McDaniel, who adopted the title of his smash hit as his stage name.

The painting is composed in the manner of a poster, with a bright red edge and garish yellow lettering. The contours of the guitar and the blue outline of the legs light up like thin neon striplights, the instrument and the legs are flat, as though they had been cut out. The shimmering Havanna brown of the background has a subtle, painterly quality. The body language of the singer is vivaciously lively. His facial expression reflects his total devotion to music, and might even be described as a physiognomic study. Bo Diddley is more than just a poster: it is the individual portrait of the singer at his work. In other paintings, Blake projects a critical, detached attitude and an almost ironic approach to the material.

ALLEN JONES

*1937

Jones' motifs almost invariably address erotic themes. Within this genre, he always remains on a very direct and even drastic level, although he varies his motifs and works in different techniques. Jones is one of the most significant representatives of English Pop Art of the 1960s. This explains certain basic elements in his choice, composition and statement of motifs. Eroticism is not seen here as the sophisticated fulfilment of an individual life, but is degraded to mere sex - just another consumer article amongst many. Like everything that can be consumed, even sex has taken on its own symbols and clichés in the simplified yet highly effective visual language of advertising and mass media.

In Man Woman Jones echoes this cliché. A long, female leg, stockinged and high-heeled, the hint of a skirt that has ridden up, a tie, part of a man's suit, headless and so flat that it seems bodiless; all these features conjure up an unequivocal situation. There is something banale and vulgar about the entire scene, but it is not without humour. Although Jones uses simple visual means, the painterly execution of the picture prevents a sense of embarrassment in the face of such an intimate presence.

RICHARD HAMILTON

*1922

From the beginning of his artistic career in the 1950s, Richard Hamilton used technical achievements in the field of visual arts. Photographs are a fundamental and important element in many of his works. Hamilton ranks amongst the leading representatives of English Pop Art. The special visual language of the media and advertising is attacked in his work, and he rails against the banal and trivial existence of the masses. His artistic statements on the spirit of the times are aimed at an audience beyond the already interested group of specialists.

On some universal beach, seen from a distant standpoint, bathers swarm like ants. The picture has been created on the basis of a postcard, sprayed over and transposed to the canvas in a complicated reproduction process. In doing so, the documentary aspect of the picture is called into question. The garish bathing accessories, a bathing-cap and a piece of flowered fabric that seem all the more garish set against the dreary colours of the actual bathing-scene, remind us of the business of pleasure and leisure that has taken on ever increasing dimensions in the world of mass tourism. Everyday images and objects, combined anew, add an absurd accent to the apparently normal.

Richard Hamilton Bathers I, 1966/67 Photo on canvas, bathing-cap and textile, 84 x 117 cm. Cologne, Museum Ludwig

DAVID HOCKNEY

*1937

The English painter David Hockney is fascinated by California. Time and time again he draws his motifs from this American coastal state. Where California is densely populated, landscape and nature become little more than a backdrop of secondary importance, destroyed by far-reaching interventions. Streets, architectural complexes and leisure areas predominate, imposed on the environment by man's unceasing need to make his mark. The epitome of Californian lifestyle and comfort is the bungalow with swimming-pool.

A flat-roofed bungalow with a glass wall, in which the buildings and palm trees opposite are mirrored, a long strip of patio, in front of which is a large swimming-pool, all set against the lucid background of a cloudless blue sky. Someone has just dived into the pool from the springboard in the foreground right; all we see is the spray of water. The chair in front of the house in empty: splendid isolation. An atmosphere of traumatic calm and unreality is briefly interrupted by the splash. The sense of cool artificiality is heightened by the static, planar, horizontal and vertical composition and by the powdery pale, subtle colours. The small strip of grass and the palm trees have remained as codes for nature.

David Hockney A Bigger Splash, 1967 Acrylic on canvas, 243.8 x 243.8 cm London, Tate Gallery

Richard Estes
Candy Store, 1969
Oil on canvas, 121.3 x 174cm
New York, Whitney Museum of American Art

Chuck Close Linda, 1975/76 Acrylic on canvas, 274.3 x 213.4cm Akron (OH), Akron Arr Museum

RICHARD ESTES

*1936

Estes adopts spontaneous situations in modern cities which, completely devoid of human presence, take on an aura of chill isolation. The glass window-front of a coffee-shop, with a view through the entrance door into the interior and the huge display window, is the trivial subject of this painting. Nuts and candies, presented on several layers, have been displayed in the window as a "picture within a picture" set behind glass in a metal frame, illuminated by neon strip-lighting. It is a confusing play of mirroring and reflections from the interior and from the opposite side of the street that ironically adds a touch of life to this huge, unpeopled still life.

The painting presents the spectral presence of a highly civilized subculture that pays homage to the fetish of consumption, viewed from a safe distance as though through a glass darkly. This kind of painting plays on the perceptions and observations of the viewer. It heightens the motifs, charging them with tension, filling them with light and shadow, reflections, mirroring, prismatic refraction and lending them an intensity that would never actually be found in such concentrated form in the real world. Throughout the painting, we find visual tension and overlapping levels of reality that arrest the viewer's gaze and provoke reflection on the situation.

CHUCK CLOSE

*1940

Chuck Close drew the attention of the critics for the first time in 1967 with his large, realistic black and white paintings: frontal portrayals of heads, like a kind of oversized passport photo, in the form of a painting on canvas. Though he remained true to his subject, he soon went on to paint in colour. Linda is staring directly at the viewer, as though into the lens of a photo booth, which coldly reproduces the facial traits, curly hair, lines and freckles, and the collar and shoulders of the dress. Although the painting is in colour, it does not seem realistic. Its photographic realism lies in the reiteration of the reddishbrown tone so frequently found in photos that are developed by automatic processes.

Close's paintings are created according to a grid system by which he divides a photo into zones of light and shade and then transposes the grid onto the canvas. He applies the paints by hand, but adds blue, yellow and red layers over his backgrounds as in a technical printing process. Close's paintings are related both to Pop Art and to Photo-Realism. His interest lies, as he claims himself, in not painting in a certain style. The technical process of painting and the photographic motif also place his work close to the field of minimal

666 UNITED STATES

FRANZ GERTSCH

*1930

The art created by Gertsch is often described as Hyper-Realism or Photo-Realism; in Europe. He is one of the best-known and most consistent representatives of this style. The monumental painting Medici shows a group of casually dressed young people standing behind a red and white wooden barrier. The title, reminiscent of the former, powerful Tuscan dynasty, merely refers to the word that can be read on the white stripe of the painted barrier.

Although Gertsch works with slides, his paintings are not simply photographs transposed to the canvas. Even at the moment of photographing, he consciously chooses the motif, the detail and the lighting. When he transposes his hugely enlarged projections onto the canvas, he remains true to the original in terms of pictorial composition, but he also undertakes some major changes. The viewer is likely to notice these changes only after lengthy observation, and the painting thus takes on the signum of an original and an almost shocking proximity: emphasis or transfiguration of colority and brushwork can vary the intensity of the painting, and in its extreme close-up view it seems to penetrate into the real space beyond the frame.

Franz Gertsch Medici, 1971 Dispersionsfarbe on canvas, 400 x 600 cm Aachen, Ludwig Forum

ARNULF RAINER

*1929

As early as 1951, Rainer turned his back on the fantastic realism of his early years. He was more interested in the painterly process of the composition of paintings and the potential for formal destruction. From 1952 onwards, he explored so-called "centralizations" and "central compositions"; in these compositions, the line is the point of departure. The paintings are an expressive accumulation of arbitrary strokes. One year later, he began photographing himself and then painting over these photos. Overpainting is a focal point in Rainer's works.

From 1969 onwards, Rainer began exploring the question of body language. During this period, his first "grimacing" photos were created, and accentuated by overpainting. Ziinglein ohne Waage is one of a series of heavily reworked grimacing photos, and its strangely punning title (paraphrasing the German saying "Zünglein an der Waage" which means "the little tongue that tips the scales" in the sense of "holding the balance of power") places it close to the world of Surrealist art. All that is left of the photo is the face in soft focus. All the other parts have been aggressively overpainted, and the paint is dripping down the canvas. Rainer also seeks inspiration in hallucinatory mind-altering substances, and in art created by the mentally ill.

Arnulf Rainer Zünglein ohne Waage (Tongue that tips no scales), 1975 Oil on photo on panel, 44.5 x 60.5 cm Private collection

SWITZERLAND/AUSTRIA

Balthus
The Artist and his Model, 1980/81
Oil on canvas, 227 x 235 cm
Paris, Musée d'Art Moderne, Centre Georges Pompidou

Fernando Botero The Family of the President, 1967 Oil on canvas, 203.2 x 195.5 cm New York, The Museum of Modern Art

BALTHUS

*1908

This painting by Balthus, whose full name is Balthasar Klossowski de Rola, is a late work of great maturity and serenity. Even in his twenties, the artist had created images of enormous intensity which he continued to use and perfect. In some of his landscapes and portraits, this purely artistic mastery appears to be predominant in the subtle handling of colour and light and in the reduction of forms heightened by colour structuring. Most of his paintings, however, especially those featuring his key motif - the young girl approaching womanhood - but also some of his street scenes, still lifes and portraits, have a distinctly erotic tension. In the paintings of Caravaggio, for example, Balthus saw the arousal of desire and latent violence as a metamorphosis of Eros.

This mood is now sublimated in an atmosphere whose tension is transposed to the realms of the enigmatic and allegorical. The model no longer beguiles with her maturing charms, and does not arouse any corrupting impulses. With the countenance of a Renaissance madonna, the girl is completely immersed in her reading. The painter, with his back to her, is contemplative and moderate.

FERNANDO BOTERO

*1932

In a freely paraphrased version of Francisco de Goya's painting *The Family of Charles IV* of 1800 (ill. p. 400) showing all the members of the ruling house of Bourbon on a large, broad canvas, Botero has created his *Family of the President*. Goya's painting is far more than just a group portrait. It is a shocking indictment of the social mores of the day, critical and ironic to the point of mordant sarcasm, due to the sheer technical brilliance of his realism. Like the incorruptible eye of the camera, which neither flatters nor omits, Goya uses a fine brush to present all the figures as they really are.

Unlike Goya, Botero's Family of the President is not intended as a portrait. It could be the presidential family of any country. Yet criticism, irony and sarcasm are evidently directed at these powerful representatives who have taken the place of former monarchs with similar powers and aims. Botero uses his own methods to portray this. His stylistic means of alienation of blowing up all the figures and objects gives them a doll-like stiffness, and an exaggerated presence. The bishop and the saluting dictator or general are revealed as parasites like the others in the painting. They have their tasks and pursue them entirely for their own ends.

668 FRANCE/COLOMBIA

WERNER TÜBKE

*1929

One of the ideals that Tübke sought to express in his art is the dignity of humankind. This theme was addressed by the Renaissance philosopher Pico della Mirandola in a text that remains valid today. Tübke is not only interested in the spiritual approach of this great era; his painting is also oriented towards the masters of the past: Mantegna, Titian, Veronese, Caravaggio, van Eyck, Bruegel, Bosch, Dürer, Cranach and Grünewald. He has painted the Livestock Brigadier Bodlenkov - a man who has earned his laurels for a socialist planned economy and is therefore deserving of a portrait, even of a museum place, just as an Old Master would have painted him.

This hero of the people sits in the saddle like a condottiere, on a horse that might have been painted by the brush of Verrocchio, surrounded by dogs that could be taken from the ceremonial procession of some Burgundian duke, and set against a meticulously painted background landscape filled with details. stretching into the far distance, reminiscent of a universal landscape of the 16th century. Tübke has said of himself that he has no sense of historical distance and that he means to "bring periods of art history to life productively and realitically". An important aspect of his art is therefore the exemplary presentation of active persons faced with a difficult fate.

Werner Tübke Portrait of the Libvestock Brigadier Bodlenkov, 1962 Mixed media on canvas on panel, 145.5 x 97 cm Leipzig, Museum der bildenden Künste

BERNHARD HEISIG

*1925

Heisig's major influences are Beckmann, Dix, Corinth, Kokoschka and Picasso, who, in parts of their oeuvre, accusingly present the horrors of this world. Heisig's figures are deformed, disfigured, injured, like all the objects in his paintings. His imagery is provocative, strident, brash.

Even paintings with a non-political content - portraits, nudes, landscapes - betray his awareness of a fragmented world. Heisig's painterly technique, like his colours and his symbolism, is accordingly expressive. He paints the same scenes over and over again, lending them a new form according to the insights gained from new angles. He often returns to work on paintings he had already considered finished.

The motif from Goethe's poem Der Zauberlehrling (The Sorcerer's Apprentice) was already familiar as a parable in the days of classical Antiquity and was handed down by Lucian. Heisig's Zauberlehrling, however, unlike the figure in Goethe's poem, cannot expect his antics to end well. Here, we see the tragic point of the poem: "The spirits I invoked ... "They are the evil spirits of war, of terror, fascism and violence. Even the most powerful master cannot undo what has been done.

Bernhard Heisig The Sorcerer's Apprentice (second version), 1978-1981 Oil on canvas, 150 x 200 cm Private collection

GERMANY

Renato Guttuso Wall of News – May 1968, 1968 Oil on cardboard on canvas, 280 x 480 cm Aachen, Ludwig Forum

Mimmo Paladino Ronda Notturna (Nightwatch), 1982 Oil on canvas, 300 x 400cm Munich, Städtische Galerie im Lenbachhaus

RENATO GUTTUSO

1912-1987

Long before he began to paint (1931) Guttuso was a convinced socialist. In his painting, he returned time and time again to such bold themes as fascism, war and the power of the church. Trained by the Futuristic artist Pippo Rizzo, he has adopted several stylistic ways of expressing his ideas. His early work leans heavily on Futurism and Cubism, later turning to a more expressive imagery.

For his *Wall of News – May 1968* he has chosen as his basis a collection of realistic motifs, that are reduced to poster-like symbols and arranged in a dynamically charged composition. The signs of inexorable power are glass skyscrapers, wrecked cars, furniture and machine parts scattered across the painting. It is the flotsam and jetsam of Western civilization. At the bottom of the picture, we see a group of armed police moving in closed ranks, brandishing their riot shields against a group of demonstrators. Below them is the caricature of a status symbol, a white sportscar, next to which we see a procession bearing red flags.

In the upper part of the picture, we see the horrors of Vietnam and the violence of whites against blacks. These are the events of 1968 evoked by Guttuso in this socially committed painting.

MIMMO PALADINO

*1948

Paladino's oeuvre contains a wide range of expressive possibilities, uniting apparently contradictory elements. His paintings are abstract and figurative at the same time, pure paintings as well as assemblages with relievo character and three-dimensionality, what should really be described as sculptures.

The title of his monumental painting *Nightwatch* is a more or less coincidental reference to Rembrandt's famous painting in the Rijksmuseum, Amsterdam (ill. p. 313). Paladino's *Ronda notturna* is not quite as easily legible as the Dutch painting of three centuries before, for its iconography is not subject to any convention. He invents codes, figures and action according to his own subjective concept.

Paladino applies a number of different spatial interpretations in this painting. The stylized couple in the pale, tent-like structure is keeping watch to ensure that the perils and spirits of the night do not gain the upper hand. The larger part of the painting is filled with flat, dislocated, weightlessly hovering bodies and fantastic creatures, patterns and symbols. These are stylized references to the real world in which we can detect certain parallels with Ottonian and Romanesque art.

ENZO CUCCHI

*1949

The hero has no face. The blood-red head with the red, swollen lips, has slipped down between his legs. He has raised his hands towards the black and flaming sky in a gesture of impotence, despair and accusation, like the praying gesture of classical Antiquity. Like Moses parting the waters of the Red Sea, he is himself caught between two threateningly close, high walls, one fiery yellow and red, the other gloomy black. He seems to have no influence or power over these forces, and is at the mercy of their inherent threat.

Cucchi, like Paladino and Clemente, has returned to the traditional medium of painting. Colour is used in an expressive, gestural painting as a material and colouristic element of strongly symbolic power. Layers of colour of enormous force, rough forms and emotionally charged simplicity give this picture its highly expressive syntax.

Cucchi's paintings are a reaction to the art forms of the 1960s and early 1970s which formed the basis on which a young generation of painters was able to build their work, albeit using their own forms of subjective and forcefully expressive visual language. His motifs explore personal feelings of threat, angst and aggression directed against the impotence of the individual.

Enzo Cucchi Headless Hero, 1981/82 Oil on canvas, 203 x 255 cm Private collection

FRANCESCO CLEMENTE

*1952

Together with Mimmo Paladino, Enzo Cucchi and Sandro Chia, Clemente is one of the main representatives of new Italian painting. It is new in the sense that it has broken away from familiar directions such as politically committed painting or arte povera, and places more emphasis on the personality of the painter. The images speak eloquently for themselves.

The huge head in Clemente's painting conceals something mysterious. In the orifices eyes, nose, ears and gaping mouth - we see chalk-white heads with fiery red lips. Heads within a head: the interpretation of this symbolism is left entirely to the spectator. The physical act of painting is not negated in the image; the rough and heavy brushwork is clearly evident, lending the composition its dramatic vitality. The view through the train window towards a green strip of landscape with a blue sky and the yellow interior with pillar, is reminiscent of Surrealist associations.

This painting does not attempt to create any connection with reality, but mirrors the inner realities of the painter, his states of mind, visions and imaginings. In formal terms, it tends towards expressive painting. The artist has deliberately eschewed carefully ordered brushwork and draughtsmanship.

Francesco Clemente Untitled, 1983 Oil and wax on canvas, 200 x 236cm Private collection

Konrad Klapheck The Mother's Prayers, 1984 Oil on canvas, 120 x 100 cm Private collection

Sigmar Polke Remingtons Museums-Traum ist des Besuchers Schaum, 1979 Oil and spray technique, stencils, on pink synthetic fur, 212 x 135.5cm Bonn, Städtisches Kunstmuseum

KONRAD KLAPHECK

*1935

Even as a student at the Düsseldorf art academy, Klapheck arrived at the themes and form of presentation so typical of his work and to which he has remained true until today. At the time, he saw his painting as an antithesis to the prevailing informel. Time and time again, he chooses to paint machinery and technical objects, smoothly schematized, and stylized into monuments. A relatively limited repertoire of everyday objects takes on an independent and almost symbolic statement in Klapheck's visual world. Liberated from their functionality and the cycle of use, in brilliantly sober portraiture, generally filling the entire picture space, and presented in close-up to the viewer, they take on a challenging and at times almost threatening presence.

Klapheck sees certain human aspects embodied in this material world: standardized types, male and female, typical situations and behaviour patterns. His titles trigger distinct associations and their subtly ironic references are also reminiscent of Marcel Duchamp and the Surrealists. Klapheck's lovingly lyrical view of these products from the lower spheres of technical banality links him with the magic realism of the 1920s.

SIGMAR POLKE

*1941

The title sounds like an advertising slogan. In German, it not only rhymes ("Traum" = "dream" with "Schaum" = "foam") but also presents a pun on the word "Schaum" which can means either "foam" in the literal sense or "hot air" in the sense of meaningless hype.

The sharp wit of the title indicates how it is to be interpreted. We see the outlines of two male heads, taken from a shaving cream advertisement, transposed as stencils onto a background of pink synthetic fur. Yellow, red, green and white patches of colour, drips and daubs, have been integrated energetically and irreverently into this strange ensemble.

In 1963, together with Gerhard Richter and Konrad Fischer, Polke founded the group Capitalist Realism, whose exhibition Leben mit Pop (Living with Pop) in a Düsseldorf furniture store called into question the mechanisms with which consumer society manipulates the individual. Polke continued to explore these themes in his later works. All his paintings and assemblages address the effects of the pseudo-comforts provided by mass production. With mordant irony, he confronts the viewer with the worst products of mass design kitsch, adopting synthetic fur, printed plastic film and patterned fabrics as his backgrounds. The contrast between these trivial materials and the motifs, gestures and slogans he presents on them, are invariably intended to create a shock effect.

GERHARD RICHTER

*1932

In the early 1960s, around the same time as the American Pop artists, Gerhard Richter was painting images from illustrated magazines: grey in grey, slightly blurred, he transposed these images to the canvas. He was interested in gaining the pictorial worlds of the mass media for art. However, unlike his American contemporaries, he was interested less in such phenomena as star cult or sensationalism as in the banality to which the media reduce images of all kinds. He wanted to transfer the neutrality and indifference reflected in the media onto his oil-paintings. Often, he would also adopt the captions from the illustrated magazines in order to make the original context clear.

Later, Richter also sought to apply this principle of transposal to paintings created according to other models. In this way, he also created paintings based on private family snapshots or the sample charts of the paint industry. His Mountains (Himalaya) raises the question of the character of images and their relation to reality with direct reference to the medium of oil-painting. The image of nature is transformed in painting, for on closer inspection of this large canvas, the areas of rock and snow dissolve into fields of black, white or grey that might just as well be abstract.

Richter works in series, returning time and time again to the same motifs, which he often repeats. In addition to a series of monochromatic grey paintings, he has also created a large cycle of generally large-scale paintings with some resemblance to the expressive gestural painting of the post-war years. These neo-abstract paintings are executed in garish acrylic paints. The abstract imagery regarded in the 1950s as the expression of artistic personality is now used by Richter to create coldly calculated effects, as he explains himself: "The overall effect then looks very spontaneous. However, there are generally lengthy periods in-between that destroy an atmosphere. It is a very carefully planned spontaneity." Richter exploits all the potential and possibilities of paint - from fine brushstroke to sprayed-on colour or paint smeared with a cloth and even raked - in order to create highlights of enormous subtlety that defy reproduction.

It took a relatively long time for Gerhard Richter to achieve international recognition. In the USA, especially, his work met with incomprehension. The constant change of motif and working techniques created a climate of insecurity that has been allayed by the major retrospective exhibitions of recent years. Today, the question of image and reproduction, reality and portrayal, addressed in all his series, is more clearly evident.

Gerhard Richter Mountains (Himalaya), 1968 Oil on canvas. 199.5 x 159.5 cm Private collection

Gerhard Richter Untitled, 1984 Oil on canvas, 200.7 x 160.3 cm Private collection

GERMANY

Markus Lüpertz Babylon-dithyrambic VI, 1975 Distemper on canvas, 162 x 130 cm Galerie Michael Werner, Cologne and New York

A. R. Penck The Birth of Mike Hammer, 1974 Acrylic on canvas, 285 x 285 cm. Basle, Öffentliche Kunstsammlung Basel, Museum für Gegenwartskunst

MARKUS LÜPERTZ

*1941

Together with Georg Baselitz and Jörg Immendorf, Markus Lüpertz ranks as one of the "new masters" of German painting, who studiously copies the approach of such 19th century artists as Makart and Lenbach. Apart from an almost imperial and thoroughly choreographed public projection, this involves the creation of large-scale paintings in which highly significant gestures indicate momentous phenomena. Babylon-dithyrambic VI is one of a series of works all bearing the same title, with which Lüpertz concluded his phase of dithyrambic paintings between 1963 and 1976. The choice of title indicates his painterly approach, evoking a Nietzschean reference and thematizing the sacrifical ode to the god Dio-

All the paintings of this period feature voluminous, sculptural objects with simple structures. Lüpertz related these pictorial symbols to the archaic ode. Towering entities formed of letters of the alphabet soar monumentally into a blue sky. The motif of the ornamental skyscraper with its abstract brushwork, decorative ornaments and stripes is linked to alphabetic signs that form the roof of the tower. These motifs belong to different linguistic levels or registers. Lüpertz attempts to combine writing and object by painterly means.

A. R. PENCK

*1939

Mike Hammer is one of the pseudonyms adopted by Penck. The painting of the same name illustrates the birth of the figure of a painter who uses a pseudonym. Penck has always been in search of an anti-style that runs against the grain of fashionable prevailing tastes or intellectual standards. In order to paint realistically, he wanted to break illusionism as a painterly style. Penck is a critical thinker, constantly in opposition to the dominant system. In his painting, he invariably endeavours to achieve the pure realisation of his idea.

He does not see the ground of his painting as a smooth surface, but as a field centred with lines of energy. The simple signs with which he constructs his paintings are often aligned around a central axis according to an evaluation of the individual elements in the picture. The individual codes are selected in such a way that they appear as pairs of opposites in the painting, subjected to an inherent axiality that determines the horizontal format of the image.

The signs and codes are reduced and condensed so that they create a general concept of objects and figure, which Penck calls "standard". This "standard" provides the possibility of repetition. Accordingly, signs from this painting can also be found in his other paintings.

674

*1938

The Family Portrait is upside-down. Looking at it in the way it is intended to be seen abruptly breaks the mould of habitual ways of seeing. The second shock comes when the spectator realises the discrepancy between the title, evoking traditional concepts of portraiture, and content: a naked couple representing the family. Since around 1969, Baselitz has been painting landscapes and figures upsidedown. In doing so, he consciously seeks to change traditional ways of seeing, and does not attempt to make things easy for himself or the viewers of his paintings. At the same time, he creates a distinctive hallmark that has established his reputation on the international art market: Baselitz has become synonymous with upside-down painting. He does not draw his themes from the field of easy entertainment, nor does he simplify his objects or aestheticise them in order to ensure "easy

Georg Baselitz works with purely painterly means. His influences are the Mannerist painters and the school of Fontainebleau. Through his close study of 1950s *tachisme*, he arrived at a subjective figurative painting. He draws upon dynamically gestural form of expressions and employs a frequently brutal rawness and distortion in order to present his themes and motifs in a way that is highly unsettling.

The starting point of Ciao America I was a woodcut Baselitz had made for the fortieth anniversary of the Springer gallery in Berlin. For each of the forty years, as he reports, he carved one more bird in the panel: "There are forty or more birds, but because they are upside-down and consist only of lines, patches and fragments of bright colour flashing through the black surface, it is difficult to tell that these are birds and how many of them there are." In transposing this motif to the canvas, he retained the black background, but heavily reduced the number of birds, capturing them within a grid-like network of colour. The choice of motif is relatively arbitrary; Baselitz' work is geared towards traditional themes of European painting, but he radically denies any interest in his pictorial motifs: "The problem is not the object in the picture, the problem is the picture as object. And the question of what is being dealt with here, whether it is a chair or a cube or a portrait, is simply not an issue." In recent years, he has thus been able to create works that lean heavily on the forms of the abstract painting of the 1950s. In this way, Baselitz not only indicates that these paintings are already an acknowledged part of the history of painting, but also attempts to take his "painting about painting" into new dimensions. Whereas the figurative motifs of his paintings had previously been intended as a means of ensuring that his work did not fall into the trap of arbitrary subjectivism, he now sought to protect his work from purely decorative effects through his brushwork and his handling of colour.

Georg Baselitz Family Portrait, 1975 Oil on canvas, 250 x 200cm Cassel, Staatliche Kunstsammlungen, Neue Galerie

Georg Baselitz Ciao America I, 1988 Oil on canvas, 250 x 200 cm Washington, Hirshhorn Museum and Sculpture Garden

Anselm Kiefer Bilderstreit (Iconoclastic Controversy), 1979 Oil on canvas, 220 x 300 cm Eindhoven, Stedelijk van Abbemuseum

ANSELM KIEFER

*1945

Bilderstreit (Iconoclastic Controversy) is a theme of enormous cultural and historical importance. Is it possible to create an image of divinity and to worship the imaged god in this way? This question serves Kiefer merely as a foil for his own interpretation of the Iconoclastic Controversy. He is interested primarily in the harrowing consequences of this theological and philosophical dispute which did not stop at rhetorical argument; he addresses the madness of war, which is a central and ever present theme in his work. His paintings are not designed as large-scale narratives, nor does he seek to present the position of the iconoclasts or image worshippers.

His *Bilderstreit* is an "image of burnt earth", an image of devastation, of brutal destruction — the invariable consequences of war, irrespective of whether it was a holy war or one conducted on baser grounds. Against the torn and scorched earth, the outlines of modern tanks are painted in white, the colour of peace, as are the names of those who were involved in the Iconoclastic Controversy that raged in the By-

zantine Empire in the 8th and 9th centuries: Theophilos, Photius, John of Damascus, Theodos Studites, Leo III, Artavasdos, Theoctistos, Theodora, Staurakios, Theodoros Melissenos. Added to the list are the names Doris and Charles Saatchi, collectors of ultra-modern art in London. In the centre is the outline of a palette, the embodiment of "art" as a field of energy.

Kiefer's paintings are a blend of landscape and history paintings. Landscape and earth signify unspoiled nature for Kiefer, remodelled by humankind into a landscape of culture and imbued with historical implications. Here, it is the earth destroyed by the horrors of war.

Kiefer does not seek to portray outward appearances, even in his images of interiors. What he shows is invariably intended as a metaphor or codification, triggering some impulse. The colours, too, have a symbolic significance in the work of Kiefer, capable of triggering atmosphere and emotion. His images invariably focus on the past that has already been experienced and suffered. It has left its traces—the traces of death, violence and destruction. His images are not direct accusations. Nevertheless, they set thought processes in motion that must necessarily bring some insight.

676

MARTIN KIPPENBERGER

*1953

Kippenberger is one of the representatives of a generation of artists whose initial success came in the early 1980s in the wake of the Neue Wilden painting. His concept of art differs fundamentally from that of his colleagues, however, for his oeuvre is not limited to a single medium. Painting, drawing, sculpture and photography make reciprocal comments, with the artist invariably taking up central themes of his work in various techniques. In this context, painting is only one of several forms of expression, whose potential and possibilities the artist calls into question conceptually. Kippenberger avoids a personal painterly style; he sees art history as a storehouse of forms, universally available and compatible.

Heute denken - morgen fertig (Think today finished tomorrow) painted in 1983 is typical of Kippenberger's oeuvre. A modern artist in this sense is concerned less with questions of detail than with central statements translated into painting. A marionette of the kind that painters use for anatomic studies is subjected to this pragmatic approach that grasps painting as a means to an end. Kippenberger, a selfstyled "non-painter" once claimed: "I am more like a salesman. Sell and negotiate ideas. I am far more to people than someone who paints pictures.'

ALBERT OFHLEN

*1954

Albert Oehlen belongs to a generation of artists who rediscovered painting at the end of the 1970s in a kind of counter-reaction to conceptual art. Together with Werner Büttner (*1954) he founded the Liga zur Bekämpfung des widersprüchlichen Verhaltens (League to Combat Contradictory Behaviour) in 1978. His early paintings are thematically provocative, his brushwork rapid, but highly virtuoso. He seems to feel that everything and anything can be painted, from a garden fence (Fence, 1982) to Four Suitcases (1991). In 1984, he created his first Mirror Images in which the artist applies fragments of mirror onto the canvas and works them in to the surface structure of his painting. By mirroring the ambient space in his painting, Oehlen takes an ironic attitude to the maxims of abstract Expressionism which allow the viewer to enter the painting. Over the years, Oehlen has increasingly turned away from reality and has developed the abstract paintings so typical of his oeuvre. Untitled is characteristic of this development. The painting consists of three canvases which the artist has joined together. As a basis, he has chosen to use printed fabrics that remain visible in the background. In garish colours, he paints against the stridency of the fabric patterns. The illusory space of the picture is systematically deconstructed by asserting the presence of the fabric patterns in places and completely covering them with forms and colours in other places.

Martin Kippenberger Heute denken - morgen fertig, 1983 Oil on canvas, 160 x 133 cm Private collection

Albert Oehlen Untitled, 1983 Oil on canvas, 240 x 240 cm Private collection

GERMANY 677

Robert Ryman Summit, 1978 Oil on canvas with metal holders, 191.7 x 183 cm Private collection

Cy Twombly
Pan (part four), 1980
Mixed media on paper in seven parts, 132.5 x 150cm
Private collection

ROBERT RYMAN

*1930

Starting anew time after time, Robert Ryman explores the elements that are indispensable for the creation of a painting and essential to it. His work is generally classified as minimal art, and his paintings can certainly be described as minimalist.

Ryman reduced his field of exploration gradually to square, white paintings. Because he regards the painting as an autonomous object, he has also devoted considerable energy to exploring the possibilities of affixing it to the wall. He has designed holders that become a constitutive part of the work itself and keep the painting at a distance from the wall, thereby emphasising the independence and autonomy of his paintings. In barely varied series, he underlines the significance of each pictorial component.

The application of paint is of key importance. Ryman's brushwork is geared entirely to the width of the brush and its capacity to absorb paint. He generally avoids completely covering the canvas with paint. The canvas often shimmers through as a contrast to the colour. The almost meditative act of painting can be experienced by the viewer who views the original, as there are no additional elements or content to distract from it.

CY TWOMBLY

*1929

The time Twombly spent at the Black Mountain College was of enormous importance to his artistic development. His teachers there included Motherwell and Kline, and his fellowstudents included Rauschenberg. All of his later works, including the series *Pan*, consisting of seven paintings of equal size, mirror the elements that he chose to include in his art at that time.

Like his teachers, who were abstract Expressionists, Twombly does not portray figurative motifs. On a monochrome background, he scratches or paints in swift and energetic brushstrokes or crayon strokes in what might be described as a "scribble". In spite of this completely abstract visual language, Twombly's titles have a reference to reality, albeit a reality that is to be grasped intellectually, as embodied by Pan, the Greek god of the fields and woods.

Twombly's paintings invariably follow a previously thought-out concept and are subject to the strict rules of an inherent law. In his work, line has a significant function. Like Paul Klee, he regards this element as a persuasive means of presenting movement and, therefore, time. His main aim has always been to express time and movement in an imaginary space. He uses colour very sparingly.

JEAN-MICHEL BASQUIAT

1960-1988

Basquiat had already achieved some local fame as a graffiti artist in New York before he began to transpose his abbreviated pictorial codes to canvas. His cryptograms, or tags, were scattered throughout the city under the pseudonym Samo, particularly in the subway. Basquiat came from a socially under-privileged background.

He was one of a generation of artists of the black and Hispanic ethnic minorities who began to break down the social barriers in the early 1980s and established themselves on the art scene. Unlike many other graffiti stars, Basquiat never gave up his social critique or his artistic protest.

ISBN contains a rich repertoire of paint traces, figural fragments, written fragments and collage elements. The black skull with the rasta hair that Basquiat has placed in a prominent position, is evidently a self-portrait. Other pictorial fragments are borrowed from the language of comics, and the small pictorial narratives in the painting tell of the popular myths of American culture. However, Basquiat also includes the art history of the 20th century. His paintings bear a remarkable affinity to the images of Cy Twombly and the art brut of Jean Dubuffet.

Jean Michel Basquiat ISBN, 1985 Acrylic and collage on canvas, 218.5 x 172.7 cm Private collection

KEITH HARING

1958-1990

Of all the graffiti artists, Haring was the most consistent in seeking to link "low" popular street culture with the "high" art of galleries and museums. His more or less traditional training at several art schools gave him a solid grounding in his craft, and he combined these techniques in his images with the new stylistic characteristics he was obliged to adopt in order to spray as rapidly as possible on walls and subway trains. Haring preferred to use large, codified pictorial elements, ensuring easy legibility and rapid recognition of motifs. Like the Pop artists of the 1960s, he frequently drew his motifs from the trivial myths of American urban life. Unlike the Pop artists, however, he did not merely quote. Comic figures such as Mickey Mouse are modified by Haring and adopted into a highly personal symbolic system in which the artist critically questions political and social problems in the USA. Haring commented on such phenomena as idol worship, mass protest and mass phenomena. His decorative talent was never limited to conventional canvases alone, and his symbols were soon to be found on all manner of everyday objects. Haring himself had become a star, and, glorified by his early death, achieved a cult-following for several years.

Keith Haring Untitled (M. Mouse), 1985 Acrylic on canvas, 296 x 364 cm Private collection

UNITED STATES 679

Julian Schnabel L'Heroïne, 1987 Gesso on tarpaulin, 259 x 457 cm Private collection

Philipp Taaffe Conflagration, 1991 Mixed media on canvas, 290 x 293 cm Private collection

JULIAN SCHNABEL

*1951

Schnabel's paintings often possess the sculptural quality of a relief. Unusual materials and found objects, from broken plates and straw to antlers, are applied to painterly backgrounds which themselves are frequently beyond the pale of the conventional artistic canon. Schnabel paints and creates collages on velvet, animal skins, Oriental rugs and sackcloth. The paintings are often of enormous dimensions, in garish colours, with calculated, hard-hitting effects. He draws his pictorial themes from American popular culture and from the European world of mythology, drawing them together with elements of expressive abstract art.

L'Heroïne is one of a series of fourteen Cognition paintings which introduced a new phase in his oeuvre. He named them after a novel by the American writer William Gaddis and exhibited them for the first time in 1987/88 in a ruined Carmelite monastery in Sevilla. The form of the cross is a reference to the stations of the cross which Schnabel "spells" as in a monumental piece of graffiti, with the names of saints, mysics and monks. The background is made of found tarpaulins from military trucks, whose rough structure, stains, rips and seams are painted with large codified forms like the war banners of the early modern era.

PHILIP TAAFFE

*1955

Taaffe lives in New York and sometimes on the Gulf of Naples. This clash of cultural influences has had an enormous impact on his more recent works. Whereas his American paintings can be seen as a direct exploration of abstract Expressionism, the work he created in Italy is a symbiosis of western painting and Arabic ornament. The source of inspiration is the specific atmosphere of Naples, which, in the course of history, has provided fertile soil for many different cultures. In Taaffe's paintings, we constantly find borrowings from a variety of eras, including Renaissance coats of arms, 19th century tile patterns and Saracen arabesques, collaged to created ornamental friezes. These historic fragments are still an important feature of the Neapolitan urban

Generally taking the form of monotypes, these ornaments are printed on a canvas primed with various shades. The background fading and spatial logic of these patterns create a productive contrast that defines the tension in Taaffe's work. In *Conflagration* the indifference of the patinated canvas takes on an almost architectural order through the vertical garlands, calming the hectic interaction between foreground and background.

APPENDIX

683 Biographies of the Artists (with list of illustrations)

759 Acknowledgements

760 Authors

ALBANI Francesco

1578 Bologna – 1660 Bologna Although soon falling into oblivion after his death, Albani achieved considerable fame and prosperity during his lifetime. With Reni and Domenichino, he studied c. 1600 under Annibale Carracci in Rome. He assisted in decorating the Aldobrandi lynettes, designed the apse of Santa Maria della Pace in Rome and worked at the court of Mantua in 1621/22. In 1625 he settled in Bologna for good. He owed his reputation as the "Anacreon of painting" to his landscapes with staffage figures. They were mostly mythological, gently balanced, set in an arcadian landscape. He was rediscovered in the 20th century because his manner of representing nature is reminiscent of Poussin and

Claude Lorrain.

Sacra Famiglia (The Holy Family), c. 1630-1635

ALBERS Josef

1888 Bottrop - 1976 New Haven, Connecticut After studying at the Berlin Academy 1913-1915, then at the College of Decorative Arts at Essen under Thorn-Prikker 1916-1920 and at Munich Academy under Franz von Stuck 1919/20, Albers continued his studies for another two years at the Weimar Bauhaus. In 1922 he took his final examinations, taught preparatory courses, supervised first the workshop for painted glass and then for furni-ture. In 1925 he became a Bauhaus master and married the artist Anneliese Fleischmann. In 1933 he was invited to the newly founded Black Mountain College in North Carolina where he taught until 1949, having giving an entire generation of American artists an insight into the ideals of the Bauhaus. His students included Motherwell, de Kooning and Rauschenberg.

From 1950 to 1960 he lectured in the Department of Design at Yale University School of Art, New Haven. He worked as visiting lecturer at many universities and institutes in America as well as at the College of Design in Ulm, Germany. As an influential art theoretician and teacher he wrote the book Interaction of Colour (1963), a School of Seeing. Albers, who had already turned to abstract art in 1920, became primarily known for his severe square-pictures, analysing problems of depth and colour in two-dimensional art which he called "Homage to the Square" from 1950 onwards. He is considered a precursor of Op Art and Minimal Art.

Study for "Homage to the Square": Star Blue, 648

ALLORI Cristofano

1577 Florence – 1621 Florence Allori received his initial training from his father Alessandro, through whom he had contact with his uncle Bronzino. But it was through his teacher Gregorio Pagani that he found his direction, initially as a painter of religious subjects. Soon he also established himself as a painter of portraits and mythological scenes. While his output was somewhat sparse on account of the painstaking care he took in preparing and executing a painting, the result was always of an unvaryingly high quality. In "Judith with the Head of Holofernes" (ill., p. 233), presumably a picture of his mistress and her mother, the rich materials vie with the deep, glowing colours and sensuous naturalness. Allori was a painter who overcame the cold stiffness in Florentine painting

233 Judith with the Head of Holofernes, 1613

ALTDORFER Albrecht

c. 1480 Regensburg (?) - 1538 Regensburg Altdorfer is one of the most talented painters in the whole of German art. Although also a draughtsman and engraver, his importance lies in the field of coloured representation. Here, only Grünewald can be compared to him because all other contemporary painters were committed to the conventions of outline and drawing qualities. Altdorfer achieved, through his colour modulation, completely new ways of expression directed at the emotions. His tendency towards the "romantic" is particularly noticeable in his landscapes. Thus it was he who painted the first picture in European art that is purely a landscape ("Danube Landscape near Regensburg", Munich, Alte Pinakothek, c. 1530), and in many of his other paintings figure and landscape merge in such a way that the scenic becomes background ("St George in the Forest", Munich, Alte Pinakothek, 1510). Altdorfer, who travelled in the Alpine countries in 1510, became the leading light of the so-called "Danube School".

There is no actual proof that he went to Italy. This seems highly probable, however, when looking at his virtuoso handling of spatial construction in the St Florian passion altar panels (after 1510). In his later work Altdorfer moves towards Mannerism in his complex depiction of moving elements, the daring approach to depth and new handling of colour.

Nothing is known about the painter's formative years and early beginnings. There is evidence that in 1505 he lived in Regensburg, where he bought property in 1513. His election to the town council in 1519 and to the inner council in 1526 shows his good standing. At the same time he served as civic architect. There is no information about his architectural work, but it is possible that he was involved in the design of the pilgrim church "Zur Schönen Madonna" (now the new Neupfarrkirche) at Regensburg.

Illustrations:

- The Agony in the Garden, c. 1515
- Susanna at her Bath and The Stoning of the Old Men, 1526
- 193 Alexander's Victory (The Battle on the Issus),

ALTICHIERO DA ZEVIO

c. 1320/30 Zevio (near Verona) - c. 1385/90 Only a single work by Altichiero's own hand remains in Verona, but there are two series of large fresco paintings in Padua, both commissioned by the aristocratic family of Lupi during the years 1379 to 1384. Otherwise there is little known about this outstanding artist, who deserves to be better treated by posterity. Records show that he lived at Verona and Padua between 1379 and 1384.

Altichiero worked almost exclusively for the despotic rulers of northern Italy. His fame was established after working for the Scaliger family in Verona, who for half a century had been great patrons of the arts, taking in Dante and employing Giotto. Altichiero, although following the example of Giotto, differs from him in that he portrays groups more distinctly, even giving them individual features, while making single figures, including holy images, appear less heroic and monumental. He looks with cool detachment at human life and emotions. He found a new way of relating religious stories, not by changing the principal figures, but by close observation of the minor characters' reactions, which he renders almost dispassionately. This is a new kind of social realism; therefore the inclusion of portraits does not seem intrusive.

The Beheading of St George, c. 1382

ANGELICO Fra

(Beato Angelico, Guido di Piero da Mugello, Fra Giovanni da Fiesole)

c. 1395–1400 Vicchio di Mugello (near Florence) – 1455 Rome

Angelico came from a well-to-do family and learned his craft from obscure painters and miniaturists. On completing his training he entered the Dominican monastery at Fiesole, between 1418 and 1421, where a strict rule was observed. This reformed branch of the Dominican order enhanced the prestige and intellectual importance of the order in the Tuscan region. Angelico held various offices as a friar, such as that of prior between 1450 and 1452. During his beatification process at the beginning of the 16th century it was claimed on various occasions that Fra Angelico was to have been appointed Archbishop of Florence in 1446 but that, at his own suggestion, the friar Antoninus (who was later canonised) was given the office. This suggests that the painter was by no means just a naive, contemplative monk, detached from reality. In 1436 Cosimo de'Medici left the San Marco monastery in Florence to the reformed Dominicans, using it as a private family chapel, and both the church and the monastery were restored at his expense. The architect Michelozzo added some new parts, including the famous library. Fra Angelico carried out the paintwork with the help of assistants between 1436 and 1445 and also after 1449. Angelico did not only undertake work for churches and monasteries of his own order, but was also some years in the service of the popes in Rome (the chapel of St Nicolas in the Vatican still remains) and in Orvieto where, according to records, he worked in 1447 with four assistants, amongst them Gozzoli.

Fra Angelico was a contemporary of Masaccio. Artistically, however, he tended towards the masters of the 14th century, such as Orcagna, and the somewhat older painters like Lorenzo Monaco and Gentile da Fabriano. With his advancing age the new discoveries of Masaccio and other young Florentines became detectable in his handling of light and the architectural severity of composition. With regard to figures and surroundings he upheld his deeply spiritualised ideal. This religious ideal of "sweetness", as it was called in contemporary tracts, had been a dominant feature of monastic piety in the 12th century

Illustrations:

- 23 St Lawrence Receiving the Church Treasures, c. 1447-1450
- Annalena Panel, c. 1445
- The Lamentation of Christ, 1436
- Entombment, 1438-1443 59
- The Annunciation, c. 1450
- The Coronation of the Virgin, c. 1430-1435

ANTONELLO DA MESSINA

c. 1430 Messina – 1479 Messina Antonello was born c. 1430 in Messina where he studied under local artists. His creative talent developed and found direction during his years of travel which took him as far as northern Italy. He probably worked in Naples around 1450. Here, the young painter was able to study major works of the Netherlandish school of painting, as King Alfonso I possessed a good collection of paintings by Jan van Eyck and Rogier van der Weyden. It is also thought that the painter Colantonio, who had studied the art of the Netherlands, taught Antonello in Naples. It was in this environment that Antonello discovered his talent for fine detail, whose textual reality is achieved by adding oil as binder, thus allowing the application of several transparent coats of colour. Learning about artistic devices employed in the Netherlands was so important that Vasari later, in the mid-16th century, assumed that Antonello

must have visited Flanders, studying under Jan van Eyck (which in terms of time alone could not have been the case).

On his northern travels Antonello met Piero della Francesca in Urbino, whose works taught him the art of perspective and clear geometric disposition of space. With this combination of talents unique in 15th century Italian painting, he reached Venice in 1475 where he stayed until 1476. His arrival must have been a revelation to the Venetian painters. He acted as catalyst, helping Venetian art to come into its own: colour modulation instead of the hitherto predominant outline. Because of this function, and the equally important one of mediator between north and south, Antonello is regarded as one of the most important figures in early Renaissance painting.

Illustrations:

- 116 St Jerome in His Study, c. 1456
- 116 Virgin Annunciate, c. 1475
- 117 St Sebastian, c. 1476
- 117 Sacra Conversazione, 1475/76

ANTWERP POLYPTYCHON → Master

APPEL Karel

born 1921 Amsterdam

Appel studied art at the Amsterdam Rijksakademie from 1940 to 1943. In 1948 he was cofounder of the Experimental Group, later called "CoBrA". To this avant-garde group belonged, besides Appel, Pierre Alechinsky, Jorn, Benjamin Constant and Corneille, and others. Together they edited a magazine and organised exhibitions. Appel's pictures express spontaneity, and are painted in powerful, gestural strokes in strong, thickly applied colours. In 1948 he received a commission for a large relief in wood for the Amsterdam town hall which provoked an outcry when unveiled. In 1950 Appel settled in Paris, and a year later the CoBrA group was dissolved. Besides oil-paintings, he produced works in ceramics, church windows, reliefs and sculptures made of wood and polyester, murals for the Stedelijk Museum in Amsterdam (1955) and for UNESCO in Paris (1959) as well as the 100 metre long Energy Wall in Rotterdam. Since 1977 Appel has lived in Monaco and New York.

Illustration:

644 Reclining Nude, 1966

ARCIMBOLDO Giuseppe (also: Arcimboldi) c. 1527 Milan – 1593 Milan

His father Biagio Arcimboldo was descended from a noble Milan family and worked as a painter on the Milan Cathedral. From 1549 to 1558 Arcimboldo was assistant to his father at the Milan Cathedral workshops and engaged in designing stained glass windows. In 1562 he was called to the court of Ferdinand I in Prague as a portrait and copy painter. In 1563 Arcimboldo painted his first set of "Seasons". The unique artistic conception of these pictures established his fame even then as master of the fantastic art of composing portraits, still lifes, landscapes and allegories consisting of plants, animals and everyday objects. In 1566 he painted the four "Elements", and there is evidence that he went to Italy in the same year. In 1569, on New Year's day, the "Seasons" and the "Elements" were presented to Ferdinand's successor, Emperor Maximilian. At the court Arcimboldo worked as architect, stage designer, engineer, art expert and organiser of festivities and tournaments. In the early seventies he produced several replicas of his "Seasons" pictures. In 1587 he left the court of Rudolf II, the successor to Maximilian, to return to Milan. As a mark of recognition he received 1550 florins from the Emperor. In 1591 he sent to Prague a portrait of Rudolf II depicted as *Vertumnus*. In the following year the Emperor bestowed on him the non-hereditary title of count palatine. The Surrealists regarded him as one of their precursors.

Illustration:

157 Spring, 1563

ASAM Cosmas Damian

1686 Benediktbeuren - 1739 Munich Cosmas Damian, together with his brother Egid Quirin, with whom he worked later, was trained by his father Hans Georg Asam, who is considered to be the founder of Baroque ceiling painting in Bavaria. In the years 1712 to 1714 the brothers travelled to Rome, where Cosmas Damian took up his studies under Pierleone Ghezzi and won an academy prize. He concentrated mainly on wall and ceiling painting of the High Baroque, in particular in the style of Cortona and Pozzo, who in 1702 had published a book of rules on quadratura, a form of ceiling decoration with architectural elements, which give the illusion of perspective and imaginary space. The work which he carried out on his return in south Germany, Bohemia, Silesia and the Tyrol betrays his Roman schooling. However, he gradually abandoned the Italian quadratura technique in which the illusionism is solely directed at the viewer (Weingarten, Aldersbach). Finally, as in the principal fresco at Osterhofen, each side commands its own viewpoint. His work, both sacred and secular, such as at Weltenburg on the Danube 1716-1721, in which his brother was also engaged as sculptor and ornamental plasterer, contains examples of late Baroque art which was to become important for the Rococo in southern Germany. Illustration:

392 The Patron of Churches St George in Adoration of Christ and Mary, 1721

ASSELIJN Jan

(also: Asselyn; "Crabbetje")

1610 Diemen or Dieppe - 1652 Amsterdam He received his fundamental training from Esasias van de Velde, who influenced Asselijn's early work, as his equestrian scenes reveal. He then went through France to Italy, where he worked in Rome for a long time. Because of his crippled left hand he was given the nickname "Crabbetje", meaning little crab, by the Dutch "Bent" school of painters in Rome. Here he received encouragement from Jan Both, Pieter van Laer and most of all Claude Lorrain, whose lucid manner he transferred to the Dutch landscape. Around 1645 he returned to Holland and settled in 1647 in Amsterdam, specialising in two categories: the animal portrait, of which "The Threatened Swan" (Rijksmuseum, Amsterdam) is the most famous example, and the landscape. His landscapes with motifs of the Roman Campagna, ruins and pastoral elements in chiaroscuro with well-observed light reflexes are representative of the Italianised direction of Dutch painting.

Illustration:

318 Italian Landscape with the Ruins of a Roman Bridge and Aqueduct, undated

AVERCAMP Hendrick

(Hendrick van Avercamp)

1585 Amsterdam – 1635 Kampen
Although born two generations after Pieter
Brueghel the Elder, Avercamp showed himself a receptive student of the famous Flemish painter. He learned his art under Pieter Isaacsz in Amsterdam and subsequently in the studio of Gillis van Coninxloo. After 1610 he went to Kampen, where his father had settled as an apothecary. Avercamp was

deaf and dumb which earned him the nickname "De Stomme van Campen". Besides landscapes depicting the sea and herds of cattle, Avercamp is known mainly for his atmospheric winter scenes in which he shows, with great skill in the art of perspective combined with a strong colour sense, the frolickings of peasants and burghers on the ice of the lakes and canals of his homeland. Although not without an undertone of the comical, his pictures seem to belong to the pure genre, as opposed to those of his exemplar Brueghel who operated on various levels.

Illustration:

301 Winter Scene at Yselmuiden, c. 1613

BACICCIO

(Giovanni Battista Gaulli; also: Baciccia) 1639 Genoa – 1709 Rome Baciccio's success and prosperity can be ascribed to his chosen fields: portraiture and the painting of ceilings. The style of his portraits shows the influence of van Dyck's pictures executed at Genoa. His portraits of Pope Clement IX (Rome, Galleria dell' Accademia Nazionale di San Luca) and Cardinal Leopoldo de' Medici (Florence, Uffizi) bear, however, the stamp of Baciccio's own lively perception and handling of light. When painting ceilings, he follows Cortona's decorative style to which he was introduced when in Rome, developing it further by extreme perspectival foreshortening. His principal works are the cupola of San Agnese and the nave vaulting and apse of Il Gesù. The sculptor and architect Bernini was Bacaccio's protector: he took the young man in when he had to flee from the plague to Rome. In 1662 he became a member of the painters' academy of San Luca, in 1674 its director. His influence as fresco painter continued into the 18th century.

Illustration:

239 The Apotheosis of St Ignatius, c. 1685

BACON Francis

1909 Dublin – 1992 Madrid

Bacon was just 16 years old when he went to London. Two years later, while working as a decorator in Berlin and Paris, his first drawings and water-colours appeared, showing the influence of Picasso. He destroyed his early oil-paintings, painted under the influence of French Surrealism in 1944, after he had found his own form of expression. He depicted almost without exception distorted human bodies and faces against diffuse-oppressive backgrounds. His paintings, often consisting of several parts, are reflections of some inner reality, a foreboding and feeling of dissolution. As early as 1955 Bacon had his first retrospective at the London Institute for Contemporary Arts. Along with his compatriot Sutherland, Bacon is one of the most important representatives of visionary painting of the postwar era.

Illustrations:

626 Self-Portrait, 1973

646 Three Studies of the Male Back, 1970

BALDUNG Hans

(called: Grien)

c. 1484/85 Schwäbisch Gmünd – 1545 Strasbourg Baldung probably completed his apprenticeship in Strasbourg at the early age of 15, when he was given the byname "Grien" (Green) because of his youth. In 1503 he entered the workshop of Dürer in Nuremberg to become one of his most prominent pupils. As one of the most eminent German artists of the 16th century, both as painter and as master of the graphic arts, his works are remarkable for their unusual combination of unveiled sensuality and dispassionate intellect which often pro-

duces a "cold fire". Besides religious commission work, Baldung preferred secular themes in which the female body, worked up into a demonic frenzy in his witch scenes, is given a major role. He was also highly regarded as a portraitist, and from about 1530 he was considered to be one of the best artists on the Upper Rhine. His development leads from the latest Gothic forms via the Italian Renaissance, whose harmony he never strove to achieve, into Mannerism. In his treatment of colour he rejected the conventional norm of clear, harmonious tones in favour of dissonance alien to nature. In this respect he represents a parallel to the masters of early Florentine Mannerism (Pontormo, Rosso Fiorentino).

Illustration:

189 The Nativity, 1520

BALLA Giacomo

1871 Turin – 1958 Rome

Except for attending some courses at the Accademia Albertina di Belle Arti in Turin, Balla was selftaught. In 1895 he moved to Rome, where he worked as an illustrator, caricaturist and portraitist. In 1900 he spent seven months in Paris on the occasion of the World Exhibition, where he was particularly impressed by the Neo-Impressionists. On his return, he was joined by Boccioni, Severini and Sironi whom he taught the new Parisian method of painting.

In 1910 he signed, together with his friends, *Marinetti's Manifesto of Futuristic Painters*, but did not take part in the activities of the group until 1913. From then on Balla attempted, often in cooperation with his Futuristic friends, to find by experiment newer forms not only for painting and sculpture, but also for theatrical scenery, the applied arts and the film. Balla's pictures stand out on account of their unusual, almost photographic qualities and the dissolution of objects into lines of movement, expressing dynamism and speed. In 1935 he became a member of the Accademia di San Luca in Rome.

Illustration:

577 Mercury Passing before the Sun, 1914

BALTHUS

(Balthasar Klossovski de Rola)

born 1908 Paris

Balthus is a descendent of an old Polish family which moved to Paris in the mid-19th century. He spent his youth in Paris, Berlin and Switzerland, and Rainer Maria Rilke discovered and promoted Balthus' talent in his early years. In 1921 Rilke published a collection of forty of the boy's panels in a folder under the title Mitsou and wrote the introduction. After his military service in 1933 Balthus became friendly with some of the Surrealists, including Giacometti and Artaud. Artistically, however, Balthus held a special postion: his extensive knowledge of the history of art explains the quotations from Giotto to Caravaggio in his paintings. Balthus painted still lifes, portraits and landscapes. Most fascinating, however, are his representations of young, still immature girls, whom he surrounds with an almost demonic atmosphere. In the thirties Balthus began to explore his second subject area: Paris street scenes. In 1961 Malraux appointed him director of the Villa Medici, the French academy in Rome. In 1977 he moved to Switzerland. Balthus' work has been shown at major exhibitions, including the New York Museum of Modern Art in 1956, the Tate Gallery London in 1968 and the Pompidou Centre in Paris in 1983. He has been an honorary member of the Royal Academy, London, since 1981. Illustration:

668 The Artist and his Model, 1980/81

BARNABA DA MODENA

active 1361 - 1383 Genoa

The Emilia region within Modena borders on Tuscany and Lombardy as well as Veneto. But the Roman papal states, which at some periods also ruled Bologna, had some influence here too. It is significant that in the mid-14th century when Tuscan art declined and Lombardian and Venetian art were at their zenith, the painters of Emilia continued to be successful beyond their home ground (Tommaso da Modena). Barnaba da Modena comes to us through his signed works and some source material, yet we know nothing of his artistic origins. No doubt he followed the example of Sienese art and would also have been conversant with the Byzantine works of Venice. Most of the time he worked in Genoa; his panels were exported from there as far as Spain. Written commissions from Piemont and Pisa have also survived. Illustration:

47 Madonna and Child, 1370

BARTOLOMMEO Fra

(Bartolommeo di Pagola del Fattorino, known as: Baccio della Porta)

1472 Soffignano (near Florence) – 1517 Florence The twelve-year-old Bartolommeo, called "della Porta" because his family home was at the Porta di San Pier Gattolino, was sent to the workshop of Cosimo Rosselli, where he was given an education in the full spirit of the late 15th century. In 1490 he founded his own workshop, together with Mariotto Albertinelli. Evidently equipped with a social sense and filled with religious fervour, he became a follower of Savonarola and entered the Dominican order in the late nineties. His creative work, briefly disrupted, led him to abandon tradition in the early years of the 16th century, and to come under Flemish influences. He explores Perugino in his representations of landscape and his drawings; he becomes fascinated with Giovanni Bellini while in Venice in 1508; and on his return studies Leonardo's new colour theories. The combined effect of these influences resulted after 1512 in works which stand out in the art of the Florentine High Renaissance. Bartolommeo not only made a lasting impression on Raphael, but as a teacher also gave direction to Rosso Fiorentino, Pontormo and the Sienese painter Domenico Beccafumi.

Illustration:

166 Annunciation, c. 1500

BASCHENIS Evaristo

1617 Bergamo (?) – 1677 Bergamo
Today his name no longer conjures up the battle scenes of his early years, but rather the still lifes with musical instruments from the legendary Cremona workshops of Amati, Girolama and Nicola. By employing artistic devices imported from the Netherlands, in particular the trompe l'wil effect, Baschenis represents his lutes and violins as strongly expressive special objects. He puts these rotund sound chambers in juxtaposition to clear, flat surfaces and uses the warm tones of their wood to produce the overall colour effect. About his life we only know that he comes from a painting family and was a priest before devoting himself entirely to painting.

238 Still Life with Musical Instruments, c. 1650

BASELITZ Georg

(Hans-Georg Kern) born 1938 Deutschbaselitz (Saxony)

From 1956 Baselitz studied at the School of Fine and Applied Arts in East Berlin under Walter Womacks, where he met Peter Graf and Ralf Winkler (A.R. Penck). A year later he changed over to the Academy in West Berlin where he studied painting under Hann Trier until 1962. He adopted the pseudonym Baselitz in 1961. Stimulated by the Surrealist manifestos of Breton, he, too, wrote manifestos to accompany his action pictures "The Night of Pandemonium" (1962), and "Why the Picture 'Great Friends' is a Good Picture" (1966). His first strictly representational pictures are directed against Tachisme and abstract art. Since 1969 he has been painting upside-down portraits and landscapes. The first woodcuts were produced in 1966; roughly-hewn wooden sculptures since 1979. A scholarship took him in 1965 to the Villa Romana at Florence. Since then he has been visiting Italy most years, taking a studio in Imperia in 1987. In 1978 he was given a professorship at the Academy of Arts at Karlsruhe. From 1983 to 1988 and then again in 1992 he lectured at the Berlin Academy. In 1995 a large retrospective was arranged for him at the Guggenheim Museum, New York. Baselitz lives at Derneburg near Hildesheim

Illustrations:

626 Motivschimmel Zerbrochene Brücke (Dappled motif broken bridge), 1986

Familienbild (Family Portrait), 1975

675 Ciao America I, 1988

BASQUIAT Jean Michel

1960 New York - 1988 New York Basquiat was born in New York as the son of a Haitian book-keeper and a Puerto-Rican mother. After a difficult childhood he began at the age of 17, together with Al Diaz, to paint graffiti in underground stations and on house-fronts under the assumed name of Samo. He did casual work and played the guitar and synthethiser in a band. The art market soon discovered Basquiat; by taking part in the documenta at Kassel in 1982 and the Whitney Biennale in New York in 1983, he became a media star. He made friends with Warhol. They painted portraits of each other and designed a number of works together. Basquiat introduced the graffiti art form to the art world without disowning his Brooklyn ghetto origins. He constructed assemblages from waste objects: materials used as surface could range from a torn bit of paper to a fridge door. He died from a drug overdose.

Illustration:

679 ISBN, 1985

BASSANO Jacopo

(Giacomo da Ponte)

c. 1517/18 Bassano – 1592 Bassano Bassano stems from a family of painters and received his training from his father, Francesco. In 1530 he was apprenticed for 5 years to the Venetian painter Bonifazio de' Pitatis. In 1549 he was appointed a councillor and consul of his home town, whose name he adopted and where he lived all his life, untroubled by great events. Bassano had a large workshop, where later four of his seven children worked. Here he produced about 180 paintings which would not have been feasible without assistance. His works show the influence of Titian and Lorenzo Lotto and late Venetian Renaissance art (Tintoretto and Veronese), whose insights he developed further. The strength of his work lies in the concentration on objects and in telling a story simply but effectively. In his realistic representation of

landscape Bassano developed a style of his own; genre painting outweighs work with religious content.

Illustration:

179 The Procession to Calvary, c. 1540

BAUGIN Lubin

c. 1610-1612 Pithiviers (Loiret) - 1663 Paris Several religious paintings of Baugin survive, including "Virgin with Child and St John" (London, Nancy, Rennes), "Birth of Mary" (Aix-en-Provence, Musée Granet). Because of his large-figured, mellow style and clear, extensive planes of colour, he was rightly called "Le petit Guide", the little Guido Reni, for he was strongly influenced by the work of this Italian painter. In contrast, his still lifes, signed "A. Baugin", are in the late style of the "School of Fontainebleau" with late Mannerist elements. Before 1789 the Cathedral of Notre Dame possessed eleven of his religious paintings. Baugin studied in Rome under Vouet, was accepted by the Académie de Saint Luc in Paris in 1645, was appointed "Peintre du Roi" in 1651, was expelled from the Academy on the grounds of founding a private school, and on closing it was re-elected. Baugin's long disputed identity is now established as these details tally exactly with those of the still life mas-

Illustration:

244 Still Life with Chessboard (The Five Senses), undated

BAUMEISTER Willi

1889 Stuttgart – 1955 Stuttgart Baumeister began his artistic career as a decorative painter. From 1908 he attended the Stuttgart Academy and from 1909 studied composition with Schlemmer under Adolf Hölzel. Repeated visits to France aroused his interest in French art, and he made friends with Léger and others. In 1919 he was one of the founders of Üecht, a group of Stuttgart artists. Baumeister was initially under the influence of the Cubists and produced figurative work which was superseded by the "wall pictures". After becoming a member of the "Circle of New Promotional Designers" in 1927, he worked a year later as teacher of typography at the Städelsche Kunstschule in Frankfurt/Main. In 1933 he was dismissed and professionally banned as a "degenerate" artist, but he continued to paint secretly at Stuttgart. His works became increasingly removed from the representational. From 1939 to 1944 he worked alongside Schlemmer at the paint manufacturer Kurt Herberts in Wuppertal. Baumeister's theoretical work The Unknown in Art was written between 1943 and 1947. From 1946 to 1955 he held a chair at the Stuttgart Academy. He is still regarded the master of abstract art in Germany. Illustration:

639 Montaru-G VI, 1954

BAYEU Y SUBIAS Ramón

1746 Saragossa – 1793 Aranjuez
Like his brother Manuel, Ramón was eclipsed by
his brother Francisco who, not least because he was
Goya's brother-in-law, found a place in the history
of art. Ramón accompanied his brother Francisco to
Madrid in 1763, where he worked in an artistic climate dictated both by the late Baroque and by
Classicism, embodied by the old Tiepolo and the increasingly influential arbiter of taste, Mengs.
Ramón seems to have been less clearly associated
with a particular school than his brother. For
example, the prevailing influence of Classicism
shows in the jointly executed frescos in the Zaragoza cathedral, while in his portraits, but especially in his etchings which he carried out to his

own design or after those of his brother or of older masters, the technique and picturesque gracefulness of Tiepolo are still detectable.

Illustration:

396 The Blind Singer, c. 1786

BAZILLE Frédéric

1841 Montpellier – 1870 Beaune-la-Rolande (near Orléans)

Bazille, who came from a well-to-do, cultured background, began to study medicine in his home town in 1859. His general interest in art induced him to study painting at the Gleyre studio when he went to Paris in 1862 for further medical studies. Here he met Monet, Renoir and Sisley. At Easter 1863 he painted with Monet at Fontainebleau, and again in June 1864 at Honfleur, where he met Boudin and Jongkind. He abandoned his medical studies. In 1865 he put up Monet at his studio in the Rue de Furstenberg, and in 1866 he exhibited at the Salon. He then shared a studio with Renoir in the Rue de la Visconti. He supported both Monet and Renoir, partly by buying their work. As Bazille was only 29 years old when he was killed in the war, his œuvre is relatively small, including portraits of members of his family and friends in various studios. His still, clear landscapes and harmonious family scenes in muted colours make him one of the most important forerunners of Impressionism.

Illustration:

505 Bathers, 1869

BEAUNEVEU André

1335 Valencienne – before 1413 Bourges Beauneveu, whose life is documented between 1360 and 1403, stemmed from Valencienne which only became French under King Louis XIV. As Bondol served King Charles V as court painter, so his fellow Fleming Beauneveu became his court sculptor. In 1371 he was ennobled by Charles V. He also worked for the Flemish Count Louis de Mâle who in addition engaged Broederlam. However, Beauneveu's most important patron was the Duc de Berry who put him in charge of all his artistic projects, including the building of the palace of Méhun-sur-Yevre. All designs and plans were worked out jointly by the duke and Beauneveu, and the latter also undertook miniature and glass painting. Beauneveu was regarded as an outstanding artist by his contemporaries. Thus, in 1393, the Duke of Burgundy sent his court sculptor Sluter and painter Jean de Beaumetz to Méhun to study the work in progress. The authenticated works of Beauneveu show that he took the academic rules of French art in the first half of the 14th century as a starting point, but handled them with great virtuosity and delicateness. Among his early work his portraits quite rightly receive most praise, such as the tomb statue of Charles V at St Denis. In his later work he explored Italian innovations, leading to richly vibrant forms.

 ${\it Illustrations:}$

The Duc de Berry between his Patron Saints Andrew and John the Baptist, c. 1390

BECKMANN Max

1884 Leipzig – 1950 New York
After spending his youth in Brunswick and Pommerania, Beckmann studied from 1900 at the Weimar Academy of Art before moving to Berlin in 1904. With the "Scene from the Sinking of the Messina" (St Louis, Saint Louis Art Museum) he formulated in 1909 the theme which was to preoccupy him all his life: the threat of catastrophe to the individual and all humanity. When war broke out in 1914 he volunteered as medical orderly,

but a nervous breakdown only a year later brought his discharge. He moved to Frankfurt am Main where he lived until 1933. Having experienced mass killing in the trenches, he abandoned biblical, historical and allegorical subjects and turned to man in his physical and spiritual anguish, as depicted in his work "The Night" (ill. p. 588) of 1918/19. In this, forms are simplified and reduced so that harsh contours and direct transition become dominant. In the following years the severity and harshness of his style seem to mellow. The contour becomes less angular and colours more brilliant, while the monumentality remains. The theatre, circus, fun fair and night-club, musichall and cabaret, are seen as analogies of human existence. In 1925 Beckmann accepted a chair at the Städelsche Art School, Frankfurt/M. In 1933 he was compelled to leave, moving to Berlin. In the triptych "Departure" (New York, Museum of Modern Art) of 1932/33, a title full of associations, he foresaw his emigration. This work started a series of nine similar, monumental compositions, all having as their theme the futility of human endeavour and our subjection to a higher power. When the "Degenerate Art" exhibition was opened in 1937, he left Germany for ever, spending the war years in Amsterdam before departing for New York in 1947.

Illustrations:

588 The Night, 1918/19

588 Dancing in Baden-Baden, 1923

BELLECHOSE Henri

c. 1380 Breda (Brabant) – c. 1440/44 Dijon In 1415 Bellechose took over from Malouel as court painter and *valet de chambre* to the Dukes of Burgundy in Dijon. He worked at the ducal residences at Talant and Saulx and the monastery Champmol near Dijon, for which he painted an altarpiece of the life of St Dionysius and a scene from the life of Mary. At court he was responsible for the decorations at festivities and also the painting of coats of arms and standards. For a time he received a good income from the duke, but when the court was removed from Dijon he had to carry out private commissions. Bellechose is regarded as the major representative of the French-Flemish version of International Gothic.

Illustration:

The Last Communion and Martyrdom of St Denis, c. 1416

BELLINI Gentile

1429 Venice - 1507 Venice

Gentile, who was somewhat older than Giovanni, was trained at the workshop of his father Jacopo. The keenness of observation with which he rendered perspective, scenery or antique fragments in his sketches became a decisive factor in his artistic development. It predestined him to be the most important portraitist of Venetian art in the 15th century. From 1450 until his death Gentile acted as official painter to the Republic. He was sent to Constantinople in 1479/80, as the Signoria of Venice had been requested by Sultan Mehmed II to send him the best portraitist. The famous portrait of this oriental potentate is now in the National Gallery, London. Next to portraiture, Gentile also excelled at large-scale historical scenes painted in the style of the early Venetian Renaissance. There is nothing in Venice to equal his panels with scenes from the Legend of the True Cross, painted c. 1500. The faithful and precise rendering of St Mark's Square and the medieval Rialto bridge make him the forerunner of Canaletto. It is true that in terms of coloration he remains well within the boundaries of 15th century traditions, whereas his younger brother was even then opening up new fields in colour modulation.

Gentile's most significant pupil and successor was Carpaccio.

Illustration:

118 Procession in St Mark's Square, 1496

BELLINI Giovanni

(also: Giambellino)

c. 1430 Venice - 1516 Venice

Giovanni was initially taught by his father Jacopo whose drawings of almost icon-like precision in the traditional 14th century method and manner influenced his early work. When Giovanni's sister Nicosia married Mantegna in 1453, close relations between Venice and Padua were established, and Giovanni began to explore the physical and spatial representation of the Early Renaissance. Under Mantegna's influence his style assumes temporarily a certain calligraphic precision ("The Transfiguration of Christ", Venice, Museo Correr, c. 1460; "The Mount of Olives", London, National Gallery, c. 1470.)

The visit of Antonello da Messina to Venice in 1475/76 seems to have liberated Giovanni's innermost talents. Without abandoning the rational structure and interaction of form and space, his colours gain in luminosity and depth; modulation of tone increasingly replaces the dividing outline, light floods the canvas. The landscape, as can be seen in many of his representations of the Virgin and Child and the Pietà, achieves a quality that marks Bellini as the most important Italian landscape painter of the Early Renaissance. His ability to endow his figures with an expression of quiet contemplation while fully conveying movement and human anatomy, remains a secret that raises him above all his contemporaries. The great works of his late art, in particular his portrayals of the Sacra Conversazione, already cross the border from Early to High Renaissance in the way artistic freedom and convention merge. As teacher of Giorgione and Titian, Giovanni, whom Dürer on his second visit to Venice from 1505 to 1507 still called the greatest painter of his time, was of immeasurable significance for Venetian art in the 16th century. Illustrations:

- 84 St Francis in the Wilderness, c. 1480 120 Sacra Conversazione (Pala di San Giobbe), c. 1487/88
- 120 Transfiguration of Christ, c. 1460
- Portrait of Doge Leonardo Loredan, c. 1501–1505
- 121 Christian Allegory, c. 1490

(known as: Canaletto; also: Belotto)

BELLOTTO Bernardo

1721 Venice - 1780 Warsaw Bellotto began his artistic career at the age of fifteen in the workshop of his uncle Antonio Canal and took over not only his speciality of veduta painting, but also largely his style and finally even his name Canaletto. Like his uncle, he also visited Rome and probably Tuscany. He worked in several regions of Italy, including Lombardy and Turin, before travelling to England in 1746. A year later he was welcomed in Dresden by Augustus the Strong. He carried out work for Maria Theresa and the Austrian nobility in Vienna, returning 1762 via Munich to Dresden where, after losing his position as court painter, he took a post as teacher of perspective painting at the Academy founded in 1764. Bellotto finally settled in Warsaw where he became court painter to Stanislas II. The close connection between uncle and nephew makes it difficult to draw a clear line between Bellotto's early work and the late work of his teacher. A cooler palette and the even greater precision of his topographical

views distinguish his independent work from that

of Canal. His principal works, such as the 14 Dres-

den vedutas, or the view of Warsaw, make him the

equal of his uncle. His topographical representations of the European royal capitals are also an important historical record on account of their exactitude and faithfulness.

Illustration:

373 Piazza della Signoria in Florence, c. 1740–1745

BERLIN NATIVITY → Master

BERLINGHIERI Bonaventura

c. 1205-1210 - after 1274

Berlinghieri was the son of the Milan painter Berlinghiero Berlinghieri, of whom some works survive. Records show that he lived in Lucca from 1228 to 1274. The sources mention his brother Barone, also a painter, and a further brother, Marco, the miniaturist. The only authenticated work of Berlinghieri is the St Francis panel in Pescia, bearing the inscription: "Anno Domini MCCXXXV Bonaventura Berlinghieri de Luc...". Thanks to the Berlinghieri family, the painting school of Lucca gained prestige far beyond the city boundaries. The Byzantine element in the father's art became even more pronounced in the works of the son, resulting in a peculiar flatness and stiffness. *Illustration:*

28 St Francis and Scenes from his Life, 1235

BERRUGUETE Pedro

c. 1450–1455 Parades de Nava – c. 1504 Avila (?) The combination of a great variety of traditions makes Berruguete one of the most versatile and important Spanish painters of the 15th century. Having been raised in the cultural ambience of the court of the Castilian "Catholic Kings", who collected pictures in Granada from the Netherlands as well as employing painters from the North, he became, after a lengthy stay in Italy, one of the most important mediators between Spanish art and the Italian Early Renaissance. In 1477 he worked with Justus of Ghent at the court of Urbino. Here Berruguete painted his portraits of famous figures, using with great sensitivity the innovations of the Italian Early Renaissance regarding form and space. Clearly he was highly thought of in Italy, not only receiving stimulation but also giving it to others, such as at the court of Ferrara. In 1483 he returned to Toledo. Unfortunately his frescos in the sacristy and cloister of Toledo Cathedral did not survive, but his mature works, including the altarpieces for the monastery of Santo Tomás and for Avila Cathedral show to this day his symbiosis of Spanish medieval tradition, Dutch faithfulness in detail, and Italian clarity of composition. Pedro was the father of the sculptor Alonso Berruguete. Illustration:

Court of Inquisition chaired by St Dominic,

BEUYS Joseph

1921 Kleve – 1986 Düsseldorf

Beuys grew up in Kleve near the Dutch border. In the war he flew a fighter plane from 1941 to 1945, crashing over the Crimea. He was found by Tartars who wrapped him in fat and felt. These two materials took on great significance in his later work. From 1947 to 1951 he studied at the Academy of Art in Düsseldorf, where he was the principal pupil of Ewald Mataré, and where Beuys himself taught from 1961 to 1972. By combining several artistic media and merging them with his life story, he attempted to achieve a unity of art and life in his work. In doing so, he also drew on anthroposophy, mythology and religion. In 1962 he became ac-

quainted with the Fluxus movement through the Korean Nam June Paik and through George Maciunas, and began to exhibit his own actions from 1963. He also produced sketches and plastic works and designed objects and environments. The symbolism of his work is drawn from magical-religious, mythical and archetypal contexts, or from personal experience. Thus the idea of felt as an insulator against the cold and fat as a source of energy and warmth stems from his own experience, representing a closeness to nature lost in our culture. Beuys advocated creativy in all walks of life – hence his attempt to gain political influence. *Illustration:*

623 Is it about a bicycle? IV, 1982

BEYEREN Abraham van

(also: Beijeren)

c. 1620/21 The Hague – 1690 Alkmaar or Overschie (Rotterdam)

Beyeren found scant recognition in his lifetime, yet today he is among the most important still life painters of his country. He was taught by his brother-in-law, the painter of fish, Pieter de Putter, which may be the reason why Beyeren began his career with the same subject matter. In 1640 he joined the Painters' Guild in The Hague, where he became a co-founder of the Confrerie Pictura in 1656. In 1657 he went to Delft, in 1663 he returned to The Hague, in 1672 he lived in Amsterdam and in 1674 in Alkmaar. He was always in financial straits; fleeing from creditors may have been the reason for his many moves and restless life. His true métier were sumptuous, tastefully arranged still lifes, breakfast tables with magnificent cloths, flowers, glasses, fruit and animals, showing the influence of de Heem. There are also fragrant flower pieces in the style of Jan Brueghel, seascapes, and his fish still lifes.

Illustration:

323 Still Life with Lobster, 1653

BINGHAM George Caleb

1811 Augusta County (Virginia) – 1879 Kansas City

Bingham grew up at Franklin on the Missouri river, on his father's tobacco farm. After an apprenticeship as cabinet-maker, and then briefly studying theology and law, he went to Philadelphia, where he attended the Academy of Arts in 1837/38. In 1844 he returned to Missouri and painted scenes from the everyday lives of farmers, trappers, traders and raftsmen, as well as genre pictures, which made him famous as the narrator of the domestic customs and traditions of the Western States. In particular, the mass distribution of copper engravings made from his own drawings brought him great popularity. On a visit to Europe from 1856 to 1859 Bingham spent most of his time in Paris and in Düsseldorf where he had contacts with the German-American painter Emanuel Leutze and the Düsseldorf School. On his return to the USA he held political posts which severely restricted his artistic activities. As expressed in his own words, his aim was to depict "social and political characteristics". His poetical, delicately coloured renderings of the Missouri river area seem, however, to be reminiscent of the early days of settlement as celebrated in Mark Twain's books. Illustration:

471 Fur Traders Descending the Missouri, c. 1845

BLAKE Peter

born 1932 Dartford, Kent Blake studied graphic art at the Gravesend School of Art, and from 1953 to 1956 he attended the Royal College of Art, London. In 1956/57 he toured Europe for study purposes, then from 1964 taught at the St Martin School of Art. After an initial realistic period he became, together with Hamilton and Richard Smith, one of the key figures of English Pop Art. Compared with other pop artists, though, he does not employ trivial pictorial clichés, but nostalgically approaches the aesthetics of the thirties. The painted collages produced since 1959 express a disarming wit and cheerful colourfulness. In 1967 he designed the record sleeve of the Beatles' LP "Sergeant Pepper". From 1969 to 1979 he lived with the "Brotherhood of Ruralists" near Bath, and then returned to London.

Illustration:

664 Bo Diddley, 1963/64

BLAKE William

1757 London – 1827 London

Blake, the son of a stocking weaver, already had visionary experiences as a child, and this was to influence the "prophetic" character of his singular artistic combination of visual art and poetry. At the age of 10 he was given drawing lessons by Henry Pars; then was taught engraving by James Basire for whom he painted medieval pictures. His own works showed very early the influence of Michelangelo in particular, whose vast human figures later became central to his work. While studying at the Royal Academy (from 1778), he became embroiled in an argument with Reynolds about the relative importance of colour and drawing. Blake took the classical view, and his entire work shows his disinclination to use colour for effect. In his illustrations of the Bible, Dante, or his own writings, the traditional relationship between picture and text was abandoned, achieving a symbolic unity of word and picture which would not be accepted until decades after his death.

Illustration:

388 Beatrice addressing Dante from her Wagon, c. 1824–1826

BLECHEN Karl Eduard Ferdinand

1798 Cottbus – 1840 Berlin

Blechen was born in Cottbus as the son of a tax official, and first worked in a bank in Berlin. In 1822 he began his art studies at the Berlin Academy. His acquaintance with the painters Friedrich and Dahl at Dresden was an important stimulus. These two artists represent the two poles covered by Blechen's work: Romanticism and Realism. His visit to Italy in 1828/29 was decisive in his development. The innumerable oil-studies carried out in Italy show him to be an open-air painter with an affinity to Turner, who was then also working there, as well as to the French painter Corot who had settled there. These studies make Blechen the most important representative of early Realism in Germany. In subsequent years his romantic strain again comes to the fore. The mood is often sombre; the figures on the brink of catastrophe or just overtaken by it. Although he was given a professorship in 1831 at the Berlin Academy, the desired public recognition was withheld. The extreme subjectivity of his work was too much out of tune with contemporary German painting. In 1835 he fell into deep depression and finally mental derangement in 1839. Illustrations:

Monks on the Gulf of Naples, c. 1829The Gardens of the Villa d'Este, c. 1830

BLOEMAERT Abraham

1564 Dordrecht or Gorinchem – 1651 Utrecht Bloemaert was trained in the workshop of his father Cornelis, a sculptor and later city architect in Amsterdam. At the age of 16 he went to Paris, where he worked under Jean Bassot and Hieronymus Francken, but was most influenced by Frans Floris, an important representative of Dutch Mannerism. He returned in 1583 to his father in Amsterdam, but then lived most of his life at Utrecht where he became superintendent of the painters' guild in 1611 and was given permission to keep a studio in the St Clare nunnery. His pupils included Cuyp, Terbrugghen, Honthorst, Weenix and Both. Bloemaert's work includes historical paintings, dramatic, multi-figured mythological scenes, and bucolic landscapes with "picturesque" huts. He never went to Italy, but through his pupils became familiar with Caravaggist chiaroscuro which had first been taken up in Utrecht and was to influence the entire country. Bloemaert's life spanned both the Mannerist 16th century at one end and the period of Rembrandt at the other.

Illustration:

287 Landscape with Peasants Resting, 1650

BOCCIONI Umberto

1882 Reggio di Calabria - 1916 near Verona Boccioni studied painting in Rome from 1898 to 1902. While there, he met Severini and Balla, who introduced him to French Neo-Impressionist ideas. In Paris he explored Divisionism and in particular Seurat's work, but its contemplative air and atmospheric stillness did not satisfy him for long. On his return to Italy he settled in Milan in 1907, the place where the greatest technical advances had been made. In 1910 he signed the Manifesto of Futuristic Painters, together with Carrà, Luigi Russolo, Balla and Severini. When with Severini in Paris in 1911, he met Apollinaire, Picasso, Braque and Dufy. Via Cubism he arrived at pictures which represent the Futuristic ideal of speed and movement. In 1914 his book Pittura, scultura futurista, dinamismo plastico was published, the definitive work on the theory and practice of Futurism.

Illustrations:

576 State of Mind II: Farewells, 1911 576 The Noise of the Street Enters the House, 1911

BÖCKLIN Arnold

1827 Basle – 1901 San Domenico (near Fiesole) Böcklin went in 1845 from Basle to Düsseldorf to study at the Academy for three years under J. W. Schirmer who painted heroic landscapes in the style of Claude Lorrain. Via Geneva, Brussels and Paris he arrived at Rome in 1850. He was full of enthusiam for the Italian landscape and the culture of Antiquity. His friendship with Reinhold Begas, Feuerbach, H. Franz-Dreber and Hans von Marées, the "German Romans", was decisive for his work. Seven years later he went via Basle to Germany, achieving his first success in Munich. Adolf Friedrich, Count of Schack, became his patron, and in 1859 King Ludwig I of Bavaria bought his picture "Pan in the Reeds" for the Neue Pinakothek. At this period his friendship with Lenbach began; a year later he became a professor at Weimar. Böcklin loved and painted Symbolist themes full of pathos, mythological scenes set in fantastic landscapes, and allegories. Towards the end of his life his work became darkly visionary, almost apocalyptic. His emotionalism, at times bordering on the humorous, brought him much criticism, but his supporters admired him fervently. He experimented with colour, explored old and new techniques and materials, including underpainting. He used a wide range of colours, and the intensity of value deepened the mood of his themes. His yearning for independence soon induced him to resign his Weimar post. He moved

to Basle, in 1871 back to Munich, then to Florence. In 1887 he went to Zurich for seven years before finally settling at San Domenico, where he died in 1901.

Illustration:
528 The Waves, 1883

BONDOL Jean

(also: Bandol, Bandolf)

born in Bruges, active 1368-1381 in Paris Bondol is first mentioned in 1368 as court painter to Charles V (the Wise) of France. He was well rewarded, and was later granted a life pension, a mark of high esteem. The inscription on the title page of the bible of Jean de Vaudetar, his only surviving work, reads as follows in translation: "In the year of our Lord 1371 this work was painted at the behest and to the glory of our illustrious lord Charles, King of France, in the 35th year of his life and the 8th of his reign, and John of Bruges, painter to the afore-mentioned King, created this painting with his own hand." Today this picture stands alone in the history of early panel painting of the Netherlands; all other examples have been lost. The esteem accorded to this painter's person and art suggests that the affected style which was the tradition in art at the regal court did not always meet the patron's expectations. The need was met by engaging realistic panel painters and sculptors from the Netherlands. Bondol also did work for other members of the royal household, such as the cartoons produced between 1376 and 1379 for Charles' brother Louis I of Anjou for the famous tapestry series of the Apocalypse of Angers, drawing on an English apocalyptic manuscript from the 13th century in royal possession.

Illustration:

60 Title page of the Bible of Jean de Vaudetar, 1371

BONINGTON Richard Parkes

1802 Arnold (Nottingham) - 1828 London Bonington came from a Nottingham family who left England in 1817 to settle in Calais. There the 15-year-old was taught the aquarelle technique by Louis Francia. In 1818 Bonington went to Paris, where he met Delacroix and made aquarelle copies in the Louvre of Dutch and Flemish landscapes. In 1821–22 he studied under Gros at the École des Beaux-Arts. In 1824 he won a gold medal at the Paris Salon. He travelled all over France and especially Normandy, painting a number of atmospheric coastal and seaport scenes, and also went to England and Scotland, occasionally accompanied by his friend Delacroix in whose studio he later worked. His journey to Italy in 1826 brought him to Venice where he was much impressed by Veronese and Canaletto. Bonington, like Constable, was one of the English artists whose landscape paintings were highly regarded in France on account of their fresh and spontaneous composition. He was one of the first in France to use watercolour paints in the open. His approach to nature as well as his technique stimulated the Barbizon painters and - with E. Isabey, Boudin and Jongkind as mediators - paved the way to Impressionism.

Illustrations:

 466 Beach in Normandy, c. 1826/27
 466 The Column of St Mark in Venice, c. 1826–1828

BONNARD Pierre

1867 Fontenay-aux-Roses (near Paris) - 1947 Le Cannet (near Cannes)

From 1886 to 1889 Bonnard studied law in Paris. However, he rejected a possible career in this field as he had already been studying art in 1888/89 at the Académie des Beaux-Arts and the Académie Julian. There he met Denis, Vuillard and Sérusier, who introduced him to Gauguin's art. In 1889 he sold a stylistically innovative poster design ("France-Champagne"). After a brief period of military service he shared a studio in 1890 with Denis and Vuillard and became co-founder of Nabis, a group of painters favouring symbolist and antinaturalist ideas. From 1891 to 1905 he exhibited at the Independents. His first poster was published, and he met Toulouse-Lautrec. From 1893 his lithographs appeared in La Revue Blanche; from 1895 Vollard published his lithographs and book illustrations which show some influence by Redon. In 1903 he exhibited for the first time at the new Autumn Salon. In 1906 he taught at the Académie Ranson. In 1905 he travelled with Vuillard to Spain; in subsequent years to Belgium, Holland, England, Italy, Algeria and Tunisia. In 1909 he visited southern France for the first time, where he bought a house in Le Cannet in 1925 and settled there for good. Best known and most popular are Bonnard's paintings in the late Impressionist manner with delicate colours of porcelain-like translucence, including interiors, portraits and female nudes as well as landscapes and street scenes. Many of his works appear intimate but are executed with a fine sense of propriety. Although a member of Nabis, Bonnard cannot be classed as belonging to a specific school or group. As with many of his contemporaries, he was fascinated by Japanese art, and this interest comes out in his work.

Illustrations:

At the Circus, c. 1897 520

Female Nude in the Bathtub, c. 1938

BOSCH Hieronymus

(Iheronymus van Aken)

c. 1450 s'Hertogenbosch – 1516 s'Hertogenbosch Bosch, a contemporary of Leonardo da Vinci, is one of the great European painters of his time. The need to decodify his symbolic language, which is no longer generally accessible, although it is essential to an understanding of the spirit of the time, often deflects from the great artistic worth of his works. Bosch's training and early work remain largely in the dark. His attention to minute detail, which also characterises his large triptychs, has led to the assumption that he was trained as miniaturist ("Garden of Delights", ill., p. 135; the "Haywain" triptych, several versions, of which one at the Prado, Madrid; "Last Judgement", Vienna, Gallery of the Akademie der Bildenden Künste). There is no proof of this, however. The disturbing world of his paintings, which often scourges the moral decadence and folly of the world, may have been induced by religious unrest before the Reformation. In the course of his development, Bosch increasingly refined his devices until he achieved a distinctive way of handling colour, combined with an equally distinctive clear outline. This marks him as a contemporary of Leonardo, whose works he may or may not have known. Bosch was, besides Geertgen tot Sint Jans, the great landscape painter in the Netherlands in the 15th and early 16th centuries. He gave the impetus to the development of the "world landscape" such as by Patinir – and also of the autonomous landscape, such as Pieter Brueghel's Seasons. It is significant that Bosch, already highly regarded in his lifetime, should have found particular favour with his "morality" pictures in the very place where the 16th century Inquisition had its worst excesses: in Spain.

Illustrations:

The Garden of Delights, c. 1510

136 The Ship of Fools, after 1490

St Jerome, c. 1500

BOTERO Fernando

born 1932 Medellín, Columbia

Botero grew up in Medellín, an industrial region of Columbia, and then went to Bogotá where he had his first exhibition. Only then did he take up his art studies at the Academía San Fernando in Madrid. In Florence he studied art history. The distinctive feature of his work is the sumptuous shape. He succeeds in combining simple narrative delight with cleverly applied traditional methods and respect for the old masters to achieve a new sensualism and grotesque drollery. In the early 1990s he caused a sensation with his monumental bronze figures of overly stout human beings, which were displayed in public places, including the Champs-Elysées in Paris. Since 1960 Botero has been living in New York.

Illustration:

668 The Family of the President, 1967

BOTTICELLI Sandro

(Alessandro di Mariano Filipepi)

1445 Florence - 1510 Florence

After an apprenticeship as a goldsmith, which was to influence his entire work, he became the pupil of Filippo Lippi from whom he took over the madonna and angel figures, but giving them more expression. There is no proof that he worked under Verrocchio, though this is probable for stylistic reasons. There he would have perfected his talent as master of the sensitively drawn line. His early work takes up the plastic realism of the past generation: the "Adoration of the Magi" (Florence, Uffizi, c. 1475) is characteristic with its clear composition, three-dimensional figures, strong, bright colours and individual treatment of the faces (Medici portraits). Later, the interest in space and physical form diminishes in favour of the richly moving line of slender figures and fine detail of jewels and richly embroidered dress ("Birth of Venus", "Primavera", ill., p. 107). But as his three frescos begun in 1481 on the lower wall of the Sistine Chapel show, Botticelli was well able to achieve monumental effects. He soon became a master of the large format: in his "Cleansing Sacrifice of the Lepers" the centre emerges naturally, the multi-figured groups connect, giving unity to the scene, and foreground, middle ground and background merge into each

In his late work the line gains in sensitivity (92 silver point drawings for Dante's Divine Comedy) and in emotional expressiveness ("Annunciation", Florence, Uffizi, 1490-1495). The religious fervour depicted in these later works may have been the result of Savonarola's sermons calling for repentance, but this tendency was already noticeable in his mature work. With his death in 1510 the 15th-century period of Italian painting came to a close.

Illustrations:

Camilla and the Centaur, c. 1482 00

104 Venus and Mars, c. 1480

106 Madonna del Magnificat, c. 1481/82

106 Pietà, after 1490

107 La Primavera (Spring), c. 1477/78

The Birth of Venus, c. 1485 107

BOUCHER François

1703 Paris - 1770 Paris

His father, a designer of embroidery patterns and ornaments, apprenticed the 17-year-old to François Lemoine. Apparently he stayed there for only three

months, and then went to work under the engraver Jean François Cars. Already in 1723 he won the Grand Prix de Rome, but did not visit Italy until four years later. On his return in 1731 he was admitted to the Academy as historical painter and in 1734 became a member. Rising from professor to rector and director of the Academy, his brilliant career culminated in his appointment as head of the Royal Gobelin factory (1755) and finally as "Premier Peintre du Roi" (1765). The young Boucher developed his style by drawing primarily on Bloemaert, Rubens and Watteau. His early work celebrates the pastoral and idyllic, sometimes in childlike diminutive. He depicts nature with ingenious artifice, also creating pure landscape. The eroticism of his shepherds and shepherdesses is given a very thin veneer of innocence. Mythological scenes with Venus as the focal point are treated on the level of mere amorousness and sensuality; there is no heroism: Mount Olympus has been replaced by the boudoir seen from the perspective of the keyhole. In his portraits, too, Boucher's work realises the Rococo in its purest form. In his final creative years he became the butt of the critics of the new morality and pathos as advocated by Diderot.

Illustrations:

336 The Toilette of Venus, 1751

The Education of Eros, 1742 354

Diana returning from the Hunt, 1745 354

The Breakfast, 1739 355

Blonde Odalisque (Portrait of Louise O'Murphy), 1752

BOURDON Sébastien

1616 Montpellier - 1671 Paris

Bourdon led a restless life. At the age of seven he became apprenticed, and he was already painting the ceiling in a château near Bordeaux when fourteen. Lacking commissions, he became a soldier, but was, however, discharged and went to Rome in 1634, where he painted pictures for an art dealer in the styles of Claude Lorrain, Sacchi, Poussin, Castiglione and L. Carracci. His brilliant technique and skill in copying were obstacles to the development of a personal style. He returned to Paris in 1637, feeling that as a Huguenot he was not welcome in Rome, and again produced "Italian" hunting and battle scenes for a dealer. Bourdon was highly regarded by his contemporaries. In 1648 he was a co-founder of the Académie Royale, where he held a chair and was appointed rector in 1655. In 1652 he acted briefly as court painter to Queen Christina of Sweden, where he painted her seated on a horse (Madrid, Prado). In Paris he decorated the Galerie des Hôtel de Bretonvilliers, later destroyed, which, according to records, seems to have been his best and most individual piece of work.

Illustration:

251 The Finding of Moses, c. 1650

BOUTS Dieric

(also: Dierick, Dirk)

c. 1410–1420 Haarlem – 1475 Leuven Bouts can, besides Memling, be considered the most significant successor to van der Weyden. Little is known about his training and early work. It is not clear whether he was Rogier's pupil or not, but this painter's work certainly became a lasting influence. Bouts developed Rogier's style almost to a radical degree in his verticalization of architecture and figures, the minute rendering of costly garments behind which the body recedes, and the reduction of the individualistic in favour of typification. It is difficult to decide whether Bouts was the representative of a specific, Protestant art of the northern part of the Netherlands, or

whether he was caught up by the wave of "re-gothicisation" sweeping over Europe after the midcentury. In any case, the characteristics already described, intensified, from the Lord's Supper altar in Leuven (1464-1467) to the justice pictures in Brussels (begun 1468). In 1475 Bouts' name first appears in the records of Leuven, where he married Katharina van der Brugghen. He worked in Leuven and became a highly respected painter. His last mention in the records dates from 17 April 1475. As to his work, a clear line still cannot be drawn between his own work and that of others, including his son Dieric Bouts the Younger. It is therefore impossible to make a fair assessment of his art. If the winged altar at Munich known as "the pearl of Brabant" is indeed by his hand, then he must have been one of the greatest landscape painters of his generation.

Illustrations:

30 The Empress' Ordeal by Fire in front of Emperor Otto III, c. 1470–1475

130 Last Supper, 1464-1467

BRAQUE Georges

1882 Argenteuil-sur-Seine - 1963 Paris Braque was apprenticed to a decorative painter in Le Havre, before studying in Paris from 1900. He attended the Académie Humbert and in 1903 the École des Beaux-Arts. The exhibition of the Fauves in 1905 impressed him so profoundly that he joined the group. In contrast to the other Fauves, Braque preferred broken colours: violet and pink. The Cézanne commemorative exhibition in 1907 and his acquaintance with Picasso, in whose studio he had seen the "Demoiselles d'Avignon" (ill. p. 569), altered his direction. He now painted surfaces penetrating each other and arched planes, a system of volumes which in 1908 the critic Louis Vauxcelles called cubes. He also reduced colour to a few tones in favour of form. During the period of analytical Cubism from 1909 to 1912 objects were broken down to become unrecognisable multifaceted planes. The resolution came after 1912 with the large-scale representation which re-united synthetic Cubism in a compositional whole. Until World War I, when Braque was called up, he worked closely with Picasso. When Braque returned after being wounded in 1917 and took up painting again, he developed his own style based on his Fauvist and Cubist experiences. Form was again combined with colour. Braque painted monumental figures and a series of mantel and table pictures. He also re-discovered landscape. After World War II he produced studio interiors and bird pictures in which objects and space, and severity and poetry, are united. The studio interiors are considered the crowning achievement of Braque's œuvre.

Illustrations:

548 Fruit bowl and glass, 1912

572 The Portuguese, 1911

572 The Duo, 1937

573 Still Life with Bowl of Fruit, Bottle and Mandolin, 1930

BRAUNER Victor

1903 Piatra Neamt (Rumania) – 1966 Paris After studying at the Academy of Fine Arts in Bucharest from 1921 to 1924 and an initial visit to Paris in 1925, Brauner settled in the French capital in 1930. He met Brancusi, Giacometti and Tanguy and in 1933 joined the Surrealists whose ideas he tried to pass on when back in Bucharest. In August 1938 he lost an eye while trying to settle an argument, having portrayed himself as one-eyed seven years earlier. His flight in 1940 took him first into the Pyrenees and then the Alps where, for lack of utensils, he discovered wax

painting. In his years of solitude he developed a comprehensive private mythology which he sought to express both visually and in verse. He returned to Paris in 1945 and broke with the Surrealists in 1948. Recurring severe illness induced him to spend three years on the Côte d'Azur where he began work with the potters at Vallauris. In the 1950s, stimulated by Heidegger's existentialism, he produced pictures which dealt prophetically with death. *Illustration*:

612 Miroir de l'incréé, 1945

BRUEGEL, BREUGHEL → Brueghel

BROEDERLAM Melchior

active 1381 - 1409 Ypern (West Flanders) There are earlier references to people of this name in Ypern, yet nothing is known about his upbringing and what affected him artistically. As in so many cases, iconoclasm and wars in the Flemish/French border lands are probably responsible for this. If it were not for the surviving altar in the Carthusian monastery at Dijon, we would not have known of his existence, except for written sources. They tell us that he was highly esteemed by Duke Philipp the Bold of Burgundy whose court painter and valet de chambre he was. He participated in the decoration of Château Hesdin, one of the richest and most finely furnished of its kind. As court artist he also painted portraits and designed costumes. It is recorded that he accompanied the altar to Dijon and visited Paris. The two surviving pictures at Dijon, which adorn a carved altar by Jacques de Baerze, show him to be a painter whose handling of the effect of light and gradation of tone was so masterly that, when in front of these pictures, one actually feels how necessary the refinement of the old technique was to oil-painting. Illustration:

61 The Presentation in the Temple and The Flight to Egypt, 1394–1399

BRONZINO Agnolo

(Agnolo Tori, Agnoli di Cosimo) 1503 Monticelli (near Florence) – 1572 Florence After an apprenticeship with Raffaelino del Garbo, the young Bronzino assisted Pontormo in 1522 with the frescos in the Certosa di Galuzzo near Florence, where he received decisive artistic impulses for his future. But he moved increasingly away from Pontormo's spiritual tendencies, favouring a highly refined, detached aestheticism. In 1539 he participated in the decorations for the wedding of Cosimo I de' Medici with Eleonora of Toledo and won such favour that he became their court painter and portraitist. His portraits, usually painted in cool colours and in which the figures are placed silhouette-like before the background, are the most refined of their kind in the 16th century. During his visit to Rome from 1546 to 1548 Bronzino studied in particular the works of Raphael and Michelangelo, from whose novel ways of portraying the figure he benefited, as is apparent in such works as the fresco "Martyrdom of St Lawrence" (Florence, 1565-1569). In his later work he developed under the influence of what were then the latest theories seeking to unlock the code of allegorical representation. In these works he manages to balance cool sensuality with an elaborate composition. The colour surface often attains an enamelled smoothness. Illustrations:

159 Eleonora of Toledo and her Son Giovanni, c. 1545

180 An Allegory (Venus, Cupid, Time and Folly), before 1545

BROUWER Adriaen

c. 1605/06 Oudenaarde (Flanders) – 1638 Antwerp By birth Brouwer was Flemish, by training Dutch. After the death of his father he probably went at the age of sixteen to Antwerp, a year later to Haarlem. Presumably he had contacts with Frans Hals at this time. In 1631 he returned to Antwerp, became a member of the Lukas Guild and ran a small workshop. Brouwer was always in debt, spending some months in prison. Rubens, who owned 17 of his pictures, probably obtained his release. On his early death during the Plague seven creditors fought over his estate. Brouwer's work always calls to mind scenes of card-playing, smoking, quaffing and brawling peasants - his favourite subjects along with "operations" by the village barber. While early paintings are of strong colour, the more mature work, under Hals' influence, is in deep brown tones, and carried out with great artistic skill and precise psychological observation. After Brueghel, Brouwer is considered the foremost painter of bucolic themes, the greatest collection of 16 of his works being in the possession of the Alte Pinakothek at Munich. Illustrations:

311 The Operation, undated

311 Peasants Smoking and Drinking, c. 1635

BRUEGHEL Jan the Elder

(also: Bruegel, Breughel, Breugel) 1568 Brussels - 1625 Antwerp Because of his penchant for certain themes and glowing enamel paint, Jan, the second son of Pieter Brueghel the Elder, was given the nickname "Velvet" or "Flower" Brueghel. His work, which distinguishes itself from his father's by a refined technique and miniature-like delicateness, was given direction by his grandmother, a miniaturist painter, and his teachers, including Pieter Goetkint and Gillis van Coninxloo. Brueghel spent the years 1589-1596 in Italy; he worked in Rome in 1593/94 and then in Milan in 1596 for Cardinal Federigo Borromeo, who became his patron. In 1597 he returned to Amsterdam and became a member of the Lukas Guild. In 1610 the Archduke of Austria, governor of the Netherlands, appointed him court painter. Brueghel was well-todo and respected, owning several houses in Antwerp as well as a considerable art collection. He was a friend of Rubens with whom he collaborated, including the magnificent flower garland in Rubens' "Madonna in the Flower Wreath" (Munich. Alte Pinakothek) while Rubens painted Adam and Eve in Brueghel's "Paradise" (The Hague, Mauritshuis). Besides historical scenes, paradisiacal images of animals, and genre scenes, he was above all a painter of landscape, often with staffage figures and animals in the foreground, and of flower pieces. As a specialist of "accessories" he collaborated with Frans Francken, Hans Rottenhammer and Momper.

Illustrations:

279 The Animals entering the Ark, 1615

288 Great Fishmarket, 1603

288 Landscape with Windmills, c. 1607

289 The Holy Family, undated

BRUEGHEL Pieter the Elder

(also: Bruegel, Breughel, Breugel)
c. 1525–1530 Breda (?) – 1569 Brussels
His nickname "Peasant Brueghel" harks back to his
depiction of peasant life, proverb and genre scenes,
unduly diminishing the importance of this great
Netherlandish painter of the 16th century. In his
representations of the life of peasants and the underpriveleged, Brueghel penetrated the outer shell,
converting them to images applicable to human
life in general, such as in the folly of the World

("Country of the Blind", Naples, Museo Nazionale di Capodimonte), the transience of material values ("The Land of Cockaigne", ill. p. 205), or the fate awaiting the power-greedy (various versions of the

"Tower of Babel", ill. p. 205).

In some respects Brueghel takes up the concerns of Bosch. He undoubtedly belongs to the phase of European Mannerism in breaking up the composition into small parts ("Proverb" pictures), or the suggestion of movement ("Country of the Blind"). On the other hand, with his later works which show a new overall unity of structure and also greater use of large figures, he paves the way for the Baroque north of the Alps. His visit to Italy in the 1550s, which took him to the far South, might have contributed to this change. His significant place as a landscape painter in the whole of European art in the 16th century is undisputed. In the "Months" pictures created around 1565, colour developed into an elemental force, pointing far into the 17th century.

Illustrations:

Netherlandish Proverbs, 1559 204

The Tower of Babel, 1563 205

The Land of Cockaigne, 1567 205

206 The Corn Harvest, 1565

Hunters in the Snow, 1565

BRUGGHEN → Terbrugghen

BURGKMAIR Hans the Elder

1473 Augsburg - 1531 Augsburg After an initial training by his father, Burgkmair was apprenticed to Schongauer at Colmar, whose style influenced his early work. After 1490 he probably travelled in Northern Italy, spending time in Venice. In 1498 he finally settled in Augsburg and took over his father's workshop. His reputation grew rapidly judging by the commissions he received (e.g. "Basilica Pictures" for the Catharine Foundation, today at Augsburg, Altdeutsche Galerie, 1501–1504). These are still in the tradition of the late 15th century, as fine detail still dominates the overall structure and composition. With the knowledge gained in Italy, Burgkmair later explored the monumental form of the High Renaissance, combining it with a brilliant, warm coloration. (St John's Altar, ill. p. 189). He also made drawings for woodcuts, especially from 1512 to 1518 with his contributions to the large commissions for Emperor Maximilian (Weißkunig, Theuerdank, Triumphal Procession of the Emperor Maximilian). Burgkmair was a key figure in opening the Augsburg art world to the Renaissance.

Illustration:

189 John the Evangelist on Patmos, 1518

BURNE-JONES Edward Coley 1833 Birmingham – 1898 London

After studying theology, Burne-Jones turned to art, and with his friends William Morris and Rossetti formed the nucleus of the Pre-Raphaelite Brotherhood. His work was extensive and varied, including paintings, drawings, designs and illustrations. Like the other members of the group, he endeavoured to revive craftsmanship, paving the way for the Art

Noveau movement. He produced designs for interior decoration, furniture, stained glass, tiles, tapestries and wall paintings for the company Morris, Marshal, Faulkner & Co, of which he was also a partner. His admiration for the Italian Renaissance found expression in his paintings. His themes are of a mythological-allegorical nature and drawn from legends and history, often including heroines with a slightly menacing air. John Ruskin was one of his friends and admirers. In 1890 he was elected to the

Royal Academy, an honour from which he resigned three years later.

Illustration.

526 King Cophetua and the Beggar Maid, 1884

BURRI Alberto

1915 Città di Castello (Umbria) – 1995 Nice From 1934 to 1939 Burri studied medicine in Perugia, and then served four years as a doctor in the Italian Army in North Africa. During this period he began to paint. When he returned from an American prisoner-of-war camp in 1945, he devoted himself wholly to painting. His first abstract paintings appeared in 1949. Together with Giuseppe Capogrossi, Ettore Colla and others he founded the Gruppo Origine in Rome in 1951. Burri then went to America where he earned his living by giving art lessons. From 1960 he worked again in Rome. His work consists of abstract pictures of closely-assembled materials, lacking any formula, in part collage, in part material montage. Colour and the origin and type of materials express strong statements. Since the early 1960s he had been experimenting with burned plastics, working with another group of artists.

Illustration:

643 Sack No. 5, 1953

CAILLEBOTTE Gustave

1848 Paris – 1894 Gennevilliers (near Paris) The son of a middle-class family, Caillebotte was left a large legacy by his father, giving him lifelong independence. In 1870 he completed his law studies and entered the École des Beaux Arts in Paris in 1873. Here he came into contact with the Impressionists and met Monet. He found his motifs in his immediate surroundings: family, street scenes, working life, and scenes from his summer visits to Yerres, especially boat parties. In 1876 he contributed for the first time to the second Impressionist exhibition; then he financed and organised subsequent events. Caillebotte was generous to his needy painter friends, including Monet, Renoir, Sisley and Pissarro, buying many of their pictures and staging exhibitions of their work. In his will, made in 1883, he left his large collection of Impressionist paintings to the French nation on condition that all 67 works were to remain together in the Louvre. He died of a stroke in 1894, and the Institute de France scandalously refused to accept the collection on the grounds that it included works by Cézanne. It was not housed in the Louvre until 1928; today it is at the Musée

Illustration:

505 Paris Street: A Rainy Day, 1877

CAMPIN Robert

c. 1380 Tournai (?) – 1444 Tournai Recent research is agreed on the identification of Robert Campin as the painter who was long called "Master of Flémalle" (named after a triptych said to have been in the Abbey Flémalle near Liège, now kept at the Städelsche Kunstinstitut at Frankfurt/Main). Some of the problem remains unsolved, however: although he is referred to in documentary records, none of his signed works survives. Sometimes he has been placed alongside the young van der Weyden, but stylistic differences speak against this. Rather, a teacher-pupil relationship should be assumed. Campin was born in about 1380 in Tournai, where he was made master in 1406/07 and presumably taught van der Weyden from 1427 to 1432. Together with the brothers van Eyck he can be considered the founder of the Early Renaissance in Netherlandish painting. Evidently outgrowing the Burgundian art of the brothers Limburg, whose

influence could still be felt in Campin's early work ("Betrothal and Annunciation of Mary", Madrid, Prado, c. 1410), he soon turned to three-dimensional figure representation and the exploration of depth ("Adoration of the Shepherds", Dijon, c. 1420). These are late works, when the painter was almost obsessed with all aspects of perspective (e.g. the Mérode altar, so called after its original location; now in New York, Metropolitan Museum, c. 1430; Werl altar, ill. p. 126). Terborch Illustrations.

86 Annunciation, undated

St Barbara, 1438

Portrait of a Man, c. 1435

CANALETTO

(Giovanni Antonio Canal) 1697 Venice - 1768 Venice

As the son of a painter of stage sets, Canaletto was trained in the craft of perspective painting for the theatre, and this was to be a decisive influence on his later work. When in Rome in 1719 he became acquainted with veduta painters. His friendship with Pannini, Vanvitelli and Carlevari resulted in his emphasis on chiaroscuro in his early work. Besides topographical views, his early work also included architectural fantasies and ruin capricci. His pictures were particularly sought after by English collectors, and Canaletto used agents who sold his pictures. The demand was so great that he went to England to paint views of London and of country houses. These pictures are already in the lighter, clearer coloration which he had adopted in the 1730s - a quality he transferred to a certain degree to his graphic work. His avoidance of strong chiaroscuro contrasts in his middle and late work led to the erroneous assumption that Canaletto had abandoned the Baroque. His treatment of light does, indeed, belong to the Baroque, while his discoveries in the coloured rendition of views were to prepare the way to the open-air painting of the 19th century.

Illustrations:

Venice: The Basin of San Marco on Ascension Day c. 1735-1741

The Courtyard of the Warwick Castle, 1751 370

Regatta on the Canale Grande, after 1735 Venice: Campo San Vitale and Santa Maria

della Carità (The Stonemasons' Yard), c. 1726/27

CANALETTO → Bellotto

CANO Alonso

1601 Granada – 1667 Granada

Cano, one of the most versatile talents in 17th century Spain, learned architectural drawing from his father, carpenter and altar builder Miguel Cano, the art of sculpting under Juan Martinez Montanés in Seville, finally studying painting from 1616 to 1621 under Francisco Pacheco, the teacher of Velásquez. His best known architectural work is the facade of Granada Cathedral with its theatrically-baroque triumphal arch motif. On Velásquez' recommendation the king appointed Cano court painter and drawing teacher to prince Balthasar Carlos. In 1643 he painted idealised images of Gothic kings for the Alcázar, which show him to be a painter with an individual style. He has been unfairly accused of eclecticism: his large-scale colour planes may be reminiscent of Reni, but the general approach is genuinely Spanish in its realistic observation and combines an independent manner with an imaginative historicism. Cano's life was eventful. In 1637 he had to flee from Seville to Madrid after injuring a duelling partner. In 1644 he was accused of the murder of his wife and threatened with torture

and imprisonment, so he escaped to his estates in Valencia. In 1650, with the king's help, he was given a sinecure by the cathedral of Granada, fell out with the clerics, was dismissed, took legal action, was ordained as priest in Madrid, and reinstated at Granada as sub-deacon, where he died impoverished.

Illustration:

265 St Isidore and the Miracle of the Well, c. 1646–1648

CAPELLE Jan van de

(also: Cappelle)

c. 1624/25 Amsterdam – 1679 Amsterdam Although quite untrained, this son of a prosperous cloth merchant belongs among the most important marine painters of the Netherlands. Painting was a pastime to him, sparked off through the study of Simon de Vlieger's drawings. It was within his means to have his portrait painted by Frans Hals and Rembrandt, and on his death he left not only a large legacy but also a collection of 197 paintings, including some by Rembrandt, Hals, van Goyen, Brouwer, and van de Velde. Capelle's seascapes, mostly in early morning or evening mood, depict ships on a calm sea or wide river estuaries, with the sunlight reflected on water, sky and ship silhouettes. Less important are his winter scenes, rustic idylls in the style of Aert van der Neer, of which some 40 remain.

Illustration:

326 Ship Scene with a Dutch Yacht Firing A Salute, 1650

CARAVAGGIO

(Michelangelo Merisi, Amerighi da Caravaggio) 1573 Caravaggio (near Milan) - 1610 Porto Ercole Michelangelo Merisi was born in Caravaggio as the son of a ducal architect. His early training was under a little-known pupil of Titian. In 1592 he went to Rome, where he earned his livelihood by painting run-of-the-mill pictures. His contact with Cesare d'Arpino, the most popular painter and art dealer in Rome at the turn of the century, brought recognition but no material independence. However, it is through the art business that Caravaggio met his first patron, Cardinal del Monte, who not only held out the possibility of working independently, but also secured for him his first public commission, from the Contarelli Chapel in San Luigi dei Francesi. Here, Caravaggio developed his characteristic treatment of light, which shoots dramatically into the dark world of his pictures, creating an intensely sharp yet alien reality.

From then on he was inundated by public commissions. Yet because of his violent temper he was constantly in trouble with the authorities. In 1606 he became embroiled in murder and had to flee, finding refuge on the estates of Prince Marzio Colonna, where he painted the Vienna "Rosary Madonna". On his wanderings he paused at Naples, painting exclusively religious themes. In Malta he was put up by the Knights of St John and painted several portraits of the grand master, Alof de Wignacourt. In 1608 he was granted the title "Cavaliere d'Obbedienza". The artistically fertile Maltese period was again interrupted by imprisonment and renewed flight. Going through Syracuse and Messina, where some major late works came into being, Caravaggio went on to Palermo and from there again to Naples. Here the news of the Pope's pardon reached him and, on arriving at Porto Ercole by ship, he was again arrested but later released. By then the ship had sailed, including all he possessed. Struck down by a fever, he died without setting foot in Rome again.

The main stages of this story of a restless and finally hounded man are reflected in his work, albeit

in an unexpected way. Just before 1600 the light, clear coloration of the early work is replaced, almost without transition, by his famous chiaroscuro, combining dynamism with dramatic expression. Then, from the Maltese period onwards, the intensity of this combination is steadily reduced. Perhaps because of his need to paint more rapidly, he began to paint more thinly, and the dark background becomes increasingly part of the overall composition, while the strong contrasting chiaroscuro effect is lessened to such a degree that it can no longer be understood merely as light and shade but as an indication of an increasing spiritualisation. Illustrations:

214 The young Bacchus, c. 1591–1593

228 Basket of Fruit, c. 1596

The Fortune Teller (La Zingara), c. 1594/95

229 The Supper at Emmaus, c. 1596–1602

230 Bacchus, c. 1598

231 The Crucifixion of St Peter, 1601

231 The Entombment, c. 1602-1604

CARPACCIO Vittore

c. 1455 (1465 ?) Venice (?) – 1526 Venice Carpaccio was the principal pupil of Gentile Bellini. In his workshop he learned the precise observation of detail, the "staging" of multi-figured historical scenes and the composition of large-scale paintings. Artistically, however, teacher and pupil differed widely. While Bellini can be considered the "chronicler" of Venice in the late 15th century, Carpaccio was the born "novelist", intermingling freely what was actually before his eyes with his own inventions or with the material of legends. At a higher level he could be called the Benozzo Gozzoli of Venetian art. If Bellini's panels of the "Legend of the True Cross" can only be imagined in their large format, it is possible to see Carpaccio's efforts as book illustrations. This impression is reinforced by his choice of colours, sometimes bordering on pastel shades, as opposed to his teacher's adherence to those colours which are typically associated with the subject matter. Carpaccio created all his major works for Venice: one of the earliest consisted of nine large panels depicting scenes from the legend of St Ursula (ill. p. 122); from 1502 to 1507 followed the scenes from the Lives of Saints George and Jerome for the Scuola di San Giorgio degli Schiavoni. A great number of panel pictures, mostly of religious content, are to be found in collections all over Europe. His mode of telling a story still belongs to the Early Renaissance, but in his brilliant rendering of the light and atmosphere of landscape and interiors, as well as in his handling of perspective, Carpaccio is already abreast of the innovations of the late work of Giovanni Bellini. Illustration:

Scenes from the Life of St Ursula, c. 1491

CARRÀ Carlo

1881 Quargnento (Piedmont) – 1966 Milan After attending classes at the Milan Brera School and working as an independent painter, Carrà joined the Futurists in 1909 and signed their manifesto. When in Paris in 1911, he met Modigliani, Picasso and Apollinaire. His work from this period shows the influence of Cubism, but in a manner that is more dynamic and not restricted to studio subjects. As early as 1915 he terminated his Futurist membership. During his military service he became acquainted with de Chirico and his ideas on "metaphysical" art when at Ferrara in 1917. The vehemence of his Futuristic period was now replaced by stillness, toned coloration and structural objectivity. His former relationship with tradition was renewed: he again occcupied himself with Masaccio, Uccello and Giotto. The result was a new Italian realism of melancholy solemnity – Carrà's third contribution to his chosen art. *Illustration:*

603 Summer, 1930

CARRACCI Agostino 1557 Bologna – 1602 Parma CARRACCI Annibale 1560 Bologna – 1609 Rome CARRACCI Lodovico

1555 Bologna – 1619 Bologna Amongst the trio of Carraccis, Agostino, Annibale's elder brother, was probably less endowed artistically and rather more important in the role of scholarly theoretician, as emerged in the task of decorating the Palazzo Farnese for which he supplied the programme and iconography. As teacher, he advocated the often disputed "academic Carraccisms". Annibale took as his starting point the Mannerist style in his early work ("Butcher's Shop", Oxford, Christ Church Library Collections), developing it through his study of Correggio at Parma (1584/85) and the works of Titian and Veronese, to a sensual classicism enlivened by an inner unrest and true-to-life naturalness, as exemplified by his "Triumph of Bacchus and Ariadne" (ill. p. 227) in the frescos at the Palazzo Farnese. He had already left the "Accademia del Naturale", later called the "eclectic" school, in 1595, which he had founded in Bologna together with his cousin Lodovico and brother Agostino. In the 49 years of his life Annibale gained importance not only for his frescos, but also as a painter of Baroque altar pieces. Lodovico was the head of the school known for its rejection of Mannerism. He also trained both his cousins in his workshop at Bologna. In 1584 they collaborated in the decoration of the Palazzo Fava, in their native city, with mythological friezes which were attacked by the Mannerists and led to the founding of the school, enabling them to uphold their views artistically and theoretically. Lodovico's religious work, in particular, radiates a new, natural and genuine devoutness. Illustrations:

225 The Beaneater, c. 1580–1590

"Domine, quo vadis?" (Christ's appearing to St Peter on the Appian Way), c. 1601/02

226 The Martyrdom of St Stephen, c. 1603/04

226 The Lamentation of Christ, 1606

Triumph of Bacchus and Ariadne, c. 1595–1605

CARRIERA Rosalba Giovanna

1675 Venice - 1757 Venice

As a pupil of Giuseppe Diamantini and Antonio Balestra, Rosalba Carriera initially gained her reputation as a painter of miniaturist portraits. August the Strong, King of Poland, was portrayed by her on several occasions. Her brother-in-law Giovanni Antonio Pellegrini seems to have encouraged her to take up pastel painting. By using this technique in portraiture and perfecting its artistic possibilities, which lie between drawing and painting, Carriera was, if not the inventor of pastel painting, at least the creator of a new influential form of portraiture the face of the age. At the age of thirty she became a member of the Accademia di San Luca in Rome. Her visit to Paris in 1720, where she painted Louis XV as dauphin (Dresden, Gemäldegalerie) and exchanged pictures with Watteau, was of great significance to French pastel painting.

369 Portrait of a Young Girl, after 1708

CASSATT Mary Stevenson

1845 Allegheny City (Pennsylvania) – 1926 Le Mesnil-Théribus (Oise)

The daughter of a banker, she moved with her family to Paris in 1851. From 1853 to 1855 she lived at Heidelberg and Darmstadt. From 1861-1865 she studied at the Pennsylvania Academy of Fine Arts in Philadelphia, then in the studio of Charles Chaplin in Paris. In 1868 she exhibited for the first time at the Salon. While studying at the Academy Raimondi in Parma in 1871, she copied Correggio and Parmigianino and became an admirer of Velázquez and Rembrandt. In 1873 she travelled to Madrid, Seville, Belgium and the Netherlands, and made copies especially of Velázquez and Rubens, before finally settling in Paris. There she met Degas in 1877, who suggested her joining the Impressionists. Her work was greatly influenced by Degas and Renoir, taking as principal subject portraits of women and children. Cassatt took part in the IV to VI and again in the VIII Impressionist exhibition. Her own work was shown by Durand-Ruel in 1891. In 1898 she visited the United States, went to Italy and Spain in 1901, and for the last time to the United States in 1908. In 1910 she became a member of the National Academy of Design in New York. In 1914 she was awarded the gold medal of the Pennsylvanian Academy of Art. Cassatt gradually lost her sight and was compelled to give up painting. It was due to her efforts that French Impressionism became known and understood in America, and also thanks to her initiative that the Havemeyer collection, now at the New York Metropolitan Museum, came into being.

Illustrations:

539 The Boating Party, c. 1893/94

539 Two Children on the Beach, 1884

CASTAGNO Andrea del

c. 1421–1423 Castagno near Florence (?) – 1457 Florence

Castagno's work must be seen in close connection with the older painter Uccello. In their major work, both take as starting point Masaccio and the great sculptors of the Early Renaissance. If Uccello's greatest concern was the art of perspective, Castagno strove to make his figures appear solid and real, although, of course, these two aspects often overlap. We know nothing of Castagno's training. When painting the prophets in the vault the of Capella di San Tarasio on the Santa Zaccaria in Venice in 1442 - the first influx of the Florentine Renaissance into Venetian art - his style was already established. Castagno's art was closest to Donatello. It was probably between 1445 and 1450 that he received a commission for frescos from the monastery Santa Apollonia in Florence. His Last Supper in the refectory represents an important step towards Leonardo's work in Milan. The "naturalness" of the frescos is due to the virtuosity of construction in which perspectival elements and real space merge, giving the illusion of great depth, as well as the lively movement and gestures of the life-sized, ample figures. Probably shortly after 1450 he painted the "Uomini famosi" fresco series in the Villa Pandolfini at Legnaia near Florence (ill. p. 98) for which the sculptural style had been prescribed. Castagno's interest in sculpture and its effect on painting were central to his work.

Illustration:

98 Farinata degli Uberti. From the series "Uomini famosi", c. 1450

CÉZANNE Paul

1839 Aix-en-Provence – 1906 Aix-en-Provence Born during the first generation of Impressionists and spasmodically also belonging to the group, Cé-

zanne nevertheless always went his own way. He was to become a great influence on subsequent generations of painters and can be regarded as the forerunner of modern painting. Introverted, never satisfied with himself, he worked steadily, partly in Aix, partly in Paris, Auvers-sur-Oise, Pontoise, or L'Estaque, and finally only at Aix where he settled. He quarrelled with his boyhood friend Zola, believing that he had been portrayed as an unsuccessful painter in one of Zola's novels. He smarted under the rejection of his contemporaries, feeling that only a few understood him, and worked untiringly, always in doubt whether he would reach his goal of transmitting artistically his perceptions rather than merely rendering them. Financially, he was always dependent on his father, but in his advanced years he at least received recognition of his art. At first destined for a banking career in his father's business house, he gave up his law studies in 1859/60, against his father's wishes, in order to study art. He went to the Académie Suisse from 1862-1865, studied the old masters, and was rejected by the École des Beaux-Arts. Until about 1870 he used thick, dense colours, later called his "baroque" style, painting narrative themes, still lifes, portraits, and studio-painted landscapes based on sketches. Although an admirer of other painters' works, he often used them as the basis of uncomplimentary versions, such as Manet's "Olympia" (Paris, Musée d'Orsay). Pissaro introduced him to the Impressionist circle with whom he exhibited unsuccessfully in 1874 and 1877. Pissaro became his mentor and persuaded him to paint in the open. Despite his close contact with the Impressionists, he did not adopt their methods, preferring to produce something "solid and lasting". He abandoned his early style and used light tone values to define the structures of forms in space, reducing them to their essential features. and so using ideas and structures in order to convey a representation of deeper meaning. Illustrations:

486 Boy with a Red Waistcoat, c. 1890–1895

510 The Card Players, c. 1890-1892

511 Still Life with Apples and Oranges, c. 1895–1900

511 Woman with Coffee-Pot, c. 1890–1895

512 Les grandes baigneuses (Bathers),

c. 1900-1905

Mont Sainte-Victoire Seen from the Quarry at Bibémus, c. 1898–1900

CHAGALL Marc

1887 Liosno (near Vitebsk) — 1985 Saint-Paul-de-Vence (near Nice)

His Jewish origins and rural upbringing in Russia had a lasting effect on Chagall's life. In 1907 he began to study painting at St Petersburg. In 1910 he visited Paris, where he came under the influence of van Gogh and the Fauves, also meeting Modigliani and especially the Cubists, whose ideas of form he explored. Through Apollinaire he came into contact with Herwarth Walden, in whose Berlin gallery Der Sturm his works were exhibited in 1914. From Berlin he returned to Russia, where he was detained by the outbreak of World War I. During this period Chagall succeeded in connecting his own ideas with those of the western avant-garde. His themes centre on his home ground at Vitebsk. On returning to France in 1922, he added to his repertoire scenes of the Mediterranean coast, the Eiffel Tower, Notre-Dame and Pont-Neuf. With Vollard's commission in 1923 to illustrate Gogol's Dead Souls, his extensive and brilliant career as an illustrator began. In 1925 he discovered the circus world which fired his imagination. His darkly glowing pictures give way to brilliant coloration. More than ever his figures and creatures seem to float in the air. With political tension and the

threat of war, his subject matter changed temporarily, such as the symbolic composition "The White Crucifixion" (Chicago, Art Institute) of 1938. Chagall spent the war and immediate postwar period in New York. After a big exhibition at the Museum of Modern Art in 1946, he returned the following year to France where, in 1950, he settled in Vence.

Illustrations:

Double Portrait with Wineglass (Bella and Marc), 1917

590 I and the Village, 1911

590 The Birthday, 1915

591 Bride with Bouquet, c. 1924/25

CHAMPAIGNE Philippe de

(also: Philippe de Champagne) 1602 Brussels – 1674 Paris

First in the studio of Jean Bouillon, then at the workshop of the miniature painter Michel de Bourdeaux, Champaigne acquired in his native city the technical knowledge on which he drew in his later work, particularly his treatment of the surface of materials. In 1620 he entered the workshop of Fouquière, a landscapist and friend of Rubens, where he came into indirect contact with Rubens. He then went to Paris, met Poussin and worked under Georges Lallemand.

In 1628 he had to abandon plans for a visit to Italy as he was appointed court painter to the Catholic Dowager Queen Maria de' Medici, succeeding Duchesnes, whose daughter he married. He worked for the Palais du Luxembourg and decorated churches with frescos. The patronage of Louis XIII and Richelieu soon opened opportunities for portrait painting which he carried out with a new classical refinement and precision, a style that was taken over by the next generation. The loss of his wife in 1638 and of his son in 1642 deepened his religious devotion and he sought closer links to a Jansenist monastery, Port-Royale de Champs, where he sent his two daughters in 1648. During this period his fine portraits of Mother Angélique Arnauld and the Paris Councillors (all in Paris, Louvre) were produced, and the recovery of his last remaining daughter Cathérine inspired him to his famous "Ex-Voto" painting (ill. p. 250). Illustration:

250 Ex Voto (Mother Superior Cathérine-Agnès Arnauld and Sister Cathérine de Sainte-Suzanne, the daughter of the artist), 1662

CHARDIN Jean-Baptiste Siméon

1699 Paris – 1779 Paris

His father, a decorative cabinet-maker and legal adviser to his guild, first sent his son to an insignificant teacher, then in 1720 to Nicolas Coypel, who taught him painting until 1728. Since 1724 he had also been enrolled at the Academy of St Luc. He gained further experience by restoring the frescos of Rosso and Primaticcio at Fontainebleau under van Loo. He first came to public notice in 1728 when he exhibited some works at the "Exposition de la Jeunesse", including the famous still life "The Ray" (Paris, Louvre), and at the recommendation of Largillière, became a member of the Academy as an "animal and fruit painter". Chardin, who had shown his work at the Salon since 1737, now also painted genre pictures as well as still lifes, but the academic hierarchy considered both these categories not worthy of much attention. In 1740 he showed the King his pictures "The Diligent Mother" (Paris, Louvre) and "Saying Grace" (ill. p. 358), and under his patronage was appointed adviser to the Academy in 1743. Public recognition of his still lifes came in the 1750s and 1760s. By now he was also trying his hand at portraiture, though with little success.

Chardin had to resign his various Academy posts in 1774 because of an eye disease. Soon afterwards his friend, the influential engraver Cochin, who had secured many commissions for him, fell out of favour. As for Chardin, his period had come to an end. The new classicism left no room for his style and choice of subjects, but he was rediscovered in the 19th century by the brothers Goncourt and especially the Impressionist painters with their new treatment of light, who saw Chardin as the last outstanding master of the *ancien récime*.

Illustrations:

344 Still Life with Basket of Strawberries,

c. 1760/61

357 Child with Teetotum, 1738

357 Girl with a Racquet and Shuttlecock, c. 1740

358 Pipe and Jug, c. 1755

358 The Grace, 1739

359 The Kitchen Maid, c. 1740

$CHARONTON \rightarrow Quarton$

CHASE William Merrit

1849 Williamsburg (Indiana) – 1916 New York After his initial training by a local portrait painter from 1867 to 1869 and in New York at the National Academy of Design during the years 1869-1871, Chase went in 1872 to the Munich Academy where he was a pupil of Karl von Piloty until 1876. Together with his American friends Frank Duveneck and John H. Twachtman he spent nine months of the year 1877 in Venice, where he was particularly impressed by Tintoretto's work. After his return to New York in 1878 he taught painting at the newly-founded Art Students League. He was an influential teacher, and his studio became the meeting place of young American artists. His contributions to many of the great American Exhibitions established his reputation. After a visit to Paris in 1881 he abandoned his brown-toned Munich style and turned to open-air painting, showing the influence of Impressionism in his lighter colours and more fluid brushwork. Further visits to Europe followed. In 1885 he became acquainted with Whistler. In 1891 he founded at his summer house on Long Island the Shinnecock Summer Art School where he taught primarily landscape painting. In 1896 the Chase Art School in New York followed, which was renamed New York Art School two years later. In 1903 he became a member of the group The Ten American Painters, and in 1908 a member of the Academy of Arts and Letters. Chase, like Whistler, can be seen as one of the great mediators of modern European painting in the USA.

Illustration:

541 Leisure, 1894

CHASSÉRIAU Théodore

1819 Sainte-Barbe-de-Samana (Santo Domingo) – 1856 Paris

At the early age of twelve years Chassériau became a pupil of Ingres who was to influence him all his life. The clarity and severity of his compositions, as well as his emphasis on outline, can be traced back to Ingres' classicism, particularly in his portraits. However, he gradually developed more independence from this dominant model and included elements of Romantic painting. He combined the classical style of Ingres with a lively and contrasting coloration reminiscent of Delacroix, under whose influence he had been since 1838. Chassériau was the only painter who succeeded in combining two such antithetical modes of painting, and so finding a style of his own. This was especially apparent in his representations

of the female nude. His picture "Esther before meeting Ahasuerus" (Paris, Louvre, 1841), shows restrained sensuousness and a refined approach to colour, and Degas regarded "The Sisters of the Artist" (ill. p. 437) as the best painting of the century. After a visit to Algeria in 1846 he concentrated on oriental scenes. Towards the end of his life he devoted himself to mural painting, his principal work being scenes of war and peace at the Court des Comptes of the Palais d'Orsay. *Illustrations:*

437 Pater Lacordaire, 1840

The Sisters of the Artist, 1843

CHIRICO Giorgio de

1888 Volos (Thessalia) - 1978 Rome

The son of a Sicilian railway engineer, Chirico attended drawing classes at the Polytechnic Institute in Athens, then went on to serious artistic education at the Munich Academy from 1906 to 1908, where he became fascinated by Max Klinger's phantastical work and Böcklin's mythological scenes. He returned to Italy in 1909 and began to paint pictures which combine object and scene in a unique way. From 1911 to 1915 he lived in Paris, almost completely untouched by Cubism. The most significant work of this Paris period is the series of "Italian Squares", combining his memories of Turin and Florence squares with antique architecture. The squares are filled with melancholy and enigmatic stillness; shadowy figures, sometimes turning into marble smoothness, hover in front of rows of arcades and windows like dead eyes. They are altogether a vision of alienation and desolation. As a soldier in World War I he met Carrà when in Ferrara in 1917, and both began to paint in this manner. Chirico also produced marionette-like display dummies besides still lifes and interiors.

Illustrations:

602 The Silent Statue (Ariadne), 1913

602 The Prodigal Son, 1922

CHRISTUS Petrus

(also: Cristus)

between 1415 and 1420 Baerle (Brabant) -

1472 or 1473 Bruges

After a long period in oblivion, Christus is today regarded as Jan van Eyck's successor. He was probably van Eyck's pupil, and on his death took over the workshop and completed van Eyck's unfinished work. His significance today lies in his further development of the art of perspective. He was the first painter in the North who arrived empirically at the law of linear perspective and who applied it. His significant portraits are marked by their concentration on just a few characteristic details. He was also the first Dutch master to place the sitter not before a neutral background but in front of a recognisable interior. After he was made master and burgher of Bruges in 1444, van Eyck's influence waned and was replaced by his interest in van der Weyden and Campin. His representation of background, often in the form of landscapes in a mood of quiet harmony, influenced later Netherlandish painters, in particular Bouts, Ouwater and Geertgen. There was no further development in his later work, of which only six signed and dated pictures survive. Illustration:

134 Portrait of a Lady, c. 1470

CHURCH Frederic Edwin

1826 Hartford (Connecticut) – 1900 New York After receiving instruction from two local artists at Hartford, Church studied under Cole at Catskill from 1844 to 1848 and was soon seen as Cole's successor in the American school of landscape painting. His large-scope, large-format landscapes differ from Cole's in their more objective and detailed representation of nature, indicating a profound knowledge of the natural sciences. In 1853 and 1857 Church visited the unexplored parts of South America. A European visit in 1868 took him by way of Greece to the Middle East; in 1869 he travelled through Labrador. The pictures he produced in the various countries show a special interest in botany, geology and metereological phenomena, but rendered in a poetic, even romantic manner in the pale-coloured light of dawn or dusk. Like Fitz Hugh Lane, Church belonged to that generation of artists after Cole who did not think it essential to go to Paris or London for inspiration. Their aim was to paint nature in the state in which God has created it before He created man. To Church, the "paradise" America in its "virginal" charm represented the elemental powers of nature. His portrayal of natural forces in America was also an expression of his belief in the powers of the New World, in the "holy fate of America", as he put it. Illustration:

472 Niagara Falls, 1857

CIMABUE

(Cenni di Pepo, called Cimabue) c. 1240 Florence (?) - after 1302 The most famous painter of his generation (documented 1272-1302), and one of the first great painters of Tuscany, Cimabue also undertook commissions outside his home ground, such as work for ecclesiastical clients in Rome, the series of large frescos in the Upper and Lower Church of St Francis at Assisi, painted glass for Siena Cathedral and mosaics for Pisa Cathedral. He obviously had a large, well-organised workshop, one of the first of its kind in 14th century Tuscany. This is probably where Giotto was trained. The kind of work produced can best be judged by the panel paintings (Madonnas, painted crucifixes): generosity of form; restriction of colour to few, usually schematically distributed tones and clear outline, but in summarily executed detail. As a panel painter the young Sienese Duccio soon became Cimabue's rival. His Santa Trinità picture may have been an attempt at accepting Duccio's challenge, but his alignment to the clever new manner of Duccio merely serves to reinforce the latter's influence, as can be seen from the panels at the Louvre from St Francis in Pisa. Illustrations:

16 Maestà (Madonna Enthroned), c. 1270 (?)

Madonna and Child Enthroned with Angels and Prophets (Maestà), after 1285

CLAESZ. Pieter

c. 1597/98 Burgsteinfurt (Westphalia) – 1661 Haarlem

Born in Westphalia, Claesz settled in Haarlem in 1617. Through him and the painter Willem Claesz Heda, with whom he was often confused, Haarlem became the centre of Dutch still life painting. While in his early work he usually depicted a collection and arrangement of various striking objects, he later developed his so-called "monochrome Banketje", or "breakfast pieces", which show objects on a white cloth, such as filled glasses, a bowl of bread, a plate of fruit, or a cut cake, all arranged as if by chance. He worked in tones of brown, ochre, white and grey, and with only a few sharp accents. The attraction of his still lifes lies in the beautifully executed reflection of light on glass, pewter and copper. Claesz was the father of the landscape painter Nicolaes Berchem.

Illustration:

306 Still Life with Musical Instruments, 1623

CLAUDE LORRAIN → Lorrain

CLEMENTE Francesco

born 1952 Naples

Clemente attended the Humanist Gymnasium in his home town where his passion for Latin, Greek, philosophy and Italian literature was awakened. When in Rome in 1968, he me Twombly, whose work made a great impression on him. In 1970 he began to study architecture in Rome, and a year later he showed his first collages. He spent some time travelling, and visited India and Afghanistan in 1973, later revisiting these countries for a longer period and absorbing some elements of their foreign cultures into his work. In 1980 he went for the first time to New York, where he set up a studio two years later. Besides New York, he lives and works also in Rome and Madras. Clemente's pictures combine abstract forms with figurative elements. Illustration:

671 Untitled, 1983

CLOSE Chuck

(Charles Close)

born 1940 Monroe (Washington, D.C.) Since 1958 Close has studied at several American universities, including the Yale University School of Art, and since 1964/65 at the Academy of Fine Arts in Vienna. He subsequently taught at the University of Massachusetts in Amherst, and in New York, where he has been living since 1967. Close is one of the most important representatives of American Hyper-Realism and Photo-Realism. He paints portraits almost exclusively. Since 1965 he has been using photographs in the passport style which he produces himself, as the basis of his work. The model's head covers the entire surface, and because of the extremely close view, even the pores of the skin and single hairs show up with great clarity in some pictures. His early work is in monochrome; since 1970 he has been experimenting with colour, using layers of primary colours to imitate printing techniques. Since 1979 he has been using Polaroid photographs as models. Since the 1980s he has been trying to lay a separate screen over the pictures, sometimes by means of papier-mâché collages. Illustration:

666 Linda, 1975/76

CLOUET François

(also: François Janet)

c. 1505-1510 Tours (?) - 1572 Paris Clouet was trained by his father Jean Clouet, but little is known of the life of either of them. François went to the French court at an early age, and on the death of his father about 1540 was granted a salary by Francis I. His successor Henry II appointed Clouet valet de chambre and painter-in-ordinary. Contemporary documents give evidence of his high reputation. Only two pictures of importance remain: the "Portrait of Apothecary Pierre Quthe" (Paris, Louvre, 1562) and the "Lady in her Bath" (ill. p. 207). Both works prove Clouet's involvement with the Italian Renaissance, in particular with Leonardo's Lombardic successors. The painter may also have had contacts with the School of Fontainebleau. Illustration:

Lady in her Bath (Diane de Poitiers ?), c. 1570

CLOUET Jean

(also: Jean Janet)

c. 1475 Brussels - c. 1540/41 Paris The origins, training, life and work of the elder Clouet lie largely in the dark. He was probably born in Flanders and perhaps trained by Quentin Massy or one of his circle. On moving to France, he rose to become court painter to King Francis I. The works attributed to him show an undeniably Netherlandish influence, particularly in the rendering of detail. While not a single signed or reliably authenticated work exists, a great number of drawings survive - probably from the period 1515-1540 - which give an insight into his artistic temperament and stylistic development. These drawings formed the basis of the attribution of paintings; no documentary records survive. It is a fact that Clouet was an accomplished, soughtafter portraitist. His works appeal on account of their elegance and a quality of portrayal which is personal and yet presented with a cool detachment.

Illustration:

207 Portrait of Francis I, King of France, c. 1535

COELLO Claudio

1642 Madrid – 1693 Madrid

His father, a bronze caster from Portugal, apprenticed him to the painter Francesco Rizi in order to equip him for taking over his workshop. Rizi, however, recognised the boy's talent for painting. Coello's further training included a visit to Italy and the study of the works of Titian, Rubens and Jan van Eyck, which were kept at the Spanish royal palaces. The court painter Juan Carreño de Miranda obtained access for him, and Coello became his successor in 1685. In 1691 the Chapter of Toledo Cathedral appointed him "titular painter" to the cathedral, where he had already painted the vestry in 1671 in collaboration with José Jiminez Donoso. Coello was predominantly a decorator of sacred buildings, including several frescos in the churches of Madrid, in the monastery of Paular and in the church of the Augustinian monastery La Manteria in Zaragoza - all painted by 1683. His masterpiece is the altar panel for the sacristy in the Escorial: "King Charles II and his Entourage Adoring the Host". Coello was pushed into the background when Giordano arrived in Madrid in 1692. Illustration:

268 King Charles II, c. 1675-1680

COLE Thomas

1801 Bolton-le-Moor (Lancashire) – 1848 Catskill (New York)

Cole came from an Anglo-American family which left England in 1818 to return to America. In England, Thomas had already been trained in drawing and woodcut. From 1823 he studied at the Academy of Art in Philadelphia and later settled in Catskill on the Hudson where he became a cofounder and an important representative of the Hudson River School which established Romantic landscape painting in America. His direct, spontaneous landscapes which he painted in the wilderness of the Catskill mountains soon found recognition and attracted New York buyers. In 1829 and 1841/42 he visited Europe, including England, Switzerland and Italy, studying in particluar the landscapes of Poussin, Claude Lorrain, Salvator Rosa and Jacob van Ruisdael. Having also absorbed philosophical and literary ideas, he introduced a new type of painting in America on his return: the symbolicmoral landscape, such as the thematic series "The Course of the Empire" (New York, Historical Society 1832) and "The Voyage of Life" (Utica, Munson-William-Proctor Institute, 1839/40). These have fantastic, symbolic settings and are full of didactic, allegorical references. In their somewhat kitschy colourfulness, accentuated by theatrical lighting, they do not attain the fine quality of his earlier atmospheric landscapes. *Illustrations*:

474 The Voyage of Life. Youth, 1842

474 The Giant's Chalice, 1833

CONSTABLE John

1776 East Bergholt (Suffolk) – 1837 London Constable was the son of a prosperous mill-owner in Suffolk, a landscape whose scenery became central to his work. He took painting lessons in Suffolk but was largely self-taught. In 1795 he went to London and took courses at the Royal Academy in 1799. As a student he copied the works of the old landscape painters, in particular Jacob van Ruisdael. He was especially impressed by the work of Claude Lorrain and the water-colour paintings of Thomas Girtin; but to him, the actual study of nature was still more important than any artistic model. He refused to "learn the truth second-hand". Unlike any other painter before him, he based his work on precisely drawn sketches made directly from nature. His early work also included portraits and some religious pictures, but from 1820 onwards he devoted himself almost exclusively to landscape painting. His themes were taken from the parts of England that he knew best, mainly Suffolk and Essex, and also Brighton.

In his pictures, Constable succeeded in capturing the light-and-shade effects of clouds and the various moods of landscape. After 1820/21, a period in which he produced a series of cloud studies, the "wind and weather" and their varying light conditions determined his landscapes as never before. His oil sketches were mostly of the same size as the finished picture, if not larger. This leads to the conclusion that to him the study was the original, containing all that mattered. And although public recognition was slowly growing, the critics never tired of pointing out that his works often resembled sketches rather than finished pictures. In 1824 his paintings were shown in Paris and were an instant success, crowned by a gold medal from the Salon. Constable's art became an enduring influence on French painting. In 1829 he became a Member of the Royal Academy.

 ${\it Illustrations:}$

416 The White Horse, 1819

463 Weymouth Bay, c. 1816

463 Salisbury Cathedral from the Bishop's Grounds, 1828

464 The Hay-Wain, 1821

464 Dedham Lock and Mill, 1820

465 The Valley Farm, 1835

COPLEY John Singleton

1738 in or near Boston (Massachusetts) – 1815 London

After the death of his father, a tobacco merchant of Irish descent, Copley first received instruction from his stepfather, the etcher Peter Pelham. As a painter Copley was largely self-taught, studying copies of old masters and also printing techniques and using all available sources of contemporary European painting. In his early twenties he was already a popular portraitist, receiving commissions from New York, Philadelphia and Canada. From 1765 onwards he exhibited in London, where his work was well received by his fellow painters. Following West's invitation, he at last visited England himself in 1774 to perfect his technique. His travels on the Continent were short but intensive. When in London he painted several striking historical pictures, including "Brook Watson being attacked by a

Shark" (Boston, Museum of Fine Arts, 1778), whose topicality had a revolutionary effect. He was made an associate (1775) and then a full member of the Royal Academy (1783). Around this time he began to align himself more with European conventions, a tendency which became more pronounced with advancing years.

Illustrations:

390 Portrait of Rebecca Boylston, 1767

390 The Death of Major Peirson, c. 1782-1784

CORINTH Lovis

1858 Tapiau (East Prussia) – 1925 Zandvoort Corinth studied from 1876 to 1880 at the Königsberg Academy and from 1880 to 1884 under Defregger in Munich. After a visit to Antwerp, where he admired Rubens, he took up further studies at the Paris Académie Julian under Bouguereau and Robert-Fleury from 1884 to 1886. While there, he was particularly impressed by the works of Courbet. From 1887 to 1891 he lived in Berlin; in 1891 he moved to Munich, where he had his first success with his landscapes, religious paintings and portraits. In Berlin, where he went in 1901, he became a member of the Secessionists and then president when Liebermann left. In collaboration with his friend Walter Leistikow he founded a painting school for women. Through his contacts with Slevogt and Liebermann he developed his Impressionist style. In 1911 he became chairman of the Berlin Secession, and in the same year suffered a stroke. From 1918 onwards he lived mostly in his country house at Urfeld on the Walchensee. Corinth's artistic development can be traced throughout his work. From the Impressionists and their forerunners he adopted the technique of broken colour planes and realistic representation. In his narrative themes this realism often borders on the grotesque. Violent brush-strokes, strong colour and compact representation, sometimes in a sombre mood, mark his later work, moving it closer to Expressionism.

Illustration:

535 Self-Portrait with Straw Hat, 1923

CORNEILLE DE LYON

(Corneille de La Haye)

c. 1500/10 The Hague – after 1574 Lyon (?)
The life and work of this master, who was not rediscovered until the end of the 19th century, even now remain obscure. A number of stylistically related, miniature-like portraits painted against a usually light, neutral background, are attributed to him. Corneille is first mentioned in 1534 in Lyon, where in 1541 he became painter to the dauphin, later King Henry II. In a document dated 1547, The Hague is given as his birthplace. In 1564 Katharina de'Medici is said to have visited Lyon in order to see the painter and his work. The last record dated 30th March 1574 confirms his privileges as painter and valet de chambre to the King. Illustration:

208 Portrait of Gabrielle de Rochechouart,c. 1574

CORNELIUS Peter von

1783 Düsseldorf – 1867 Berlin

Cornelius belonged to the instigators of idealistic fresco painting in 19th century Germany. In 1811 he had joined the Nazarenes in Rome, having already made "old German art" his model, at the encouragement of the brothers Boisserée and Canon Wallraf. In 1816 he painted two frescos of the Old Testament story of the life of Joseph for the Prussian consul-general Bartholdy at the Palace Zuccari. These brought him such fame that he was called both to the Düsseldorf and Munich

Academies simultaneously in 1819. He accepted both appointments, commuting between these cities, but finally deciding on Munich. Here he was appointed director of the Academy in 1824 and, unlike in Düsseldorf, he had the opportunity to paint large frescos. However, he fell out with King Ludwig I of Bavaria over his wall paintings in the Ludwigskirche in Munich, and went to Berlin in 1840 where he made the designs for the planned Camposanto. With their exhibition in 1859 in Berlin and Düsseldorf, Idealism celebrated a late triumph.

Joseph makes himself known to his brothers, c. 1816/17

COROT Jean-Baptiste Camille

1796 Paris - 1875 Paris

After an apprenticeship of five years in a drapery business, Corot studied painting from 1822 to 1825, first under the painter Michallon, then under the Classical landscape painter Victor Bertin, and copying works by Joseph Vernet and others, including the 17th century Dutch masters. Convinced that "man can only be an artist when he has recognised in himself a strong passion for nature", he painted, or mostly sketched, outdoors, working in the forest of Fontainebleau, at Dieppe, Le Havre, Rouen and at Ville d'Avray where his father owned a house. His first visit to Rome from 1825 to 1828, which was to become decisive in his artistic development, produced a number of oil-studies painted from nature, views of historical Roman monuments and the scenery surrounding Rome. They are of an unusual freshness, catching the light and atmosphere of different times of the day with delightfully subtle variations in tonal values. The actual paintings based on these studies, for example, the "View of Narni" (Ottawa, National Gallery of Canada, 1826), painted for the 1827 Paris Salon, are in comparison rather formal, in the manner of the New Classicism.

On his return from Italy Corot worked in various parts of France. He also visited Italy again (in 1834 and 1843), and went to Holland (1854) and England (1862). His friendship in the late 1840s with the Barbizon painters Rosseau, Millet, Troyon and Dupré greatly influenced his art. Around this time he changed his style; his romantic-lyrical landscapes ("Paysages intimes") interpret nature in her various moods, and in the most delicate dull silver tones. His landscapes had an inspiring influence on the Impressionists, who wished to include him in their first Exhibition.

Illustrations:

418 View of Genoa, 1834

View of the Colosseum from the Farnese Gardens, 1826

Le Coup de Vent (The Gust of Wind), c. 1865–1870

435 Agostina, 1866

436 Woman in Blue, 1874

436 The Studio (Young woman with a mandolin),

CORREGGIO

(Antonio Allegri)

c. 1489 Correggio (near Modena) – 1534 Correggio

After his training, probably in Bologna and Ferrara, Correggio developed his own style based on Leonardo and 16th century Venetian painting. His innovations were of the utmost importance to European art. He developed new ways of handling light and colour, creating the illusion of open walls and ceilings. Stimulated by the treatment of light by Mantegna (Camera degli Sposi in Mantua, Palazzo Ducale) and Leonardo (Sala delle Asse, Milan, Cas-

tello Sforcesco), Correggio opened up the refectory ceiling in the Convento di San Paolo in Parma (1518/19) purely by using his new painterly devices. The cupola frescos in San Giovanni Evangelista (Christ ascending to heaven, 1521–1523) and in Parma Cathedral ("Ascension of Christ in Glory", 1526–1530), show that he did away completely with the upper margin so that his frescos cover the entire cupola.

In his altar pieces and mythological scenes Correggio increasingly abandoned outline, using colour and light to balance forms and in this way achieving an overwhelming radiance. The High Renaissance structure, whose principle was founded on the antithesis of statics and dynamics, was transformed by Correggio to asymmetry and movement, as shown by his foreshortened figures whose posture is often complicated. ("Madonna and St Sebastian", Dresden, Gemäldegallerie, c. 1525; "Madonna and St Jerome", Parma, Galleria Nazionale, c. 1527). Correggio's treatment of light and shade ("The Nativity", Dresden, Gemäldegallerie, c. 1530; "Zeus and Io", ill. p. 175) was to point far into the future. Illustrations:

174 Leda and the Swan, c. 1531/32

174 Zeus and Antiope, c. 1524/25

75 Zeus and Io, c. 1531/32

The Abduction of Ganymede, c. 1531/32

CORTONA Pietro da

(Pietro Berrettini)

1596 Cortona - 1669 Rome

As an architect and painter of easel pictures and interior decorations, this versatile and talented artist already achieved fame in his lifetime. He received his initial training under the Florentine Andrea Commodi with whom he went to Rome in 1613 to complete his studies under Baccio Ciarpi. Early works, such as the "Triumph of Bacchus" (Rome, Pinacoteca Capitolina, c. 1625), still show the marked influence of Carracci. From 1623 he worked under the patronage of the Sacchetti, decorating their villas in Ostia and Castelfusano with frescos. His greatest patrons were, however, the Barberini. He not only painted for them the frescos for the Santa Bibiana church (1624-1626), including various altar pieces, but also the ceiling of the salon in the Palazzo Barberini (Rome, 1633–1639) which contained the greatest number of frescos in contemporary Rome. Here, Cortona proved himself as a great innovator of interior decoration. From 1640 to 1647 he worked in Florence where, under Ferdinand II, he painted the entire upper floor rooms facing the street in the Palazzo Pitti. Cortona also had great talent as a panel painter, as can be seen in such works as "The Sacrifice of Polyxena" or the "Rape of the Sabines" (both Rome, Pinacoteca Capitolina). Illustration:

236 Holy Family Resting on the Flight to Egypt, c. 1643

COSSA Francesco del

1436 Ferrara – 1477/78 Bologna With Cosmè Tura and Ercole de' Roberti, Cossa was one of the great trio of the Ferrara school of painting. Although less fantastic in temperament than Tura, it is sometimes difficult to distinguish the one from the other. For example, the "Allegory of Autumn" has been variously ascribed to either, but the powerful, statuary representation, the purity of outline reminiscent of Piero della Francesca, the brilliance of colour and the abundance of light flooding the landscape – which can also be traced back to Piero – point to Cossa rather than Tura (Berlin, Gemäldegalerie). Very possibly Donatello's work in Padua also played an important role in formulating the young painter's style. In his early work he en-

deavoured to create solid figures despite the dominance of dress, using the devices of perspective in his construction of space. In the 1460s he collaborated with Tura on the most important project of the Early Renaissance in Ferrara: the decoration of the Sala dei Mesi in the Palazzo Schifanoia. Although only fragments of it survive, Cossa's contribution depicting the months of March, April (ill. p. 113) and May fortunately remain in good condition. It appears that Cossa, though a master of the fresco, received less recognition and financial reward than Tura. He moved to Bologna where he died in 1477/78.

Illustration:

113 Allegory of the Month of April, 1470

COTÁN Juan Sánchez

1561 Orgaz (near Toledo) - 1627 Granada Cotán's life was uneventful. He was trained by the Mannerist painter Blas del Prado from Toledo. In 1604 he joined the Carthusian order and entered El Paular monastery near Segovia. Eight years later he moved to the order's monastery in Granada which he decorated with frescos. He died there aged 66. Although the influence of his realism continued into the later part of the 17th century in various respects, during his lifetime Cotán's style seems to have been uniquely personal. In particular in his "Bodegones", the kitchen pictures, and in his still lifes, he developed an unmistakable language of his own in its umcompromising clarity and downright expression. The ascetic, so often emphasised in the scenes of monastic life and images of saints in baroque Spanish painting, does not enter into the world of inanimate objects in Cotán's work.

Illustration:

259 Still Life (Quince, Cabbage, Melon and Cucumber), c. 1602 (?)

COURBET Gustave

(Jean-Désiré Gustave Courbet) 1819 Ornans (near Besançon) – 1877 La Tour-de-Peilz (near Vevey)

After attending the grammar school at Besançon, Courbet began to study law in Paris in 1840. In painting he was largely self-taught, learning his art by copying the old masters (Velázquez, Hals, Rembrandt and the Venetians) in the Louvre, and in Holland where he stayed in 1846. In 1844 he exhibited for the first time at the Salon. In 1848 he met Corot, Daumier and Baudelaire. The themes of his early works, taken from Goethe's Faust and the books of Victor Hugo and George Sand, still bear the strong mark of Romanticism which he was soon to reject. These early works include landscapes, painted at Fontainebleau, and portraits of members of his family ("Juliette Courbet", Paris, Musée du Petit Palais, 1844) as well as self- portraits. He was first accepted at the Salon in 1843 with his picture "Courbet with Black Dog" (Paris, Musée du Petit

In 1849/50 his first "realistic" pictures are produced at his home town of Ornans: "Peasants from Flagey returning from Market", "The Stone Masons" (destroyed in 1945, kept at Dresden, Gemäldegalerie), and "Burial at Ornans" (ill. p. 444) which were considered revolutionary. Revolutionary they certainly were in their choice of subject, depicting the life of simple people (Courbet rejected all traditional subject matter) with an unsentimental, down-to-earth manner of representation. Courbet aimed at a realistic art with a social function. "I maintain that painting is clearly a concrete art whose existence lies only in the representation of real and existing objects..." Courbet's work is characteristic in its strong brush strokes, sometimes applying paint directly with the spatula,

mostly in dark tones. Maupassant observed the painter at work at Etretat in 1869, giving a pointed account of his method: "In a large, empty room a gigantic, grimy and untidy man applied blobs of white paint to a large, empty canvas with a kitchen knife. From time to time he went to the window, pressed his face against the pane and looked out at the storm. The sea came so close as if to smash the house, covering it with spume and noise... The work became "The Wave" and brought disquiet to the world."

When, in 1855, Courbet was rejected by the jury of the World Exhibition, he set up his own "Pavillon du Réalisme" next door to the exhibition building in protest and as an example of his perception of art, demonstrating it by displaying forty of his pictures. One of them was the "Painter's Studio" (ill. p. 446), which included a picture of his friend, the Socialist philosopher Proudhon, whose political convictions had a great influence on Courbet. Courbet was very successful with his work in Germany where he stayed in Frankfurt am Main in 1858/59 and in Munich in 1869. He joined the Paris Commune in 1871 and was given the task of protecting the museums from war damage. When the Commune was defeated, he was sentenced to six months' imprisonment. He took refuge in Switzerland in 1873. Courbet, who influenced and advised the budding Impressionists, has become a major representative world-wide of a naturalistic realism which shows up inconsistencies in reality by means of artistic devices.

Illustrations:

The Cliffs at Etretat after the Storm, 1870

443 The Winnowers, 1853

Young Woman on the Banks of the Seine, 1857

444 Burial at Ornans, c. 1849/50

The Painter's Studio: A Real Allegory, 1855

COUSIN Jean the Elder

c. 1490/1500 Soucy (near Sens) - c. 1560 Paris Cousin achieved high recognition during his lifetime. Registered as master in his Paris guild in 1538, he received all kinds of commissions from representative bodies, including some for panel pictures, decorations for festivities, tapestry cartoons and clerical dress designs. There was no need for him to serve at the court and so he was able to live the independent life of a prosperous burgher. His book on perspective, Livre de perspective, was for a long time a kind of textbook used in French workshops. The extent of his œuvre is as yet unclear. His best-known panel painting, "Eva prima Pandora" (Paris, Louvre, c. 1550), encourages the assumption that he was connected with the School of Fontainebleau. In any case, the plastic rendering of figures as well as the coloured modulation of outline indicate his interest in the art of the Italian High Renaissance.

Illustration:

208 St Mammès and Duke Alexander, 1541

CRANACH Lucas the Elder

1472 Kronach – 1553 Weimar

Lucas Sunder or Müller, who named himself after his Upper Franconian home town Kronach, probably spent his first years of training in his father's workshop. Nothing is known about his further training and his years of travelling. There is evidence that he worked C.1500–1504 in Vienna, making drawings for woodcuts and also painting. He had evidently studied Dürer's graphic art intensively. In his paintings, however, he showed at this time an imagination tending towards "romanticism", combined with an emotionalism heightened by colour – characteristics which formed the basis

of his genius ("Crucifixion", Vienna, Kunsthistorisches Museum, c. 1500; "Crucifixion", Munich, Alte Pinakothek, 1503; "Resting on the Flight to Egypt", ill. p. 196). In the works of this period, today regarded as the "true" Cranach, landscape and theme are brought to an atmospheric unity which must have impressed the young Altdorfer deeply. Cranach can be regarded as one of the founders of the Danube school.

In 1504 he moved to Thuringia, following an invitation to become court painter to Frederick the Wise, and in 1505 settled permanently at Wittenberg. This concluded his first creative phase in which he produced his most important work belonging to the Dürer era. This gave place to a completely new style for which the courtly climate must at least in part have been responsible. A visit to the Netherlands in 1508 brought him into contact with Dutch art and indirectly with the conventions of the Italian Renaissance. Cranach's love of fine detail increased at the same rate as his intellectual perception of construction ("Torgau Altar", Frankfurt am Main, Städelsches Kunstinstitut, 1509), proportionally losing the rapt spontaneity of his early work. There is a faint echo of it in some works, such as his picture of "Cardinal Albrecht of Brandenburg before the Crucified One" (ill p. 196). Cranach soon gained great esteem in Wittenberg. As a friend of Luther, he became the great portraitist during the Reformation without, however, committing himself to any particular confession. In the second quarter of the 16th century, while his workshop was flourishing, Cranach increasingly favoured a style tending towards the over-refined and Mannerist. This is especially noticeable in his depiction of the female nude, such as the panels of the Fall of Man and of Venus and Lucretia. This, too, may have been partly induced by courtly life with its predilection for erotic representation.

Illustrations:

196 Rest on the Flight to Egypt, 1504

196 Cardinal Albrecht of Brandenburg before the Crucified One, c. 1520–1530

97 Hercules and Omphale, 1537

CRANACH Lucas the Younger

1515 Wittenberg – 1586 Weimar

Cranach the Younger was a pupil of his father. In the mid-1530s he began to play an increasingly important role in his father's workshop, finally taking it over at his death. Although generally just as successful as his father, he never achieved his artistic greatness. Because he adopted his father's late style, there have been problems with attributing some of the works ("The Fountain of Youth", ill. p. 197; "Portrait of Lucas Cranach the Elder, Florence, Uffizi, 1550). His work, however, lacked the breadth of emotion and imaginative spontaneity which mark his father's art. His best works include portraits and simple versions of allegorical and mythical scenes.

Illustration:

197 The Fountain of Youth, 1546

CRESPI Giuseppe Maria

(called: Lo Spagnuolo)
1665 Bologna — 1747 Bologna
Despite the fact that Crespi never left his home town, he has nothing in common with what marked the academic school of painting at Bologna two generations earlier. Crespi abandoned the heavy corporeality in favour of mobile, strong figures of a new naturalness. Luigi Crespi, his son, a mediocre painter and his father's biographer, stated that his father had studied the effect of light in nature. In his set of paintings "The Seven Sacraments" (Dresden, Gemäldegalerie) Crespi not only proves to be a

close observer of gesture, movement and facial expression, but that he also found new ways regarding chiaroscuro. It is this irregularity and unpredictability of light and shade which animates his genre scenes ("Peasant Family", Budapest, National Museum; the "Fair of Poggio a Caiano", Florence, Uffizi). In pictures, such as "The Flea" (ill. p. 239) or "Kitchen Maid" (Florence, Uffizi), his persuasive power lies in the total abstention from excessive allegorical elevation and the humorous lightness of the narrative style.

Illustration:

239 The Flea, c. 1707-1709

CRIVELLI Carlo

c. 1430–1435 Venice – before 5 August 1500 Ascoli Piceno (?)

Although an outstanding talent within Venetian art of the Early Renaissance, Crivelli never succeeded in achieving a synthesis of his artistic abilities. He received his decisive impressions by working within the circle surrounding the workshop of Francesco Squarciones at Padua and studying the early works of Mantegna. The school of Ferrara, in particular Cosmè Tura, also became important in his later work, not only in developing his "goldsmith's style", but also in his combined depiction of several unrelated scenes set in unreal spatial surroundings ("Madonna della Passione", Verona, Museo di Castelvecchio). He lived in Venice until 1457 and then went into exile after being threatened with imprisonment, working first at Zara (today Zadar, Dalmatia), then in the late 1460s at Ascoli Piceno where he painted his major works. The large polyptych in the cathedral of Ascoli Piceno (1473) is characteristic of his style: sharply-angled, modelled figures clad in stiff-textured garments, often as if made of metal, which in this way create a unity with the splendour of the painted jewels and carved frame

Illustration:

112 Annunciation with St Emidius, 1486

CUCCHI Enzo

born 1949 Morro d'Alba (near Ancona)
Cucchi lives and works in Ancona and Rome. After his training by a restorer, he worked from 1966 to 1968 as a surveyor before devoting himself entirely to art. Together with Sandro Chia, Francesco Clemente and Mimmo Paladino, he is a member of the Arte cifra group. This movement does not advocate concentration, but rather openness; not clarity of expression, but, as its name suggests, "chiffre". With his drawings and pictures, Cucchi enters an enigmatic world that is sometimes demonic, sometimes slightly comical. His with drawal to an entirely self-contained artistic subject may, however, not be as absolute as it appears.

Illustration:

671 Headless Hero, 1981/82

CUYP Aelbert

(also: Cuijp)

1620 Dordrecht – 1691 Dordrecht Cuyp, whose repertoire embraces portraits, land-scapes, animals and still lifes, could best be compared to Rembrandt in terms of versatility, although his reputation was based on landscape painting. He was a pupil of his father Jacob Gerritsz, and also a pupil of Bloemaert, but his study of the works of van Goyen with his harmonious goldenyellow coloration became the decisive factor in his art. His favourite subject matter was Dordrecht and its surroundings with the canals, the peaceful river flats and plains where the cattle graze under a

radiant sky imparting a warm glow to the scene. Be-

cause of his fine handling of light in all its nuances

he was called the "Dutch Claude Lorrain". In his later work, after 1660, the influence of the Italianised landscape and classical pastoral, as depicted by Jan Both, became even more pronounced. The range of colours is extended, and mountains and rocks, antique ruins and idyllic shepherds enter his pictures.

Illustration:

323 Rooster and Hens, undated

DAHL Johann Christian Claussen 1788 Bergen – 1857 Dresden

After working as a decorative painter in his Norwegian home town of Bergen, Dahl studied landscape painting at the Copenhagen Academy from 1811 to 1818. Here he was impressed with Jens Juel and Eckersberg, but his decisive influence was the study of the Dutch masters of landscape of the 17th century. One of them, Allaert Everdingen, had visited Norway and subsequently developed a type of "northern landscape" based on his impressions. This style was later taken up by the Norwegian national movement in the 19th century. Alongside the "Italian landscape", the "northern landscape" also became established on the Continent in the early 19th century. Stimulated by his first extensive travels through Norway in 1826, Dahl added to his existing range of motifs - waterfalls, moving clouds and windswept trees - by exploring the bare plains of the high mountain regions and their cloud formations. Dahl was an innovator in the art of German as well as Norwegian landscape painting. In 1818 he settled at Dresden, joining the circle of Friedrich and Carus. In 1824 he was, like Friedrich, appointed professor at the Dresden Academy. Dresden and its surroundings feature frequently in his work, in which the sky often occupies the largest part of the canvas. During his visit to Italy in 1820/21 he found subject matter for a third range of themes.

Illustration:

462 View through a Window to the Chateau of Pillnitz, c. 1824

DALÍ Salvador

(Salvador Felipe Jacinto Dalí y Domenech)
1904 Figueras (Catalonia) — 1989 Figueras
Dalí was a trouble-maker even in his student
days. After three years at Madrid Academy he was
expelled in 1924. In 1925 he became interested
in Sigmund Freud's psychoanalysis, but his
dreams and visions did not take centre stage until
the height of Surrealism in Paris, where Dalí settled in 1929. He interpreted "The Evening
Prayer" or "Angelus" by Jean-François Millet (ill.
p. 442) as a symbol of sexual repression, and the
story of William Tell as a legend of incestuous mutilation ("The Enigma of William Tell", Stockholm, Moderna Museet).

Dalí described his way of not portraying the visible object but rather its associations, as a "paranoid-critical method". After a stay at Cadaqués with René Magritte, Luis Buñuel and Paul Eluard and his wife Gala, the Muse of the Surrealists, Gala remained with Dalí. He took part in all the activities of the Surrealists until 1937, when Breton announced his official expulsion. He travelled in Italy from 1937 to 1939, studying Andrea Palladio's architecture and Renaissance and Baroque painting. In 1940 he went to America where he proclaimed his return to classical art. In 1949 he returned to Port Lligat in Spain and converted to Catholicism. In 1951 his Mystical Manifesto appeared. In 1971 a Dalí Museum was opened, and it was transferred to St. Petersburg in Florida in 1982. In 1979 the Pompidou Centre in Paris put on the largest-ever Dalí retrospective, afterwards moving on to London.

Illustrations:

556 The Temptation of St Anthony, 1946

613 The Persistence of Memory, 1931

613 Burning Giraffe, 1936–1937

DAUBIGNY Charles-François

1817 Paris - 1878 Auvers-sur-Oise Daubigny was given instruction by his father, a landscape painter. After visiting Italy, he worked at the Louvre in Paris as a restorer and also as an illustrator in 1836. In 1840 he studied briefly under Delaroche. He had his first success at the Salon in 1840 with a picture painted in the heroic landscape style, but his graphic work became more important in the 1840s. He met Corot in 1852, who encouraged him to paint directly from nature, and this friendship became decisive. Daubigny, the youngest of the Barbizon school of painters, took as his motif the river scenery of the Seine, Oise and Marne. The strong coloration, the light and fluid brushwork, as well as the light-flooded atmosphere of his work make him a direct precursor of the Impressionists. In order to capture the changing character of river life, he had a studio boat fitted out in 1857. In it he cruised the Seine and Oise all summer, enabling him to paint larger pictures from nature. Monet later adopted the same method. From Auvers-sur-Oise, where he settled in 1860, he undertook various journeys: in 1866 and again in 1870/71 to England, in 1868 to Spain, and in 1870 and subsequent years to the coast in Holland. In 1872 he acted as adviser to Cézanne. In 1874 he was invited to show his work at the first Impressionist exhibition. Although the pictures he produced in the 1850s won the admiration of buyers and also official public recognition – he received the first-place medal of the Salon three times - his later works, which, under the influence of Courbet, were of a larger format with less careful brushwork, aroused strong criticism, with his pictures described as "unfinished" and sketchy. Illustration:

DAUMIER Honoré

438 Landscape at Gylieu, 1853

1808 Marseille – 1879 Valmondois (near Paris) Daumier was first sent as trainee and errand-boy to a legal official, then worked in a bookshop, and in 1822 finally entered the studio of Alexandre Lenoir, a former pupil of David. At the same time he studied antique sculpture in the Louvre as well as copying Titian and Rubens. In about 1828 he learned the new technique of lithography. As an enthusiastic Republican he began to draw political caricatures, one of which led to six months' imprisonment. From 1832-1835 he was a member of the staff of the paper La Caricature which published his "masks" – caricatures of politicians and scathing satires. When the law against the freedom of the press put an end to this work in 1835, he changed over to the Charivari, a paper committed to social criticism. His caricatures of the Parisian petty-bourgeoisie soon attracted attention. He was also ruthless in exposing the upper classes and directed his scathing wit against legal restrictions and against the monarchy and parliament, against the Church and the Establishment as well as the Academy and Classicism. To him, only the lowest class deserved his sympathy.

In 1845 Daumier began to paint pictures, primarily using literary subjects taken from the writings of Cervantes and Molière, and also from the lives of ordinary people. With paintings such as "Washerwoman" (ill. p. 440) and "Third Class Carriage" (New York, Metropolitan Museum of Art, c. 1862) he became a major representative of social realism in painting. There is no other painter in the 19th century to equal the succinctness with which he

presented his figures like monumental silhouettes with wide brushstrokes in pasto on the canvas. Balzac quite rightly compared him to Michelangelo. Daumier strove for a career as painter and sculptor but was constantly compelled to resort to lithography for journalistic purposes as a means of earning a livelihood. In 1865 he retired to Valmondois near Auvers-sur-Oise where, in 1879, he died impoverished and almost blind in a house which Corot had given him.

Illustrations:

- The Emigrants, 1852/55 440
- 440 The Washerwoman, c. 1860
- Don Quixote, c. 1868 44 I
- The Melodrama, c. 1860 44 I

DAVID Gerard

c. 1460 Oudewater (near Gouda) – 1523 Bruges David is the only Dutch painter who, without direct knowledge of Italy, achieved an overall unity of structure comparable to that of the Italian High Renaissance. For his starting point he went back over two generations to the brothers van Eyck, combining their concept of reality with current ideas on the representation of space and figure in 15th century Netherlandish painting. It is not known where David received instruction, but the influence of Rogier van der Weyden and Hugo van der Goes in his early work is undeniable. In 1484 he was registered as a member of the Bruges guild. His commissioned work was predominantly for ecclesiastical clients and reached its highest perfection when the subject matter portrayed a certain fixed state (triptych "The Baptism of Christ", ill. p. 199). Scenic elevation did not always suit his temperament ("The Wedding at Canaan", Paris, Louvre, c. 1503). David's great skill in unifying figure and landscape was of great importance for future development. Many followed his example in Bruges, particularly in book illumination.

Illustrations:

- The Mystic Marriage of St Catherine, 199 c. 1505-1510
- The Baptism of Christ, c. 1505

DAVID Jacques-Louis

1748 Paris – 1825 Brussels

David's beginnings still had their roots in Rococo painting. After the early death of his father, a haberdasher, he was brought up by two uncles, an architect and a builder, who fostered his artistic talent. Boucher became his friend and adviser. At his recommendation David began studying under Vien in 1766. Several attempts to win the first Academy Prize failed, plunging him into despair. Finally, in 1774, he gained the prize which opened his way to Rome, where his teacher Vien had just been appointed director of the French Academy. Here David copied antiquities with great dedication; Rome became his most important experience, effecting the change from a painter of the Rococo to Neo-

On his return from Rome in 1781 he was accepted by the Academy, becoming a full member two years later. Besides portraits, he painted almost exclusively historical works with classical themes. His basic attitude found expression in the "Oath of the Horatii" (ill. p. 365). For its completion David went to Rome with his family where the picture was a triumphant success, just as at the Paris Salon in 1785. Politically, David ranged himself with the extreme left-wing of the Revolution, voting for the death of the King. In 1794 he headed the Convention and abolished the Academy. French art history owes much to his defence of artists and works of art as well as medieval monuments. After periods of imprisonment, he became a follower of Napoleon who appointed him

first painter to the Emperor in 1804. After the fall of Napoleon David was banished, and he went to live in Brussels where he spent his remaining creative years. Today, David's reputation owes more to the portraits than to his large historical pictures. As teacher of the most important painters of 19th century France he is the true artistic founder of the new epoch.

Illustrations:

- The Death of Marat, 1793 364
- 365 The Oath of the Horatii, 1784
- 365 Madame Récamier, 1800
- Napoleon in his Study, 1812 366
- Napoleon Crossing the Alps, 1799 366

DEGAS Edgar

(Hilaire Germain Edgar de Gas)

1834 Paris - 1917 Paris

Degas came from a cosmopolitan, well-to-do family. Soon after taking up legal studies, he discovered his interest in painting, in particular in Ingres and the masters of the Italian Renaissance. Between 1853 and 1859 he studied at the Ecole des Beaux-Arts in Paris, worked at the studio of Louis Lamothe and travelled widely for study purposes. His early work showed his concern with classical painting in terms of subject matter as well as composition. But he was open to other influences, such as Japanese art, and also Symbolist tendencies to which he was introduced by his friends Moreau and Puvis de Chavannes. He joined the Impressionist group and exhibited with them between 1876 and 1881, and again in 1886, though he loathed the label and never painted in a purely Impressionist style. His work was suffused by a very personal kind of psychological observation and a profound interest in modern life. His themes always deal with people and city life; raw nature did not inspire him.

Degas painted a great number of portraits. From 1862 onwards he liked to present a subject repeatedly, looking at it from various angles and aspects, such as the scenes of horse-racing, later washer-women and ironing-women, the world of the theatre - he was particularly fond of dancers street and city scenes, and the female nude. From 1880 he began to work in pastel, developing his technique and finding new applications. Detail and narrative elements were abandoned in favour of a more generous disposition of space and the exploration of colour in all its tints and tones, aiming deliberately at sketchiness, the "unfinished". Degas also produced a great number of lithographs, drawings, engravings and monotypes. From 1909 failing eyesight caused him to turn to sculpture, leaving many wax models of dancers, horses and female nudes to be cast in bronze after his death.

Illustrations:

- Ballet (The Star), 1876/77 481
- The Gentlemen's Race: Before the Start, 1862 494
- Dance Class at the Opéra, 1872 494
- Absinthe, 1876 495

DELACROIX Eugène

(Ferdinand Victor Eugène Delacroix)

1798 Saint-Maurice-Charenton (near Paris) -

After studying music, Delacroix first received instruction in painting at the studio of P. Guérin in Paris. In 1816 he entered the Ecole des Beaux-Arts, where he met Géricault, his junior by seven years, whom he much admired. He was also impressed by Goya's drawings and the work of Veronese and Rubens. His first great work "Dante and Virgil in Hell" (ill. p. 414), shown at the Salon in 1822, excited great attention. Two years later his "Massacre of Chios" (ill. p. 432) led to still greater

recognition. Having seen Constable's pictures at the Salon, he overpainted this painting and added highlights a few days before the opening of the Salon. The discovery of Constable and his friendship with Bonington caused Delacroix to visit London in 1825. Through the study of Constable's work he adopted a fresher and livelier coloration.

Back in Paris, Delacroix was now the leader of Romantic painting in France. This brought him much criticism from the Classicists, most of all from Ingres. He drew his subject matter from literary sources, such as Dante, Shakespeare and Goethe; also from the works of the Romantics, the novels of Walter Scott and Byron's poetry. In 1832 he visited Morocco, being a member of an ambassadorial mission sent to the Sultan of Morocco, also taking in Algiers, Oran, Tangiers and southern Spain. His enthusiasm for this exotic world with its brilliant light knew no bounds, inspiring him to produce hundreds of drawings and water-colours. From these, he painted later in Paris his most beautiful and colourful pictures, including the famous harem scenes (ill. p. 433) and the series of lion hunts (ill. p. 431). From 1834 he was engaged in large-scale decorative works, including those in the Salon du Roi in the Palais Bourbon (1833-37), the library in the Palais du Luxembourg (1845-47) and the church St. Sulpice (1861). In 1857 he finally became a member of the Academy, after seven years of candidature. Mounting criticism caused him to withdraw from the world in his final years, and he died in complete isolation in 1863. The passion, subjectivity and sensualism of his subject matter, as well as his methods of composition and coloration, made him a Romantic of a kind all his own and one of the greatest painters of the century. His conception of the intrinsic value of the overall colour effect was to be an emboldening influence on the Impressionists.

Illustrations:

- Orphan Girl at the Cemetery, 1823
- The Bark of Dante (Dante and Virgin in 414 Hell), 1822
- The Lion Hunt, 1861
- The Massacre of Chios, 1824 432
- Liberty Leading the People (28th July 1830), 432
- Women of Algiers, 1834 433

DELAUNAY Robert

1885 Paris - 1941 Montpellier

After an apprenticeship with a decorative painter, Delaunay became acquainted with the ideas of the Pont-Aven group while visiting Brittany in 1904. He began to study in depth the Neo-Impressionistic colour principles as well as philosophical works. His Eiffel Tower series, 1910, proclaimed his Cubist tendencies. With his "Windows" (ill. p. 575) and "Contrasts" (ill. p. 575), 1912/13, he established his artistic independence and significance. Apollinaire coined the term "Orphism" to describe Delaunay's colour Cubism, transforming the idea of colour into sound and musical resonances. His pictures were based on the principle that all colour tones develop from the circling rhythm inherent in the colour. This idea determined Delaunay's work until 1921, moving steadily closer to abstract art. In 1937 he designed the decorations for the pavilions of aviation and railways at the Paris World Exhibition. Illustrations:

- Simultaneous Windows on the City, 1912
- Simultaneous Contrasts: Sun and Moon, c. 1912/13

DELVAUX Paul

1897 Antheit (near Liège) - 1994 Furnes Delvaux first studied architecture from 1917 to 1924, and then painting at the Académie des Beaux-Arts in Brussels. His early work was marked by the influence of Belgian Expressionism and his admiration for Ensor. In 1932, at a Brussels fairground, he saw the waxwork figures of the Musée Spitzner. The impression of these figures was so strong that they repeatedly became the subject of his pictures. His acquaintance with the work of Chirico, Magritte and Max Ernst, whose pictures were shown at the "Minotaure" exhibition, 1934, caused him to produce pictures in the style of veristic Surrealism and to contribute to several international Surrealist exhibitions. After his visits to Italy in 1938 and 1939 his palette lightened, and, influenced by the Italian Renaissance, he began to include classical landscapes in his pictures. In the late 1940s and in the 1950s he produced stage sets and wall paintings. In 1950 he was called to the École Nationale d'Art et d'Architecture as professor of monumental painting, where he taught until 1962. He was president of the Académie des Beaux-Arts in 1965/66. Delvaux, who was the most important representative of Belgian Surrealism after Magritte, was in his old age honoured by many retrospectives and decorations.

Illustration:

610 The Encounter, 1938

DENIS Maurice

1870 Grandville (Manche) - 1943 Saint-Germain-

From 1888 Denis studied at the Paris Académie Julian where he made the acquaintance of Bernard, Bonnard and Sérusier. He also knew Vuillard from his schooldays. Sérusier introduced him to the ideas of the school of Pont-Aven, and Gauguin in particular made a profound impression on Denis. In 1890 Denis founded with his friends from the Académie Julian the Nabis group. He shared a studio with Bonnard and Vuillard. In 1892/93 he designed the scenery for the Théâtre de l'Œuvre. His group portrait of the Nabis painters, entitled "Hommage à Cézanne", was painted in 1901. He visited Germany in 1903. In 1906 he visited Cézanne at Aix with Bernard and Roussel. Besides his impressionistic portrait studies and garden scenes he painted Symbolist pictures of an increasingly religious character, using a predominantly two-dimensional Art-Nouveau style. While visiting Italy he had become inspired by the masters of religious art in the Early Renaissance, in particular Piero della Francesca and Fra Angelico, and this he now expressed in his series of large-scale paintings for churches. He was also a book illustrator and lithographer, and his theoretical publications explored the ideas of Symbolism. He taught, at the Académie Ranson from 1908. In 1919 he founded, together with Rouault, workshops for religious art. He is considered one of the great restorers of French religious art. Illustration:

519 The Muses, 1893

DERAIN André

1880 Chatou (near Paris) - 1954 Garches Derain was self-taught before attending the Académie Carrière in Paris from 1898 to 1900. Matisse and Vlaminck, whom he met in 1901, were to become important for his art. Military service disrupted his studies from 1901 to 1904, though he resumed them briefly at the Académie Julian. In the summer of 1905 he worked with Matisse in Collioure on the Mediterranean, and showed his work at the Paris autumn Salon which led to his being classed as one of Les Fauves (wild beasts). Shortly afterwards he came under the influence of Cubism, after having spent several months with Picasso in Avignon in 1908. His study of Antiquity

led him back to a traditional manner of painting in 1921.

Illustration: 563 Boats at Collioure, 1905

DINE Iim

(James Dine)

born 1935 Cincinnati

Dine studied from 1935 to 1957 at the University of Cincinnati, the Boston Museum School and finally at Ohio University. Since 1958 he has been living in New York. As a challenge to Abstract Expressionism, he began by setting up "environments" and staging "happenings". As he felt artistically close to English Pop Art, he went to London in 1967. In his paintings, too, he remained true to the third dimension, working with collages and assemblages, and creating several levels of reality by overlapping canvases in one picture. His work usually shows everyday objects in unusual surroundings. In this way the objects take on a significance of their own, such as a dressing gown which Dine calls a self-portrait. Subsequently, heart shapes and classical sculpture, such as the Venus of Milo, became his subject matter. In the 1980s he produced large wall pictures for outdoor display in Boston and San Francisco. Dine has been a member of the American Academy of Art and Letters since 1980.

Illustration:

660 Cardinal, 1976

DIX Otto

1891 Untermhaus (near Gera) - 1969 Hemmenhofen (Lake Constance)

Dix was the son of a railwayman. After an apprenticeship with a decorative painter he studied at the Arts and Crafts School in Dresden. After World War I he continued his studies at the Academy in 1919. In 1920 Dix adopted a relentless, committed verism concerned with contemporary issues. In 1922 he began to work in Düsseldorf, where his etching "The War" was produced in 1924. During this time he also painted a large number of pictures with a technical skill little short of that of the old masters but with exaggerated facial expressions and physical features. He continued painting portraits when in Berlin from 1925 to 1927, including those of children. After his call to the Dresden Academy in 1927 he produced the triptychs "The City" (Stuttgart, Galerie der Stadt) and "The War" (Dresden, Gemäldegalerie Neue Meister) - visions of experienced and impending dread. After his dismissal from the Academy in 1933 he retired to Hemmenhofen on Lake Constance where he continued to devote himself to apocalyptic themes.

Illustration:

589 Portrait of the Artist's Parents, 1921

DOESBURG Theo van

(Christian Emil Marie Küpper) 1883 Utrecht - 1931 Davos

When Doesburg had a first exhibition of his work in The Hague in 1908, he still painted in an Impressionistic style. It was not until 1916 that he adopted geometric painting. Together with the architects Oud and Wils he worked on architectural projects. In 1917 he changed to Neo-Plasticism and founded with Mondrian the group De Stijl and became the publisher of, and contributor to the magazine bearing the same name. He sympathised briefly with the Dada movement, introducing it to Holland in 1922 and founding the magazine Mecano. He moved to Paris in 1923. He published his theoretical work Principles of the New Art in 1924 as one of the series of Bauhaus textbooks.

From this period also date his first contra-compositions which announced a new development of his art, describing it as "elementarism". The dynamic diagonal became the most important structural element.

Illustration:

596 Simultaneous Counter-Composition, c. 1929/30

DOMENICHINO

(Domenico Zampieri)

1581 Bologna – 1641 Naples

Domenichino was, with Reni, one of the most important successors of the Carraccis. He was trained by Lodovico Carracci in his home town, then assisted Annibale Carracci in Rome from 1602 onwards. His early work, such as the "Maiden and the Unicorn" (ill. p. 234) shows that besides the influence of both Carraccis there was already an individual, classically clear style which found expression in his characteristic monumental work, including the fresco in the oratorio of San Gregori Magno (Rome), his depiction of the martyrdom of Andrew, and also his frescos of the Nilus Legend in the Abbey of Grotta Ferrato (1609/10). On Annibale's death (1609) Domenichino became the foremost Bolognese landscape painter. In his landscapes of a typically greenish-grey coloration he explored during the years 1610-1615 new principles of composition which were later taken over by Claude Lorrain. In the field of interior decoration he demonstrated alternatives to the formulations of Cortona, as can be seen in the choir and cupola pendentives of Sant' Andrea della Valle, Rome. His panel paintings were masterly in their complex yet clearly structured composition and dramatic effect. Dominichino later worked in Naples, but there he met with hostility. He died there without having completed his work in the cathedral, leaving a great number of drawings which tell us how meticulous his preparatory work was.

Illustrations:

218 The Assumption of Mary Magdalene into Heaven, c. 1617-1621

234 The Maiden and the Unicorn, c. 1602

DOMENICO VENEZIANO

(Domenico di Bartolomea da Venezia) c. 1410 Venice or Florence - 1461 Florence Although Domenico was a highly important painter, few of his works survive. He called himself a Venetian yet we do not know whether he was born in Venice or whether his father moved from Venice to Florence before his birth. But it is not unreasonable to assume that his background was such as to promote an artistic talent which made him a unique figure in the development of colour in early 15th century Florentine painting. Little is known about his life. In the 1430s he worked in Perugia. In 1438 he wrote to Piero de'Medici, asking for help in obtaining commissions in Florence and expressing his intention of producing work comparable to that of the greatest living masters - Fra Angelico and Filippo Lippi. The choice of names was significant. Domenico was not primarily interested in problems of space and figure treatment, but in those of colour. His letter of application was evidently successful. In about 1440 he painted the frescos in San Egidio (now Santa Maria Nuova) with the assistance of his greatest pupil, Piero della Francesca. Not a trace of them has survived. Its loss may have left what is possibly the greatest gap in our knowledge of the development of Florentine Early Renaissance painting. With his signed "Sacra Conversazione" (ill. p. 98) he proves himself as a painter of the highest order. Although he had studied Masaccio, Uccello and Castagno with regard to the representation of space and figure, his first

concern was to find new ways of colour treatment. The intensity of colour can be increased by adding more oil as binder, and this technique was used in modern times to create "atmospheric" light effects. Illustrations:

Portrait of a Young Woman, c. 1465

Madonna and Child with Saints (St Lucy Altarpiece), c. 1442-1448

DONGEN Kees van

(Cornelis Theodorus Maria van Dongen) 1877 Delfshaven (near Rotterdam) - 1968 Paris Dongen was first sent by his family to a decorative art school to be trained as a technical draughtsman. He felt drawn to painting, however, and at the age of twenty broke with his family and settled in Montmartre in Paris. At first he had to take on casual work, such as porter in the market halls, but once he had joined the Fauves in 1906 and somewhat later had become a guest member of the Dresden Brücke group, he could live from his painting. Around 1907 he lived at Bateau-Lavoir in the Rue Ravignan, where he met Picasso. His financial security was assured after signing a contract with the Galerie Bernheim-Jeune in 1908. Van Dongen was a masterly colourist; his paintings stand out for their intensive, voluptuous colour effects and emotive contrasts. After World War I he became a sought-after portraitist of high-society personalities, probably because he did not prettify his

Illustration:

564 Portrait of Fernande, 1905

DOU Gerard

(also: Gerrit Dou)

1613 Leyden – 1675 Leyden

Dou was, during his lifetime and throughout the 19th century, one of the most respected genre painters in Holland. He was taught by his father, a stained glass artist, and went on to be trained by Bartholomeus Dolendo, a copper engraver, where he painted on small copper plates. After a further spell of training with another stained glass artist and also in his father's workshop, Dou studied from 1628 to 1631 under Rembrandt, who was then just 22 years old. When Rembrandt moved to Amsterdam, Dou remained in Leyden, set up his own workshop in 1632 and became a founding member of the Leyden Lukas Guild in 1648. Dou was one of the most talented and independent pupils of Rembrandt, from whom he took over the chiaroscuro effects and structuring of interiors, sometimes rendered in the light of candles or lamps ("Evening Class", Amsterdam, Rijksmuseum), and also the scenes of ordinary life. He is considered the most important representative of the so-called "fine painting", a very detailed style of painting, requiring the finest brushes and often a magnifying-glass to give a realistic rendering of the smallest detail. His work ranged from small genre scenes, with old women and men at work, interiors of small general stores, medical consultations ("The Dropsical Lady", ill. p. 320), to biblical subjects, portraits ("Young Mother", The Hague, Maritshuis) and still lifes. Dou remained all his life in Leyden, even declining an invitation to work at the English court of King Charles II. His best known pupils were Frans van Mieris the Elder and Gabriel Metsu. Illustration.

320 The Dropsical Lady (The Doctor's Visit), c. 1663 (?)

DUBUFFET Jean

1901 Le Havre - 1985 Paris

After obtaining his higher school-leaving certificate and doing two-years' training in painting at the

Academy in Le Havre, Dubuffet went to Paris in 1918 to complete his studies at the Académie Julian. A year later he met Suzanne Valadon, Max Jacob, Léger and Dufy. In 1924 he went to Buenos Aires as a technical draughtsman, and a year later entered his father's wine business. He did not paint again until 1942, showing his work in Paris two years later. From 1945 he began to collect art brut, pictures of children and mental patients, which fascinated him because of their elemental powerfulness, and which he admired for their originality and independence from traditional, conventional subjects. In 1947 he founded the art brut movement and opened a gallery in order to disseminate and gain recognition for this art form. In July 1962 he began to produce two- and three-dimensional work under the title "L'Hourloupe", and in the 1960s he added musical experiments. In 1976 he presented his art brut collection to the city of Lausanne. He then returned to the simple forms of his early years, producing pictures, panels and sculptures. Illustrations:

640 Le Métafisyx, 1950

640 Business Prospers, 1961

DUCCIO DI BUONINSEGNA

c. 1255 Siena (?) – c. 1318 Siena

Duccio is first mentioned in 1278 in connection with small commissions for book-cover paintings. His first great unquestioned work was the Madonna in the Uffizi in Florence, executed for the Chapel of the Brotherhood of the Laudesi in the Dominican church Santa Maria Novella in Florence (ill. p. 17), probably to rival Cimabue. With this work Duccio's artistic standing was established before that of Giotto, despite the enmity between Duccio's home town of Siena and Florence. Besides smaller pictures destined to enhance private devotion, Duccio painted the famous altarpiece for Siena cathedral, the Maestà (the Virgin in Majesty). This huge work, painted on both sides, represents on the front the enthroned Madonna with angels and saints ranged by her side and, kneeling at her feet, the patrons of Siena. The predella depicts episodes from the Life of Christ; the retable those of Mary's death. The back shows the Passion and Resurrection of Christ. The work is no longer complete, having been dismantled in the 18th century. Some of the smaller panels are in various museums, others were lost.

Duccio's work is known for its profound closeness to Byzantine art. He used it, however, as a starting point for finding his own individual style which became independent of Byzantine origins. He was very open to contemporary art, represented by the sculptors to the Siena cathedral, Niccolò and Giovanni Pisano, whose adherence to antique and Gothic sculpture coupled with passion of expression led to the modification of Byzantine rules (most apparent in the Crucifixion depicted on the back of the Maestà altarpiece). Also noticeable is the influence of French art and of Duccio's older Florentine contemporary Cimabue - perhaps also the innovations of Giotto. Duccio exercised great influence in his time; he left behind him a prosperous workshop with painters who carried on in his style. He was remarkable for his stimulating effect on others - unlike that of Giotto and the Florentine painters - who had a stultifying influence on the younger generation of Sienese painters such as Simone Martini and the brothers Lorenzetti. These, however, were to overshadow their teacher's fame with their own great artistic contribution.

Illustrations:

- The Temptation of Christ on the Mountain,
- Ruccellai Madonna (Maestà), c. 1285
- Christ Entering Jerusalem, 1308–1311

- 33 Madonna of the Franciscans, c. 1300
- Adoration of the Magi, 1308-1311
- Peter's First Denial of Christ and Christ Before the High Priest Annas, 1308-1311

DUCHAMP Marcel

1887 Blainville-Crevon (near Rouen) - 1968 Neuilly-sur-Seine

As the son of a Normandy lawyer, whose other three children - Jacques Villon, Raymond Duchamp-Villon and Suzanne Crotti - also devoted themselves to art, Duchamp studied first at the Académie Julian in Paris, where he was initially influenced by Cézanne, then by the Fauves, the Cubists and the Futurists. His picture "Nude Descending a Staircase" (ill. p. 594), which was shown for the first time in New York in 1913, made him famous overnight in the USA, while he remained a marginal Cubist in France. Duchamp introduced the phrase "ready-made". He maintained the view that the creation of a work of art is already implied in the choice of subject matter, as exemplified in 1913 by his "Bicycle-Wheel on a Kitchen Stool". In 1915 Duchamp went to the USA, but returned via Buenos Aires to Paris, where he established contact with the Dadaists gathering around Tristan Tzara. Shortly afterwards he went again to New York, where he collaborated with Man Ray in publishing New York Dada in 1921. With his principal work "The Bride Stripped Bare By Her Bachelors", also called "Large Glass" (ill. p. 594), on which he worked from 1915 to 1923, he broke finally with traditional painting. He experimented with a great variety of techniques.

594 Nude Descending a Staircase, No. 2, 1912

The Bride Stripped Bare By Her Bachelors (The Large Glass), c. 1915-1923

DUFY Raoul

1877 Le Havre – 1953 Forcalquier (Basses-Alpes) Dufy already worked in a coffee import business at the age of 14, attending evening classes at art school. In 1900 he was granted a scholarship at the Ecole des Beaux-Arts in Paris. From 1904 he had contact with the Fauves and was greatly influenced by Matisse. When staying with Braque in L'Estaque, he briefly moved closer to Cubism, and his palette became almost monochrome. From 1912 his coloration began to brighten and his style to become freer. He travelled widely, transmitting his impressions to his landscapes which combined intensive light effects with brilliant colour. In 1920 he settled at Vence, and his preferred subjects became horse-racing, beach scenes and concert scenes. For the World Exhibition in Paris in 1937 he produced his most important work, the huge mural "Fée Electricité" in which figures and objects are inserted with deliberate naivety into the overlapping colour planes. Illustration:

563 Sailing Boat at Sainte-Adresse, 1912

DUGHET Gaspard

(called: Gaspard Poussin)

1615 Rome - 1675 Rome

His brother-in-law Nicolas Poussin was his teacher, but Dughet soon became independent both financially and artistically, devoting himself almost entirely to landscape painting, including series of large frescos (Palazzo Dora, Palazzo Colonna and San Martino ai Monti, all of them in Rome). Although he never left Italy, he absorbed into his work a great variety of influences including foreign ones. Bril, Elsheimer, Domenichino, Rosa and Claude Lorrain were all just as important as Poussin in developing Dughet's style. His work was particularly popular in England and Germany in the 18th and 19th centuries. Goethe said that in these pictures there "seemed to live a human race of few necessities and noble thoughts".

Illustration:

250 Landscape with St Augustine and the Mystery of the Trinity, c. 1651–1653

DUPLESSIS Joseph-Siffred

(also: Silfrède Duplessis)
1725 Carpentras – 1802 Versailles

Duplessis' father was a surgeon who abandoned his profession in order to devote himself to painting, so Duplessis obtained his earliest instruction from him. When in Rome he made the acquaintance of Vernet and Subleyras, whose pupil he became. In 1749 he returned to his home town and painted landscapes for the local hospital. In 1752 he went to Paris and introduced himself to the Academy with his portrait of the Abbé Arnaud (Carpentras, Musée Duplessis). In 1774 he became a member of the Academy and court painter to Louis XV. Perhaps his best-known work is the magnificent picture of the composer "Portrait of Christoph Willibald Gluck" (ill. p. 362). Failing eyesight and hearing caused him to leave his apartment in the Louvre in 1792. He retired to the monastery of Villeneuve-lès-Avignon where he had already spent four years in his childhood. However, he returned to Paris in 1796 in order to take up the post of curator at the Versailles museum. Illustration:

362 Portrait of Christoph Willibald Gluck, 1775

DÜRER Albrecht

1471 Nuremberg – 1528 Nuremberg Dürer's work is often, and quite rightly, regarded as the quintessence of the spirit of German art. A master of the graphic arts as well as painting, Dürer, through his extraordinarily dynamic development, laid the foundations of the German High Renaissance. He was the most important mediator between Italian and German art, and it could be said that there was an interactive effect. While Italian art opened up for him new vistas of artistic conception and painterly representation, Dürer's graphic art acted as a stimulus on Italian painting of the 16th century. In his late period he began to assess in his theoretical writings his new insights on realistic representation as well as the problems posed by it, a process whose intellectual penetration had already been set in motion in Italy three generations earlier.

As the son of a Hungarian goldsmith who settled in Germany, he may well have learned his father's craft before entering the workshop of Nuremberg's leading painter, Michael Wolgemut, in 1486. In 1490 he went on tour through the southwestern parts of the country, also visiting Basle and Colmar where he discovered that Schongauer, whom he admired and who had given him direction in his early work, was no longer alive. In 1494 he went to Venice for the first time. A year later he opened his own workshop in Nuremberg and became acquainted with a circle of humanists, one of whom, Willibald Pirckheimer, was to become a life-long friend. Graphic works featured largely in his early period. The linear design of his fifteen woodcuts of the "Apocalypse" achieved a height of expression never reached before. This was followed by sets of woodcuts entitled "The Great Passion" (1498-1500) and the "Life of Mary' (1501-1511).

His second visit to Italy from 1505 to 1507, which again centred on Venice and where he studied in particular Giovanni Bellini, brought his

development to maturity, making him one of the great European painters of the High Renaissance. His "Feast of the Rosary" (Prague, Národni Galeri), which he painted for the German merchant group in Venice, is the first proof of his new conception. Apart from a visit to the Netherlands (1520/21), Dürer remained in Nuremberg, highly esteemed and becoming a great supporter of the Reformation in the last decade of his life. There he produced his major works ("The Adoration of the Trinity", ill. p. 188; "Four Apostles", ill. p. 187), also painting many portraits, including "Hieronymus Holzschuher" (ill. p. 149). His famous, so-called master engravings date from the period 1513/14 ("The Knight, Death and the Devil", "Melancholia", "Jerome in his Cell"). Dürer's aquarelles depicting topographically accurate views represented a first step in the development of pure landscape painting. The extent of his surviving work is astounding: about 70 paintings, 350 woodcuts, 100 copper engravings, 900 drawings plus the water-colours. Dürer's influence on subsequent generations was immense. In the 19th century, when German "medieval" art was rediscovered, a veritable Dürer renaissance occured which often led to a falsified image of the

Illustrations:

149 Portrait of Hieronymus Holzschuher, 1526

186 Self-Portrait, 1498

187 Portrait of a Young Venetian Woman, 1505

187 Four Apostles (John, Peter, Paul and Mark), 1526

188 The Nativity (Paumgartner Altar), c. 1502–1504

188 The Adoration of the Trinity, 1511

DYCE William

1806 Aberdeen - 1864 Streatham (Surrey) Dyce studied at the Scottish Academy, Edinburgh, and the Schools of the Royal Academy, London, becoming a member in 1848. In 1825 and again from 1827 to 1830 he stayed in Italy, mainly Rome, where he studied the works of Raphael and the earlier masters, and had close contacts with the German Nazarenes, Overbeck, Cornelius and Schnorr von Carolsfeld who greatly influenced his art. From 1830 to 1837 he worked as a portraitist in Edinburgh. His interest in art education and industrial design brought him an appointment by the newly founded Government School of Design in London to visit and report on the methods of the state-run art colleges in France, Prussia and Bavaria. In 1840 he became Director of the School of Design in London. Through his connections with the Nazarenes, Dyce was considered in England to be an expert on fresco painting, resulting in various commissions for murals, including in 1844 the frescos in the robing-room of the House of Lords and later for Lambeth Palace, Buckingham Palace and others. He also produced stained glass designs, usually on religious themes. Himself devout, he was an ardent supporter of the High Church. He maintained that society's aim should be to create a government which combined powers temporal and spiritual. This corresponded with the views of the German Nazarenes, whose often dry and hard method of painting he adopted in his early work, later becoming influenced by the Pre-Raphaelites, such as Millais and

Illustration:

Pegwell Bay in Kent. A Recollection of October 5th, 1858), c. 1859/60

DYCK Anthony van

1599 Antwerp – 1641 London Van Dyck, next to Rubens the most important Flemish painter, was the seventh child of a well-todo silk merchant in Antwerp. After the early death of his mother he was sent at the young age of eleven to be trained by the Romanist Hendrik van Balen. In 1615 he already had his own workshop and an apprentice. In 1618 he was accepted as a full member of the Lukas Guild. From 1617 to 1620 he was the pupil and assistant of Rubens, who considered him his best pupil. They became friends, van Dyck living at Rubens' house and painting many pictures on his own after Rubens' design. Van Dyck's great talent, his untiring diligence and perhaps also Rubens' friendship combined to bring him commissions of his own very soon. Besides religious and mythological scenes he also painted some important life-like portraits, which were to become his main work. His pride and ambition made it hard for him to stand in Rubens' shadow in Antwerp. He therefore followed an invitation from the Earl of Arundel to London, where he stayed several months. From 1621 to 1627 he lived in Italy, studying the works of Giorgione and Titian. He entered Genoa on a white horse, a present from Rubens, also visiting Rome, Venice, Turin and Palermo. Titian's influence shows clearly in his paintings of Madonnas and Holy Families; works such as the "The Tribute Money" or "The Four Ages of Man" could almost have been by the great Venetian painter himself.

In 1627 he returned to Antwerp, where he was given a triumphal welcome. He received many commissions for churches, and became court painter to the Archduchess Isabella in 1630. In March 1632 King Charles I called him to England as court painter where he remained, apart from short visits abroad, until his end. Van Dyck became the celebrated portraitist of the English court and aristocracy, and created in this field a style typically his own. In under ten years he painted over 350 pictures, of which 37 were of the King and 35 of the Queen. His extravagant way of life - he had five servants - required a constant flow of commissions and a large studio. Often he merely made a portrait sketch, painting face and hands and leaving the rest to be completed by his assistants. He worked feverishly, weakened by thirty years' hard work and perhaps already feeling signs of his impending illness, rushing in his last years between England, Antwerp, Paris and back to England. But his great plans - frescos in the Banqueting Hall in Whitehall for the English kings, the decoration of the hunting castle of Philip IV in Madrid and a series of paintings in the Louvre for the French monarch - did not materialise, perhaps partly because his fees were exorbitant. Although van Dyck lacked the necessary vitality that Rubens possessed in addition to his genius, he created with his representative portraits, which are marked by their dignity, elegance and detachment as well as close psychological observation and fine use of colours, a type of painting that influenced many generations. He was in particular a stimulus to English painters, such as Gainsborough, Reynolds and Lawrence. Illustrations:

282 Portrait of a Member of the Balbi Family, c. 1625

307 Susanna and the Elders, c. 1621/22

307 St Martin Dividing his Cloak, c. 1618

308 Portrait of Maria Louisa de Tassis, c. 1630 308 The Count of Arundel and his son Thomas,

1636
309 Equestrian Portrait of Charles I.

Equestrian Portrait of Charles I, c. 1635–1640

ECKERSBERG Christoffer Wilhelm

1783 Sundeved – 1853 Copenhagen Eckersberg's artistic standing in Danish painting is comparable to that of Ingres' in France. As the pupil of the classicist Abraham Abildgaard at the Copenhagen Academy, Eckersberg established his style while working at David's studio in Paris from 1811 to 1813. He favoured a classicism mellowed by a natural surface treatment. A visit to Rome, 1813-1816, extended his repertoire to include light-toned, strictly perspectival veduta painting. On his return he settled in Copenhagen and became a professor at the Academy in 1818 and one of the most sought-after Danish portraitists. He also painted seascapes. Although upholding the old traditions, which are given expression through his objectivity in representation using a strong line, his unambiguity of colour and his perspectival construction, as a teacher he was always open to new ideas. Many of his pupils became the Danish realists of the second generation in the 19th century, preferring sketchiness, unusual perspective and subjective colour and light treatment.

Illustrations:

- 461 View through three northwest arches of the Colosseum in Rome. Storm gathering over the city, 1815
- 461 Nude (Morning Toilette), c. 1837

ELSHEIMER Adam

1578 Frankfurt am Main – 1610 Rome If coping with mass was a central problem of Baroque painting, it seems surprising that one of its most prominent founders worked only in small, even tiny, formats. Nevertheless the work of Elsheimer, who died at the age of 32, was largely taken up with this question. His earliest known work "Sermon of John the Baptist" (Munich, Alte Pinakothek, c. 1598) showed some new impressions in addition to the influence of the painters of the Danube School to whom his teacher Philipp Uffenbach had introduced him. In 1598 Elsheimer had come by way of Munich to Venice, where he was much impressed by the work of Bassano and Tintoretto. These new influences already find expression in his "Conflagration of Troja" (Munich, Alte Pinakothek), probably produced while still in Venice. On the small copper plate (Elsheimer painted exclusively on copper) he created a night-time drama of great fascination, achieved through his handling of light and with a bold combination of foreground scene and background.

In 1600 he moved to Rome where Bril and Rubens as well as Caravaggio and Annibale Carracci became of great importance to the gregarious and popular Elsheimer. The figures of Caravaggio and the landscapes of Carracci enabled Elsheimer to find his own direction, which was to make him famous: a new relationship between figure and space which is absolutely natural and convincing. This becomes apparent in works, such as "Myrrha" (Frankfurt am Main, Städelsches Kunstinstitut) and "Flight to Egypt" (ill. p. 255). The end of his not always very easy life was tragic. Goudt, the Dutch patron, imitator, copyist and posthumous forger of Elsheimer, who had supported him financially and found customers for his engravings, had Elsheimer thrown into the debtors' prison, presumably because not enough work was forthcoming. Shortly after his release Elsheimer died. Illustrations:

The Glorification of the Cross, c. 1605

255 The Flight to Egypt, 1609

ENSOR James

1860 Ostend – 1949 Ostend Ensor received his earliest instruction in Ostend before attending the Academies of Ostend and Brussels from 1877 to 1880. His darkly dramatic interiors, landscapes and portraits were a renunciation of traditional conventions as taught by the academies. His landscapes owe something to both realism and Impressionism. From 1885 he sent

work regularly to be exhibited by the Les XX group, of which he was a founder member in 1883, his work having been rejected by the Salons. On a visit to England in 1886 he discovered the light and airy world of Turner. This experience induced him to move closer to the Impressionists. In his principal work, "Christ Entering Brussels in 1888" (Antwerp, Koninklijk Museum voor Schone Kunsten), religious ideas mingle with the realities of life. The analogy to Christ entering Jerusalem is depicted as a ghostly and uncanny identification of the artist's rejection by the world. After 1900 Ensor's creativity diminished. The themes of his pictures painted in sublime, rich colours, and also of his bizarre etchings, were the expressions of nightmares and a fantastic imagination: ghosts, masks, skeletons tussling over a herring, and scenes ridiculing the legal and medical professions.

Illustrations:

- 559 Skeletons Fighting for the Body of a Hanged Man, 1891
- Portrait of the Artist Surrounded by Masks, 1899

ERNST Max

1891 Brühl (near Cologne) – 1979 Paris Ernst studied philosophy at Bonn University from 1909 to 1914, painting only in his spare time. After military service he returned to Cologne in 1918 where he founded a Dada group, with Arp. In 1921 he showed his collages in Paris at the invitation of Breton. He settled in Paris in 1922 and became one of the founders of the Surrealist group, which gathered around Breton. His initial interest in hollow pipe forms was partly due to de Chirico's influence and partly based on the Surrealist idea of tension between interior and exterior, the conscious and unconscious. His subject matter in the late 1920s included forest scenes, crowds, whirlwinds and bird monuments. He introduced several new painting techniques, such as frottage, grattage and decalcomany, which were to bring the stimulus of the coincidental into the creative process. Many collage sets were produced from engravings extracted from old illustrated papers. In 1938 Ernst left the Surrealists; in 1939 he was interned, leaving France and emigrating to the USA in 1941. Despite the recognition he received in America he returned to Paris in 1953, where he settled. Illustrations:

608 Elephant of the Celebes, 1921 608 Après nous la maternité, 1927

609 The Temptation of St Anthony, 1945

ESTES Richard

born 1936 Kewanee (Illinois)

Estes studied at the Art Institute of Chicago from 1952 to 1956, moving to New York in 1959 where he has since been living and working. At first he worked as illustrator and layouter to support himself, but from 1966 he has devoted himself entirely to painting. Only a year later he had his first oneman exhibition at a New York gallery. His works belong to the category of American Hyper-Realism and Photo-Realism. Like the painters of Pop Art, Estes chooses his subjects from everyday surroundings. Photographs and picture postcards are his raw material. He sometimes uses phosphorescent colours to highlight a scene and give it glamour. The streets, house facades, shopwindows and drugstores in his pictures are void of life. Although he uses real situations as a starting point, his pictures are more than a silent, minute reportage of his chosen detail of reality. He imbues them with an atmosphere of glassy stillness, an aura of abandonment and loneliness, giving them an almost magical light. They are hypermodern mystifications, fictions of a mood, aroused by the magic of an otherwise ordinary material world heightened by neon lights and reflections.

Illustration:

666 Candy Store, 1969

EYCK Jan van

c. 1390 Maaseyck (near Maastricht) - 1441 Bruges Jan van Eyck can claim as much importance for northern painting as must be conceded to Masaccio in Italian art. His mastery in rendering the human figure, his modern understanding of portraiture, his minutely observed landscapes and brilliant perspectival construction of interiors combine to give a suggestion of reality which can only be called "Renaissance" to distinguish it from medieval art. In addition, van Eyck was the principal representative of a new epoch in colour technique. Though not the inventor of oil-painting, as Vasari assumed, van Eyck was the first master of this medium and developed a process, called glazing, in which successive transparent layers of paint are applied to the canvas, thus achieving a high colour depth. He used this method with very great success, particularly in imparting an amazing degree of realism when painting jewels and richly adorned fabrics. He was highly respected and esteemed. Until 1422 he served at the court of Duke Johann of Bavaria in The Hague, painting and restoring pictures. He was also highly regarded at the court of Philip the Good of Burgundy who entrusted him with various diplomatic missions. From about 1430 he lived and worked in Bruges as painter to the court and city. His overall contribution to Flemish painting in the first half of the 15th century remains unclear as long as there is no authenticated work by his brother Hubert, with whom he collaborated on the famous altarpiece in the cathedral of Ghent (ill. p. 125) which was completed in 1432 and bears his brother's inscription. As Hubert died in 1426, Jan van Eyck continued to work alone on the altar for another six years on his own to complete it.

Illustrations:

- 87 Portrait of Cardinal Nicola Albergati, c. 1432
- Giovanni Arnolfini and His Wife Giovanna Cenami (The Arnolfini Marriage), 1434
- The Virgin of Chancellor Rolin, 1434–1436 Madonna in a Church, c. 1437–1439
- 124 The Virgin and Child in a Church, 1437
- Ghent Altar (central section), 1432

FABRITIUS Carel

1622 Midden-Beemster - 1654 Delft His name is the Latinised form of "carpenter", a trade which Fabritius, the son of a schoolmaster, had at first taken up. Between 1641 and 1643 he worked in Rembrandt's workshop in Amsterdam, whose most individual and important pupil he was to become. In 1650 he moved to Delft, entering the Lukas Guild two years later. His short life ended tragically. He died in the explosion of a powder magazine, which devastated almost a quarter of Delft, and with him perished the greater part of his work. Those that survive – only just under a dozen – are, however, quite unlike what would be expected of a Rembrandt pupil. Fabritius did not take up a speciality as so many others did, but covered the wide range of portraiture, genre pictures and still life. In particular, he opened up new ways in handling space and perspective, sometimes using trompe l'æil effects. He also differed from Rembrandt in the treatment of light, placing dark figures against a light background. During the few years he worked in Delft he had a great influence on the local school of painters, especially on de Hooch and Vermeer. The latter was his pupil and continued to develop his particular conception of how light should be used.

Illustration: 324 The Goldfinch, 1654

FANTIN-LATOUR Henri

(Henri Ignace Jean Théodore Fantin-Latour) 1836 Grenoble - 1904 Buré (Orne) Fantin-Latour was the son of an Italian painter and drawing master and a Russian mother who moved to Paris in 1841. He received his earliest instruction from his father, attended the drawing school of Lecocq de Boisbaudran from 1850 to 1854, studied briefly at the Ecole des Beaux-Arts and worked spasmodically in the studio of Courbet. He copied the drawings of Flaxman and the paintings of Titian and Veronese at the Louvre, admired Delacroix, Corot and Courbet and became friendly with Manet and Whistler. He was rejected by the Salon in 1859. He visited England three times between 1859 and 1864 where he worked and sold some of his pictures. In 1861 he exhibited for the first time at the Salon, then regularly, and also at the controversial Salon des Refusés from 1863. Fantin-Latour painted a great number of landscapes, genre scenes and most of all still lifes of flowers, which established his fame in France, as well as portraits of artists. In 1870 he painted the famous picture "Un Atelier aux Batignolles" (Paris, Musée d'Orsay) with portraits of his friends. Despite his contact with the Impressionists he rejected their principles and did not take part in their exhibitions.

Illustration:

501 Still Life ("Aux Fiancailles"), 1869

FATTORI Giovanni

1825 Livorno - 1908 Florence Fattori studied under Antonio Baldini in Livorno and from 1846 to 1848 under Giuseppe Bezzuoli at the Accademia di Belle Arte in Florence. In 1850 he continued his studies in Florence. He moved in the circles of the Caffè Michelangelo where discussions ranged from politics to new forms of art. He painted his first open-air studies. In 1861 he won first prize at the "Concorso Ricasoli" with his painting "The Italian Field after the Battle of Magenta". From 1861 to 1867 he lived mostly at Livorno, painting realistic scenes of the country population. He spent the summer of 1867 at Castiglioncello with Martelli, the supporter and theoretician of the Macchiaioli. In 1869 he taught at the Florentine Instituto di Belle Arti. In 1872 he went to Rome and in 1875 to Paris where he became very interested in Corot. In 1891 he published a scathing polemic against the Pointillists. In 1900 he became a member of the Accademia Albertina in Turin. Fattori is regarded as one of the major representatives of the Macchiaioli although he disapproved of the Impressionists all his life. Illustration:

530 Roman Carts, 1873

FAUTRIER Jean

1898 Paris – 1964 Châtenay-Malabry (near Paris) In 1908 Fautrier went to live in London and later to study at the Royal Academy and the Slade School of Art. In 1917 he returned to France. At first his work met with little success although he had the strong support of André Malraux and Jean Paulhan. He therefore gave up painting between 1934 and 1939 and worked as hotelier and ski-instructor in the French Alps. It was not until after the war, when he showed the picture series "Otages" on which he had been working since 1941, that he received recognition as an innovator. In 1960 he received the Grand Prix of the Venice Biennale.

Illustration:

641 Nude, 1946

FEININGER Lyonel

1871 New York - 1956 New York Feininger's parents were both musicians of German origin. He left New York at the age of sixteen to continue his music studies at Hamburg but changed his mind and turned to painting. From 1887 to 1891 he studied at the School of Decorative Arts in Hamburg, moving on to the Academy of Arts in Berlin and finally, for six months in 1892, to the Académie Colarossi in Paris. The following year he returned to Berlin, producing caricatures for magazines to support himself. In 1906 he went to Paris for a further two years where he met the circle of German painters around Matisse and also made contact with the Cubists, becoming particularly drawn towards Delaunay. From 1908 to 1919 Feininger lived again in Berlin. The Blauer Reiter group of painters invited him to exhibit at their first German Autumn Salon in 1913. His first architectural compositions were produced in 1912. In subsequent years he painted again his Thuringia village and town scenes in the style he had developed and named "Prismaism", a type of crystalline cubism. Walter Gropius called him in 1919 to the newly-founded Bauhaus at Weimar,

1933. Illustration:

600 Marktkirche in Halle, 1930

where he taught painting and graphic art until

FETTI Domenico

(also: Feti)

c. 1589 Rome - 1623 Venice

In his early years in Rome Fetti had discovered the landscape style of Elsheimer which was clearly discernible in his work, such as "The Flight to Egypt" (Vienna, Kunsthistorisches Museum). At that period he also became influenced by Saraceni and the Caravaggists in his handling of light although in his work it became looser, more diffuse, hinting already at Guardi. In 1614 he was appointed court painter to Duke Ferdinand II of Gonzaga in Mantua whose collection of paintings Fetti was able to admire. He was particularly enthusiastic about the brilliance of colour in Rubens' works

Fetti is primarily known for his small parable pictures which in this form had not been painted before. The "Parable of the Labourers in the Vineyard" (Dresden, Gemäldegalerie) and the "Parable of the Pearl of Great Price" (Kansas City, Nelson Gallery and Atkins Museum), in particular, demonstrate in their genre-like conception and flowing brushwork Fetti's artistic individuality. In Mantua Fetti also painted frescos, including some monumental work carried out in the cathedral and the Palazzo Ducale. On returning to Rome, at the age of only 34, he died. He can be considered as one of the founders of northern Italian painting of the 17th century.

235 Melancholy, c. 1620

FEUERBACH Anselm

1829 Speyer – 1880 Venice

Like so many artists who settled in Rome, Feuerbach belonged to the German Romans. He came from a family of intellectuals and also received a thorough education, studying at Düsseldorf Academy (under Wilhelm von Schadow), and at Munich, Antwerp and Paris. In 1855 he briefly kept a studio in Karlsruhe before starting on a visit to Italy. In 1857 he settled in Rome, making friends with Arnold Böcklin and Reinhold Begas. His greatest influences were Andrea del Sarto and Raphael and, having had a classical education, he painted primarily sublime allegorical, mythological and religious subjects. In 1872 he received a

call to the Academy in Vienna, but did not feel happy there. Feuerbach died in 1880 on a visit to Venice.

Illustration:

531 The Garden of Ariosto, 1863

FLEGEL Georg

c. 1566 Olmütz (Moravia) – 1638 Frankfurt am Main

Nothing is known of Flegel's beginnings, but presumably he received his training in the Netherlands. There is evidence that he worked at least from 1594 in Frankfurt am Main, at first as an assistant to Martin van Valckenborch, whose paintings he adorned with fruit and flowers. On his way to becoming the first, pure still life painter in Germany, his work as a miniaturist was of particular importance; for example, in about 1607 he illuminated the breviary of Duke Maximilian I of Bavaria. Flegel's early still lifes therefore bear strong marks of this finely detailed art, including small decorative additions ("Fruit Still Life", Kassel, Staatliche Kunstsammlungen, 1589; "Still Life", ill. p. 256). Flegel subsequently (since 1611) arrived at a much more unified, considered composition. With one of his last pictures, the "Still Life with Candle" (Cologne, Wallraf-Richartz-Museum, 1636), he succeeded in creating a work of tremendous atmospheric power and artistic simplicity. Illustration:

FONTAINEBLEAU → School of Fontainebleau

FONTANA Lucio

256 Still Life, undated

1899 Rosario di Santa Fé (Argentina) – 1968 Comabbio (near Varese)

In 1914/15 Fontana studied in Milan at the Instituto Tecnico Carlo Cattaneo, then at the Accademia di Brera from 1920 to 1922. In 1922 he returned to Buenos Aires, where he worked at sculpting in his father's studio. In 1930 he went back to the Brera in Milan for further advanced studies. Until 1934, in this middle period of his artistic development, his work centred on the human body, but he then founded an association of Italian abstract artists and a year later became a member of the group Abstraction-Création in Paris. Despite this he also produced representational work until 1947. In 1936 his manifesto on Italian abstract art was published in Milan. From 1940 to 1947 he again lived in Buenos Aires where the Manifesto Blanco was published, to which he had contributed. The first "Concetti Spaziali" were not produced until 1949. Fontana became known for these spatial concepts and also for his monochrome, slit or torn canvases.

Illustration:

654 Spatial Concept, 1959

FOUQUET Jean

c. 1415–1420 Tours (?) – c. 1480 Tours Historical records give us almost no direct information about the life and work of the most famous French painter of his day. The only authenticated works are the miniatures in the "Antiquités judaïques" (Paris, Bibliothèque National). Documentary sources of the 15th and 16th centuries show that he was a painter of international repute, and these allow a reconstruction of his artistic development. Fouquet probably received instruction in the illumination of manuscripts under Flemish-Burgundian masters, possibly the brothers von Limburg. In any case, the decoration of precious manuscripts took a prominent place throughout his life. In the 1440s Fouquet went to Italy where

he painted a portrait (now lost) of Pope Eugene IV, who died in 1447, which provides a clue to when Fouquet must have stayed there. A commission from this high quarter allows us to assume that the painter must have been of an age to justify his reputation. Fouquet's contact with Italian art – in particular with Uccello's and Castagno's advanced treatment of figures – were decisive in developing his style further. As court painter to the French monarch from 1475, he succeeded in combining these diverse influences to achieve a courtly classicism, marked by a certain detachment and severe construction, which is unique in the art of the 15th century.

Illustrations:

140 Madonna and Child, c. 1450

140 Portrait of Guillaume Juvenal des Ursins, c. 1460

FRAGONARD Jean-Honoré

1732 Grasse (Provence) - 1806 Paris Fragonard was the son of a glove-maker and tanner. He came to Paris in his childhood. At first he worked as assistant to a lawyer who noticed his artistic talent. In 1747 he was given instruction by Chardin, and a year later was accepted by Boucher who had insisted on prior grounding. Boucher entered him for the Rome 1752 competition, which he won. Fragonard then studied three years at the Ecole des élèves privilégés under van Loo, concentrating in particular on the Dutch masters, before being accepted by the Académie de France in Rome. He travelled through Italy and on his return to Paris became a member of the Academy. He soon resigned, however, as the membership he had entered the Academy as an historical painter - evidently did not suit his artistic interests and social tastes. Between 1765 and 1770 his subject matter was frequently of an amorous-erotic nature. He also painted landscapes and portraits. "The Swing" (ill. p. 360), 1767, dates from that period. Fragonard was not very successful with prominent givers of commissions, such as Madame Dubarry.

Fragonard remained a brilliant colourist to the end. Works such as the "Love Vow" (Orléans, Musée de Peinture et de Sculpture) or "Sacrifice of Roses" (Buenos Aires, Museo Nacional de Arte Decorativo) show the pathos of a monumentalised passion in the Classicist manner. Under David's protection he survived the turmoil of the French Revolution, but the new generation, in particular the Empire period, had no use for his aesthetics which were still rooted in the Rococo. He had to leave his residence in the Louvre in 1806 and died in the same year, almost forgotten.

Illustrations:

343 Progress of Love: The Lover Crowned,

c. 1771–1773

360 Blind Man's Bluff, c. 1760

360 The Swing, 1767

361 The Stolen Shift, c. 1767-1772

361 The Music Lesson, c. 1770–1772

FRANCIS Sam

1923 San Mateo (California) – 1994 Santa Monica Francis studied botany and medicine at Berkeley from 1941 to 1943, then, after military service in the air force, studied painting and art history from 1948 to 1950. In a crash during a test flight he sustained injuries to his spine, and he began to paint while in hospital and sanatorium in 1944. On his recovery he visited France, Italy, Mexico, India, Japan and Thailand. His work is related to Abstract Expressionism. Until 1949 Francis painted primarily irregular, cell-like colour forms with thinned-down oil or acrylic paints. From 1950, during a stay in Paris, these characteristic

designs began to resemble monochrome planes. Soon, however, he returned to brilliant colour designs. In 1959 Francis settled in Santa Monica, California. His vast murals excited particular attention

Illustration:

635 Basel Mural II, 1956–1958

FRANCKE → Master

FRANCKEN Frans the Younger

1581 Antwerp – 1642 Antwerp Francken was the most successful and productive member of an Antwerp family of artists. He received instruction from his father Frans the Elder, became master in 1605 and deacon of the Lukas Guild in Antwerp in 1614. He painted works for churches ("Altar of the Four Crowned", Antwerp, Koninklijk Museum voor Schone Kunsten), biblical and historical scenes as well as genre pictures. However, his special domain was the so-called "Kunstkammer" – the depiction of a picture gallery. His meticulous rendering of rooms with hung paintings or antiquities are a cultural and historical source of the first order. These works give us an insight into art, not only at court, but also in private hands

Illustration:

300 Supper at the Burgomaster Rockox, c. 1630–1635

FREUD Lucian

born 1922 Berlin

The grandson of Sigmund Freud and son of the architect Ernst Freud, Lucian Freud spent his early childhood in Germany. The family emigrated to England in 1932. After a brief spell in the merchant navy he began to study art at the Dedham School of Arts and Crafts in 1942 and then at Goldsmiths' College in London. Despite the war and lack of opportunity to follow the development of modern art, Freud had already established his style by 1947. From the start he found his subject matter in his immediate surroundings. With psychological exactitude and an analytical eye he dissects on the canvas familiar objects, acquaintances and friends. The result is that Freud succeeds in conveying in his work an unusual closeness between the painter and his model. Most of his sitters, to whom he repeatedly returns, remain anonymous, an exception being the portrait of Francis Bacon from 1952, recording the close friendship between the two painters. Towards the late 1950s his precise, realistic style became a little looser and the compositions lost some of their severity, without any reduction in care and precision.

Illustration:

645 The Big Man, c. 1976/77

FRIEDRICH Caspar David

1774 Greifswald – 1840 Dresden
Friedrich was the son of a soap-maker and chandler, and studied under Jens Juel at Copenhagen
Academy from 1794 to 1798. From 1798 he lived in Dresden until his death, interrupted only by his travels to Greifswald, Rügen, Neubrandenburg, the Harz mountains and northern Bohemia. In 1816 he became a member of the Dresden Academy, in 1824 professor extraordinary. Friedrich was the founder of German Romantic landscape painting. He combined in his work a hitherto unknown closeness to reality, the impressions of his travels and wanderings, with the metaphysics of light aroused by Christian and Neo-Platonic ideas. The origins of his landscape art lie in 18th century veduta painting.

This already comprised a foreground with viewing level against a background of an interesting landscape, and there was already an interest in the grandeur of nature; in the idiom of the time, the "sublime" natural phenomena, such as lonely mountain ranges and seas which served the enlightened as a trigger for religious feeling and insight. But Friedrich's pictures have no longer any of the touristic interest of the 18th century landscape. His nature scenes embody the externalised mood of the figures in the foreground; they are "atmospheric landscapes", to use 19th century terminology. They are always determined by two components: the objective conditions of nature and the mood of the observer, the back of whose figure is often magnified in the picture. The limitless distance, as opposed to the limited position of the onlooker in the foreground in Friedrich's pictures, points at the two sides of human existence - body and soul, the earthbound and the divine - which from early times have comprised the fundamental dichotomy of Christian and Neo-Platonic thinking. Friedrich was a philosophical painter. His friends included not only painters such as Runge, Dahl, Kersting and Gerhard van Kügelgen, but also poets like Ludwig Tieck as well as scientists and philosophers. He was a fervent patriot, which explains the symbolism hinting at the wars of independence in many of his pictures.

Illustrations:

412 The Stages of Life, c. 1835

447 Abbey under Oak Trees, 1809

Mountain Landscape with Rainbow, c. 1809/10

Wanderer looking over a sea of mist, c. 1817/18

The Lone Tree (Village Landscape in Morning Light), 1822

449 Chalk Cliffs on Rügen, 1818

FROMENT Nicolas

c. 1430 Uzès (Gard) - c. 1485 Avignon Together with the Master of the Annunciation of Aix and Enguerrand Quarton, Froment explored the artistic possibilities of 15th century Provençal painting. Thanks to its geographical location, Provençe was open to the most diverse influences. As Froment painted the Lazarus triptych (Florence, Uffizi) for the Minorite monastery in Mugello near Florence in 1461, his first authenticated work, his date of birth may be assumed to have been around 1430 at the latest. Although this work must have been produced in Italy, it shows no Italian influence whatsoever, but rather points to his training in the Netherlands in the neighbourhood of Bouts. Records show Uzès as his place of birth. The possession of several houses in Uzès about 1470 indicates prosperity obtained through substantial commissions. Since 1475/76 he worked for King René, who commissioned the surviving major work, the Moses triptych in Aix-en-Provence (ill. p. 141). He then decorated the King's palace in Avignon, and his name appears repeatedly in account books until 1479. Unfortunately none of these works, nor his designs for tapestries and festive decorations, have survived. Froment, whose work consists mainly of unauthorised attributions, remained all his life a follower of the Dutch school. However, his few authenticated works show a dynamic development towards a more liberal treatment of space and landscape and a more realistic approach to detail. Illustration:

141 Moses and the Burning Bush, 1476

FUSELI Henry

(also: Füssli, Füßli, Fuessli, Fueslin, Füßlin, Johann Heinrich)

1741 Zurich – 1825 Putney Hill (near London) Füssli was the second son of the Zurich portraitist and author Johann Caspar Füssli. His early contact with the teachings of Johann Jakob Bodmer familiarised him with the figures of world literature, and these were to remain a major source for his artistic inspiration. Ordained in 1761 as a pastor in the Zwinglian Reformed church, he left Zurich two years later for political reasons, travelling via Berlin to London where he made his new home. Initially he made his living from literary work. Artistically he was engaged in illustrating the works of his favourite authors, particularly Shakespeare. It was Reynolds who persuaded him to concentrate entirely on the fine arts. He travelled through Italy, visiting Florence, Venice and Naples and lived for eight years in Rome. This period, during which Michelangelo's monumental style left deep impressions on his artistic feeling, became a lasting influence. After a short stay in Zurich on his return from Italy, he began to paint extensively in London. "The Nightmare" (Detroit, Institute of Arts, and Frankfurt am Main, Goethe-Museum), probably his most popular work, excited great attention when it was exhibited at the Royal Academy, to which he was elected in 1790. In the history of style, Füssli's significance lies in his early romantic Classicism which allowed him to develop a strange monumentalisation of the dreamlike and macabre. His often misunderstood importance as colourist probably lies in his novel, draughtsman-like treatment of colour.

Illustration:

379 Titania and Bottom, c. 1780–1790

GAINSBOROUGH Thomas

1727 Sudbury (Suffolk) – 1788 London Gainsborough was the fifth son of a well-to-do cloth manufacturer. Because of his early talent for drawing he was sent to London at the age of thirteen. There he studied etching under the Frenchman Gravelot, a pupil of Boucher. Apart from being influenced by the French Rococo, to which he was introduced by Hayman at St Martin's Academy, Gainsborough's landscapes were particularly affected by 17th century Dutch landscape pictures which he had copied and restored in his early years. Between 1747 and 1759, in Sudbury and Ipswich, he produced this type of landscape as well as working in the style of the French pastoral idyll. In 1746 he secretly married Margaret Burr, the illegitimate daughter of the Duke of Beaufort, which ensured him financial independence.

While the pure landscape was not highly appreciated in England, Gainsborough succeeded in combining full-length figure portraits with landscape, mostly depicting a location on the estate of the nobility he portrayed, and thereby becoming the founder of a new version of arcadia in the dispassionate English style. In 1759 he moved to the fashionable resort of Bath, where, inundated with portrait commissions, he developed his style further by studying van Dyck, whose work could be seen in many country houses around Bath. In 1774 he removed to London where as portrait-painter he had to vie with Reynolds and his pupils. He became increasingly interested in lighting effects, as popularised by experiments carried out by the theatrical decorator Loutherbourgh. Gainsborough succeeded in becoming the favoured portraitist of the royal family. In 1782 he painted in Windsor a series of oval portraits of the royal couple and their thirteen children.

After some dispute he retired from the Royal Academy, of which he had been a founder member in 1768, and in the 1780s he began to arrange summer exhibitions at his private house. His final cre-

ative years are marked by a sensitive, poetic style and ethereal coloration. His free compositions, or fancy pictures as he called them, date from this time. In these Gainsborough surpassed his exemplar Murillo, sensitively exploring the theme of this childlike and rustic genre in an old-masterly browntoned tenebrism. Gainsborough was a pioneer in landscape painting. Apart from his extremely personal style of portraiture and a short-lived fashion of imitating his "fancy pictures", he had an important influence on 19th century landscape painting.

- 347 Miss Anne Ford (Mrs. Philip Thicknesse), 1760
- Robert Andrews and his Wife Frances, c. 1750
- 384 The Watering Place, 1777
- 385 The Morning Walk, c. 1785/86
- 386 Woman in Blue, before 1780
- 386 Lady and Gentlemen in a Landscape, c. 1746/47

GAUGUIN Paul

1848 Paris – 1903 Atuona Hiva-Oa (Marquesa Islands)

The son of an émigré Republican journalist, Gauguin spent his earliest years 1849-1855 in Lima (Peru); then he went back to Orléans and Paris. He went to sea from 1865 to 1871, then worked in banking from 1871 to 1883 in Paris. In 1873 he married the Danish woman Mette Gad with whom he had five children. In 1874 he met Pissarro and other Impressionists, began to study at the Académie Colarossi and exhibited at the Salon for the first time in 1876. In 1879 he painted with Pissarro in Pontoise and exhibited with the Impressionists at their exhibitions IV to VIII from 1879 to 1886. In 1881 he painted with Pissarro and Cézanne. In 1882 he moved to Rouen, then to Copenhagen, and got into financial distress. He returned to Paris in 1885, leaving his family behind in Denmark. In 1886 he painted for the first time at Pont-Aven where he met Bernard. In Paris he became acquainted with the brothers van Gogh and travelled with the painter Laval to Panama and Martinique in 1887. While with Bernard and others at Pont-Aven in 1888, he changed to a "synthetic symbolism" in his Brittany paintings. He exhibited at Theo van Gogh's gallery. His stay with Vincent van Gogh at Arles ended the friendship. In 1889 he contributed to the Les XX exhibition at Brussels and at the Café Volpini during the Paris World Exhibition. He painted at Pont-Aven and Le Pouldu, influenced by Sérusier, Denis and Bonnard.

In 1891, after auctioning his works and quarrelling with Bernard, Gauguin travelled to Tahiti in order to escape from European urban civilisation. While there he contracted syphilis. From 1893 to 1895 he stayed in Paris, Copenhagen and Brittany. He was not successful with his large, colourful South Seas pictures symbolising life, the incunabula of "exoticism" and "primitivism". From 1895 to 1901 he was again in Tahiti, also producing sculptural work. His physical condition worsened, aggravated by alcohol. In 1897 he published his autobiographical writings Noa Noa, which are still read. In 1898 he tried to commit suicide. In 1900 the art dealer Vollard offered him a contract. In 1901 Gauguin removed to the Marquesa island of Dominique, where he fought against the colonial administration and was sentenced in 1903. He died utterly exhausted and impoverished at the age of 54.

Illustrations:

- 489 When will you marry? ("Nafea faa ipiopo?"), 1892
- 514 Tahitian Women (On the Beach), 1891
- 514 Breton Peasants, 1894
- 515 Contes barbares (Barbarian Tales), 1902

GEERTGEN TOT SINT JANS

(Gerrit van Haarlem)

c. 1460–1465 Leyden (?) – before 1495 Haarlem Geertgen's great importance for late 15th century Dutch painting is in inverse proportion to the small number of authenticated works. Probably born in Leyden, he may have been trained in the southern parts of the Netherlands, perhaps under Aelbert van Ouwater. But more important to his art were van der Weyden and van der Goes. Geertgen's reputation rests equally on the expressive gravity of his figures and on his masterly skill in landscape painting. In his early works, such as the "Three Kings" triptych (Prague, Národni Galeri), Geertgen drew on van der Weyden, but interpreting his style to suit his generation's courtly, refined, more elaborate taste. The "Crucifixion' altar painted for Haarlem's St John's church, probably after 1484, of which only the right wing of the Lamentation survives (Vienna, Kunsthistorisches Museum), shows a freer arrangement and treatment of figures with regard to size as well as expression, and also his characteristic depiction of landscape which was to culminate in the small panel of "St John the Baptist" (ill. p. 134). With these tendencies Geertgen seems to have represented an opposing current to that of contemporaries who, like him, worked for the order of the Knights of St John at Haarlem, and from which his name derived. His "Nativity" (London, National Gallery), with its amazing chiaroscuro, also shows how difficult it is to put Geertgen into a general category.

Illustration:

St John the Baptist in the Wilderness, c. 1485–1490

GENTILE DA FABRIANO

(Gentile di Niccolò di Giovanni Massi) c. 1370 Fabriano - 1427 Rome Gentile, born in Fabriano, was the son of a cloth merchant. He probably received a thorough introduction to Sienese art at an early age, but there are signs which speak for his training at the great cultural centres of Milan and Verona. The clear evidence is that he visited Venice between 1408 and 1414. There he became famous with his paintings, particularly those in the Doge's Palace. One of his Venetian pupils was Jacopo Bellini who became a famous painter in his own right although later overshadowed by his sons Giovanni and Gentile. Nothing of Gentile da Fabriano's Venetian work survives, nor of the commissions carried out for the Malatesta in Breseia, or for the Pope in the Lateran Basilica in Rome or his Sienese works. In 1427 he died while working on the frescos in the Lateran Basilica; his assistant and pupil Pisanello carried on this work, taking over the workshop and also taking up the artistic legacy of his mentor.

Gentile can be regarded as fulfilling that for which Sienese art was striving in the first half of the 15th century. With his methods of gilding and wealth of colour effects and surface structures, he created an art of great charm both to the eye and to the touch. His style was eminently suitable for expressing the ruling classes' love for splendour and magnificence, and this may have contributed to his extraordinary success. Amongst his contemporaries he ranked as the master of the masters, and perhaps rightly so. Art history singles him out for other reasons, and particularly for his innovative treatment of light which was far ahead of his time: the gilded background is seen as a source of light irradiating the scene or casting shadows. He was also one of the first to use the medium of the freehand drawing as a basis of further studies and sketches.

Illustrations:

53 A Miracle of St Nicholas, 1425

- St Nicholas and the Three Gold Balls,
- The Adoration of the Magi, 1423

GENTILESCHI Orazio

(Orazio Gentileschi Lomi)

1563 Pisa – c. 1639/40 London

During his apprenticeship with Aurelio Lomi, his brother or half-brother, and Bacci Lomi, his uncle. Gentileschi familiarised himself with the Florentine Mannerist tradition of Agnolo Bronzino and Jacopo Carrucci da Pontormo. In Rome, where he stayed in 1580, he studied the art of Caravaggio. Gentileschi was successful in uniting both these strands to a style of his own, such as in the "Baptism of Christ" for Santa Maria della Pace in Rome or the "Stigmata of St Francis" for San Silvestro in Capite (Rome). After a two years' stay each at Genoa and Paris, where he was in the service of Maria de' Medici, he followed the call of the Duke of Buckingham to the English court in 1625 where he executed interior decorations on a monumental scale though on canvas. Late works, such as the "Lute Player" (ill. p. 228), are captivating because of their balanced coloration and composition as well as their brilliant painterly technique. Orazio's daughter Artemisia, stylistically close to her father, also achieved fame among her contemporaries. Illustration:

228 The Lute Player, c. 1626

GÉRARD François Pascal Simon

1770 Rome - 1837 Paris Gérard's family lived in Rome until 1780, where his father served as steward at various courts. After the family's return to Paris, Gérard entered the studio of Jacques Louis David at the age of 16 and soon became his favourite pupil. In 1790 he travelled to Rome to sort out some family affairs after his father's death. He married a younger sister of his mother. Soon Gérard had to return to Paris to avoid being registered as an emigrant. As the Revolution deprived him of the ability to earn his living as a portraitist, he worked as an illustrator of the works of Racine and Virgil. He became successful as a painter of historical scenes, winning the competition to commemorate the meeting of the National Assembly of 10 August 1792. However, he soon turned again to the painting of portraits which enjoyed popularity on account of their careful preparation and classical detachment. He remained successful through the period of the Restoration. In 1817 he became court painter to Louis XVIII, and was ennobled in 1819.

Illustration:

423 Madame Récamier, 1805

GÉRICAULT Théodore

(Jean Louis André Théodore Géricault) 1791 Rouen - 1824 Paris

Géricault's large œuvre came into being during a creative period lasting only twelve years. He loved horses and was a passionate rider, and therefore left numerous sketches and pictures dealing with this subject which are unsurpassed in their vividness and realism. He became famous with one of these equestrian pictures, "The Charging Chasseur" (ill. p. 425), which in 1812 was his first work to be exhibited at the Salon. The passionate, impetuous manner of his depiction was a renunciation of Classicism, heralding the Romantic period. With his "Epsom Derby" (ill. p. 427), produced just a few years before his death, he paved the way for the Impressionists. Géricault entered the studio of the equestrian artist and battlefield painter Carle Vernet in 1808, changing in 1810 to Guérin, whose Classicism did not appeal to him. His intensive exploration of the Antiquity and the masters of the 16th and 17th centuries became decisive for his art. He made innumerable copies in the Louvre of the works of Rubens, Caravaggio, Velázquez, Rembrandt, van Dyck and Raphael. When in Italy in 1816/17, he was particularly impressed by Michelangelo. In England, where he stayed from 1820 to 1822, Constable became important, and also Wilkie and Hogarth. It is possible to trace the influence of most of these painters in his work.

The unequalled realism of Géricault's portraits and pictures of animals, however, is founded on the intensive study of nature - in the countryside, at race courses, in stables and at public festivals. His determination to capture human nature under the most extreme conditions meant that he never avoided working in hospitals, institutions for the insane, and morgues. These pictures give an account of Géricault's own eventful life - his spasmodic political enthusiasms, his joining the Musketeers of the King's army, and also his passionate, unrequited love for many years for the wife of a friend. He died painfully at the age of 33 as the result of a riding accident.

Illustration:

- The Madwoman (Manomania of Envy), 415 1822/22
- Officer of the Imperial Guard (The Charging Chasseur), 1812
- The Quicklime Works, c. 1821/22
- The Raft of the Medusa (sketch), 426 c. 1818/19
- The Epsom Derby, 1821
- The Kleptomaniac, c. 1822/23 427

GERTSCH Franz

born 1930 Möhringen (near Bern) Gertsch studied from 1947 tof 1950 at the painting-school of Max von Mühlenen in Bern. He is one of the European exponents of Photo-Realism. In his monumental canvases, produced since 1969, the motifs appear in extreme magnification. As an image to start from, he uses slides produced by himself. By intensifying and accentuating the projected image on the canvas, Gertsch not only achieves a hyperrealistic effect, but also attempts to dematerialise his subject. In the 1970s he produced family and group scenes. After painting his last picture in oil in 1986, the portrait "Johanna II", he began to produce numerous large-scale woodcuts in the hyperrealistic manner.

Illustration:

Medici, 1971

GHIRLANDAIO Domenico

(Domenico di Tommaso Bigordi)

1449 Florence – 1494 Florence Ghirlandaio was the antithesis to Botticelli in Florentine painting of the second half of the 15th century. Botticelli's refined, courtly art stands in juxtaposition to Ghirlandaio's depiction of the prosperous middle-class, where love of detail is dominated by brilliantly marshalled mass scenes. In his lavishly decorated "contemporary" architecture and distant landscapes, Ghirlandaio owed more to the traditions of the first half of the century. Above all, he is the one painter of his generation in Florence to have been destined for large-scale work, and therefore a born fresco painter. Already in 1481 he was one of the circle of selected artists to paint the lower half of the Sistine Chapel. His second major work was the decoration of the private chapel of the Sassetti family at Santa Trinità in Florence from 1483 to 1485. Scenes from the Life of St Francis were given the setting of 15th century Florence, and even now some of his views of the city are of particular value as an historical source. Ghirlandaio told his stories in a lively manner, easily grasped by the imagination. Some details, such as figure arrangement, point to a Dutch influence, as demonstrated by his altar picture in the Sassetti chapel. The Last Supper fresco in the refectory of Ognissanti (ill. p. 108) painted in 1480, a subject he used again in San Marco, was important in the way Ghirlandaio succeeded in bringing actual architecture into the scene. His creativity reached its culmination with his work in the main choir of Santa Maria Novella (1485-1490).

Illustrations:

108 Last Supper, 1480

Old Man and Young Boy, 1488 108

GIACOMETTI Alberto

1901 Stampa (Graubünden) – 1966 Chur Giacometti studied sculpture at the Ecole des Arts et Metiers in Geneva. In 1920/21 he went to Italy and remained in Rome for some time. In 1922 he went to Paris and became a pupil of the sculptor Émile Bourdelle at the Académie de la Grande Chaumiére. In 1929 he met Aragon, Dalí and Breton and joined the Surrealists in 1932. Sartre and Simone de Beauvoir introduced him to Existentialism. Both his sculptural art and his painting deal almost exclusively with the human figure. Giacometti spent the years 1942 to 1945 in Geneva. He then returned again to Paris, devoting himself intensively to painting. In protracted and frequently repeated attempts he produced portraits principally of his wife Annette and close friends. His concern was to apply the principles of his late sculpture to painting, with particular emphasis on the development of the human head. Illustration:

645 Portrait of Jean Genet, 1955

GIORDANO Luca

1634 Naples – 1705 Naples

Giordano, who obtained instruction from his father Antonio and from Ribera, ranks as the first Baroque "virtuoso" in the sense of the 18th century. The number of his oil-paintings is estimated to be over 5000, which brought him the nickname "fa presto" (do it quickly). He also had the ability to copy any style. While he was greatly influenced by Ribera in his early years, he later developed a style which showed his familiarity with Rubens, van Dyck, Cortona, and most of all the great Venetian painters such as Titian and Veronese whom he had discovered on a visit to the northern parts of Italy in the early 1650s.

In 1654, having returned to his home town, he received a commission for two paintings for the choir of San Pietro ad Aram, and he produced the "Madonna of the Rosary" (Naples, Galleria Nazionale), the "Ecstasy of St Alexius" (Arco, Chiesa del Purgatorio) and "Tarquinius and Lucretia" (Naples, Galleria Nazionale). On a second visit to Venice in 1667 he painted there the "Ascension of Mary" for Santa Maria della Salute, which in its generous conception is reminiscent of Cortona. Giordano's fame was established with his two large St Benedict cycles for Monte Cassino (destroyed 1943) and San Gregorio Armeno (Naples). From 1679-1682 he worked spasmodically on the ceiling of the gallery in the Palazzo Medici-Riccardi in Florence. Charles II called him to the Spanish court in 1692, and in the following ten years Giordano produced major works, such as the frescos in the San Lorenzo church at Escorial and the bible scenes in the Buen Retiro palace near Madrid. He returned via Genoa, Florence and Rome to Naples in 1702. One of his last important works was the fresco in the cupola of Tesoro Certosa di San Martino.

Illustration:

238 The Fall of the Rebel Angels, 1666

GIORGIONE

(Giorgio Barbarelli, Giorgio da Castelfranco) c. 1477/78 Castelfranco Veneto – 1510 Venice In the development of Venetian painting Giorgione's work provides the link between Giovanni Bellini and Titian. Giorgione was trained by Bellini, who also provided a decisive stimulus. Giorgione's "Madonna di Castelfranco" (ill. p. 164) shows the influence of both Bellini and Antonello da Messina in its clarity of composition and richness of colour scale, while already revealing greater dynamism in the articulation of surface and less dependence on the drawing. In subsequent works, landscape gains in importance, by far exceeding Bellini's possibilities. The aim was not, however, to create "pure" landscape, as was the case north of the Alps with Dürer, Altdorfer and Wolf Huber. Giorgione's starting point was always the representation of the human being, whose moods and dreams are reflected in the landscape. But this was not the only way in which he achieved the fusion of figure and landscape; rather, it was done through acute sensitivity of colour aimed at producing the right atmospheric effect ("La Tempesta", ill. p. 165; "Concert Champêtre", ill. p. 164, perhaps completed by Titian; "Venus", Dresden, Gemäldegalerie, c. 1505–1510). Giorgione's works are often mysterious in subject matter. He certainly exercised a lasting influence on the younger Titian with his soft modelling of forms in which line is replaced by colour. Giorgio Vasari stated with great admiration that Giorgione would put brush straight to canvas without preliminary sketch.

Only a few of his paintings survive, although it is difficult to identify those works that can be attributed to him with certainty. The versatility of his talent can be assessed only from the remaining frescos for the façade of the Fondaco dei Tedesci (Hall of the German Merchants in Venice, 1508). His most significant contribution was the representation of the figure in space, freely moving and from all sides visible, and this idea was further developed by the great Venetian painters of the 16th century.

Illustrations:

- Virgin and Child with SS Francis and Liberalis (Madonna di Castelfranco),1504/05
- 164 Concert Champêtre, c. 1510/11
- 165 La Tempesta, c. 1510

GIOTTO DI BONDONE

1266 (?) Colle di Vespignano (near Florence) – 1337 Florence

According to legend - Giotto was one of the first artists to become a legend - he was discovered by Cimabue as a boy, making drawings of his father's sheep. He certainly was a pupil of Cimabue. But he was able to work independently, as the frescos in the Upper Church in Assisi show and which can be attributed to him with complete certainty. Impressed by ancient Roman art, French sculpture (in particular Rheims and eastern France) and the Tuscan sculptors Giovanni Pisano and Arnolfo di Cambio, he developed his own conception which showed no particular influence. It is not certain whether he was involved in the painting of the famous cycle of the Life of St Francis in the Upper Church of Assisi. Considering that several masters and any number of assistants were engaged in carrying out this work, and also that Giotto had at that time not yet fully developed his own characteristic style, the main works of the cycle could well have been painted by him. However, his masterpiece was undoubtedly the decoration of the private chapel built by the financier Enrico Scrovegni for his family in the Arena of Padua, 1303 to 1305. Documentary sources tell us that he was the most famous painter of his generation in Italy. He received innumerable offers of

work from leading lords and princes, including from the Pope and his cardinals in Rome (copy surviving) and Bologna, from King Robert of Anjou for the large cycles in Naples, the Scaligers in Verona and Visconti in Milan. He probably also worked in other Italian cities. All these works, and also some cycles dealing with profane subjects, have been lost. Of his late work only some badly preserved frescos in the side chapels of Santa Croce in Florence survive in outline.

Giotto was an excellent organiser. He had a large workshop with a great number of well-trained assistants so that he was in a position to undertake even the largest of commissions. In this he is comparable to Rubens. And it is safe to assume that he was also a good businessman which, at the time, meant that as a leading painter he was able to charge exorbitant fees. This was customary up to the times of Dürer and Titian. Towards the end of his life he was appointed chief architect of the city of Florence. This was often no more than a title, but Giotto seems to have worked at it. He is generally considered to be the pioneer of modern painting, but his effect on his professional contemporaries in Florence was so overwhelming that they were reduced to mere followers, albeit capable ones. His influence was more fruitful in Siena and the northern parts of Italy; in Florence not until a century later with the generation of Masaccio.

Illustrations:

- 8 The Devils Cast out of Arezzo, c. 1296–1297
- 13 The Crucifixion, 1303–1305
- The Marriage Procession of the Virgin, 1303–1305
- 29 Enthroned Madonna with Saints (Ognissanti Madonna), c. 1305–1310
- Joachim Takes Refuge in the Wilderness, c. 1303–1305
- 31 Anna and Joachim Meet at the Golden Gate, 1303–1305
- 32 The Lamentation of Christ, 1303-1305
- 32 St Francis Giving his Cloak to a Poor Man, between 1296 and 1299

GIOVANNI DA MILANO

(Giovanni di Jacopo di Guido da Caversago) born in Caversaccio (near Milan), active between 1346 and 1369, mostly in Florence Giovanni was probably trained in Lombardy which had its own painting school of good reputation. Like Giotto, he was brought to Milan by the Viscontis

Giotto, he was brought to Milan by the Viscontis (though in the last year of Giotto's life). From the start Giovanni was thus in touch with Florentine innovations. There is evidence that he himself lived in Florence from 1346 but continued to carry out commissions in Lombardy. It was not until 1366 that he became a Florentine citizen. His major work are the frescos of the Capella Rinuccini in the sacristy chancel of Santa Croce in Florence. Giovanni proved himself to be one of the few painters who went beyond Giotto in Florence. He owed his fine colour modulation and his evenness of application to Sienese panel painting, but without becoming an imitator. From his background in northern Italy he brought a close study of nature, especially of animals. His figures appear solemn, their faces idealised. The ambivalence between ideal beauty and actual nature - so typical in the International Gothic style - is already evident in Giovanni's work.

Illustration: 64 Pietà, 1365

GIRARD D'ORLÉANS

active 1344-1361 in Paris

Probably coming from the family of the painter Evrard d'Orléans, Girard worked as a furniture decorator at the French court from 1344. In 1352 he was

appointed court painter and *valet de chambre* to John II, at whose direction he added to the collection of oil-paintings by Jean Coste at the Vaudreuil palace in Normandy. Only a few of his authenticated works survive: apart from the portrait of John II, taken from a square triptych and produced during his incarceration in England, there is information about a much admired Madonna, which he painted for the small Carthusian monastery in Paris and at whose feet he was buried.

67 Portrait of John II "the Good", King of France, c. 1349

GOES Hugo van der

c. 1440-1445 Ghent - 1482 near Brussels Van der Goes is, apart from the somewhat younger Bosch, the most important Dutch painter in the second half of the 15th century. Little is known about his life, and his artistic origins are also unclear. A certificate of 1480 confirms that his home town was Ghent, and as he was granted the master title in Ghent in 1467, he must have been born about 1440-1445. As early as 1477 he abandoned his workshop, entering the Red Monastery near Brussels where he died in 1482 after a severe mental illness. His masterpiece, known as the Portinari Altarpiece (ill. p. 133) is the only surviving work that can be attributed to him with absolute certainty, although there are others that can be assigned to him with some safety (Monforte Altarpiece, ill. p. 132; diptych depicting the "Fall of Adam, the Lamentation of Christ and St Genoveva", Vienna, Kunsthistorisches Museum, ill. p. 132). Hugo van der Goes had at his disposal all the techniques of the earlier Dutch masters, in particular Rogier van der Weyden, as regards spatial disposition, the true-to-life construction of the human body and the representation of luxurious detail to look like the real thing. Yet he handled these devices in a completely different sense, putting to service the heightened expressiveness of gestures and faces, and not excluding the "uncomely" With his Portinari Altarpiece he brought about a revolution in Florentine painting, as the works of Ghirlandaio and Filippino Lippi demonstrate, but which becomes most evident in Leonardo da Vinci's work. Illustrations:

132 The Fall of Adam, before 1470

- 132 Adoration of the Magi (Monforte Altar), c. 1470
- Adoration of the Shepherds (Portinari Altar), 1476–1478

GOGH Vincent van

1853 Groot-Zundert (Northern Brabant) – 1890 Auvers-sur-Oise (near Paris)

This Dutch painter, son of a clergyman, only had a short creative period of about ten years. All his life he remained very close to his younger brother Theo, who provided for him, as Vincent only sold one single picture during his painting career. Van Gogh worked first for art dealers in The Hague, London and Paris; then as a private teacher. Later he became a Methodist preacher among the Belgian miners of the Borinage, to bring them help and salvation. After his dismissal there, he decided to become an artist. Initially he painted sombre scenes from the life of the poor which show his personal engagement with his subject, using darktoned colours and a rough, sharp-edged technique ("Potato Eaters", various versions). Although he sought friendship, all his relationships failed because of his tragic and melancholic temperament and his emotional outbursts. All his life he suffered from loneliness, his only consolation being painting. He often went back to his parents' home at

Nuenen, where the most important of his Dutch pictures were painted between 1883 and 1885. Until 1886 he was at Antwerp, where he entered the Academy for a few months, but he preferred to paint in the open. After discovering the charms of Japanese woodcuts he tried to transfer some of the motifs into oil. These woodcuts had a revolutionary effect on his style. He began to use lighter colours, and his two years in Paris from 1886 to 1888 became the most important period in his artistic career. He was introduced to the Impressionists, Symbolists and Pointillists, and also met Gauguin. In 1888, in search of the southern light, he went to Arles, where Gauguin visited him. In 1889 he went at his own request into an asylum at St Rémy, where he continued to paint, and in 1890 moved to Auvers-sur-Oise, where his friend and patron Doctor Paul Gachet lived. Unfortunately this medical attention could not help him, and, in despair of his condition, he shot himself. Between 1888 and his death van Gogh produced, in just thirty months of feverish creativity, those 463 paintings which established his worldwide fame and made him one of the founders of modern 20th century painting, in particular in the fields of Expressionism and Fauvism.

Illustrations:

488 Flower-Garden, 1888

521 The Langlois Bridge at Arles, 1888

Harvest at La Crau, with Montmajour in the Background (Blue Cart), 1888

The Artist's Bedroom in Arles, 1889

522 Portrait of Doctor Gachet, 1890

523 The Church at Auvers-sur-Oise, 1890

GORKY Arshile

(Vosdanik Adoian)

1904 Khorkom Vari (Armenia) – 1948 Sherman (Connecticut)

Gorky was one of the key figures of abstract Expressionism in the USA. He was born in the cultural centre of Armenia, famous for its fresco painting, book illumination, architecture and sculpture. In 1908 his father emigrated to America, and the family followed in 1920, as they lived in fear of the Turks. Gorky taught himself to paint, guided by Cézanne's work. From 1922 to 1924 he studied at the Boston New School of Design. Exhibitions of Surrealist art in New York introduced him in the 1930s to the works of Picasso, Miró and Masson. While under their influence he painted some murals which had been commissioned by the American government. Gorky developed an idiom which became less and less objective until it arrived at the purely abstract. His pictures and drawings are divided into colour fields and "hybrid forms". Around 1947 he turned away from Surrealism and also spoke against abstract Expressionism, in spite of having himself exercised great influence on the painters of that tendency. When, after a serious road accident, his right-hand became paralysed, Gorky committed suicide.

Illustration:

629 The Liver is the Cock's Comb, 1944

GOSSAERT Jan

(called: Mabuse)

about 1478/88 Maubeuge (Hennegau) – about 1533–1536 Breda (?)

It is not known where Gossaert was trained, and the stylistic assessment has not yet offered many clues about this. From 1503 to 1507 he lived and worked in Antwerp. Decisive in his development was a visit to Rome in 1508/09 in company with Philip of Burgundy for whom he had to draw ancient architecture and sculpture. On his return he nevertheless adhered at first to the traditions of the Dutch masters, copying the works of Jan van

Eyck, for example. However, after 1515 his Italian experience gradually took effect as can be seen particularly in his depiction of architecture as well as his interest in three-dimensional figure painting. His "Neptune and Amphitrite" (Berlin, Gemäldegalerie, 1516) reflects, in the Herculean representation of the nude figures, the impressions Gossaert had received from Michelangelo's ceiling in the Sistine Chapel. When called in 1515 by Philip of Burgundy to decorate the Soubourg palace near Middelburg, Gossaert was able to carry out court commissions without being bound by Guild regulations. He concentrated on mythological scenes and portraiture, favouring large-scale, "statuary" figures which, although modelled on the ideal body of Italian antiquity, nevertheless bear traces of ordinary characters of the day. Gossaert played an important role in introducing a northern Renaissance style with an Italian flavour.

Illustration:

201 Danaë, 1527

GOYA Francisco José de

(Francisco José de Goya y Lucientes) 1746 Fuendetodos (near Saragossa) – 1828 Bordeaux

Goya was trained in Saragossa by José Luzan, a pupil of Giordano and Solimena, before going to Madrid. There he entered the studio of Francisco Bayeu, his future brother-in-law, who worked under Mengs at the court of Charles III. After visiting Italy in 1770/71, Goya was asked to provide designs for the royal tapestry works. In 1780 he became a member of the Real Academia de San Fernando, later to become its deputy prinicpal and then principal. Having carried out court commissions since 1781, he was appointed as a court painter in 1786, painter to the royal chamber in 1789, and principal court painter in

Goya started painting in the Spanish version of the Rococo manner, intermingled with French and Italian elements, but from 1792 his style changed drastically. During that year he became deaf as a result of a severe illness. In a series of uncommissioned paintings he created, under the mask of ordinary genre scenes, a world of terror and nightmare ("The Burial of the Sardine", ill. p. 399; "Procession of the Flagellants"; the "Mad-House"; the "Session of the Inquisition" – all Madrid, Academia de San Fernando). During the same period he produced "Los Caprichos", consisting of 80 etchings (published 1799) to "scourge human vices and errors", as he wrote. With his "black paintings" of the Quinta del Sordo (Madrid, Prado) he reached the pitch of his portrayal of the negative and unaccountable in human existence. Under the pressure of the Restoration Goya left Spain and emigrated to Bordeaux. The deeply questionable in human nature, which is also expressed in Goya's portraits, did not find full recognition until the 20th century.

Illustrations:

341 Portrait of Doña Isabel de Porcel, 1805

397 The Clothed Maja, c. 1797

397 The Naked Maja, c. 1797

398 Don Manuel Osorio Manrique de Zúñiga,

398 Plucked Turkey, between 1810 and 1823

The Burial of the Sardine (Carnival scene), c. 1808–1814

400 The Family of Charles IV, 1800

GOYEN Jan van

1596 Leiden – 1656 The Hague

Van Goyen was born ten years before Rembrandt in Leiden. His father sent him as a child to learn drawing, then to several unimportant painters to be trained, but van Goyen does not seem to have much profited by it. He travelled for a year in France, then in 1616 took up studies under the skilled landscape painter Esaias van de Velde in Haarlem. He then returned to Leiden, became a member of the Lukas Guild in 1618 and moved to the Hague in 1631. He won and lost money in property speculations and became the victim of a large tulip-bulb swindle. This compelled him to produce a large output, which in turn had a negative effect on the price of his pictures, although all his work was of a high standard. Van Goven specialised in landscape painting and was one of the most important painters in this field at the time, although his true worth was not recognised until he was rediscovered by the Impressionists. He depicted quiet, peaceful scenery with dunes, the sea and rivers, also seascapes and winter scenes in a style quite of his own. His early work showed the influence of van de Velde with strong colouring, a great many figures, coral-like trees and heavy clouds. From about 1630 his style changed, becoming more simplified with almost monochrome colouring in green-greys or yellow-browns. After 1640, in his "toned period", he used almost exclusively a warm brown. Uncluttered river scenes with low horizons and vast areas of sky predominate. His most important pupil was his son-in-law Jan Steen.

Illustrations:

305 Landscape with Dunes, c. 1630–1635

305 River Landscape, 1636

GOZZOLI Benozzo

(Benozzo di Lese di Sandro) 1420 Florence – 1497 Pistoia

Like many other painters of the early Renaissance. Gozzoli initially trained as a goldsmith, which enabled him to work in Ghiberti's workshop, 1444-1447, and assist him on the Paradise Gates. At the age of 27 he began to work with Fra Angelico in Orvieto and Rome. Both these masters were to influence his entire work. From Ghiberti he learned precision in depicting the finest detail and how to tell a story vividly, and Fra Angelico's legacy was his bright coloration, which Gozzoli succeeded in transmitting to the art of fresco painting. It is an astounding phenomenon that Gozzoli, the greatest "fanatic of detail" amongst all the Florentine masters of the early Renaissance, should have been primarily involved in the field of monumental painting. His first major independent commission was the fresco work in the choir of San Francesco in Montefalco with scenes from the Life of St Francis (1450-1452). This cycle could have helped him to secure another commission in 1458, the decoration of the chapel of the Medici Palace (ill. pp. 80, 102). Stimulated by the prestige attached to this commission and the abundance of materials at his disposal (including gold), Gozzoli created the most fascinating "story" of a 15th century Florentine. His subsequent cycles were of an equally high standard. Sienese and Umbrian art of later generations derived a great stimulus from Gozzoli's work. Illustrations:

80 Procession of the Magi (detail), 1459–1461

Procession of the Magi (detail), 1459–1461

GRASSI Giovannino de'

documented from 1389, died 1398 Giovannino was court artist to the Visconti in Milan. He is first mentioned in connection with work on the building of Milan cathedral by the Visconti. His versatility was amazing. He produced several sculptures (a medium which, according to

records, did not suit him), decorated church banners, painted altarpieces, made designs for church windows, probably also made a wooden model of the cathedral, and acted as adviser on the building of the Pavia monastery. Of all this work, almost nothing has survived. As with Michelino da Besozzo we have to resort to his book illuminations in order to get an idea of his work. There remains in the Bergamo library a book of signed sketches which is of the greatest artistic value with its astonishing animal studies and other scenes. But there is the problem that some of the drawings seem to have been done direct from nature, some copied from paintings, and also that the sketches are not all by the same hand. So it was probably a workshop production, especially as it is known that Grassi was assisted in his work by his brother Porrino and his son Salomone as well as others. His artistic origins are not clear - much of the older Lombardian art has been lost. But he had many followers, his most important pupil and successor being Michelino da Besozzo.

Onions. From the herbal "Tacuinum Sanitatis", c. 1380–1390

GRECO El

(Domenikos Theotokópoulos, called: "El Greco", The Greek)

c. 1541 Phodele (Crete) – 1614 Toledo As a most unusual phenomenon in 16th century European painting, El Greco combined the strict Byzantine style of his homeland with influences received during his studies in Venice and the medieval tradition of his country of adoption, Spain. El Greco obtained his training as icon-maker in a monastery. He then went to Venice where Titian became his greatest mentor. In Titian's workshop he developed the brilliance of colour which became a lasting element in his entire work. But he was also moulded by Tintoretto's Mannerist style, as is shown in his delight in bold perspectival foreshortening, the complicated movements of figures and groups of figures, the elongation of proportions and his strong chiaroscuro.

In 1570 El Greco went by way of Parma to Rome, where he met Michelangelo. He criticised his "Last Judgment" severely, offering to produce a better composition. This attitude is a particularly telling example of historical irony. The only painter of the very highest order to come from the land where the art of classical Antiquity was born, failed to understand the High Renaissance ideal of bodily beauty. El Greco's acquaintance with Spanish humanists in Rome and the expectation of commissions in connection with the rebuilding of the monastery of El Escorial might have been what led him to migrate to Spain in 1577. At first he was in the service of Philip II ("Dream of Philip II", El Escorial, 1580), then settled in Toledo in 1580 where he received a great number of church commissions and also became a popular portraitist. Historical records tell us of many disputes with commissioners about inappropriate interpretation of religious themes, unusual coloration, elongation of figures, but also old-fashioned representation.

In the course of his development El Greco became gradually detached from the reality of representation. He distorted the human figure, abandoned logical space construction and also used colour no longer objectively. It is possible that his Byzantine legacy may have been responsible for his growing asceticism. For a long time almost forgotten, interest in him revived in the early 20th century on account of his tendency towards the abstract and his depiction of dream-like scenes. He is now considered as one of the most important representatives of European Mannerism.

Illustrations:

- The Dispoiling of Christ (El Espolio), c. 1590–1600
- 210 The Agony in the Garden, c. 1595
- The Burial of Count Orgaz, c. 1586
- The Holy Family with St Anne and the young St John Baptist, c. 1594–1604
- 212 View of Toledo, c. 1604-1614

GREUZE Jean-Baptiste

1725 Tournus (Sâone-et-Loire) - 1805 Paris Greuze was the sixth of nine children. His father was a slater and wanted to have his son trained as an architect. But the son's talent won, and in 1749 he was sent to Lyon to study under the painter Charles Grandon. In 1750 Greuze went to Paris, and from 1755 studied at the Academy under Natoire. He spent two years in Italy, but this visit left no deep impressions. With his moralising genre pictures Greuze satisfied public taste, which had undergone a change and had grown tired of the Rococo manner. Subjects such as "The Cheated Blind Man", "The Paralytic Served by his Children", "The Much-Loved Mother", "The Ungrateful Son" and "The Chastened Son" found favour with the influential critic Diderot, who called this kind of painting "peinture morale", and so greatly contributed to Greuze's success. A parallel in the literary world could be found in the works of Jean-Jacques Rousseau. Although received by the Academy on the strength of an historical painting, he was categorised as a genre painter which disappointed him. His genre paintings gradually assumed heroic elements normally found in historical painting. Today he is held in high esteem as a portraitist.

Illustrations:

The Lamentation of Time Passing, c. 1775L'Accordée du Village (The Village

Betrothal), 1761

GRIS Juan

(José Victoriano Gonzáles)

1887 Madrid - 1927 Boulogne-sur-Seine Gonzáles changed his name to Gris when studying at the Arts and Crafts School at Madrid from 1902 to 1904. At the same time he worked as an illustrator for satirical papers. In 1906 he went to Paris and rented a studio in the Bateau-Lavoir where Picasso lived at the same time. The art dealer Kahnweiler encouraged him to follow the example of the Cubists, Picasso and Braque. Gris' first oil-paintings were produced in 1911. His Cubist pictures showed from the start a richer colour scale, as did his collages. It was his intention to bring together in a synthesis the various phases of Cubism. He used strong colours and lively forms, like a chequer-board pattern, and triangles. This was followed by his architecturally arranged pictures, a period which lasted three years. These works, in which composition governs form and colour, have an air of great calm. It was not until 1919, when the art dealer Léonce Rosenberg exhibited his works, that Gris received public attention, which enabled him to live from his painting.

Illustrations:

568 The Teacups, 1914568 Le Déjeuner, 1915

GROS Antoine-Jean

1771 Paris – 1835 Bas-Meudon (near Paris) Already at the age of 14 Gros became a pupil of David after having received instruction from his father, a miniature painter. He was accused of Royalist tendencies and had to flee to Italy in 1793. There he lived mainly in Florence and Genoa, producing miniatures and portraits for his livelihood. A meeting with Napoleon in Milan in 1796 established his career. His first commission was "Napoleon at Arcola" (ill. p. 424). The dynamism displayed in this work already set it apart from David's cool severity of style. On his return to France in 1799 he painted with great success colossal battle scenes to celebrate Napoleon's martial prowess, including "Bonaparte Visiting the Plague-Stricken at Jaffa" (Paris, Louvre, 1804) and "Napoleon on the Battlefield at Eylau" (ill. p. 424). Under Rubens' influence his compositions became more lively and his handling of colour more intensive. The Romantics, in particular Delacroix, were impressed by the freshness and vigour of his work. As under Napoleon, Gros was also during the Restoration the official portrait painter of society. In 1824 he was made a baron. When David went into exile to Brussels in 1816, he handed over his studio to Gros and urged him as head of the Classicist school to strive against the Romantics. Gros' lifeless compositions of mythological subjects which then followed were rejected by the Romantics and also by his own pupils, who turned to the great Classicist Ingres. At the age of 65, depressed by his failures, he committed

Illustrations:

424 Napoleon at Arcole, November 17, 1796, 1796

Napoleon on the Battlefield at Eylau, February 9, 1807, 1808

GROSZ George

1893 Berlin – 1959 Berlin Grosz, who was expelled from school because of unruliness, studied at the Dresden Academy from 1909, then at the Arts and Crafts School in Berlin from 1911. He found his direction by studying the satirical draughtsmen of the Simplicissimus. In 1913 he spent six months in Paris and began painting in oils. After two years' military service, Grosz returned wounded to Berlin in 1916. His pictures dating from that period were futuristically structured visions, dominated by caricature-like, distorted figures who are embroiled in a hopeless muddle of things. In 1917 Grosz was again called up, but was soon transferred to a mental institution. On his recovery in 1918 he became connected with the politically active Berlin Dadaist group around Johannes Baader, Raoul Hausmann, Richard Huelsenbeck and John Heartfield. In about 1920 Grosz developed a decidedly naturalistic style with a dissecting perspicacity and biting sarcasm. He was several times summoned to appear in court about his graphic work. A visit to New York led to a decision to settle there in 1932, before the suppression of his art under the Hitler regime began. Illustration:

589 The Funeral – Dedication to Oskar Panizza, 1917/18

GRÜNEWALD Matthias

(Mathis Gothart Nithart)

c. 1470–1480 Würzburg (?) – 1528 Halle Joachim von Sandrart entered this painter's name erroneously as Grünewald in his *Teutsche Akademie* (1675). His real name was Mathis Neithart or Nithart, and he later called himself Gothart. Grünewald is, beside Dürer, the most important representative of Northern painting at the turn of the 15th to the 16th century, and he is also Dürer's complete opposite. As Dürer's foremost artistic device was the line, so was Grünewald's colour, which he used to achieve new heights of expressiveness. And while Dürer turned to the new dis-

coveries of the Renaissance in the course of his development, Grünewald generally continued to adhere to the Middle Ages. Tradition and "progress" cross each other in unexpected ways in the works of these two masters. And yet Grünewald was a man of the Renaissance in the way he lived and applied his many talents. In 1509 he became court painter to archbishop Uriel von Gemmingen at Aschaffenburg, and in this capacity he had to supervise the rebuilding of the palace there. In 1516 he started on a fixed income at the court of the elector Albrecht von Brandenburg where he worked as a painter and architect and also as a designer of fountains. He had to leave this post in 1520 because of his Lutheran convictions.

His major works include the "Isenheim Altar" (ill. p. 190), "The Mocking of Christ" (ill. p. 190) and the "Erasmus-Mauritius" panel (ill. p. 191); two pictures of the Crucifixion (Basle, Kunstmuseum, 1505; Washington, National Gallery, c. 1520); four figures of saints in grisaille for the wings of Dürer's Heller Altar (Donaueschingen, Fürstliche Gemäldegalerie, and Frankfurt am Main, Städelsches Kunstinstitut, 1501-1512); the "Stuppach Madonna" (Stuppach, Pfarrkirche) which formed part of the Maria-Schnee-Altar in Aschaffenburg (1517-1519), as did the "Founding of Santa Maria Maggiore" (Freiburg, Augustinermuseum); and the "Crucifixion" and "Christ Carrying the Cross" of the Tauberbischofsheim Altar (Karlsruhe, Kunsthalle, c. 1525). Illustrations:

190 The Mocking of Christ, c. 1503

190 Crucifixion (Isenheim Altar), 1512-1516

191 The Meeting of St Erasmus and St Maurice, c. 1520–1524

GUARDI Francesco

1712 Venice - 1793 Venice

Guardi obtained his initial training at the workshop of his older brother, together with whom he also seems to have worked later. As a veduta painter he took as starting point the work of Michele Marieschi and Canaletto, while his figure painting owed something to Magnasco and Tiepolo, the Guardis' brother-in-law. Like Canaletto and Bellotto, Guardi took his veduta production abroad, where the demand was, primarily the English art market. But he increasingly moved away from mere topographical rendition and towards a poetical view, in which Venetian effects of light are used to convey mood. His sensitive brushwork sets off the shimmering air and reflections of light on water, making the objects in the picture tremble and vibrate. Besides this, Guardi was also engaged in figurative painting, but it was not until mid-century that he carried out independent commissions. Around 1770 he painted the twelve-part series "Feste dogali", in which he depicted Venetian state ceremonies. Francesco, whose work is sometimes not easy to distinguish from his brother's, was also a graphic artist. His work in this field has a captivating spontaneity, and belongs among the best produced in the 18th century.

Illustrations:

372 Venetian Gala Concert, c. 1782

373 Capriccio, c. 1745

GUERCINO

(Giovanni Francesco Barbieri)

1591 Cento (near Bologna) – 1666 Bologna "Il Guercino" (the squint-eyed) was a nickname given because of the squint in his right eye. He was the leading painter of the Bolognese school alongside Reni. He was taught by Paolo Zagnoni in Bologna and was influenced by the work of Lodovico Carracci. Between 1615 and 1617 he painted interior decorations in Cento and produced religious

works ("The Four Evangelists", Dresden, Gemäldegalerie) and landscapes ("Landscape in Moonlight", Stockholm, National Museum). At the commission of Cardinal Alessandro Ludovisi, later Pope Gregory XV, he painted the frescos in the oratorio of San Rocco, Bologna. His visit to Venice in 1618, where he met Palma il Vecchio, served to develop his style further ("Et in Arcadia ego", Rome, Galleria Nazionale d'Arte Antica; "Martyrdom of St Paul", Modena, Galleria Estense). In subsequent years his pictures became increasingly lively and dramatic, primarily achieved by the contrast of light and shade. In 1621 he followed a call to Rome by Pope Gregory XV, for whom he worked until his death. Here he painted his best-known work, the "Aurora", on a ceiling of the Villa Ludovisi. He explored his Roman experience when he returned to his home town, drawing in particular on Domenichino and Reni ("The Virgin with St Bruno", Ferrara, Pinacoteca Nazionale; "Ecstasy of St Francis", Dresden, Gemäldegalerie). There was now more pathos, and his freshness was replaced by an idealised Classicism; light and colour became cooler. On Reni's death in 1642 Guercino became the head of the Bolognese school. His attempts at regaining his former lively style were, however, not always successful. Illustration:

236 The Return of the Prodigal Son, 1619

GUILLAUME DE MACHAUT → Master

GÜNTHER Matthäus

1705 Tritschengreith (Upper Bavaria) – 1788 Haid (near Wessobrunn)

After basic instruction in Murnau, Günther became the pupil and assistant of Cosmas Damian Asam. He had no direct contact with Johann Evangelist Holzer, who was his junior, but he acquired out of his estate various drawings and can be considered his legitimate artistic successor. He was made master in Augsburg in 1731 and subsequently worked as an independent fresco painter. In 55 years he decorated over sixty rooms. His main works were produced in the Benedictine churches at Amorbach and Rott am Inn, the Augustinian Canonical churches at Indersdorf and Rottenbuch, the parish churches at Sterzing, Mittenwald and Oberammergau, and the Great Hall at Sünching castle. Günther worked in Bavaria, Swabia, Franconia and the Tyrol and can be considered as one of the most important representatives of south German fresco painting. Illustration:

393 The Apotheosis of St Benedict, c. 1761–1763

GUTTUSO Renato

1912 Bagheria (near Palermo) - 1987 Rome After studying law for a year in Rome, Guttuso, who was self-taught, began to paint. His political attitude was unmistakably anti-Fascist. In 1940 he joined the Communist Party and three years later a partisan group. In 1947 he was co-founder of the Fronte Nuovo delle Arti in Rome. Guttuso is the leading personality of Italian Social Realism. His socio-critical themes are given emphasis by his dramatic, expressive style. His art had its roots in the folk art of his Sicilian birthplace. He regarded himself as working in the tradition of Dürer, Courbet and Picasso. Between 1948 and 1960 he participated regularly in the Biennale in Venice. In 1952 and 1972 he received the Soviet Lenin Prize. In 1968 he accepted a chair at the Hamburg Kunsthochschule. From 1975 his political activities became more and more demanding, culminating in his election as a senator of the Italian Republic.

Illustration:

670 Wall of News - May 1968, 1968

HALS Dirck

1591 Haarlem – 1656 Haarlem

Dirck was the younger brother of Frans Hals who was probably also his teacher, but the painters who influenced Dirck were Esaias van de Velde and Willem Buytewech. Apart from a few small portraits, he devoted himself exclusively to the painting of conversation pieces - the cheerful domestic life of prosperous burghers in their houses or gardens. He was not interested in the serious side of life; in his work he depicted people in conversation or while flirting, making music and dancing, eating and drinking. His interiors are hardly worked out, all the emphasis is put on fashionable dress and colourful representation. He succeeded in putting across people's high spirits through facial expression, costly dress, posture and loose grouping.

Illustration:

298 Merry Company, undated

HALS Frans

c. 1581-1585 Antwerp (?) - 1666 Haarlem Frans Hals was the son of a cloth-maker from Mecheln. He was Flemish by birth and was born in Antwerp or Mecheln. His parents moved to Haarlem, where his younger brother Dirck was born in 1591. Apart from one or two short visits to Antwerp and Amsterdam, Hals never left Haarlem. About 1600-1603 he was trained in the workshop of Karel van Mander who is most remembered for his writings on the history of art. In 1610 he became a member of the Lukas Guild, and in 1644 its head. He was highly esteemed in Haarlem, as is shown by the fact that he received altogether eight commissions for the large civic guard pictures. But Hals was often in debt as his portraits were not "elegant" enough for contemporary taste, so that he never became a fashionable painter. Also, he had to provide for ten children from his two marriages. In 1652 he had to auction his furniture and his paintings to pay the baker, and shortly before his death he received poor relief in the form of money and peat. It is often maintained that his poverty was the result of his extravagant life-style, but there is no evidence for this.

Hals is the most important Dutch portrait painter. His surviving work comprises about 300 paintings, and the majority of these are portraits and group portraits. Although also a genre painter after 1626 when he had become familiar with the Utrecht Caravaggists, these still remained portraits except that they also contained symbolic accessories or were painted in a narrative manner. Hals certainly was the foremost painter of the Dutch group portrayal. Already with his first commission, 1616, the "Banquet of the Officers of the St George Civic Guard" (ill. p. 295), he revolutionised this branch of painting which had so far been restricted to lining up several single portraits. But he never presented the scene in a theatrical fashion, as Rembrandt did with his "Night Watch", and each of his sitters is given individual and equal attention. His last two group portraits were the "Regents" (Haarlem, Frans-Hals-Museum, 1664) and "Regentesses of the Old Men's Almshouse in Haarlem" (ill. p. 298). These represent the end of the great era of this type of painting - there are just a few examples of it in the 18th century, and with its waning, the vitality and Baroque theatricality are replaced by a pessimistic, melancholic resignation about the human condition.

In his large single or double portraits, as in the life-size "Portrait of Willem van Heythuysen" (ill. p. 297), Flemish elements and the influence of Rubens become evident, with the background showing views and scenic staffage. His special devices used for livening up the picture are most evident in his genre portraits ("The Gypsy Girl", ill. p. 296; "The Merry Drinker", ill. p. 296; "Malle

Babbe", Berlin, Gemäldegalerie, c. 1629). With a spontaneous and seemingly improvised brushstroke, he produces light reflections on the faces, objects, cloth and lace, thus creating an effect of immediacy as well as vitality. Apart from his son Dirck and the imitator of his style, Judith Leyster, his pupils included the Ostade brothers; he also greatly influenced Steen and Terborch. Illustrations:

Two Singing Boys, 1626 283

Banquet of the Officers of the St George 295 Civic Guard in Haarlem, 1616

Young Man with a Skull (Vanitas), c. 1626

The Merry Drinker, 1628 296

The Gypsy Girl, c. 1628–1630 296

Portrait of Willem van Heythuysen, 297 c. 1625–1630

Regentesses of the Old Men's Almshouse in Haarlem, 1664

HAMILTON Richard

born 1922 London

Hamilton, an important representative of critical English Pop Art, was trained as a draughtsman, then attended the Royal Academy Schools and Slade School of Art from 1948 to 1951. He taught at the Central School of Arts and Crafts in London, at King's College of the University of Durham and at the Royal College of Art in London. Since 1953 he has collaborated closely with other artists in organising exhibitions at the London Institute of Contemporary Arts and the Hatton Gallery of Newcastle University. Hamilton is a great admirer of Duchamp; he reconstructed his "Large Glass" and organised in 1966 the comprehensive Duchamp retrospective at the Tate Gallery in London. Hamilton's work, which deals critically with the world of consumerism, is always ironic and sometimes full of biting sarcasm. After having experimented with polaroid self-portraits in the 1970s, he turned to computer art in the 1980s. Illustration:

665 Bathers I, 1966/67

HARING Keith

1958 Kutztown (Pennsylvania) - 1990 New York Haring began early, drawing comic characters, using as models figures from television cartoon films. After high school he went to the Ivy School of Art in Pittsburgh, changing over in 1978 to the New York School of Visual Arts, where he studied under Keith Sonnier and Joseph Kosuth. Already in 1982 he had his first one-man exhibition at the Tony Shafrazi Gallery, and in the same year took part in the Kassel documenta.

Haring developed a simple, symbolic sign language in which thick black lines surround schematic figures in fluorescent colours. In the New York underground he used empty spaces on walls between advertising posters, and he painted Tshirts, buttons and also plaster casts of sculptures. In 1986 he opened the "Pop Shop" which sold multiples and everyday objects painted by Haring. In this way he set out to remove the division between high and trivial cultures. In 1989 he founded the Keith Haring Foundation for the support of social projects, and a year later he died of AIDS. Illustration:

679 Untitled (M. Mouse), 1985

HARTUNG Hans

1904 Leipzig – 1989 Antibes Hartung already made drawings and painted watercolours in his schooldays. In 1924/25 he studied philosophy and history of art at Leipzig University and then attended the Academies at Leipzig and Dresden. After spending a year on Menorca in

1932, he settled in Paris. In 1939 he joined the Foreign Legion. After the war he became a French citizen and returned to painting, for which he found wide recognition from 1949. Hartung's abstract pictures are compositions of bundles of brushstrokes, whose effect is based on extreme reduction. Besides graphic art he also produced an extensive photographic work, mostly in the 1960s and 1970s.

Illustration:

636 T 1956-9, 1956

 $HAY Jean \rightarrow Master of Moulins$

HECKEL Erich

1883 Döbeln (Saxony) – 1970 Hemmenhofen (Lake Constance)

Heckel, the son of a railway engineer, began to study architecture in Dresden in 1904, but then gave up after three terms. In 1905 he became the organiser of the Brücke, a group of Expressionist artists. In 1910 Heckel turned away from his former Brücke style, replacing flowing lines, rounded contours and his light decorative rhythm, with sharper edges which in their extreme simplification resembled woodcuts. When he moved to Berlin in 1911, he took over the studio of Otto

In 1913 the Brücke was dissolved, and Heckel developed his own individual style which achieved a crystalline density. Out of this he developed his many-layered meditative lyricism. From 1915 he served as a medical orderly in Flanders, where he met Beckmann. He explored social problems, depicting poverty and despair, the old and hungry, the blind, wounded and mentally deficient. But nature had always had a special attraction for him, and later he painted mountain scenes and views with dunes and hills, forests and lakes. Illustration:

Windmill at Dangast, 1909

HEDA Willem Claesz.

c. 1593/94 Haarlem – 1680 Haarlem Along with Pieter Claesz., with whom he is often confused, Heda was the most important representative of the Haarlem school of still life painting. Little is known about his life. In 1631 he was a member of the Lukas Guild, and in 1637 he is mentioned several times as its chairman. After painting a small number of portraits and religious pictures, he began to specialise in the "breakfast" still lifes with their tasteful arrangements. These are not depictions of heavily-laden, magnificently appointed festive boards, but ordinary tables with just a few items, such as the remains of a cake, a half-empty wineglass, a pewter jug, cracked nuts or a burnt-out clay pipe, giving the impression that a simple meal has just been finished. The description "still life" did not exist until mid-century. There was the distinction between "Ontbijtje", the breakfast arrangement, and the "Banketje", the light meal. Heda's still lifes are conservative in their coloration, moving between a golden yellow, brown, grey and a silvery white. Therefore Heda's and also Claesz.'s works are referred to as "monochrome banketies"

Illustration: 304 Still Life, 1631

HEEM Jan Davidsz. de

1606 Utrecht – c. 1683/84 Antwerp De Heem came from a family of Dutch-Flemish still life painters. He probably received his early training from his father, then from Balthasar van der Ast in Utrecht. The years between 1628 and

1631 he spent in Leiden, then settled at Antwerp where he became a member of the Lukas Guild in 1636. In 1669 he returned to Utrecht, and records show that he was again in Antwerp in 1672. This shows that he was active in both the northern and southern parts of the Netherlands, and this is reflected in his work. His first still lifes are in tone still reminiscent of Heda and Claesz., while later flower pieces and fruit baskets suggest the influence of the Flemish painters Daniel Seghers and Snyders in their Baroque-like magnificence of coloration. De Heem's speciality were large, elaborate pictures of opulently appointed dining tables laid with silverware, fine glass and fruit baskets, often accompanied by a large lobster to provide a brilliantly coloured accent. He also painted beautifully arranged and minutely detailed flower and fruit pieces, combining subtly painted botanical details with elements of the vanitas type of still life (caterpillars attacking the fruit, beetles in the flower buds). These pictures, in all their richness and glory, are almost without comparison in Dutch painting.

Illustration.

317 Still Life, undated

HEEMSKERCK Maerten van

1498 Heemskerk (near Haarlem) – 1574 Haarlem Heemskerck is one of the main representatives of the so-called Netherlandish Romanists. After training in Haarlem and Delft he entered the workshop of Jan van Scorel, only by a few years his senior, in 1527, probably working as his assistant rather than pupil. He visited Rome in 1532 and remained there probably until 1537. The exact archaeological precision of his drawings of ancient structures makes them highly valuable source documents on Roman monuments at the time. He was certainly back in Haarlem in 1538 as he received a commission for a winged altar with scenes of the Passion of Christ and the Legend of St Lawrence in that year. He soon acquired a high reputation as a painter of altarpieces and portraits. His contact with Haarlem humanist circles was reflected in his allegorically encoded representations. In 1540 he was appointed deacon of the Lukas Guild in Haarlem and was granted tax exemption in 1572 on account of his artistic achievements. After his period in Rome, Michelangelo's influence made itself felt in Heemskerck's three-dimensional modelling of figures. His coloration was often cool and his painting technique smooth, to suit the wooden panel rather than the canvas.

Illustration:

203 Family Portrait, c. 1530

HEISIG Bernhard

born 1925 Breslau

Heisig, who now lives in Leipzig, is probably the most important painter of the former GDR. In 1941/42 he went to the College of Decorative Arts in Breslau, but his studies were interrupted by military service. In 1946/47 he worked as a graphic artist in Breslau and recommenced his studies in 1948 at the College of Applied Art in Leipzig, continuing at the College of Graphic Art and Book Production until 1951. In 1961 he became principal of the Leipzig Art College, but was dismissed in 1964 for his criticism of the state of the arts and for demanding more artistic freedom. From 1968 to 1976 he worked freelance as a painter and graphic artist. In 1976 he again became principal of the Leipzig Art College, remaining in this post until his retirement in 1987. In 1989, in protest against the "misuse of power and corruption", he returned his two national prizes (1972 and 1978) awarded under the former regime.

Illustration:

669 Der Zauberlehrling (The Sorcerer's Apprentice), 1978–1981

HILLIARD Nicholas

(also: Heliard, Hildyard, Helier) c. 1547 Exeter – 1619 London

The great English art of portraiture of the 18th century had its beginnings in the works of Hilliard more than a hundred years earlier. Having no examples in this field to draw on, he used as a starting point for his painting the highly developed traditions of book illumination and the goldsmith's art. Himself the son of a goldsmith, he went to London to be trained by the goldsmith and jeweller to Queen Elizabeth I from 1562 to 1569. With great technical precision, he painted a portrait of the Queen as early as 1570 (Welbeck Abbey). In the next decade Hilliard's style gained in elegance of both form and conception (Self-Portrait, London, Victoria and Albert Museum, 1577). Already in the late 1560s, and after a visit to France, Hilliard was the leading miniature portraitist of royalty, as confirmed by his picture of James I, and going on to include the entire royal court. After 1580 he introduced the oval form of his, now often full-length, miniatures of which the "Young Man among the Roses" (London, Victoria and Albert Museum, c. 1588) is one of the finest examples. During this period he also succeeded in conveying individual expression in his pictures, and it is in this that he was of particularly valuable service to the next generation.

Illustration:

254 Portrait of George Clifford, Earl of Cumberland, c. 1590

HOBBEMA Meindert

1638 Amsterdam – 1709 Amsterdam Hobbema was the son of a bargee. He lost his mother early and grew up in an orphanage. Between 1657 and 1660 he was a pupil of Jacob van Ruisdael, on whose style his work was largely based, to the extent that it is easy to confuse their works. He always lived in his home town, except for brief visits to Deventer, Haarlem and Middelharnis. In 1668 he married a servant of the mayor, who procured him the position of weights and measures inspector, which involved calculating wine and oil casks according to Amsterdam measures. During this time he seems to have given up painting, especially as it had not provided him with an income. One of the few authenticated works dating from this late period is "Avenue of Middelharnis", 1689 (ill. p. 331). Hobbema was a landscape painter, but not of the typically flat Dutch coastal scenery. He rendered overgrown dunes and wooded tracts with powerful trees and dark, dense foliage, enlivened by rivulets and mills, cottages and small figures. His colours were a strong green, yellow and brown, later interspersed with light, silvery tones. His landscapes provide a bridge to 18th century landscape painting.

Illustration:

331 Avenue of Middelharnis, 1689

HOCKNEY David

Hockney Bawline Bradford (Yorkshire)
Hockney studied from 1953 to 1957 at the Bradford College of Art, then from 1959 to 1962 at the Royal College of Art in London. Even before he left the Royal College, he had been awarded his first prize for his art; he found recognition and success from the start. In 1961/62 he went to New York and Berlin; later he paid another, prolonged visit to the USA and also to Egypt, and went to other European countries and East Asia.

His first theatre designs date from 1966. He taught at Iowa University, the Universities of Colorado, Berkeley and others. In 1969 Hockney worked as visiting professor at the Hamburg Kunsthochschule. He lives in London and California. Hockney developed a stylised realism combined with two-dimensional ornamentations. He has a penchant for cool to shrill acrylic colours and often works with his own photographs as models. Since 1982 he has been producing polaroid collages. In the late 1980s his first computer and fax drawings appeared. Illustration:

665 A Bigger Splash, 1967

HODLER Ferdinand

1853 Gürzelen (near Berne) – 1918 Geneva Hodler was one of the few Swiss painters to achieve international fame. He had a difficult childhood, lost his parents early, and had a hard life as a young man. From 1871 to 1876 he studied at Geneva Art School under B. Menn who promoted him and introduced him to the works of his friends Ingres, Delacroix, Corot, Courbet and Manet. Hodler took a special interest in Corot and the French Impressionists, and his painting technique became moulded by Impressionism and realism. In 1878/79 he spent nine months in Madrid. He then developed his monumental style, which contained Symbolist and Art Noveau elements, with flat coloration, definite outline, symmetrical composition and parallel forms. He produced portraits and historical pictures, mostly of a symbolic nature. In 1891 he travelled to Paris and joined the Rose-Croix group, exhibiting at the Salon de la Rose-Croix in Paris in 1892. His tendency towards monumental representation resulted in many mural commissions, receiving first prize in 1897 for his design for the armory in the Zurich national museum. Critical opinion was divided on his achieve-

From 1901 to 1905 he took part in the Vienna Secession, and also showed his work at the Secessions in Munich and Berlin. He visited Italy in 1905 and 1911. In 1907 he decorated walls in Jena University. In 1913 Hodler was made an Officer of the French Legion of Honour. During this time he produced the decorations in the town hall of Hanover. A great retrospective of his work was held in 1917 in Zurich. His detractors thought him an exponent of the unattractive; his followers praised his honest, energetic exploration of his subject matter.

Illustrations:

Autumn Evening, 1892

Communication with the Infinite, 1892

HOFMANN Hans

1880 Weißenburg (Bavaria) – 1966 New York Hofmann spent his childhood and youth in Munich. In 1904 he went to Paris, where he studied at the Académie de la Grande Chaumière and became acquainted with Matisse, Delaunay, Braque, Pascin, Gris and Picasso. On his return to Munich he opened a school of modern art. In 1930-1931 he held summer seminars at Berkeley University in California and taught the following year at the Arts Student League in New York, where he settled. At his own school in New York, which he ran from 1934 to 1958, he greatly influenced that generation of American abstract painters through his teachings and theories. Until the early 1940s Hofmann adhered to Expressionist traditions; then he developed an abstract Expressionism which achieved its powerfulness through strong form, unbroken colours and free manner of painting.

Illustration: 630 Blue in Blue, 1954

HOGARTH William

1697 London – 1764 London Hogarth, the son of a schoolmaster, was apprenticed to a silversmith and engraver in 1712, where his interest in copperplate engraving was aroused. He studied at Vanderbank's Academy in St Martin's Lane and at the art school of the court painter Thornhill, whose daughter he married in 1729, and whose work left him with a life-long ambition to become an historical painter. While he was never to be successful in this field ("Sigismunda" London, Tate Gallery, 1759), he soon became wellknown as an engraver and painter of pictures, such as the series "A Harlot's Progress" (1732), "A Rake's Progress" (1735) and "Marriage à la Mode' (1742-1744). These became so popular that he had to to take precautions against plagiarism. Hogarth was unfairly accused of uncouth dilettantism in his religious work ("Ascension" triptych, St Mary Redcliffe, Bristol, 1756). His versatility also extended to art theory, such as his treatise directed against academic rigidity, "The Analysis of Beauty", published in 1753. In portraiture, one of his best works was "Captain Thomas Coram" (London, Foundling Hospital, 1740). Although Hogarth, who on Sir James Thornhill's death became the principal of his art school, had no direct followers, he is regarded as the founder of the English school of painting, and especially of portraiture.

Illustrations:

340 Marriage à la Mode: Shortly after the Marriage, 1744

80 The Graham Children, 1742

380 Self-Portrait, 1745

381 The Shrimp Girl, c. 1740

382 Heads of Six of Hogarth's Servants, c. 1750–1755

HOHENFURTH → Master

HOLBEIN Hans the Younger

c. 1497/98 Augsburg - 1543 London Amongst the great German masters of the 16th century Holbein may be singled out without reservation as the only Renaissance artist. Unlike any other he was, both in education and career, a cosmopolitan. At the early age of sixteen, after instruction by his father, he went off as a journeyman with his brother Ambrosius. He is first mentioned in 1515 in Basle, where he entered the workshop of Hans Herbster. His first public commissions were carried out in Lucerne in 1517. From there he probably visited Lombardy and Emilia in northern Italy. This is not supported by documentary evidence, but it is reflected in his work of the early 1520s. In 1519 Holbein became a member of the painters' guild in Basle, and in 1524 he stayed in France. The watershed of his career was his journey to England in 1526, where he went by way of the Netherlands, equipped with a letter of recommendation from Erasmus of Rotterdam. There he lived from 1532, despite tempting offers from the city of Basle.

Between 1515 and 1528 he carried out a number of outstanding religious commissions ("Madonna of Solothurn", Solothurn, Städtisches Museum, 1522; "The Dead Christ in the Tomb", Basle, Kunstmuseum, 1521). In the Basle painting one can see in his powerfully expressive depiction of Christ a parallel to Grünewald, which Holbein succeeded in combining with razor-sharp observation, which showed his genius for portraiture.

From 1528 he indeed concentrated solely on

portrait painting. In London he executed portraits of the German merchants of the Steelyard, then soon came to the notice of Henry VIII and members of his court. His observation of detail, psychological penetration of his sitters and superb handling of colour made him the greatest portrait painter of German art. He also produced excellent graphic work (e.g. the series of woodcuts "Dance of Death", completed about 1526; 91 woodcut designs on the Old Testament, completed 1538). Illustrations:

- The Ambassadors (Jean de Dinteville and Georges de Selve), 1533
 Madonna of Mercy and the Family of Jakob
- Madonna of Mercy and the Family of Jakob Meyer zum Hansen (Darmstadt Madonna), c. 1528/29
- Portrait of the Merchant Georg Gisze, 1532

HOMER Winslow

1836 Boston – 1910 Prout's Neck (Maine) Together with Thomas Eakins, Homer is one of the most important American painters of the second half of the 10th century. He began his career as a lithographer in Boston, but soon decided to work as an independent artist. He studied the woodcut technique which had not yet become popular in America. His chroniclers speak of Impressionistic influences and those of the Japanese woodcut in his work. In 1859 he moved to New York, where he worked as an illustrator on Harper's Weekly. From the time of the Civil War, his drawings for this magazine depict war scenes and daily life in time of war without sentimentality or false heroism. When he began painting in oil, he transferred to it the principles of woodcut design, developing a fine sense of colour in his composition. Homer preferred open-air subjects and excelled in pictures of popular life. In later life he lost interest in figurative representation and turned to marine painting.

Illustration: 540 Breezing Up, 1876

HONTHORST Gerrit van

(also: Gerard van Honthorst; called: Gherardo della Notte)

1590 Utrecht - 1656 Utrecht Honthorst was one of the most versatile Dutch artists. His work included biblical scenes, allegories, genre pictures, portraits and wall and ceiling decorations. He was also one of the few to achieve great prosperity. At first he studied under Bloemaert in Utrecht. In 1610 he went to Rome for ten years, where he was greatly influenced by Caravaggio and, although he did not meet this great artist himself, he systematically explored his chiaroscuro effects in his work. Dark rooms lit by candles, torchlight, hidden or channelled sources of light in dark spaces - these became typical subjects of his work. Because of his taste for artificially lit night scenes he was called "Gherardo della Notte" while in Italy. On his return to Utrecht in 1622 he became a member of the Lukas Guild. In Rome he had painted mostly religious subjects ("The Nativity", "Adoration of the Shepherds", both Florence, Uffizi), but now he turned to mythological subjects and genre scenes of soldiers, card-players and carousers ("Cheerful Company", Munich, Alte Pinakothek). Most of his many commissions were for portraits. In 1628 he went to England to paint portraits of King Charles

I and the Queen. In 1637 he became court painter

to Prince William of Orange and settled in The

Hague. He painted many illustrious persons, including King Christian VI of Denmark and the

Elector of Brandenburg, and he gave painting lessons to the Bohemian Queen Elizabeth and her

daughter. His financial position was such that he could lend her the large sum of 35,000 guilders in 1651. Honthorst spent his final six years in his home town of Utrecht.

Illustration:

304 The Incredulity of St Thomas, c. 1620

HOOCH Pieter de

(also: Hoogh, Hooghe) 1629 Rotterdam - after 1684 Amsterdam (?) His career as a painter developed very slowly. The son of a bricklayer, he received his early training under Nicolaes Berchem in Haarlem. Around 1650 he worked for a cloth merchant and art collecter in Rotterdam as painter and valet de chambre, whom he had to accompany on his travels to Leiden, The Hague and Delft. After his marriage in Delft he was accepted as a member of the Lukas Guild in 1655 although not actually a citizen of the town. In about 1667 he moved to Amsterdam, where he remained to the end of his life. De Hooch's most important creative period was his years at Delft. Under the influence of Vermeer and the Rembrandtpupil Fabritius he painted genre scenes which depict the idyll of Dutch domestic life, including interiors, courtyards and garden scenes. A gentle light radiates the scenes, and the figures and objects seem to pause as if in a still life. Typical for de Hooch, whose colours are warmer and softer than Vermeer's, are perspectival rooms and vistas through open doors. In his Amsterdam period, where he liked to move in elegant society, his often plain and simple interiors were replaced by grand rooms with marble mantelpieces and pilasters. His rendering became hard and over-meticulous, his

284 The Courtyard of a House in Delft, 1658 329 A Woman and her Maid in a Courtyard,

329 The Card-Players, c. 1663-1665

HOOGSTRATEN Samuel van

coloration cold and dry.

Illustrations:

(also: Hoogstraaten, Hoogstraeten) 1627 Dordrecht - 1678 Dordrecht Hoogstraten received his earliest training from his father Dirck at Dordrecht, then in 1642 entered the workshop of Rembrandt and returned in 1648 to his home town. In the 1650s he stayed in Vienna to carry out work for the Emperor Ferdinand III and also visited Rome, which was exceptional in the tradition of Dutch painting. He married in 1656 in Dordrecht and went with his wife to London from 1662 to 1666. On his return to The Hague he joined the painters' guild "Pictura". In 1670 he finally settled in Dordrecht, where he was appointed provost of the mint. Hoogstraten was less known as a painter than as an experimenter and art theorist. In 1678 he wrote his Inleyding tot de Hooghe Schoole der Schilderkonst. He worked with optical instruments and constructed perspectival "peepshow" boxes (London, National Gallery), specialising in trompe l'æil illusionism. In his painting he initially followed Rembrandt, but then developed his own manner and subject matter. Illustration:

328 Still Life, c. 1666–1678

HOPPER Edward

1882 Nyack (New York) — 1967 New York Hopper studied at the New York School of Art from 1900 to 1906. Between 1906 and 1910 he travelled widely in Europe, spending a great deal of time in Paris, where he painted street scenes in the Impressionist manner. He settled permanently in New York in 1908. From 1924 onwards, after the exhibition of his work at the Frank K.M. Rehn

Gallery, his subject matter moved away from the world of French painting and he concentrated entirely on American life. Modern civilisation became his subject, and he was particularly fascinated by urbanization, the expansion of industry and the excesses of American architecture. Many of his pictures are realistic depictions of street scenes, views over roofs and abandoned houses. He intensifies the sinister atmosphere by showing them at different times of the day and in different weathers. Hopper, who kept aloof from the avantgarde stream in Europe and America, created as no other a realistic picture of American urban life and landscape. In 1968 his widow gave all the works he left to the Whitney Museum of American Art in New York. Illustrations:

555 Nighthawks, 1942 601 Nightwindows, 1928

HUET Paul

1803 Paris - 1869 Paris

As a student of the Ecole de Beaux-Arts, Huet worked in the studios of Guérin and Gros, where he made life-long friends of Delacroix and Bonington. His greatest influence was Bonington, with whom he often worked and he spent some time studying in Normandy in 1827. More important still for his further development, as for that of Delacroix, was his encounter with Constable's work at the Paris Salon in 1824.

This is how he described it: "The young school's admiration was boundless... It was perhaps for the first time that one felt such warmth, such luxuriant nature, such greens, no blacks, no rawness, no mannerism." Stimulated by Constable, whom he often copied, Huet painted his landscapes mostly in Normandy and the forest of Compiègne, where he moved to in the early 1820s. Unlike the other painters of the Barbizon school to which he belonged, Huet was primarily interested in the dynamism of nature. His wildly romantic pictures of primeval forests, the excited play of the sea and billowing clouds in wind and weather, made him one of the founders of French "Paysage intime" landscape painting. Illustration:

438 Breakers at Granville, c. 1853

HUGUET Jaume

(Jaime)

before 1414 Valls (near Tarragona) – 1492 Barcelona

Huguet is the principal representative of 15th century Catalan art, which remained almost untouched by the innovations of the early Renaissance and so continued in the medieval tradition. There are no records documenting his work before the year 1448, when he received a commission for the James altar at Arbeca. Until 1486 he produced a great number of multi-sectioned altar retables, including those of St Abdon and Sennen (today in Santa María at Tarasa, 1458-1460) the the Three Kings altar (Barcelona, Museo de Historia de la Ciudad, 1464). Huguet's style was not remarkable; he kept to a background of gold, with a minimum of spatial features and little indication of depth. The growing abundance of commissions led over time to an ever-increasing share of work being done by assistants in his workshop. This in turn led to the use of stereotyped characters and a loss of painterly quality.

138 Last Supper, after 1450

HUNDERTWASSER Friedensreich

(Friedrich Stowasser)

born 1928 Vienna

Hundertwasser attended the Montessori school in Vienna and studied briefly at the Vienna Kunstakademie in 1948. In 1949 he adopted his pseudonym. His colourful work is influenced by Viennese Art Noveau and also by Klee. He has become a wellknown figure for his spectacular appearances in public, his commitment to environmental issues and his general way of life. In 1959 he arranged with Bazon Brock the happening "Endless Line" in Hamburg. Hundertwasser travelled widely; since the 1970s he has been spending much time in the South Sea islands. After producing ceramic mural pictures for the decoration of buildings (such as for the Rosenthal company in Selb), he has become involved since 1982 in ecological architecture and has designed several buildings. Hundertwasser lives in New Zealand.

Illustration:

655 The Great Way, 1955

HUNT William Holman

1827 London – 1910 London

Hunt already began to paint during his training for commerce, copying works of the old masters, including those of the 15th century Flemish and Italian schools, which were to remain influential throughout his life. Much of his work is marked by an intense, fine colouring, a meticulous sense of detail, a preference for painting from nature, and a tendency to symbolism in presenting his subjects. In 1845 he joined the Royal Academy schools and met Rossetti and Millais. This acquaintance was significant in that it eventually led to the foundation of the Pre-Raphaelite Brotherhood, a group of idealistic young men whose aim it was to return English painting to former heights. John Ruskin felt close to this group and supplied the theoretical foundations for their aims. Hunt believed that if art was to be reformed it had to go back to the old religious, moral ideas, and these became central to his work, which was executed in a solid, craftsman-like manner. Besides Biblical subjects, he often returned to old English myths and sagas. Hunt's works are intensely symbolic, every small detail contributing to the intended message. By today's standards, this often meant crossing the border into sentimentality. However, he based his work on realistic observation and natural rendition and showed great skill in his treatment of colour and light. Hunt visited Palestine several times to paint the scenery and spent the years 1866-1868 in Florence. His work was greatly respected in his time and he received the Order of Merit in 1905.

Illustration:

526 The Hireling Shepherd, 1851

INDIANA Robert

(Robert Clark)

born 1928 New Castle (Indiana) Indiana studied Pop Art at the John Herron School of Art at Indianapolis, the Art Institute of Chicago and, when staying in Scotland in 1953/54, at the Edinburgh College of Art. He has been living in New York since 1954. He produces Pop Art works based on letters, words and symbols of a poster-like character in a large, planar hard edged manner. Since 1966 the word "Love" has been his favourite motif, of which he designed a stamp for the American postal service in 1973. In New York he became acquainted with Kelly whose concepts made an impression on his work. Besides his pictures he has also produced a great number of silkscreen prints. Since 1969 Indiana has lived in Vinalhaven (Maine). Illustration:

660 The American Dream, I, 1961

INGEBORG-PSALTER → Workshop

INGRES Jean Auguste Dominique 1780 Montauban – 1867 Paris

Ingres' father, a sculptor and decorative plasterer, instructed his son in drawing and sent him to Toulouse Academy in 1791. In 1797 he became a pupil of David and in 1799 was accepted by the Ecole des Beaux-Arts. In 1801 he won the Grand Prix de Rome with "The Envoys of Agamemnon" (Paris, Musée de l'Ecole Nationale Supérieure des Beaux-Arts). In 1806 he introduced himself as a portraitist at the Salon but received much criticism for his works, among them his great portraits of the Rivière family. During the same year he went on an Academy scholarship to Rome, where he stayed until 1819, producing his much admired portrait drawings of French society. Here he studied Antiquity and the works of Raphael, Holbein and Titian and became greatly influenced by Masaccio's work when he came to Florence in 1819. He developed his own style, independent of his master David, as his early work, the "Valpinçon Bather" (ill. p. 429) from 1808, shows.

He returned to Paris in 1824 and began to teach. In 1825 he received the Order of the Legion of Honour from King Charles X and was elected a member of the Academy. His "Apotheosis of Homer" (Paris, Louvre, 1827), which seems to embody Ingres' own artistic and literary beliefs, is characteristic of his classicism based on the study of Raphael. His precisely drawn and painted portraits show more freedom than his other works in their life-like perception. He was also a master draughtsman, perhaps the most important of the 19th century, leaving 4000 sketches and drawings to his home town of Montauban. The Salon's disapproving attitude to his "Martyrdom of St Symphorian", 1834, (Autun Cathedral), caused him to accept the directorship of the French Academy in Rome from 1835 to 1841. On his return to Paris he met at last with enormous success and received the Order of Merit in 1845. As president of the Ecole des Beaux-Arts (from 1850) he became the leader of the Classical school. At the World Exhibition 1855 he was represented by 48 of his works. In opposition to Delacroix and other Romantics and the Realism of Courbet, Ingres upheld the Classic idealism with its clarity of line and sensuality of colouring based on a close study of nature. Illustrations:

421 Madame Inès Moitessier Seated, 1856

Joan of Arc at the Coronation of Charles VII in Reims Cathedral, 1854, 1854

428 The Turkish Bath, 1862

429 Valpinçon Bather, 1808

430 Mademoiselle Rivière, 1806

430 Louis-François Bertin, 1832

IVERNY Jacques

active 1411–1435 in Avignon

The attribution of the fresco cycle of La Manta to Iverny has been disputed, but no acceptable alternative has instead been put forward. Doubters have been reluctant to accept that in early 15th century representation there was a wide gap between profane and sacred subjects, and that there is also a great similarity between Iverny's signed altarpieces and the religious scenes contained in this cycle. There is no doubt, however, that these frescos are the work of a French artist, which is not surprising as both the older and the younger Marchese of Saluzzo, whose palace was about forty miles south of Turin, lived most of their time at the French court. The frescos are also remarkable in that they comprise a large picture of the fountain of youth, which makes those who bathe in it young again and amorous. This is unaccountably placed in the same room with a picture of an altarpiece showing the

Crucifixion. Very little is known about Iverny, except that he spent his longest period at Avignon. It appears that he travelled widely and was familiar with the art as practised at the courts of northern France.

Illustration:

61 Five Heroines; c. 1420

JAWLENSKY Alexei von

(Alexei Georgevich von Jawlensky) 1864 Torschok (Russia) – 1941 Wiesbaden Jawlensky began to paint when still a young lieutenant in Moscow. As an officer he was transferred to St Petersburg in 1889, where he attended the academy of arts. He asked for his discharge in 1896 and went with Marianne von Werefkin to Munich, where he studied at the Ažbè school and met Kandinsky. In 1903 and 1905 he went to France to show his work at the Salon d'Automne and became acquainted with Matisse, whom he met again in Paris in 1907 and 1911. Together with Kandinsky he founded the New Artists' Association Munich in 1909. During this time his work reached a culmination with its large figure paintings, such as the 'Woman with the Fan" (ill. p. 579). At the outbreak of the First World War he had to leave Germany and settled in Switzerland. In the following years expression was gradually replaced by contemplation, piety and self-examination, becoming most apparent in his "meditations" in which his icon-like portraits became pictures of devotion. Illustrations:

546 The Red Shawl, 1909

579 Woman with a Fan, 1909

JOHNS Jasper

born 1930 Augusta (Georgia) Johns studied at the University of South Carolina in 1947/48. Military service took him to Japan in 1949. On his return in 1952 he worked as a bookseller and in New York with Rauschenberg as a window-dresser at Tiffany's. In 1966 he designed scenery and costumes for the Merce Cunningham Dance Company and worked with the composer John Cage. With Rauschenberg, Johns belongs to those artists who introduced decisive new elements into the art which followed Abstract Expressionism. His one-man exhibition in 1958 is seen as the beginning of Pop Art, yet his art also goes in other directions. Initially John's works concentrated on a relatively small repertoire of subjects, such as the American flag, letters, numbers and shooting targets produced in the early 1950s. He also produced assemblages of actual objects and everyday artefacts in cast metal. Johns lives at Stony Point (New York). Illustrations:

621 False Start, 1959

652 Flag, 1954/55

653 Untitled, 1980

JONES Allen

born 1937 Southampton

From 1955 to 1959 Jones studied at the Hornsey School of Art in London and then for a further year at the Royal College of Art with Kitaj and Hockney. He is one of the best-known English Pop artists. From the early 1970s he taught at art colleges in the United States, Canada and Germany. He presents his motifs extracted from sex magazines in a cool yet provoking manner. His female bodies made of fibreglass – clad in corsets and high-heeled shoes, and intended as furniture – are disarming in their cheekiness. For these he finds his motifs in the sadomasochistic literature of the subculture.

Illustration:

664 Man Woman, 1963

IONGKIND Johan Barthold

1819 Lattrop (near Rotterdam) – 1891 La Côte Saint-André (near Grenoble)

Jongkind grew up in Vlaardingen near Rotterdam, where he worked as a solicitor's clerk. After his father's death he studied at the drawing academy in The Hague in 1836/37. From 1846 to 1853 he lived in Paris, working in the studio of Isabev and studying at the Picot studio. He met Israëls and Chassériau and became friends with Stevens, Courbet and Troyon. In 1848 he exhibited for the first time at the Salon. In 1850 he went to Etretat in Normandy and again in 1851 with Isabev to Le Havre. Under the influence of French landscape painting his style became sketchy and his colours more brilliant, taking on Impressionist elements. In 1855 he returned to Holland and lived until 1860 in Rotterdam. His work seems beset by psychological problems. He met Courbet when in Paris in 1857. From 1860 to 1870 he again lived in poverty as a bohemian in Paris. He met Boudin, Monet and Mme Fesser, a compatriot, with whose support he conquered his personal problems. In 1862 he worked with Monet and Boudin at Le Havre and from then on was more successful in selling his brilliantly coloured pictures. He settled at La Côte-Saint-André near Grenoble in 1874 where, apart from short visits to the Provence and Paris, he lived until his death. Here his colours became visibly airier and his style more simplified. Be set by mental illness, paranoia and the misuse of alcohol, Jongkind died at the mental institution of Saint-Rambert near Grenoble.

524 The Maas at Maasluis, 1866

JORDAENS Jacob

1593 Antwerp - 1678 Antwerp The son of a linen merchant, Jordaens was the pupil of Adam van Noort, under whom Rubens had studied briefly. He was classed as a "water painter" when joining the Lukas Guild in 1615, probably because he painted water-colours on linen which served as wall-hangings and which his father sold. In 1621 he was appointed deacon of the Guild. His reputation as designer of decorations brought in 1634 a commission from the Antwerp magistrate to collaborate on the decorations for Prince Ferdinand's visit under the supervision of Rubens, in whose workshop Jordaens had been employed previously. Within the orbit of Rubens he not only carried out the latter's designs, such as the large canvases for the Torre de la Parada near Madrid, but adopted his style, making it his own. After Rubens' death, he became the leader of the Antwerp school, carrying out innumerable commissions for Church and Court between 1640 and 1650, including 22 pictures for the salon of Queen Henrietta Maria at Greenwich, work for the Scandinavian and French courts, as well as the "Triumphs of Prince Friedrich Heinrich of Nassau" at the Huis den Bosch near The Hague, one of the few decorations of this kind to be found in Dutch palaces. Jordaens painted historical, allegorical and mythological scenes and was also a painter of religious themes and genre pictures. He was one of the great Flemish Baroque painters along with Rubens and van Dyck.

Illustrations:

302 Allegory of Fertility, c. 1622

The Family of the Artist, c. 1621 302

The Satyr and the Farmer's Family, after

JORN Asger

(Asger Oluf Jorgensen) 1914 Vejrum (Jutland) – 1973 Århus In 1929 Jorn moved to Silkeborg, where he began to paint a year later. In 1936/37 he worked in the studio of Léger while in Paris. In 1941 he was a cofounder of the magazine Helhesten, and while under German occupation he published the paper Long og Folk. He was one of the founders of the CoBrA group and published monographs about its members. His first book Salvation and Chance was produced while recovering from tuberculosis at a sanatorium in Silkeborg. Jorn often explored a subject in a series of works, such as the "Wheel of Life", 1952/53, "From a Silent Myth", and the "Swiss Suite", a series of 32 etchings produced on a prolonged visit to Switzerland. Jorn also wrote on art and its relationship to society. From 1956 he lived in Albisola (Italy) and Paris. He was a member of the group of International Situationists from 1956 to 1961. He founded the Institute for Comparative Vandalism in 1962.

Illustration:

Without Boundaries, c. 1959/60

KAHLO Frida

(Magdalena Carmen Frieda Kahlo Calderón) 1907 Coyoacán (Mexico City) - 1954 Coyoacán In a motoring accident in 1925 the 17-year-old Frida Kahlo suffered severe spinal injuries which led to a number of operations and hence her preoccupation with the subject in her work. Her very personal pictures express her mental state and view of the world in a direct, popular idiom. In 1928 Kahlo joined the Mexican Communist Party and met the painter Rivera whom she married a year later. In 1932 they both went to the USA for two years, where Rivera painted several murals. In 1938 Kahlo had her first one-woman exhibition in New York. In the same year Breton, who had come to Mexico to meet Leon Trotski, stayed at her house. In 1939 she went to Paris to exhibit her work, and met Surrealist painters and writers. In 1943 she began to teach at the art school La Esmeralda, but because of her former injury was soon forced to hold her classes at home. Her condition deteriorated rapidly in the late 1940s; she had to wear a steel corset and could only get about in a wheelchair. She had her first one-woman exhibition in Mexico in 1953 and died of pneumonia a vear later.

Illustration:

604 Self-Portrait with Monkey, 1938

KALF Willem (also: Kalff)

1619 Rotterdam – 1693 Amsterdam Kalf was considered by his contemporaries as having exceptional intellectual gifts and being wellversed in the arts. He probably received his training from Frans Ryckhals and Hendrick Pot. In 1640 he went to Paris for six years, where he was a success with his pictures of kitchens and interiors of peasant dwellings. With these pictures of untidy storage rooms and passages cluttered with tools and female servants, he created a genre that Chardin was to revive in the 18th century. But he was first and foremost a still life painter, initially depicting simply laid breakfast tables with the remains of the repast, glasses and pewter or silver vessels, which were reminiscent of the "monochrome banketjes" of the Haarlem painters Claesz. and Heda. In compliance with the demands of the well-to-do Dutch merchant class, Kalf later produced luxurious still lifes with rich table covers, Venetian glass, Chinese porcelain and silver bowls containing tempting fruit. These are never gaudy, as can be the case with Flemish pieces, and they captivate by their suggestion of texture. Brilliant colours and the sensitive

use of light effects suggest Rembrandt's influence. Most of these pictures date from the Amsterdam period between 1646 and 1663. From then on Kalf seems to have given up painting in favour of art dealing.

Illustration:

322 Still Life, c. 1653/54

KANDINSKY Wassily

1866 Moscow – 1944 Neuilly-sur-Seine Kandinsky abandoned his legal career by turning down a lectureship at the university in 1896 in favour of studying painting at the Ažbè school in Munich. There he met his compatriot Jawlensky. In 1900 he changed over to the Academy, studying under Franz von Stuck, and where he met Klee. In 1901 he was a co-founder of the Phalanx group of artists. His pictures from 1901 to 1905 evoke a Russian fairy-tale world with Art Nouveau and Neo-Impressionist elements. He travelled all over Europe between 1904 and 1908. When he moved with Gabriele Münter from Munich to Murnau in 1908, his painting became influenced by the Fauves and Bavarian glass painting. In 1909 he was one of the founders of the New Artists' Association Munich. In 1913 he painted his first abstract water-colour which he later dated as from 1910 (ill. p. 550), soon to be followed by his first abstract painting in oils. This step he had already discussed in his book Concerning the Spiritual in Art, 1912. He also expounded his ideas in the Almanac Der Blaue Reiter which he published in collaboration with Marc. At the outbreak of the First World War he returned to Moscow, and now the dramatic in his Munich work was replaced by a stricter order. He returned to Germany in 1921, and Walter Gropius called him to the Weimar Bauhaus in 1922 where he met Klee again. While there he developed a disciplined geometrical style, which he again substantiated theoretically. In 1926 he published his book Punkt und Linie zu Fläche (Point and Line to Plane). The political opposition to the Bauhaus caused Kandinsky to leave Germany again in 1933. He moved to Neuilly-sur-Seine near Paris, where he met many leading painters, including Chagall, Léger, Miró, Mondrian and Hans Arp, the last named becoming his close friend. Through the influence of Arp and Miró he returned to the organic form combined with the geometric structure already in his pictures, and his coloration became brighter. Illustrations:

550

Untitled, 1910 (1913) Study for "Improvisation 8", 1910

Improvisation George, 1914

581 Sky Blue, 1940

The Arrow (La Flèche), 1943 581

KAUFFMANN Angelica

1741 Chur (Switzerland) – 1807 Rome Taught by her father, a Vorarlberg painter, Angelica Kauffmann already painted remarkable pastel portraits at the early age of 15. On extensive Italian travels she developed a thorough knowledge by copying the old masters. She became a member of the Academies of Florence and Rome, and her meeting with Johann Joachim Winckelmann was decisive in pointing her in the Classical direction. From 1766 she lived in London for 15 years, becoming a Royal Academician and working with the architect Robert Adam, amongst others. On her return to Rome she became the centre of a salon which Goethe and Herder attended. Her portraits owe much to Reynolds and Mengs, while her Classical religious and mythological pictures were based on the study of Antiquity seen with the eyes of Winckelmann.

Illustration:

379 Self-Portrait, 1780

KELLY Ellsworth

born 1923 Newburgh (New York) After studying at the Pratt Institute, then doing military service from 1943 to 1945, and then further studies at the School of the Museum of Fine Arts, Kelly went to Paris in 1948 to attend the Ecole des Beaux-Arts. Under the influence of Constructivist painters, such as Hans Arp and Georges Vantangerloo, as well as the geometric abstractions of Vasarely, Kelly soon developed an abstract style in which geometric planes in different colour tones were slotted into each other. On his return to the USA in 1954 he worked on a further reduction of his visual language, returning to single, precisely structured, objectified pictures. Through his mathematically calculated sculptures, Kelly achieved a new type of representation in the 1970s, the socalled "shaped canvas", in which neutrally applied colours are coordinated with clearly defined planar

Illustration:

forms.

651 Red Blue, 1968

KERSTING Georg Friedrich

1785 Güstrow – 1847 Meißen

Like many German artists of his time, Kersting came from a narrow middle-class background. After the death of his father, a glazier and glass painter, a well-to-do relative sent Kersting to the Copenhagen Academy from 1805 to 1808. He then settled in Dresden, where a friendship developed with Gerhard von Kügelgen and with Friedrich. With the latter he went on a walking tour through Silesia and Bohemia. Kersting painted exclusively interiors, a branch of painting which had become established in the Netherlands in the 17th century. His pictures often show sparse working and living quarters as an image of the concentrated intellectual life led by their inmates. These are often occupied with reading, his favourite subject apart from painting his friend Friedrich, and quite in tune with his unemphatic but delicately coloured work.

Illustration:

451 Reader by Lamplight, 1814

KEYSER Thomas de

c. 1596/97 Amsterdam – 1667 Amsterdam
De Keyser was the son of a sculptor and architect and, until Rembrandt's arrival in Amsterdam in 1632 the town's leading portraitist. He specialised in large-scale group portraits and also painted smaller, crowded pictures of families and groups ("The Anatomy of Dr Sebastiaen Egbertsz. de Vry", Amsterdam, Rijksmuseum). He abandoned painting altogether between 1640 to 1654 and became a dealer in basalt stone. Later he produced pictures of the rich Amsterdam middle classes mounted on their steeds – a way of depiction formerly reserved for the aristocracy. From 1662 until his death he supervised the building of the new Amsterdam town hall.

Illustration:

306 Equestrian Portrait of Pieter Schout, 1660

KHNOPFF Fernand

1858 Grembergen (East Flanders) — 1921 Brussels Khnopff's work included oil-paintings, water-colours, coloured drawings and etchings. Like Klinger he also produced polychrome sculpture and designed interiors and theatre scenery. He abandoned his legal studies to attend art school in Brussels under Xavier Mellery, who gave him an understanding of painting as the bearer of a profound, hidden meaning, and so introduced him to the rudiments of Symbolism. In 1877 Khnopff visited Paris, where he was much impressed by the work of Moreau and

Delacroix. He was also an admirer of the Pre-Raphaelite painters. In 1883 he was a founder member of "Les XX", to which both painters and writers belonged. Many of his friends were writers, and he illustrated some books for Georges Rodenbach and Gregoire Le Roy. His work is characterised by delicate coloration and an aesthetic, reticent manner of painting, wrapping his subjects in idealised and generalised allegories. His female figures are inscrutable sphinxes and chimaeras, strangely beautiful creatures of an icy eroticism. Khnopff himself embodied the dandified type of artist, who lived in a fantasy house with blind windows, decorated to his own design.

Illustration:
524 I Lock My Door upon Myself, 1891

KIEFER Anselm

born 1945 Donaueschingen Kiefer studied law and Romance languages at Freiburg (Breisgau) and took drawing lessons from Peter Dreher. He decided to concentrate on art and attended the Karlsruhe Academy in 1969, where he was taught by Horst Antes. The following year he went to study under Beuys at the Academy in Düsseldorf, where he produced his first paintings in a poetic, expressive style. His themes were always heroic or mythological allegories. Since 1980 he has been interested in "Margarete" and "Sulamit" from the Death Fugue by Paul Celan. In the 1990s he has produced large plastic works, such as his fighter planes constructed of lead sheets, carrying a mythical freight. A travelling exhibition has also shown the great number of Künstlerbücher (artists' books) produced over several

Illustration:

676 Bilderstreit (Iconoclastic Controversy), 1979

KIPPENBERGER Martin

born 1953 Dortmund

In 1972 Kippenberger studied briefly at the Art College in Hamburg. He moved to Berlin in 1978, where he opened the Kippenberger Office and organised exhibitions with Walter Dahn, Werner Büttner, Albert Oehlen and others. The exhibition "Arbeit ist Wahrheit" with Büttner, Kippenberger and Oehlen was at the Folkwang Museum, Essen in 1984. In 1986 he went to study in Brazil, and in 1988 moved to Los Angeles. In 1990 he was visiting professor at the Städelschule, Frankfurt am Main. He had a one-man exhibition at the Museum of Modern Art, San Francisco in 1991. In 1993 he founded the Museum of Modern Art on Syros and had a one-man exhibition at the Pompidou Centre, Paris. His 1994 exhibition "The Happy End of Franz Kafka's America" was at the Boymans van Beuningen Museum, Rotterdam. His sculpture "Exit of the Underground Station Dawson City West" was unveiled in 1995 for an open-air public display in Dawson City, Canada. Kippenberger lives and works in Cologne and on Syros, Greece.

Illustration:

677 Heute denken – morgen fertig, 1983

KIRCHNER Ernst Ludwig

1880 Aschaffenburg – 1938 Frauenkirch (Switzerland)

Kirchner went to Dresden in 1901 to study architecture. He interrupted these studies briefly in 1903 to go to art school in Munich. After his examinations he devoted himself to painting, although largely self-taught. In 1905 he founded the Brücke group with Heckel, Schmidt-Rottluff and Fritz Bleyl. Initially he and his friends were influenced

by Neo-Impressionism and van Gogh's work, developing a style based on flat, pure colours which represented a parallel to the Fauvism in Paris. Ideas of "primitive" art, seen in the Museum of Ethnology, were added later. Faces became masks, bodies were depicted in grotesque positions, and limbs distorted. Kirchner left Dresden in 1911 and moved to Berlin. There he found the subject matter suited to his lively, restless temperament: the large city, to whose hectic and unnaturalness he could give expression as no other. His street scenes seem to hum with the city's hustle and bustle. In 1914, after having just been called up for military service, he suffered a severe nervous breakdown. He never quite recovered, convalescing at first in Germany and then moving to Switzerland in 1917, where he remained until taking his own life. Here, in depicting the peaceful landscape of mountains and valleys, he found a new, spiritualised form of expression.

Illustrations:

584 Negro Dance, c. 1911

584 The Red Tower in Halle, 1915

585 The Street, 1908/19

KITAJ Ronald B.

born 1932 Chagrin Falls (Ohio) Kitaj studied at the Cooper Union in New York in 1950, at the Vienna Academy in 1951, at the Ruskin School of Drawing, Oxford, in 1958, and finally from 1959 to 1961 at the Royal College of Art in London. Between his studies in Vienna and Oxford he went to sea and taught himself painting. In London he influenced his fellow students Jones and Hockney, who were to become Pop Artists. Kitaj himself, however, never belonged to this movement as he did not take his subjects from mass culture but from philosophy and the works of poets, such as T.S. Eliot and Ezra Pound, as well as from the world of politics. By applying Surrealist collage methods he succeeded in combining a variety of subjects into a startling arrangement full of allusions. In 1970 he taught as visiting professor at the University of California in Berkeley, then at several art institutions in Britain. In 1995 he was awarded the prize for painting at the Venice Biennale.

Illustration:

663 Value, Price and Profit, 1963

KLAPHECK Konrad

born 1935 Düsseldorf

Klapheck studied from 1954 to 1958 under Bruno Goller at the Düsseldorf Academy. While still a student he found his subject matter, which he has used since then in a variety of new ways: figurative machine pictures in "prosaic super-representationalism". His first picture with typewriter dates from 1955. While in Paris for six months, he came to know the work of Duchamp. In the early 1960s he became friendly with the Surrealists around Breton. Klapheck had his first one-man exhibition at the Galerie Schmela in Dusseldorf in 1959. In 1979 he was given a professorship at the Dusseldorf Academy.

Illustration:

672 The mother's prayers, 1984

KLEE Paul

1879 Münchenbuchsee (near Berne) – 1940 Muralto (near Locarno)

Klee's father, a music teacher, was German, his mother Swiss. He himself played the violin and stayed close to music all his life. The decision whether to devote himself to music or painting fell in 1898 when he went to study painting in Munich. After attending the private art school of

Heinrich Knirr, he studied from 1900 at the Academy under Franz von Stuck. In 1901 he went to Italy, in 1905 to Paris. During the years 1902-1906, which he spent in Bern, he produced etchings inspired by Francisco de Goya, Ensor and Aubrey Beardsley. He then returned to Munich where he met Macke and in 1911 Kandinsky and took part in the second exhibition of the Blauer Reiter. During a further visit to Paris in 1912 he became acquainted with Delaunay whose essay About the Light he translated. He also saw the works of Braque and Picasso. His particular concern with both the potential and the demands of colour caused him to travel to Tunis with Louis Moilliet and Macke in April 1914. His impressions were fused with the predetermined order of colour fields. The water-colours of this period were mas-

In 1916 Klee was called up for military service. On his discharge in 1919 he began painting in oil. In his pictures he developed the representational out of abstract forms. His essay Creative Confessions, started in 1918, appeared in 1920, and in the same year he was given an appointment at the Bauhaus. His geometric grid now was often accompanied by drawings of a subtle humour. In 1931 Klee became professor at the Academy in Düsseldorf. From this period date his divisionist pictures in which colour is applied in small dots similar to the method of pointillism. To evade the pressures of rising fascism, he returned to Bern in 1933, where he began to produce large-scale pictures. His work is often ambiguous or somewhat ironic, but it never loses touch with the real world. Illustrations:

598 Villa R, 1919

599 Senecio, 1922

599 Around the Fish, 1926

KLEIN Yves

1928 Nice - 1962 Paris

Klein, who had studied Oriental languages amongst other subjects, had the idea in 1947 to explore the monochrome in music. He composed the Monotone Symphony based on a single tone, of which further versions appeared until 1961. He travelled to various countries and stayed in Japan for two years, where he became a black belt in judo in 1953. On returning to Paris he ran a judo school. From 1949 onwards he produced monochrome pictures; the "International Klein Blue" (IKB) dates from 1956, an ultramarine he developed by himself. To him, the monochrome canvases were the embodiment of his mystical ideas about the cosmic power of colour. At the Avant-Garde Festival in Paris in November 1960 a photograph was shown of Klein flying, in the only edition of the magazine Dimanche. He experimented with unorthodox subject matter, such as presenting empty rooms, creating "Anthropometrias" (impressions of female bodies dipped into "Klein"-blue) and "Cosmogonias" (traces of the effects of nature) and from 1961 fire pictures.

Illustration:

Monochrome Blue, Untitled (IKB 3), 1960

KLIMT Gustav

1862 Baumgarten (near Vienna) – 1918 Vienna From 1876 to 1882 Klimt studied at the Vienna Arts and Crafts School and, together with nineteen other artists, joined the Jugendstil (Art Noveau) movement in 1897. He became a co-founder of the Vienna Secession and was its president until his resignation in 1905. To this day his work still has both its admirers and its detractors. He is criticised for his massed repetitive decorative elements, and his gold backgrounds and jewelled co-

loration are considered to be outside the bounds of "great art". Stylisation carried to the point of ornamental dissolution is typical of his style, as is the craftsmanlike execution. Like many of his contemporaries he favoured Symbolist representations, such as "Hope" (Turin, Galleria Galatea), "Music" (Munich, Neue Pinakothek) and "Fulfilment" (Strasbourg, Musée des Beaux-Arts). His portraits are both delicate and magnificent, his less numerous landscapes mosaic-like, with their dotted brushwork. Klimt's work, which is now highly esteemed, greatly influenced the development of the Vienna Jugendstil and also the arts and crafts movement, as represented by the Wiener Werkstätte founded in 1903. Illustrations:

536 Flower Garden, c. 1905/06

536 The Virgin, c. 1913

KLINE Franz

1910 Wilkes-Barre (Pennsylvania) – 1962 New York

From 1931 to 1935 Kline studied in Boston, and from 1936 at the Heatherley School of Fine Art in London. He moved to New York in 1938, where he met de Kooning who aroused his interest in abstraction. He began to paint portraits, seated figures in rocking chairs, pictures of trains and the Pennsylvania landscape. He often gave his abstract paintings titles associated with his Pennsylvanian childhood memories. Towards the late 1940s he established his personal attention-grabbing style, painting increasingly large canvases and restricting himself almost totally to black and white. Around 1950 he produced powerful tectonic constructions which, by his own admission, had been influenced by Mondrian. From the mid-fifties he returned to brilliant reds, yellow, orange and purple, also browns and greys, but remaining true to his former idiom.

Illustration:

634 New York, 1953

KLINGER Max

1857 Leipzig — 1920 Großjena (near Naumburg) Together with Slevogt and Hodler, Klinger studied under Karl Gussow in Karlsruhe and Berlin. He was much impressed by Goya, Menzel and Rembrandt, studying in particular their graphic work. He began his career with a series of etchings which successfully appeared in 1878. Subsequently he also produced paintings, but later devoted himself almost entirely to sculpture, using variously coloured materials. His works tended towards the dreamlike and imaginative, and contain Symbolist as well as Jugendstil (Art Noveau) elements.

Illustration:

533 Landscape by Unstrut, 1912

KØBKE Christen Schjellerup

1810 Copenhagen – 1848 Copenhagen Købke became Eckersberg's pupil in 1828, after having studied at the Copenhagen Academy since 1822. Like his teacher, he concentrated on portrait and landscape painting. His pictures of Danish life are usually small in format, carried out in fine, broken or dotted brushwork capable of putting life into the smallest detail. Contrary to Eckersberg he did not choose the all-inclusive panoramic view, but discovered small, secret corners in the country or near the towns, which he rendered from an unexpected perspective and in limpid daylight. Købke was one of the most important representatives of light-toned, open-air painting and early realism in Copenhagen. Following his Italian sojourn from 1838 to 1840 he painted primarily from his

Italian travel sketches, abandoning the small format. His work lost the fresh directness of the earlier period.

Illustration:

462 The Shore at Dosseringen, 1838

KOCH Joseph Anton

1768 Obergiblen (Tyrol) – 1839 Rome Coming from a poor background, Koch started work as a shepherd. He gained the support of the Bishop of Augsburg and was sent for his education to the Dilling Seminary and finally to the Karlsschule in Stuttgart for artistic training. As Schiller before him, Koch escaped from the intolerable constraints imposed at this school, making his way first to Strasbourg and then Switzerland. He had joined the Jacobin Club at Strasbourg, but the Swiss countryside, removed from all political strife, allowed him to express his ideals of freedom artistically. The mountain studies, which Koch made on his extensive walking tours, formed the basis for his large compositions, including "Schmadribachfall" (ill. p. 450), "Swiss Landscape" (ill. p. 450) and "The Hospice on the Grimselwald Glacier" (destroyed, formerly Leipzig, Museum der bildenden Künste). These works were not produced, however, until Koch had studied contemporary classic landscape painting in Rome, which enabled him to create a new monumental type of Alpine painting. Apart from a brief period in Vienna from 1812 to 1815, Koch lived in Rome from 1795 until his death. Here he found his subject matter for his landscapes in the Alban mountains and especially the area around Olevano. In these he combined Poussin's classic approach to landscape with direct observation of nature, which he captured in his sketches and water-colours. Illustrations:

450 Swiss Landscape (Berner Oberland), 1817

450 Schmadribachfall, c. 1821/22

KOKOSCHKA Oskar

1886 Pöchlarn (Danube) – 1980 Villeneuve (Lake Geneva)

Kokoschka studied from 1905 to 1909 at the Vienna School of Applied Arts, simultaneously working at the Wiener Werkstätte from 1907, and received from 1908 the active support of the architect Adolf Loos and writer Karl Kraus. The Wiener Werkstätte edited his colour lithographs for his work of poetic writing The Dreaming Boys, which represent a high point in the art of illustration in the Jugendstil (Art Noveau style). In 1909/10, his period of the psychological portrait, the model is not so much depicted, but rather dissected. In 1910 he went to Berlin to work on Herwarth Walden's Sturm, but returned a year later to become an assistant at the Vienna School of Applied Arts. The male - female conflict, already dealt with in the drama Mörder, Hoffnung der Frauen (Murder, Women's Hope), was transformed in 1914 into an allegory of unrestrained love relationships in his pictures "Whirlwind" (Basel, Kunstmuseum). In 1915 Kokoschka returned seriously wounded from the front, having volunteered for service. In 1917 he settled in Dresden, becoming a teacher at the Academy in 1919. In addition to his portraits, he discovered the cityscape as a new subject. From 1924 he travelled all over Europe, painting large-scale pictures of famous cities in strong colours. He left for Prague in 1934 and emigrated from there to London in 1938, but finally settled in Switzerland in 1953. Illustration:

586 Venice, Boats at the Dogana, 1924

KONINCK Philips

(also: Coning, Coningh, Goningh, Koning) 1619 Amsterdam – 1688 Amsterdam

Konincks' father was a goldsmith, his older brother Jacob a painter, who taught him from 1639 to 1641 in Rotterdam. He returned to Amsterdam in 1641, possibly becoming a pupil of Rembrandt who became a friend to whom he owed much. Characteristic of his work are large-scale panoramic landscapes, mostly seen from a slight elevation allowing a view over wide stretches of flat or slightly hilly land under a great expanse of sky. Waterways and paths intersect the landscape, houses are dotted in the foreground. These landscapes were most mostly carried out in warm, brown-yellow tones. As a sideline, Koninck operated a ferry service between Amsterdam and Rotterdam.

322 Village on a Hill, 1651

KONRAD OF SOEST

c. 1370 Dortmund – after 1422 Dortmund Konrad came from a family of painters who had settled in Dortmund two generations before his birth, while still retaining connections to Soest. A record of his marriage in 1394 survives; the witnesses, came from some of the town's more respected families. He was possibly trained in Westphalia, as the structure and thematic perception of his work follow older local traditions. However, other elements point at his extensive knowledge of French and Netherlandish art, so much so that one could be tempted to draw inferences from his painting about much that has been lost in those countries. During the period that produced the Wildung altar retables (1403) he must have had a large workshop with distinct areas of allocated responsibility, as it is inconceivable that all the scenes could come from one hand (ill. p. 75). A major work from his later work is the retable in the Marienkirche in Dortmund, of which only fragments remain. During 1413 to 1422 he is mentioned in connection with his membership in the Brotherhood in St Nicolai in Dortmund. He probably died soon afterwards. Konrad's fame went far beyond his home boundaries, making his influence felt as far as the coast and central Germany.

Illustration:

The Nativity, 1403

KOONING Willem de

born 1904 Rotterdam

From 1916 de Kooning worked for four years for an art dealer in Rotterdam, attending evening courses at the Academy. In 1926 he entered the USA illegally. In 1930 he met Gorky, with whom he then shared a studio and who was to be an important influence. He taught summer courses at the Black Mountain College and at Yale, and travelled to Rome and San Francisco. In the 1930s he painted several murals as part of an official arts support programme. De Kooning is, with Pollock, one of the most important painters of abstract Expressionism. His first one-man exhibition was not held until 1948, and he became one of the leading avant-garde personalities and influential artists of the 1950s. During the 1930s and 1940s de Kooning specialised in the depiction of three main themes: men, women and abstractions; towards the end of this period his manner of painting grew in intensity. After 1950 he returned to his subject "Woman", while continuing with his abstract compositions. During this period his work was marked by a heightened colour intensity and density which in turn was replaced by lighter tones and larger, more reduced forms. He painted abstract landscapes after 1955 and, encouraged by Henry Moore, started producing large-scale sculpture in

1970. In 1963 he built himself a studio at Springs on Long Island. In spite of a serious illness in 1989 he continues to paint incessantly while cared for by his daughter.

Illustrations:

616 Untitled, 1970

631 Woman, I, 1950-1952

Untitled, III, 1980

KUPKA František

1871 Opocno (Bohemia) – 1957 Puteaux (near

After an apprenticeship as a saddler and attendance at the Prague Academy from 1888 to 1891, Kupka studied at the Vienna Academy for two years. In 1895 he moved to Paris, then to Puteaux in 1904, where he associated with Jacques Villon, Léger, Gris, Duchamp, Metzinger and Archipenko. He regularly exhibited his Neo-Impressionist pictures at the autumn Salon, supplementing his income by producing illustrations. He became deeply interested in theosophy, Eastern philosophy and spiritualism. Around 1910 he turned to abstract painting. His knowledge of colour theory and the discoveries of modern physics inspired this work in which he attempted to express both movement and light in terms of colour. At the Paris autumn Salon in 1912 he showed his first entirely non-representational paintings whose titles already give an indication of their closeness to music ("Amorpha: Fugue à deux couleurs" and "Chromatique chaude"). In 1914 he volunteered for military service. From 1918 to 1920 he was a visiting professor in Prague, when his work began to show the influence of the world of machines and of jazz music. During the years 1931-1934 he was a member of the group Abstraction-Création. It was not until the 1940s and 1950s that through exhibitions and acquisition of his work by the world's great galleries Kupka received due recognition as one of the pioneers of ab-

Illustration:

592 The Language of Verticals, 1911

LAM Wifredo

1902 Sagua la Grande (Cuba) – 1982 Paris Lam came from a cosmopolitan family - a Chinese father and a European-African mother, and was trained at the San Alejandro Academy in Havana, continuing his studies in Madrid and Barcelona in 1924. In 1928 he saw for the first time African sculptures from Guinea and the Congo. These were to influence his art as much as the work of Picasso. whom he met in Paris in 1937. While in Paris he met artists of the Surrealist group with whom he took flight to Marseilles in 1940. In 1941 he took ship with Breton, Masson and Lévi-Strauss to Martinique, going on to Cuba. On his return to Paris in 1945 he began to lead a restless life between continents. He moved to Albisola Mare in Italy in 1964. Lam can be regarded as an outstanding exponent of the Surrealist endeavour to incorporate African and Caribbean mythology into art. His subject matter centred around Cuban gods and myths, voodoo culture and the dangers and wildness of the jungel.

612 Umbral (Senil), 1950/51

LANCRET Nicolas

1690 Paris - 1743 Paris

Lancret received early instruction in engraving and drawing, then at the age of 17 became the assistant of the history painter Pierre Dulin in Paris. He was not very successful in this field and the hoped for Rome prize of the Academy was not forthcoming, so on entering the studio of Gillot, who had also

been the master of Watteau, Lancret gave up history painting. Two landscapes secured him membership of the Academy in 1718. His pictures show from the very beginning the influence of Watteau, with whom he soon quarrelled. A renewed attempt at history painting failed in 1723/24. He now devoted himself to the pastoral idyll and "fêtes galantes". Pictures such as "The Swing" (ill. p. 353) made him something of a mediator between Watteau and Fragonard, although he never achieved their subtle poetic qualities. On Pater's death, Lancret completed the series of illustrations for La Fontaine's fables. With the exception of the "Tiger Hunt" (Amiens, Musée de Picardie) and his portraits, Lancret remained faithful to his so-called 'Watteau genre".

Illustration:

353 The Swing, undated

LANFRANCO Giovanni

(also: Giovanni di Stefano)

1582 Terenzo (near Parma) – 1647 Rome As the pupil of Agostino Carracci he worked from 1600 to 1602 on the decoration of the Palazzo del Giardino in Parma. A short time after his master's death he was mentioned in Rome in the circle surrounding Annibale Carracci. In 1605, while in Rome, he decorated the Camerino degli Eremiti in the Palazzo Farnese (destroyed). Around 1610 he returned briefly to his home town, painting altarpieces for churches in Parma and Piacenza. Again in Rome, he carried out the two works which were to make him famous: the ceiling in the Loggia des Casino Borghese with its extreme foreshortenings ("Olympian Meeting") and the fresco in the cupola with the "Assumption of the Virgin" for Sant'Andrea della Valle. These were to serve as an example to Pozzo and Baciccio with their characteristic powerfulness and monumental grandeur. In 1633/34 Giovanni Lanfranco made his way to Naples, where he carried out a number of large commissions, including the cupola of Gesù Nuovo and the frescos in Santi Apostoli, where he concentrated on achieving dramatic vividness rather than careful execution.

Illustration:

235 Hagar in the Wilderness, undated

LARGILLIÈRE Nicolas de

1656 Paris – 1746 Paris

Largillière first studied art in Antwerp, qualifying as a master artist in 1672. Two years later he went to London, working with the Flemish-born Peter Lely and also for the court. To avoid persecution as a Catholic he had to return to Paris in 1682. With a portrait of Charles Le Brun he was accepted as a member of the Academy. He was again in London in 1685/86 in order to paint the royal couple at the coronation. Alongside Hyacinthe Rigaud, Largillière was the most sought-after portraitist among royalty, nobility and the middle classes. As a teacher - he became professor at the Academy in 1705 he upheld the Flemish tradition which had long played an important part in French painting. He was also a master of the group portrait and the still life.

Illustration:

352 The Strasbourg Belle, 1703

LASTMAN Pieter

1583 Amsterdam – 1633 Amsterdam Rembrandt was briefly a pupil of Lastman around 1622/23 and copied his master's work in his early career, and yet Lastman has almost been forgotten. The son of a messenger, Lastman was apprenticed to Gerrit Sweelinck, a pupil of Cornelis van Haarlem, which explains the influence of the old Haarlem

school on his work. However, more important was his visit to Italy in about 1603-1607 which took him to Venice and Rome. His meeting with Caravaggio and the Carraccis, and most of all his close contact with Elsheimer, whose landscape composition and figure painting impressed him deeply, gave him a new direction. On his return to Amsterdam he dedicated himself to history painting centering on biblical scenes and ancient mythology. He tells his stories in a manner that is both realistic and original. His landscapes of Antiquity are often arranged with groups of figures in splendid dress and rich colours ("Odysseus and Nausicaa", various versions are at Brunswik, Augsburg, Munich; ill.

Illustration:

294 Odysseus and Nausicaa, 1619

LA TOUR Georges de

1593 Vic-sur-Seille (near Nancy) – 1652 Lunéville Even in his lifetime La Tour must have been one of the most admired painters. He was ennobled, appointed "peintre du Roi", lived a luxurious life, had powerful patrons and so was able to charge enormous fees (such as for his "Peter Denying Christ", Nantes, Musée des Beaux-Arts, 1650). This is especially surprising as he never left his home ground, except for a brief visit to Paris and a still disputed journey to Rome, and yet he produced up-to-date work without subordinating himself to modish tendencies. He soon fell into oblivion after his death, until the revival of his work in the 1920s when artists of the New Objectivity (Neue Sachlichkeit) mistakenly thought they discovered in him an artistic predecessor of their own concepts. Only about twenty of his works survive, and these can be divided into his early stylised "day pieces" and the later "night pieces". But both attribution (he only rarely signed his work) and chronological order must remain questionable. Unlike the Utrecht Caravaggisti, La Tour, who was probably introduced to Saraceni, Caravaggio or Gentileschi by his colleague Leclerc, gave less and less attention to accurate detail. His strange lighting effects, particularly in his late work, do not create blurred forms but instead sharp contours. His figures, even when only barely and in part illuminated, have an extraordinary plasticity. In a work like the "The Card-Sharp with the Ace of Spades" (ill. p. 242) the figures seem to embody an inscrutability which is further enhanced by the enamel-like, opaque painting technique.

Illustrations:

Hurdy-Gurdy Player, c. 1620–1630 242 The Card-Sharp with the Ace of Spades, 242

St Sebastian Attended by St Irene, c. 1634-1643

LA TOUR Maurice Quentin de

c. 1620-1640

1704 St-Quentin (Aisne) - 1788 St-Quentin Leaving his poverty-stricken home at the age of 15, La Tour first entered the workshop of an etcher in Paris, then worked in the studio of the painter Jacques-Jean Spoëde. With a letter of recommendation from an English ambassador he went to England where he was much impressed by van Dyck's art of portrayal. On his return to Paris he took up pastel painting, possibly inspired by Rosalba Carriera's success in Paris in 1720/21. After some experiments he soon came to excel at pastel portraits, surpassing all his rivals, even Peronneau, and gaining great favour at court. La Tour was most demanding in his art so that the execution of a work was often slow, and it was nine years before he produced a work which would admit him to the Academy. His portrait of Mme de Pompadour of

1755 (Paris, Louvre) and of the "President de Rieux in his Study" (Paris, Louvre) represent two of the few full-length pastel portraits in existence. His portraits show a vigorous handling and a perceptive grasp of character. Illustration:

362 Self-Portrait, 1751

LAWRENCE Thomas

1769 Bristol – 1830 London

Thomas Lawrence was the 14th of sixteen children of a customs officer and later publican. An early fondness of acting and drawing drew attention to the child prodigy. When only ten he drew portraits of fifty prominent Oxford personalities. He was given some instruction sin pastel and oil-painting, but was largely self-taught, studying private art collections. In 1789 he introduced himself with the full-length portrait of Lady Cremorne (Bristol, City Art Gallery) at the Royal Academy. He was a great admirer of Reynolds, and in effect became his successor on his death. Lawrence's acting talent showed itself in the way he posed and presented his sitters. In 1792 he became principal painter to the king, two years later a member and in 1820 president of the Royal Academy. He received his peerage in 1815, the same year he was asked to paint the leading personalities at the Congress of Vienna. His influence on Victorian portrait painting was fundamental.

Illustrations:

389 Portrait of Master Ainslie, 1794

Portrait of Lady Elizabeth Conyngham, c. 1821-1824

LE BRUN Charles

1619 Paris – 1690 Paris

Having been the pupil of Perrier and Vouet, Le Brun was appointed "peintre du Roi" at the age of eighteen and received his first commissions from Cardinal Richelieu in 1640. Two years later he went with Poussin to Rome, where he studied and copied the works of Reni, the Carraccis, Raphael and Cortona. After returning to Paris in 1646 he soon developed his own style and was commissioned to decorate various great houses (Hôtel Lambert, Hôtel Nouveau), became co-founder of the Académie Royale in 1648 and there held the first of his famous "leçons" in the same year. His contact in 1657 with the government minister Fouquet resulted in the commission for the design of decorations in the Vaux palace (ceiling and wall frescos, 1658) and his appointment as director of the Gobelins manufactory. His introduction at court by Mazarin in 1660 brought him many commissions and the appointment as "first court painter" (1662). As the virtual dictator of the arts, Le Brun also designed furniture of massive silver, triumphal arches, fireworks and catafalques. Twenty years later he worked with his assistants on the decorations of the Petit Galérie des Louvre, designed decorations for Versailles, where he also decorated the Grand Escalier (1674-1678, destroyed) and decorated Colbert's Sceaux palace (destroyed) and Marly (destroyed). Le Brun, who in his lifetime was the most comprehensive, famous and influential artist of his epoch, is almost forgotten today.

Illustrations

Martyrdom of St John the Evangelist at the Porta Latina, c. 1641/42

Chancellor Séguir at the Entrance of Louis XIV into Paris in 1660, 1660

LÉGER Fernand

1881 Argentan (Normandy) – 1955 Gif-sur-Yvette Léger worked as an architect's draughtsman in Paris until 1903. Like so many other painters, he was

deeply impressed by the 1907 Cézanne exhibition at the Salon d'Automne. From 1908 he lived in the artists' colony Zone with Delaunay, Archipenko, Laurens, Lipchitz and others. From 1910 he exhibited at Kahnweiler's gallery, who also represented Picasso and Braque, and began to move towards Cubism. However, the analytic dissection of surface did not appeal to him; he was much more interested in an art evolving from pure colours and rhythms as realised in his "form contrasts".

Léger's war experience 1914-1916 helped him find his true subject matter: the mechanisation of our world. His forms since 1917 took on such a tubular appearance that a critic remarked mockingly that Léger's art should not be called Cubism, but "tubism". In these works, figures enliven the inanimate mechanised world. His friendship with Le Corbusier inspired him to produce designs for wall decorations, mosaic and stained glass from 1920. The beginning of his "monumental" period was marked by his depiction of figures with stencil-like outlines. From 1927 they again began to take on forms that became increasingly organic and realistic. Illustrations:

574 The Stairway, 1914

Three Women (Le Grand Déjeuner), 1921 574

LEIBL Wilhelm

1844 Cologne – 1900 Würzburg Today regarded as one of the great German painters, Leibl found little recognition and success in his lifetime. From 1864 to 1869 he studied in Munich under Karl Theodor von Piloty and Wilhelm von Kaulbach. At first he adhered to the oldmasterly manner, painting portraits and genre scenes in muted tones. Already in his student days he had formed the "Leibl circle", gathering likeminded painters, such as Trübner, around him. However, this group did not organise itself formally or put forward any specific ideas. At the first International Art Exhibition at the Munich Glaspalast in 1869 Leibl had his first success with his "Portrait of Frau Gedon" (Munich, Neue Pinakothek). Here he met Courbet, whose work, and in particular the "Stonemasons" (formerly Dresden, Gemäldegalerie), impressed him so strongly that he spent 1869/70 in Paris. Here he saw the work of the early Impressionists, but it was Manet who inspired him most. In opposition to the "city art trade" he left Munich in 1873, retiring to remote Bavarian villages. From this period date his genrelike scenes of gloomily-lit interiors of peasant dwellings and rural life ("Three Women in Church", ill. p. 532). His fine detail and technical skill are reminiscent of the old Dutch masters, while his late work is marked by Impressionist influences.

Illustration:

532 Three Women in Church, 1881

LELY Peter

(Pieter van der Faes)

1618 Soest (near Utrecht) – 1680 London After studying in Haarlem, Lely travelled to England in 1641 when William of Orange married Mary of England; he obtained access to the court by painting the bridal couple. He also was in the service of the Earl of Northumberland, copying paintings by van Dyck for him. This work was to have a key influence on his style. Lely also admired the work of Dobson and Fuller, as can be seen from his portraits of the "Duke of York" (London, Syon House) and the "Children of Charles II" (Petworth). In 1656 he was given leave to visit Holland; the effect was the replacement of the van Dyck elegance of his painting with Flemish elements, such as landscape backgrounds in his portraits. Charles II appointed him principal painter in 1661 at a considerable salary, and at the time of the Restoration Lely dominated Stuart portrait painting. During this period he painted his best work, including portraits of ten ladies of the court known a the "Windsor Beauties", 1662–1665 (Hampton Court). His late work is characterised by a velvety chiaroscuro – again close to van Dyck's work – and looser brushwork. His success was crowned by the bestowal of a knighthood in 1680.

Illustration:

254 Henrietta Maria of France, Queen of England, 1660

LE NAIN Antoine c. 1588 Laon – 1648 Paris LE NAIN Louis c. 1593 Laon – 1648 Paris LE NAIN Mathieu 1607 Laon – 1677 Paris

The three brothers, who all used the same signature on their work and therefore represent an attribution problem to this day, probably trained under an unknown Dutch master in Laon and then settled in Paris

Antoine, master painter to the Abbey St Germain-des-Près from 1629, showed the Dutch influence most. He preferred the small format, painting single and group portraits in a strong, dramatic manner ("Family Meeting", Paris, Louvre, 1642). In 1629 he became a citizen of Paris, where the three unmarried brothers amassed a considerable fortune, appointing each other heirs to their estates. He and his brother Louis were founding members of the Academy (1648).

Louis, also called "Le Romain" because of the Italian influence in his style, was probably artistically the most important of the three. Starting with the narrative genre of the so-called "Bambocciades", he developed an individual manner of portraying rural life ("Peasants at their Cottage Door", ill. p. 241). His work is marked by sparse but cleverly used coloration in tones of brown and grey and an atmosphere of solemnity and peace.

Mathieu seems to have concentrated on religious subjects, such as "The Nativity" (Paris, Louvre). Van Dyck's influence is apparent in such works as the "Tric-Trac Player" (Paris, Louvre), whose elegance stands out against the rustic pictures of Antoine and Louis. On the death of his two brothers Mathieu completed their unfinished works, adding to the already existing difficulty of distinguishing between them.

Illustrations:

241 La Charette (The Cart), 1641

241 Peasants at their Cottage Door, undated

LENBACH Franz von

1836 Schrobenhausen (near Munich) – 1904 Munich

Lenbach came to painting by a circuitous route. He studied it briefly in the Munich studio of Karl Theodor von Piloty, then travelled to Italy and Spain and went with Hans Makart and L. C. Müller to Egypt. Lenbach was a portrait painter, and in his work he clearly showed his admiration for the old masters, whom he had copied and whose sonorous tonal values came out in his own work. Like his friend Makart he was a society painter and liked to present himself as a painter-prince. He lived in a splendid Italian-style villa in Munich, now a museum, where he received his friends, including Otto von Bismarck. He had other well-appointed residences in Berlin and Vienna, and from 1882 he spent his winters at the Palazzo Borghese in Rome. Illustration:

531 Young Boy in the Sun, c. 1860

LEONARDO DA VINCI

1452 Vinci (near Empoli, Tuscany) – 1519 Cloux (near Amboise, Loire)

Leonardo was the embodiment of the Renaissance ideal of the universal man, the first artist to attain complete mastery of all branches of art. He was a painter, sculptor, architect and engineer besides being a scholar in the natural sciences, medicine and philosophy. He received his artistic training under Verocchio in Florence, with whose workshop he retained contacts even after having become an independent master. He left Florence for Milan in 1482, working at the court of Duke Lodovico Sforza in the capacities of painter, sculptor and engineer until 1499. When the French invasion of the city caused the Duke to leave, Leonardo returned to his home ground, but worked again in Milan from 1506 to 1513. In 1513 he went to Rome, and in 1516, at the invitation of King Francis I, to France as court painter.

With his "Last Supper" in Milan (ill. p. 161) Leonardo created the first work of the High Renaissance. His representation of the theme has become the epitome of all Last Supper compositions. Even Rembrandt, generally standing aloof from Italian art, was unable to resist its impact. Leonardo's work revolutionised both pictorial and painterly possibilities. While drawing had dominated over colour in the Early Renaissance, with Leonardo the outline was increasingly replaced by the use of mellowed colours which allowed one form to merge with another.

Leonardo was never quite understood in Florence, but this was more than made up for by his influence on 16th century Venetian art. His theories on art too were influential. He also supported his new ideas about painting with a sound theoretical basis. A number of projects remained uncompleted, such as the wall painting of the Battle of Anghiari in the Palazzo Vecchio in Florence, the numerous designs for the two equestrian monuments of Lodovico Sforza and Marshal Trivulzio in Milan, and also some architectural designs (Pavia cathedral). Illustrations:

146 Virgin and Child with St Anne and St John the Baptist, c. 1495

148 Mona Lisa, c. 1503–1505

161 Last Supper, 1495-1498

161 Adoration of the Magi, c. 1481

162 Virgin of the Rocks, c. 1483

162 Virgin of the Rocks, completed c. 1506

163 The Virgin and St Anne, c. 1508

LE SUEUR Eustache

1616 Paris - 1655 Paris

The decoration of the Hôtel Lambert in Paris announced a new style which was established by Le Sueur in the 1640s. While his early mythological paintings from 1644 still owed much to his master and friend Vouet, whose workshop he entered at the age of fifteen and with whom he had painted the ceilings in the Cour des Aides and the Hôtel Bouillon, his later work, such as "Melpomene, Erato and Polymnia" (ill. p. 253) or "Phaëthon in the Chariot" (1647-1649) were strongly influenced by Poussin. The academic classicism of Le Sueur, who also made Gobelin designs after Raphael's loggia frescos, is shown clearly in his 22 panels on the life of St Bruno for the Chartreuse de Vauvert (1645-1648). He often collaborated with his brothers Pierre, Antoine and Philippe, and at times was also assisted by his brother-in-law, Thomas Goussé. Le Sueur, who was one of the founders of the Academy in 1648 and was appointed court painter in the same year, combined cool clarity with an almost sentimental sensitivity, detached dignity and skill at conveying the idea of movement.

Illustration:

253 Melpomene, Erato and Polymnia, c. 1652–1655

LEYDEN Lucas van

1494 Leiden – 1533 Leiden

Besides being taught painting in his father's workshop, the young Lucas also learned the goldsmith's and armouror's craft which must have brought his outstanding talent in the art of engraving to its full development. He certainly was exceedingly precocious in that art, as Carel van Mander confirmed. After 1508 Lucas worked in the workshop of Cornelis Engelbrechtsz. His passion for the realistic depiction of figure, landscape and architecture became merged with the coloration and characteristic outline of Italian Mannerism after his meeting with Gossaert around 1527. Problems still exist with the attribution of his painted works and their stylistic development. But he left a great number of engravings which were greatly influenced by Dürer, whom he had met on his visit to Antwerp in 1521.

Illustration:

202 Lot and his Daughters, c. 1520

LEYSTER Judith

(also: Leijster)

1609 Haarlem – 1660 Heemstede

With her father, a Haarlem brewer, Judith came to Utrecht in the 1620s. There she was introduced to the characteristic handling of light by the Utrecht Caravaggisti, such as Honthorst and Terbrugghen. In about 1630 she was probably a pupil of Frans Hals in Haarlem, whose style she followed in her portraits and genre scenes, but giving the impression of some superficiality compared with her mentor. In 1636 she married the genre painter Jan Miense Molenaer and achieved for a brief period a personal note with her small multi-figured genre scenes and her preference for light blue and light grey tonality.

Illustration:

317 Carousing Couple, 1630

LICHTENSTEIN Roy

born 1923 New York

Lichtenstein studied art at the Ohio State University in Columbus from 1940 to 1943. From 1946 to 1950 followed a period of further study, concluding this at the Art Students League in New York. He at first followed in terms of both motif and style Frederic Remington, the major representative of the glorification of the "wild West", but came under the influence of abstract Expressionism in 1957. This period ended in 1961 when he found his personal idiom which made him an exponent of American Pop Art. For models he used comic strips and cartoons which he applied to the canvas greatly enlarged, sometimes with dotted grids after the Beday system. He produced Pop versions of famous paintings by Picasso, Mondrian and others. His colours are brilliant, clear and limited to a few primary tones, and his outlines are always boldly drawn in black.

Between 1964 and 1966 he produced sunsets, landscapes, ancient ruins and a series with brush strokes. In 1966 he discovered an interest in Art Deco of which he became a collector and which provides the inspiration for his paintings and sculptures. Lichtenstein is primarily a painter, but he has also produced designs for works in ceramic, steel and glass which have been produced industrially. *Illustrations:*

625 Razzmatazz, 1978

662 M-Maybe (A Girl's Picture), 1965

LIEBERMANN Max

1847 Berlin - 1935 Berlin Liebermann was taught drawing before attending the Weimar Academy from 1868 to 1872. In 1871 he met in Düsseldorf the Hungarian painter Mihály von Munkácsy who inspired him to work on his successful painting "The Goose-Pluckers" (Berlin, Nationalgalerie). In the same year he visited Holland for the first time, and from 1913 he travelled there every year. From 1873 to 1878 he lived in Paris, where he followed the work of Courbet, Millet and Ribot, spending the summer months in Barbizon. He visited Venice in 1878 and settled in Munich for six years. In 1884 he returned to Berlin. Liebermann went three times to Italy, was co-founder of the Berlin Sezession in 1899, was elected to the board of the German Artists' Association in 1904 and became the president of the Academy of Fine Arts in 1920. Initially he adhered to realism, but towards 1890 came under the influence of Impressionism. Besides paintings, he produced drawings, water-

Illustration:

works.

The Parrot Walk at Amsterdam Zoo,

colours and etchings, and also wrote theoretical

LIMBURG Paul, Jean, Herman

after 1385 Nimwegen (?) - c. 1416 Bourges (?) The three brothers came from the Aachen area. Their father was a picture-carver, their uncle the celebrated Burgundy court painter Jean Malouel (Malwael). According to records the two younger brothers Jean and Herman were apprenticed to a Paris goldsmith in 1399. In 1402 the three received a commission from Duke Philip the Bold of Burgundy to illuminate a so-called Bible Moralisée (which still survives). The fee was considerable, which leads to the assumption that they must already have had a good reputation. On Philip's death all three went into the service of the Duke of Berry. On the Duke's moving the workshop to Bourges in 1411, Paul, the eldest and most prominent of the brothers, was presented with a grand house previously inhabited by the Duke's treasurer. A close relationship existed between the Duke and the artists, and, according to records, Paul in particular often received presents and was appointed "valet de chambre" in 1413, while another brother was made a canon of the cathedral chapter at Bourges. The death of all three brothers is documented in 1416, probably caused by an epidemic. They had not yet reached their thirtieth year, leaving Très Riches Heures uncompleted. The Duke died in the same year at the age of 76. The brothers seem to have based their work on the art of Malouel. The Duke of Berry admired the art of Lombardy, and it is probable that the three miniature-painters visited that part of Italy with commissions from the Duke. Their work can be seen as the climax of painting around the turn of the century, being the culmination of one period and a transition to the next.

Illustrations:

- Miniature on the Prayer "On preparing for a journey", after 1410
- 62 Expulsion from Paradise, 1414–1416
- 63 Calendar of the months: January, 1414–1416
- 63 The Temptation of Christ and The Castle Méhun-sur-Yèvre, 1414–1416
- 64 Calendar of the month: June, 1414–1416

LINDNER Richard

1901 Hamburg – 1978 New York Lindner studied at the school of applied arts in Nuremberg from 1922 to 1924, then at the Munich school and academy, and finally in 1927/28 at the Berlin academy. From 1929 to 1933 he was artistic director of the publisher Knorr & Hirth in Munich. Nazism forced him to leave for Paris in 1933, where he worked as a graphic designer. He then emigrated to the USA in 1941. There he supported himself as an illustrator of books and magazines, including Vogue and Harper's Bazaar. He was naturalised in 1948, and from 1950 he devoted himself again to painting. In his early years Lindner had been involved with German Expressionism, then with the Neue Sachlichkeit. He now developed a style combining his early impressions with his experiences as an illustrator and his encounter with American Pop Art. Lindner taught at the Pratt Institute in Brooklyn from 1952 to 1965. From 1971 he had made his home in New York and Paris.

Illustration: 656 The Meeting, 1953

LIOTARD Jean-Étienne

1702 Geneva - 1789 Geneva

Liotard, whose family was French, was trained as a miniature-painter and engraver in Geneva. In 1723 Jean-Baptiste Masse became his teacher in Paris. His friendship with Lemoine inspired him to take up pastel and portrait painting. A visit to Rome, where he copied old masters, in particular Correggio, was followed by eastern travels in 1738, accompanied by Sir William Ponsby. During his five-year stay in Constantinople he adopted Turkish customs and traditions. In Vienna he painted the Empress Maria Theresia's family and the famous "Chocolate Girl" (Dresden, Gemäldegalerie). As portrait painter he worked in Venice, Lyon, Paris and London before settling finally in his home town in 1757. His work is characterised by light coloration and detailed rendering of a world almost without shadows. Liotard's perfectly even surfaces give away the fact that he had trained as an enamel painter. Illustrations:

Turkish Woman with Tambourine, c. 1738–1743

378 Portrait of François Tronchin, 1757

LIPPI Filippino

c. 1457 Prato - 1504 Florence

The son of Fra Filippo Lippi studied under his father, assisting on his last work, the apse decoration in Spoleto cathedral. In 1472 he is mentioned in connection with Botticelli, who influenced him greatly. His earliest panels are hardly distinguishable from those of his great master. Around 1481 Filippino must already have had a reputation in Florence as he was commissioned to complete the fresco cycle in Brancacci chapel which Masaccio and Masolino had left unfinished. By incorporating Flemish elements which determined the brilliance of his colours, the young painter reached the pinnacle of his career over the next few years ("The Vision of St Bernard", ill. p. 109). In the 1490s Filippino intensified Botticelli's melodious lines to convey a feverish unrest ("Adoration of the Magi", 1496). While in Rome, where he studied ancient monuments with great passion, he painted the frescos in the Caraffa Chapel of Santa Maria sopra Minerva. In these, he explored Antiquity, but appointed it a place restricted to detail, and in the overall conception and exuberant ornamentation brother all principles of this era's art. He again adopted this manner in the Strozzi Chapel of Santa Maria Novella in Florence, completed in 1502. In these works the vitality of the figures, the freedom of line and the complexity of architecture often seem to approach a complete lack of restraint. Here, the gates were thrown open for the "anticlassical" stance of 16th century art, where Mannerism would find its stimulus; even Michelangelo must have acquainted himself with Filippino's repertoire of figures before embarking on the Sistine Chapel in 1506.

**Illustration:*

109 The Vision of St Bernard, c. 1486

LIPPI Fra Filippo

c. 1406 Florence – 1469 Spoleto

Lippi is one of the most important successors to Masaccio. In 1421 he entered the monastery of Santa Maria del Carmine in Florence and was able to observe the decorative work in progress in the Brancacci Chapel. He used this experience in his first work, the frescos in the cloisters of the monastery (1432), now only surviving in fragments, with their plastic figures and individual facial expressions. His Madonna of Tarquinia, 1437 (Rome, Galleria Nazionale), is in her clear articulation reminiscent of Masaccio's altarpiece in Pisa. In the 1440s, complex movements and a restless treatment of drapery are discernible ("Annunciation", Florence, San Lorenzo). These were the elements on which his great pupil Botticelli informed himself. With the decoration of the cathedral choir in Prato between 1452 and 1465, his artistic development reached its culmination, ranking him with Fra Angelico among the most outstanding fresco painters of his time

Lippi was chaplain to Santa Margherita in Prato from 1456, but he had to leave the order as he had formed a relationship with the nun Lucretia Buti, who bore him a son, Filippino (born about 1457), who as a pupil and assistant of Botticelli was to give the latter's late style certain Mannerist features. In his own late period Lippi painted various versions of the "Adoration of the Child", the most famous being the one produced for the house chapel of the Palazzo Medici (now in Berlin, Gemäldegalerie). With its fairy-tale atmosphere created by light and shade, the rich use of gold and the magnificent flower carpet, this panel represents one of the finest achievements of the period.

Illustration:

The Feast of Herod. Salome's Dance, c. 1460–1464

LISS Johann

(also: Jan Lys)

c. 1595 Oldenburg – c. 1629/30 Venice His surviving works are few, the facts about his life sparse. After an early training by his father, he went by way of Amsterdam, Haarlem, Antwerp and Paris to Venice where he remained, except for a stay in Rome of unknown duration, until his death during the Plague. The significance of his time in Haarlem can be seen clearly in his many genre scenes which show his familiarity with late Haarlem Mannerism, specifically the works of Goltzius and Buytewech. His later work in high Baroque owed more to the young Jordaens in Antwerp. When in Rome, Liss became influenced by Fetti, the Carracci and Bril, as well as by the Caravaggists, whose ideas were already known to him through the Flemish branch. Poelenburg in Rome provided a contact with mythological painting which in Liss's work, however, always remained bound up in landscape. While the "Outdoor Morra-Game" (Kassel, Staatliche Kunstsammlungen, c. 1622) still showed the Dutch genre painter, his late religious work, such as the altarpiece with the "Inspiration of St Jerome" (Venice, San Niccolò da Tolentini), characterised by its flaky-loose brushwork and light coloration, was to become significant for 18th century Venetian painting.

256 The Death of Cleopatra, c. 1622–1624

LISSITZKY FI

(Eliezer Markovic Lissitzky)

1890 Polschinok (near Smolensk) – 1941 Moscow After studying architecture, which he began in Darmstadt in 1909, Lissitzky returned to Moscow in 1914. Chagall called him to the art school at Witebsk in 1919. He joined the Unovis (new art) group led by Malevich and started painting his "Proun" series aimed at complete spatial reorganisation. "Proun" (= pro unovis), in combining Supremacist and Constructivist ideas, aimed to burst open closed space by means of asymmetry, disharmony and arythm, and so offering the human being a non-Euclidian, dynamic, spatial consciousness, open on all sides. In 1921 he became the head of the architectural faculty "Wchutemas". In the 1920s Lissitzky was the most important artistic mediator between eastern and western Europe. In 1923 he was able to realise a "proun" room in Berlin, and he arranged exhibition rooms in Dresden and Hanover for non-representational art. Illustration:

596 Proun 19D, c. 1922 (?)

LOCHNER Stefan

c. 1400 Meersburg (?) - 1451 Cologne According to records, Lochner (documented 1442-1451) was born in Meersburg, Lake Constance, but came from Constance to Cologne. It is not known where he was trained and when he came to Cologne. The dating of his work points to the fifth decade of the 15th century. Lochner must have been familiar with contemporary Dutch art (Campin and van Eyck), but direct thematic adoptions are rare. Undoubted is the fact that he orientated himself towards the older masters when in Cologne. The personal always comes first in his art; any connections with schools or contemporary painting stand back. Lochner always used his artistic devices to correspond closely with subject matter, purpose and requirements. With his freshness of colour and charm of style he had no equal in central Germany until Schongauer. Lochner was elected to the city council of Cologne in 1447 and 1450 which proves that he was highly respected. He also had a flourishing workshop, where his book illuminations were produced, and where the work was carried on after his death during the Plague in 1451. Illustrations:

Adoration of the Child, 1445 76

76 The Presentation in the Temple, 1447

The Virgin of the Rose Garden, c. 1448

LONDON THRONE OF GRACE → Master

LONGHI Pietro (Pietro Falca)

1702 Venice - 1785 Venice

Like other Venetian painters of the Rococo, Longhi studied in Bologna, first under Antonio Balestra, then under Crespi. In about 1730 he was back in Venice. He was not successful, either with his early historical paintings nor with his religious works, so, from the 1740s, under Crespi's influence, he began to paint mainly genre pictures recording Venetian life. In the manner of Watteau and his successors he created a personal form of conversation piece, depicting fashionable Venetian society with a fine, wry irony. In 1756 he became a member of the Academy, where he taught from 1758 to 1780. The affinity between Longhi's genre pictures and Goldoni's comedies (Longhi had contacts with him) is often pointed out, and rightly so. Longhi was also a considerable portrait painter. Illustrations:

The Rhinoceros, c. 1751 374

The Tooth-Puller, c. 1746-1752 374

LORENZETTI Ambrogio

c. 1290 Siena (?) – c. 1348 (?) Siena (?) Ambrogio was probably the younger brother of Pietro Lorenzetti and so came from the same artistic background. Ambrogio, who is recorded as active in Siena from 1319 to 1347, paid at least two lengthy visits to Florence. This might explain his profound knowledge of Giotto's art and of his successors, and also the interaction in his work between Sienese and Florentine art, particularly with respect to the small-scale devotional picture. His treatment of space was the most advanced of his time, and his observation of nature was as remarkable as his brother's. His manner of painting was light and assured, using movement to express rhythm and emotion. Unlike Pietro's sombre air, Ambrogio created a bright, relaxed atmosphere. Illustrations:

- Madonna and Child Enthroned, with Angels and Saints, c. 1340
- Allegory of Good Government, c. 1337-1340 40
- Life in the City. From: The Effects of Good Government, c. 1337-1340
- Life in the Country. From: The Effects of Good 41 Government", c. 1337–1340
- Nursing Madonna, c. 1320-1330

LORENZETTI Pietro

c. 1280-1290 Siena (?) - 1348 (?) Siena (?) Lorenzetti is recorded as active from 1306 (?) until 1345, but as is the case with other great Sienese masters we know little about his life, and the chronology of his work presents problems, although some signed and dated paintings survive. If the work carried out in 1306 for the city of Siena was by his hand, then he must have been born no later than around 1290. The first dated work is the altarpiece (1320) in the Pieve di Arezzo. The frescos in the Lower Church of Assisi (ill. p. 38) are possibly somewhat earlier. These show that Pietro attempted a synthesis of Duccio and Giotto, whose work he must have studied. Even elements of Cimabue can be recognised, as can the innovations of Simone Martini and the expressive powerfulness of Giovanni Pisano. And yet an individual style emerges, showing an astounding feeling for time and season, light and shade, and an acute awareness of the realities surrounding human life. In his frescos Pietro aimed at massed effects, sometimes at the cost of thematic clarity, while using a completely different approach in his panel works. The contrast demonstrates the scope and adaptability of his art. He preferred cool colours, particulary green and grey tones. Pietro, who was probably the elder brother of Ambrogio, sometimes collaborated with his brother, and it is probable that both died during the great Plague of 1348 which wiped out half the population of Siena.

Illustrations:

- Birth of the Virgin, 1342 37
- Sobach's Dream, 1329 38
- The Deposition, c. 1320-1330 38

LORENZO MONACO

(Piero di Giovanni)

c. 1370 Siena (?) - c. 1425

Records show that Lorenzo Monaco was active in Florence between 1388 and 1422, and he was probably born in Siena. Of the Sienese painters, the most influential for his work was Simone Martini, but his tonal sequence also suggests the influence of Pietro Lorenzetti. His early Florentine work showed his involvement with the Giotto successors, such as Agnolo Gaddi. Although these influences again became subordinate, Lorenzo Monaco never returned to the planar strictness of the older Sienese school. In 1390 he became a Camaldolese monk in Florence, entering the monastery of Santa Maria

degli Angeli. In 1402 he was accepted by the Florentine Guild. It seems that he left the closed monastic community at this time, but without giving up his orders. In 1414 he rented a house belonging to the monastery. He produced a number of miniatures in the service of the monastery. No other painter in Florence around 1400 went as far as Lorenzo in terms of stylisation of form and colour: sometimes he departed entirely from plausibility. But it would be unjust to call him a mere decorative artist; he opened up possibilities in the representation of the spiritual and visionary. Illustrations:

- The Annunciation, c. 1410–1415
- Adoration of the Magi, 1421/22

LORRAIN Claude

(Claude Gellée, called: Le Lorrain) 1600 Chamage (Lorraine) - 1682 Rome At the age of fourteen Lorrain came to Rome and, while working in artists' studios, came to the notice of Agostino Tassi, the landscape painter, who gave him lessons. Except for a period in Naples (1619-1624) and in his home country (1625-1627), he always remained in Rome. There he painted frescos of landscapes in the Palazzo Crescenzi and Palazzo Muti. He became a member of the Accademia di San Luca in 1634, and three years later was regarded as the leading landscape painter in Rome. He attracted the attention of the leading nobility and church dignitaries. Amongst others, the King of Spain commissioned seven religious paintings for his palace Buen Retiro. However, all his life his speciality remained the landscape in various forms, presenting it as veduta, as mythological scene and as a stage for stories from the Old Testament. His figure representation, influenced by the so-called multi-figured "bambocciades", was not very adept and often not carried out by himself. His landscapes, unlike those of Poussin, are characteristic in their relaxed, peaceful air, and painted in a large range of muted tones. With their bright atmosphere and their use of pieces of architecture of Antiquity as items of stage scenery they set an example for classical landscape painting in the 18th and 10th centuries

Illustrations:

- Landscape with Cephalus and Procris 248 reunited by Diana, 1645
- Landscape with Apollo and Mercury, c. 1645
- Seascape in Sunrise, 1674

LOTH Johann Carl

(also: Lotto, Carlotto)

1632 Munich - 1698 Venice

After receiving instruction from his mother and father Johann Ulrich, who himself had been inspired by Caravaggio and Saraceni in Rome, Loth went to Italy in 1653, stopping first in Rome. There he studied the works of Caravaggio and his successors, and proceeded to Venice where, in 1663 he was given the title "gran miniatore" by his fellow artists. His lively manner of depiction was to set an example for southern German Baroque painting, introduced by his pupils Rottmayr, Strudel and Saiter. This style already marked his work in the churches of Venice and the Terra Ferma. Loth's contact with the Venetian Tenebrosi (so-called because of their contrasting use of light and shade and sombre coloration) is apparent in his "Death of St Andrew Avellino" (Munich, Theatinerkirche, 1677). This work also shows his own, closely human approach to the subject. For his mythological and religious scenes he favoured large-figured compositions, defined and dominated by the figures in the foreground. Late works, such as "St Joseph and the Child Jesus, God in his Glory, and Mary" (Venice,

San Silvestro, 1681), show his great talent in fusing earthly and heavenly elements to achieve a realistic whole. Loth, who was greatly esteemed in his lifetime, is now largely, though unfairly, forgotten. Illustration:

258 Mercury piping to Argus, before 1660

LOTTO Lorenzo

c. 1480 Venice – 1556 Loreto (Marches) Lotto, one of the most important 16th century Venetian painters, lived an unsettled life far away from his home town. He grew up in Venice under the influence of Giovanni Bellini and the works of Antonello da Messina before travelling in the Marches and being introduced to the works of Melozzo da Forlì and Signorelli. These sharpened his understanding of perspectival construction and precise presentation of human movement. His work in the Vatican (1509–1511), of which no traces remain, indicates early success which, however, did not endure. Although recognised while working in Bergamo from 1513 to 1525, his lack of success in Venice caused him to retire to the Marches in 1549. In his religious works Lotto abandoned traditional patterns of composition. He was also an outstanding portraitist.

Illustrations:

158 Portrait of a Young Man, c. 1506–1508

179 Portrait of a Lady as Lucretia, c. 1530

LOUIS Morris

(Morris Louis Bernstein) 1912 Baltimore - 1962 Washington Louis studied from 1927 to 1932 at the Maryland Institute of Fine and Applied Arts. Between 1936 and 1943 he lived in New York, then in Baltimore until settling in Washington in 1952. Initially, he was totally under the influence of abstract Expressionism, and it was not until 1957, liberated by the destruction of over 300 pictures, that he developed his purely colouristic style and became an important personality in American painting. He worked on four large series: Veils (1954-1959), Blossoms (1959/60), Unfurleds (1960) and Stripes (1961/62). He saturated unprimed canvases with thinned-down acrylic paint, occasionally using a stick to direct the stream of paint. As the colours were absorbed into the canvas, a soft fusion was created. His friendship with Noland from 1952 had a reciprocal influence on their work. They both taught at the Washington Workshop Center of the Arts.

Illustration:

650 The Third Element, 1965

LUDWIG PSALTER → Workshop

LÜPERTZ Markus

born 1941 Liberec (Reichenberg, Bohemia) From 1956 to 1961 Lüpertz studied at the Krefeld College of Applied Arts and at the Düsseldorf Academy. In 1963 he moved to Berlin. In opposition to all contemporary abstract trends, he began to paint simple, representational pictures in the Expressionist manner. From 1966 he called his style "dithyrambic", after the ancient Greek choral hymn in honour of Dionysus, the god of fertility. His pictures, intended to express the beauty of even ordinary everyday objects, were to be comparable to poetry. From 1969 to 1977 he produced a series of "motif" pictures, aking to still lifes compositions which consist of combinations of objects symbolising the past, such as steel helmets, shovels and flags. His "style" pictures from 1977, in which he used abstract ideas of the 1950s, were again replaced by more objective subjects in the

late 1980s and 1990s. He also produces monumental polychrome bronze figures. În 1976 Lüpitz was appointed professor at the Karlsruhe Academy of Fine Arts, and since 1986 he has been teaching at the Düsseldorf Academy, becoming its rector in то88

Illustration:

674 Babylon-dithyrambic VI, 1975

MABUSE → Gossaert

MACKE August

1887 Meschede (Sauerland) - 1914 Perthes-les-Hurlus (Champagne)

While studying at the Düsseldorf Academy, Macke designed stage sets for Louise Dumont, the director of the city's theatre. In 1907 he went to Paris for the first time where he was introduced to French Impressionism and Gauguin. In 1907/08 he studied under Corinth in Berlin. He met Marc in 1909, and contact was established with the New Artists' Association Munich. Macke worked on the Almanac, and on the Blauer Reiter exhibition at the Galerie Thannhauser in Munich, and in 1912 was one of the organisers of the Sonderbund exhibition in Cologne. He went once more to Paris, accompanied by Marc, to visit Apollinaire and Delaunay. He became the German Orphist, with his carefree, brightly coloured paintings in prismaic structure. In the spring of 1914 he travelled to Tunis with Moilliet and Klee for a brief but most fruitful time: his brilliant, clearly arranged water-colours executed there became the highlight of his work. A few weeks after the outbreak of war he was killed in action.

587 Girls among Trees, 1914

MADONNA OF EICHHORN → Master

MADONNA OF NEUHAUS → Master

MADONNA OF ST VEIT → Master

MAGNASCO Alessandro

(called: Il Lissandrino)

1677 Genoa – 1749 Genoa

Magnasco was trained in Milan in the workshop of the Venetian painter F. Abbiati. Starting off as a portrait painter, he soon discovered his true, lifelong theme: landscapes peopled with mysterious, often sinister figures. In 1703 he returned to Genoa, travelled in Emilia and became a court painter at Florence. He worked again in Florence from 1711 to 1735, then finally settled in Genoa. Various strands affected his development. Apart from the Genoan tradition, there are Lombardian traces of Morazzone and Crespi, which he owed to his training. The 17th century Neapolitan "macchia" manner - a spontaneous, patchy method of painting with a penchant for small, genre-like figures - also seems to have influenced his work. His monastic scenes, rendered in browns applied in impasto, were his favourite subject, together with religious and mythological themes. This points to a close affinity to Jacques Callot. Illustrations:

368 Seascape with Fishermen and Bathers,

The Wise Raven, c. 1703-1711

MAGRITTE René

1898 Lessines (Hennegau) - 1967 Brussels After the family had moved to Brussels, Magritte attended there the Académie des Beaux-Arts from 1916 to 1919. He met the Constructivist Victor Servranckx and began to paint abstract geometric pictures, supporting himself by designing posters and advertisements. In 1924 he saw a reproduction of Giorgio de Chirico's "Le chant d'amour" which made a deep impression and caused him to change direction. He founded a group whose aims resembled those of the Paris Surrealists. In 1927 he moved to Perreux-sur-Marne near Paris, living in close contact with Paul Eluard and André Breton. Magritte occupies a special place within the Surrealist movement. He did not experiment, nor did he adopt new techniques. His style was conventional in that he attempted to express comprehensible ideas and perceptions. In 1930 he returned to Brussels, and from then onwards was represented at all Surrealist exhibitions.

Illustrations:

611 The Menaced Assassin, 1927

611 Palace of Curtains III, c. 1928/29

MALEVICH Kasimir

1878 Kiev – 1935 Leningrad In 1895 Malevich began to study at the Kiev academy. From 1900 he lived in Moscow, where he met Larionov and Gontscharova. In 1910 he took part in the first exhibition of the Jack of Diamonds group of artists. In the following years he passed through phases of Symbolism, Fauvism, Cubism and Futurism, while developing his own style. He reached an important point in his career with the design of scenery in 1913 for the Futuristic opera "The Triumph over the Sun", using abstract, geometrical shapes. At the last Futurist exhibition in Petrograd in 1915 he showed his Supremacist compositions, including the famous picture "Black Square on White Ground" (St Petersburg, Russian Museum).

In 1916 in his paper From Cubism and Futurism to Supremacism he made a plea for the necessity of abstract art. After the October Revolution in 1917 he taught at the Moscow State Art School. From 1919 he was involved in the establishment of modern art schools in Witebsk and from 1922 in Petrograd, where he worked with his pupils on the plastic transposition of his ideas. With the "new economic policy" in 1921 began the attacks on the "new art". At the exhibition "15 Years of Soviet Art" in 1932 the works of the "revolutionary artists", including those of Malevich, hung in a separate room - as a warning.

Illustrations:

Suprematist Painting, 1916 553

Suprematist Composition, 593 c. 1914–1916

Knife-Grinder, 1912

MALOUEL Jean

(Jan Maelwael)

documented 1397 in Paris, died 1415 Dijon Malouel came from the Dutch province of Geldern. In 1397 he was recorded as a painter to the French Queen. A year later he became court painter to the Dukes of Burgundy in Dijon. He supervised the decoration of the Carthusian monastery of Champmol and was commissioned to paint five altarpieces. He also designed the decorations for court festivities. Malouel, alongside Bellechose, is regarded as one of the outstanding exponents of the International Gothic style in Burgundy. The two paintings attributed to him, "Madonna with Angels and Butterflies" (Berlin, Gemäldegalerie, c. 1410) and "Pietà" (ill. p. 66) stand out for their skilled composition, plasticity of figures and sensitive handling of colour.

Pietà (La grande Pietà ronde), c. 1400

MANET Édouard

1832 Paris - 1883 Paris

Manet came from a well-to-do background. He came to painting by an indirect route. First he studied law, and then went to naval college, before taking up an artist's career. In 1855 he began six years of study under Couture at the Paris Académie des Beaux-Arts. He devoted much time to copying the old masters in the Louvre, and completed his training by making a number of study tours of Italy, Holland, Germany and Spain. The works of Velázquez and particularly Goya helped form his outlook. Therefore in his early work he often chose Spanish subjects and those of other old masters, giving them his own stamp, however. Initially he gained acceptance at Salon exhibitions with his almost conventional choice of colours and themes, but his famous "Déjeuner sur l'herbe" (ill. p. 491) was rejected and caused a scandal because of the presence of a completely naked female model sitting among clothed men.

Although a contemporary and friend of the Impressionists, whose work he admired, he did not follow the aims of pure Impressionism in his own painting. However, when painting in the open, elements of this style can be detected in his work. To him, colours were the supreme device, and in his art he explored their tonal values, limiting himself to a small range of colours, and sometimes contrasting them. As with Degas, his themes were contemporary Paris life, but Manet also portrayed political events, such as the "Execution of Maximilian" (Mannheim, Kunsthalle). Serene interior scenes and the depiction of familiar surroundings and friends occur frequently. He painted portraits of his friend Morisot, of his wife, and of the writers Zola and Mallarmé, and also of politicians and art patrons, including Georges Clemenceau and Antonin Proust. With great skill he captured the peaceful atmosphere in country scenes or by the sea, or cheerful moments in Paris cafés or at the races, making no emotional statements, but using colour tones for expression. His delicate handling of tones is most apparent in his still lifes. Zola, Mallarmé and Baudelaire admired him and paid tribute to his art. In 1881 he was made a member of the Legion of Honour.

Illustrations:

- 485 A Bar at the Folies-Bergère, 1881/82
- 491 Déjeuner sur l'herbe, 1863
- 491 Portrait of Émile Zola, 1868
- 492 Luncheon in the Studio, 1868
- 492 Argenteuil (The Boating Party), 1874
- 493 The Balcony, c. 1868/69

$MAN RAY \rightarrow Ray$

MANTEGNA Andrea

1431 Isola di Carturo (near Padua) – 1506 Mantua Together with Giovanni Bellini, albeit with different artistic aims, Mantegna was largely responsible for spreading the ideas of Early Renaissance painting in northern Italy. He studied in Padua under Francesco Squarcione, who also collected and sold antiquities and coins, thus introducing his pupil to this field. But most important for Mantegna's artistic development was the sculptor Donatello, who from 1443 created the high altar for San Antonio in Padua. From him he learned how to paint anatomically correct figures, how to achieve precision when tracing details, and not least how to compose a picture with accurate perspective. By 1448 the young painter showed himself almost independent in style when decorating the Ovetary Chapel of the Eremitani Church in Padua (most of it destroyed in World War II). In 1460 Mantegna became court painter to the Gonzaga family in Mantua. There he painted the frescos of the Camera degli Sposi in the Castello, whose illusionistic ceiling painting and other elements point forward to the structural problems of Mannerism and the Baroque (ill. p. 115). In about 1490 he began to produce engravings of great artistic and technical perfection which contributed greatly to the dissemination of Early Renaissance innovations north of the Alps.

Illustrations:

- 85 Portrait of Cardinal Ludovico Trevisano, c. 1459/60
- 114 Agony in the Garden, c. 1460
- 114 Dead Christ, c. 1480
- The Gonzaga Family and Retinue, finished 1474

MANUEL Niklaus

(called: Deutsch)

c. 1484 Berne – 1530 Berne

Equally talented as painter, draughtsman and woodcarver, Manuel was also a statesman, reformer and poet. He was probably trained as a glass painter. His early works, documented from about 1515, point to the tradition of late Gothic, Swiss painting. Manuel later developed in the direction of the Danube School, with strong, atmospheric emphasis on landscape and lively movement of figures ("Death as Mercenary Soldier Embracing a Girl", "Bathsheba in the Bath", Berne, Kunstmuseum, both 1517). Sudden foreshortenings also show the Mannerist influence. His later works deal mainly with secular subjects. Like all artists of his generation, Manuel was deeply interested in political and religious affairs of the day. In 1516 he joined the French army during the Lombardic war. From 1518 he travelled on political missions and became one of the principal representatives of the Swiss Reforma-

Illustration:

198 The Judgment of Paris, c. 1517/18

MARC Franz

1880 Munich - 1916 Verdun After studying theology and philology, Marc turned to painting in 1900 and studied art at the Munich Academy. After a lengthy visit to Brittany and Paris and to the Athos monasteries in Greece, he returned to the mountains of Upper Bavaria and also to his studio in Munich in 1905. In the same year Marc found a theme of his own: the animal. In 1909 he moved to Sindelsdorf in Upper Bavaria. A year later he met Kandinsky, Jawlensky and Marianne von Werefkin, became friends with Macke, and soon his first "blue horses" appeared. The colour was meant to depict basic essence, not actual appearance. Together with Kandinsky he organised the two Blauer Reiter exhibitions in 1911/12 and published the Almanac of the same name. With Macke he visited Delaunay in Paris in 1912. From then on, his classical animal pictures took the form of crystalline divisions. Colour, form and movement became a unity, serving at the same time as a symbol of his view of the world: the unison of all creatures with Creation. Illustration:

587 Tyrol, c. 1913/14

MARQUET Albert 1875 Bordeaux – 1947 Paris

In 1890 Marquet began his studies at the Ecole des Beaux-Arts in Paris, where he met Matisse who became his life-long friend. In 1897 he studied under Gustave Moreau. In order to support himself, he worked with Matisse on the decorations of the Grand Palais of the World Exhibition of 1900. At the 1905 exhibition of the Salon d'Automne his pictures were shown alongside those of Matisse, Derain and Vlaminck, and these caused the critic Louis Vauxcelles to coin the description Fauves. Marquet's name became known, and he travelled widely, visiting Saint-Tropez and Normandy, Hamburg, Naples, Munich, Morocco, Holland and Algeria. He also went to Egypt, Rumania, Russia and Scandinavia. He always came back to Paris, and finally settled there in 1945. His works reflect his many experiences. His technique was to apply colour sparingly, in muted tones of grey and green, setting few accents.

Illustration:

562 The Beach at Fécamp, 1906

MARTINI → Simone Martini

MARTYROLOGY OF GERONA → Workshop

MASACCIO

(Tommaso di Ser Giovanni di Simone Guidi Cassai)

1401 San Giovanni Valdarno (Arezzo) – 1428 Rome

Masaccio is considered the greatest master of Italian Early Renaissance painting. Within a time span of about five years he practically formulated the programme for future generations. Little is known about his training. Decisive for his development were the great Florentine sculptors Donatello and Nanni di Banco, and he also explored the early works of Brunelleschi. In the field of painting the only adequate comparison possible is with Giotto: over a period of about a century, Masaccio was the only painter whose work ranked with that of Giotto, in that Masaccio used all painterly devices at his disposal to convey genuine human feeling. In 1422 he was appointed master of the Florentine guild. From 1424 he worked with Masolino on the decoration of the Brancacci Chapel in the Carmine in Florence (ill. p. 93 ff.), creating a little later the great fresco of the Holy Trinity in Santa Maria Novella (ill. p. 93). With these works he achieved the high point of his artistic creativity, showing absolute assurance in the use of the perspective system together with the ability to suggest the mass and volume of objects in the round. Architecture and landscape appear natural but do not serve as ends in themselves. As in the works of Giotto, they are used to heighten the central scene, further emphasised by a completely novel handling of light and shade. Illustrations:

- 82 Adoration of the Magi, 1426
- 93 The Trinity, 1425/26
- 93 St Peter distributes the Goods of the Community and The Death of Ananias, c. 1426/27
- 94 The Tribute-Money, 1426/27

MASO DI BANCO

active in Florence 1320 – 1350
As a master painter Maso worked under Giotto on the great frescos in the Castel Nuovo at Naples, commissioned by King Robert d'Anjou. With Taddeo Gaddi, Maso is one of the most important pupils of Giotto known to us. He is noted for his strict spatial compositions. Between 1340 and 1350, Florence went through a crisis, suffering under a famine and economic and political upheaval. According to records, Maso di Banco was adversely affected by all this.

St Sylvester Sealing the Dragon's Mouth,

between 1340 and 1350

MASSON André

1896 Balagny-sur-Thérain (Oise) - 1987 Paris After studies at the Brussels academy, Masson went on the advice of Émile Verhaeren to Paris in 1912. He was called up in 1914 and, severely wounded, and had to spend some time in a sanatorium. In 1922 he returned to Paris, joining the Surrealists gathered around Breton in 1924. He belonged to the group until 1929 and then again from 1937. Masson developed a method of automatic drawing which came close to the Surrealist concept of uncontrolled thought processes and which he later applied to his linear paintings. From 1934 to 1936 he lived in Catalonia, returning to Paris in 1937. From 1941 to 1945 he lived in New York and Connecticut. After the war he lived again in Paris and Aix-en-Provence. Masson illustrated a number of books and developed new graphic printing techniques. Illustration:

605 Meditation on an Oak Leaf, 1942

MASSYS Quentin

(also: Matsys, Metsys)

c. 1465/66 Leuven – 1530 Antwerp Massys probably received his training in Leuven under the influence of Bouts. His work remained rooted in Netherlandish art, but he adopted elements of the Italian Renaissance to which he must have been introduced indirectly. Little is know about his early work. His "Anna Altar" (Brussels, Musées Royaux, 1507-1509) shows his fully developed style. Elements of van der Weyden and the use of new insights into figure and space representation are combined in his "St John Altar" (Antwerp, Koninklijk Museum voor Schone Kunsten, 1508–1511). For Massys, the figure, often monumentalised, formed the central point of his work. Hence his talent for portraiture, which he sometimes used as the starting point in his genre paintings (ill. p. 200). Illustrations:

The Money-Changer and his Wife, 1514
Portrait of a Canon, c. 1510–1520 (?)

MASTER OF THE ANTWERP POLYPTYCH

active about 1400 in southern Holland and on the Lower Rhine

Stylistic and iconographic details suggest that the painter of these six small panels lived in the region of Aachen around 1400. Some of them are now in the Walters Art Gallery in Baltimore and the rest are in the Museum Meyer van den Bergh in Antwerp. The work probably comes from the Champmol monastery near Dijon; its construction is very much like the Orsini polyptych by Simone Martini (ill. p. 36). The centre piece consists of two pictures, the Nativity and the Crucifixion; on the left we see the Annunciation, and on the right the Resurrection. The backs of the outer pieces show (without a gold background) the Baptism of Christ and a picture of St Christopher. *Illustration:*

MASTER OF THE BERLIN NATIVITY

60 Nativity, c. 1400

active c. 1330–1340 in southern Germany Because of its resemblance to the manuscript clm 17005 dating from the years 1330–1340 in the Bavarian Staatsbibliothek (state library), Munich, it is possible to date and place the Berlin picture fairly accurately. The manuscript was given by the Emperor Ludwig the Bavarian to the Schäftlarn monastery, south of Munich. The painter probably worked in Munich, possibly also in Nuremberg, as the Heilsbronn altarpiece from c. 1346 is in the same tradition. Other works from his circle can be seen at the Bavarian Nationalmuseum, Munich. The

painter had direct knowledge of Italian art. In form and coloration, but also in the way of embossing and applying the gold ground, he came particularly close to Florentine art. He also seems to have been familiar with Sienese painting.

Illustration:

44 Nativity, c. 1330-1340

MASTER OF THE EICHHORN MADONNA

active c. 1350 in Prague

Named after the Madonna panel which came from Eichhorn castle in Moravia, but probably originating in Prague. No other work of this master survives. In terms of motifs, there is an affinity with the Master of Hohenfurth, but he surpasses the latter's work. If there had been a connection at all, it could only have been a master-pupil relationship between Eichhorn and Hohenfurth. The picture seems to be an early work, taking into account the desire of Emperor Charles IV for greater dignity and monumentality in works of art.

45 Eichhorn Madonna (from Eichhorn, Moravia),c. 1350

MASTER FRANCKE

c. 1380 Hamburg (?) - c. 1436 Hamburg Francke (documented 1424-1436) seems to have come from a family of shoemakers who had moved to Hamburg from Zutphen in Geldern. His probable date of birth was about 1380, as he was several years younger than Konrad von Soest, who was one of his masters. Francke entered the Dominican monastery of St John in Hamburg, where he worked as a painter. He probably did not have a large workshop, but even as a monk his freedom of movement was barely restricted, and he probably gained extensive knowledge of Western art through travelling. He was highly regarded by the Hamburg merchants who supplied him liberally with commissions, and he even produced work for Reval and for the See of Münster. His influence was great and continued well into the 1460s. Unfortunately, the major part of his work was destroyed in the iconoclasm of the Reformation

Illustration:

75 The Miracle of the Wall, 1414

MASTER OF GUILLAUME DE MACHAUT

active c. 1350-1355 in Paris

This illuminator's work, which was discovered and dated by François Avril, comprises several manuscripts mainly produced for the court. He is called after the most important of these, the collected works of Guillaume de Machaut who, although a theologian, wrote courtly literature. His main subject was courtly love, allegorically veiled with many adorning and erotic elements, and presented in the over-refined manner of courtly life of about 1340. This style of writing ran parallel to contemporary tastes in art. It also reflected that fashion in dress, which was designed to emphasise the rounded contours of the body, using rich materials with a wealth of adornments, such as flounces, frills and ribbons. In painting, nature was beginning to find a place, but in a most artificial manner. The Master of Guillaume de Machaut succeeded in producing in his large workshop a fantasy world that met the demands of contemporary taste.

The Tale of the Lion: The Secret Garden, c. 1350–1355

MASTER OF HOHENFURTH

active c. 1350 in Bohemia The master is named after a series of nine panels from the Cistercian monastery of Hohenfurth in southern Bohemia, now at the Národni Galeri in Prague. As G. Schmidt rightly stated, this not very significant artist combined elements of varying origins and traditions and used a variety of motifs without much originality. This may explain the heterogeneity of the works.

44 The Agony in the Garden, c. 1350

MASTER OF THE KAUFMANN CRUCIFIXION

active c. 1340 in Prague

Of this important master only this one panel from the Kaufmann collection survives (now Berlin, Gemäldegalerie). This painting is doubly precious as it proves the excellence of Bohemian panel painting in central Europe around 1330-1340, and that already several significant painters were active in Prague at the beginning of the reign of Charles IV, including the masters of the Glatzer Madonna and the Boston Death of Mary. Although the work still cannot be placed with full authority, it contains two motifs used by the Master of Hohenfurth (ill. p. 44), and also its underpainting and flesh colour as well as choice of colours and method of application, all are similar to that only found in contemporary Bohemian painting. The Master of the Kaufmann Crucifixion was familiar with the new insights of Italian art, but he showed no preference for a particular painter or school, and he certainly was no imitator. He seems to have delighted in strange head-dress, some of which are clearly the product of his own imagination. His artistic achievement lies in his creation of stark contrasts, so unlike the homogeneous opposites in Italian concepts. Expressiveness and ideality, the beautiful and the ugly, are placed side by side. Illustration:

The Crucifixion, c. 1340

MASTER OF THE LONDON THRONE OF GRACE

active c. 1420–1440 in Austria
Named after a painting of the Throne of Grace at
the National Gallery, London, probably originating
in Styria. This master belonged to the same group
of painters as the Master of the Offerings. Whether
they worked wholly in Vienna and surroundings or
in Styria is not yet clear. Nor could be established
satisfactorily whether the little panel from St Lambrecht was, in fact, the work of the Master of the
London Throne of Grace. This panel shows in terms
of coloration the influence both of Bohemian and
Franco-Flemish art. The dating of it of "around
1420" is the result of a hypothetical identification
by the Benedictine monks of St Lambrecht.

Illustration:

73 Madonna, c. 1420

MASTER OF MOULINS

(Jean Hay or Hey)

active c. 1480- after 1504

A French painter and miniaturist of Dutch origin, he was named after a triptych in the cathedral of Moulins. The portraits on the altarpiece of the patrons Duke Peter II of Bourbon and his wife Anna would indicate that the painter worked in court circles, and from about 1483 in the province of Bourbonnais. In contrast to the somewhat older Fouquet, the Master of Moulins rejected a worldly approach. To the number of late 15th century panel paintings grouped around the triptych also belong, amongst others, "Charles II of Bourbon, Cardinal Archbishop of Lyon" (Munich, Alte Pinakothek), "Joachim and Anna Meeting at the Golden Gate" (London, National Gallery, 1500) and "St Mauritius

with Patron" (Glasgow, Art Gallery and Museum, c. 1500). It cannot be accepted that the Master of Moulins was identical with Jean Perréal, who worked for the Bourbons about 1500 and subsequently for the French royal court until his death in 1529. Instead, it now seems certain that he was the Dutch painter Jean Hay (or Hey). His oil tempera technique shows Dutch influences, as does his emphasis on sumptuous detail, while the clarity of composition indicates a knowledge of Italian art. The reticence of expression and discipline of construction anticipate "classicist" tendencies, which were to determine French painting in the 16th and particularly in the 17th centuries. Illustrations:

- The Virgin in Glory, surrounded by Angels, c. 1489-1499
- The Nativity of Cardinal Jean Rolin, c. 1480

MASTER OF THE NEUHAUS MADONNA

active c. 1400 in Prague

It is not certain whether the painting was destined for Neuhaus. This was probably one of those pictures which were painted in Prague studios and stored in readiness to be acquired by visitors to the city. There is, however, a fresco of a Madonna of the same type in the Minorite church at Neuhaus, albeit from a later date, which might be significant in terms of provenance. The work itself is in bad condition, the upper part having been restored. There is a stylistic similarity with the book illuminations of the missal dated 1409 of the Prague Archbishop Sbinko von Hasenburg (in Vienna).

Illustration:

71 Madonna, c. 1400

MASTER OF THE OFFERINGS

active c. 1420-1435 in Austria

This is the tentative name for a number of pictures which, according to G. Schmidt, should be subdivided. This convinces on close scrutiny. The artists were certainly Austrian, and were active in and around Vienna, probably also in Styria, around the time 1420-1440. They were partly influenced by the paintings of the Bohemian Master of Wittingau, but also by Italian painting of the 14th century, as well as Western tendencies, such as the Limburg brothers (note the execution of dress). The workshop produced a great number of drawings, not so much in the sense of the Italian sketch but rather in the manner of a pattern book. Very possibly a group of painters worked here under a master around 1420. They followed and varied his style, but always repeated the same type of picture and individual motifs. Their influence was noticeable as far as Regensburg and central Franconia. The panel shown here probably belongs to one of the earliest and best works.

Christ at the Foot of the Cross with Mary and John, c. 1420

MASTER OF THE PARADISE GARDEN

active c. 1410-1430 on the Upper Rhine Because of iconoclasm and periods of war in the Upper Rhine region much of the work was destroyed, but remaining examples show that the art of this region exercised a great influence during the 14th and 15th centuries. During the first part of the 15th century the Councils of Constance and Basle would have had a stimulating effect on art production. Because of its affinity to other local works, such as the Strawberry Madonna at Solothurn, the Frankfurt Paradise Garden is undoubtedly a work of Upper Rhenish art, but it cannot be stated with authority whether it was

painted at Strasbourg, Basle, Constance or elsewhere. The Crucifixion panel at the Colmar Museum gives some indication as to its style. This panel dates from 1410 and was painted by a painter trained at the Bruges school, as the study of illuminations carried out there demonstrates. This explains the closeness of some of the motifs used in the Paradise Garden to the early works of the van Eyck brothers. Illustration:

74 Garden of Paradise (Virgin in Hortus conclusus with Saints), c. 1410

MASTER OF THE PÄHL ALTAR

active c. 1400 in Prague

The provenance of the altar retable from Pähl castle on the Ammersee, which belonged to the Augsburg bishops, is still posing problems because it seems very unlikely that it was painted for this chapel, dedicated to St George. All attempts to trace its origins to Salzburg or Augsburg have failed. In terms of motif and composition it is undoubtedly Bohemian; there are elements which point back to Master Theoderich or the Master of Wittingau. This allows it to be placed in Prague around 1400. This master's art aimed less at invention than at the modification of old motifs. Dress, gestures and heads are typified but at the same time refined, a process analogous to French art of about 1300. Great importance is attached to subtle colour toning and clever surface effects. These were works which appealed to a circle of buyers less interested in thematic innovation than in aesthetic refinement.

Illustration:

The Crucifixion of Christ between John the Baptist and St Barbara, c. 1400

MASTER OF THE RAIGERN ROAD TO CALVARY

active c. 1415–1430 in southern Moravia The master is named after a group of picture panels which came from the Benedictine monastery at Raigern. There is no certainty, however, that they were specifically created for the monastery. Most of his surviving works come from Moravia, the eastern part of what is now the Czech Republic. This, in turn, does not mean that they were painted there: other, similar works were produced in Prague. Besides, it is certain that in terms of motif the Prague school, perhaps that of the Master of Wittingau, served as their example. There is also some affinity to the early works of the illumination workshops and the Martyrdom of Gerona (ill. p. 72), which is another argument in favour of Prague. The painter seems to have sympathised with Hussite reform without breaking entirely with the old church; at least he painted subjects, such as the legends of saints, which do not correspond with

Illustration:

72 The Road to Calvary, c. 1415–1420

MASTER OF THE ROHAN BOOK OF HOURS

documented c. 1420–1430 in Paris The master was named after a book of hours in the Bibliothèque Nationale in Paris, formerly in the possession of the Rohan family. But it was produced for Jolanthe of Aragon, of the French house of Anjou. She also owned the Belles Heures and the Très Riches Heures of the Duc de Berry, on whose death in 1416 they had come down to her. The master was therefore able to study them there, as well as the many illuminated manuscripts produced for the family in Italy, mostly in Naples. In this book of hours only very few pictures are by the master's own hand, either in the preliminary drawing or comple-

tion. This was generally the case with manuscripts created for the nobility. He was probably a panel painter (at the Laon museum are kept some from his workshop) who carried out book illumination as a sideline. He was not a model court painter, belonging to the generation of the Bohemian Hussite painters, producing unlovely, inelegant work, with a dislike of all decoration. Not without reason did he become the first painter to specialise in the theme of death.

Illustration:

65 Lamentation, c. 1420–1427

MASTER THEODERICH

active from 1359, died c. 1381

In 1359 there was mention of a property owned by Theoderich, court painter to the emperor. He was later entitled "familiaris" in the court records, suggesting that he was a court painter in only a limited sense. In 1367 he received tax exemption for an estate at Morin, at the foot of Karlstein castle, which formerly probably belonged to his predecessor at the court, the Strasbourg painter Nikolaus Wurmser. The exemption was granted for Theoderich's "artistic and solemn paintings" for the chapel which were "innovative" (also in the technical sense). These words from the emperor's own lips were praise indeed. Yet nothing is known about the master's origins and artistic training. His starting point was Bohemian and Italian art, with some elements of north German art. This can be seen especially in the sculpture of the Parler-Hütte, which incorporates the style of 13th century heftiness with a monumental heaviness. It appears that Theoderich met his patron's taste absolutely with his backward-looking monumentality and the integration of various tendencies, including Italian, western and Byzantine elements. Between 1355 and 1375 Bohemian art was entirely under his domination.

Illustrations:

St Gregory, c. 1360–1365

The Crucifixion, c. 1370 68 St Jerome, c. 1360–1365

MASTER OF TREBON active c. 1380–1390 in Bohemia Nothing is known about this master. He was named after his principal work, the altarpiece in the Augustinian canonical church at Wittingau in southern Bohemia. The high altar was consecrated in 1378, so the work was then already completed or perhaps very soon afterwards. The Jérén epitaph, modelled on Wittingau's art, was completed in 1395, setting the upper limit on the date of the altarpiece. The work carried out at Wittingau coincided with the monastic reforms instituted by the emperor. It is therefore presumed that the master's workshop was in the capital city rather than in southern Bohemia. A Madonna panel from his workshop discovered in Raudnitz north of Prague seems to confirm this. The reconstruction of the altarpiece still presents problems. It can be assumed that the two panels shown are from the so-called "workingday side" of the retable as the painter used as reddish ground instead of gold.

In this work the master made use of assistants. It is certain that he had a large workshop and was very influential. We can only speculate about his artistic origins; Italian elements are entirely lacking in his work, while the influence of early Bohemian art is detectable. For example, the motif for the soldier on the left in the Resurrection is taken from the Master of the Madonna of Eichhorn (ill., p. 45), and his handling of light can be traced to Master Theoderich. It is possible that the Wittingau master received inspiration from Franco-Flemish panel painting, but of this nothing survives except for the

works of Broederlam which belong to a somewhat later period. The Master of Wittingau was an innovator with regard to contextual and formal representation, and his excellence as a colorist made him the outstanding artist in central Europe between 1350 and 1400.

Illustrations:

69 The Agony in the Garden, c. 1380-1390

69 The Resurrection, c. 1380–1390

MASTER OF ST VERONICA

active c. 1400-1420 in Cologne

This master, whose work was typical of Cologne art of about 1400–1420, is named after the Munich painting. Due to the fact that his style was typical of many Cologne artists of the time and also because Cologne had its own traditional school of painting, and this master greatly influenced other contemporary painters, it is difficult to attribute and date individual panels with any authority. In the course of secularisation all historical sources were lost, none of his works is dated, nor can patrons be established with accuracy.

Illustration:

74 St Veronica with the Sudarium, c. 1420

MASTER OF THE ST VITUS MADONNA

active c. 1390-1400 in Prague

The only surviving work of this painter of the late 14th century is the panel in St Vitus cathedral, Prague. It is not known whether it was destined for the cathedral or whether it actually depicts one of the bishops. The mitre could signify a canon of Prague cathedral or even one of the Benedictine or Cistercian abbots of Bohemia. The saints shown around the frame, namely Wenceslaus, Vitus, Sigismund, Adalbert and Procopius, are all patron saints of Prague cathedral, but at the same time also major saints of Bohemia. Of the stylistic factors which might suggest a date of origin, the small frame reliefs would date the panel clearly before 1400. Illustration:

71 Madonna, c. 1390–1400

MASTER OF THE WILTON DIPTYCH

active c. 1390-1395

The unknown master of the Wilton diptych was probably English and worked at the English court from about 1380 to 1395. He painted in the International Style and was given this name because his diptych was formerly housed at Wilton, the seat of the Earl of Pembroke. This is his only surviving work. It is outstanding in its delicate coloration, fine handling of line and precisely developed ornamentation.

Illustration:

67 The Wilton Diptych, c. 1395 (or later)

MATHIEU Georges

born 1921 Boulogne-sur-Mer (Pas-de-Calais) After going to school in Boulogne, Versailles and Rouen, Mathieu studied law and English. For a year he taught English at the Lycée de Douai, then French at the American University in Biarritz. A book by Edward Crankshaw about Joseph Conrad inspired him to paint. His first attempts in 1947 were abstract works. In turn he was influenced by Wols, Pollock and de Kooning, finding his own style in about 1948 and becoming one of the most important representatives of French Tachism. He became noted for his public appearances, at which he produced instant, improvised pictures, often applying the colour to the canvas straight from the tube - a method used in Action Painting. Since 1962 he also produced large sculptures and murals as well as designs for furniture and tapestries. In

1967 he designed a series of posters for Air France. He also produced theoretical works and organised group exhibitions.

Illustration:

637 The Decapitation of Olivier III, 1958

MATISSE Henri

1869 Le Cateau-Cambrésis – 1954 Nice Matisse studied law and worked in a solicitor's office in his home town. While recovering from an appendicectomy in 1890 he began to paint, moving to Paris in order to study art. Rejecting an academic training, he became a pupil of Moreau, like Rouault and Marquet. In the Louvre he copied the works of Poussin and Chardin, painting in their chiaroscuro manner. While staying in Brittany in 1896 he returned to Impressionist painting. In about 1900 he recognised the independent value of colour and the effect of its luminosity. He began to analyse the works of Cézanne, van Gogh and Gauguin in order to find a new synthesis. While with Signac at Saint-Tropez in 1904 he adopted this painter's pointillist manner. This he gradually abandoned, using longer brushstrokes which finally became areas of colour divided by darker outlines. His work "Luxe, calme et volupté" (Luxury, Peace and Voluptuousness), 1907, became a landmark of the Fauvist style inspired by him. In 1909 he painted the large pictures "Dance" (ill. p. 547) and "Music" (St Petersburg, Hermitage) for the Russian collector, Shtshukin.

Towards 1910 he adopted intensy brilliant coloration and simplified forms, lines and colour contrasts to a high degree, creating images of pure joy, unhampered by decorative and ornamental effects. In 1913 he visited Morocco. In the following years, up to 1917, his work temporarily tended towards Cubism. In 1918 he moved to Nice, and his style became looser and softer. From 1943 he lived at Vence near Nice. During this period he produced papiers découpés, stuck-together arrangements of cut-out shapes from painted-over paper. His late work lacked the serenity and ease which marked his former concern with perfection and harmony.

Illustrations:

547 Dance (La Danse), 1910

565 Dance (La Danse, first version), 1909

565 The Piano Lesson, 1916

566 The Green Stripe (Madame Matisse), 1905

566 Odalisque with Red Trousers, 1921

Decorative Figure on an Ornamental Background, c. 1925/26

MATTA Roberto

(Roberto Sebastián Antonio Matta Echaurren) born 1911 Santiago de Chile

Matta studied architecture until 1932, then went to work with Le Corbusier in Paris from 1934 to 1935. He met Picasso and observed the progress of his work on "Guernica", and travelled around Europe and the Soviet Union. His first pictures in the Surrealist manner date from about 1937. Two years later he went to New York, joining the Surrealists and becoming greatly influential in the New York art scene, with his abstract works comprising all the elements of psychic automatism. His contribution to abstract Expressionism was significant, and he greatly influenced Gorky and Motherwell. With the latter he worked and visited Mexico. In 1948 he returned to Europe, living in Rome from 1949 to 1954, then in Paris and Tarquinia (Italy). During the 1960s and 1970s he was involved in the peace movement and travelled several times to Cuba. He painted a number of large murals, including those at the University of Santiago de Chile and the UNESCO building in Paris. Illustration:

629 Le Vertige d'Eros, 1944

MAULBERTSCH Franz Anton

(also: Maulpertsch)

1724 Langenargen (Lake Constance) – 1796 Vienna After an unremarkable apprenticeship Maulbertsch studied at the Vienna Academy. He was particularly impressed by the frescos of Paul Troger. This influence can be seen in, for example, his work in the Piarist Church in Vienna (completed 1753). There are also Venetian influences (Piazzetta) in his work, and these he used to arrive at his very specific and personal style. Troger's chiaroscuro reappears in mysteriously glowing colours, conveying a hazy atmosphere. In addition to his large and varied productions on walls and ceilings, Maulbertsch also made sketches in oil, and these became works of art in their own right. In the second half of his life Maulbertsch showed an amazing adaptibility to the Classicist movement without abandoning his Rococo origins entirely. His 1794 ceiling fresco in the Strahov monastery library could be called a counterpart of Mengs' Parnassus in the Villa Albani. Illustration:

394 Adoration of the Virgin, 1757

MELÉNDEZ Luis Eugenio

(also: Menéndez)

1716 Naples – 1780 Madrid

Meléndez received early instruction from his father, a well-known painter of miniatures who worked for the Spanish court. His self-portrait of 1746 (Paris, Louvre) shows his outstanding ability as a portrait painter. After visiting Rome and Naples he worked for King Charles III of Spain. Apart from religious works, he was particularly noted for his still lifes. He painted 44 still life panels for the palace at Aranjuez, of which 39 are now kept at various European and American museums. Meléndez continued the Spanish still life tradition in terms of motif and in coloration, as represented by Sanchez Cotán and Zurbarán: simple pottery, fruits of the fields and gardens, and wooden kitchen utensils in unpretentious arrangements and in colours which stand back from the glow of muted accents.

Illustration:

396 Still Life with Melon and Pears, c. 1772

MELOZZO DA FORLÌ

1438 Forlì – 1494 Forlì

Melozzo came from an artistic family: his uncle was an architect, his brother a goldsmith and his brother-in-law a painter. He was trained in his home town by the painter Ansuino da Forlì, who introduced him to perspectival principles as developed by Mantegna and Piero della Francesca. He first worked in Forlì, then in the 1470s and early 1480s mostly in Rome, where he painted several frescos of which only fragments survive. Around 1475 and then again after 1480 he collaborated with Justus van Gent on the portraits of scholars and allegories of the "Liberal Arts" for the Palazzo Ducale in Urbino. In 1484 Melozzo returned to Forlì where he worked on frescos in the churches of Loreto and Forlì. His work is noted for its precise representation of character and mastery of perspective laws, which make him the precursor of illusionistic ceiling painting.

103 Sixtus IV; his Nephews, and his Librarian Platina, c. 1480

MEMLING Hans

(also: Memlinc or Hemling)

c. 1430–1440 Seligenstadt (Main) – 1494 Bruges After having long been regarded as the greatest Dutch painter of the late 15th century, Memling is now less admired. Little is known about his training and early work. Perhaps he was trained in Cologne or one of the workshops in the Rhine region, before moving to the Netherlands. In 1465 he is mentioned in Brussels; from 1466 he worked in Bruges. He was possibly a pupil of Rogier van der Weyden; in any case, Memling's earliest authenticated works were greatly influenced by him. He also drew on Bouts, as shown in his altarpiece of the Life of Mary, 1468 (London, National Gallery). However, he soon developed his own style which is characterised by the great charm of the figures in movement and expression, beautiful colours and narrative richness. Memling could be called the Dutch Gozzoli except that he did not achieve the latter's depth of expression and great skill in figure arrangement. His paintings form the sum of accurately observed and life-like details ("Scenes from the Life of Mary", Munich, Alte Pinakothek, 1480), but there is generally little personal development. His late work shows elements of the Early Italian Renaissance ("Madonna and Child", Florence, Uffizi).

Illustrations:

- The Martyrdom of St Ursula's Companions and The Martyrdom of St Ursula, consecrated 1489
- 131 Portrait of a Praying Man, c. 1480–1485

MENGS Anton Raphael

1728 Aussig (Bohemia) - 1779 Rome By giving him the Christian names of Corregio and Raphael, Mengs' father, a painter of miniature and director of the Dresden Academy, destined his son for a painting career. At the early age of 12 he copied Raphael's frescos in the Vatican. Mengs began his career in Dresden, where he became noted for his fine pastel portraits, and was appointed court painter in 1746. While in Rome he converted to Catholicism and received a professorship at the Capitolinist Academy. A turning point was his meeting with Winckelmann, with whom he developed the theoretical principles of Classicism. In 1762 his book Thoughts on Beauty and Taste in Painting appeared. He broke away from the Baroque manner of ceiling painting, using realistic perspectival principles in his ceiling painting at the Villa Albani, 1761. He accompanied Charles III of Spain via Sicily to Madrid, where he executed various paintings for the king and reorganised the royal academy, becoming an authority on matters of art. His classicist-eclectic doctrine ushered out the Rococo, as represented by Tiepolo, in Madrid. Illustration:

394 Allegory of History, c. 1772/73

MENZEL Adolph Friedrich Erdmann von 1815 Breslau – 1905 Berlin

The son of a teacher and lithographer, Menzel taught himself the art of engraving and painting. After the early death of his father in 1832, he had to support his family, which had moved to Berlin in 1830. His first success came with his illustrations for Kugler's Geschichte Friedrichs des Großen (The Life of Frederick the Great), 1838-1842. This gave Menzel his subject-matter. Subsequently he made a name for himself with his scenes depicting the life of Frederick the Great, such as the "Flute Concert at Sanssouci" of 1852 (Berlin, Nationalgalerie), becoming established as the painter of Prussian history. From then on he retained his connections with the house of Hohenzollern in Berlin, later also painting contemporary royal scenes, including the "Coronation of King William I at Königsberg on 18 October 1861" (Hanover, Niedersächsische Landesgalerie). In 1853 he became a member of the Prussian Academy of Arts, in 1856 he received a professorship, in 1883 he was made vice-chancellor of the Order "Pour le mérite"; and in 1898 he was ennobled.

Menzel was not only a masterly and tireless draughtsman, but also a brilliant painter of oilstudies made straight from nature. In this field he had no equal in Germany at the time. Beginning with members of his family and friends, he later added views from windows and country scenery. In his late period he often chose multi-figured scenes which are somewhat reminiscent of the works of the Impressionists in their directness of capturing a moment in time, but nevertheless distinct in their great range of colours, handling of light and careful preparation. His most important realistic work dating from this period was the "Iron Rolling Mill" (Berlin, Nationalgalerie) of 1875 showing industrial workers during production. Before painting it he made innumerable studies at the Königshütte works in Silesia. He was highly esteemed, and decorated by the court at Berlin. Illustrations:

458 The Berlin-Potsdam Railway, 1847

458 A Paris Day, 1869

459 The Artist's Sister, 1847

METSU Gabriel

(also: Metzu)

1629 Leiden – 1667 Amsterdam Metsu received early instruction from his parents who were both painters. Later he probably studied under Nicolaus Knüpfer in Utrecht, as did Steen. Initially he worked in Leiden, where he became a founding member of the Lukas Guild in 1648, but moved to Amsterdam in 1657. His early work comprised historical, biblical, mythological and allegorical works influenced by the Rembrandt school. After 1650 he concentrated on interiors and genre

scenes, depicting refined middle-class life in warm colours and soft outline. Under the influence of the Leiden fine manner he later paid great attention to detail, particularly rich fabrics, without becoming over-polished.

Illustration:

330 The King Drinks (Beanfeast), c. 1650–1655

MICHELANGELO BUONARROTI

(Michelagniolo di Ludovico di Lionardo di Buonarroti Simoni)

1475 Caprese (Tuscany) - 1564 Rome As western art's giant of sculpture, no equal can be found for Michelangelo except in classical art. His painting as well as his architectural design was always based on plastic concepts. Though intended by his father to be a scientist, the boy's passionately felt vocation for art soon put an end to any such plans. When aged thirteen, he was allowed to become an apprentice in the workshop of the painter Ghirlandaio, where he probably only learned basic skills. Michelangelo greatly admired Giotto and Masaccio, as his early drawings after their works testify. He might also have known the famous goldsmith and bronze caster Bertoldo di Giovanni. His first works, the bas-relief "Battle of Centaurs and Lapiths" and the "Madonna on the Staircase" (Florence, Casa Buonarroti) reveal the true sources of his plastic art: on the one hand Antiquity, and on the other the highly expressive works of Donatello. Lorenzo de' Medici, showing uncanny intuition for spotting artistic talent, accepted the promising youth to work in the school in the Medici garden which contained a collection of classical sculptures.

Michelangelo reinforced these early impressions while in Rome from 1496 to 1501. Here he created the "Pietà" for St Peter's, his only signed work. Returning to Florence, aged 25, he was next engaged on the colossal "David". In this work he fully realised his perception of the human figure born in the spirit of Antiquity, which filled his contempo-

raries with an uneasy reverence. Between 1501 and 1505 he also received his first painting commissions, including the only authenticated panel of the "Holy Family" (so-called "Doni-Tondo", ill. p. 167). The fresco "Battle of Cascina", of which detail drawings for the cartoon survive, was never executed. In 1505 Michelangelo was summoned to Rome by Pope Julius II to design his sepulchral monument – a gigantic venture which was thwarted by lack of finance and eventually by the Pope's death. Meanwhile the Pope had a new project in mind. In 1508 Julius asked Michelangelo to paint the ceiling of the Sistine Chapel (ill. p. 167 ff). Michelangelo had completed this monumental task by 1512, after having done the work in two stages and under great pressure. As a painter he had produced his masterpiece with its great interpretation of Genesis, the whole concept being conveyed by the human figure and gesture alone.

Michelangelo's subsequent works were also dominated by the human figure. In 1534 he finally settled in Rome. Required to paint the altar wall of the Sistine Chapel, he produced a second masterpiece, the "Last Judgement" (ill. p. 153), 1536-1541. He also painted the frescos for the Vatican's Capella Paolina of the "Martyrdom of St Peter" and the "Conversion of St Paul" (1542–1550). As distinct from all Last Judgement representations that had gone before, Michelangelo's rendering of the subject, which covers the entire altar wall (14.83 x 13.30), is a vision of the end of the human race in which the light of redemption cannot overcome the powers of darkness. With this work he overstepped the limits of contemporary religious understanding; his naked figures in particular were thought offensive. In 1559 the first alterations were made to it by Daniele da Volterra at the behest of Pope Paul IV; after that, the work was four more times overpainted. It remains in this state to this day.

In his later life Michelangelo devoted himself increasingly to architectural projects. In 1546 he directed the building of the Palazzo Farnese and began the new design of Capitol Square. A year later he was made chief architect of St Peter's. With his design for the dome he gave the Eternal City its distinctive landmark. But just as the painter in Michelangelo could never forget the born sculptor, neither could the architect: he did not create "rooms" in the ordinary sense, but "modelled" walls and surfaces.

As no artist before him, Michelangelo threw off the shackles of tradition, opening up entirely new worlds of artistic expressiveness. His work bears witness to his own lived-through experiences and sufferings, and no-one knew better from bitter experience what abandoning the rules meant. There were immense dangers in shaking off restrictions in order to broaden the scale of expression, even when upholding artistic tradition at the same time. With Michelangelo a new kind of artist was born, and he has had an enormous influence on artists ever since. Rubens, who during his 8 years in Italy studied Michelangelo with an intensity and devotion as no other, carried over many of his innovations into the Baroque.

Illustrations:

- Damned soul descending into Hell (detail from the Last Judgement), 1536–1541
- The Holy Family (Doni-Tondo), c. 1504/05
- 167 Delphic Sibyl, c. 1506–1509
- 168 The Creation of Adam, c. 1510

MICHELINO DA BESOZZO

(Michelino Molinari)

active 1388-1442

Michelino came from Pavia and is mentioned as a fresco painter in 1388, according to which he must have been born around 1370 at the latest. A contemporary source states that he could paint animals

excellently before learning to speak. His contemporary Alcherius, who in his capacity as artistic agent to the Duc de Berry met Michelino in 1410 in Venice, called him "the most outstanding of all painters in the world". Documents in connection with the building of Milan cathedral praise him as "pictor supremus", the greatest painter, and master of stained glass art. None of these works carried out for the cathedral, which was founded by Gian Galeazzo Visconti, survives, nor does any of his architectural work. His talent for animal painting would indicate a training under Giovannino de' Grassi; Stefano di Giovanni (or da Verona) was probably his pupil. His remaining work comprises mostly miniatures in the French manner, which he surrounded with backgrounds of flowers and other ornamentation invented by himself. He was a fine colourist and accomplished portrait painter. Illustrations:

- 48 The Christ Child Crowns the Duke. Illustration to P. da Castelletto's obituary of Giangaleazzo Visconti, c. 1402/03
- 48 The Mystic Marriage of St Catherine, c. 1410–1420

MIERIS Frans van the Elder

1635 Leiden – 1681 Leiden

Mieris, whose father was a goldsmith and diamond cutter, was first apprenticed to a glass painter. He then studied under Dou, the grand master of the very detailed style of painting developed in Leiden, who called him "a prince amongst his pupils". In 1655 he became a member of the Lukas Guild, in 1658 its deacon. He never left Leiden, even refusing an invitation from Archduke Leopold William, governor of Holland, to work at the court in Vienna. He specialised in portraiture and small-sized domestic scenes as well as conversation pieces with an erotic overtone. His cabinet pictures are considered his best work with their delicate handling of light and colour and precise rendering of detail ("House Concert", Schwerin, Gemäldegalerie; "Oyster Feast", St Petersburg, Hermitage).

Illustration:

330 Carousing Couple, undated

MIGNARD Pierre

1612 Troyes - 1695 Paris

At the age of twelve Mignard entered the workshop of Bouchers in Bourges, then continued his studies at Fontainebleau, decorating the chapel of the palace Coubert en Brie when aged fifteen. After studying several years under Vouet in Paris, he went to Rome in 1636, where he worked first as a copyist but soon received commissions for portraits, altarpieces and room decorations. His Madonna pictures, known as "Mignardes", met popular taste in their soft, light manner. The portrait of Pope Alexander VII, painted in 1655 after visits to Mantua, Parma, Bologna, Modena and Venice, showed his great skill in characterisation. On his return to Paris in 1660, his artistic and stylistic approach brought him the enmity of Le Brun but also a great number of commissions, including portraits of the Queen Mother, Mazarin and King Louis XIV. In collaboration with his friend Dufresnoy, he painted the much admired decorations in the cupola of Val-de-Grâce in 1663. In 1664 he was appointed director of the Académie de St Luc, and he was ennobled in 1687. On the death of Le Brun in 1690 he became "principal court painter" and director of the Royal Academy. Illustration.

251 Girl blowing soap bubbles (Marie-Anne de Bourbon), 1674

MILLAIS John Everett

1829 Southampton – 1896 London

Millais was one of the few artists whose life and career were not marred by difficulties and enmities, and who was rewarded and honoured in his lifetime. When studying at the Royal Academy in London, he met William Holman Hunt and Dante Gabriel Rossetti and, contemptuous of contemporary English art and its academic rules, they founded the Pre-Raphaelite Brotherhood. Lofty moral ideals and ideas were to be made the subject of painting. The painters of this group chose intense imaginative scenes with close imitation of the smallest details of nature. Millais later abandoned the Pre-Raphaelite manner - he broke with John Ruskin, the group's great supporter - and adapted his style to popular taste as he cared about his standing in society. He was eventually ennobled and became president of the Royal Academy. Illustration:

527 Ophelia, 1851

MILLET Jean-François

1814 Gruchy (near Gréville) – 1875 Barbizon
The son of a Normandy peasant, he received his
first art training in Cherbourg. A civic scholarship
enabled him to go to Paris and work in the studio
of the history painter P. Delaroche from 1837 to
1839. Subsequently he scraped a living together by
selling portraits and pictures of gallant scenes in the
Rococo manner. Between 1841 and 1845 he lived
in Cherbourg, a town he often returned to later in
life. Here, and also in Le Havre, he produced his
few seascapes. In 1849 he joined the Barbizon
school and lived in relative poverty at Barbizon,
where he had the companionship of Troyon, Diaz,
Dupré and Rousseau. In the early 1850s he found
his true métier, the depiction of peasant life.

His best-known pictures date from this period, including "The Sower" (Boston, Museum of Fine Arts, 1850), which brought him success at the Salon in 1851; "The Binders" (Paris, Louvre, 1850), "The Gleaners" (ill. p. 442) and "The Angelus" or "Evening Prayer" (ill. p. 442). In these works he depicted the hardships of peasant life, but not in the rational and unemotional manner of Courbet. Rather, he endows the frugal existence of these people with an almost religious solemnity created by a twilight atmosphere cast over their large figures. "True humanity full of great poetry" is revealed in the plight of the peasants. In 1867 Millet received a prize at the Paris World Exhibition, but generally he found little recognition. His social conscience made him suspect, and also his works were often considered sentimental. But nevertheless they exercised great influence worldwide in the development of Realism, and in particular on the works of Pissarro and van Gogh. At an auction in 1889 his "The Angelus" (ill. p.442) fetched the sensational sum of 553000 francs.

 ${\it Illustrations:}$

442 The Gleaners, 1857

The Evening Prayer, c. 1858/59

MIRÓ Joan

1893 Montroig (near Barcelona) – 1983 Palma de Mallorca

While attending a business school, Miró was already going to art classes at the Academy La Lonja in Barcelona. He then worked briefly in a chemist's shop before taking up his studies at the Francisco Gali art academy, 1912–1915, where he was introduced to Impressionist and Fauvist painting. In 1917 he met Picabia in Barcelona, and when visiting Paris in 1919 he made the acquaintance of Picasso and his circle. He began to explore Cubism, was briefly interested in the Dada movement, and moved to Paris in 1920.

Here his art achieved its first height with the poetic realism of his paradisiacal landscapes. Gradually his pictures lost depth, giving way to purely flat painting when Miró joined the Surrealists in 1924 and signed their Manifesto. A strong element of fantasy entered his work, and he also made more abstract paintings.

In 1925 he first showed his works at the Surrealist exhibition. In collaboration with Max Ernst he designed in 1926 the costumes and scenery for Sergei Diaghilev's Ballets Russes. In 1928 he went to Holland to paint his "imaginary portraits" after old masters, at the same time producing his first collages. New forms appeared, and Miró's work turned into a fantastic play of realistic attributes and imagery. In the 1930s, with looming political events, the wittily playful element in his works, of airy figures and floating phantoms with spindly limbs, disappeared. In 1937 he designed the wall decorations for the Spanish pavilion at the Paris World Exhibition, and posters proclaiming the Spanish Republic. Returning to Barcelona in 1942, he began to produce his first ceramics in 1944. In 1956 he finally settled in Palma de Mallorca. His late works again combined lithe figurations of human and animal elements with an artful, naive cosmology.

Illustrations:

554 The Poetess, 1940

606 Harlequin's Carnival, c. 1924/25

606 Hirondelle/Amour, 1934

607 People and Dogs before the Sun, 1949

MODIGLIANI Amedeo

1884 Leghorn - 1920 Paris

After studying briefly at the academies of Florence and Venice, Modigliani came to Paris in 1906 where he led a life dominated by illness, alcohol and drugs. He met Picasso and became friends with Maurice Utrillo and Soutine and was for a time the neighbour of the sculptor Constantin Brancusi who encouraged him to take up sculpture. As a result, he produced caryatids and female heads - influenced in part by the African sulpture he so admired. After experimenting with new media of expression, his own style became fully established around 1915/16. He preferred rust colours, and his subjects were elongated figures with curiously shaped eyes and noses, and oval heads sitting on tube-like necks. In his nudes, a permissive sensuality is encased within severe outlines. All his life he portrayed the people who surrounded him: artists, writers, friends, servants and children, and only when staying with the painter Survage at Cannes and Nice did he paint some landscapes influenced by Cubism. Illustrations:

578 Bride and Groom, c. 1915/16

578 Reclining Nude on White Pillow, 1917

MOHOLY-NAGY Lázló

1895 Bácsborsod (Hungary) – 1946 Chicago After studying law in Budapest, Moholy-Nagy did military service from 1914 to 1917; he was badly wounded and began to draw while recovering. He completed his studies in 1918, but decided to turn to painting. He went via Vienna to Berlin in 1919/20, where he produced his first "photogrammes" in collaboration with his wife, the photographer Lucia Schulz. His early work was influenced by the Constructivists Malevich and El Lissitsky, but all his life he constantly experimented with materials and techniques. In 1923 he became a teacher at the Weimar Bauhaus, where he worked with metals and in 1926 published his book Painting, Photography, Film. After 1928 he worked in Berlin in various capacities, including scenery builder, exhibition organiser and

art theoretician. In 1934/35 he went to live in London, where he made films and published several documentary works. He also produced sculptural artefacts of plexiglass. In 1937 he was appointed principal of the New Bauhaus at Chicago which, however, soon closed down due to lack of funds. He founded his own School of Design, which he ran until his death.

Illustration:

592 Composition Z VIII, 1924

MOMPER Joos de

(also: Joost, Joes, Josse, Jodocus de Momper) 1564 Antwerp - c. 1634/35 Antwerp As Bloemaert's influence in Utrecht reached far into 17th century Baroque, so did Momper's in Antwerp. He was a member of an artistic family and was trained by his father Bartholomew. In 1581 he joined the Lukas Guild and became its principal in 1611. It can be assumed that Momper went to Italy and that this journey also took him to Treviso, where the Flemish landscape painter Lodewijk Toeput (Pozzoserrato) worked. In 1594 he was engaged for the decorations for Archduke Ernst's reception in Antwerp. Momper's landscapes, whose subject is frequently mountain scenery, were reminiscent of Pieter Brueghel and followed the usual colour scheme: brown foreground, grey-green middle ground and blue background. But he avoided all Mannerist artificiality, letting nature speak for itself, as also did his successor Seghers. Momper also painted summer and winter scenes of his home country.

Illustration.

287 Winter Landscape, c. 1620

MONDRIAN Piet

(Pieter Cornelius Mondriaan)

1872 Amersfoort (near Utrecht) – 1944 New York Mondrian came from an artistic family. He studied at the Rijksakademie in Amsterdam under A. Allebé from 1892 to 1897, where he was particularly impressed by Breitner and the landscapes of The Hague and Amsterdam schools. In 1904/05, while on a painting tour in Brabant and Overijssel, he was already painting in a manner detached from what one sees. He continued painting landscapes in the Impressionist style of The Hague and Amsterdam schools until 1906. In 1909 he incurred severe criticism with fauvist-like landscapes at the exhibition at the Stedelijk Museum in Amsterdam. His years in Paris from 1911 to 1914 were greatly influenced by Cubism. The following years in Amsterdam were decisive in his development. In 1915 he met van Doesburg, with whom he formed the group De Stijl in 1917. In the journal bearing the same title he published a series of articles on new directions in painting. His journey into abstraction started in 1917 with his first paintings of rhythmical horizontals and verticals (plus-minus compositions), followed by those with geometrical grid patterns. Returning to Paris in 1919, he published Le Neo Plasticisme in 1920. From this period date his pictures of coloured rectangles with black outlines, the colours being soon reduced to the primaries plus black, grey and white. This trend continued over the next few years, developing an increasing purity of style. In 1930 Mondrian joined the Cercle et carré group and a year later the Abstraction-Création. In 1938 he went to London, then emigrated to New York in 1940. There his style changed once more, replacing the black grid with coloured lines dividing small, colour rectangles. Illustrations:

Broadway Boogie-Woogie, 1942/43 552

Oval Composition (Tree Study), 1913 597

Composition No. II; Composition with Blue 597 and Red, 1929

MONET Claude

1840 Paris – 1925 Giverny (near Paris) Monet's family moved from Paris to Le Havre in 1843, where the young Claude met the painter Boudin in 1855 in the latter's long-established framing shop, where artists could also display and sell their works. Boudin recognised the boy's talent and began to work with him, converting him to painting in the open. Boudin was soon urging his protégé to go to Paris for a proper training, so Monet took up his studies at the Académie Suisse in 1859, where he met Pissarro. Monet was at this time a great admirer of Delacroix, Corot, Millet and Courbet, and he visited Daubigny and Constant Troyon to get their advice. He also met the open-air painter Jongkind, who impressed him greatly. He was called up for military service in Algeria in 1861, but for health reasons was allowed to return to Paris the following year. He was not on good terms with his family, who refused to support him financially. He found more congenial company amongst intellectuals and artists at the Brasserie des Martyrs – a meeting-point of the Realists and their followers. From 1862 he also frequented the studio of Gleyre, where he met Bazille, Sisley and Renoir, and together with Pissarro these painters formed a friendly group.

Monet had his first public success at the Salon in 1865, receiving a good review from the critic Paul Mantz in the Gazette des Beaux-Arts. But Monet was to pursue aims which led away from the accepted taste of the art establishment. The siege of Paris caused him to go to London with his family in 1870/71 where he met the art dealer Durand-Ruel through the mediation of Daubigny. He then spent some time in Holland. Although he had rented a house in Argenteuil from 1872 to 1877, he often returned to Paris to meet his friends and try to sell his pictures. Only Durand-Ruel, his painting friends and a few collectors appreciated his work, for which he charged little. By the 1870s he had fully developed his style and had banned black from his palette altogether, replacing it with blue. As a means of mutual support several artists formed the Société des Artistes Indépendants, which one critic derided by calling them the "Impressionists" after the title of one of Monet's works. The centre of the group consisted of Monet, Sisley, Pissarro and Renoir, but others joined although they did not conform stylistically, including Cézanne, Degas, Morisot and Cassatt. Manet, like Fantin-Latour, remained aloof although sympathetic to their aims. Between 1874 and 1886 the group held eight exhibitions and several auctions of their pictures, and gradually small successes and some recognition followed.

In 1878 Monet lived at Vétheuil near his beloved Seine; in 1879 his wife died. In 1881 he moved to Poissy, and from 1883 he finally settled at Giverny, where he created his famous garden with water-lily ponds, finding at last some measure of peace and also inspiration. Here he spent his final years, often receiving friends and never losing interest in what went on in the world. Illustrations:

Impression: Sunrise, 1873

The Red Boat, Argenteuil, 1875 498

498 Le Pont de l'Europe, Gare Saint-Lazare,

Women in the Garden, 1867 499

The Waterlily Pond, 1900 500

Waterlilies (Green Reflections),

c. 1916-1921

MORANDI Giorgio

1890 Bologna - 1964 Bologna

Morandi grew up in an old patrician villa, where he lived until his death. He worked briefly in his father's trading business, then studied art at the Accademia di Belli Arti in Bologna from 1907 until

1913. Early influences on his work were Cézanne, Renoir and Monet. His first still lifes and landscapes date from 1911. He supported himself by working as a drawing-master at various schools in Bologna. In 1918 his first, strangely constructed, "metaphysical" still lifes were produced, but by 1920, again under the influence of Cézanne, Morandi had returned to a more traditional manner of representation, albeit in a style completely his own. His still lifes show everyday objects, such as cups, salad bowls, bottles and vases. Colour, form and light melt into each other, whereby the distinction between objects and space becomes ever less defined. Illustration:

603 Still Life, 1920

MOREAU Gustave

1826 Paris - 1898 Paris

Moreau's talent for painting showed itself early and, after studying briefly at the Ecole des Beaux-Arts, he continued his studies with Picot whose studio had a high reputation academically. Moreau admired Delacroix and classical art, and was greatly influenced by Chassériau, a fellow painter who died early. In 1857 he went to Italy for four years, returning with a number of landscape sketches in watercolour and pastel. From then on his direction was clear: themes with allegorical, symbolist content presented in a rich, glowing manner. In 1892 he was appointed professor at the Ecole des Beaux-Arts, his pupils including Matisse, Rouault and Marquet. Some time before his death, he gave his house to the nation for conversion to a museum; it can still be visited.

Illustration:

509 The Apparition (Salome), c. 1875

MORISOT Berthe

1841 Bourges - 1895 Paris

Morisot was the daughter of a senior civil servant of the Département Cher and a great-niece of the Rococo painter Fragonard. She received her first drawing lessons in 1857. In 1859 she made the acquaintance of Fantin-Latour in the Louvre. From 1860 to 1862 she studied with her sister Edma (later Mme Pontillon) under Corot. He encouraged her to paint in the open at Auvers-sur-Oise. There she met Daubigny. Her first landscapes were shown at the Salon in 1864. Her friendship with Manet began in 1868. He painted her and became her mentor. Between 1874 and 1886 she took part in all the Impressionist exhibitions except the fourth, which she missed because of illness. In 1874 she married Manet's brother Eugène. From 1881 to 1883 she had a house built in Paris, opening it as a meeting-place for painters and writers every Thursday. Her visitors included Degas, Caillebotte, Monet, Pissarro, Whistler; also Puvis de Chavannes, Duret, Renoir and Mallarmé, the last becoming her best friend and greatest admirer. In 1882 she showed her work at the G. Petit gallery, and in 1887 at Les XX in Brussels. In 1894, for the first time, the nation acquired one of her paintings. A commemorative exhibition in 1895 at Durand-Ruel's showed 300 of her works and was introduced by Mallarmé. Her daughter Julie married a son of the collector and painter Henri Rouart, her niece Nini Gobillard became the wife of Valéry. Morisot contributed greatly to Impressionism with her fresh and sensitive studies of women and children. Illustration:

501 Young Woman Powdering Herself, 1877

MOSER Lukas

c. 1390 Weil der Stadt – after 1434 Lukas Moser (documented 1419–1434) was born in Weil der Stadt near Stuttgart, but probably

worked mostly in Ulm, where he also produced designs for glass paintings. Moser is noted for his retable of the Magdalen altar in Tiefenbronn (ill. p. 78), this being his only signed and authenticated work. This is remarkable for its inscription on the frame which sounds like the plaintive cry of an ageing artist: "Schri kunst schri und klag dich ser, din begert iecz niemen mer so o we 1432 lucas moser, maler von wil maister dez werx bit got vir in." But in terms of style Moser was one of the most modern of painters in his time, which might have been the reason why he felt rejected and not understood. Or perhaps his cry can be traced back to the hostile Hussite attitude to art, or to the reforms of the Council of Constance. No doubt Moser had knowledge of the art of northern Italy, perhaps even of the older Tuscan painting. He probably visited the Provence and southern France and had direct knowledge of Franco-Flemish inno-

Illustration:

78 Magdalene Altar, 1432

MOTHERWELL Robert

1915 Aberdeen (Washington) – 1991 Provincetown (Massachusetts)

From 1935 Motherwell studied at Stanford University in California, the California School of Fine Arts, Valencia, at Harvard, and at New York's Columbia University. He studied philosophy, art history and archaeology. He was a painter, writer, editor of art journals, and teacher. Apart from his paintings, he was also noted for his collages and prints. In 1941 experimented with printing techniques with Kurt Seligman, and consolidated these in 1945 in Stanley William Hayter's "Studio 17" He made a name for himself with his Surrealist theories and automatism in 1941, and soon became one of the most important exponents of abstract Expressionism and Action Painting, along with Pollock and de Kooning. His works are intellectually thought through, and without the spontaneous ferocity and sensualism of those of Pollock and de Kooning, as well as less aggressive. Motherwell also designed wall paintings, including those for the Kennedy Building in Boston. He also was an influential writer and publisher on art. In 1944 he began to publish modern art documents in book form. Together with William Baziotes, Newman and Rothko he founded the avant-garde art school "Subjects of the Artists", teaching there for a year. He also taught at Hunter College as well as Black Mountain College, 1950-1959. From 1970 until his death he lived in Greenwich (Connecticut).

Illustration.

634 Elegy to the Spanish Republic No. 34, 1953/54

MOUNT William Sidney

1807 Setauket (New York) - 1868 Setauket William Mount was apprenticed to his brother Henry, a sign painter, in 1824. After further studies at the National Academy of Design he returned in 1827 for two years to his home in Long Island. Until 1836 he earned his living in New York by portrait painting, but he made a name for himself with his scenes of contemporary life, today seen as typically American folk scenes. With these, he became one of the first American open-air painters. He soon became popular, with his fresh, almost Impressionist manner of painting and uncomplicated compositions, which were to become available in mass-produced reproductions. He kept open house for a circle of writers and painters at his farm Stony Brook. In the 1850s, when his creativity declined, he became engaged in spiritualist studies

Illustration:
471 The Horse Dealers, 1835

MUELLER Otto

1874 Liebau (Silesia) – 1930 Breslau After leaving school, Mueller was trained as a lithographer until 1894. On the advice of Gerhart Hauptmann he studied at Dresden Academy until 1896. In 1898 he studied briefly with Franz von Stuck in Munich and began to paint under the influence of Böcklin, Hans von Marées and Ludwig von Hofmann. After working quietly in his home town, he moved to Berlin in 1908, where his friendship with the sculptor Wilhelm Lehmbruck became important for his development. Here he became co-founder of the Neue Sezession and a member of Die Brücke. As his style developed, he used a limited range of colours, painting in a dull, fresco-like, distemper technique. He painted variations on his lyrical theme of people in harmony with nature. During military service, 1916-1918, he made sketches of scenes untouched by war, which he later used for his paintings. In 1919 he received an invitation to teach at Breslau Academy. The summers of 1920 and 1923 he spent with Heckel, to whom he was greatly attached, at the Flensburg Förde, where he produced his few landscapes. In subsequent years he visited Dalmatia, Hungary and Rumania, often travelling with gipsies.

Illustration:

585 Lovers, 1919

MULTSCHER Hans

c. 1390 Reichenhofen - c. 1467 Ulm Together with Witz, Multscher is regarded as the most important German painter and sculptor of the first half of the 15th century. During the iconoclastic disruptions his first signed work, the sculpted Karg altarpiece in Ulm Cathedral, was badly damaged in 1531. All that remains is the spatial structure divided into several levels, with the window opening backwards, and some figures of angels. The Man of Sorrows on the central pillar of the Western portal of the Cathedral probably dates from the same period. The sandstone model for the sepulchral monument of Duke Ludwig the Bearded (Munich, Bayerisches Nationalmuseum) can be dated around 1434. While the master endowed this work with painterly qualities which hint at his sculptural interests, his painted panels of 1447 of the Wurzach altarpiece are full of sculptural vitality. (It is presumed that this altarpiece came from the parish church in Landsberg on the Lech, ill. p. 143). In the 1450s Multscher added woodcarving to his repertoire. The figures of St Barbara and St Magdalen (Rottweil, Lorenzkapelle) let the structure of the body show under the folds of the drapery, the latter being no longer just purely ornamental. Multscher's finest work was the main altar for the Frauenkirche in Sterzing, 1456-1459. Unfortunately this work, too, has been tampered with. The shrine figures, however, are still in place. They differ from the Rottweil figures in that they look immensely lively, almost passionate, in movement and rendering of drapery, reaching almost a Baroque richness. The panels are closely related to those at Wurzach in terms of motif, but suggest the hand of a younger master. Illustration:

143 Resurrection, 1437

MUNCH Edvard

1863 Løten (Hedmark) – 1944 Ekely (near Oslo) Munch came from a family of famous artists and scientists. Tragic family events mark his œuvre. In 1868 his mother died, in 1877 his favourite sister

Sophie died, and his father began to suffer from melancholia. In 1881 Munch began to study at the royal drawing school in Oslo, and under Krohg painted light-flooded, naturalist landscapes and studies of people. In 1885 he visited Paris for the first time. During this period he developed a personal style, using colour and form as vehicles to express atmosphere. In 1889 he had his first one-man exhibition, which brought him a state scholarship. Returning to Paris, 1889-1892, he took drawing lessons from Bonnat and studied the old masters and Impressionism. He visited Berlin in 1892 and exhibited his work at the Verein der bildenden Künstler which caused a scandal and had to be closed. This was followed by the foundation of the Berlin Secession. From 1894 he used many graphic media, publishing a large number of famous illustrations around 1900. In the 1890s he lived mostly in France, Italy and Germany. From 1896 to 1898 he showed his work at the Salon des Indépendants in Paris. In 1902 he exhibited his "Frieze of Life", a series of pictures begun in 1893, at the Berlin Secession of which he became a member in 1904. After a mental breakdown he returned to Norway in 1908, settling in the small fishing town of Kragerø. In 1916 he completed three large murals for Oslo University. From 1916 he lived in Ekely, near Oslo. In 1921/22 he decorated the dining hall at the Freia chocolate factory in Oslo. His eyesight began to fail in the 1930s.

Illustrations:

560 Puberty, 1895

560 Girls on the Bridge, 1901

MURILLO Bartolomé Esteban

c. 1617/18 Seville - 1682 Seville Murillo was the youngest of fourteen children of a doctor in Seville, where he probably remained all his life, a visit to Madrid in 1642 being unsubstantiated. Being orphaned at the age of ten, he was apprenticed early to a painter by the name of Castillo. He gained sudden fame with the cycle of paintings he did for the cloisters of the the Franciscan monastery in Seville (1645/46). While his earliest works show him working in a tenebrist style derived from Zurbarán and then in the style of Ribera with a preference for cool colours, he soon developed his characteristic style of soft forms and warm colours, which owed something to the works of van Dyck, Rubens and Raphael which he had studied in local collections. Today considered somewhat sentimental, his genre scenes nevertheless represent a new way of perception ("Grape and Melon Eaters", Munich, Alte Pinakothek; "Little Fruit-Seller", ill. p. 267). When Hegel said about Murillo's beggar children that they sat on the ground "contented and blissful almost like Olympian gods", he cleared them of pathos, and so brought out the sensitisation for simple objects and feelings which would first find full expression in the 18th century. Murillo's many devotional pictures, particularly of the Madonna, reflect a piety which was sensitive and close to the people. Apart from this new approach he commanded a brilliant painterly technique, which made him the head of the Seville school. He also founded the Academy of Seville and became its president. Illustrations:

223 The Pie Eater, c. 1662–1672

265 Annunciation, c. 1660–1665

266 La Immaculada, undated

266 The Toilette, c. 1670–1675

267 The Little Fruit-Seller, c. 1670–1675

NATTIER Jean-Marc the Younger 1685 Paris – 1766 Paris

Nattier received early training from his father Jean-Marc the Elder and then probably was the pupil of

Jouvenet. He studied the older masters in the Galerie du Luxembourg, particularly Rubens. At the early age of fifteen he received an Academy prize for a drawing after Rubens, which pleased Louis XIV so much that he had an engraving made of it. The Russian ambassador sent the young Nattier to Amsterdam to paint members of the Tsar's family who were staying there. Nattier's achievement was to translate the traditional type of mythological portraiture into the language of the Rococo (e.g. "Mademoiselle de Lambesc as Minerva", Paris, Louvre, 1737; "Madame Bouret as Diana", Lugano-Castagnola, Thyssen-Bornemisza Collection, 1745). These paintings, which were not meant to turn the sitters into mythological figures but merely give them their attributes, created a vogue amongst the court ladies and favourites of Louis XV. As such, they form a significant aspect of Louis Quinze painting. Nattier's works are noted for their mother-ofpearl-like lustre, in contrast to High Baroque coloration.

Illustration:

353 Madame Henriette as Flora, 1742

NAY Ernst Wilhelm

1902 Berlin - 1968 Cologne

Nay began to teach himself, but in 1925 attended the Berlin art academy for three years, where Carl Hofer trained and encouraged him. In 1931 he was awarded the Rome Prize. He turned increasingly to Surrealist abstraction, first in his compositions resembling still lifes, then in his large-figured pictures. His art was branded as "degenerate" under the Nazi regime. He often visited the Lofoten islands off Norway to seek in the bleak landscape inspiration for his abstractions. After the war he lived at Hofheim/Taunus, and moved to Cologne in 1951. His exploration of the abstract lasted well into the 1950s. Around 1955 his first round disc compositions were produced, which were of a decorative and sometimes nervous, strong coloration. In the 1960s he adopted elements of the Informel, and noticeably so from 1963 in his series of "Eye Pictures".

Illustration:

639 Yellow Chromatic, 1960

NEWMAN Barnett

1905 New York – 1970 New York Newman came from a family of Polish Jews. From 1922 to 1930 he studied philosophy and ornithology as well as art at the Art Students' League. In about 1930 he became acquainted with Still, Pollock, Adolph Gottlieb and Milton Avery. He destroyed his early work, but allowed his writings to be published. His theoretical essays The First Man was an Artist, 1947, and The Sublime is Now, 1948, appeared in the journal Tiger's Eye, of which he was co-editor. He did not develop a personal style until the age of 43, when he began to paint "mystical abstractions", variations on the theme of thin vertical colour lines against a monochrome background. With these works he became one of the most important representatives of minimalist colour surface painting. After a first one-man exhibition in 1950, which engendered much hostile criticism, he retired from the world of art for eight years, but subsequently gained wide recognition with the picture series "Stations of the Cross".

Illustration:

650 Vir Heroicus Sublimus, 1950/51

NICHOLSON Ben

1894 Denham (Buckinghamshire) – 1982 London Nicholson's parents were both painters, but he himself studied only briefly at the Gresham School in Holt and at the Slade School of Art in London.

When in Paris in 1921, he became greatly inspired by the works of Braque, Matisse and Picasso. In exploring Cubism, Nicholson developed his own idiom in that he transferred three-dimensional natural phenomena to the two-dimensional canvas, turning the picture into an autonomous object. In the early 1930s he made his first purely abstract reliefs: cut-out geometrical forms in varying colours arranged in several layers. During this period Nicholson became a member of the Abstraction-Création group to which he belonged until 1937. In 1940 he moved with his second wife, the sculptress Barbara Hepworth, to Cornwall where, together with the sculptor Naum Gabo, the abstract group Painters of St Ives was formed. After 1945 objective elements returned to his work. Besides strictly geometrical abstractions, he produced still lifes and landscapes reduced to a sketch-like structure. His late work was again marked by its geometric harmony. Nicholson was the major representative of concrete art in England. Illustration:

614 Still Life, 1947

NOLAND Kenneth

born 1924 Asheville (North Carolina) Noland studied from 1946 to 1948 at the Black Mountain College in New York and in 1948/49 with Ossip Zadkine in Paris. He then taught until 1956 at various institutions in Washington. Together with Louis he developed colour surface painting with diluted paints. Noland is also a hardedge painter and minimalist artist. Painters of minimalist art deliberately reduce all elements in their work. Noland worked first with disc-like colour fields, then turned to horizontally arranged colour bands in soft, harmonious colours. In the mid-1980s Noland discovered computer art. In collaboration with the architect I.M. Pei, he designed buildings for the Massachusetts Institute of Technology.

Illustration:

651 Ember, 1960

NOLDE Emil

(Emil Hansen)

1867 Nolde (near Tondern) – 1956 Seebüll (near Neukirchen)

Nolde began his career by learning to carve in Flensburg, and then worked as a craft teacher in St Gallen from 1892 to 1898 before further studies in Munich, Paris and Copenhagen. In 1901 he joined the Berlin Secession group, and in 1905 he was briefly associated with the Dresden Brücke group, leaving it in 1907. As a pugnacious loner, he agitated against the art policies of Liebermann, president of the Berlin Secession, and was expelled from the group in 1911. From then on he only spent the winter months in Berlin, painting on the island of Alsen in the summer. In 1913/14 he went on an expedition which took him through Russia, China and Japan, and as far as Polynesia. From 1940 he lived permanently in Seebüll, Schleswig-Holstein. Nolde's work belongs in subject matter and style to the more emotional branch of Expressionism. His pictures are marked by the dissolution of forms and glowing intensity of colour. His renderings of nature are usually very dramatic and often seem threatening in their combination of bilious, dark colours. From about 1910 he began painting religious subjects. To express what the inner eye saw he used distortion, ugliness and elements of primitive art. His generally positive attitude to National Socialism did not prevent his being denounced as "degenerate" in 1933.

Illustrations:

582 Christ among the Children, 1910

582 Nordermühle, 1932

OEHLEN Albert

born 1954 Krefeld

Oehlen was trained in the book-trade. From 1978 to 1981 he studied at the art college in Hamburg. He first painted large-scale pictures which expressed his critical attitude to society. In 1984 he exhibited at "Wahrheit ist Arbeit" (Truth is Work) at the Folkwang Museum in Essen (with Werner Büttner, Georg Herold and Kippenberger). International exhibitions followed, including 1984 "Von hier aus" (Point of departure), Düsseldorf; 1988 "Deutsche/Amerikanische Kunst der späten 80er Jahre" (German/American art of the late 80s), Düsseldorf and Boston; 1989 "Bilderstreit" (Iconographic controversy), Cologne; 1991 "Metropolis", Berlin. His first abstract paintings were produced towards the end of the 1980s. In 1991 he paid his first visit to Los Angeles (overpainting of representational subjects). Computer pictures were produced and also abstract oil-paintings. Further exhibitions: 1993 "Der zerbrochene Spiegel" (The cracked mirror), Vienna and Hamburg; 1995 Wexner Center, Columbus (Ohio); 1994 retrospective at the Deichtorhallen, Hamburg. Oehlen lives in La Palma,

Illustration:

677 Untitled, 1983

ORLEY Bernaert van

c. 1488 Brussels – 1542 Brussels Orley holds an important position in Flemish painting at the transition from Early to High Renaissance. Trained to follow the example of the great "old" Flemish masters, as his early works demonstrate ("Lamentation of Christ" from the triptych of Philippe de Hanetou, Brussels, Musées Royaux, c. 1515), he increasingly adopted the classical form language of the Italians ("Last Judgment Altar", Antwerp, Koninklijk Museum voor Schone Kunsten, 1525). It is not known whether he had ever been to Italy, but he met Dürer on his visit to Holland in 1521, and this could have had a mediating influence. Noted both for his great altarpieces and fine portraits, Orley enjoyed early high esteem in his native town and was appointed painter to Margaret of Austria, the governess of the Netherlands.

Illustration:

202 Holy Family, 1522

OSTADE Adriaen van

(Adriaen Hendricx)

1610 Haarlem – 1685 Haarlem

The father, Jan Hendricx, came from Ostade near Eindhoven, and his sons Adriaen and Isaac adopted this name as painters. In 1627 Adriaen was a pupil of Frans Hals in Haarlem (as probably was the somewhat older Brouwer), where he joined the Lukas Guild in 1634. He was one of the most popular Dutch painters, specialising from the start in genre painting of peasant life. Initially he painted small pictures showing humble interiors and shabby inns with peasants in dim lighting carousing or brawling. Later the tones became warmer, the interiors more pleasant, and open-air scenes were added, including genre portraits of organ-grinders and pedlars. From about 1650 this tendency continued, the work showing greater accuracy and lighter colouring. One could say that the development ran from Rembrandtesque chiaroscuro towards Delft genre painting. The exaggerated manner of his early work had little to do with Dutch peasant life but was meant to make the town-dweller laugh. Ostade's most important pupils were his younger brother Isaac, and Steen.

Illustration:

319 Peasants Carousing in a Tavern,

. 1635

OUDRY Jean-Baptiste

1686 Paris – 1755 Beauvais

Oudry was a pupil at the Académie de St.-Luc, where his father was principal. He received further training under Michel Serre, who introduced him to 17th century Dutch painting which was then experiencing a revival. He then became a pupil of Largillière, under whom the same influences were reinforced. Oudry's thematic spectrum is particularly wide. He is noted for his animal and still life pictures, but he also painted landscapes and was a successful portrait painter. He made a name for himself as a religious painter, too, and for this reason was accepted by the Academy in 1719. From 1726 Oudry made designs of hunting-scenes on a commission from the King for the Gobelin tapestry works in Beauvais, becoming its director in 1734. One of his most famous designs was Les Chasses de Louis XV consisting of a series of eight large tapestries. His landscapes show Ruisdael and Berchem as the source of inspiration, while the still lifes are of extreme refinement and elegance, as for example the one depicting a white duck (ill. p. 352) which is painted entirely in variations of white and silver tones.

352 Still Life with White Duck, 1753

OVERBECK Johann Friedrich

1789 Lübeck – 1869 Rome

Overbeck, from an upper-class Lübeck family, can be regarded as the founder of German Romantic art. His study of Italian and German late medieval and Renaissance art made him a dissatisfied student at the Vienna Academy, where he enrolled in 1806. In 1809 he formed with his like-minded friend Franz Pforr the Lukasbund (after St Luke, the patron saint of painters), the first modern association of artists. Art was to go back to religion and to the honest craftsmanship of the Middle Ages. The Protestant members of this group, including Overbeck, converted to Catholicism. In the same year connections with the Academy were broken off, and the young artists moved to Rome, where they found refuge at the monastery of San Isidoro and could realise their ideas on life and art. They were given the nickname "Nazarenes" by the Italians because of their hair style, and this is how the movement was called. Their first commission came from the Prussian consul Bartholdy to decorate the Casa Zuccaro with frescos. The theme chosen was the Old Testament story of Joseph. The decoration of the Casino Massimo with scenes taken from the "Liberation of Jerusalem" by Torquato Tasso was the next project, completed in 1827. After this the group dissolved, and Overbeck was the only one who remained in Rome.

Illustration:

454 Italia and Germania (Sulamith and Mary), 1828

PACHER Michael

c. 1435 Bruneck (Tyrol) – 1498 Salzburg Pacher was one of the few 15th century artists equally gifted in painting and wood sculpture. His training and early work are still a matter of conjecture. His altarpiece in the Liebfrauenkirche of Sterzing, completed in 1457/58, may have been inspired by Multscher. Records show that Pacher was active in Bruneck in 1467, where he ran a large workshop. His altarpiece depicting the crowning of Mary in the shrine of the parish church in Gries near Bozen, begun in 1471, was a preliminary step to his masterpiece in St Wolfgang in the Salzkammergut (ill. p. 144), a winged altar combining reliefs, statues and panel paintings. For this, the contract was signed in 1471, and Pacher himself had to deliver the work, signed 1481, to St Wolfgang and to install it.

In this work, the crowning of Mary interweaves with the rich forms of the tracery into a unified pattern of lines, and light and shade create the suggestion of unlimited depth. The life-size figures, in particular those of St Wolfgang and St George beside the closed shrine, reveal Pacher as a contemporary of Verrocchio and Pollaiuolo: both north and south of the Alps, efforts were being made to depict the human figure moving in space and seen from different angles. The paintings of the altar wings are reminiscent of the works of Mantegna in their bold treatment of perspective, which Pacher could possibly have studied in Verona, Mantua and Padua. And while Pacher in his capacity of carver introduces elements of this art into painting, the painter in Pacher uses his insight into carving to deal with surface. With the "Church Fathers Altar" (ill. p. 144) created in 1483 for the Neustift monastery near Brixen, Pacher reached a point at which the borders between painting and sculpture in the north were no longer clearly distinct. Illustrations:

- The Resurrection of Lazarus (St Wolfgang Altar), 1471–1481
- St Augustine and St Gregory (Church Fathers' Altar), c. 1480

PÄHL ALTAR → Master

PALADINO Mimmo

born 1948 Paduli (near Benevento) Paladino studied from 1964 to 1968 at the Liceo Artistico di Benevento. He now lives most of the time in Milan, where he had his first successes, and in his home town of Benevento. Together with Clemente, Chia and Cucchi he is one of a generation of young Italian painters who, supported by critics, reacted to the somewhat tired art scene, and who succeeded in making a name for themselves within a very few years. Paladino's art is individual and less based on style than on inner dictates. His pictures are produced as a kind of psychological projection of archetypes and symbols on to the canvas. He uses objects in his works, which are mostly abstract, and also paints flat pictures giving almost no sense of space but full of objective, symbolic allusions. He has paid several visits to Brazil, the first in 1982. Since then a fascinating combination of African and Catholic cultural elements has entered his work.

670 Ronda Notturna (Nightwatch), 1982

PALMA (IL) VECCHIO

(Jacopo Negretti)

1480 Serina near Bergamo – 1528 Venice Probably in the 1490s Jacopo was already apprenticed to Francesco di Simone da Santacroce in Venice, and there picked up the basic techniques of painting. But for composition, coloration and the portrayal of the human character, his inspiration came from the somewhat older Giorgione and Titian. In 1513 Palma became a member of the Scuola di S. Marco which commissioned a history painting from him. He enjoyed high esteem in Venice, commanding fees comparable to those of Titian. Many of his commissions came from churches for paintings in the classical Renaissance style in the manner of Giorgione, and in Palma's work this style came to a full flowering, particularly in terms of coloration. His religious themes, of which Mary and the Child surrounded by saints was a subject often repeated, are characteristic in their well-balanced composition and lack of drama. He was particularly noted for his fine portraits. Illustration:

173 Diana discovers Callisto's Misdemeanour, c. 1525

PARMIGIANINO

(Girolamo Francesco Maria Mazzola)

1503 Parma – 1540 Casalmaggiore (near Parma) In following the style of Correggio, Parmigianino also became his most significant successor in 16th century painting in the Emilia region. His "Self-Portrait before a Convex Mirror" (Vienna, Kunsthistorisches Museum, 1523), which was to recommend him to the Pope, already shows him at the height of his art. The wealth of imagination and delicacy of approach shown in this work already hint at the dissolution of the ideal of High Renaissance portraiture. During his visit to Rome from 1524 to 1527 he was particularly impressed by Raphael and Giulio Romano. This did not, however, cause him to abandon his Mannerist tendencies. On his return to Emilia he worked predominantly in Parma and surroundings, carrying out many notable religious works and portraits. He also executed several frescos, and in this field he contributed greatly in removing the division between painting and sculpture (Scenes from the story of "Diana and Actaeon", Fontanellato, Kastell, c. 1523; "Virgins carrying Urns", Parma, Santa Maria della Steccata, between 1531 and 1539). Parmigianino was influential both in his native region and in Venice. Illustration:

180 Madonna of the Long Neck, c. 1534-1540

PATINIR Joachim

(also: Patenier)

c. 1480 Dinant, near Namur (?) - 1524 Antwerp No records exist about Patinir's training and early work. In 1515 he was elected as master to the Antwerp Lukas Guild. He is noted as one of the earliest painters to make landscape a main element in pictorial composition, developing a so-called "world landscape", a bird's-eye view, with a seemingly endless horizon. This brought him international fame during his lifetime. Thus, three of his paintings were mentioned in 1523 in the records of the Palazzo Grimani in Venice, and Dürer also frequently mentioned him in his notes on his travels in the Netherlands. Patinir had a huge influence on succeeding generations as well as on his contemporaries. About twenty of his signed paintings cannot be regarded as pure landscape. He mostly depicted religious scenes, but his figures seem incidental to his landscapes.

Illustration:

201 Landscape with Charon's Bark, c. 1521

PECHSTEIN Max

1881 Zwickau – 1955 Berlin After an apprenticeship as a decorative painter, Pechstein studied in 1900 at the College of Applied Arts and 1902-1906 at the Academy in Dresden. In 1906 he met Heckel and joined the group Die Brücke. Initially influenced by Munch and van Gogh, he became interested in the Fauves once he had met van Dongen. He inclined more to the decorative rather than to deformation, and was therefore welcomed to exhibit at the Berlin Secession in 1908 and 1909. Being excluded in 1910, he founded with other artists in this position the Neue Secession. He had contacts with the Neue Künstlervereinigung München (New Artists' Association) and met Marc, Macke and Kandinsky. He left the Brücke in 1912. As an enthusiast of "primitive art" he visited the Palau Islands in the South Seas in 1914. Returning to Germany via Manila, Japan and the USA, he was called up for military service in 1915. After the war he joined the Arbeitsrat für Kunst (Arts Council) and the Novembergruppe. In 1922 he was elected a member of the Prussian Academy of Arts, where he taught until dismissed during the Nazi period when his paintings were condemned as "degenerate".

Illustration: 586 Open Air (Moritzburg), 1910

PENCK A.R.

(Ralph Winkler)

born 1939 Dresden

Penck was taught drawing at the Deutsche Werbeagentur, Dresden, but in painting he is selftaught. From 1965 he began to develop his "system and world pictures" which were to become his theme. These are canvases covered over with characters and little figures reminiscent of children's drawings, cave drawings and contemporary logos. From 1968 he was recognised as a painter, although under the East German regime he was often forced to carry out other tasks, working as a postman, stoker, night-watchman and margarine packer. From 1971 to 1976 he was a member of the Lücke (gap) group of artists. Repeated invitations to exhibitions in the West caused him to be expatriated in 1980. After living in the Rhineland, he moved to London in 1983, then to Dublin and New York. He has been teaching at Düsseldorf Academy since 1988. He also produces wooden sculpture, casting them in bronze since 1982. Illustration:

PERUGINO Pietro (Pietro di Cristoforo Vannucci)

674 The Birth of Mike Hammer, 1974

c. 1448 Città della Pieve – 1523 Fontignano Perugino was one of the masters who widened the scope of the Umbrian school, making Perugia an artistic centre of great excellence and thus paving the way to the High Renaissance. Today his fame has been eclipsed by Raphael, who was his greatest pupil and owed much to him. Perugino probably studied under Benedetto Bonfigli, but more important was his long stay in Florence from 1472. There he may have worked in the workshop of Verrocchio and have been introduced to the new developments in depicting space and the physical form. But his lasting influence was Piero della Francesca, who taught him how to balance surface with space and to structure large-scale compositions. Perugino became one of the greatest fresco painters of his time (in 1481 he was one of the artists chosen to embellish the Sistine Chapel; Crucifixion in the chapter house of Santa Maria Maddalena dei Pazzi, Florence, 1493-1496; frescos in the Collegio del Cambio, Perugia, from 1499). His panel paintings already show an almost classical balance in their composition. This harmony is also reflected in the expression, movement and gestures of his figures and not least in his landscapes which succeed in heightening the overall atmosphere.

Illustrations:

Christ giving the Keys to St Peter, III

c. 1482

The Vision of St Bernard, 1489

PIAZZETTA Giovanni Battista

1683 Venice - 1754 Venice Piazzetta received early instruction from Antonio Molinari, but Crespi in Bologna became his real teacher. To him he owed his loose manner of painting; an earthy, warm palette competing with whites, and a chiaroscuro used to create an atmosphere rather than the pathos which had been produced until recently by Liss and Loth. When he left Crespi and returned to Venice in 1711, his art presented a complete contrast to the prevailing Venetian style as represented by Ricci, Pellegrini and Amigoni. It was not until the 1720s that Piazzetta used lighter tones. His scenes from the Old and New Testaments were painted in the genre style, and have an almost tactile closeness.

Piazzetta is regarded one of the most important representatives of 18th century Venetian painting.

369 Beggar-Boy, c. 1740 (?)

PICABIA Francis

1879 Paris - 1953 Paris Born in Paris of Spanish parents, Picabia attended various art schools in Paris. Until 1908 he painted in the Impressionist style, but then came under the influence of the Fauves and Cubists. In his search for new experiences he produced his work "India-Rubber" (Paris, Musée National d'Art Moderne) in 1909 which became a precursor of abstract art. He continued this trend while staying mostly in the USA from 1913 until 1915. Out of these sharpedged, abstract works developed his "machine" pictures, which raise questions about the value of technical progress. In 1916 he returned to Europe and the Paris Dadaists. He made collages of buttons, matches, feathers and other non-artistic materials. The series of "transparencies" begun in 1927 are regarded as his most individual achievement. In these, linear representations are superimposed on a foundation layer.

Illustration 595 Catch as catch can, 1913

PICASSO Pablo

(Pablo Ruiz y Picasso)

1881 Málaga - 1973 Mougins (near Cannes) His father was a drawing-master, an artist in his own right, who promoted his son's early talent. Picasso went to complete his studies in Madrid in the advanced course at the Academy of San Fernando. In 1899 he went to Barcelona, where he frequented the café of the intellectuals, "El Quatre Gats". In 1900 he went to Paris for the first time. During this period he painted music-hall and circus pictures, now only signing them with "Picasso", his mother's maiden name. His dominant colour was an almost monochrome blue-green his so-called "blue period". In 1904 he settled in Paris, moving into a studio in the Bateau-Lavoir. His "blue" period was followed by the "rose' period. He met Matisse and later Derain, and also made the acquaintance of Gertrude Stein, his first patron.

In 1906 he made an intensive study of Cézanne's work. An exhibition at the Louvre of pre-Roman, Iberian sculpture excited a lasting interest. From 1907, before meeting Kahnweiler and Braque, his style began to take a dramatic, revolutionary direction. His "Demoiselles d'Avignon" (ill. p. 569) completed the breach with formal and aesthetic 19th century ideas of painting. This was the key work leading into Cubism, which at the end of 1909 entered the initial "analytical" phase and was further developed by Picasso and Braque around 1912 as a parallel to "synthetic" Cubism. In the spring of 1912 he produced his first threedimensional "picture", which included sheet metal and wire, shortly followed by his first collage. His collaboration with Braque and Derain came to an end when those two were called up in August

Through Jean Cocteau's friendship with Diaghilev, Picasso won commissions for the "Ballets Russes". In 1917 he visited Rome, Naples and Pompeii. During this time he met Igor Stravinsky and Erik Satie. Besides abstract works still rooted in Cubism, he again returned to more classical figurative painting between 1920 and 1924. In the 1930s he continued to move between these two poles, creating his major works. In 1937 he produced his picture "Guernica" (ill. p. 549) for the Spanish pavilion at the Paris World Exhibition, using abstraction, deformation and anatomical dissection to express the feeling aroused by the bombardment of the town by the German air force. In 1930 he had begun a series of 100 etchings for the art dealer Vollard depicting scenes from his workshop in the Boisgeloup castle in Normandy, and from the Minotaur myth, which included autobiographical elements. The work was published in 1939 under the title "Suite Vollard". During the Second World War Picasso lived in Paris, painting deformed, tortured heads of women and severe still lifes, and he wrote the Surrealist piece "How to catch desires by their tails". After the liberation of Paris in 1944 he joined the French Communist Party, and in 1946 he moved to the Côte d'Azur. He turned to designing pottery in 1950 and began exploring the works of older masters, producing variations on paintings by Velázquez, Delacroix and Manet. He also produced sculpture and illustrated books.

Illustrations:

The Kiss, 1925 402

Portrait of Dora Maar, 1937 544

549 Guernica, 1937

Les Demoiselles d'Avignon, 1907 569

"Ma Jolie", 1914 570

Three Women at the Spring, 1921 570

Girl before a Mirror, 1932

PIERO DELLA FRANCESCA

(Piero di Benedetto dei Franceschi)

c. 1420 Borgo San Sepolcro (near Arezzo) - 1492 Borgo San Sepolcro

Piero was probably trained in a Sienese-Umbrian workshop, where he developed his power as a colourist and his interest in landscape painting. Between 1439 and 1445 he explored the new ideas on space and physical form of the Florentine Early Renaissance, and he experimented with colour while assisting Domenico Veneziano with the now lost fresco cycle in San Egidio (now Santa Maria Nuova). By adding a larger proportion of oil as binder it was possible to achieve atmospheric lighting effects. As Veneziano's successor, Piero became a pioneer in this field. After 1452 he created his most famous fresco works in S. Francesco of Arezzo, 'The Discovery of the Wood of the True Cross" (ill. p. 100). These show not only Piero's advanced knowledge of perspective and mastery of colour, achieving almost luminous effects as never before in fresco painting, but also his geometric orderliness and skill in pictorial construction. With his innovations he paved the way for the High Renaissance. From 1469 mention was made of him at the court of the Montefeltre in Urbino, where he came into contact with Dutch art. Already celebrated in his life-time, Piero was greatly influential in northern Italian art in the second half of the 15th century. Later, he also set down his theoretical ideas in writing.

Illustrations:

Senigalla Madonna, c. 1460–1475 83

The Baptism of Christ, c. 1440–1450

Double Portrait of Federigo da Montefeltro and his Wife Battista Sforza, c. 1470

The Discovery of the Wood of the True Cross and The Meeting of Solomon and the Queen of Sheba, after 1452

PIERO DI COSIMO

(Piero di Lorenzo)

1462 Florence – 1521 Florence

Piero came from an artistic family and at the age of 18 entered the workshop of Cosimo Roselli, whose name he adopted and with whom he travelled to Rome in $14\hat{8}1/82$ to assist in painting the frescos in the Sistine Chapel at the Vatican. He specialised in the decoration of Cassoni, heavy chests, whose unusual format he covered with skilled compositions.

His early work was influenced by Filippino Lippi; later he received stimulation from the works of Ghirlandaio and Dutch masters. At the turn of the century he followed Leonardo, who had again returned to Florence, in his treatment of colour. Piero di Cosimo knew how to combine these varied strands, producing atmospheric and dramatic moments occasionally bordering on the grotesque. For this reason his work was highly valued by the Surrealists.

Illustrations:

112 Death of Procris, c. 1510

112 Venus and Mars, c. 1498

PISANFLLO

(Antonio di Puccio Pisano) before 1395 Pisa - 1455 Rome Pisanello's father came from Pisa, his mother from Verona, both these cities then being under the rule of the Visconti. His training was undertaken in the Lombardy region, though it is not possible to say exactly where. We do know that he worked with Gentile da Fabriano on the decoration of the Doge's Palace in Venice, and earlier he may have been his

pupil. It is said that Pisanello participated in the "Adoration of the Magi" at the Uffizi (ill. p. 54), bathing painting the horses and other animals. It is certain that he assisted Fabriano with the frescos in the Lateran Basilica in Rome and completed them after Fabriano's sudden death. A large number of drawings survive of both masters, which in itself is remarkable for the time, but more important are the conclusions to be drawn from these about their work. They show an intense interest in the study of nature, such as animals and plants, and other subjects or observation, whether it be a hanged man or a bathing girl. There is in addition a new preoccupation with Antiquity, which led to copying Roman sarcophagus reliefs and statues. The collection also includes copies made of contemporary works, such as those by Michelino da Besozzo and Altichiero, and by the Tuscan innovators Donatello, Fra Angelico and Luca della Robbia. Pisanello received commissions from most of the northern Italian noble families, including the Gonzaga in Mantua, the Este in Ferrara and the Malatesta in Rimini, and

also from King Alfonso of Naples. But he never be-

came dependent on any of these patrons. He was

closeness to nature, and his fame continued even

after the new Florentine art had become dominant.

greatly admired for his animal drawings and

Illustrations: The Vision of St Eustace, c. 1435 51

Portrait of Lionello d'Este, 1441 (?) 52

The Virgin and Child with Saints George and Anthony Abbot, c. 1445

PISSARRO Camille

1830 Charlotte-Amalie (Antilles) - 1903 Paris As the son of well-to-do parents Pissarro was sent to a school in Passy near Paris from 1842 to 1847. Despite his early promising talent he worked first in his father's business on the island of St Thomas from 1847 to 1852. Finding little fulfilment in the life of a merchant, he left St. Thomas in 1852 and travelled via Caracas to settle in Paris in 1855. There he discovered his great admiration for Corot at the World Exhibition held at that time. From 1859 to 1861 he studied at the Académie Suisse, where he encountered Monet, Guillaumin and Cézanne. This led to a fruitful and life-long friendship with Monet. Like Monet, he escaped the war in France by going to London in 1870/71. There he married Julie. He was particularly impressed with Turner's work. Pissarro was one of the most active members of the Impressionist group, giving his support freely and working together with his

friends. Between 1872 and 1878 he worked at Pontoise, often together with Cézanne, and from 1879 also with Gauguin. He was the only painter who participated in all eight Impressionist Exhibitions between 1874 and 1886. He received some financial support from Murer, a café proprietor, during the years 1876-1879.

From 1882 to 1884 he lived at Osny, and around this time produced a series of pictures of peasant life and began to become interested in Socialism. In 1883 he had his first one-man-exhibition at Durand-Ruel. His son Lucien, a graphic artist and painter, moved to London. In 1884 he settled permanently in Eragny on the river Epte, his political views shifting towards anarchism. In 1886 he exhibited at Durand-Ruel in New York. His sight began to fail in 1888. In 1889 he was represented at the Paris World Exhibition and Les XX in Brussels. In 1890 he visited London, later returning several times. In 1894 he was in danger of being arrested as an anarchist and had to flee to Belgium. In 1896 and 1898 he was in Rouen, painting views of the town and harbour and always remaining loyal to the Impressionist school. Between 1897 and 1903 he produced many impressions of Paris boulevards, and also painted in Dieppe and Le Havre. In 1900 he again showed his work at the Paris World Exhibition, finally gaining universal recognition.

Illustrations:

Landscape at Chaponval, 1880 482

Red Roofs (Village Corner, Impression of 496 Winter), 1877

The Old Marketplace in Rouen and the Rue de l'Epicerie, 1898

POLIAKOFF Serge

1900 Moscow - 1969 Paris

Poliakoff left Russia in 1918 during the revolution, settling in Paris in 1923, where he studied music and earned his living as a guitarist. He began to study art in Paris in 1929/30, first at the Académie Frochot, then at the Académie Bilbul and the Grande Chaumière. From 1935 until 1937 he studied at the Slade School of Art in London. On his return to Paris he became acquainted with Kandinsky. Sonia and Robert Delauny and Otto Freundlich. He was granted French citizenship in 1962. Poliakoff developed a very personal variant of abstract painting. In the 1940s his handling of colour was discreet and calming. This was followed by a period when he coloured his irregular, adjoining fields with great intensity, provoking a reaction of keen fascination. Initially he had to support himself by working as a textile designer, but from 1950 onwards he found wide recognition as a painter. Illustration.

637 Composition, 1959

POLKE Sigmar

born 1941 Oels (Lower Silesia)

Polke's family moved to Germany in 1953. He was trained as a stained glass artist, then studied at Düsseldorf Academy with Karl Otto Götz, Gerhard Hoehme and Beuys from 1961 to 1967. Polke's work is concerned with the effects of manipulation by the mass media. He treats the subject ironically, applying the painterly devices of classic modern painting, but also using materials of the sub-culture. He delights in exploring motifs taken from Picabia, side by side with kitsch and advertising. His pictorial world is tending increasingly towards the magical and diabolical, which is further emphasised by his skilled use of chemical agents which cause gradual colour changes due to environmental influences. Illustration:

Remingtons Museums-Traum ist des Besuchers Schaum, 1979

POLLAIUOLO Antonio del (Antonio di Jacobo d'Antonio Benci)

1432 Florence - 1498 Rome Trained as a goldsmith, then probably the pupil of Donatello, Pollaiuolo was one of the most versatile talents to exercise influence on the future development of 15th century Florentine art. The moving physical form in space was a subject he explored as a sculptor in bronze, and as a painter, engraver and draughtsman. The aim was no longer to produce a vigorously modelled, polychrome "statue", but sculpture in the round. His small bronzes in particular became desirable objects for collectors, a field which he helped to open up. But his talent for small-format work, applying his early training in the goldsmith's workshop, was an expression of only one aspect of his skill. His artistic development culminated in his two great monuments for St Peter's in Rome (Popes Sixtus IV, completed 1492, and Innocent VIII, completed 1496). While the figures in relief are reminiscent of the northern Schongau school in the handling of contour and drapery, the figure of Innocent, reaching far out into space, does not appear old-fashioned today in the vicinity of Lorenzo Bernini's Baroque monuments. His younger brother Piero (1443–1496) worked alongside Antonio in the Pollaiuolo workshop. From 1460 Antonio also turned to painting, engaging in themes similar to those of his sculp-

Illustration:

ture

103 The Martyrdom of St Sebastian, 1475

POLLOCK Jackson

1912 Cody (Wyoming) – 1956 Easthampton (New York)

Pollock grew up in California and Arizona. From 1928 to 1930 he studied at the Manual Arts High School in Los Angeles and from 1930 to 1933 in New York. There he met Thomas Hart Benton, the most important representative of American Scene painting, with whom he painted murals. He also took part in the US government programme for wallpainting from 1936 to 1943. In 1939 Pollock received psychiatric treatment for his alcoholism and this led him to study the works of C.G. Jung, and he became particularly interested in his theory of archetypes. In 1942 he met Motherwell, the most important exponent of abstract Expressionism, and the Surrealist painter Matta. He occupied himself with the unconscious in art, and began to write Surrealist poems. His early work was abstract with elements of primitive, mostly Indian, art in stylised form. In 1945 Pollock married the painter Lee Krasner. A year later he began to develop a completely new style. With this he made a name for himself, becoming a key figure in American painting. Long before this his work had shown that he was turning away from the conventional use of brush and easel. This he finally achieved with his "drip painting" The canvas is placed on the floor, and paint is dribbled and splashed over it spontaneously from perforated cans. An inner tension or relaxation, a psychic automatism determines the speed, the rhythm, the action. With this, Pollock achieved the high point of his expressive energy. In 1943 he had his first one-man exhibition in New York. In 1956 he died in a car accident.

Illustrations:

619 Painting, 1948

632 Blue Pole, 1953

PONTORMO

(Jacopo Carrucci da Pontormo)

1494 Pontormo (near Empoli) – 1556 Florence Pontormo can be regarded as one of the most interesting figures in 16th century Italian art and also as an exponent of Florentine Mannerist painting. Like Rosso Fiorentino, a pupil of del Sarto, his early work still reflected the High Renaissance, apart from increased movement (fresco of the "Visitation" in the forecourt of Saint Annunziata, Florence, 1514–1516). In subsequent years Pontormo abandoned this style, with its balanced composition, logical construction, idealised figure representation and clear coloration ("Sacra Conversazione", Florence, San Michele in Visdomini, 1518).

Pontormo's fresco cycle in the cloister of Certosa di Galluzzo near Florence, 1530, draws on an intensive study of Dürer's graphic art. Then, in the following period, Pontormo increasingly set out to portray movement in all its forms and directions ("Visitation", Carmignano parish church, near Florence). By distortion of the ideal physical proportions elongated figures with small heads - exaggerated perspective and use of relatively harsh, vivid colours, he transposed traditional pictorial themes into a new sphere in some respects related to medieval art. His late works, particularly in the rendering of figures, strongly reflect Michelangelo's influence, whom he met around 1530 in Rome. A favourite of the Medici, he carried out much important fresco work, which has, however, not survived. Pontormo's portraits belong to the greatest achievements in this field in Florentine painting.

Illustrations:

155 Joseph in Egypt, c. 1515

181 Deposition, c. 1526–1528

POST Frans

1612 Leiden – 1680 Haarlem

Post is unique amongst Dutch painters in that he depicted almost exclusively Brazilian landscapes, being the first European to paint views of South America. From 1637 to 1644 he accompanied Prince Johann Moritz von Nassau-Siegen, the governor of the region colonised in 1630 by the Dutch West India Company. Post spent most of the time in Pernambuco and the delta region of the Rio São Francisco. On his return to Haarlem, where he became a member of the Lukas Guild in 1646, he painted about a hundred pictures of his impressions of his travels, using his sketches and drawings, and also improvising from memory. These works were exotic views of grey rivers coursing through green, hilly landscapes, with realistic renderings of the flora and fauna, and natives in traditional costume in their villages under palm trees. A bluish-green tone predominated, and he retained the traditional pattern of Dutch view painting.

Illustration:

318 Hacienda, 1652

POTTER Paulus

1625 Enkhuizen – 1654 Amsterdam Potter was probably trained by his father Pieter, a landscape and still life painter, who had moved from Enkhuizen to Amsterdam. He became a member of the Delft Lukas Guild in 1646, lived sporadically in The Hague, but the last two years of his life again in Amsterdam. Potter is famous for his animal pictures, mostly sheep, goats and cows grazing peacefully and in complete harmony with the landscape. He is regarded as the actual founder of animal painting, in that his animals become the subject rather than playing an incidental role. His lifesize "Bull" (The Hague, Mauritshuis) is still admired today. Although a painter of realism, he also adopted elements of Italianised pastoral landscape, probably attributable to his collaboration with Karel Dujardin.

Illustration:

324 Peasant Family with Animals, 1646

POUSSIN Nicolas

c. 1593/94 Villers-en-Vexin (Eure) - 1665 Rome The son of an impoverished family, Poussin received some early training from the painter Varin, who was travelling through his town. More thorough training followed in Paris, 1612-1624, as assistant to Champaigne and pupil of the Mannerist Lallemand, reinforced by independent study of predominantly Italian art in the Royal Collections. After several unsuccessful attempts, he finally went to Rome in 1624 with his patron and supporter Marino. The latter was a celebrated poet who introduced Poussin to ancient mythology and Ovid's works. Marino wrote an epic entitled Adone (1623) which was illustrated by Poussin. In Rome he worked for some time with Domenichino and developed his own style by exploring and perfecting Annibale Carracci's ideas on classical landscape

Already in his thirties, his palette became lighter and he showed a tendency to poetical and idealised representation of subjects from Antiquity and the Bible ("The Inspiration of the Epic Poet", Paris, Louvre, 1630; "Martyrdom of St Erasmus", Rome, Musei Vaticani, 1629). His knowledge of the literary and pictorial traditions of Antiquity and of the Renaissance, and his contact with contemporary intellectuals, plus his knowledge of history, all combined to turn Poussin into the prototype of a Classical painter. With his Arcadian yearnings, his idealisation of friendship and manly virtues, and his predilection for sentimental resignation, he set a course for the moral and doctrinal tendencies of future generations of painters. During a brief stay in Paris, 1640-1642, he painted the Hercules scenes for the Louvre at the invitation of Richelieu and Louis XIII. Finding the artistic climate unfavourable, he returned to Rome and friends such as Dughet and Lorrain, and never left the city again. Illustrations:

- Triumph of Neptune and Amphitrite, 1634
- 245 Midas and Bacchus, c. 1630
- 245 Landscape with Three Men, c. 1645-1650
- 246 Echo and Narcissus, c. 1627/28
- 246 Moses Trampling on Pharaoh's Crown, 1645
- 247 St Cecilia, c. 1627/28

PRENDERGAST Maurice Brazil

1859 St. John's (Newfoundland) – 1924 New York

Prendergast initially supported himself by working as an advertisement painter in Boston, attending evening classes at the Star King School. In 1886/87 he visited England, then went to France from 1891 to 1894. In Paris he met Whistler, Manet and Bonnard, who all influenced him greatly. He was also impressed by the Nabis group and, like many contemporary artists, by Japanese woodcuts. Prendergast was one of the first American artists to discover and admire Cézanne. In 1894 he returned to Boston, painting the surrounding scenery. A second visit to Europe from 1898 to 1900 also took him to Italy, where he spent most of his time studying the old masters in Venice. Back in America he often visited New York in search of inspiration, painting in a serene, late Impressionist style. In 1908 he exhibited with The Eight group. In 1909/10 he was again in Paris, and on his return worked during successive summers on the New England coast. In 1913 he participated in the legendary Armory Show in New York, where he finally settled a year later. As a committed Impressionist and Post-Impressionist, Prendergast was one of the painters who pioneered this style in the USA.

Illustration:

541 Ponte della Paglia in Venice, 1899

PRETI Mattia

(called: Il Cavaliere Calabrese) 1613 Taverna (Calabria) – 1699 Valletta (Malta) Preti joined his brother in Rome in 1630. He probably studied in Modena, Parma, Bologna and Venice until 1641, when he returned to Rome to become a member of the Maltese Order. Initially influenced by the Roman High Baroque, including Lanfranco and Cortona ("Alms-Giving of St Charles Borromeo" for San Carlo ai Cartinari, c. 1640), he developed a vigorous style of his own which reflected the influence of Guercino combined with a Venetian treatment of colour, as shown in his frescos in Sant' Andrea della Valle (1651) and San Biago (Modena, 1653-1656). Between 1656 and 1659 Preti produced votive pictures against the Plague in Naples, using sombre colours which show his great skill at rendering the human figure. "Absalom's Feast" (Naples, Galleria Nazionale, before 1660) and "Belshazzar's Feast" (also Naples, before 1660) typify Preti's complicated method of composition and his startling light effects. Preti spent his last years as a Knight Hospitaller in Malta where he achieved a most touching depiction of human deeds and sufferings with his "Scenes

from the Life of St John the Baptist" for San Gio-

vanni (Valletta). *Illustration:*

237 The Tribute-Money, c. 1640

PRUD'HON Pierre Paul

1758 Cluny - 1823 Paris

Prud'hon began his career as painter at the Dijon Academy under François Devosge and continued his studies at the Paris Academy. In 1784 he won the Prix de Rome, which took him to Italy from 1785 to 1788. Although this coincided with David's triumphs in Rome, he remained unimpressed by this painter's Neo-Classicism. He became a friend of the sculptor Antonio Canova and studied the art of Antiquity. The masters of the Renaissance, in particular Leonardo and Correggio, were to become his greatest influence. On his return to France he settled in Paris, supporting himself with the sale of his drawings and miniature paintings. His first important commission came in 1798 for a ceiling painting in the palace of Saint-Cloud. This was followed by similar orders with allegorical themes. The Empress Joséphine was his most influential patron, and Prud'hon became the portrait painter of the royal family. Napoleon's second wife, Marie-Louise, also admired him, securing many commissions for him and employing him as her drawing-master. In the prevailing austere Neo-Classical atmosphere he occupied a rather isolated position, yet his sensitive handling of colour and composition helped to usher in Romanticism.

Illustration:

423 Empress Joséphine, 1805

PUCELLE Jean

active between 1319 and 1335 in Paris
This greatest of illuminators at the French court
was probably trained in the workshop of Maître
Honoré of Amiens, perhaps already working there
around 1315. The first written record is a money
order from between 1319 and 1324 for the design
of a seal of the Brotherhood of the Hospital St.
Jacques aux Pélerins in Paris. The master is mentioned in small signatures as well as inventory
notes. In the Duc de Berry's inventory Jeanne
d'Evreux's book of hours is recorded as Heures de
Pucelle. In those days, naming the book after the
artist was a great honour. Pucelle's style was carried on by his assistants almost until the end of
the 14th century, and often copied at the request
of King Charles V and also of the Duc de Berry.

The artist must have visited Italy around 1320 judging by his thorough knowledge of Duccio's works and his use of motifs taken from Giotto and other Italian painters.

Illustration:

43 The Betrayal of Christ and The Annunciation (from the Book of Hours of Jeanne d'Evreux), between 1325 and 1328

PUVIS DE CHAVANNES Pierre

1824 Lyon - 1898 Paris

Puvis came from a family of the old gentry. After studying law, he went to Paris where he was trained in the studio of Henri Scheffer, and later under Thomas Couture. Like Moreau, he was influenced by the works of Chassériau. He had his first success at the Salon in 1850, but it took nine further years to have another picture accepted. In 1854/55 he received his first commission for a fresco painting, and decorative, monumental works in this field were to become his speciality. Many of these were not easily accessible, which for a long time prevented proper appreciation of his work. His manner of painting, too, was an obstacle initially. He did not follow the Impressionists, nor did his work come into the category of history painting. His pictures showed a strict linear ordering with simple colour-areas. His choice of subjects allows us to place him as a Symbolist, as he preferred allegorical themes as well as religious and historical subjects with classical figures and poses. In 1887 he had his first large exhibition at Durand-Ruel; in 1890 he became cofounder and in 1891 chairman of the Société Nationale des Beaux-Arts which supported the causes of French artists.

Illustration:

509 The Poor Fisherman, 1881

QUARTON Enguerrand

(also: Charonton, Charton, Charretier) c. 1410 Diocese of Laon - 1461 or later Avignon (?) No other work in European painting of the Early Renaissance has presented as many research problems as the large panel painting of the "Pietà" (ill. p. 139). This work came from Villeneuve-lès-Avignon and was rediscovered at the "Les primitifs français" exhibition in Paris in 1904. In an endeavour to place this work, it has been attributed to various artists, including to the Catalan master Bartolomeo Bermejo and the great Portuguese painter Nuño Gonçalves. The painting cannot be compared with any other work from around 1450-1460, with its utter lack of physical effect and the depth of emotion shown in the faces and gestures of the figures, each seemingly isolated in their own grief. It must be assumed that the painter knew Italian art (unity of composition), Catalan painting (ascetic severity of the heads), and also Dutch works (precision of detail). Only in recent times has it been possible to attribute the work to Quarton, a major master of the Avignon school. Records show that he lived in Aixen-Provence before 1440 and from 1447 to 1466 in Avignon. In collaboration with Pierre Villate he painted the "Madonna with the Mantle" in 1452 (Chantilly, Musée Cluny) and around 1453/54 the "Coronation of the Virgin" (ill. p. 139)

- 139 Coronation of the Virgin, c. 1453/54
- 139 Pietà, c. 1460

RAPHAEL

(Raffaello Santi)

1483 Urbino – 1520 Rome

Raphael's fame as the greatest painter of the Western world will continue despite certain dectracting voice which made themselves heard at the beginning of the 20th century. He began his apprenticeship with his father Giovanni, learning basic manual skills, but would have had greater artistic and educational benefits from the circle surrounding the court of Montefeltre. Fundamental to his development was his training under Perugino, whom he later assisted. Here Raphael learned the art of composition and gained the knowledge which enabled him to merge landscape and figure sensitively, and so develop the dreamy sensitivity of expression so characteristic of his work, particularly of his Madonnas.

His move to Florence in 1504 at the age of 21 marked a decisive period in his stylistic development. There a large field of artistic possibilities open to him, particularly with regard to design and form, which he was capable of assimilating within a few years. Figure and space were at the heart of his learning. Raphael had an extraordinary power of assimilation without falling into the trap of eclecticism. In exploring the works of the past and present he only adopted such elements which served to perfect his own original artistic personality. Already in 1508 his fame began to spread when Pope Julius II called him to Rome for the decoration of apartments at the Vatican. His fellow countryman Donato Bramante, who was engaged in the rebuilding of St Peter's, may have helped to secure this commission. His first large work in the Stanza della Segnatura (1509-1512, ill. p. 172) already shows his personal conception of design and form with figures combining statuesque dignity with freedom of movement. However, with his decoration of the Stanza d'Eliodoro (1512-1514) he achieved further heights in dramatic expression, suggestion of depth and colour modulation (the "Liberation of Peter" is the first large "night picture" of European art). Raphael crossed the border between High Renaissance and Mannerism as demonstrated in the large panel paintings of his late period ("Sistine Madonna", Dresden, Gemäldegalerie, 1512/13; group portrait "Pope Leo X with Cardinals Giulio de' Medici and Luigi de' Rossi", ill. p. 151; "Transfiguration", ill. p. 172).

The large number of commissions for fresco cycles (Loggias at the Vatican, Farnesina) and other works resulted in the organisation of a large workshop. Of great importance for Raphael's work was his contact with Antiquity while in Rome (in 1514 he was appointed prefect of the Roman antiquities). His significance as an architect can now only be traced in outline. In 1514 he became chief architect of St Peter's; in 1515/16 he built the Palazzo Madama in Rome and designed the Palazzo Vidoni-Caffarelli, also in Rome (1515) as well as that of the Pandolfini in Florence (1517-1520). In just two decades of creativity Raphael's work made unique, influential history, outgrowing the 15th century, leading the High Renaissance to its peak and finally paving the way for Mannerism, often leaping ahead to the Baroque.

Illustrations:

- Pope Leo X with Cardinals Giulio de' Medici and Luigi de' Rossi, 1518/19
- 170 Madonna of the Meadows, 1505/06
- 171 Marriage of the Virgin (Sposalizio della Vergine), 1504
- 171 Madonna di Foligno, c. 1512
- The Transfiguration, c. 1517–1520
- The School of Athens, 1511/12

RAIGERN ROAD TO CALVARY → Master

RAINER Arnulf

born 1929 Baden (near Vienna) Rainer studied from 1947 to 1949 in Villach at the Staatsgewerbeschule. In 1950, after one day's attendance, he left the College of Applied Arts in Vienna, and after only three days Vienna Academy. His early work was inspired by Surrealism. From 1951 he gave up figurative representation, after exploring Expressionism and Tachism. During the next two years he produced his "atomisations" which dissolved surface and form, and "blind drawings". From 1953 he developed his "overpaintings" which came to form the basis of his work. Around 1964 he painted pictures after experimenting with hallucinogenic drugs. Rainer also visited psychiatric clinics for inspiration, his aim being to fathom the depths of his personality through art. Since 1969 he has been using photographs of himself for his overpaintings. Subsequently he used prints of old masters, and since 1977 pictures of death-masks and faces. In the 1080s he returned to religious subjects and produced a series of crucifixions and pictures of martyrs, angels and of catastrophies. Illustration:

667 Zünglein ohne Waage (Tongue that tips no scales), 1975

RATGEB Jörg

c. 1480 Schwäbisch Gmünd – 1526 Pforzheim Nothing is known about Ratgeb's early life and training. He was one of the most unconventional artists during the Dürer period and was evidently inspired by Grünewald. As a journeyman he went to Flanders and northern Italy, as shown by the handling of colour and composition of his first authenticated work (Catherine Altar in the parish church of Schwaigern, 1510). From 1514 to 1517 Ratgeb painted in the cloisters and refectory of the Carmelite monastery in Frankfurt/M one of the most important fresco cycles of the time, with scenes from salvation history (severely damaged in 1944). Ratgeb's predilection for foreshortening and for exaggerated figure movement is most marked in the Herrenberg Altar (ill. p. 198). During the Peasants' Revolt he vigorously supported the side of the peasants and was executed in 1526. Illustration:

198 The Flagellation of Christ, 1518/19

RAUSCHENBERG Robert

born 1925 Port Arthur (Texas)

Rauschenberg had a thorough education and was trained in Kansas City, in Paris, and from 1948 to 1949 by Albers at the Black Mountain College, where he himself taught in 1952. There he organised "happenings" with John Cage, Merce Cunningham and David Tudor. Motherwell, Kline and Jack Tworkov also taught at the College. A likeminded artist friend was Jasper Johns, and their studios were in the same building from 1955 to 1960. After producing a series of black and white pictures, he began in 1953 to make his "combined paintings" which incorporated pictorial elements, whole and fragmented objects. He also produced collages and material assemblages. The pictorial parts are Action paintings, but the realistic objects lead away from the abstract. Rauschenberg has been one of the major influences on American Pop Art. From about 1970 he has been working with cardboard with which he entered the field of Minimal Art. In the 1980s he produced sculpture from scrap metal and pictures etched with acid on metal plates. In 1966 he founded with the engineer Billy Klüver the company "Experiments in Art and Technology" (E.A.T.). Since 1984 he has been working on the project entitled "Rauschenberg, Overseas Cultural Interchange" (ROCI), which provides work for artists worldwide. He also travels with dance and theatre groups for whom he produces sets.

Illustrations:

657 Charlene, 1954

657 Trophy I, 1959

RAY Man

(Michael Radnitzky?)

1890 Philadelphia - 1976 Paris

As one of the most imaginative exponents of Dadaism, Ray was a man of many talents: sculpture, photography, film, literature, architecture. He frequented the avant garde circles in New York, in particular the Gallery Stieglitz. After meeting Duchamp and Picabia in 1915, he devoted himself to Dadaism, taking part in the manifestations and exhibitions in New York from 1916 to 1921 and the publications "391" and New York Dada. He followed Duchamp to Paris in 1921, joining the circle around Tristan Tzara, Breton and Picabia. He experimented in the fields of photography and film, and produced collages and other artefacts. Later he joined the Surrealists, becoming their "official" photographer, and also returned to painting. From 1940 to 1951 he worked in Hollywood. He then returned to Paris.

Illustration:

The Rope Dancer Accompanies Herself with her Shadows, 1916

RAYSKI Ferdinand von

(Louis Ferdinand von Rayski) 1806 Pegau (near Leipzig) – 1890 Dresden Rayski was the son of an aristocratic cavalry officer and received a corresponding education. From 1823 he attended the Dresden Academy. A visit to Paris in 1834/35, where he became most enthusiastic about the works of Géricault, was decisive for his development. Subsequently he devoted himself to painting equestrian subjects and battle scenes in a free, pasto manner. He also painted portraits of the Saxon and Prussian landed gentry on whose estates he was a frequent visitor. From the 1850s Rayski was the first German portrait painter to use colour as a determining device rather like the early Impressionists, subordinating form and giving preference to tones of grey, black and brown. He is noted for his sensitive portrait studies

Illustration:

460 Portrait of a Young Girl, c. 1840

REDON Odilon

(Bertrand-Jean Redon)

1840 Bordeaux – 1916 Paris Until the war of 1870/71 Redon lived in Bordeaux. The son of a well-to-do explorer and a Creole mother, he was delicate, sensitive and introverted. As a child he loved drawing and reading. The botanist Armand Clavaud, whom he met when he was fifteen, introduced him to contemporary art and biology. He became strongly influenced by Rembrandt and made his first etchings, of which he sent a sample to the Salon in Paris in 1867. After 1870 he lived mostly in Paris, where he met Corot and Courbet and he greatly admired Delacroix. He often went to the Louvre with Fantin-Latour to copy works. Through Fantin-Latour he developed an interest in lithography, and in 1879 his first series of lithographs, entitled "Dreaming", appeared. The fantastic and dream-like was to become the theme of his work, which was strongly rooted in Symbolism. The writer Joris-Karl Huysmans greatly admired Redon's art and described his graphic works and those of Moreau in his controversial fin-de-siècle novel A Rebours. Durand-Ruel showed Redon's work in his gallery, and in 1884 Redon became a cofounder of the Salon des Indépendants, contributing to its first exhibition. In 1886 he took part in the eighth Impressionist exhibition and also exhibited with Les XX in Brussels. He was on friendly terms

with the Nabis group and with Gauguin, as well as

with the writers Mallarmé, Gide and Valéry. Hav-

ing until then published mainly lithographs, he

started in the 1890s to produce paintings. He worked a great deal in pastels, and his pictures display a colouring which is delicately muted but nevertheless intensive. From 1900 until his death he lived quietly in Bièvres near Paris. Illustration:

513 Still Life (Flowers), c. 1910

REINHARDT Ad

1913 Buffalo (New York) - 1967 New York After studying art history at Columbia University in New York under Meyer Schapiro from 1931 until 1937, Reinhardt attended for two years the National Academy of Design. From 1937 to 1947 he was a member of the American Abstract Artists group. During the war he worked as an art critic on a New York paper and served as a marine photographer. After the war he continued his studies of art history, specialising in Far Eastern art. From 1947 he taught at Brooklyn College and numerous other American educational institutions. He travelled widely in the 1950s and 1960s, visiting Europe and Asia. As an extension to Mondrian's abstract art, he attempted to achieve a purely self-sufficient art with a minimum of devices, terminating in his pictures of black squares in which slight shading can only be detected after prolonged observation. As both an artist and critic of contemporary art and a writer on the avant-garde, Reinhardt exercised considerable influence on many artists of the 1960s and 1970s. Illustration:

648 Red Abstract, 1952

REMBRANDT

(Rembrandt Harmensz van Rijn) 1606 Leiden - 1669 Amsterdam Rembrandt, the son of a miller and a baker's daughter, was originally intended to become a scholar. He went to Latin School and then enrolled at the University of Leiden. After only a year he left to become apprenticed from 1622 to 1624 to a mediocre Leiden painter, Jacob van Swanenburgh. More important for his artistic development, however, was the short period of about six months that he spent training under Pieter Lastman in Amsterdam. In 1625 he began a working association with his friend Jan Lievens in Leiden, finally moving to Amsterdam in 1631/32. In the history of Dutch painting this date represents an important milestone, as Rembrandt was to become the incomparable representative of Amsterdam art. He soon established himself in Amsterdam, received many commissions and opened a large workshop. In 1634 he married Saskia, a lawyer's daughter, who brought a considerable dowry into the marriage. In 1639 he bought a large house, never quite paid for, which he filled with works of art and curios. Soon his passion for collecting exceeded his finances. In 1642, the year he painted "The Night Watch" (ill. p. 313), Saskia died, and from 1649 he lived with Hendrickje Stoffels whom he could not marry without losing Saskia's legacy to their son Titus. In 1656 he went bankrupt, and his house and all possessions were put up for compulsory auction. Rembrandt spent his final years in poverty and isolation in rooms on the outskirts of Amsterdam, his powers of creation undiminished.

Rembrandt was the most universal artist of his time and he influenced painting for half a century, irrespective of schools or regional style. From his many fields of activity his pupils developed their own specialities, ranging from trompe l'æil painting to the very detailed Leiden style. Unlike most Dutch painters of the time, who worked in fairly narrow fields, Rembrandt depicted almost every type of subject. Although Amsterdam's leading portraitist for a decade ("Jan Six", Amsterdam,

Foundation Six), also doing group portraits ("The Staalmeesters", ill. p. 316), he was a painter of numerous biblical scenes ("The Sacrifice of Isaac". St Petersburgh, Hermitage), of mythological works ("Philemon and Baucis", Washington, National Gallery) and landscapes ("Landscape in Thunderstorm", Brunswik, Herzog-Ulrich-Museum) as well as still lifes ("The Slaughtered Ox", ill. p. 315). In his work, branches of painting often overlapped, as for example in the group portrait "The Night Watch", where he took liberties with a number of rules.

Rembrandt's fame rests on his continual development of pictorial devices and unvarying excellence of execution (unlike the works of Rubens, many of which were left in part to workshop routine), as well as on his brilliant handling of light and shade and his ability to suggest states of mind through facial expression.

Apart from his greatness as a painter he was a powerful draughtsman and etcher. About 300 of his etchings survive. In this field he extended the technical and artistic possibilities, for example introducing the chiaroscuro effect, raising it to an art form in its own right. Amongst his approximately 1500 drawings, the landscape scenes are particularly captivating in their serenity and harmony despite the spontaneous handling of line.

Illustrations:

276 Self-Portrait with Stick, 1658

- The Artist in his Studio, c. 1626-1628 312
- The Anatomy Lesson of Dr. Nicolaes Tulp, 312 1632
- The Night Watch, 1642 313
- Self-Portrait aged 63, 1669
- The Descent from the Cross, 1633 315
- The Slaughtered Ox, 1655 315
- The Syndics of the Amsterdam Clothmakers' 316 Guild, 1662
- Aristotle Contemplating the Bust of Homer, 1653

RENI Guido

1575 Calvenzano – 1642 Bologna

The son of a musician, Reni was also musically gifted, but began his training as a painter at the age of nine in the workshop of Calvaert, then at thirteen in that of the Carracci brothers. In 1598 he was already involved in the façade decoration of the Palazzo Pubblico in Bologna. He went to Rome with Albani in 1602; he returned to Bologna and again left for Rome in 1605, where he was to spend many years. His patron Cardinal Caffarelli-Borghese secured innumerable commissions for him, causing him to employ assistants. Later, he went in for mass production to pay for his passion for gambling.

In 1622 he returned to Bologna and became the leader of the Bolognese school on the death of Lodovio Carracci. In early works, such as the "Coronation of Mary, with Saints" (Bologna, Pinacoteca Nazionale, 1595), Reni combined Mannerist and also northern elements with those of the Roman High Renaissance, that had been revived by the Carracci. The "Crucifixion of St Peter" (Rome, Pinacoteca Vaticana, 1603) may be seen as an example of his Caravaggist period, which was followed by the development of a personal style around 1608 (Samson frescos, Vatican). His most celebrated work, "Aurora", a ceiling fresco in the Palazzo Rospigliosi, 1612–1614, combines a clear palette and harmonious composition with masterly figure representation. His Madonna pictures (e.g. "Madonna del Rosario", Bologna, Pinacoteca Nazionale), to which Reni owed his fame in his lifetime and until the 19th century, no longer appeal today with their grand and monumental perfection. Illustrations:

- The Massacre of the Innocents, 1611
- The Baptism of Christ, c. 1623

RENOIR Pierre-Auguste

1841 Limoges - 1919 Cagnes-sur-Mer (near Nice) The son of an impecunious tailor, he moved with his family to Paris in 1844. He was apprenticed as a painter to a Paris porcelain-maker, 1854-1858, and then painted fans and blinds. From 1860 to 1864 he studied painting under Gleyre and at the Academy, where he met Bazille, Monet and Sisley who became life-long friends. The young painters worked together, copied the old masters in the Louvre, or painted at Barbizon in the open. Renoir exhibited at the Salon in 1864 and 1865, but was rejected by the Salon in 1866 and 1867. Together with Monet he stayed in 1867 with Bazille, with whom he shared a studio between 1868 and 1870, frequented the Café Guerbois and met Manet. When living in Bougival in 1869, he developed with Monet the Impressionist manner of painting. Subsequently he went to paint with Monet in Argenteuil and took part in the first three Impressionist Exhibitions, 1874-1877, and showed his work at the Salon, 1878-1881.

In 1880 he met his future wife, Aline Charigot. He broke his right arm and painted with his left hand. In 1881 he visited Algeria, and later went to Italy. In 1882 he painted a portrait of Richard Wagner in Palermo and visited Cézanne in L'Estaque. Visits to Jersey, Guernsey and the Côte d'Azur followed. His work was now sometimes characterised by firmly outlined, rounded figures. In 1886 he exhibited with the Les XX group in Brussels, also in New York through Durand-Ruel, and at G. Petit in Paris, but refused to show his work at the Paris World Exhibition in 1889. He married Aline in 1890, with whom he was to have three sons. During this period he returned to painting in intense colours and loose brushwork, producing mainly nudes and landscapes. For the first time in 1892 the French nation bought one of his pictures, in a transaction arranged by Mallarmé. Visits to Spain and Brittany (Pont-Aven) followed. In 1894 Renoir was executor of Caillebotte's will in which he left his collection of Impressionist paintings to the nation. During a visit to Germany he visited Bayreuth and Dresden in 1896. He again broke his arm when he fell off his bicycle in 1897. In 1808 he visited Holland. He began to suffer from rheumatism, and after 1899 spent much of his time in southern France. In 1900 he was represented in the centenary exhibition of French art at the Paris World Exhibition, and was made a Knight of the Grand Cross of the Legion of Honour. His work was also increasingly shown abroad. During this time his health deteriorated further, his hands becoming crippled with gout. In 1904 he bought the house "Les Colettes" in Cagnes. A retrospective of his work was held at the 9th Biennale in Venice in 1910. During that year he visited Munich. In 1911 he was made an Officer of the Legion of Honour. In collaboration with R. Guino he began to produce sculpture in 1913. In 1919 he became Commander of the Legion of Honour and one of his paintings was hung in the Louvre.

Like Monet, Renoir delighted in painting family scenes and depicting life in the city and the country. Pure landscapes were unusual for Renoir; his main interest was in people, and women held a special fascination for him. He also produced still lifes and portraits. Although he adopted the broken brushwork of the Impressionists, his works had a character of their own, distinguishing themselves from those of Monet, Sisley and Pissarro though their gaiety and brilliance of colour. *Illustrations:*

477 The Swing, 1876

484 Two Girls, c. 1881

502 The Painter Sisley and his Wife), 1868

502 Bal au Moulin de la Galette, 1876

503 La Première Sortie (The First Outing), c. 1876/77

504 On the Terrace, 1881

504 Bather with Long Blonde Hair, 1895

REPIN Ilya Yefimovich

1844 Tschuguev (Ukraine) – 1930 Kuokkala (Finland)

Repin was trained as an icon painter. In 1863 he came to St Petersburg where he studied at the Academy of Fine Arts for six years, gaining the Grand Gold Medal. In 1873 his picture "Volga Tower" was shown in Vienna at the World Exhibition. With a scholarship he travelled in Italy and France, 1873-1876, and then lived in Moscow from 1877 to 1882 before returning to St Petersburg, where he met Tolstoy. In 1894 he accepted a professorship at the Academy, and became rector in 1898/99. From 1878 to 1891, and again from 1897, he was a member of the "Wanderers" whose aim was to take art to the outlying regions of Russia. Repin specialised in genre pictures and portraits, the former having an overtone of social criticism. After his West European tour with Stassov in 1883 he adopted Impressionistic elements. In 1887 he visited Italy and Germany, and the Paris World Exhibition in 1889. Further travels took him to England, Germany and Switzerland, later to Constantinople and Jerusalem. He bought a house in Kuokkala; there were signs of paralysis in his right side. In 1900 he was again in Paris, acting as juror at the Paris World Exhibition and becoming a member of the Legion of Honour. In 1917 he retired to Kuokkala, which had by then become part of Finland. Repin was noted for his portraits; he painted many of the distinguished Russian personalities of his time. The inspiration received from Courbet and the Impressionists did not find entry into his work until late in his life.

Illustrations:

Zaporozhian Cossacks (sketch), c. 1878

542 Portrait of Vera Alekseevna Repin, 1882

REYNOLDS Joshua

1732 Plympton (Devon) - 1792 London Reynolds was the son of a clergyman and was sent at the age of seventeen to study under the popular portrait painter Thomas Hudson in London. For some years he worked in his teacher's somewhat dry style in Plymouth, London and Devonport. His meeting with William Gandy (Gandy of Exeter) inspired him to adopt a new technique and a more fluid style, probably influenced by his study of Rembrandt. He went to Rome via Lisbon and Algeria with his patron Admiral Keppel, where he was particularly impressed by the works of Raphael and Michelangelo. Here he produced his famous "Caricaturas", portraits of English visitors to Rome. He returned by way of Florence, Parma, Venice and Paris to London, where he settled in 1753. Here he painted a portrait of Keppel depicted in the pose of the Apollo of Belvedere after a shipwreck (Greenwich, National Maritime Museum). Through the use of such citations and dramatic events Reynolds attempted to elevate portraiture to the level of historical painting. In 1768 he was appointed president of the newly-founded Royal Academy. In his Discourses, given annually at the awards ceremony, he presented the theory of the Grand Manner, that art must be more idealistic than realistic. His contact with Gainsborough, who came to live in London in the 1770s, remained loose, probably because of their difference in temperament. His last visit to the Continent in 1781, mainly devoted to the study of Rubens' works, also took him to Antwerp and Düsseldorf, amongst other places. Reynolds, who was knighted in 1769, was one of the

great British painters of the 18th century and influenced generations of portrait painters. *Illustrations:*

346 Portrait of Susanna Beckford, 1756

383 Sarah Siddons as the Tragic Muse, 1784

383 The Infant Samuel, 1776

RIBERA Jusepe de

(also: José de Ribera; called: Lo Spagnoletto) 1591 Játiba (near Valencia) – 1652 Naples In Valencia Ribera was trained by Ribalta, who introduced him to his tenebrism, a technique of painting in a dark, low key, characterised by contrasting use of light and shade. On his travels to Parma, Padua and Rome, Ribera became acquainted with the works of Raphael, Correggio, Titian and Veronese. In 1616 he settled in Naples and developed a style which owed much to Caravaggio. There he became painter to the Spanish Viceroy and later to his successor, the Duke of Monterrey, who procured for him commissions from the Augustine monastery in Salamanca ("Nativity", "Pietà", "The Virgin with Saints Antony and Augustine", 1631-1635). He subsequently abandoned the dark and sombre style, finding new ways of treating light and using brilliant colours (12 pictures of the prophets, Naples, Museo Nazionale di San Martino, 1637/38). His "Boy with a Clubfoot" (ill. p. 259) is typical of his more mature style, both thematically and in terms of pictorial composition. During this period of realism he had a leaning towards harrowing subjects, the crippled and malformed. Italian, Spanish and Flemish painters were engaged in his workshop, and while Ribera was of particular importance to Neapolitan art, great painters, such as Rembrandt and Velázquez, also found him an inspiration. Illustrations:

The Boy with a Clubfoot, 1642

260 Archimedes, 1630

260 Martyrdom of St Bartholomew, 1630

261 St Christopher, 1637

RICHTER Gerhard

born 1932 Waltersdorf (Oberlausnitz) Richter worked initially as a painter of stage sets and posters in Zittau before attending the Dresden Academy, 1952-1955. On moving to West Germany he took up further studies for three years, from 1961, under Karl Otto Götz at the Düsseldorf Academy. Together with Konrad Fischer-Lueg and Sigmar Polke he arranged an "Action" in a furniture store in 1963, proclaiming capitalist realism in the manner of a parody. In 1964 he produced his first works with snapshots and magazine photographs. Richter often copied these in smudged tones of grey in enlarged form, retaining their context. He collected the originals, his own photographs and other pieces used to form an atlas, which has been displayed at exhibitions since 1972. Apart from these works occupying a place between Photo-Realism and Pop Art, he has produced coloured landscapes and cloud pictures, candle still lifes, and also roughly painted aerial views and paintings of RAL colour sample cards. From about 1968 he began to paint mostly large-scale "abstract pictures" based on structural studies, which impress with their colour intensity. He has been teaching at the Düsseldorf Academy since 1971. Illustrations:

627 Ema – Akt auf einer Treppe (Ema – Nude descending a staircase), 1966

673 Untitled, 1984

Mountains (Himalaya), 1968

RICHTER Ludwig

(Adrian Ludwig Richter)

1803 Dresden - 1884 Dresden

The son of a copper engraver, Richter made a name for himself with his woodcut illustrations for books of fairytales, folklore and traditional songs. He began to work in this field in 1838 and retained an interest in it until the end of his life. Initially he wanted to become a landscape painter. This wish was granted in 1823, when he received a scholarship for a visit to Rome offered by the Dresden bookseller Arnold. In Rome he met Koch and the Nazarene group of painters, and produced idyllic Italian landscapes. On his return to Dresden, where he was appointed professor of landscape painting at the Academy in 1836, he continued with this subject, but lack of funds for another visit to Italy caused him to change direction. In search of new themes, he took his students on walking tours along the Elbe valley and through parts of Bohemia, using the studies made on these tours as a basis for his compositions. It appears that here he found what he had expressed in his Italian pictures: a harmonious relationship between man and nature. His last oil-painting dates from 1847. Illustration:

457 Church at Graupen in Bohemia, 1836

RIGAUD Hyacinthe (Jacinto Rigau y Ros)

1659 Perpignan - 1743 Paris

Rigaud's surviving business records reveal that he had an extensive workshop and employed speciality painters for flower decorations, textiles and background battle scenes and landscapes. After his early training in Montpellier and Lyon, Rigaud came to Paris in 1681, where already in 1682 he aroused Le Brun's interest with his historical painting "Cain building the City of Enoch". Le Brun urged him to take up portrait painting, and Rigaud soon became popular, and also known in court circles, where his van Dyck-inspired manner was met with approval under the absolutist monarchy of Louis XIV. Despite the fact that he used assistants, Rigaud proved to be an acute reader of character, as is evident in his portraits of "King Philip V" (Madrid, Prado, 1701) and that of "Elisabeth Charlotte, Duchess of Orléans" (Brunswik, Herzog-Anton-Ulrich-Museum, 1713). In his famous portraits of the "Sun King", however, he showed his mastery as a colourist and ability to satisfy ceremonial demands in pose and expression.

Illustration:

Portrait of Louis XIV, 1701

RIVERA Diego

1886 Guanajuato (Mexico) - 1957 Mexico City Rivera was already studying at the S. Carlos Academy in Mexico City at the age of ten. A scholarship enabled him to visit Europe in 1907 and continue his studies in Madrid and Paris. The works of Cézanne and Picasso inspired him to adopt the Cubist manner. However, a visit to Italy in 1920/21, where he spent several months studying Renaissance fresco painting, caused him to change direction. On his return to Mexico he received commissions to produce large-scale wall paintings. His cycle in the Ministry of Education in Mexico City, 1923-1928, already showed his personal style. His monumental compositions narrate the story of the life of ordinary Mexican people. In 1927/28 he travelled to the USSR, but later he was expelled from the Communist Party because of his Trotskyist tendencies. From 1929 to 1935 he decorated the Mexican National Palace, taking as his theme the history of Mexico from the time of the ancient civilisations to the modern age.

He received various commissions from the USA, but because of ideological differences his work in the Rockefeller Center in New York in 1933 was not completed. Until late in life he received more work than he could cope with, mostly murals of Mexican history. Rivera, who was married to Frida Kahlo, is regarded as one of the three great Mexican mural painters, in company with Orozco and Siquieros. Illustration:

604 The History of Mexico: Huastec Civilization, 1930-1932

ROBERT Hubert

1733 Paris - 1808 Paris

Robert's father was valet de chambre to the Marquis de Stainville, later to be Duc de Choiseul, who promoted the boy's talent. Robert accompanied the Marquis to Rome, where he attended the French Academy. Under the influence of Pannini's work and the etchings of Piranesi he painted pictures of ruins from Antiquity. In 1760 he visited with the Abbé de Saint-Non the recently discovered ruins of Pompeii and Herculaneum. Robert combined in his work representations of real and imaginary ruins, even depicting ruin versions of existing buildings. After spending eleven years in Italy, he returned to Paris in 1765, where he became a member of the Academy a year later. In 1784 he was appointed as the King's garden designer and curator of his art collection. He produced plans for redesigning the park at the Palace of Versailles along the lines of an English garden. During the Revolution he belonged to the commission, which also included Fragonard, that was to turn the Louvre into a museum. His best-known works are depictions of actual events, such as "The Conflagration at the Paris Opera" and "The Razing of the Bastille' (both Paris, Musée Carnevalet), and "Demolition of the Houses on the Pont du Change" (Munich, Alte Pinakothek).

Illustration:

367 The Porta Octavia in Rome, undated

ROHAN BOOK OF HOURS → Master

ROMNEY George

1734 Dalton-in-Furness (Lancashire) - 1802 Kendal (Westmorland)

The son of a cabinet-maker, Romney worked first in his father's workshop before being apprenticed to Christopher Steele, a portrait painter and former pupil of Carle van Loos. Romney set himself up in London in 1762 and aroused public attention with his painting "The Death of General Wolfe". His travels to France and Italy between 1764 and 1775 introduced him to French Neo-Classicism, Antiquity and the masters of the Roman High Renaissance. On his return to London he worked as a portrait painter and developed an interest in literary themes, making many drawings. His most famous sitter was Emma Harte, later Lady Hamilton, whom he presented in many mythological and literary roles. Bad health compelled him to retire to Kendal in 1795. Romney is considered one of the most important British portrait painters of the 18th century, along with Gainsborough and Reynolds.

Illustration:

388 The Leigh Family, c. 1767–1769

ROSA Salvator

1615 Arenella (near Naples) – 1673 Rome Rosa was one of the most versatile talents of his period, working as painter, poet, etcher, actor-musician and composer. After an apprenticeship with

his uncle and brother-in-law he studied under Falcone, in whose style he later painted the wild battlepieces which made him famous ("Battle Scene", Florence, Palazzo Pitti, c. 1640). In his bizarre scenes of witchcraft and dramatic landscapes he showed an emotional and personal world which was the antithesis of the Classical stereotype. In the second half of the 1640s Rosa began to paint allegories of death, which have only now found due recognition (L'umana fragilità, Cambridge, Fitzwilliam Museum, 1651/52). He left Rome for Florence in 1640, where he lived for nine years and founded the Accademia dei Percossi, where he gathered a circle including painters of all kinds. Rosa was highly educated, and his intellectualism found expression in his philosophically condensed art and in the complex thoughts found in many of his pictures.

Illustration:

237 Democritus in Meditation, c. 1650

ROSENQUIST James

born 1933 Grand Forks (North Dakota) Rosenquist studied at the University of Minnesota, 1952-1955, and in New York at the Art Students' League, 1957-1959, under Indiana and Jack Youngerman. In his spare time he worked as a designer and poster painter. Rosenquist, who is considered one of the major representatives of American Pop Art, produces objective motif assemblages. These consist of everyday objects and pictorial advertising material, which are arranged on large canvases. He uses simple, immediately recognisable objects without any attempt at Symbolism, an exception being his vast mural "F III" (3x26m) which aims to depict the interaction between man and technology in contemporary American society. This work went on a world tour from 1965 until 1968. In the 1970s Rosenquist was active in the movement opposing America's role in the Vietnam war, and he supported the democratic rights of artists. He settled in Aripeka, Florida, in 1983.

Illustration

663 Marilyn Monroe I, 1962

ROSLIN Alexander

1718 Malmö – 1793 Paris Roslin was noted for his portrait painting in the 18th century. After studying in Sweden he worked at the margrave's court in Bayreuth, 1745-1747. On his visit to Italy in 1747 he studied the works of Titian, Veronese, Reni and the Carracci. The Duchess of Parma, a daughter of King Louis XV, recommended him to the French court. In 1752 he arrived in Paris, where, apart from brief intervals, he settled for the rest of his life, becoming a close friend of Boucher. His manner of painting appealed to the aristocracy, and by the 1770s he had established himself as the favourite portrait painter of the nobility. His pictures show great skill in rendering texture and in capturing the characteristic essence of his sitters. In 1774 he received a call from the Stockholm court; in 1775 he became court painter in St Petersburg, returning via Warsaw and Vienna to Paris in 1778. His popularity waned as Neo-Classical tendencies became fashionable after the Revolution, but nevertheless Roslin left an enormous number of works. Illustration:

Woman with a Veil: Marie Suzanne Roslin, 1768

ROSSETTI Dante Gabriel

(Gabriel Charles Rossetti)

1828 London – 1882 Birchington-on-Sea (Kent) Rossetti's father was a Dante scholar and had to

leave his native Italy because of his liberal political attitude. In 1843 Rossetti began his training, and from 1846 he studied at the Royal Academy in London. He then worked with Hunt and Ford Madox Brown, and in 1848 was one of the founders of the Pre-Raphaelite Brotherhood. Most of his work was produced in the spirit of this movement, although he soon left it again. Many of his themes were taken from Dante or the *Morte d'Arthur* and have a strong overtone of Symbolism. In his later work he concentrated on single studies of allegorical females. *Illustration*:

527 The Bride, 1865–1866

ROSSO FIORENTINO

(Giovanni Battista Rossi)

1494 Florence - 1540 Paris Rosso was one of the few Italian painters of the 16th century who refused to work within the rules of the High Renaissance. His tendency to distortion, to breaking up the human body into geometrical areas, and his unconventional treatment of colour, meant that due recognition was withheld until the beginning of the 20th century. It was only when art turned away from its traditional aim of creating ideal representations of what we see, that Rosso's work became interesting to such groups as the Expressionists, Cubists, and particularly the Surrealists. However, the modern view of Rosso's work was again based on a misconception. His intention had not been to create an aesthetically pleasing work, but to find a new way of expression that transcended realistic experience. Like Pontormo, to whose early work Rosso's coloration and figure representation have an affinity, Rosso was probably a pupil of del Sarto. Under this master Rosso would have been fully trained in the art of the High Renaissance and its further possibilities. Already in his first work, the fresco of the "Assumption" in the forecourt of Saint Annunziata in Florence (1517), his Mannerist tendencies were detectable, and this development established itself in his great altarpieces of the following years While in Rome, 1524-1527, he also became strongly influenced by Michelangelo, whose Sistine ceiling he had studied.

In 1530 he received a call from King Francis I to Paris, and during the following decade he was mostly engaged in decorating the Palace of Fontainebleau. His principal contribution was the design of the gallery of Francis I, in which he created a unity of frescos, decorative elements and plasterwork. Together with the Bolognese painter Primaticcio, he founded the Fontainebleau school, which did much to disseminate Renaissance ideas north of the Alps.

Illustration:

181 Desposition, 1521

ROTHKO Mark

(Markus Rothkovitz)

1903 Dvinsk (Lithuania) – 1970 New York Rothko's family emigrated to Oregon when he was seven years old. He first studied at Yale University, then under Max Weber at the Art Students' League in New York, 1924–1929. Together with Adolph Gottlieb he founded the Expressionist group The Ten in 1935. In about 1938 he began to take an interest in Surrealism and engaged in the study of Greek mythology and metaphysics, Jung's theory of archetypes and primitive art.

He produced his first pictures depicting forms floating in space from 1947. Three years later he had evolved his distinctive manner. In 1949 he founded with William Baziotes, Motherwell and Newman the Subject of the Artist School, which only functioned for a year. He taught until 1955 at its successor, Studio 35. In 1950 he travelled in Eu-

rope, and from 1951–1954 he taught as assistant professor at Brooklyn College. In 1958 he received the lucrative commission of painting a mural in the Seagram Building. After 1960 his palette became noticeably darker and gloomier. In 1964 he decorated a chapel in Houston designed by Philip Johnson for Jean and Dominique De Menil. Rothko committed suicide in 1970. He was one of the most significant representatives of flat area colour painting.

Illustrations:

620 Red, Green, Blue, 1955

649 Number 10, 1950

ROTTMANN Carl

1797 Handschuhsheim (near Heidelberg) – 1850 Munich

Rottmann came from a family of painters and therefore had early contact with other Heidelberg artists. In 1821 he began to study historical painting at Munich Academy and went on nature studies in the Bavarian mountains. A visit to Italy, 1826-1828, and again in 1829, introduced him to the Roman manner of open-air painting. Important for his development was his meeting with the Bavarian Crown Prince, who lived in Rome and was to become King Ludwig I. He commissioned Rottmann to paint the "Italian Cycle" in the Munich Hofgarten Arcades (1830-1833), a series of frescos depicting Italian landscapes, a subject often repeated by Rottmann. Another major work was the "Greek Cycle", for which Rottmann had made nature studies during a visit to Greece in 1834/35 and which were destined for the Neue Pinakotek in Munich. These were encaustic paintings (a technique with hot wax colours that are fused after application), and Rottmann worked on them until his death. In these landscapes, the architectonic structure of strictly classical composition is combined with a dramatic treatment of colour expressed through light and other natural phenomena.

Illustration:

455 Sicyon and Corinth, c. 1836-1838

ROTTMAYR Johann Michael

1654 Laufen (Upper Bavaria) – 1730 Vienna Trained by his mother, Rottmayr received decisive inspiration from Loth, in whose workshop in Venice he worked from 1675 to 1688. He came through Passau and reached Salzburg in 1689 (mythological ceiling frescos, Archbishop's Palace). During this period he also produced panel paintings which still owed much to the Venetian "tenebrosi", but he soon evolved his own powerful, drastic style with popular appeal. He visited Frain (in Moravia) and Prague, and then moved on to Vienna. While there he succeeded in getting commissions around Austria and southern Germany. Particularly in his fresco painting Rottmayr was successful in freeing himself from the illusionist manner of presenting architecture, as practised by Pozzo, for example, and in discovering illusionist devices in the field of colour and figure composition (Apotheosis in the cupola of the ancestral hall of Vranov castle, Frain, 1696). Like Altomonte, Rottmayr prepared the way to a new form of monumental painting by closing up all ceiling space and introducing a coloration which foreshadowed the Rococo. The finest examples of this are the ceiling frescos of the castle at Pommersfelden (1716-1718), those in the church of Melk monastery (1716-1722), and the Karlskirche in Vienna (1726).

Illustration:

258 St Benno, 1702

ROUAULT Georges

1871 Paris – 1958 Paris

Rouault served his apprenticeship under a painter of stained glass, and it was his task to restore medieval windows. Later he studied with Moreau, under whose influence he remained until 1903. His early works were mostly religious themes treated in Rembrandt's chiaroscuro manner. After Moreau's death, Daumier and Toulouse-Lautrec inspired him to turn to other subjects. His palette was dark and sombre until he came into contact with the Fauves in 1905, when he began to choose colour for expression. His figures - clowns, prostitutes, peasants, labourers, judges - are drawn in wild, powerful brushstrokes against a glowing background, boldly outlined in black. In their iridescent, brilliant coloration they reveal Rouault's early connections with the stained glass art.

Illustrations:

561 The Holy Face, 1933

561 The Old King, 1937

ROUSSEAU Henri

1844 Laval - 1910 Paris

Rousseau, known as "Le Douanier" because he was a customs officer who painted in his spare time, had no artistic training whatsoever and did not devote himself to painting until he took early retirement at the age of 40. He took painting seriously, copying in the Louvre, but allowing his heart and feeling to dictate irrespective of academic rules, examples and theories. The simplicity of his pictures, which were painted in strong, cheerful colours with figures in stiff poses, aroused much derision. Pissarro was one of the first to recognise his talent, and Gauguin also took him seriously. Picasso possessed some of his pictures, which are now in the Louvre. His portraits, still lifes, landscapes and exotic scenes are the first examples of a manner of painting which came to be called "naive". Painters in this field treat the subject in their own visionary way without realistic analysis or intellectual reflection. Illustration:

513 War, 1894

ROUSSEAU Théodore

(Pierre Etienne Théodore Rousseau) 1812 Paris – 1867 Barbizon

Already as a boy of ten Rousseau made drawings in the open in the Boi de Boulogne. In 1829 he became a pupil of Charles Rémond at the Ecole des Beaux Arts in Paris. In the Louvre he copied the works of Claude Lorrain and the Dutch masters and studied the more recent British artists, including Constable and Bonington. He also painted in the open and was probably the first to work in the woods of Fontainebleau. He became known at first through his nature studies, which he had brought back from the Auvergne, where he stayed in 1830. He travelled extensively to capture French landscapes, visiting Normandy, Brittany, Provence, the Jura region and the Vendée. From 1836 he stayed regularly in Barbizon, a village near Fontainebleau, to paint there, and almost spending all his time there between 1848 and 1863. In 1867 he was chairman of the painting judges at the Paris World Exhibition. Rousseau's enthusiasm was centred on nature: "To hell with the civilised world! Long live nature, the forests and the poetry of old." His determined effort to save the Compiègne forest resulted in the formation of the first nature conservation movement in the world. It follows that he painted predominantly wooded scenery and trees, which he rendered realistically and yet atmospherically in their seasonal and diurnal changes. Long before Monet he captured one and the same motif at different times of the day. For a long time his pictures were rejected by the Salon. It was not until the

1850s that he had some success. Although his friends, the Barbizon painters Jules Dupré and Constant Troyon, gained more public recognition, it was Rousseau who was the spiritual leader of this colony of artists.

Illustrations:

439 The Chestnut Avenue, 1837

439 Oak trees near Apremont, 1852

RUBENS Peter Paul

1577 Siegen (Westphalia) - 1640 Antwerp His father was a Calvinist and so had to live in exile from Antwerp, so Rubens grew up in Cologne. On his father's death, his mother returned to Antwerp in 1587, where he was brought up and educated in the Catholic faith. At the age of fourteen he entered the household of a Flemish princess as a page, and later studied under Tobias Verhaecht, a landscape painter, then under Adam van Noort, and the last four years until 1600 under Otho Venius. While still working in the latter's workshop he was accepted as master in the Lukas Guild in 1598. In 1600 he visited Italy, and while in Venice attracted the attention of Duke Vincenzo Gonzaga, finally taking up residence at his court in Mantua. Rubens accompanied the duke on his travels to Florence and Rome, and was sent by him with gifts and paintings on a diplomatic mission to Spain in 1603. In Venice, Rome and Genoa, Rubens copied Titian, Tintoretto and Raphael, and also the works of contemporaries, including Caravaggio, the Carracci and Elsheimer. Having already executed several large commissions in Italy, he returned as a successful painter to Antwerp in 1608.

There he was appointed court painter in 1609 to the Regent Albert and Isabella, receiving an annual salary of 500 guilders, and was exempted from the guild's restrictions and taxation. He received permission to establish himself outside the regent's residence, which was in Brussels, and married Isabella Brant, daughter of the town clerk (ill. p. 291). In 1610 he built himself a large house and studio. During his Antwerp period, until 1622, he received a flood of commissions from the church, state and nobility, employing in his large workshop many pupils who later became famous to help with the work. They included van Dyck, Jordaens, Snyders and Cornelis de Vos. The Gobelin factory produced tapestries after his sketches, and engravers used his paintings, disseminating the "Rubens style" all over Europe. His largest commission was for a series of 21 paintings of the life of the Queen Dowager Marie de'Medici for the Palais Luxembourg in Paris, for which he received a fee of 20.000 ducats (ill. p. 292). Between 1623 and 1631 he travelled frequently on diplomatic missions, visiting London and Madrid, where he received peerages from both Charles I of England and Philip IV of Spain. The most important painter of the International Baroque thus became the first artistic aristocrat, whose fame and wealth constantly increased. Isabella Brant died in 1626; a year later he sold his great art collection, which included works by Raphael, Titian, Tintoretto and himself, for 100.000 guilders to the Duke of Buckingham, and in 1630 he married the 16-year-old Helene Fourment, whom he immortalised in many portraits. After the death of Queen Isabella he gradually withdrew from court and bought Steen castle near Mecheln. His last big commission was the decoration of the Spanish king's hunting lodge, Torre de la Parada near Madrid, which he designed but was no longer able to carry out himself.

Rubens, the great Baroque master, successfully brought together in his style northern and Flemish elements of this period with those of Italy. His influence on the painters of his century was enormous, as it was on sculpture and architecture. His

sometimes gigantic "pictorial inventions", which do not always appeal to today's taste, were pioneering in composition, design and the art of colour, taking as subject all major themes of painting: Biblical scenes and lives of the saints, mythology and subjects of Antiquity, and also peasant scenes, landscapes and portraiture. "My talent is such," he wrote, "that no undertaking, however large and varied in theme, has ever gone beyond my self-confidence."

Illustrations:

- Portrait of Susanne Fourment (La chapeau de paille), c. 1625
- Venus at a Mirror, c. 1615
- 290 The Four Philosophers, c. 1611
- 290 Stormy Landscape with Philemon and Baucis, c. 1620
- Rubens with his first wife Isabella Brant in the Honeysuckle Bower, c. 1609/10
- The Landing of Marie de' Medici at Marseilles, c. 1622–1625
- The Rape of the Daughters of Leucippus, c. 1618
- 293 Hippopotamus and Crocodile Hunt, c. 1615/16
- 294 The Three Graces, 1639

RUISDAEL Jacob van

(also: Ruvsdael)

c. 1628/29 Haarlem - 1682 Haarlem Ruisdael's father was a frame-maker and art dealer. He probably studied under his uncle Salomon or the landscape painter Cornelis Vroom. He was already accepted into the Lukas Guild in Haarlem at the age of 20, but also seems to have studied medicine and to have practised it although he did not receive his doctorate until 1676. Ruisdael belonged to the greatest of Dutch landscape painters and was certainly dominant in this field in the second half of the century. During his early period he mostly painted dune landscapes in the surroundings of Haarlem. After 1650 he visited with his friend Berchem the eastern parts of Holland and the wooded, hilly regions of the Rhineland. His range from then on included hilly landscapes traversed by rivers, with mighty, gnarled oaks, picturesque waterfalls and old water mills, often spanned by clouded sky. These works were to have a particularly strong influence on the Romantics. In the 1660s, after Ruisdael had settled in Amsterdam, he also painted panoramic views of cities, winterscapes and vedutas. His most important pupil was Hobbema.

Illustrations:

- 280 The Windmill at Wijk bij Duurstede, c. 1670
- Two Watermills and an Open Sluice near Singraven, c. 1650–1652

RUNGE Philipp Otto

1777 Wolgast (Pomerania) - 1810 Hamburg Runge's father was a grain merchant and ship owner. When still a child, Runge already showed an extraordinary talent at cut-out silhouettes. His brother Daniel helped him greatly in his career, introducing him to artists and supporting him financially through his Hamburg trading company. Runge studied at Copenhagen Academy, 1799-1801, then visited Friedrich at Greifswald and went to Dresden. During this time he became fascinated with the works of the poet and dramatist Ludwig Tieck, whom he visited in Berlin. He fell in love with Pauline Bassenge, a fundamental experience for his artistic as well as his personal life. After marrying her in 1804, he returned with her to Wolgast. Runge often suffered from ill-health, and from 1807 he and his family lived with his brother in Hamburg. In Runge's drawings, etchings and paintings, real objects are mere indications of a world imbued with God's spirit, in which substance and light represent two different levels of an all-embracing spiritual unity, the material and the immaterial. His work on colour theory formed the basis for his metaphysical light and colour treatment, with symbolic elements drawn from Protestant Baroque mysticism.

Illustrations:

- 413 The Hülsenbeck Children, 1805/06
- 452 Rest on the Flight into Egypt, c. 1805/06
- The Artist's Parents, 1806
- 453 Morning (first version), 1808

RUYSDAEL Salomon van

(also: Ruisdael)

c. 1600–1603 Naarden – 1670 Haarlem Ruysdael, the uncle of Jacob van Ruisdael, came to Haarlem in 1616, where he probably trained in the workshop of Esaias van de Velde, and became a member of the Lukas Guild in 1623. He must have been highly respected because he was made borough councillor, 1659-1666. His early dune and wood scenes, painted predominantly in yellowbrowns and grey-greens, are reminiscent of his teacher and of the works of van Goyen. His best works were produced after 1645: landscapes with wide, peaceful rivers, fringed with trees, on which drift boats or ferries, houses and spires, and a deep blue sky with only a suggestion of cloud formation on the far horizon. Illustration

310 The Crossing at Nimwegen, 1647

RYMAN Robert

born 1930 Nashville (Tennessee) Ryman studied at the Tennessee Polytechnic Institute, 1948/49, and the George Peabody College for Teachers in Nashville, 1949/50. In 1952 he settled in New York where his interest in painting became more pronounced. Until 1960 he worked as an attendant at the Museum of Modern Art, where he met other artists, including Dan Flavin and Sol LeWitt, who were also exponents of Minimal Art like himself. In his first works dating from the early 1950s he explored the evolutionary process of pictures; to this day his work is determined by his interest in these matters. In the late 1950s Ryman opted for the square format, and his more extensive colour scale became later limited to white. His explorations concentrated on how the diverse handling of brushwork was affected by different surfaces and how colour reacted to it, and in this way he produced several sequences of paintings. Since the 1960s he has also investigated the visual effects achieved by fastening pictures to the wall, and the fastenings and holders became an integral part of his work. The strict ordering of his work and concentration on the very few features which constitute his pictures, make him an outstanding representative of American conceptual art.

Illustration: 678 Summit, 1978

SAENREDAM Pieter Jansz.

(also: Zaenredam)

1597 Assendelft – 1665 Haarlem

The son of a famous engraver, Saenredam worked for ten years in the workshop of Frans Pietersz Grebber before becoming independent in 1623. He specialised in architectural views and especially in church interiors, establishing this theme as a branch of painting in its own right in Dutch art. He minutely prepared each work with sketches and drawings, and with his accurate representation of perspective and proportion, and skilled handling of light effects, achieved a wonderful suggestion of

lightness and spaciousness with only a few colour tones. He also produced exterior views, faithful representations of actual buildings, whose main attraction lies in their sparse linearity. *Illustration:*

310 Church Interior in Utrecht, 1642

SÁNCHEZ COTÁN → Cotán

SANDRART Joachim von

1609 Frankfurt/Main - 1688 Nuremberg Today Sandrart is less known for his painting than for his theoretical work Teutsche Academie der edlen Bau-, Bild- und Mahlerey-Künste [German Academy of the Fine Arts and Architecture] (Nuremberg, 1675-1679), a historically arranged compendium of great significance to German art history writings. In Strasbourg (training under Stoßkopf), Prague (assistant to Sadeler), Utrecht (working with Honthorst), London, Bologna, Venice and Rome, Sandrart had met the most famous artists of his time, including Rembrandt, Rubens and Liss. From today's point of view he seems to have had little originality, yet his contemporaries regarded him as the best German painter of his generation. His large repertoire included portraits, altarpieces, mythological and allegorical scenes as well as historical paintings. Illustration:

257 November, 1643

SARGENT John Singer

1856 Florence, - 1925 London The son of an emigrant American doctor, Sargent studied at the Accademia delle Belle Arti in Florence, 1870-1874, and worked in the studio of Carolus-Duran in Paris in 1874. In 1879 he visited Spain, where he saw the works of Velásquez. From 1880 to 1882 he stayed in Holland, studying Frans Hals. His painting "Madame Gautreau" created a scandal at the Salon in 1884. He left for London, making friends with Whistler, whose studio he took over in 1885. In 1886 he became a co-founder of the Impressionist association The New English Art Club. From 1888 he began to gain attention with his portraits, working exclusively as a portrait painter in England and America between 1893 and 1906. In their characteristic realism, but also pleasing representation, his portraits were aimed at meeting upper-middle-class taste. In 1890 he became a member of the Legion of Honour, in 1894 a member of the National Academy of Design in New York, and in 1897 a member of the Royal Academy, London. In 1907 he turned to landscape painting, mostly in water-colour, and in 1914 went to the Continent to paint in the open. Among his most notable works are his mural decorations at Boston Public Library, 1890-1916. He produced war scenes in northern France in 1918. In the 1920s he painted wall decorations in the Boston Museum of Fine Arts and the Widener Library at Harvard University.

Illustration:

The Daughters of Edward Darley Boit,

SARTO Andrea del

1486 Florence – 1530 Florence

The son of a tailor (hence the nickname del "Sarto"), he was trained by Piero di Cosimo in the late 15th century tradition, but after studying the works of Leonardo, Raphael and Michelangelo, he developed around 1505 his own style which made him a major representative of the Florentine High Renaissance. From about 1517 he began to break through these conventions ("Madonna delle Arpie", Florence, Uf-

fizi), moving towards Mannerism ("Sacrifice of Isaac", Dresden, Gemäldegalerie, c. 1527). Equally brilliant in drawing as in painterly techniques, he exercised a strong influence on Rosso and Pontormo, who, in turn, inspired his own late work. The range of his development becomes apparent by a comparison of frescos of the life of San Filippo Benizzi (Florence, forecourt of Saint Annunziata, 1508–1510), which seem to consist of many small parts, and those of the life of St John the Baptist in the Chiostro dello Scalzo in Florence (1514–1526), which are monochrome and give an impression of overall unity.

Illustration: 166 Pietà, c. 1519/20

SASSETTA

(Stefano di Giovanni)

c. 1392 Siena (?) – 1450 Siena

The first record of Sassetta dates from 1423. Nothing is known about his origins and training. His work shows that he orientated himself towards the art of Simone Martini and also of Lorenzetti, without becoming an imitator, as did some of the painters of the Sienese school. In opposition to the local trend he also received inspiration from the schools of Lombardy and Florence, as shown in his handling of space. In terms of theme and form he went beyond all Sienese painters of the 15th century. His contemporaries placed him next to the great masters of the Trecento, and he had so many imitators, that many of their works were long regarded as carried out by this master's own hand. *Illustrations*:

- 55 The Mystic Marriage of St Francis, 1437–1444
- 55 The Procession of the Magi, c. 1432–1436

SAVERY Roelant

(also: Ruelandt Savery) 1576 Kortrijk – 1639 Utrecht

In 1590 Savery came with his parents to Holland, living first in Haarlem, then in Amsterdam. This is reflected in his work, which shows Dutch and Flemish influences. He worked for the Emperor Rudolf II in Prague, 1604–1612, and in 1615/16 went to the court of the Emperor Mathew in Vienna. He then lived at Utrecht, becoming a member of the Lukas Guild in 1619. He delighted in late Mannerist extremes, taking as starting point the wild, romantic landscapes of van Coninxloo and Jan Brueghel's love of detail. Typical of his work are landscapes which are often dotted with ancient ruins or with a Noah's ark in the background, with all kinds of beasts romping about, both native and exotic. Despite their faithfulness in observation and detail, these pictures suggest in their bold coloration a paradisiacal, fairy-tale world.

299 Landscape with Birds, 1628

SCHICK Gottlieb

1776 Stuttgart – 1812 Stuttgart

Schick was the son of a publican and tailor, and was sent for early training to the Stuttgart Karlsschule, where he received a broad education in the humanities. He then became a pupil of David in Paris and subsequently went to Rome for further studies, as was usual at the time. His most noted works were created in 1802 in Stuttgart, before he went to Rome, "Heinrike Dannecker" (Stuttgart, Staatsgalerie), the portrait of the wife of his teacher and friend, the sculptor Johann Heinrich Danecker, and the portrait of "Wilhelmine von Cotta" (ill. p. 451), the wife of the famous Tübingen publisher. In these pictures Schick succeeded in combining Classicist form with uncon-

ventional liveliness of expression. In Rome, Schick was introduced by Wilhelm von Humboldt to the circle of German intellectuals gathered there, including Ludwig Tieck, the Schlegel brothers and the philosopher Schelling. His portraits of members of the Humboldt family count as some of his best works, although he also aspired at rendering mythological and allegorical themes as well as those from Roman history ("Apollo amongst the Shepherds", Stuttgart, Staatsgalerie). *Illustration:*

451 Wilhelmine von Cotta, 1802

SCHIELE Egon

1890 Tulln (Austria) – 1918 Vienna Although Schiele's brief period of creativity took place during the era of the Vienna Jugendstil, which he actively supported, he nevertheless followed his own personal inclinations, developing a style which contained Art Nouveau elements but already pointed towards Expressionism. He attended the Vienna Academy of Fine Arts, 1906–1909, was involved in the foundation of the Neukunstgruppe in 1909, and worked for the Wiener Werkstätten, an arts and crafts establishment. He admired van Gogh and Toulouse-Lautrec and was influenced by Munch and Hodler. His friendship with Klimt brought with it a reciprocal artistic influence which proved to be fruitful to both. Although his early work took into account major ideas of the Vienna Jugendstil, Schiele soon converted these into his own idiom of flat and ornamental representation, choosing as subjects the human figure and landscape. His colours were lively, almost glowing, because he accorded colour the highest place in the scale of expressiveness. He exaggerated and distorted his subjects, using bold perspectival angles and feverish colour accents. Drawings make up the greater part of his work, and his oil paintings always followed the concept of prior drawings. Schiele died in 1918 of the Spanish influenza, as did Klimt.

Illustrations:

- Female Model in Bright Red Jacket an Pants, 1914
- 537 Krumau Landscape (Town and River), 1915/16

SCHLEMMER Oskar

1888 Stuttgart – 1943 Baden-Baden After completing his apprenticeship in a workshop specialising in marquetry, Schlemmer went to the School of Applied Arts and then studied at the Academy in Stuttgart, 1905–1909. In 1910 he paid an extended visit to Berlin, and in 1912 he became a pupil in the class of Adolf Hoelzel in Stuttgart. Walter Gropius invited him to the Weimar Bauhaus in 1920, where he became first the head of mural painting, then took over the workshop of wood and stone sculpture. He became widely known when his Triadic Ballet was first performed in Stuttgart in 1922, which involved model figures clad in stereometric costumes to act as "people in space". His aspirations in this field found their culmination when appointed head of the theatrical set workshop at the Dessau Bauhaus, where he was able to establish an experimental stage. His exploration of the relationships between and the effects of space, form, colour, tone, movement and light found pictorial expression in his mural paintings and various pictures. In 1929 he accepted an invitation to the Breslau Academy, then going to the Vereinigte Staatsschulen in Berlin in 1932, before being dismissed from his teaching position by the National Socialists in 1933.

Illustration:

600 Bauhaus Stairway, 1932

SCHMIDT-ROTTLUFF Karl

1884 Rottluff (near Chemnitz) - 1976 Berlin In 1905 Karl Schmidt followed his schoolfriend Heckel to Dresden to study architecture. There they founded with Kirchner and Fritz Bleyl the Brücke group. As a self-taught painter Schmidt's early work was under the influence of Neo-Impressionism. In approaching Fauvism his colour fields became broader and more brilliant. Schmidt painted landscapes, still lifes and nudes as well as portraits. He also produced a great number of graphic works, particularly woodcuts. By 1910 he had abandoned Impressionist coloration in favour of clear colours, and his now more simplified forms resulted in a tighter pictorial structure. In 1911 he moved with the other Brücke members to Berlin. Elements of Cubism and traces of African sculpture now entered his figurative representations. His bodies appeared heavy, large, block-like and primitive, and were framed by curving and angular black outlines. A similar tendency is detectable in his landscapes. In the mid-1920s his pictures became more relaxed, more scenic, and showed greater spatial depth. Under the repressive working conditions in the Third Reich - he had been banned from painting since 1941 - his pictures had an air of melancholy and depression.

Illustration:

583 Gap in the Dyke, 1910

SCHNABEL Julian

born 1951 New York

Schnabel's family moved in 1965 from New York to Texas, where Julian studied at the University of Houston, 1969-1972. In the following two years Schnabel attended the Independent Study Programme of the New York Whitney Museum, supporting himself by casual labour. Like his fellow artist David Salle, who had made his name in the early 1980s, Schnabel entered the art scene in 1979 with his one-man exhibition at Mary Boone's gallery in New York. His mainly large-scale works combine unusual backgrounds, such as velvet and carpet, with objects, such as porcelain fragments or deer antlers, while fragmented lettering is worked wildly into the picture. From the mid-1980s Schnabel also began to produce collages, etchings and bronze sculpture.

Illustration:

680 L'Heroïne, 1987

SCHÖNFELD Johann Heinrich

1609 Biberach an der Riß – 1682 Augsburg After an apprenticeship in Memmingen, Schönfeld went via Basle, where he studied Callot's works and the Dutch Mannerists, to Rome and Naples for further studies in 1633. In 1652 he settled in Augsburg, where he lived until the end of his life. He began to apply all he had seen and learned: the serene, classical landscapes of Nicolas Poussin in Rome, the multi-figured, lively compositions of Salvator Rosa in Naples, the fine coloration of the Venetian masters. From being a painter of smallfigured, mythological and Biblical scenes in broad atmospheric landscapes, Schönfeld developed under the Italian influence, and particularly the Neapolitan example, into an imaginative, original and versatile artist whose themes included mythology, triumphal processions, historical subjects, battlepieces, genre scenes and imaginary landscapes. He also took up new subjects ("The Treasure-Hunters", Stuttgart, Staatsgalerie, 1662), developed a finelygraded, light coloration and had many followers in southern Germany. He was regarded as the most important German painter between 1630 and 1680. Illustration:

257 Il Tempo (Chronos), c. 1645

SCHONGAUER Martin

c. 1450 Colmar – 1491 Colmar

His name probably derives from the town of Schongau, although the family are recorded among the gentry of Augsburg since 1329. Schongauer's father Caspar, evidently a well-known goldsmith, moved from Augsburg to Colmar in 1445. Martin was first sent to study at the University of Leipzig, then learned engraving and drawing in his father's workshop before being trained as a painter, probably under Caspar Isenmann in Colmar. Schongauer is the most outstanding engraver and draughtsman in German art before Dürer. So far 115 engravings and 52 drawings by him have been authenticated, and added to these innumerable copies after his works have survived. He was a master of fine detail and most imaginative in his handling of line. In this he followed the general tendency of European art in the 1470s and 1480s - comparable, perhaps, to the somewhat older Botticelli in Italy. Major elements in his figurative and landscape painting make it reasonable to assume that he visited the Netherlands, where he might have gained particular inspiration from van der Weyden and his fol-

Illustration:

143 Madonna of the Rose Bower, 1473

SCHOOL OF FONTAINEBLEAU

c. 1530 - c. 1570

This name is given to the group of artists, predominantly from Italy, who were involved in the decoration of the palace of Fontainebleau, begun in 1528 under Francis I. They brought Mannerist style elements to France and contributed greatly to their introduction north of the Alps. With the arrival of Rosso Fiorentino in 1530, Primaticcio in 1531, and Niccolò dell'Abbate in 1552, Fontainebleau became the centre of exchange between Italian and French art. Notable works combining various artistic branches are the galleries of Francis I (Rosso) and Henry II (Primaticcio).

During the so-called second school of Fontainebleau (from 1590) a decorative style was developed under the leadership of the Antwerp artist Ambroise Dubois and two French painters, Toussaint Debreuil and Martin Fréminet, which through printed copies became widely distributed all over Europe. It is not always possible to determine the relative degree to which Italian, French and Dutch masters contributed.

Illustrations:

- 150 Gabrielle d'Estrées and One of her Sisters in the Bath, c. 1594–1599
- 209 Diana the Huntress, c. 1550
- 209 Landscape with Threshers, c. 1555–1565

SCHUMACHER Emil

born 1912 Hagen (Westphalia)

From 1932 to 1935 Schumacher attended the School of Applied Arts in Dortmund where, following his parents' wishes, he studied commercial art. Initially he worked as a painter and lithographer before being called up for compulsory service as an engineering draughtsman in the armaments industry, 1939-1945. Under the influence of the works of Christian Rohlfs, he began to paint Cubist landscapes after the war, but through a visit to Paris in 1951 and acquaintance with the German painter Wols he found his own pictorial idiom, closely related to the Informel. In his now entirely abstract works he uses colour as a pure substance, achieving depth by building it up, occasionally to almost relief-like thickness. From 1958 to 1960 Schumacher was professor at the Hamburg College of Fine Arts, and from 1966 to 1977 he taught at the Karlsruhe Academy. During this period he developed a style between painting and relief by introducing materials such as lead, asphalt, sisal and paper which are hammered into the surface. In recent years Schumacher's style has become more serene.

Illustration:

643 Spatial Division, 1955

SCHWIND Moritz von

1804 Vienna – 1871 Munich Schwind was the son of a senior civil servant and was educated at a public school and university in Vienna. His painting was concerned with the visual representation of Romantic literature and music, and was influenced by his friendship with poets and musicians, including Franz Grillparzer, Nikolaus Lenau and Franz Schubert. The foundations of his idealistic style had been laid by his teachers at the Vienna Academy, and later by Cornelius, whom he met in Munich in 1828. He worked in Karlsruhe and Frankfurt am Main before being appointed professor at the Munich Academy in 1847. Schwind delighted in the chronological depiction of a story, as was possible in fresco painting (Wartburg, Vienna Hofoper), or in painting a picture which unites a number of small scenes, a kind of panel painting invented by him in analogy to poetry and music ("The Symphony", 1852, Munich, Neue Pinakothek). He produced many small pictures with romantic scenes from his own memories or from literature, most of which are now at the Munich Schack-Galerie ("Morning Hour", "The Honeymoon").

Illustration:

Fairy Dance in the Alder Grove, c. 1844

SCHWITTERS Kurt

1887 Hanover – 1948 Ambleside (Westmorland) Schwitters studied art in Hanover, Dresden and Berlin, 1909-1914, then returned to Hanover. There he wrote a poem in the style of the Expressionist writer August Stramm. In 1918 he showed his first series of abstract paintings at the Berlin Sturm, the gallery of Herwarth Walden. During this time he had his first contacts with the Dadaists in Zurich and Berlin, including Hans Arp, Raoul Hausmann and Hannah Höch. In exploring new pictorial and sculptural forms of expression he developed the idea of the Merz picture. In 1919 he produced his first Merz assemblage consisting of a variety of pasted-on objects, and published his first collection of poems, Anna Blume, which are constructed according to the same principles. In 1922 he attended the Weimar Dada congress and helped van Doesburg in bringing Dadaism to Holland. From 1920 he used the title Merz for all his works, in particular his "total sculpture", the Merzbau in his house in Hanover, and also for the magazine which he published between 1923 and 1932. In 1932 he became a member of Abstraction-Création. Illustration:

609 Merz 25 A. The Constellation, 1920

SCOREL Jan van

1495 Schoorl (near Alkmaar) – 1562 Utrecht After an apprenticeship with Jacob Cornelisz in Amsterdam, Scorel went south on an extended tour, visiting Dürer in Nuremberg, painting his first representative work in Obervellach in Austria ("Sippenaltar", 1520), then travelling via Venice to Rome. Here Pope Adrian VI, a native of Utrecht, appointed him painter to the Vatican and successor to Raphael as Keeper of the Belvedere. From Rome he went on a pilgrimage to the Holy Land. In 1524 he settled in Utrecht and as the leading Netherlandish "Romanist" developed a brilliant career as a painter and teacher. Highly educated, equally endowed

with intellect and spontaneity, he created a wealth of altarpieces and portraits in which Italian art merged with native tradition.

Illustration:

203 Mary Magdalene, 1529

SEBASTIANO DEL PIOMBO

(Sebastiano Luciani)

c. 1485 Venice – 1547 Rome

Sebastiano was trained in the workshop of Giovanni Bellini and under Giovanni Battista Cima. He had close contacts with Giorgione, after whose death he went to Rome in 1511 to carry out fresco decorations of mythological themes for the banker Agostino Chigi in the hall of the Villa Farnesina. In Rome he met Raphael, whose style is reflected in some of Sebastiano's portraits. Their friendship turned into enmity in 1515, and Sebastiano turned to Michelangelo, whose formal ideas he expressed in some of his religious works. After a visit to Venice he returned to Rome in 1528/29, where in 1531 he became keeper of the papal leaden seal, hence his name. Sebastiano became famous as a portrait painter; his mythological and religious paintings showed too often a dependence on the works of his two famous friends. Illustration:

173 Cardinal Carondelet and his Secretary, c. 1512–1515

SEGANTINI Giovanni

1858 Arco (Lake Garda) – 1899 near Pontresina (Engadine)

Segantini grew up in poor circumstances and was apprenticed to a decorative painter. He attended evening classes at the Brera Academy in Milan, 1875-1879, received a contract from the art dealer Grubica, and went for five years to Puisano to make nature studies. During this period he was fascinated by Swiss mountain scenery and peasant life. He usually chose the large format, painting in light, brilliant colours, using broken brushstrokes and dazzling lighting. In 1886 he settled in Savognin, and from 1894 he lived in Maloja in the Upper Engadine. From 1890 he devoted himself increasingly to allegorical themes with Symbolist influences ("Cross Mothers", Vienna, Kunsthistorisches Museum). In 1898 he became a member of the Vienna Secession. In 1909 the Segantini Museum in St Moritz was opened. His work is regarded as belonging both to Symbolism and to the Jugendstil.

Illustration:

530 The Hay Harvest, 1899

SEURAT Georges

1859 Paris - 1891 Paris

Seurat, the son of a bailiff, took drawing lessons from 1875 and later copied works in museums. In 1878/79 he studied at the Academy and read works on colour theory. After military service in 1880 he settled in Paris. In 1883 a large drawing was accepted by the Salon, and he began a large painting, an open-air scene, in the pointillist, or divisionist manner. In 1884 he met Signac and, with other likeminded artists, the Society of Independent Artists was founded to hold its own exhibitions. In 1885 he worked on the Paris Seine island Grand Jatte and in Grancamp on the coast of Normandy. He met Pissarro, who followed his style. In 1886 Seurat aroused great attention at the VIII Impressionist Exhibition with his picture "Sunday Afternoon on the Island la Grande Jatte" (ill. p. 507). He began to show his work alongside that of Pissarro and Signac; he met the art theorist C. Henry, and was in contact with Symbolists and anarchists. In 1887 he exhibited at Les XX in Brussels, attending the opening. In 1888

he painted in Port-en-Bessin, in 1889 on the coast of Crotoy, and again showed his work at Les XX in Brussels. In 1890 he painted in Gravelines and laid down his theories in writing. His arrogance contributed to the disintegration of the Neo-Impressionist movement. In 1891 he was once again represented at Les XX, and he died of diptheria.

Seurat belonged to the generation of painters who could build on the inventions of early Impressionism and develop them further. Impressed by the colour experiments of his precursors, which, however, still owed much to intuition or chance and therefore still left room for individual artistic expression, Seurat began to study scientifically developed theories of colour, starting with those of Chevreul and Blanc. These studies enabled him to construct his paintings in accordance with the principle of optical mixture, or broken colour, which made him the initiator and leading representative of pointillism. From then on Seurat's works were based entirely on theoretical considerations; nothing was left to chance, each dot of colour had its appointed place. Each painting involved drawn-out preparation, working out the optical effect to be achieved. After Seurat's early death, his friend Signac took on the task of expounding his theories and gathering followers to find recognition for Seurat's endeavours. Seurat influenced many artists of the 20th century with his attempt at basing painting on a scientific footing and his adherence to strict forms. Illustrations:

- 506 Model, Front View (study for "Les Poseuses") 1887
- 506 Bathing at Asnierès, c. 1883/84
- 507 Sunday Afternoon on the Island of La Grande Jatte, 1884–1886

SEVERINI Gino

1883 Cortona - 1966 Paris

Severini went to Rome in 1899, where he attended evening courses at the Villa Medici. His meeting with Balla and Boccioni became decisive for his artistic career. He began to paint pictures influenced by divisionism. From 1906 he lived in Paris, where he discovered the works of Seurat and met Modigliani, and signed the Manifesto of Futurist Painting of 11 February, 1910. From this period date his first cabaret and dancing girl scenes. Severini kept the Milan Futurists in touch with Paris, and also organised their 1912 exhibition in Paris. During this period he produced his best work. Apart from an increasing interest in movement and light, there were other features, such as the superimposition of chronologically separated events brought together by memory.

Illustration:

577 Spheric Expansion of Light (Centrifugal),

SIBERECHTS Jan

1627 Antwerp – c. 1700–1703 London Siberechts joined the Antwerp Lukas Guild around 1648/49. Before that he had probably visited Italy, as his early works bear a resemblance to the Italian landscapes painted by the Dutch painters Both, Berchem and Dujardin. In the 1660s his Flemish landscapes usually concentrated on a limited view, such as a meadow, a ford or a roadside embankment, with carts, animals, peasants or servant girls in greygreen or bluish coloration and silvery light. In 1672 he went to London, where he carried out commissions for the Duke of Buckingham. In England he painted actual views of country estates. His landscapes, now in warm brown tones, began to open outwards.

Illustration:

328 Landscape with Rainbow, Henley-on-Thames, c. 1690

SIGNAC Paul

1863 Paris – 1935 Paris

The son of a saddler, Signac abandoned plans of becoming an architect and began to paint in 1880. He attended the Academy of Bing in 1883 and became interested in Monet and Guillaumin. In 1884 he was a co-founder of the Independents. He became friendly with Seurat, whose divisionist-pointillist manner he adopted in his cityscapes, river scenes and figure painting. In 1886 he took part in the VIII Impressionist Exhibition. Durand-Ruel began to show his work in New York, and it was also shown in Nantes, together with Seurat's and Picasso's works. During this period Signac was much involved in organising exhibitions and writing reviews.

In 1887 he went with Seurat to Brussels and for the first time visited the Mediterranean (Collioure). In 1888 he exhibited for the first time with Les XX in Brussels. In 1889 he visited van Gogh at Arles, illustrated theoretical works of C. Henry and joined the anarchists. In 1890 he made the first of several visits to Italy and became the first foreign member of Les XX. In 1892 he married Berthe Roblès, a relation of Pissarro, and sailed from Brittany to Marseilles. He remained keen on sailing for the rest of his life. He painted many landscapes and seascapes, both in oil and water-colour, using mosaic-like blocks of pure colour. In 1893 he bought a house in Saint-Tropez, which was then becoming a popular seaside resort and a meeting place for modern painters. In 1896 he made his first visit to Holland. In 1899 he published his theoretical aims for Neo-Impressionism D'Eugène Delacroix au Néo-Impressionisme. In 1907 he visited Constantinople, and in 1908 became the president of the Independents. Like his friend Seurat, Signac was an important representative and leader of Neo-Impressionism. After his initial leaning towards Monet's style, he became a whole-hearted follower of Seurat's technique and theories.

Illustrations:

483 Riverbank, Petit-Andely, 1886

508 Two Milliners, Rue du Caire, c. 1885/86

508 The Port of Saint Tropez, 1907

SIGNORELLI Luca

(Luca d'Egidio di Maestro Ventura de'Signorelli) c. 1450 Cortona – 1523 Cortona

Born in the borderland between Tuscany and Umbria, it is likely that Signorelli received his artistically formative training in Florence, where he would have come under the influence of Florentine sculpture, particularly bronze casts. He probably studied under Pollaiuolo and Verrocchio for some years. Signorelli's special interest was the human figure in action. One of the main concerns of Florentine painting of the early 15th century had been the plastic, convincing rendering of the human body on the flat canvas, and this theme was taken up again by Signorelli; no longer, however, in an endeavour to depict three-dimensional forms, but rather to record exact details. His religious and secular subjects demonstrate his mastery in this field. Already in 1481 he was one of the artists chosen to participate in the fresco cycle below the window area in the Sistine Chapel (amongst others, Botticelli, Ghirlandaio and Perugino were engaged in this work). Piero della Francesca's influence on Signorelli should not be over-emphasised. Although his tendency to abstract composition ("Virgin and Saints", Perugia, Domopera, 1484) and his handling of lighting effects may have been influenced by Piero, Signorelli's intention was not to create an atmosphere flooded with light, but to use strong light and deep shadow to model the forms of the body. Signorelli reached the height of his development with his frescos depicting the Last Judgement in Orvieto cathedral (1499-1504, ill. p. 110).

Illustrations:

Portrait of a Lawyer, c. 1490–1500 IIO The Damned Cast into Hell (detail), 1499-1503

SIMONE MARTINI

(Simone di Martino)

c. 1280–1285 Siena – 1344 Avignon The assumed date of birth is based on a 16th century source but it is probably correct, even though Simone's first signed work, the fresco of the Maestà in the Palazzo Pubblico in Siena, dates from 1316. His versatility of talent has made it impossible so far to reconstruct his life chronologically. The Maestà in Siena, the devotional pictures for Cardinal Orsini and the altarpieces, such as those for Pisa and Orvieto, all show some affinity. But there is evidence in all his works that he had studied Duccio with the same intensity as he had Giotto, and French art, plus the field of sculpture and in particular Giovanni Pisano. This diversity of influences is still clearly detectable in the Orsini polyptych. It is certain, however, that around 1315 Simone must already have been a famous master to have received the commission in Siena and to be mentioned in the records of 1317 as being employed as an ennobled artist by Robert d'Anjou at an astonishingly high salary. During this period the Neapolitan kings of Anjou and their circle were his major patrons. His large workshop also produced works for the city of Siena and other parts of central Italy.

Simone introduced some of the most significant innovations, especially in the field of devotional picture painting, such as the so-called Madonna dell'Umiltá (Mary kneeling and suckling the child). From 1339 he is mentioned in Avignon, where he worked for Cardinal Stefaneschi and other senior clerics. He left a school of followers of his style, both in Siena and Avignon. Some of his inventions became almost common property in the 14th century. Already celebrated in his lifetime praised even by Petrarch, for whom he executed several works - his fame continued not only in Siena, where in the early 15th century he was considered the greatest Sienese painter of all, but also north of the Alps.

Illustrations:

Maestà, 1315/16 18

Guido Riccio da Fogliano, c. 1328 35

Musicians. Detail from: St Martin is dubbed 35 a Knight, between 1317 and 1319

The Road to Calvary (part of the Orsini Polyptych), c. 1315 (or later)

The Desposition (part of the Orsini Polyptych), c. 1315 (or later)

SISLEY Alfred

1839 Paris - 1899 Moret-sur-Loing (near Paris) Sisley came from a middle-class English background and was intended to become a merchant. He started drawing between 1857 and 1862. Then he studied in the studio of Gleyre in Paris, where he met Monet, Renoir and Bazille. In 1863 he began to paint in the open with his friends in Chailly-en-Bière near Barbizon. In 1865 he worked with Renoir, Monet and Pissarro in Marlotte and also with Monet on his boat on the Seine. In 1866 he showed his work for the first time at the Salon. He married Marie Lescouezec, with whom he had two children. He was rejected by the Salon in 1867 and became a co-founder of the "Salon des Refusés". He began to paint in Honfleur, and in 1868 went with Renoir to Chailly and showed his work at the Salon. He was again turned down by the Salon in 1869, and began to frequent the Café Guerbois in Paris. In 1870 he was represented at the Salon with his Impressionist work. He stayed in Voisins-Louveciennes during

the Commune in 1871. Durand-Ruel showed one of his pictures in London and began to buy his work regularly from 1872. In the following years he painted mostly in Argenteuil, Bougival and Louveciennes, producing Impressionist village and river scenes and snowscapes. In 1874 he took part in the first Impressionist exhibition, and the singer and art collector J.B. Faure financed his visit to England. From 1875 to 1877 he lived in Mary-le-Roi. In 1875 an auction was held at the Hôtel Drouot to sell his pictures and those of other Impressionists, with little success.

In 1876 and 1877 he showed his work at the second and third Impressionist exhibitions, and a further auction was held. He moved to Sèvres, where he was aided financially by the inn-keeper Murer and the publisher Charpentier. In 1878/79 Duret helped him out of his financial difficulties by finding some buyers. From 1880 to 1882 he lived in Veneux-Nadon near Moret and had a one-man exhibition at Charpentier's publishing house, which printed the journal La Vie moderne. In 1882 he participated in the seventh Impressionist exhibition. Durand-Ruel showed his work in Paris in 1883, without success, but nevertheless arranged to show it in London, Boston, Rotterdam and Berlin in 1885. Together with Renoir and Pissarro, he again exhibited at Durand-Ruel in 1888. In 1889 he had a one-man show at Durand-Ruel in New York. Sisley now settled permanently at Moret and continued to paint Impressionist landscapes until the end. He reached the height of his career with his series of paintings from 1893/94, which followed Monet's manner. In 1894 he worked in Normandy as the guest of the collectors Murer and Depeaux. In 1897 a large retrospective took place at G. Petit without any success with critics and buyers. During that year he painted on the English coast. In 1898 it was diagnosed that he suffered from cancer. His lack of funds prevented him from becoming a French citizen. When his estate was auctioned in 1899, his paintings rapidly rose in value. He was the first of the Impressionists for whom a small memorial was erected, in Moret in 1911.

The Bark during the Flood, Port Marly, 1876 497 The Bridge of Moret, 1893 497

SLEVOGT Max

1868 Landshut (Bavaria) – 1932 Neukastel

Slevogt studied at the Academy of Fine Arts in Munich, 1884-1890, where he was influenced by Leibl and Trübner. In 1889 he went to Paris to study at the Académie Julian, and the following year continued his studies in Italy. In 1893 he became a member of the Munich Secession and the Freie Vereinigung. From 1896 he worked for the magazine Simplizissimus, and Leistikow put him into contact with the Berlin Secession. In 1900 he visited the Paris World Exhibition and in 1901 he went to Frankfurt am Main, where his famous, brilliantly-coloured zoo pictures were produced. He then lived in Berlin, working mostly on portraits and teaching a class at the Academy. In 1914 he went to Egypt and painted landscapes flooded with sunlight. He became a member of the Academy of Fine Arts in Berlin, and in 1915 went to Belgium to paint war scenes. After 1918 he settled in Neukastel, where he produced his graphic cycles, over 500 illustrations of Goethe's Faust. His murals in the concert hall in Neukastel date from 1924, and he carried out further fresco commissions in Berlin, Bremen (1927), and the Friedenskirche in Ludwigshafen (1932). In 1924 he created the sets for Don Giovanni for the Dresden Opera.

Illustration:

The Alster at Hamburg, 1905

SNYDERS Frans

(also: Snijders)

1579 Antwerp – 1657 Antwerp Snyders' parents kept an inn well-known for good food, which many artists frequented. In about 1592/93 he studied under the younger Pieter Brueghel, then Hendrik van Balen. In 1602 he joined the Lukas Guild, then travelled in Italy for a time, returning in 1609. In 1611 he married a sister of the painter Cornelis de Vos. Apart from his domestic scenes, which showed the Mannerist influence, Snyders created two new categories of painting: the hunting still life and the "larder" picture. He excelled as a painter of still lifes, often magnificent, tastefully arranged banqueting scenes in intensive colours, showing game, poultry, fruit and all kinds of tableware fit for a palace, which he sometimes further enlivened by adding living, jumping animals. Snyder transformed the still life into a lively scene, and also produced minutely observed, dramatic hunting scenes. He was one of Rubens' assistants, who employed him as specialist for animals, fruit and flowers. Illustration: 299 Still Life, 1614

SOEST → Konrad of Soest

SOULAGES Pierre

born 1919 Rodez (Aveyron)

Soulage's studies at the College of Graphic Arts in Montpellier were cut short by the war. During the German occupation he worked in the vineyards, then set up a studio in Paris in 1946. Here he met Picabia, Hartung and Léger, amongst others. On a visit to the USA he met American artists and museum staff, including J.J. Sweeney, the director of the Museum of Modern Art in New York. Soulage's Tachisme compositions soon became recognised, and his work was shown world-wide at one-man and group exhibitions. In 1987 he designed a monumental wall tapestry for the newly-built Finance Ministry in Paris. In 1995 he completed a series of stained glass windows for the Abbey of Conques.

Illustration:

636 Painting 21. 6. 53, 1953

SOUTINE Chaim

1893 Smilovitchi (near Minsk) - 1943 Paris As the tenth of eleven children of a poor Jewish tailor, Soutine had a hard childhood. However, after working in an art school at Vilna, he made his way to Paris in 1913. In 1916 he moved into one of those ramshackle ateliers, known as La Ruche, where Chagall also lived. Modigliani introduced him to the art dealer Léopold Zborovsky, who encouraged him in 1919 to attempt landscape painting at Céret. The following three years were his most important period, during which he produced a great number of landscapes in impasto, using intensely brilliant colours. The overall effect was one of tortured disquiet. On his return to Paris in 1923 the American collector Albert Barnes bought all the pictures kept in his studio. This new prosperity tempered Soutine's vehemence, but he succeeded in reaching another height with a series of "battle scenes", with which he paid homage to Rembrandt. Figures in uniform were another of his favourite subjects.

Illustration:

605 Page at Maxim's, c. 1925

SPITZWEG Carl

1808 Munich - 1885 Munich Spitzweg is still regarded as one of the most popu-

lar 19th century painters. By profession he was an apothecary, and began to teach himself painting in the 1820s. Most of his pictures have a humorous side which he achieved by depicting the yearnings for higher things of people with rather limited horizons, both intellectually and materially. Thus the aspiring poet in his leaky garret, or the portly, elderly widower ogling a passing young girl. In 1851 Spitzweg travelled with his Munich painting friends to Paris and then London, where he was particularly impressed by the works of the Barbizon painters and the works of Constable. This experience led him increasingly to landscape painting, in which he explored the open brushwork technique of the Barbizon school. From then on his figures became incidental, mere witty asides, rather than the main focus of his pictures.

Illustration:

460 The Poor Poet, 1839

STAËL, Nicolas de

1914 St Petersburg – 1955 Antibes When only two years old, Staël was made a page at the St Petersburg court. After the Revolution in 1919 his family emigrated first to Poland and then to Brussels, where he studied at the Academy of Fine Arts from 1933 to 1936. He first worked as a painter of theatrical sets. From 1938 he lived in Paris. He began his career by painting portraits and still lifes, but he destroyed most of his early works, in particular his water-colour landscapes. His friends included Braque and Léger. After experimenting for some time in the field of Tachisme, de Staël developed an original form of abstract painting in which the suggestion of figure, landscape or still life is implicit, using the palette knife to create large, flat areas of colour. From the early 1950s, the representational element became increasingly evident in his pictures. He committed suicide in 1955.

Illustration

638 Figure on the Beach, 1952

STEEN Jan

c. 1625/26 Leiden - 1679 Leiden Steen and Ostade were the two most popular and versatile of the Dutch genre painters. Steen led an unsettled life, often moving home, but he cannot have been an undisciplined drunkard, as has often been suggested, because he produced around 800 paintings. Steen was the son of a Leiden brewer, and there he was introduced to the very detailed style of painting developed in Leiden which was to become important in his later career. He enrolled briefly at the university in 1646, probably to avoid military service. In 1648 he was one of the founding members of the guild. He probably received his training in Utrecht and worked in the workshops of Ostade and van Goyen. In 1649 he married a daughter of van Goyen in The Hague, where he remained until 1654. He then took over a brewery in Delft, which soon failed, and then moved to Warmond near Leiden. From 1661 to 1670 he was in Haarlem, and finally settled for the last ten years of his life again in Leiden where he obtained a licence to operate a tavern. In his portrayal of merry or riotous drinking scenes, weddings, fairs and other themes drawn from popular life, he proved himself a most acute observer of this particular milieu, whose study his life and occupation had given him ample opportunity. But he was also at home with the depiction of refined society and modish interiors. His style was never fixed, tending sometimes towards Ostade and Brouwer, then again towards de Hooch, Terborch or Vermeer. He treated human follies and weaknesses with humour and wit, revealing the hidden moral and "truth" as Molière did in his comedies

Illustrations:

278 Rhetoricians at a Window, c. 1662–1666

325 The Lovesick Woman, c. 1660

325 The World Upside Down, c. 1660

STEFANO DI GIOVANNI

(Stefano da Verona, Stefano da Zevio) c. 1374/75 – after 1438

More recent research has changed the received image of this important artist of northern Italy. It has also brought to light his new name: Stefano di Giovanni or da Francia (from France). His father was the painter Giovanni d'Arbois (in the Franche Comté), who had been invited by the Duke of Burgundy to leave Lombardy and become his court painter. Unfortunately nothing of his work remains; it would have thrown some light on how he combined early Burgundian painting with that of Lombardy. His son Stefano must have had a good knowledge of French art, though it is not known whether he went to France. What can be substantiated is an extensive visit to Padua, 1396-1414, and an earlier visit to Treviso. His activity in Verona is first recorded in 1425. If his "Virgin of the Rose Garden" had actually been painted for the nunnery of San Domenico in Verona before finding its way to the museum, then it must have been produced in 1425 or later. His surviving work includes some important drawings, mostly still in Verona and the surrounding area, as well as many frescos. Important for his stylistic development was the somewhat older Michelino da Besozzo.

49 The Virgin of the Rose Garden, c. 1425

STELLA Frank

Illustration.

born 1936 Malden (near Boston)

From 1954 to 1958 Stella studied history and art under Steven Greene and William C. Seitz at Princeton University. While staying in New York in 1959 he developed his general concept: broad black lines in a symmetrical, horizontal-vertical arrangement. These deliberately impersonal pictures were produced with almost mechanical precision. In exploring flat area colour painting he attempted to achieve a total lack of effect by eradicating painterly devices almost completely. He chose paint and utensils used in house decoration for painting his symmetrical, regular patterns. Towards 1966 he produced a series of works whose compact inner form stood in contrast to the frame, and he also began to produce work in copper and aluminium paint. His first "shaped canvas" was created, a canvas cut to suit the painted form. From about 1975 his work became more relaxed, and he produced montages made of multi-coloured, bent aluminium strips. In 1983 he was visiting professor at Harvard University. In 1990 his first three-dimensional plastic works were produced, and in 1992 his first architectural designs were executed, including that for a museum of modern art in Dresden.

653 Guadalupe Island, Caracara, 1979

STILL Clyfford

1904 Grandin (North Dakota) – 1980 New York From 1931 to 1933 Still studied at Spokane University (Washington), where he subsequently taught art. There followed many other teaching assignments at colleges and universities in California, Virginia and New York, where many of the painters of Abstract Expressionism held positions, including Tobey and Rothko. In the 1930s and 1940s he concentrated on abstracting figure and landscape painting, taking Cézanne and van Gogh as his starting point. Then under the influence of Surrealism he turned to representations of the unconscious and

mythological themes. From about 1947 his mature style evolved: large-scale canvases covered in black, framed by strong, contrasting colours, which channelled his manner of painting into a serene, meditative direction.

Illustration:

630 Untitled, 1954

STROZZI Bernardo

(called: Il Cappuccino)

1581 Genoa – 1644 Venice

Strozzi received his early training under the Sienese painter Sorri, who introduced him to Tuscan traditions and the works of Barocci. Further influences on his development came from Lombardian artists, notably Crespi. But it was Rubens, who came to Genoa in 1607, and the works of van Dyck who were to become the inspiration of his work in the first decade of the 17th century. This was most noticeable in his handling of colour and the amplitude of the female figure, as shown in his picture "Woman playing the Gamba" (Dresden, Gemäldegalerie). Strozzi, who had entered the Capuchin Order at the age of 17, executed fresco paintings only in his early youth. His knowledge of the works of Caravaggio and his followers found expression in his genre scenes, which also reveal Flemish inspiration. With his move to Venice in 1630 he entered a new creative phase which led to a simplification of composition and greater serenity ("St Sebastian", Venice, Museo Correr), during which he gradually approached the personal, free character of his mature work.

Illustration:

234 Vanitas Allegory, c. 1635

STUART Gilbert

1755 North Kingston (Rhode Island) – 1828 Boston

Stuart grew up in ordinary, small-town circumstances. In 1769 he was apprenticed to the travelling artist Cosmo Alexander, who took him with him to Scotland. After his teacher's death Stuart set up a studio in Newport, Rhode Island, in 1773 and began to specialise in portraits. In 1775 he went to England and two years later became a pupil of Benjamin West. Here he remained until 1782, studying Continental and in particular English traditions in portraiture, such as those of Reynolds and Gainsborough. His popularity as a portrait painter enabled him to live the life of a successful artist in London and Dublin. In 1792/93 he returned to America where he became the leading portraitist of his time. He moved to Philadelphia, which was then the capital city, where he lived until 1795. He portrayed many distinguished Americans, including George Washington, of whose portrait he made many copies to be sold. He also painted all subsequent Presidents and in this way became the pictorial chronicler of the young republic. In 1805 he settled in Boston, and there spent his last years beset by debts and his addiction to drink. Illustration.

391 Portrait of Don José de Jaudenes y Nebot, 1794

STUBBS George

1724 Liverpool – 1806 London

Stubbs was an illustrator of scientific anatomical works before becoming a painter, particularly of animals. His illustrations for a work on obstetrics date from 1751, and in 1766 he published *The Anatomy of the Horse*, illustrated by his own engravings. Another large work was *A Comparative Anatomical Exposition of the Structure of the Human Body with that of a Tiger and a Common Fowl*, 1817. He travelled to Rome and then Morocco, where he observed a horse

being attacked by a lion, and this experience was to become important for his development. He later repeatedly depicted scenes of animals fighting ("Horse frightened by a Lion", Liverpool, Walker Art Gallery). Together with Ben Marshall, Stubbs is the most important representative of animal portraiture, a genre that captures British fondness and enthusiasm for animals. He experimented in working in enamel on copper, and also on china plaques provided by the Wedgwood potteries, working jointly with Josiah Wedgwood. Apart from his devotion to animal subjects, he also painted scenes of traditional English rural life. However, with his concern for anatomical accuracy and remarkable control of line and shape, Stubbs exercised an enduring influence on the European tradition of animal painting. Illustration:

387 "Molly Longlegs" with Jockey, c. 1761/62

STUCK Franz von

1863 Tettenweis (near Passau) – 1928 Munich Von Stuck was, with Lenbach, one of the great Munich painters. After three years at art school and college he studied at Munich Academy, where he came under the influence of Wilhelm von Diez, Böcklin and Lenbach. He was a co-founder of the Munich Secession and was appointed professor in 1895. He was an inspiring, tolerant teacher and always intent on promoting the talent of his students. During his lifetime his works were well represented at the Salons and exhibitions. His style was influenced by the Jugendstil, and he painted pictures of a Symbolist and allegorical nature.

Illustration:

533 The Dinner Party, 1913

SUTHERLAND Graham

1903 London - 1980 London Sutherland studied graphic art at Goldsmiths' School of Art, London. From 1921 to 1926 he worked as a book illustrator and poster designer, then taught at the Chelsea School of Art. In the mid-1930s he turned to painting and under the influence of Surrealism produced landscape forms charged with mystery and drama. From 1941 to 1945 he was an official war artist, painting pictures of bombed buildings in London and southern England. After the war he produced a number of religious paintings. While the original source of inspiration for his gloomy, imaginative pictures had been the austere scenery of western Wales, his palette lightened under the influence of regular visits to the Côte d'Azur, though his vegetal subjects remained as disturbing as ever. In the late 1950s Sutherland's work became more abstract. During this period Sutherland portrayed many distinguished personalities, including Winston Churchill and Konrad Adenauer. Illustration:

614 The Bridle Path, 1939

TAAFFE Philip

born 1955 Elizabeth (New Jersey) He studied at the Cooper Union, New York (BFA, 1977). In the early 1980s he explored the works of Op Art artists, such as Bridget Riley, translating them into new pictorial constructions. Besides his interest in Op Art techniques Taaffe also experimented with Newman's work. From 1988 to 1992 he stayed in Naples. During this period he studied ornamental forms of various cultural fields. In the late 1950s he produced acrylic pictures based on diverse printing techniques with elements of collage, which he subsequently gradually reduced further. From 1982 his work was shown regularly at galleries in Europe and America. He was represented at the following exhibitions: "German and American Art of the Late 1980s", Düsseldorf and Boston (1988); "Post Abstract Abstraction", Aldrich (1987); "Doubletake", Vienna and London (1992) and "ARS 95", Helsinki (1995). Taaffe was also invited to the "Whitney Biennale" in New York in 1987, 1991, 1995. He lives in New York.

Illustration:

680 Conflagration, 1991

TANGUY Yves

1900 Paris – 1955 Woodbury (Connecticut) Tanguy spent much of his childhood in Brittany and came to love the scenery. He first joined the French merchant navy, and while working on a cargo ship visited England, Spain, Portugal and South America between 1918 and 1920. After military service he turned to painting in 1923, having been much impressed by a picture by de Chirico displayed in the window of the Paul Guillaume gallery in Paris. Tanguy was entirely self-taught. In his pictures de Chirico's spatial limitations are turned into long perspectives, and architectural elements and figures are eliminated. This process led Tanguy to a subject which was to become a never-ending source of inspiration to him: the boundlessness of the sea. In 1925 he met Breton and other Surrealist painters and began to take part in their exhibitions with his imagined landscapes, abstract and sculptural works. Like many Surrealists he emigrated to America in 1939.

Illustrations:

The Five Strangers, 1941 557

610 The Palace of the Window Cliffs, 1942

TÀPIES Antoni

born 1923 Barcelona

Tapies studied law in Barcelona from 1943 to 1946, at the same time attending the Academy for two months. In 1948 he was a co-founder of the group Dau al Set and the magazine of the same name. His starting point was the Surrealists, and he came under the influence of Picasso, Miró and Klee. But he soon began to produce collages for which an extended range of materials was available, and in this field he continued to work. His interest in mythology and philosophy was transferred to his work in the form of symbols and runes carved into the surface or perhaps appearing as pictorial symbols. To Tapies, these have a magic and cosmic significance, as does colour.

Illustrations:

642 Relief in Brick Red, 1963

642 Armchair, 1982/83

TENIERS David the Younger 1610 Antwerp – 1690 Brussels

While his father David Tenier the Elder, from whom he received his principal instruction, had been unsuccessful and was even put into the debtors' prison, Teniers the Younger became known all over Europe and amassed a considerable fortune. In 1633 he became a master in the Antwerp Guild, and in 1637 he married a daughter of "Velvet Brueghel", who brought a large dowry into the marriage. In 1645 he was elected deacon of the Lukas Guild, and in 1651 he was appointed court painter to Archduke Leopold Wilhelm and keeper of his pictures in Brussels. He painted still lifes, landscapes and portraits, but was happiest in his scenes of popular Flemish life depicting rustic interiors with card-players, village fêtes, taverns and other themes, in which he was much influenced by Brouwer. Of particular note are his gallery pictures, in which he showed the works contained in the Archduke's collection as in a photograph. He also made small-scale copies of 246 pictures in this collection, another record which helped to retrace the fate of several Titians, Giorgiones and Veroneses. Illustration:

319 Twelfth Night (The King drinks), c. 1634-1640

TERBORCH Gerard

(also: Gerard or Gerrit ter Borch) 1617 Zwolle – 1681 Deventer Terborch studied drawing under his father, then was apprenticed to Pieter de Molyn in Haarlem. In 1635 he started on his five-year-travels, visiting England, Italy and France, later also Spain. On his return he worked in Haarlem, Amsterdam and Münster, where he painted "The Treaty of Westphalia" (Peace Treaty of Münster) which marked the end of the Thirty Years' War, before settling at Deventer in 1654. In his predominantly small-scale interiors and conversation pieces and in his masterly portraits, Terborch depicts the life of refined society, limiting himself to one or only a few figures and presenting sparsely furnished interiors. His pictures have an air of stillness and restraint and are characterised by a beautiful, cool tonality and an exquisite ability to render the texture of rich materials, features which point to Metsu, de Hooch and Vermeer. Illustrations:

281 A Concert, c. 1675

The Card-Players, c. 1650 32 I

The Letter, c. 1655 32 I

TERBRUGGHEN Hendrik

(also: Hendrick ter Brugghen) c. 1588 near Deventer – 1629 Utrecht Terbrugghen grew up in Utrecht, where he received instruction from the late Mannerist painter Bloermaert. In 1604 he went to Italy for ten years. There he may have been in direct contact with Caravaggio, either in Rome or Naples, and also met his followers, including Gentileschi and Saraceni, whose influence became decisive. With Baburen and Honthorst he brought the chiaroscuro technique to Utrecht, where he became a member of the Lukas Guild in 1616. His religious, halflength figure pictures probably met with little enthusiasm, for he increasingly turned to genre painting, choosing as subjectmatter drinking, card-playing and musical scenes. He was the most vital and uncompromising member of the Utrecht school. The soft lighting developed by him anticipated the Delft school. Illustration:

 $THEODERICH \rightarrow Master$

301 The Duo, 1628

THORN-PRIKKER Jan

1868 The Hague – 1932 Cologne After studying in The Hague, Thorn-Prikker was professor at the Munich school of applied arts, 1920-1923, then taught in Düsseldorf and later at the school of applied arts in Cologne. He was one of the most prominent representatives of the Dutch Jugendstil, but also incorporated elements of pointillism and Symbolism. His major concern was with the applied arts, which he led to new heights. His most important work in this field was his stained glass, with which he found many followers in Germany. He also produced ceramic and batik works. His paintings follow the ornamental principles of the Jugendstil with themes of a mostly symbolist, allegorical content. With his geometrical stylisation he often came close to abstract art. Illustration:

525 Madonna among the Tulips, 1893

TIEPOLO Giovanni Battista

(also: Gian Battista Tiepolo) 1696 Venice – 1770 Madrid

Tiepolo was the son of a ship-broker. His teachers were Lazzarini and the old masters, amongst whom he studied Titian and Tintoretto and in particular Veronese, to whose style he owed much. In 1719 he married a sister of the painter Guardi. His eldest son was Giovanni Domenico, who later became his assistant and successor. Tiepolo's early work still showed the influence of Piazzetta, Bencovich and Ricci. A high point in his early career were the frescos in the archbishop's palace in Udine (ill. p. 376), which anticipated his mature style. The sombre 17th century tonality was giving way to a light, transparent palette. This new lightness also determined the coloration of his many panel paintings. In the 1740s his son became his most faithful assistant in dealing with the large number of often extensive commissions flowing in from Venice, Milan, Bergamo and Vicenza. His finest achievement and largest of undertakings abroad was the commission by the Prince-Bishop of Würzburg to decorate the ceiling of the Kaisersaal and the huge staircase of his nearly completed residence at Würzburg with historical and allegorical scenes glorifying the bishopric and the noble family to which the Prince-Bishop belonged. A further period of eight years filled with a wealth of commissions in and around Venice went by before a second call from abroad arrived. In 1762 Tiepolo and his son travelled to Spain, partly on a diplomatic mission, but mainly to follow an invitation by Charles III to decorate the royal palace in Madrid. Tiepolo never returned to Italy but died in Madrid, where his art was to be replaced by Neo-Classicism as expounded by Winckelmann who had an influential follower in Mengs.

Tiepolo's son Giovanni Domenico (1727–1804), besides acting as assistant to his father on large commissions, was an original painter of religious and secular works in his own right. He brought his father's enigmatic imagination into the bizarre world of the *commedia dell'arte*, the fun-fair and carnival genre, in which his cool tonality became increasingly rationalised. Like his father he was also a master of drawing and of the graphic arts.

 ${\it Illustrations:}$

- 339 St Charles Borromeo, c. 1767–1769
- 375 Rinaldo and Armida, 1753
- 376 Rachel concealing the Images of the Gods,
- 376 Sarah and the Archangel, 1726–1728
- Hagar and Ismael in the Wilderness, c. 1732

TINTORETTO

(Jacopo Robusti)

1518 Venice - 1594 Venice In the great triad of 16th century Venetian art, Tintoretto upheld Mannerist principles more rigorously than either Titian or Veronese. Jacopo Robusti, called Il Tintoretto because his father was a dyer by trade, was trained in the workshop of Titian. He was first mentioned as master in 1539. Between 1548 and 1563 he painted several large-scale pictures of the "Miracle of St Mark". They stand out in their vehement dynamism achieved by bold foreshortening and exaggerated gestures. This was new in Venetian painting, as was the plastic modelling of the forms which went beyond Michelangelo's inventions. Also, the overall unity of the composition was disturbed by flickering light. It is not known whether Tintoretto ever went to Rome, but he is said to have made studies of copies of Michelangelo's and Giambologna's paintings and of ancient art, even for his later works, when light became the determinant factor in his art. According to Marco Boschini, Tintoretto used to set up a scene with

small wax figures equivalent to the painting he had in mind, and then experimented with light sources. From 1564 to 1587 he was engaged in the decoration of the Scuola di San Rocco; the comprehensive scope of this work demonstrates the quality and range of his talents. Alongside works of the highest order stood those in which the virtuoso effect gained the upper hand. But it has to be taken into account that Tintoretto had a large workshop and inexhaustible energy which made any commission welcome.

Illustrations:

- The Origin of the Milky Way,
- c. 1575–1580 (?) 182 St George and the Dragon, c. 1550–1560
- 182 Christ with Mary and Martha, c. 1580
- Vulcan surprises Venus and Mars, c. 1555Susanna at her Bath, c. 1565

TISCHBEIN Johann Heinrich Wilhelm

1751 Haina (Hesse) - 1829 Eutin

Tischbein belonged to an artistic family branching out in all directions, and in whose circle he received early instruction. After studying under his uncle Johann Heinrich Tischbein the Elder at Kassel, another uncle, Johann Jacob Tischbein, took over, with whom he worked in Hamburg and Holland. From 1777 to 1779 he worked as a portrait painter in Bremen and Berlin. He then went to Italy, remaining there for almost twenty years. His friendship with Goethe produced the well-known portrait "Goethe in the Roman Campagna" (ill. p. 395), which he completed in Rome in 1787. In 1789 he was appointed director of the Accademia di Belle Arti in Naples. After returning home and settling in Hamburg in 1801, he was called seven years later to the court of the Duke of Oldenburg, at whose court in Eutin he worked until his death. Illustration.

395 Goethe in the Roman Campagna, 1787

TITIAN

(Tiziano Vecelli)

between 1473 and 1490 Pieve di Cadore (Venetia) – 1576 Venice

Titian was the most outstanding painter of the 16th century. At a time when Mannerist tendencies became prevalent, he took over the heritage of the High Renaissance and carried it further. Although the standards of "classical art" of about 1500 were his guideline, he endowed them with a new dynamism for greater effect. He played a unique role in the history of colour and found ways of achieving unprecedented freedom in pictorial composition, making him not only the most important precursor of European Baroque (Rubens), but also a lasting influence on painters until the late 19th century. Manet, for example, studied and copied his work in the Louvre.

Titian's training under Giovanni Bellini was decisive for his career. In his workshop he probably also worked with Giorgione, his senior by ten years. The artistic temperament of these two young painters was obviously closely related, because to this day their contributions are inseparable in some pictures. Titian's "Assumption of the Virgin" altarpiece in Santa Maria dei Frari in Venice (1516–1518) represented an important innovatory development in Venetian painting, both in composition and handling of colour. With this work, he had created an entirely new type of altarpiece which was to set a standard for the future, also in terms of dimension and the way it merged with the space of the building. It ushered in a "proto-Baroque" phase in Titian's development. His "Madonna with Saints and members of the Pesaro family" (1519-1528, also in Frari) represented a similar milestone in the "Sacra Conversazione"

field. Apart from altarpieces Titian painted religious pictures, mythological, poetical and allegorical subjects, and excelled as a portrait painter. The constant refinement of his painterly devices made the canvas his ideal medium, according the fresco a background role.

Already in 1530 Titian had become of European eminence. In 1533 the Emperor Charles V called him to his court and made him a Count Palatine. But Titian never left Venice for very long. In his late work colour achieved an almost "Impressionistic" effect ("Annunciation", Venice, San Salvatore, 1565; "Christ Crowned with Thorns", ill. p. 178). By abandoning all outlines, he contrived to let air, light and colours unify the scene, so transcending earthly experience. Illustrations:

- Portrait of a Bearded Man ("Ariosto"), c. 1512
- 176 Venus of Urbino, c. 1538
- 176 Bacchanalia (The Andrians), c. 1519/20
- 177 La Bella, c. 1536
- 178 Christ Crowned with Thorns, c. 1576
- 178 Pietà, c. 1573–1576

TOBEY Mark

1890 Centerville (Wisconsin) – 1976 Basle Tobey began his career as a fashion designer. In 1922 he took up the study of Chinese calligraphy and the teachings of Eastern philosophy, specialising in the Baha'i religion. He travelled extensively in Europe and the Middle and Far East, also spending periods in a Zen monastery in Japan. His "white writings", a network of fine, calligraphically modelled patterns, initially showed slight representational elements, but became increasingly abstract, being an expression of his meditative-contemplative approach to life. Tobey settled at Basle in 1960, where the humanist tradition appealed to him, but he also spent periods in Seattle, Chicago and New York.

Illustration:

635 North-west current, 1958

TOMMASO DA MODENA

c. 1325/26 Modena – before 16.7. 1379 Tommaso was the son of a painter called Barisino dei Barisini, and his own son Bonifacio also became a painter. Tommaso was probably trained in Bologna. By the mid-14th century the Bolognese School with masters like Vitale da Bologna had eclipsed Tuscan art. Tommaso obviously also had knowledge of Sienese art, including the works of Simone Martini. He probably produced miniatures as well as panel paintings. He lived and worked in Modena, but carried out commissions all over northern Italy. Most notable were his frescos in Mantua and Trento as well as those in Treviso. The Emperor Charles VI commissioned him to paint panel pictures for Karlstein castle. His most famous work, however, is the series of portraits of Dominican theologians of 1352 which he painted for the chapter hall in the Dominican church of Treviso, which showed him to be a shrewd reader of character. The heads of these "famous men" of the order are beautifully drawn, sitting in their little studies, and arranged in order of their clerical importance. Tommaso seemed to be happiest in rendering the figure or groups of figures, without much interest in spatial problems.

Illustration:

The Departure of St Ursula, c. 1355–1358

TOOROP Jan

1858 Poerworedio (Java) – 1928 The Hague The son of a Dutch government official stationed at Java, Toorop studied at the Technical College in Delft, 1876–1878, at the Reichsakademie in Amsterdam, 1878–1880, and finally at Brussels Academy, 1880–1882. He was influenced by Gustave Courbet and James Ensor. In 1884 he met Whistler in London and became a member of the Belgian group of artists Les XX, where he showed his work regularly.

On a visit to Paris in 1885 he discovered Seurat and began to paint in the pointillist manner. In 1886 he moved to The Hague, and in 1892 he organised the first large van Gogh exhibition in Holland. In the 1890s he adopted Symbolist elements and became the most important representative of Dutch luminism, a technique in which adjoining broad colour dots achieve the appearance of a mosaic. In 1911 he became president of the Moderne Kunstkring. After converting to Catholicism in 1905 he began to concentrate on religious and mythical subjects.

Illustration:

525 The Three Brides, c. 1892/93

TOULOUSE-LAUTREC Henri de

1864 Albi – 1901 Château Malromé (Gironde) Toulouse-Lautrec was the descendant of an old French noble family. He broke both legs in childhood and this prevented their normal growth. Though saved by the family fortune from any financial worries, he resolved on taking up painting as a profession, studying under Cormon from 1882-1886. There he met Bernard and van Gogh, amongst others, and began to paint in light colours in an Impressionistic manner. His subject matter became intimately connected with the life he led. He frequented theatres, cabarets, circuses, bars, dance-halls and brothels, rendering these scenes realistically but as seen through the lens of his genius. He showed his work on Montmartre. He spent every summer by the sea. In 1886 he had a brief relationship with the model Suzanne Valadon, who was also a painter, and during this year his first drawings were published in magazines. In 1888 he showed his work at the Les XX exhibition in Brussels, and Théo van Gogh bought one of his pictures for the Goupil gallery. In 1889 he exhibited for the first time at the Salon des Indépendants and became a regular at the newly-opened Moulin Rouge. In 1890 he went with Signac to the Les XX exhibition in Brussels, then visited Spain. In 1891 he joined the Impressionists and Symbolists at their exhibition in the gallery Le Barc de Boutteville and began to produce posters in a novel, stylised manner for bars, music-halls and book publishers. His poster of the singer Aristide Bruant made him famous overnight. In 1892 he visited Brussels and London.

In 1893 he had his first one-man exhibition at Goupil and contributed to other exhibitions. From time to time he lived in brothels to draw and paint there. Between 1894 and 1897 he travelled in France and Belgium, Holland, Spain, London and Lisbon. He exhibited at the Salon Libre Esthétique in Brussels, had contact with the Nabis group of artists and the journal La Revue Blanche, and became increasingly dependent on alcohol. He collapsed in 1899 and was taken to mental hospital in Neuilly, against which his friends protested, but he continued to drink. In 1901 he suffered a partial paralysis and died at his mother's château. Toulouse-Lautrec painted with verve and excelled in graphic art. His lithographs and posters are still being copied today. Only lightly touched by Impressionism, his work had a stamp of its own, characterised by his handling of line and the dynamic use of colour. Illustrations:

487 Jane Avril Dancing, 1892

516 Two Women Dancing at the Moulin Rouge, 1892

Henry Samary, 1889

517 The Clownesse Cha-U-Kao, 1895

518 The Toilette, 1896

518 Interior in the Rue des Moulins, c. 1894

TROGER Paul

1698 Welsberg near Zell (Tyrol) – 1762 Vienna Little is known about Troger's beginnings. He went to Italy, visiting Venice, Rome and Naples. There he became influenced by the works of Pittoni and Solimena. His first great work was the cupola fresco in the Kajetanerkirche in Salzburg, 1727. In his development as a fresco painter he soon abandoned the sombre, dark tonality of his early work in favour of a more colourful palette which, inspired by Rottmayr, achieved an increasing lightness in his late work (Maria Dreieichen, 1752). In his panel paintings he never achieved this but continued to present his religious scenes in dark contrasts of light and shade. In his frescos he skilfully adapted his handling of colour and his composition to the architecture and the spatial conditions. His spontaneous, often even sketchy approach became a source of inspiration to many significant fresco painters, including Bergl and Maulbertsch, Knoller and Zeiller. Illustration:

393 St Sebastian and the Women, c. 1746

TRÜBNER Wilhelm

1851 Heidelberg – 1917 Karlsruhe Trübner studied at the Karlsruhe Academy under K.F. Schick in 1867/68 and at the Munich Academy under A. von Wagner in 1868. At the International Art Exhibition in Paris he became acquainted with the works of the Impressionists. In 1869 he received private tuition in Stuttgart, and in 1870 he took up his studies again at the Munich Academy. He met Leibl in 1871, who advised him to leave the Academy, and in the same year he joined the Munich association of realist painters. In 1872/73 he went with Carl Schuch to Italy, in 1873 to Brussels and then to the Chiemsee where, from 1890, he spent many summers. From 1875 to 1884 he again lived in Munich, and in 1876 he painted with Schuch in Weßling and Bernried. In 1879 he visited Paris, and in 1884 London. In the 1890s he began to abandon his dark tonality and gradually adopted the light colouring of the Impressionist manner. With his friends Corinth and Slevogt he joined the Munich Secession in 1894. From 1896 he taught at the Städelsche Kunstinstitut in Frankfurt am Main, then was appointed professor at the Karlsruhe Academy in 1903, where he worked until 1907.

Illustration:

532 Landscape with Flagpole, 1891

TÜBKE Werner

born 1929 Schönebeck (near Magdeburg) After an apprenticeship as a decorator and training at a craft school in Magdeburg, Tübke went to Leipzig to study at the College of Graphic Arts. This was followed by further studies at Greifswald University, where his subjects were art history and psychology. From 1954 he worked as a painter in Leipzig. He began to lecture at the Leipzig Academy in 1964, was appointed professor in 1972, and held the post of rector for some years. In 1984 he taught at the Salzburg summer academy. In the early 1970s came his first opportunity to visit Italy, and the direct contact with the Italian masters became important for his work. His sometimes monumental historical paintings and murals show undeniable traces of the old masters. As an official artist Tübke participated at the documenta 3 (1964), the documenta 6 (1977) and showed his work at many other exhibitions abroad. In 1973 he

was made rector of the Leipzig College of Graphic Arts. Between 1983 and 1989 he painted with the help of assistants the panorama of the Peasants' War in Bad Frankenhausen, which measures 1722 square metres and is the largest work in oil in the world.

Illustration:

69 Portrait of the Libvestock Brigadier Bodlenkov, 1962

TURA Cosmè

(Cosimo)

c. 1430 Ferrara - 1495 Ferrara About the middle of the 15th century Ferrara developed under the rule of Borso d'Este into a cultural centre of the first order, particularly in the field of painting. Here an independent school evolved which stood in sharp contrast to those in Tuscany, Lombardy and Venice. Of this, Tura was the leading master and oldest representative. Being of about the same age as Mantegna, he had, as Mantegna, studied under Francesco Squarcione in Padua, where he had obviously taken a great interest in the works of Donatello. On his return to Ferrara in 1456 he was appointed court painter to Borso d'Este. Unfortunately details on his manifold activities there are scanty, but his surviving panel paintings give a glimpse of his artistic personality. Architectural elements inspired by Antiquity (organ wing depicting the Annunciation, in the cathedral museum, Ferrara, 1469), fantastic landscapes, sharply outlined almost like etchings, and brilliant perspectival constructions which defy logical spatial unity, add up to a style which in varying degrees characterised the artists of the Ferrara School (Francesco del Cossa, Ercole de'Roberti). Tura's Roverella Altarpiece, dating from before 1474 (only the central panel with the Madonna Enthroned survived, now in London, National Gallery), exemplifies his style in its abstract spatial composition and ornamental grouping of figures reminiscent of heraldic principles. Between 1460 and 1470 Tura collaborated with Cossa in painting the Pictures of the Months in the Palazzo Schifanoia; their respective contributions cannot always be separated (ill. p. 113). Illustration:

113 St George and the Dragon and The Princess, c. 1470

TURNER J.M.W.

(Joseph Mallord William Turner) 1775 London – 1851 London

Turner was only fourteen years old when he was admitted to the Royal Academy. He started his career by painting water-colours and producing mezzotints which were strongly influenced by John Robert Cozen's work. He started painting in oil from 1796 in the Classicist manner of Wilson and Poussin, and these paintings found general approval. Turner, who was one of the most prolific painters of his time, made extensive travels in many parts of England, Scotland and Ireland, and also on the Continent (France, Belgium, Holland, Germany, Italy).

In 1802 he made his first visit to Paris, studying the old masters in the Louvre, giving particular attention to Dutch seascapes and Claude Lorrain, which greatly influenced his work. In 1804 he had his first private exhibition in his own house. During this period his style was beginning to evolve; atmospheric light effects were gaining in importance. His visits to Italy in 1819 and 1829 completed this process.

Like the works of Constable, his seemingly effortless water-colours and oil-sketches were drawn from nature, as for example his series of landscapes painted from a boat on the Thames in 1807. But his way of seeing the world differed vastly from Constable's view. Turner's pictures transcend the ordinary world; they are visions conveying the power of nature. In his atmospheric depictions of shipwrecks and natural disasters, perhaps inspired by such works as the "Battle of Trafalgar" by Loutherbourg, who lived in Turner's neighbourhood, reality and fantasy merge, and colour becomes a metaphor for the power of natural forces. By abandoning form or showing it only in shadowy outline, Turner endowed colour with a power of its own. This development was to be especially influential on the art of the 20th century. Illustrations:

- A19 Rome from Mount Aventine, 1836
- 468 Snow Storm. Hannibal and his Army crossing the Alps), ca. 1810–1812
- 468 Peace Burial at Sea, 1842
- The "Fighting Téméraire" Tugged to her Last Berth to be Broken Up, 1838
- 470 Rain, Steam and Speed The Great Western Railway, 1844
- 470 Snow Storm Steam-Boat off a Harbour's Mouth making Signals in Shallow Water, and going by the Lead. The Author was in this Storm on the Night the Ariel Left Harwich, 1842

TWOMBLY Cy

born 1929 Lexington (Virginia)
In 1948/49 Twombly studied at the Boston School of Fine Art, and in 1950/51 at the Art Students'
League, then at the Black Mountain College. The next few years he lived partly in Europe, partly in America, until settling in Rome in 1960. He usually produces a series of pictures, bringing them together in cycles. From abstract Expressionism he developed his own, strongly calligraphic idiom. His pictures have a strongly modelled background with rhythmically interwoven, blurred lines in delicate colouring.

Illustration: 678 Pan (part four), 1980

UCCELLO Paolo

c. 1397 Pratovecchio (near Arezzo) – 1475 Florence Uccello was one of the most versatile founders of the Italian Early Renaissance, although his later reputation did not reflect his true significance. His first formative experience came from working with Ghiberti, whom he assisted with the decoration of the paradise doors of the Florence baptistry. Nothing survives of his contribution to the mosaics of San Marco in Venice, but his frescos of the Genesis in the Chiostro Verde of Santa Maria Novella in Florence (c. 1430) show that he was a follower of Ghiberti and that he was firmly rooted in the International Gothic style (Gentile da Fabriano, Pisanello). It comes therefore as a great surprise to note his change of direction in the 1430s. Developing an intense interest in perspective under the influence of Masaccio's and Donatello's works, he became engrossed in the problem of rendering figures that would stand out in space and appear solid and real. His first great achievement was the equestrian picture of John Hawkwood (ill. p. 96), followed by the Noah scenes in the Chiostro Verde in Santa Maria Novella (c. 1450), which anticipate Mannerist pictorial construction, such as the spatial "crater" in the Flood scene with its effect of compelling the eye to travel down into the depth. Proof of Uccello's obsession with perspective are his drawings in the Uffizi of objects which he made look transparent in order to be able to show them in their stereometric complexity. Unfortunately he outlived his own time: after painting his three battlepieces of "Battle of San Romano" (ill. p. 97), commissions dwindled away as general taste changed and demanded courtly refinement.

Illustrations:

- 96 Equestrian Portrait of Sir John Hawkwood, 1436
- 96 St George and the Dragon, c. 1456
- 97 Battle of San Romano (left panel), c. 1456
 - Battle of San Romano (centre panel), c. 1456
- 97 Battle of San Romano (right panel), c. 1456

UHDE Fritz von

1848 Wolkenburg (Saxony) - 1911 Munich Uhde's talent was recognised and supported by his parents. After passing his school-leaving examinations, he enrolled in 1866 at the Dresden Academy. He left after only a few months to pursue a military career, c. 1867-1871, advancing to cavalry captain. He studied painting in his spare time. In 1876 he visited Hans Makart in Vienna, whose dark, dramatic style influenced him. Makart refused him as pupil, and after a stay in Paris, in 1879 Uhde also tried in vain to be accepted by the Academy in Munich. He settled in Munich in 1880, where he met Liebermann who introduced him to painting in the open and encouraged him to visit Holland in 1882. In 1892 Uhde became a cofounder of the Munich Secession. He developed a manner of painting reminiscent of Impressionism, but his approach was realistic. His subjects were mostly of a religious nature, Biblical scenes presented in modern dress. Illustration:

In the Garden (The Artist's Daughters), 1906

UTRILLO Maurice

(Maurice Valadon)

1883 Paris - 1955 Dax (Landes) Utrillo was the illegitimate child of the painter Suzanne Valadon. He lived an unsettled life and developed a dependency on alcohol. In 1902 his mother was advised by a doctor to encourage him to paint. This did not cure him of his addiction, but proved that he had an astonishing natural talent. His output was large, although his work was repeatedly interrupted by periods of treatment in clinics. His main theme was the streets of Montmartre, and he had no problem selling these pictures. From 1909 he rarely painted from nature, using picture postcards as his model. After a suicide attempt in 1924 he retired to his mother's home, the Castel St.-Bertin (Ain). There he returned to producing graphic works at the encouragement of his publisher Frapier. It was not until the 1930s that Utrillo was able to free himself of his addiction. He married, and organised many exhibitions. His success with his street scenes probably caused him to look no further for other subjects.

562 Impasse Cottin, 1911

Illustrations:

VALDÉS LEAL Juan de

1622 Seville – 1690 Seville

Valdés Leal, who was trained by Castillo y Saavedra in Córdoba, developed a very personal, unusual style which he retained all his life. Already in the pictures painted for the Clares of Carmona in 1653/54 ("Saracens Attacking the Monastery of St Francis") he showed a high degree of exaltedness in form and expression which was to mark the entire work of this last great exponent of Andalusian Baroque. Within his style he employed two diverse ways of treating colour side by side, one being marked by a palette of delicate, fine pinks and grey tones of lucid quality, and the other by deep, often sombre shades of green, violet and deep reds. While he employed the first method for a series of pictures of the St Jerome cycle for the monastery of San Jeronimo

in Seville (1657/58), he chose the second technique for greater effect in his two large Vanitas Allegories for the hospital de la Caridad, also in Seville (1672). *Illustration*:

268 Allegory of Death, 1672

VALENTIN DE BOULOGNE

(also: Jean de Boullongne) 1594 Coulommiers – 1632 Rome

As the most important representative of the French Caravaggists, Valentin de Boulogne came to Rome in 1612, where he was introduced to Caravaggio's work by Vouet and Manfredi. Valentin subsequently developed geometrical rules to deal with chiaroscuro, working out a system for light and shade effects. In Rome he belonged to a group of Scandinavian and German artists who called themselves "Bentvögel" and had chosen the motto "Bacco, Tabacco e Venere" (To Bacchus, tobacco and Venus). Through this group he came into contact with thieves, drunks, prostitutes, receivers of stolen goods and other members of an underworld which he vividly portrayed. Apart from scenes of popular and soldiering life ("Disputing Card-Players" Tours, Musée des Beaux-Arts; "Musicians and Soldiers", Strasbourg, Musée des Beaux-Arts), he also produced religious works, preferably scenes from the Old Testament ("Judgment of Solomon", Paris, Louvre; "Judith and Holofernes", Valletta, Nationalmuseum).

Illustration:

244 The Concert, c. 1622–1625

VALLOTTON Félix

1865 Lausanne – 1925 Paris

Vallotton came to Paris at the age of 17 to study at the Acádemie Julian. There he became impressed by the works of van Gogh, Gauguin and the Symbolists. It became his maxim never to aim at painting anything as it can be seen in nature. In his work he combined Symbolist and Art Noveau tendencies, and it is marked either by a dream-like aestheticism or a cold, revealing realism. He painted landscapes, portraits and genre scenes and also perfected the art of the woodcut, producing many single works and also some series. His realist pictures influenced the artists of the Neue Sachlichkeit. Illustration:

528 Sandbanks on the Loire, 1923

VARIN Quentin

c. 1570 Beauvais – 1634 Paris

Today his name is usually mentioned in connection with Poussin, whose first teacher he was. Varin himself was trained in Beauvais by François Gaget, then worked as a journeyman in the workshop of Duplan in Avignon (1597–1600). Maria de'Medici became his patroness in Paris, where he also assisted in decorating the Luxembourg and became "peintre du Roi" in 1623. He adopted some formal elements of the Fontainebleau school by emulating them at a somewhat superficial level, and painted his figures in strangely elongated proportions on his oversized canvases.

Illustration:

240 Presentation of Christ in the Temple, c. 1618–1620

VASARÉLY Victor de

(Gyözö Vásárhelyi)

born 1908 Pécs (Hungary)

From 1928 to 1930 Vasarély studied under Sándor Bortnyik who introduced him to the works of the Russian Constructivists, an influence that was to remain with him. In 1930 he settled in Paris, where he worked as a graphic artist. From 1944 he devoted himself again to painting and produced works which were the result of the systematic observation of optical stimuli generated by graphic means. Art was to do away with conventional means and to utilise modern media and techniques, thus becoming part of everyday life. By playing with variations on geometrical abstractions he arrived at his dazzling optical patterns, which he patented. Geometric forms in brilliant colours or in black and white are arranged within a grid in such a way that a fluctuating movement is achieved. Vasarély is the most creative representative of Op Art. His first kinetic pictures date from 1951. From 1955 he designed wall pictures made of metal and ceramics, mainly for buildings in France. He has been living in Annet sur Marne since 1961. In 1970 a museum dedicated to him was opened in Gardes (Vaucluse), apart from those in Pécs and Budapest. In 1976 he set up the Vasarély foundation in Aix-en-Provence.

Illustration:

655 Arcturus II, 1966

VELÁZQUEZ Diego

(Diego Rodríguez de Silva y Velázquez) 1599 Seville – 1660 Madrid

Velázquez' father was the descendant of a noble Portuguese family, which was to become a significant factor in his career at the Spanish royal court. He studied briefly under Herrera the Elder, then was apprenticed to Francisco Pacheco whose daughter Juana he married in 1618. During that year his first dated painting was produced. In 1622/23 he travelled with his father-in-law to Madrid, to be introduced at the court. There he was appointed "pintor del Rey", but, as was the custom of the day, without a fixed income. Thanks to Pacheco many valuable details of Velázquez' early career have been handed down. For example he recorded that his sonin-law took samples of his art to present at the court, and these consisted of "bodegones", interior scenes with a strong still life element, such as "The Water Seller of Seville" (London, Wellington Museum, C.1619/20) and "Christ in the House of Martha and Mary" (ill. p. 269). Pacheco remarked that this kind of painting was still new in Spanish art and that he generally disapproved of it unless "painted as Velázquez painted it"

Velázquez' estimation at court rose rapidly. After a painting competition in 1627 he was appointed court door-keeper and later, in 1652, court marshall. Important was his meeting with Rubens, who visited the Spanish court on a diplomatic mission in 1628. Perhaps this inspired him to visit Italy, where he met Ribera in Naples. After having been appointed painter to the royal chamber in 1643, he had another opportunity to visit Italy five years later in order to buy pictures for the royal collection. In Rome he was honoured by being made a member of the Accademia di San Luca after having exhibited one of his pictures publicly. Two years before his death he was made a knight of the Order of Santiago. This was due to the King's mediation, as it required proof of never having earned his living by working with his hands. As one of the foremost artists of the 17th century, he owed something to the School of Seville, but achieved a style which was entirely his own. Although open to the innovations of Titian, Caravaggio and Rubens, he transformed any inspirations he received in his own inimitable manner.

Illustrations:

- Portrait of Philip IV of Spain in Brown and Silver, c. 1631
- 269 Christ in the House of Martha and Mary, c. 1619/20
- 269 Los Borrachos (The Drinkers), 1628/29
- 270 The Surrender of Breda, 1635
- 270 Prince Baltasar Carlos, Equestrian, c. 1634/35

- 271 A Dwarf Sitting on the Floor (Don Sebastían de Morra), c. 1645
- Venus at her Mirror (The Rokeby Venus), c. 1644–1648
- Las Meninas (The Maids of Honour), 1656/57

VELDE Willem van de, the Younger

1633 Leiden – 1707 London

With his father, also a marine painter, Willem came to Amsterdam in 1636. Here his brother Adriaen was born, who became a landscape and animal painter. Willem received early instruction from his father, then was apprenticed to Simon de Vlieger, who specialised in seascapes. In 1652 he was made an independent master in Amsterdam, and in 1672 King Charles II called him to England, where he was made court painter. Together with Capelle he introduced a new type of marine painting, giving his ships individuality as in a portrait and presenting sea-faring as a dramatic event. His sea-battles and ships at sea, usually in calm or only slightly choppy waters, are notable for their precision of detail and fine colour and for the light effects which skilfully convey mood and atmosphere. Illustration:

326 The Cannon Shot, undated

VENEZIANO → Domenico Veneziano

VERMEER Jan

(Jan van der Meer, Jan Vermeer van Delft) 1632 Delft – 1675 Delft

Although Vermeer was one of the greatest of Dutch genre painters, with Frans Hals and Rembrandt, and his work is unique in the history of art, very little is known about his life. He was the son of a weaver in silk and satin, who later became an art dealer and inn-keeper. Vermeer was probably a pupil of Fabritius. In 1653 he married Catharina Bolens, whom he often portrayed in his pictures, and became a member of the Delft Lukas Guild. He worked slowly and therefore his output was small, and insufficient to keep a large family, although he achieved fairly high prices. He tried to supplement his income by acting as an art dealer, but this also failed. Only one of his 36 surviving paintings is dated ("The Procuress", Dresden, Gemäldegalerie, 1656).

'Diana and her Companions" (The Hague, Mauritshuis) and "Christ in the House of Martha and Mary" (Edinburgh, National Gallery) probably date from about 1655, a period when he explored Italian art and came to terms with the Utrecht Caravaggists. These were followed by genre scenes, conversation pieces, in which detail and gestures are still somewhat over-emphasised. The pictures with which Vermeer's name is now mostly associated were painted shortly before and after 1660, including "Girl Reading a Letter at an Open Window",
"The Milkmaid", "Woman Holding a Balance" (ill.
p. 332) and "The Artist's Studio" or "Allegory of Painting" (ill. p. 334). In these intimate scenes, light itself seems to have become the subject of the picture; a moment of stillness captured on canvas. Vermeer stands apart from his contemporary genre painters through his superb draughtsmanship and skill in perspective, his colour harmonies, in which cool blue and a brilliant yellow predominate, and his incomparable ability in setting enamel-like highlights which impart a glow to surfaces. In his late work his treatment of light lost some of its poetry, his drawing became less fluid, and the interiors less simple. On his death his pictures were auctioned off and he was forgotten, and it was not until towards the end of the 19th century that his true significance was recognised.

Illustrations:

- 285 Street in Delft ("Het Straatje"), c. 1657/58
- 332 The Lacemaker, c. 1665
- 332 Woman Holding a Balance, c. 1665
- View of Delft, c. 1658–1660
 Allegory of Painting (The Ar
- 334 Allegory of Painting (The Artist's Studio), c. 1666
- 334 Young Woman Seated at a Virginal, c. 1675

VERONESE Paolo

(Paolo Caliari)

1528 Verona – 1588 Venice

Veronese studied under Antonio Badile in Verona from 1541, but his true masters were the Venetian painters Titian and Tintoretto as well the painters of the Emilia region, including Parmigianino. In 1553 he went to Venice, where he was called Veronese after his place of birth. Veronese was the opposite of Tintoretto: while the latter moved into Mannerism, Veronese's art was securely rooted in the Italian High Renaissance. His works not only reflect the religious and political unrest of his time, but also the love of pomp and worldly splendour of Venetian life. In so far as content often seems to have been subordinated to form in his works, he was also a typical representative of 16th century art. This is why three centuries later Cézanne saw him as the precursor of pure form.

His first large commission was the decoration of the sacristy and ceiling in San Sebastiano, Venice, in 1555/56. For this he executed a great many pictures on canvas with bold perspectival views and foreshortening of figures. During a visit to Rome in 1560 he studied in particular Michelangelo's work in the Sistine Chapel. In subsequent works the impressions he received there found application in the plastic modelling of figures in movement and the further development of illusionistic spatial depth. A major example of this period are his frescos in the Villa Barbaro in Maser executed in the early 1560s (ill. p. 184). Veronese's influence reached far beyond his time. The virtuosity of his composition not only played an important part in the works of Rubens and Tiepolo, but also had many followers amongst the European painters of the Baroque; and his handling of colour remained of importance in French art until the 19th century. Illustrations:

- Allegory of Vice and Virtue (The Choice of Hercules), c. 1580
- 184 Giustiana Barbaro and her Nurse, c. 1561/62
- Allegory of Love: Unfaithfulness, c. 1575–1580
- 185 The Finding of Moses, c. 1570–1575

VERROCCHIO Andrea del

(Andrea di Michele Cione)

c. 1435 Florence – 1488 Venice

Verrocchio was a goldsmith, sculptor, carver and painter, but it was in the field of sculpture that he excelled in the second half of the 15th century. After his training under the goldsmith Giuliano del Verrocchio, whose name he adopted, he schooled himself in the works of Donatello, not in a pupilteacher relationship, however, but in a spirit of idealised rivalry which seeks completely new solutions for one and the same task (statue in bronze of David, c. 1476; equestrian statue of Colleoni in Venice, 1480-1488). While Donatello's approach conveyed a closed, solid strength, Verrocchio excelled in expressing an almost nervous, concentrated energy. And instead of a fixed aspect, he presented his subject from nearly all aspects, and later even all aspects, anticipating the 16th century Mannerist approach.

Little is known about his early work. It was not until 1472 that he made his mark as a leading mas-

ter of his generation with his sepulchral monument for Piero and Giovanni de'Medici (San Lorenzo, Old Sacristy). The culmination of his achievement was the bronze group "The Incredulity of St Thomas" (1464-1482) at Or San Michele. From about 1475 Verocchio's workshop became a kind of academy of arts comparable to that of Lorenzo Ghiberti in the second quarter of the century. It is difficult to separate Verrocchio's works in the field of painting from that of his pupils: a number of important painters were trained at his workshop, Leonardo da Vinci being the most famous of them, and they remained in his workshop longer than was required. Other painters who emerged from this workshop include Lorenzo di Credi, Perugino and Signorelli. Verrocchio's paintings "The Baptism of Christ" (ill. p. 109) and the "Sacra Conversazione" in Pistoia cathedral (1478) are the finest representations of these subjects in Early Renaissance Florentine art, alongside those of Domenico Veneziano.

Illustration:

109 The Baptism of Christ, c. 1475

VIEIRA DA SILVA Maria Elena

1908 Lisbon – 1992 Paris

Vieira da Silva is one of the key figures of the Ecole de Paris. Initially she intended to become a sculptor and received training in Paris from Emile Bourdelle and Charles Despiau, but then changed to painting. In 1928/29 she worked with Orthon Friesz and Léger and was drawn into the circle of young avantgarde painters, but she was also inspired by the works of Bonnard, the late medieval Sienese masters and the Cubists. She began her career by working as an industrial designer and illustrator of books and magazines. From 1940 to 1947 she lived in Portugal and Brazil, then returned to Paris. Her work is often categorised as belonging to the Informel, but she has always remained true to the principle of her own pictorial aesthetic. Typical for her pictures are spatial, architectonic and urban compositions drawn in fine lines and beautiful tonal harmonies which in her later work give place to more abstract, lyrical arrangements.

Illustration:

638 The Library, 1949

VIGÉE-LEBRUN Elisabeth

(Marie Louise Elisabeth Vigée-Lebrun)

1755 Paris - 1842 Paris

Vigée-Lebrun received early training from her father, a painter in pastels. Other teachers and those helpful in her career were Doyen, Vernet, Davesne and Briard. She also copied the old masters, particularly Dutch art. She soon became a celebrated portrait painter and was appointed court painter to Marie-Antoinette. She became a member of the Academy in 1783. She had to leave France in 1789 because of her court connections. From that time she travelled widely, visiting Vienna, Dresden, Berlin, London, St Petersburg and Switzerland, and was inundated with academic honours and commissions. Her emotional, idealising portraits of women and children, which were often criticised for their sentimental touches, were representative of an international style of portraiture already in transition; the characteristics come out more fully in her many self-portraits.

Illustration:

Portrait of Madame de Staël as Corinne, c. 1807/08

VLAMINCK Maurice de

1876 Paris - 1958 Reuil-la-Gadelière As a young man Vlaminck supported himself as a violinist in a suburban orchestra. He was an enthusiastic cyclist and took part in many races. Around

1900 he began to paint with Derain in Chatou in the vicinity of Paris. After a visit to the van Gogh exhibition in 1901 he became intoxicated with colour. Until 1907 he painted pictures in violent brushstrokes and unmixed colours which in their boldness outstripped all other Fauves. In 1908 the Fauvist movement began to split, and Vlaminck temporarily turned to Cézanne and the Cubists for inspiration until he adopted a type of "romantic realism", following Derain's example. His work became darkly dramatic. From 1918 he lived quietly in the country.

Illustration:

564 Les Bateux-Lavoirs, 1906

VOS Cornelis de

c. 1584 Hulst (Zeeland) - 1651 Antwerp Vos was the brother-in-law of Snyder and was accepted as a master in the Antwerp Guild in 1608, but worked as an art dealer for a time. In 1635 he worked with Jordaens as assistant to Rubens on the decorations for the reception of Cardinal Ferdinand. From 1636 to 1638 he worked with Rubens on the decoration of the hunting-lodge Dorre de la Parada near Madrid. Vos was primarily a portrait painter of Antwerp society and of family groups. In their restrained elegance and fine observation of character his portraits approach those of van Dyck. Among his best works were those of children ("The Painter's Daughters", Berlin, Gemäldegalerie), which stand out for their freshness, naturalness, and alertness of expression and fine colouring.

Illustration:

300 The Family of the Artist, c. 1630–1635

VOUET Simon

1590 Paris - 1649 Paris

Vouet received only basic training from his father, a sign painter, but his talent developed rapidly; he is said to have been called to England at the age of fourteen to paint portraits. After visiting Constantinople and Venice, he came to Rome, where he became influenced by Caravaggism in the manner of Valentin ("The Birth of Mary", San Francesco a Ripa, c. 1622). Reni's monumentality, the classical serenity of Domenichino's work and the ideas of Lanfranco and Guercino were also to have a lasting effect. In Genoa, where he met Strozzi, he produced one of his major works, the Crucifixion for San Ambrogio (1622). Louis XIII recalled him to France as "peintre du Roi" (1627) where Vouet always intent on furthering his career and never turning down a commission - produced works of great beauty and loftiness. Apart from painting altarpieces and portraits he also designed tapestries in his richly decorative style. He worked in the royal residence St Germain, the Palais du Luxembourg, Fontainebleau and the Louvre. His most important paintings include "Lot and his Daughters" (Strasbourg, Musée des Beaux-Arts, 1633) and the "Allegory of the Victor" (Paris, Louvre, 1630). In his studio many of the great decorative painters of the age were trained, including Le Brun, Mignard and Le Sueur.

Illustrations:

The Toilet of Venus, c. 1628–1639 22 I Saturn, conquered by Amor, Venus and

Hope, c. 1645/46

VUILLARD Édouard

1868 Cuiseaux (Saône) - 1940 La Baule (Loire-

Vuillard was a life-long friend of Bonnard, with whom he shared a studio, and with whom his work offers a parallel. In 1888 he came to Paris to study at the Académie Julian, and a year later was already participating in founding the Nabis group. Despite his friendship with Gauguin, Maurice Denis and Paul Sérusier, he never adopted Symbolist or pointillist elements. His work shows his interest in Japanese art, and there are also traces of the Art Nouveau style. He is noted for his intimate paintings of domestic interiors and he also painted still lifes, portraits and street scenes in fresh, delicate colours in the Impressionist manner. For Revue Blanche he produced illustrations and designed posters and interiors.

Illustration:

519 Portrait of Toulouse-Lautrec, 1898

WALDMÜLLER Ferdinand Georg

1793 Vienna – 1865 Hinterbrühl (near Vienna) Waldmüller was the most important Viennese representative of the Biedermeier style. His main subjects were portraiture and the landscape, and he later added genre scenes. From 1807 he studied at Vienna Academy, at whose gallery he became curator in 1829 and also professor at the Academy. In the full knowledge of the difficulties of an artist's life - so far his wife, an actress, had provided for both of them - he risked again in the 1840s the financial security that the Academy gave him. As a dedicated Realist he attacked in two polemical papers of 1846 and 1849 the idealist doctrines expounded by his colleagues at the Academy. This led to a cut-back in salary and pension, and Waldmüller lived in rather restricted circumstances in later years. Although finding recognition outside Austria, he was not rehabilitated until 1864. Like his friend Franz Steinfeld, he was interested in colour as seen in daylight. In his landscapes he developed a realism akin to photography and explored particularly the effects of extreme sunlight. Illustration:

455 The Last Calf, 1857

WARHOL Andy

(Andrej Warhola)

1928 Pittsburgh – 1987 New York From 1945 to 1949 Warhol studied at the Carnegie Institute of Technology in Pittsburgh. He then went to New York where he became one of the key figures of Pop Art. While working as an illustrator and graphic artist he developed his technique of the "blotted line", the first step to the reproduction process which was to become the basis of his pictorial work. From 1960 he produced pictures after comicstrips, then motifs from the world of American consumerism, such as Coca-Cola bottles, dollar notes and Campbell soup cans. He also used subjects found in newspapers and magazines, such as snapshots of road accidents. In his New York Factory, which was set up in 1962, he produced his portraits of famous personalities, photographic works, films and music, often in team-work. He also published the magazine Interview and organised TV shows and multi-media concerts with the pop group Velvet Underground. For his later works he chose more conventional subjects, such as old master paintings (e.g. Leonardo's "Last Supper") or Schloss Neuschwanstein built by King Ludwig II of Bavaria. Illustrations:

658 200 Campbell's Soup Cans, 1962

658 Do it Yourself - Landscape, 1962

659 Marilyn, 1964

WATTEAU Jean-Antoine

1684 Valenciennes – 1721 Nogent-sur-Marne As the son of a craftsman Watteau was apprenticed to a decorative painter at the age of eleven. About five years later he left for Paris and joined the Flemish artists' colony in St Germain-des-Prés. His master Claude Gilot introduced him to the world of the theatre and elegant society. After a dispute with

Gilot he painted for the art dealer Sirois scenes from military life in 1709/10. In 1712 he was accepted by the Academy, and five years later he became a member with his "Pilgrimage to Cythera" (ill. p. 349). As this picture did not fit into any of the existing categories, a new one was created, and Watteau became a "peintre des fêtes galantes". In this way Watteau's own creation, the elegant party group, achieved respectability in academic circles. From then on, Watteau's work became dominated by the poetical representation of love. The theatre, music, the conversation piece and mythical scenes, all enter the realm of love. His extremely fine palette reveals Flemish influences, particularly that of Rubens, and his draughtsmanship was superb. His patron Crozat's collection of graphic works by Renaissance masters gave him ample scope for study in this field. Apart from elegant party scenes, Watteau excelled in the portrayal of scenes from Italian comedy. In the last two years of his life he suffered from tuberculosis. He went to London for treatment and on his return retired to Nogent-sur-Marne, where he died, not yet aged forty.

Illustrations:

Scale of Love (La gamme d'amour), 342

c. 1717-1719

L'Indifférent, 1717 349

Pilgrimage to Cythera, c. 1718/19 349

350 Gilles (Pierrot), 1721

The Indiscretion, 1717 350

Fêtes Vénetiennes, 1719

WENCESLAS BIBLE → Workshop

WESSELMANN Tom

born 1931 Cincinnati

From 1951 to 1955 Wesselmann studied psychology at the University of Cincinnati, then attended the Academy of Arts and went for further studies to the Cooper Union in New York, where he settled. Wesselmann is an important representative of American Pop Art. He began his career with collages while under the influence of Matisse and de Kooning - two opposing examples to follow. He then turned to painting interiors, colourful and poster-like, often with female nude figures - a subject he was to return to repeatedly. At the same time he produced collages of food illustrations, sometimes presented in relief form. He is noted for his series 'Great American Nudes" dating from the early 1960s. In the 1970s he produced pictures on freestanding canvases which are an attempt at eliminating the boundaries between painting and sculpture. From about 1983 he has been concentrating on drawings which are transferred to aluminium or steel and then cut out.

Illustration:

661 Bathtub 3, 1963

WEST Benjamin

1738 Springfield (Pennsylvania) – 1820 London West began his career as a portrait painter in Philadelphia and New York. One of his sitters persuaded him to try his hand at history painting, and the result was the "Death of Socrates" (Nazareth, Pennsylvania, Stites Collection), his first attempt in this field. Patrons enabled him to visit Rome by granting him a scholarship, the first American artist to be helped in this way. There he found a new patron in Cardinal Albani. He joined the circle of leading artists gathered in Rome and became friendly with Mengs and Johann Joachim Winckelmann. He was appointed as a member of the Academy, both in Florence and Parma. On his intended return journey to America he stopped off in London in 1763 and remained there for the rest of his life. He had a brilliant career, becoming a founding member of the Royal Academy in 1768 and historical painter

to the royal court in 1772. West was also a respected teacher, especially of fellow American artists in London, including Copley, Trumbull, Sully, Stuart and Pratt.

Illustration:

391 Colonel Guy Johnson, c. 1775/76

WEYDEN Rogier van der

c. 1400 Tournai - 1464 Brussels

Rogier was the leading Dutch painter to follow in the tradition of the brothers Jan and Hubert van Eyck. Unlike any other painter of the 15th century outside Italy, he extended Dutch art in respect of both composition and figure development, and his innovations became widespread in northern art. His influence spread as far as Italy, particularly with respect to his painting techniques, and he was much respected there. Surprisingly late, in 1427, he became a pupil of Campin. To identify his early work as that of his master, as has been attempted, is not tenable. In 1432 he became an independent master, and in 1436 official painter to Brussels city. A visit to Rome in the Holy Year of 1449/50 brought about the most fruitful exchange between northern and Italian art in the 15th century. Rogier continued what Campin and also Jan van Eyck had begun, perfecting anatomical considerations and the perspectival representation of interior space and landscapes. Direct references to the older masters, such as in his various representations of St Luke painting the Madonna, which hark back to van Eyck's Rolin Madonna (ill. p. 123), became far less frequent from about 1440 as he strove to find an artistic balance between space and picture plane. The figures are more sparsely proportioned, interiors and drapery become more elegant, and the realistic depiction of detail gains in importance in the overall design. Illustrations:

88 Crucifixion in a Church, c. 1445

Madonna with Four Saints (Medici 127 Madonna), c. 1450

Descent from the Cross, c. 1435-1440 127

Adoration of the Magi (Columba Altar), 128 c. 1455

Mary Magdalene, c. 1452 129

Entombment, c. 1450

WHISTLER James Abbot McNeill

1834 Lowell (Massachusetts) - 1903 London Whistler grew up in New England. In 1843 the family moved to Russia, where he received his first drawing lessons at the St Petersburg Academy in 1845. On the death of his father in 1849 the family returned to America. In 1851 he became a cadet at the military college at West Point, but decided to follow art as a profession. In 1855 he went to Paris, entering the studio of Gleyre in 1856. Important for his artistic development was his meeting with Fantin-Latour and Courbet; other friends included Manet, Monet and Degas. On his rejection by the Salon in 1859 he left Paris for London. His work during this period showed the Japanese influence. In 1866 he visited Chile. Around 1870 his first "nocturnes" were produced, an exquisite series of Thames etchings, intended to capture the poetic mood of pictorial and musical harmony. This theme was to hold his attention for nearly a decade. From the 1870s he increasingly turned to painting portraits, which formed his major source of income until the 1890s. In 1878 he sued Ruskin for libel. Despite winning a moral victory, Whistler was driven into bankruptcy by the cost of the action. From 1886 to 1888 he was the president of the Society of British Artists In 1892 the Goupil Gallery in London arranged a successful one-man-exhibition of his work. Whistler's aesthetic approach found expression in the subtle effect of delicate colours and

tone values. His portraits, landscapes and interiors exercise great charm. His manner of painting owes less to the analytical technique of Impressionism, but rather more to the colour impressionism developed in the 17th century. Illustrations:

538 Rose and Silver: La Princesse du Pays de la Porcelaine, 1864

Caprice in Purple and Gold, No 2: The Golden Screen, 1864

WILKIE David

1785 Cults (Fife) - 1841 at sea, near Gibraltar Wilkie studied art in Edinburgh and from 1805 at the Royal Academy in London, of which he became a member in 1811. He began his career by painting portraits, but after a great success in 1806 at an exhibition of his genre pictures, he devoted himself for the next two decades almost exclusively to this branch of painting, for which he became famous. His pictures of popular life, often endearing and sometimes with an overtone of caricature, were painted in the manner of the 17th century Dutch genre picture and reminiscent particularly of Ostade and Teniers. They met the taste of the new, rich middle-classes of a country which was poised to become the richest in the world. Between 1825 and 1828 he travelled on the Continent and on his return began to take up history painting. His deep and glowing coloration and generous design show an interest in Correggio, Velázquez and Murillo. In 1840 he embarked on travels in the Near East, visiting Constantinople, Jerusalem and Alexandria. He died at sea during his return to England. Illustration:

467 Reading the Will, 1820

WILSON Richard

1714 Penegoes (Wales) – 1782 Colommendy (Wales)

Wilson was a pupil of Thomas Wright in London and, like his master, specialised in portrait painting to begin with. His visit to Italy (1750–1758) took him first to Venice, then to Rome. While in Italy he decided to abandon portrait painting for landscape, later becoming the first great British landscape painter. The principal sources of his inspiration were Poussin, Lorrain and Vernet, and he also owed something to Dutch landscape painting of the late 17th century. Among his finest works are his English landscape and Welsh mountain scenes, which are executed with topographical accuracy and show great skill in composition and a finely graded palette in the way they convey the expanse and peace of the lakes and hills. Illustration:

387 View of Snowdon from Llyn Nantlle, c. 1766

WILTON DIPTYCH → Master

WITTE Emanuel de

c. 1617 Alkmaar – 1692 Amsterdam Witte, who became a member of the Lukas Guild in 1636, initially painted mythological and religious scenes as well as portraits. When he settled in Delft around 1640, he began to specialise in scenes of church interiors, perhaps having been inspired by Fabritius' perspective art. From 1651, when he moved to Amsterdam, until his death by suicide, he concentrated almost exclusively on architectural painting. But unlike Saenredam, whose main concern was accuracy of representation, Witte also painted imaginary buildings or mixed features of several churches. He chose unusual interior sections, in which architectural elements often appear askew,

and used light effects in the typical Delft manner, so that the atmosphere thus created seems to become the actual subject of the picture. His large airy compositions are often relieved by dark figure groups in the foreground, perhaps in conversation or listening to a sermon, and often accompanied by dogs.

Illustration:

320 Church Interior, c. 1660

WITTINGAU → Master

WITZ Konrad

c. 1400 Rottweil - 1445 Basle or Geneva Witz was the most versatile of Germanic artists in the first half of the 15th century. In various respects his significance was comparable to that of Masaccio and Jan van Eyck. His birthplace Rottweil was an important trading centre lying outside the boundaries of feudal or ecclesiastical rule, which might have played a part in Witz's artistic approach to life, although little is known about his early training. Historical records give only a few clues about his life and work. In 1434 he was accepted by the Basle Guild as "Meister Konrad von Rotwil", and in the same year was granted citizenship by the city. His signature and the date 1444 on his painting "Miraculous Draught of Fishes" (ill. p. 142) on the Geneva altarpiece represent the last news of his life and work. Witz was as much concerned with the plastic modelling of figures as with perspectival problems. With his rendering of the polychrome "statue" ("Mirror of Salvation" altarpiece) Witz went far beyond the inventions of both Masaccio and van Eyck. It has been mooted that he might also have worked at woodcarving, but of this no proof exists. The handling of perspective in his interiors ("Annunciation" in Nuremberg; "Mary and Catharine in Church", Strasbourg) may just be based on experience and judgment, but the resulting suggestion of depth is remarkable. In his landscapes and renderings of architecture he always aimed at giving a true and accurate picture of what he saw. It is certain that he had knowledge of Dutch art and possibly also of Italian painting. Illustrations:

142 Sabobai and Benaiah, c. 1435

142 The Miraculous Draught of Fishes, 1444

WOLS

(Alfred Otto Wolfgang Schulze) 1913 Berlin - 1951 Paris Schulze, who called himself Wols from 1937, moved with his family to Dresden in 1919. In 1932 he went to Berlin to apply for training at the Bauhaus. However, on the advice of Moholy-Nagy he went to Paris where he painted, wrote, and worked as a portrait photographer. He met Max Ernst, Léger, César Domela, Arp and Amédée Ozenfant. In 1937 he was the official photographer of the Paris World Exhibition. On the outbreak of war in 1939 he was interned, and after his flight in 1940 he lived in hiding in Cassis near Marseilles, where he made drawings and water-colours. In 1942 he sought refuge in Montélimar. There he met the writer Henri-Pierre Roché, who became his supporter. His first exhibition of water-colours at the Drouin gallery in 1945 was not successful. A year later he returned to Paris, and an exhibition of his work at the same gallery in 1947 became a sensation. He met Sartre and Simone de Beauvoir, who helped him in his further career. He shared his artistic interests with Giacometti and Mathieu. His drawings, water-colours and paintings were at first influenced by the psychic automatism of the Surrealists and produced under the influence of drugs and alcohol. Later he became more interested in

combining vehement brushwork with a structure approaching the relief.

Illustration:

641 Le Bateau ivre, 1945

WOOD Grant

1892 Anamosa (Iowa) - 1942 Iowa City Wood studied at the Minneapolis School of Design and Handicraft (1910/11), then worked as a designer, and from 1914 to 1916 had a silversmith's workshop in Chicago with Christopher Haga. In 1920 he visited Paris, where he attended the Académie Julian in 1923/24. While his early landscapes and portraits were painted in the Impressionist manner, he later adopted a hard, precise realism influenced by German Renaissance art and the Neue Sachlichkeit, with which he had come into contact on his visit to Germany in 1928. On his return to America he founded the Stone City Colony and Art School (Iowa) in 1932 and taught at the University of Iowa from 1934 until 1941. His uncompromising portraits of the farmers and townspeople of the American Mid-West, plus his landscapes, make him an important representative of American Realism.

Illustration:

601 American Gothic, 1930

WORKSHOP OF THE GERONA MARTYROLOGY

active about 1405-1425

This work combined a number of different styles in manuscript illumination, although a convincing differentiation has a yet to be made. The so-called Joshua master of the Antwerp Bible was involved; also the school of the martyrology in the Diocesan museum of Gerona, and of the illuminations taken from the book of John of Mandeville in the British Library. This group of illuminators already dominated the direction taken by Prague miniaturist painters in the first decade of the 15th century and carried on well into the second decade. Stylistically their work combined Western influences with those from northern Italy, and a close connection to panel painting is also detectable because techniques were used normally only to be found in panel painting. To the combined effect of these examples, the workshop added a stricter pictorial composition. Illustration:

The Story of Creation, c. 1415

WORKSHOP OF THE INGEBORG PSALTER

First quarter of the 13th century Entitled after the psalter of Queen Ingeborg of France, second wife of King Philippe Auguste. She came from Denmark, but her husband expelled her from court. A reconciliation took place in 1213, and the psalter was probably given to her on that occasion. It was produced in a workshop in Paris, which employed two principal painters and several assistants. The work of the two miniature artists is of equal standard, and they produced further illuminated manuscripts, both in collaboration and separately, mainly for the French court. A good knowledge of Byzantine art and close contact with contemporary northern French and English masters of illumination can be assumed, as with the works of the Meuse goldsmith Nikolaus von Verdun. The miniatures appear as a complete series of pictures before the text, and without reference to the text, with two double pages of illuminations followed by two blank pages.

Illustration. Embalming of the Body of Christ and The Three Marys at the Empty Tomb. From the Psalter of Queen Ingeborg of Denmark, C. 1213

WORKSHOP OF THE LOUIS PSALTER

Third quarter of the 13th century This royal workshop operating in Paris is referred to by its most important production, the Psalter produced for King Louis IX of France, commonly called Saint Louis. Another magnificent psalter, now in Cambridge, probably belonged to Louis' sister, the Abbess Isabella. The dating of these works can only be estimated by reference to other recorded events and stylistic considerations (after 1258, the year in which one of the King's daughters married the Count of Champagne, but before 1270, the year of the King's death). The workshop was well organised, and there are indications that the master had formerly worked on the illuminations of manuscripts for the royal library of Sainte Chapelle in Paris. Although the work was executed by at least six contributors, the hands are difficult to separate, a sign that the master had impressed his style on his assistants. The uniformity of decoration and pictorial conception point at the mid-13th-century, a period of transition when the first tendencies towards a standardisation of this art become apparent. The basic principles were established, and only the level of refinement and lavish use of rich materials then served as distinguishing features. Illustration:

Joshua Stops the Sun and Moon. From the Psalter of Louis IX of France, c. 1258–1270

WORKSHOP OF THE WENCESLAS BIBLE

active about 1390-1410 in Prague This was actually a loose connection of several workshops led by various masters, some of whom are known to us by name because of their signatures, others having been given tentative names with reference to their work. It is nevertheless acceptable to regard these artists as belonging to the "Workshop of the Wenceslas Bible". As most of their commissions came from royal courts, they must have been conversant with esoteric Symbolism and trends in taste. This meant that some of them must have had close connections to persons in court circles who understood the meaning of the private Symbolism at court and so could invent witty references between the principal picture and the bordering miniatures. The artists took as their starting point the older Bohemian and Italian, particularly Bolognese, art of illumination. At the end of the royal patronage around 1405 - the Wenceslaus Bible, for example, remained unfinished - the workshop was dissolved.

Illustration:

Title illustration to Ptolemy's "Quadripartitus", c. 1395-1400

WRIGHT OF DERBY Joseph 1734 Derby – 1797 Derby

Wright studied under Thomas Hudson in London. In 1771 he became a member of the Society of Art and in 1784 of the Royal Academy. A visit to Italy, 1773-1775, gave him the opportunity to study the old masters. Caravaggio and his followers seem to have fascinated him particularly, as shown in his later work with its dramatic light contrasts. On his return to England he tried briefly to set up a portrait practice in Bath, but then went back to Derby, where he remained. Although primarily a portraitist, he also worked on his discovery of the "scientific genre painting". He developed an understanding of how to refine the effect of lighting in order to bring emotion into an apparently objective atmosphere. In landscapes, too, he was innovative in his use of light sources.

382 Experiment with an Airpump, 1768

ZICK Januarius

(also: Johann Rasso Januarius Zickh) 1730 Munich - 1797 Ehrenbreitstein Zick received early instruction from his father, the painter Johann Zick, who was an exponent of the Rococo "Rembrandt manner" in easel painting, but in fresco painting followed the tradition of Asam and Bergmüller. In 1757 Zick went to Rome to complete his training under Mengs. Nevertheless he remained true to the Bavarian Rococo manner even though some classical elements entered his work. His first important commission was the decoration of the Watteau room in Schloß Bruchsal (1759), and his greatest work in fresco is in the Klosterkirche of Wiblingen (1778–1780). Zick also produced fine panel paintings, etchings and architectural designs. His work is representative of the critical transitional period leading from the Rococo to Neo-Classicism.

Illustration

395 Gottfried Peter de Requilé with his two sons and Mercury, 1771

ZIMMERMANN Johann Baptist

1680 Gaispoint (near Wessobrunn) – 1758 Munich Zimmermann grew up in the arts and crafts milieu of Wessobrunn which is famous for its school of stucco-work. He received his training as a painter in Augsburg. It appears that he worked as a stuccoer until 1720. As a fresco painter he often collaborated with his brother Dominikus, an architect (e.g. church at Steinhausen, 1730/31). While in other European countries fresco-painting was already in decline in the first half of the 18th century, it still flourished in southern Germany. Belonging to the same generation as Asam, Zimmermann (with his brother) was the leading master of the early Bavarian Rococo. In his ceiling decorations he abandoned the illusionist element and introduced terrestrial zones around the edges so that the open vault of heaven is framed by bucolic or idyllic landscape scenes (Hofkirche St Michael in Berg am Laim, Munich, 1739; Great Hall in Schloss Nymphenburg, Munich, 1757). Architectural elements, ornament and picture merge along the borders. The high point of his art is the decoration of the Wieskirche, one of his brother's late works, where Zimmermann achieved an overall perfection in his handling of colour and design.

Illustration:

392 The Nymph as Symbol of Nymphenburg (Ceiling fresco), 1757

ZURBARÁN Francisco de

1598 Fuente de Cantos (Estremadura) – 1664 Madrid

Zurbarán was trained in Seville in 1616/17 by an unknown painter and settled in 1617 near his

birthplace to paint a large number of religious pictures for the monasteries of Seville. His work included many pictures of saints at prayer and devotional still lifes in the spirit of the Counter-Reformation. His tenebrist style, reminiscent of Herrera the Elder, with its massively simple figures and objects, clear, sober colours and deep solemnity of feeling expressed in thickly applied paint, made him the ideal painter of the austere religion of Spain. In Seville, where he settled in 1629, he became the leading artist. There he produced many altarpieces and decorated a number of monasteries with extensive fresco cycles. His fortunes fell with Murillo's rise. Having been appointed "pintor del rey" in 1634, he was compelled to supplement his income by acting as an art dealer only a decade later. In 1658 he moved to Madrid, where he entered the Santiago Oder. Caravaggio, Velázquez, El Greco, Cotán, Dürer, Raphael, Titian - all these left traces in his work, which is nevertheless of great originality.

Illustrations:

262 The Death of St Bonaventura, 1629

262 St Hugo of Grenoble in the Carthusian Refectory, c. 1633

263 St Margaret, c. 1630-1635

264 The Ecstasy of St Francis, c. 1660

264 Still Life with Lemons, Oranges and Rose, 1633

Acknowledgements

The editor and publisher wish to express their gratitude to the museums, public collections, galleries and private collectors, the archivists and photographers, and all those involved in this work. The editor and publisher have at all times endeavoured to observe the legal regulations on the copyright of artists, their heirs or their representatives, and also to obtain permission to reproduce photographic works and reimburse the copyright holder accordingly. Given the great number of artists involved, this may have resulted in a few oversights despite intensive research. In such a case the copyright owner or representative should make an application to the publisher.

The copyright of all works shown is the property of the artists, unless stated otherwise, or of their heirs, or representatives, or legal successors: Albers: © VG Bild-Kunst, Bonn 1995. – Appel: © De Tulp Pers, Hilversum. – Bacon: © Marlborough Fine Art, Londres. - Balla: Héritiers Giacomo Balla. - Balthus: © VG Bild-Kunst, Bonn, 1995. – Baselitz: © Galerie Michael Werner, Cologne and New York. - Basquiat: © VG Bild-Kunst, Bonn, 1995. - Baumeister: © VG Bild-Kunst, Bonn, 1995. – Beckmann: © VG Bild-Kunst, Bonn, 1995. – Beuys: © VG Bild-Kunst, Bonn, 1995. - Blake: Waddington Galleries Ltd, Londres. -Bonnard: © VG Bild-Kunst, Bonn, 1995. – Botero: © Fernando Botero. Braque: © VG Bild-Kunst, Bonn, 1995. – Brauner: © VG Bild-Kunst, Bonn, 1995. – Burri: © Héritiers Alberto Burri. – Carrà: © VG Bild-Kunst, Bonn, 1995. - Chagall: O VG Bild-Kunst, Bonn, 1995. - Chirico: O VG Bild-Kunst, Bonn, 1995. - Clemente: © Francesco Clemente, New York. - Close: © Chuck Close, New York. - Cucchi: © Enzo Cucchi. - Dalí: © VGBild-Kunst, Bonn, 1995/Demart pro arte B.V. - Delaunay: © VG Bild-Kunst, Bonn, 1995. - Delvaux: © VG Bild-Kunst, Bonn, 1995. - Denis: © VG Bild-Kunst, Bonn, 1995. -Derain: © VG Bild-Kunst, Bonn, 1995. - Dine: © Pace Gallery, New York. Dix: © VG Bild-Kunst, Bonn, 1995. – Doesburg: © VG Bild-Kunst, Bonn, 1995. Dongen: © VG Bild-Kunst, Bonn, 1995. – Dubuffer: © VG Bild-Kunst, Bonn, 1995. – Duchamp: © VG Bild-Kunst, Bonn, 1995. – Dufy: © VG Bild-Kunst, Bonn, 1995. – Ensor: © VG Bild-Kunst, Bonn, 1995. – Ernst: © VG Bild-Kunst, Bonn, 1995. – Estes: © VG Bild-Kunst, Bonn, 1995. – Fautrier: © VG Bild-Kunst, Bonn, 1995. – Feininger: © VG Bild-Kunst, Bonn, 1995. -Fontana: © Archivio Lucio Fontana, Milano. – Francis: © VG Bild-Kunst, Bonn, 1995. – Freud: © Lucian Freud, Londres. – Gertsch: © Franz Gertsch, Rüschegg-Heubach. – Giacometti: © VG Bild-Kunst, Bonn, 1995. – Gorky: © VG Bild-Kunst, Bonn, 1995. – Gris: © VG Bild-Kunst, Bonn, 1995. – Grosz: © VG Bild-Kunst, Bonn, 1995. – Guttuso: © Archivi Guttuso. – Hamilton: © VG Bild-Kunst, Bonn, 1995. - Haring: © Keith Haring Etsate, New York. - Hartung: © VG Bild-Kunst, Bonn, 1995. - Heckel: © Succession Erich Heckel, Gaienhofen. – Heisig: © VG Bild-Kunst, Bonn, 1995. – Hockney: © Tradhart Ltd., Slough, Berkshire. - Hofmann: @ Hans et Maria Hofmann Memorial Galleries, Berkeley. - Hetertwasser: © Jeram Harel Management, Vienne. - Indiana: © Star of Hope, Vinalhaven. - Jawlensky: © VG Bild-Kunst, Bonn, 1995. Johns: © VG Bild-Kunst, bonn, 1995. – Jones: © Allen Jones, Londres. – Jorn: © Jon Palle Buhl, Copenhague. – Kahlo: © Instituto Nacional de Bellas Artes, Mexico City. - Kandinsky: © VG Bild-Kunst, Bonn, 1995. - Kelly: © Elsworth Kelly, Spencertown. - Kiefer: O Anselm Kiefer, La Ribante. - Kippenberger: O Martin Kippenberger, Cologne. - Kirchner: © Galerie Henze & Ketterer AG, Wichtrach/Berne. - Kitaj: © Ronald B. Kitaj. - Klapheck: © Konrad Klapheck, Düsseldorf. - Klee: © VG Bild-Kunst, Bonn, 1995. - Klein: © VG Bild-Kunst, Bonn, 1995. - Kline: © VAGA Inc., New York. - Kokoschka: © VG Bild-Kunst, Bonn, 1995. - Kooning: © VG Bild-Kunst, Bonn, 1995. - Kupka: © VG Bild-Kunst, Bonn, 1995. – Lam: © VG Bild-Kunst, Bonn, 1995. – Léger: © VG Bild-Kunst, Bonn, 1995. – Lichtenstein: © VG Bild-Kunst, Bonn, 1995. -Liebermann: © Marianne Feilchenfeldt, Zurich. - Lindner: © VG Bild-Kunst, Bonn, 1995. – Lissitzky: © VG Bild-Kunst, Bonn, 1995. – Louis: © Garfinkle & Associates, Washington. – Lüpertz: © Galerie Michael Werner, Cologne et New York. – Magritte: © VG Bild-Kunst, Bonn, 1995. – Marquet: © VG Bild-Kunst, Bonn, 1995. – Masson: © VG Bild-Kunst, Bonn, 1995. – Mathieu. © Georges Mathieu, Paris. - Matisse: © VG Bild-Kunst, Bonn, 1995/Succession Matisse. – Matta: © VG Bild-Kunst, Bonn, 1995. – Mirò: © VG Bild-Kunst, Bonn, 1995. – Moholy-Nagy: © VG Bild-Kunst, Bonn, 1995. – Mondrian: © 1995 ABC/Mondrian Estate/Holzmann Trust. - Morandi: © VG Bild-Kunst, Bonn, 1995. – Motherwell: © VG Bild-Kunst, Bonn, 1995. – Mueller: © VG Bild-Kunst, Bonn, 1995. - Munch: © The Munch Museet/The Munch Ellingsen Group/VG Bild-Kunst, Bonn, 1995. – Nay: © Elisabeth Scheibler-Nay, Cologne. – Newman: © Barnett Newman Estate, New York. – Nicholson: © VG Bild-Kunst, Bonn, 1995. – Noland: © VG Bild-Kunst, Bonn, 1995. – Nolde: © Donation Seebüll Ada et Emil Nolde, Neukirchen-Seebüll. – Oehlen: © Albert Oehlen, Hambourg. – Paladino: © Mimmo Paladino, Milano. – Pechstein: © Max Pechstein Communauté d'auteurs, Hambourg. - Penck: © Galerie Michael Werner, Cologne et New York. - Picabia: © VG Bild-Kunst, Bonn, 1995. – Picasso: © VG Bild-Kunst, Bonn, 1995. – Poliakoff: © VG Bild-Kunst, Bonn, 1995. – Polke: © Sigmar Polke, Cologne. – Pollock: © VG Bild-Kunst, Bonn, 1995. - Rainer: © Atelier Arnulf Rainer, Vienne. - Rauschenberg: © VG Bild-Kunst, Bonn, 1995. – Ray: © VG Bild-Kunst, Bonn, 1995. – Reinhardt: © VG Bild-Kunst, Bonn, 1995. – Richter: © Gerhard Richter, Cologne. – Rivera: © Kettenmann de Doniz, Mexico City. - Rosenquist: © VG Bild-Kunst, Bonn, 1995. - Rothko: © VG Bild-Kunst, Bonn, 1995. - Rouault: © VG Bild-Kunst, Bonn, 1995. – Ryman: © John Weber Gallery, New York. – Schlemmer: © Property of the family of Osker Schlemmer. - Schmidt-Rottluff: © VG Bild-Kunst, Bonn, 1995. - Schnabel: © Julian Schnabel, New York. - Schumacher: © VG Bild-Kunst, Bonn, 1995. – Schwitters: © VG Bild-Kunst, Bonn, 1995. – Severini: © VG Bild-Kunst, Bonn, 1995. - Signac: © VG Bild-Kunst, Bonn, 1995. – Slevogt: © VG Bild-Kunst, Bonn, 1995. – Soulages: © VG Bild-Kunst, Bonn, 1995. – Staël: © VG Bild-Kunst, Bonn, 1995. – Stella: © VG Bild-Kunst, Bonn, 1995. - Still: @ Clifford Still, New Windsor. - Stuck: @ Eva Heilmann, Baldham. - Sutherland: © VG Bild-Kunst, Bonn, 1995. - Taaffe: © Philip Taaffe, New York. - Tanguy: © VG Bild-Kunst, Bonn, 1995. - Tapies: © VG Bild-Kunst, Bonn, 1995. – Thorn-Prikker: © Heirs of the artist – Tobey: © VG Bild-Kunst, Bonn, 1995. - Toorop: @ Heirs of the artist - Tübke: @ VG Bild-Kunst, Bonn, 1995. – Twombly: © Cy Twombly, Rom. – Utrillo: © VG Bild-Kunst, Bonn, 1995. – Vasarely: © VG Bild-Kunst, Bonn, 1995. – Vieira da Silva: © VG Bild-Kunst, Bonn, 1995. - Vlaminck: © VG Bild-Kunst, Bonn, 1995. – Vuillard: © Bild-kunst, Bonn, 1995. – Warhol: © VG Bild-Kunst, Bonn, 1995. - Wesselmann: O VG Bild-Kunst, Bonn, 1995. - Wood: O VG Bild-Kunst, Bonn, 1995. - Wols: © VG Bild-Kunst, Bonn, 1995.

The locations and the names of owners of the works are given in the captions to the illustrations unless otherwise requested or unknown to the publisher. Below is a list of archives and copyright-holders who have given us their support. Information on any missing or erroneous details will be welcomed by the publisher. The numbers given refer to the pages of the book, the abbreviations a = above, b = below.

Antella (Firenze), Scala Istituto Grafico Editoriale S.p.A.: 40. - Basle, Öffentliche Kunstsammlung Basel, Kunstmuseum: 599a. – Berlin, Archiv für Kunst and Geschichte: 36b, 39, 44b, 54, 78, 118.f., 122, 144a, 203b, 204, 246a, 533a. -Bottrop, Dr. U. Schumacher: 643b. – Città del Vaticano, Monumenti Musei e Gallerie Pontificie (Photo: A. Bracchetti/ P. Zigrossi): 168f. – Ecublens, Archiv André Held: 242a, 243, 305a, 315a, 320b, 321a, 322a, 324a, 332a, 332b, 349b, 355, 365b, 423a, 424b, 437, 442b, 443b, 444f., 449, 495, 501b, 502b, 509b, 510, 517a, 521b, 523, 524a, 572a, 602b, 638a. – Florence, Raffaello Bencini: 94f. – Graz, Akademische Druck- et Verlagsanstalt: 27a, 27b. – Cologne, Galerie Michael Werner: 674a. – Copenhague, Petersen: 461a, 461b. – London, Tate Gallery: 465, 466a. - Lucerne, Faksimile Verlag Lucerne: 62b, 63, 64a, 64b. - Milano, Gruppo Editoriale Fabbri: 29, 50f., 100f., 108a, 110b, 113b, 115, 117a, 117b, 133, 161b, 164a, 166a, 166b, 171a, 171b, 183b, 184a, 196a, 197a, 200a, 202a, 202b, 225a, 226b, 231b, 233b, 235a, 238a, 239a, 239b, 241b, 246b, 248a, 252b, 253b, 262b, 265a, 290a, 295a, 298a, 299b, 306a, 316a, 333, 351, 354a, 354b, 359, 360a, 364, 365a, 367a, 367b, 368b, 370a, 370b, 373a, 374b, 376a, 376b, 378b, 388a, 391a, 426, 427b, 434a, 443a, 454b, 462b, 463a, 463b, 530a, 530b, 532a, 538a, 538b, 641b. - Munich, Archiv Alexander Koch: 58b, 76a, 103a, 104f., 106b, 112a, 114a, 116a, 123a, 126a, 126b, 127b, 131b, 136, 137, 138b, 140b, 142b, 144b, 178a, 179a, 183a, 184b, 187b, 188a, 189a, 189b, 190a, 192a, 192b, 193, 194, 195a, 195b, 196b, 198a, 201a, 245a, 245b, 247, 249, 254a, 255b, 256a, 260a, 260b, 261, 263, 264a, 265b, 266a, 266b, 269a, 269b, 270b, 271, 272a, 272b, 287a, 288a, 288b, 289, 291, 293, 297, 298b, 300a, 300b, 301a, 301b, 302b, 303, 304a, 304b, 307a, 308a, 308b, 309, 310a, 311b, 314, 317a, 317b, 319a, 319b, 320a, 321b, 323a, 324b, 325a, 326a, 328a, 329a, 329b, 330a, 330b, 331, 334b, 353b, 356, 357a, 363a, 363b, 371, 373b, 374a, 375, 378a, 379a, 379b, 380a, 381, 383b, 384a, 384b, 385, 389a, 389b, 392b, 394a, 395a, 396b, 397a, 397b, 398b, 399, 400, 431, 434b, 440b, 441a, 450b, 451a, 451b, 453, 455a, 455b, 456b, 457a, 457b, 458b, 460a, 464b, 469, 492a, 493, 496a, 499, 500a, 502a, 503, 504b, 506b, 508b, 511a, 512a, 513a, 513b, 515, 516, 517b, 518a, 519a, 526b, 527a, 527b, 529a, 529b, 531a, 531b, 532b, 533b, 534b, 535b, 536a, 536b, 537a, 537b, 542a, 542b, 576b, 578b, 579a, 581b, 583a, 583b, 585b, 586a, 588a, 589a, 589b, 591, 598, 607, 609a, 641a. – Munich, Bayerisches Nationalmuseum: 70b. – New York, Pace Gallery: 660a, 666b. – Paris, Musée Picasso: 402, 544. -Peißenberg, Artothek: 2, 74b, 77, 127a, 143b, 182b, 185, 186, 191, 197b, 256b, 267, 305b, 310b, 323b, 372, 429, 459, 528a. – Prague, Národni Galerii: 45b. – Tokyo, Archiv Kodansha: 227, 559a, 559b. – Venise, Osvaldo Böhm: 120a, 120b, 377. – Weert, Smeets: 313. – Vienna, Kunsthistorisches Museum: 238b. – Vienna, Österreichische Galerie, Belvedere: (Photo: Fotostudio Otto, Vienna): 393a. - Zurich, Thomas Ammann Fine Art: 616, 659. -The remaining illustrations used belong to the collections mentioned in the captions or to the editor's archive, the archive of the former Walther & Walther Verlag, Alling, the former archive of KML, Munich, and the archive of Benedikt Taschen Verlag, Cologne.

Authors

INGO F. WALTHER, studied medieval studies, literary history and the history of art at Frankfurt am Main and Munich. Publications on the history of art and literature from the Middle Ages to the 20th century, including Gotische Buchmalerei (1978); Sämtliche Miniaturen der Manesse-Liederhandschrift (1981); Codex Manesse (1988). Editor of German versions of many international exhibition catalogues, including Paris -Berlin (1979); Salvador Dalí (1980); Pablo Picasso (1980); Paris - Paris (1981). Works published by Benedikt Taschen Verlag include the monographs on Vincent van Gogh (1986); Pablo Picasso (1985); Paul Gauguin (1988) and Marc Chagall (with Rainer Metzger, 1987); the catalogue of works Vincent van Gogh. The Complete Paintings (with Rainer Metzger, 1990), as well as the extensive monographs edited by him - Pablo Picasso (1992) and Impressionisme (1992). Walther is the editor of Masterpieces of Western Art.

HERMANN BAUER, doctorate 1955 with thesis on Rocaille. 1969–1973 Ordinarius for history of art at Salzburg University, from 1973–1994 in same capacity at Munich University. Coeditor and author of Corpus der barocken Deckenmalerei in Deutschland. Book publications include Der Himmel im Rokoko (1965); Kunst und Utopie (1965); Kunsthistorik (1976); Rubens (1977); Holländische Malerei im 17. Jahrhundert (1979); Johann Baptist und Dominikus Zimmermann (with Anna Bauer, 1985); Kunst in Bayern (1985); Klöster in Bayern (with Anna Bauer, 1985); Barock (1992). Contributed the chapter on the Baroque in the Netherlands.

EVA GESINE BAUR studied Germanistik, history of art, musicology and psychology in Munich. Post-doctoral collaboration in a DFG project at Munich University, then work as journalist. Editor and editor-in-chief of various journals. As a freelance journalist since 1989 she works for television and writes books on psychological subjects and art (*Meisterwerke der erotischen Kunst*, 1995). Contributed the chapter on the *Rococo and Neoclassicism*.

BARBARA ESCHENBURG, doctorate 1970 on the sculptor Christian Daniel Rauch; collaboration on catalogues of the Neue Pinakothek in Munich. 1980–1989 worked for Munich Stadtmuseum, since 1989 at Lenbachhaus, Munich. Publications include Spätromantik und Realismus (inventory catalogue of Neue Pinakothek, 1984); Landschaft in der deutschen Malerei vom Spätmittelalter bis heute (1987); Der Kampf der Geschlechter. Der neue Mythos in der Kunst 1850–1930 (exhibition catalogue, Lenbachhaus, Munich, 1995), as well as essays on landscape painting and 19th century German art. In collaboration with Ingeborg Güssow contributed the chapter on Romanticism and Realism.

VOLKMAR ESSERS, doctorate 1972 with a thesis on the sculptor Drake. Since 1975 curator at the Kunstsammlung Nordrhein-Westfalen in Düsseldorf. Collaboration on educational exhibitions about Klee, Picasso, Max Ernst and Kandinsky. Book publications include *Johann Friedrich Drake* (1976); *Paul Klee* (1992); *Julius Bissier* (1993). Monographs on Pierre Bonnard, René Magritte, Max Ernst, Oskar Schlemmer, and others. Benedikt Taschen Verlag published Essers' *Henri Matisse* (1986). Contributed the chapter on *Classical Modernism*.

INGEBORG GÜSSOW, doctorate 1971, then various positions including one with the Bayerische Staatsgemäldesammlungen and the Haus der Bayerischen Geschichte in Munich. Publications on medieval goldsmith's art and museum pedagogy; exhibition catalogue *Kunst und Technik der 20er Jahre* (1980). In collaboration with Barbara Eschenburg contributed the chapter on *Romanticism and Realism*.

CHRISTA VON LENGERKE, doctorate 1980 with a thesis on the history of object representation from Antiquity to the present times. Works as a journalist and art critic; collaboration on books, catalogues and exhibitions. Since 1980 teaches history of art at Munich University. Contributed the chapters on *Impressionism*, Art Nouveau and Jugendstil and on Contemporary Painting.

ANDREAS R. PRATER, doctorate 1974 on Michelangelo's *Cappella Medicea*; postdoctoral work 1984 on *Licht und Farbe bei Caravaggio*. Since 1994 professor of the history of art at Freiburg University. Contributed the chapter on the *Baroque*.

ROBERT SUCKALE, studied at Berlin, Bonn, Paris and Munich. Since 1980 professor of the history of art at Bamberg University, since 1990 at the TU Berlin. Publications include *Die gotische Architektur in Frankreich* 1140–1270 (with Dieter Kimpel, 1985); *Die Hofkunst Kaiser Ludwigs des Bayern* (1993). Has published a great number of works on European art and architecture between 1100 and 1530. Contributed the chapter on the *Gothic*.

MANFRED WUNDRAM, doctorate 1952 with a thesis on Lorenzo Ghiberti. 1955–1957 research at the Institute of Art History, Florence. 1967/68 member of the Harvard University Center for Renaissance Studies in Florence. 1970–1989 professor of the history of art at Bochum University. Publications include Donatello und Nanni di Banco (1969); Frührenaissance (1970); Europäische Baukunst: Renaissance (1972); Raffael (1977); Renaissance und Manierismus (1985); Florenz (1993). Palladio (with Thomas Pape, 1988) published by the Benedikt Taschen Verlag. Contributed the chapters on the Early Renaissance and on Renaissance and Mannerism.

• *